# CABINS

HÜTTEN / CABANES

ILLUSTRATIONS BY
**CRUSCHIFORM**

Philip Jodidio

# CABINS

## HÜTTEN / CABANES

TASCHEN

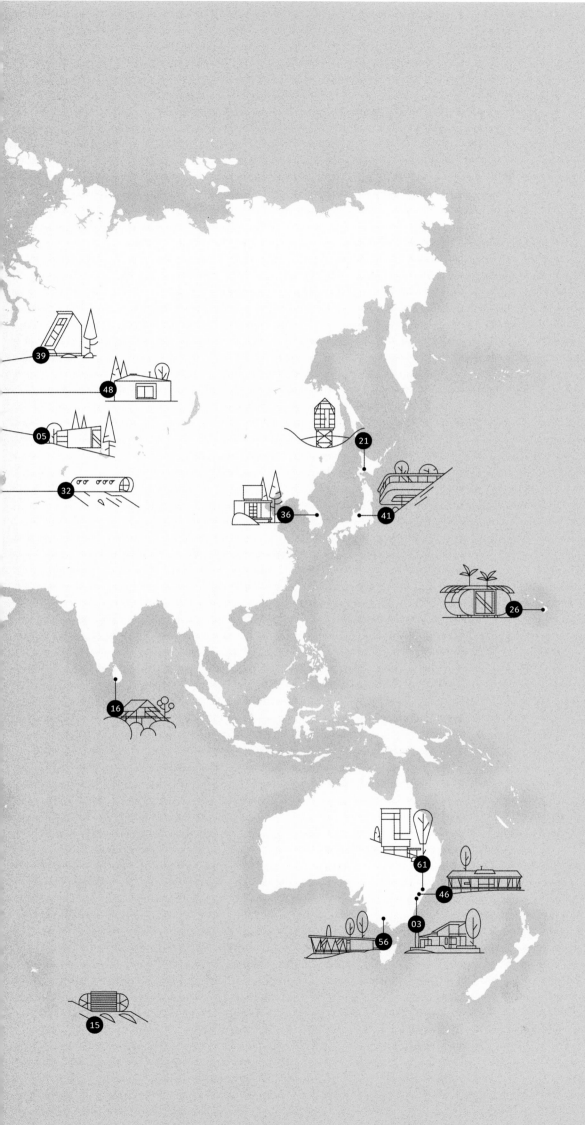

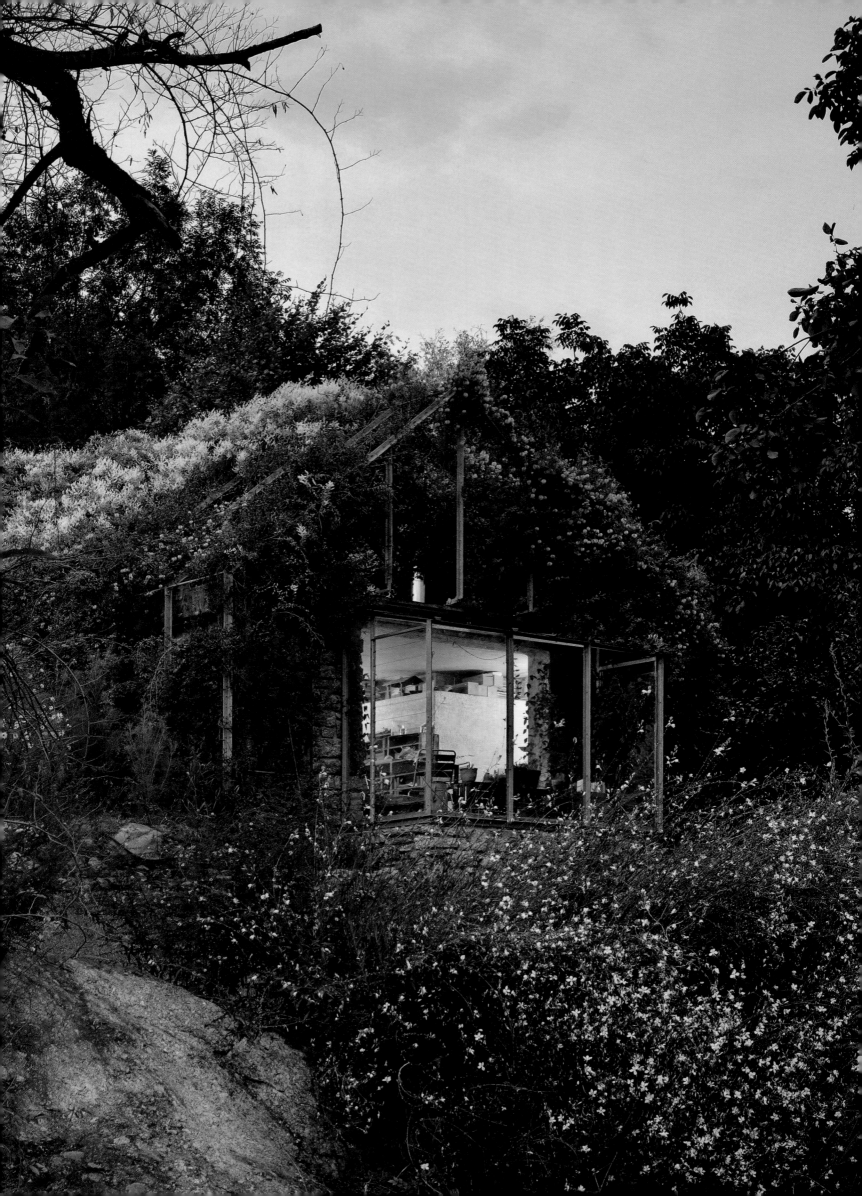

# FIT TO ENTERTAIN A TRAVELING GOD

*I went to the woods because I wished to live deliberately, to front only the essential facts of life, and see if I could not learn what it had to teach, and not, when I came to die, discover that I had not lived. I did not wish to live what was not life, living is so dear; nor did I wish to practice resignation, unless it was quite necessary. I wanted to live deep and suck out all the marrow of life, to live so sturdily and spartan-like as to put to rout all that was not life, to cut a broad swath and shave close, to drive life into a corner, and reduce it to its lowest terms.*

Henry David Thoreau, ***Walden; Or, Life in the Woods,*** 1854

The cabin that the American poet and philosopher Henry David Thoreau built near Concord, Massachusetts, in 1845, and lived in for 14 months, in many respects symbolizes the reasons that men and women seek refuge in very small abodes, far from the stress and pollution of cities. The idea of returning to nature is all the more prevalent today when what remains of the wilderness is severely threatened by urbanization or by the substances that "modern" life disseminates in the air and water. When excess and "luxury" are the driving forces of some societies, more and more people feel the need to scale down to an absolute minimum, to live opposite the rising sun, or to hear the sounds of nature every day. This is not to say that cabins cannot offer a good deal of comfort—in fact the majority of those seen in this book do come with all the amenities of "civilization"—but the reasoning behind building cabins could well bring some to cast aside the vast carbon footprint of everyday life in industrialized societies.

Despite their 19th-century ring, the words of Thoreau, in describing his cabin on Walden Pond, still serve to explain what many seek in building their own small home in the wilderness. He wrote:

*When first I took up my abode in the woods, that is, began to spend my nights as well as days there, which, by accident, was on Independence Day, or the Fourth of July, 1845, my house was not finished for winter, but was merely a defense against the rain, without plastering or chimney, the walls being of rough, weather-stained boards, with wide chinks, which made it cool at night. The upright white hewn studs and freshly planed door and window casings gave it a clean and airy look, especially in the morning, when its timbers were saturated with dew, so that I fancied that by noon some sweet gum would exude from them. To my imagination it retained throughout the day more or less of this auroral character, reminding me of a certain house on a mountain which I had visited a year before. This was an airy and unplastered cabin, fit to entertain a traveling god, and where a goddess might trail her garments. The winds which passed over my dwelling were such as sweep over the ridges of mountains, bearing the broken strains, or celestial parts only,* of terrestrial music. The morning wind forever blows, the poem of creation is uninterrupted; but few are the ears that hear it. Olympus is but the outside of the earth everywhere.[1]

## J'AI UN CHÂTEAU SUR LA CÔTE D'AZUR

Where Thoreau's reasoning had to do with a philosophy of life, it was an attempt to return to basics, a motivation that seems also to have governed the Cabanon de vacances built between 1951 and 1952 at Roquebrune-Cap-Martin by Le Corbusier. Beginning in 1948, the architect worked nearby on vacation residence schemes called Roq et Rob. Although those projects were never brought to fruition, Le Corbusier did create the only structure he ever built for himself, a cabin measuring just 3.66 x 3.66 x 2.26 meters in size in Roquebrune. Prefabricated in Corsica, the "Cabanon" is located near the famous house of his friend Eileen Gray (Villa E.1027, 1924), and just next to a bar called "L'Etoile de Mer" that belonged to the client for Roq et Rob, Thomas Rebutato. Built with industrial materials, and with a rough, even rustic, wood appearance, the Cabanon was an experiment with Corbu's idea of the Modulor, the system of human proportions that he invented in 1943. Despite its apparent simplicity, the Cabanon is the result of careful thought, with its furnishings arranged in a spiral pattern, for example. In 1954, Le Corbusier bought 1290 square meters of land from Rebutato, including the Cabanon, and in return, he designed and built five "Unités de camping" for his client.[2] The architect clearly liked Roquebrune-Cap-Martin and his small cabin. He said: "J'ai un château sur la Côte d'Azur, qui fait 3,66 mètres par 3,66 mètres. C'est pour ma femme, c'est extravagant de confort, de gentillesse" (I have a castle on the Riviera that measures 3.66 meters by 3.66 meters. It is for my wife, it is a place of extravagant comfort and kindness). Surely, a place "where a goddess might trail her garments." As fate would have it, Le Corbusier drowned in the sea at Roquebrune on August 27, 1965. André Malraux, then Minister of

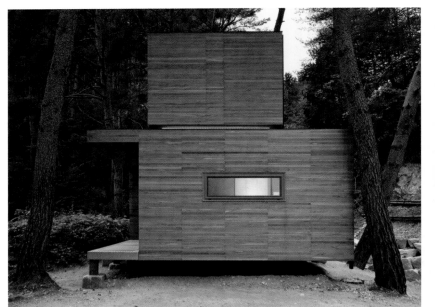

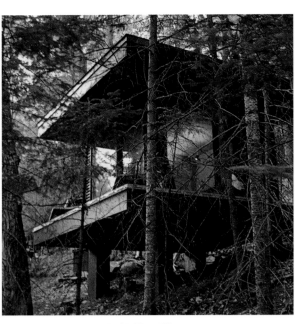

MONK'S CABIN → 268                    FRANKE-MIRZIAN BUNKHOUSE → 178

Culture of France, pronounced the funeral oration in the courtyard of the Louvre on September 1 and Le Corbuser was buried as he had wished, next to his wife in Roquebrune-Cap-Martin.

The examples of Thoreau and Le Corbusier are, of course, not randomly chosen, but are deeply indicative of the attraction of cabins, both in terms of philosophy and of architecture. One of the projects featured here, the Sustainable Cabin (Crowell, Texas, 2008–10, page 366), was built by students and professors from Texas Tech University, who specifically refer to both historic examples. It was built with the contemporary equivalent of what Thoreau spent (28 dollars and 12½ cents, which today is $683.08). According to the professor who led the project of the Sustainable Cabin, Upe Flueckiger: "Historical precedents for this project are Henry David Thoreau's Cabin at Walden Pond… and Le Corbusier's Cabanon… Both projects are studies of the minimal spatial needs for living. Furthermore, they are examples of structures that successfully relate to their sites and to the environment. Both projects were built under significant budget constraints, which are seldom considered in the design studios of our architecture schools."

The idea of the proximity to nature as a source of inspiration of course evokes certain religious beliefs. Corbu's concept of "extravagant comfort" involved just 13 square meters of living space. For a Buddhist monk who is well known in Korea, the architect Kim Hee Jun offered five meters more, in his Monk's Cabin (Pyeongchang, South Korea, 2009, page 268), but the central space, or *bang*, measures only 2.7-meters square (7.29 square meters), and yet, with its 5.5-meter-high ceiling, according to the architect, it "becomes a part of the landscape through open doors, while its closed doors allow light to resonate with the traces of nature."

## FRAGILE, IN THE WILD WINTER FOREST

Another Asian example begins to show the variety of effects and goals that the architects of cabins seek. Just 27 years old, the "environmental artist" Hidemi Nishida designed the 20-square-meter Fragile Shelter (Sapporo, Japan, 2010–11, page 172). Intended as a place for meetings or parties, the Fragile Shelter is lifted off the ground to protect it from extreme winter weather conditions; it also follows the ground level, as though reacting in an organic way to its site. Located in what the architect calls a "wild winter forest," this structure seeks to define the limits of the meeting of architecture and nature: physically and intellectually "fragile," it touches lightly

on the ground—a characteristic of most of the cabins published in this book.

Very small cabins located in wilderness settings are a frequent area of interest for architects, particularly young ones, although there are exceptions to that rule as well. An interesting case is that of the 21-square-meter Island House (Breukelen, the Netherlands, 2011–12, page 220) conceived by 2by4-architects from Rotterdam. This cabin is intended to "customize the interaction with the surrounding natural setting" on its narrow island site. Few clients would imagine that in such a small space they could have a shower, toilet, kitchen, closets, and storage, as well as a sleeping area. With façades that open completely onto a wooden terrace, the Island House appears to hover above its aquatic location, allowing users to view the sunrise and the sunset with only a minimal degree of protection and, of course, a relative degree of comfort.

## COMPLEX EXPERIENCE, SIMPLE FORM

Challenging even the reduced size of the Cabanon, the Nido (Sipoo, Finland, 2011, page 290) was designed by Robin Falck when he was 19 years old (2009). Falck wanted the nine-square-meter structure "to maximize the use of this space, just having the essentials and stripping away all the unnecessary parts." His use of leftover materials, locally sourced wood, or flax insulation highlights a very definite trend in the cabins created by architects or designers in recent years—a real concern for nature and an emphasis on minimizing sources of pollution. It seems logical that in creating a reduced living space, owners and architects are also anxious to show signs of environmental responsibility.

Also in a Nordic setting (Ingarö, Sweden, page 66), Cabin 4:12 by Joakim Leufstadius of the Stockholm firm Imanna Arkitekter is a 12-square-meter structure that boasts no fewer than four different spaces, echoing the architect's desire to "create a complex experience through a simple form." With one façade that can be opened completely and glazing that is placed with views of the surrounding forest in mind, Cabin 4:12 experiments in a willful manner with minimal living conditions, and the fullest possible experience of the wilderness.

The Dovecote Studio (Snape Maltings, Snape, Suffolk, UK, 2009, page 122) by the architects Haworth Tompkins measures 29 square meters in floor area and cost £155000 to build. Intended for a single artist, it is part of the music campus at Snape Maltings founded by Benjamin Britten on England's Suffolk coast. More sophis-

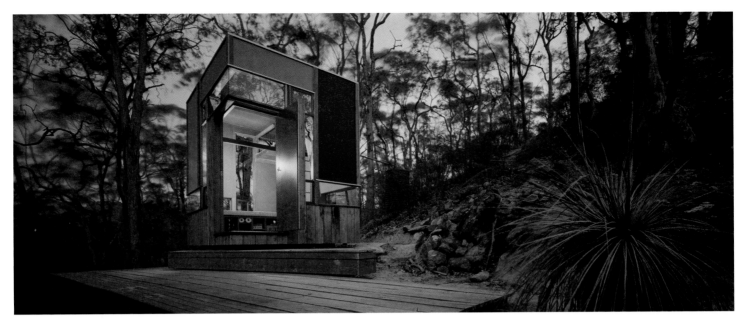

ZIG ZAG CABIN → 444

ticated in its conception than other cabins published here, the Dove-cote Studio is made of welded Cor-ten steel that was lined in spruce plywood. Fabricated nearby, it was lowered into place with a crane in the ruins of a 19th-century dovecote. Facing the North Sea, it is surely an excellent place for work and contemplation—another of the frequently sought-after virtues of any cabin worthy of the history laid down by the likes of Thoreau and Le Corbusier.

Other examples of artist's studios created in a cabin mode are also published here. The Diane Middlebrook Studios (Woodside, California, USA, 2011, page 108) comprise four 26-square-meter units designed by Cass Calder Smith (CCS Architecture). Reserved for writers working in the Djerassi Resident Artists Program, these "sleep/work cabins" were designed with a freestanding, pre-engineered steel roof that carries solar panels. The location of the cabins is intended to maximize views of the Santa Cruz Mountains overlooking the Pacific. Clad in unfinished red cedar boards, the cabins include large, sliding glass doors and private outdoor spaces. The northeast-facing sides contain clerestory windows angled toward the surrounding ridgelines and trees. Rectangular holes in the steel canopy create patterns of light and shade and align with skylights in the cabins, giving each unit a window to the sky.

## NO PRECIOUS MATERIALS

Europe is, of course, not the only part of the world where cabins have been fashionable, in a time of environmental concerns and economic difficulties. For just $20 000, Dan Molenaar of Mafcohouse, (Toronto), designed and built the Franke-Mirzian Bunkhouse (Haliburton, Ontario, Canada, 2013, page 178). This house has a usable floor area of just 9.3 square meters. It uses a high-efficiency wood stove, photovoltaic panels power the lighting and the interior is finished in Douglas fir. Placed near Drag Lake (Haliburton), it has corrugated-steel exterior siding and cedar is used for the deck. At the other end of the world, the Zig Zag Cabin (Wollombi, New South Wales, Australia, 2002, page 444) by Drew Heath is another effort to define minimum living requirements. With a floor area of 10 square meters, the house includes two sleeping areas on the ground level and a bunk bed located on a suspended mezzanine. The twisted wood frame of the house that is held together by a plywood beam allows for window and door openings at each corner. Masonite and cypress pine were used, in keeping with the architect's rejection of "precious materials."

## HANGING FROM A TREE, PERCHED ON A MOUNTAIN

Cabins are, of course, primarily used for escape to the wilderness, for time to think, and to be surrounded by peace. Yet, such small structures can have other purposes, as several examples published in this book demonstrate. More and more hotels are being created with cabins—either perched in trees or placed in unusual locations, such as a mountaintop. Then, too, a number of artists and designers have seized on this mode of expression to make different points that usually have some urgency in the contemporary context.

Andreas Wenning, the German founder of baumraum, a well-known designer of tree houses, has ventured into a larger enterprise with the Tree House Resort (Schrems, Austria, 2013), located in a quarry to the east of the Austrian city. Tree houses and cliff residences, each about 20 square meters in size, form this complex, where cabins are but part of a whole. The same idea has been applied, in quite a different spirit, at the Treehotel in Harads, Sweden. After calling on a number of other architects, the owners of the hotel asked the Oslo team of Rintala Eggertsson to create their latest and largest tree-house suite, called Dragonfly (2013, page 128). Suspended from eight pine and spruce trees, the three-bedroom cabin can sleep up to six guests. Clad in weathered steel and lined with plywood, the structure quite obviously brings clients closer to nature, in relatively great comfort. Tree houses are, in a sense, the ultimate type of cabin, to the extent that the trees they are suspended from are properly protected. Along with the sensation of being quite literally in a natural setting, they also offer the unexpected, and potentially destabilizing, sensation of blowing in the wind.

The same architects are the authors of the Hut to Hut project (Kagala, Karnataka, India, 2012), a 27-square-meter structure developed for a budget of $75 000 in a design-and-build workshop with students from the University of Science and Technology in Trondheim, following an international seminar about the future of ecotourism in the Western Ghats region of India. The aim of the project was to use locally produced materials and renewable energy sources. The architects explain: "The hut represents a possibility for the local population to invest in the growing environmentally conscious segment of the tourist market, while maintaining their traditional culture and lifestyle."

Even further off the beaten track is the astonishing LEAPrus hotel, located at an altitude of 3912 meters above sea level on the slopes of Mount Elbrus (Caucasus, Russia, 2013, page 242). A total of five structures made of fiberglass or sandwich panel covered with

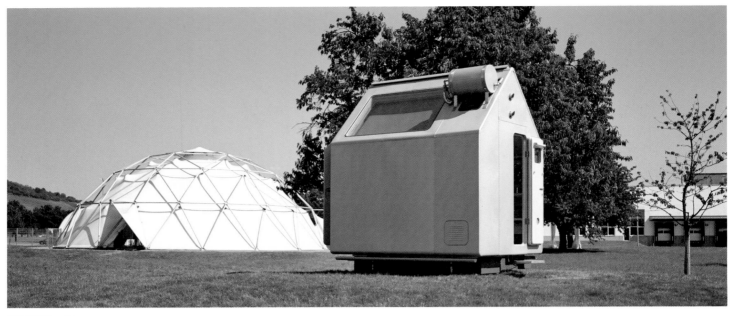

**DIOGENE** → 118

aluminum sheet house 49 beds, toilets, reception, and staff accommodations, and a restaurant with kitchen, all of this with a total usable floor area of 106 square meters. The authors of this project, LEAPFactory, based in Turin, (Italy), also created the Gervasutti Refuge (Mont Blanc, Courmayeur, Italy, 2011), a 30-square-meter mountain hut placed at an altitude of 2835 meters on the side of Mont Blanc, the tallest mountain in Western Europe. Assembled with the aid of helicopters and made out of 600-kilo composite laminate sandwich modules, these refuges can be dismantled without damage to the sensitive mountain sites. Though the Gervasutti Refuge resolutely avoids trying to "blend in" with its surroundings, its reversible nature and its minimal ecological impact do, at any rate, make it a model for future high-altitude designs.

## MODULES AND LODGES

The DROP Eco-Hotel (2012, page 134), by the Barcelona architects In-Tenta, is similarly made up of 25-square-meter modules manufactured with wood, steel, and polycarbonate. These modules in the form of tubes with bubble windows can be transported easily by truck and set up on adjustable steel legs. Photovoltaic panels on the roof and a rainwater collection system for use in the bathroom reduce environmental impact. The concept provides for the accumulation of a certain number of modules to create entire hotels, in any type of location. A similar logic was applied by the Graz (Austria) firm Studio WG3 to their 19-square-meter Hypercubus (Graz, Austria, 2010, page 214). At a cost of €63 500 per unit, these mobile structures have reinforced-concrete foundations surmounted by a laminated lumber framework, and plywood walls. According to the architects, the point of these schemes was "to develop a minimal apartment intended for two people. Aimed at the area of tourism, the scheme entails industrial manufacturing, transport capability, interior space optimization, self-sufficiency, memorable and recognizable architecture, and economic efficiency." The prototype module can be vertically stacked to create a "hotel-like structure." More traditional in concept, the 20 new lodges of the Longen-Schloeder Winery (Longuich, Germany, 2011–12, page 256) by architect Matteo Thun each measure 20 square meters in floor area. Located in the Moselle River Valley, these cabins, whose forms are inspired by local architecture, are made with stone quarried nearby. Wood, "original fabrics, and natural materials" mark the interiors, while large glass doors connect interior and exterior.

## STAND A LITTLE OUT OF MY SUN

Much closer to the spirit that animated an architect like Le Corbusier, the Italian Renzo Piano has recently experimented with the idea of "minimum" dwelling conditions. His Diogene cabin (Weil am Rhein, Germany, 2013, page 118) has a floor area of just 7.5 square meters for an approximate cost of €20 000. According to Piano, this project is based on "the idea of realizing a minimum refuge which can be used for emergencies, working in a small scale, and being self-sufficient and sustainable. A small residential unit using only natural energy sources." The cabin, created for the furniture manufacturer Vitra, can be easily transported, and is made with XLAM panels (three intersecting, glued layers of cedar). Vacuum panels and triple-glazed windows ensure insulation, while photovoltaic panels, a geothermal heat pump, a rainwater collection system, and low-energy lighting are also part of the ecological strategy of Diogene. Inside, a foldable sofa bed, a wooden table, and lightweight aluminum boxes for storage form a spartan but practical living environment. The project is named after the Greek philosopher Diogenes, who said: "The human being has made every gift of God more complicated." The philosopher is said to have lived in a barrel, and to have destroyed his last item of property, a small wooden pot, when he saw a boy drinking from his hands. Legend has it that Alexander the Great met the philosopher and asked him what wish he would most like to have fulfilled, to which Diogenes answered: "Stand a little out of my sun." Showing both his own tolerance and understanding, the emperor is said to have replied: "If I were not Alexander, I would like to be Diogenes."[3]

Though the definition of cabins used for this book tends to give preference to wilderness locations and limited size, the genre also makes its appearance in urban settings. Shelter ByGG (Porto, Portugal, 2012, page 328) designed by Gabriela Gomes is an 11-square-meter shelter that costs €36 500. This small, "habitable sculpture" is made of wood, OSB (oriented strand board), Expanded Cork Agglomerate, and CORKwall for the external covering. According to Gomes: "This is an experimental object that combines sculpture, design, and architecture, defying new experiences with space and questioning relations of artistic enjoyment and habitation issues." Non-polluting and recycled materials were used and solar energy is employed. Clearly, this object is as much at ease in an urban setting as it might be in a city environment.

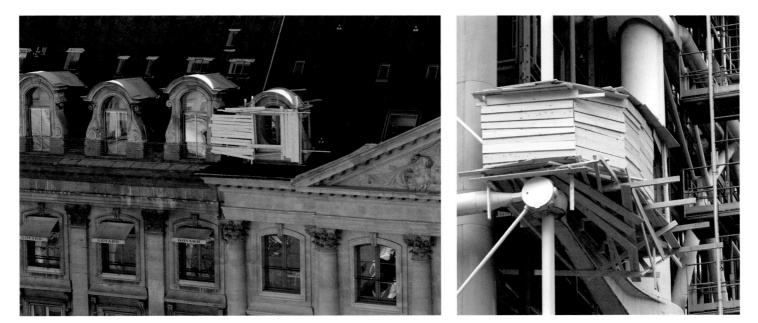

"TREE HUTS IN PARIS" → 390

## AN INCONGRUOUS ERUPTION

Quite to the contrary, the "Tree Huts in Paris" (2008–13, page 390) by the Japanese artist Tadashi Kawamata are intimately related to their French locations. Kawamata has worked in this way in Paris and elsewhere since 2008, in the Tuileries Gardens (2008), the Monnaie de Paris (2008), and the Centre Pompidou (2010), before his most recent installation at the Place Vendôme (2013). He compares these works to tribal huts, to the shelters of homeless people, or even to pigeon houses. Like cabins in more "natural" settings, these structures evoke refuge, but do so in a spirit of resolute contradiction with their urban environment. Unlike almost all the other cabins included in this book, Kawamata's structures are not intended to be lived in, but rather to make an incongruous "eruption" in an environment of classical architecture—or in the case of the Centre Pompidou, a more modern one. Indeed, the other cabins published in this book, even those of extremely limited size, are basically intended for the well-off. Kawamata calls on another interpretation of the cabin, one that is strictly made up of reused materials, evoking misery as much as any desire to escape the pace of urban life. Tadashi Kawamata's installations often take on the dimensions of architecture, but always share an apparently disordered accumulation of used materials. Another creator who has become well known for creating apparently chaotic cabins is the Canadian Richard Greaves.

## DISAPPEARING INTO THE WILDERNESS

As those who have visited the Western United States, or its other wilderness areas, can testify, the country is blessed with vast areas that are beyond the reach of urbanization and most forms of immediate pollution. It is also the country of the kind of individualism that inspired Thoreau and other artists. Finally, the United States, beyond the realities of a disfavored population, has a large number of people who have the means to build unusual structures in natural settings. Some of these exceed the size of what might technically be called a cabin, but nonetheless share with the genre an immersion in a natural setting, sometimes with more comfort than Le Corbusier would have deemed advisable in such circumstances, surely.

The Washington architects Olson Kundig, and particularly Tom Kundig, have in some sense been pioneers in the area of architecturally sophisticated shelters that nonetheless give an impression of rugged self-reliance. The Delta Shelter (Mazama, Washington, USA,

2005) measures a generous 93 square meters. Lifted off the ground on stilts on a site that is subject to flooding, the shelter has four sliding, double-height steel shutters that open with a hand-cranked mechanism, allowing the shelter to be protected from severe weather, or during the absence of the owner. Because its location is remote, the Delta Shelter was prefabricated and assembled on site. The relatively rough plywood interior finishes echo the use of untreated rusting steel for the cladding. The architect explains: "When in use, the Delta Shelter provides unparalleled views of the majestic landscape of rural Washington; when it is closed up, the cabin stands like a sentry in the aspen forest." The idea of watching over a wilderness setting in a protective way is coherent with the ethos of the cabin, or of its (part-time) wilderness dweller. The Tye River Cabin, also by Kundig (Skykomish, Washington, USA, 2005, page 414), is a 116-square-meter structure made with wood recovered from an old warehouse, poured-in-place concrete, and steel. With two bedrooms and a bathroom, the structure uses a geothermal heat pump. As for it aesthetics, the architects say: "With time, the cabin will become more and more muted, eventually disappearing into the forest." This remark is of interest because it does reveal the desire of cabin designers and surely their inhabitants to somehow become part of the natural environment—not necessarily in the way of "organic" styles of architecture, but out of a real effort to enter into symbiosis with nature. The Olson Cabin (Longbranch, Washington, USA, 1959/2003) was created by Kundig's partner, Jim Olson, in and around an old family cabin. Olson sought to unify the original cabin and its later additions using galvanized steel columns and laminated wood beams. The living room has a full-height glazed opening that is intended to give the impression that there is no barrier between interior and exterior. Elements of the original cabin are visible as inner walls in the new structure, which employed only certified lumber. Though most of the cabins published here are new, in this instance, both the natural setting and the older architecture are subsumed into a coherent whole.

Two cabins by another well-known American firm, from Austin, Texas—Andersson-Wise—are featured here. The founders of the firm, Arthur Andersson and F. Christian Wise, took up their work after a long collaboration with Charles Moore, one of the noted postmodern architects. Their Cabin on Flathead Lake (Polson, Montana, 2007, page 80) measures a modest 56 square meters in floor area. It overlooks Flathead Lake in Western Montana, and is situated to observe the natural setting and wildlife, which includes ospreys and eagles. The structure is set up on six steel piers that are anchored

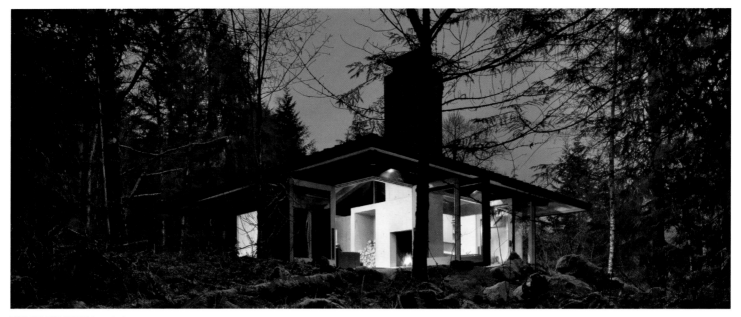

TYE RIVER CABIN → 414

in concrete blocks on the sloped site. The cabin has no heating or cooling system and running water is pumped from the lake below. The Lake House (Austin, Texas, 2002, page 234) by the same architects is more than twice as large (121 square meters). This off-grid residence was built on a steeply sloped site on the shore of Lake Austin. It was designed to "exert minimal impact on its surroundings." It has full-height openings and is naturally ventilated.

A representative of the growing trend toward the reuse of shipping containers in architecture, the Container Guesthouse (San Antonio, Texas, USA, 2009–10, page 102), by the San Antonio architect Jim Poteet, has an area of 30 square meters. It is intended to "create the maximum effect with the minimum of architectural gesture." This guesthouse has a shower and composting toilet, and a large glazed sliding door and end window. A garden on the roof is elevated to allow free airflow. The insulated interior is lined with bamboo plywood, while the rear of the container has mesh panels that are covered with evergreen vines for shading. Recycled telephone poles were used for the foundation, and exterior light fixtures were made with blades from a tractor disk plow. The reuse of existing materials, first and foremost the container itself, along with energy-saving strategies, makes this a kind of prototype for future cabins—economical, efficient, and potentially attractive to live in.

## COCOONING ON THE HILLSIDE

The California architects Taalman Koch have worked extensively in the area of "intelligent" houses, often located far from urban or suburban settings. Their Clearlake IT Cabin (Clearlake, California, USA, 2010–11, page 96) is a 74-squre meter home and office for a lighting designer who was seeking to escape from Los Angeles. The house is lifted 1.2 meters in the air by a prefabricated, light-gauge, galvanized-steel, platform structure on a sloped site. Above the platform, lightweight aluminum columns and beams were assembled on site. A minimal, open plan was designed with large areas of glazing to provide views of the natural setting. Reclaimed cypress was used for the floors, including outdoor terraces, cabinetry, and custom-made furniture. An off-grid solar panel system is located higher on the same slope to provide all energy for the house.

A young Seattle firm zeroplus created the Sneeoosh Cabin (La Conner, Washington, USA, 2006–07, page 334), a 106-square-meter structure that seeks to fully respect its site. The oldest trees present on the site were preserved, determining the precise loca-

tion of the cabin, which is lifted off the ground, engendering minimal disturbance to the soil. The volume's transparent-glass main floor offers a full view of the setting, "dissolving the boundaries between inside and out." A large sliding door on the west face of the living room opens onto a deck and stairs that lead to a stone patio. Beneath a broad roof, a "cocoon-like encasement" contains the sleeping areas. A steel-brace frame and glulam beam system were used to ensure that the structure can withstand the elements and an earthquake. These aspects of the architectural design of the Sneeoosh Cabin speak clearly to some of the most significant goals of modern cabin architecture. Again, protection of the site, connection of interior and exterior, or rather of the residents to the natural environment, and a sense of being protected despite the surrounding wilderness are all part of the motivations and accomplishments of such designs. How best to protect the land, and residents, in locations where nature can be severe—these are questions that any architect poses in cabin design.

## ECO-FRIENDLY OR ECO-TERRIFYING

Aside from the artistic uses already cited, cabins can serve functions other than just being places to reside. The unusual Outlandia Fieldstation (Glen Nevis, Lochaber, UK, 2008–10, page 296) by Edinburgh architect Malcolm Fraser measures just seven square meters in floor space. It is an off-grid tree-house observatory and field station conceived by the art partnership London Fieldworks (Bruce Gilchrist and Jo Joelson) as a flexible meeting space for creative artistic collaboration and research. Erected on a forested 45-degree slope, it was partly built with trees cut down on the site. The architect states: "The low-impact, eco-friendly use of timbers recovered from the site was the opposite (of the) high-impact, eco-terrifying, helicoptered concrete drops for the foundations." The lucidity of the architect in this instance is revealing of a simple truth of even the most "eco-friendly" cabin designs. Materials are often brought in from great distances with mechanical means—perhaps inevitable given modern construction methods, but also potentially quite damaging to the environment. This aside from the fact that human presence in any wilderness setting is likely to upset local animal life, or even delicate flora. All may not be as idyllic as some would have it in the land of the mountain cabin.

In principle destined to be inhabited, but in reality still unoccupied for administrative reasons, the Welcome Bridge (Tilburg, the

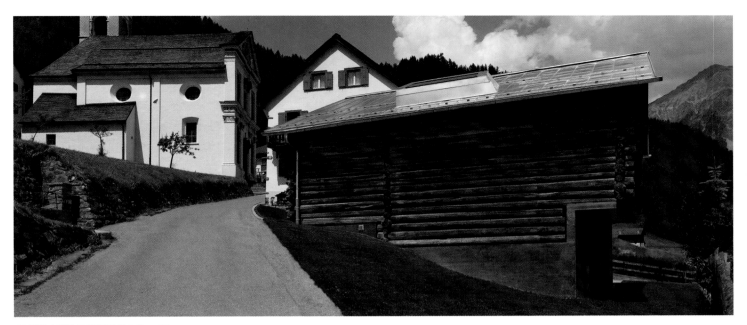

CLAVO LAIN RENOVATION → 88

Netherlands, 2011–13, page 432) by the architect and artist John Körmeling features a 112-square-meter cabin that is literally suspended from a drawbridge, hanging 4.5 meters above the ground when the bridge is open. Winner of a Dutch competition for the design, Körmeling was already known for somewhat controversial, or perhaps more aptly, humorous structures, such as his Rotating House (Tilburg, 1999–2008) or Echt iets voor u, the "shortest covered bridge in the world" (Van Abbemuseum, Eindhoven, 2006). Here, the isolation of the inhabitant of the cabin, in principle, the bridge master, is not related to the wilderness but rather to the fact that the cabin hangs in the air, observing the movement of boats and cars, almost like an alien spectator.

## BACK TO THE ALPS

Any survey of contemporary cabins would be incomplete without reference to what may be the most "typical" of structures in the category—the Alpine cabin, similar to so many seen in the Swiss or Austrian mountains. Quite intentionally, examples chosen here are not all that typical. The Clavo Lain Renovation (Lain, Switzerland, 2011–12, page 88) by the team of Hans-Jörg Ruch does not really involve a mountain cabin as much as a brilliantly restored and rather spacious (175 square meters) hay and cattle barn. Realizing that the gaps between the interlocking timber beams that formed the old structure were left on purpose to provide aeration, Ruch decided not to modify this important element of the design for the sake of immediate comfort. The architect states: "The challenge was to bring daylight into the rooms without cutting windows into the timber construction." An inner shell was placed inside the existing structure—allowing light in but protecting the residents from the elements. A new base in black concrete with an additional large window was added in a manner that did not require the original wooden building to be dismantled. The architect states: "The inner shell is constructed out of insulated wood-frame elements which were inserted through the roof and were put together on site. The new volume is covered with a layer of tar, which creates a fascinating contrast with the historical timber construction. In each phase, the architectural interventions were driven by a strong respect for the historical building." As he has shown in other renovations, for example, in the town of Zuoz, Hans-Jörg Ruch has mastered the art of renovating old wood or stone buildings in a way that lends decided modernity to the structures without removing their traditional cores.

The window he adds in Lain, with the slanting rays of light that it admits to the building, bring to mind the "Skyspaces" of the artist James Turrell, with whom the architect is familiar.

Another, even more overtly contemporary interpretation of the Alpine cabin is that given by the Austrian architects Marte.Marte. Their Mountain Cabin (Laterns, Austria, 2010–11, page 282) measures 87 square meters in floor area. Made with "carefully hewn rough concrete," the house has oak front doors and untreated oak floors, as well square windows of different sizes with solid oak frames. Inside the structure, a spiral staircase connects the living area on the upper level with the two private areas on the lower level, where the bedrooms and relaxation areas "are interlocked like a puzzle." The entire design gives an impression of solidity that is in many ways a reflection of the rather harsh beauty of the natural setting. Not directly inspired by old mountain cabins, the house is clearly an effort to reinterpret the genre—although the classification as a "cabin" in this instance may have as much to do with the official name of the project as it does with its appearance.

Located far from the Alps, the Alpine Cabin (Vancouver Island, Canada, 2008–13, page 34) by the architects Scott & Scott is an off-grid snowboard refuge set on the northern end of Vancouver Island. Locally sourced Douglas fir columns, rough-sawn fir lumber, cedar cladding for the exterior, and a planed fir interior finish were used for the cabin. The design was intended to avoid machine excavation, and to withstand heavy snowfalls and predominant winds. The cabin has no electricity and is heated with a wood stove. Water is brought from a local source and carried in. The cabin is located at 1300 meters above sea level and is accessible by gravel road five months out of the year, while during the other months, equipment and materials are carried by toboggan to the site. Because of its difficult access and off-grid nature, this type of cabin may, of course, be considered more "authentic" in its modernity than concrete houses with hot and cold running water and high-speed Internet connections.

## WHILE REALITY IS FABULOUS

Cabins are so popular that any number of structures might have been selected for this book. As is the case with the other Architecture Now! volumes, a broad variety of cases have been intentionally chosen to give an idea of the breadth of the genre, in terms of appearance, of use, or even of size. A cabin then might first be considered a small structure intended for living in the midst of the wilderness. Because

of environmental concerns in recent years, new construction tends to seek out the best way to build without damaging a site, or perhaps to allow for easy demolition. It might be pointed out that older cabins, almost inevitably made with local wood or stone, never posed the problems of pollution or even demolition that today's architecture engenders. Rather, in the Alps, for example, old, abandoned cabins tend to fall first into disrepair and then to disappear altogether into the environment, their wood and stone returning to the earth from which they came. Unfortunately, steel and polycarbonates are not as easily absorbed into the earth. With economic upheavals and reconsideration on the part of many persons of the consumerist model of society, cabins are popular, too, because they represent a search for a less onerous and less destructive way of living. Le Corbusier's postwar research on his own minimal living conditions was an intellectual one that he assumed fully in his own life. The Cabanon is a kind of monk's cell pitched on the coast of Roquebrune-Cap-Martin. If the proportions are right (the Modulor) and the basics of life are provided, is it really necessary to have more and more space in contemporary houses, or might a small space be more in keeping with the world as it is? Renzo Piano's Diogene scheme for Vitra speaks to the issue of minimal living conditions in another manner, alluding to postdisaster relief as well as a philosophical stance that tends to seek less rather than more, at least in terms of material consumption. It is interesting to note that in the first example cited here, that of Henry David Thoreau's cabin on Walden Pond, the philosophical aspects of his way of living are intimately related to the minimal comforts and size of the structure. Turning away from "shams and delusions," he sought rather a simple cabin "fit for a traveling god."

*Shams and delusions are esteemed for soundest truths, while reality is fabulous. If men would steadily observe realities only, and not allow themselves to be deluded, life, to compare it with such things, as we know, would be like a fairy tale and the Arabian Nights' Entertainments. If we respected only what is inevitable and has a right to be, music and poetry would resound along the streets. When we are unhurried and wise, we perceive that only great and worthy things have any permanent and absolute existence that petty fears and petty pleasures are but the shadow of the reality. This is always exhilarating and sublime. By closing the eyes and slumbering, and consenting to be deceived by shows, men establish and confirm their daily life of routine and habit everywhere, which still is built on purely illusory foundations.[4]*

Henry David Thoreau, **Walden; Or, Life in the Woods,** 1854

Philip Jodidio,
Grimentz, Switzerland

1   Henry David Thoreau, Walden, *Where I Lived, and What I Lived for.* http://thoreau.eserver.org/walden02.html, accessed on November 11, 2013.
2   http://eileengray-etoiledemer-lecorbusier.org/le-cabanon/, accessed on November 11, 2013.
3   Documentation provided by RPBW, the office of Renzo Piano.
4   Henry David Thoreau, Walden, *Where I Lived, and What I Lived for.* http://thoreau.eserver.org/walden02.html, accessed on November 11, 2013.

# OBDACH FÜR EINEN WANDERNDEN GOTT

*Ich zog in den Wald, weil ich den Wunsch hatte, mit Überlegung zu leben, dem eigentlichen, wirklichen Leben näherzutreten, zu sehen, ob ich nicht lernen konnte, was es zu lehren hatte, damit ich nicht, wenn es zum Sterben ginge, einsehen müsste, dass ich nicht gelebt hatte. Ich wollte nicht das leben, was nicht Leben war; das Leben ist so kostbar. Auch wollte ich keine Entsagung üben, außer es wurde unumgänglich notwendig. Ich wollte tief leben, alles Mark des Lebens aussaugen, so hart und spartanisch leben, dass alles, was nicht Leben war, in die Flucht geschlagen wurde. Ich wollte einen breiten Schwaden dicht am Boden mähen, das Leben in die Enge treiben und auf seine einfachste Formel reduzieren.*

Henry David Thoreau, *Walden oder Leben in den Wäldern,* 1854

Die Hütte, die Henry David Thoreau 1845 in Concord, Massachusetts, gebaut und 14 Monate lang bewohnt hat, steht in vielerlei Hinsicht stellvertretend für jene Gründe, die Menschen dazu bewegen, sich in kleine Behausungen zurückzuziehen, weit weg vom Stress und vom Schmutz der Städte. Der Wunsch, in die Natur zurückzukehren, ist heute umso weiter verbreitet, als die Überreste einst unberührter Wildnis durch fortschreitende Urbanisierung und die Verschmutzung mit jenen Substanzen ernsthaft bedroht sind, die infolge unserer „modernen" Lebensweise in Luft und Wasser gelangen. Ist der Wunsch nach Überfluss und „Luxus" erst zur treibenden Kraft einer Gesellschaft geworden, verspüren mehr und mehr Menschen das Bedürfnis, sich auf das Nötigste zu beschränken, mit Blick auf den Sonnenaufgang zu wohnen, jeden Tag den Geräuschen der Natur zu lauschen. Keine Frage, auch kleine, abgelegene Häuser können ein großes Maß an Komfort bieten, und ein Gutteil der in diesem Band versammelten Projekte ist durchaus mit allen „zivilisatorischen" Annehmlichkeiten ausgestattet. Die Überlegungen aber, die dem Bau von kleinen Häusern in der Natur wesensmäßig zugrunde liegen, könnten den ein oder anderen durchaus dazu veranlassen, den gewaltigen $CO_2$-Verbrauch, den das Alltagsleben in den Industrieländern verursacht, beiseite zu werfen.

Nach wie vor lässt sich an Thoreaus Beschreibung seiner am Walden Pond gelegenen Hütte – obwohl aus ihr unüberhörbar das 19. Jahrhundert spricht – sehr gut nachvollziehen, worum es vielen Menschen geht, die sich ein eigenes kleines Haus in der Wildnis bauen wollen. Thoreau schreibt:

*Als ich anfing, meinen Wohnsitz im Walde aufzuschlagen, das heißt, nicht nur den Tag, sondern auch die Nacht dort zu verbringen, was zufällig auf den Unabhängigkeitstag, den 4. Juli des Jahres 1845 traf, war mein Haus noch nicht für den Winter fertig, sondern bot nur einstweilen gegen den Regen Schutz, war ohne Bewurf, ohne Kamin und hatte Wände aus rauen wetterfleckigen Brettern mit klaffenden Ritzen, die dafür sorgten, dass es in der Nacht kühl blieb. Die geraden, weißen, behauenen Pfosten und neugehobelten Türen- und Fensterrahmen gaben* *ihm ein sauberes und luftiges Aussehen, besonders morgens, wenn das Holz mit Tau gesättigt war, sodass ich denken musste, am Mittag würden würzige Harztropfen hervorquellen. In meiner Fantasie behielt es den ganzen Tag mehr oder weniger diesen morgenfrischen Charakter. Es erinnerte mich an ein Haus auf einem Berg, das ich im vorigen Jahr besucht hatte. Das war eine luftige Hütte, ohne Bewurf, die würdig gewesen wäre, einem wandernden Gotte Obdach zu bieten; eine Göttin dürfte darin ihre Gewänder nachschleppen lassen. Die Winde, die über mein Haus hinzogen, waren solche, wie sie über Bergesgipfel brausen; sie tragen gebrochene Klänge, nur die himmlischen Bestandteile irdischer Musik, zu mir herüber. Der Morgenwind weht immerfort, das Gedicht der Schöpfung klingt ununterbrochen weiter, aber wenige Ohren vermögen es zu hören. Überall außerhalb der Erde ist der Olymp.*[1]

## J'AI UN CHÂTEAU SUR LA CÔTE D'AZUR

Wo Thoreaus Überlegungen lebensphilosophisch inspiriert waren, hatten sie mit dem Versuch einer Rückkehr zum Wesentlichen zu tun – eine Motivation, die auch Le Corbusiers zwischen 1951 und 1952 in Roquebrune-Cap-Martin erbautem Cabanon de vacances zugrunde zu liegen scheint. Anfang 1948 hatte der Architekt ganz in der Nähe an Entwürfen zu einer Ferienhausanlage mit dem Projektnamen „Roq et Rob" gearbeitet. Zwar wurden die Pläne nie realisiert, dafür aber baute Le Corbusier in Roquebrune eine Hütte, die gerade einmal 3,66 x 3,66 x 2,26 m groß ist und das einzige Gebäude darstellt, das der Architekt je für sich selbst gebaut hat. Das auf Korsika vorgefertigte Cabanon befindet sich unweit des berühmten Hauses von Le Corbusiers Freundin Eileen Gray (Villa E.1027, 1924) und in direkter Nachbarschaft der Bar „L'Etoile de Mer", deren Inhaber Thomas Rebutato der Auftraggeber der bereits erwähnten Ferienhaussiedlung war. Bei der aus Industriematerialien erbauten Hütte mit ihrer spartanischen, wenn nicht gar urwüchsigen Holzerscheinung handelte es sich um ein Experiment auf Grundlage des sogenannten Modulor-

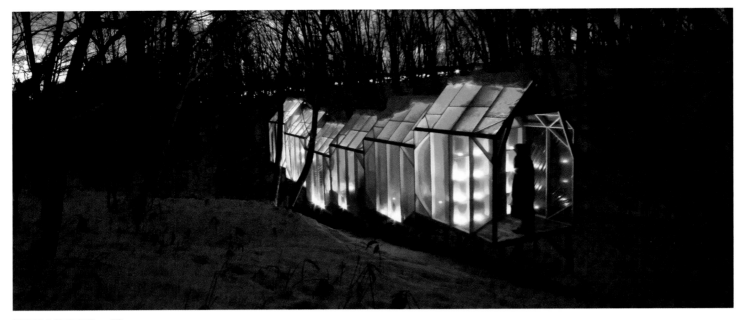

FRAGILE SHELTER → 172

Systems, einer von Le Corbusier 1942 entwickelten, am Maß des Menschen orientierten Proportionssystematik. Ihrer augenscheinlichen Einfachheit zum Trotz ist die Hütte das Resultat sorgfältiger Überlegungen, wovon beispielsweise das spiralförmig angeordnete Mobiliar zeugt. 1954 erwarb Le Corbusier ein 1290 m² großes Grundstück von Thomas Rebutato, auf dem sich auch das Cabanon befindet; im Gegenzug entwarf und baute er für Rebutato fünf Unités de camping.² Dem Architekten gefielen Roquebrune-Cap-Martin und seine kleine Hütte sehr. So sagte er: „J'ai un château sur la Côte d'Azur, qui fait 3,66 mètres par 3,66 mètres. C'est pour ma femme, c'est extravagant de confort, de gentillesse." (Ich habe ein Schloss an der Côte d'Azur, das 3,66 x 3,66 m misst. Es ist für meine Frau, und es ist ein freundlicher Ort von allergrößtem Komfort.) Ein Ort, an dem „eine Göttin […] ihre Gewänder nachschleppen lassen" könnte. Wie das Schicksal es wollte, ertrank Le Corbusier am 27. August 1965 im Meer vor Roquebrune. André Malraux, seinerzeit französischer Kulturminister, hielt am 1. September im Hof des Louvre eine Grabrede. Wunschgemäß wurde Le Corbusier in Roquebrune-Cap-Martin an der Seite seiner Frau beerdigt.

Thoreau und Le Corbusier finden an dieser Stelle natürlich nicht rein zufällig Erwähnung. Beide stehen für die große Anziehungskraft von eher kleinen Behausungen in der Natur, sowohl in philosophischer als auch architektonischer Hinsicht. Eines der in diesem Band vorgestellten Projekte, die von Studenten und Professoren der Texas Tech University gebaute Sustainable Cabin (Crowell, Texas, 2008–10, Seite 366), verweist ganz konkret auf beide historische Vorbilder. So war das Projekt unter anderem dadurch motiviert, im Hinblick auf den finanziellen Aufwand dem aktuellen Gegenwert des Budgets nachzueifern, das Thoreau zur Verfügung gestanden hatte (28 Dollar und 12,5 Cents bzw. heute 683,08 \$). Der leitende Professor des Projekts, Upe Flueckiger, erklärt: „Historische Vorläufer dieses Projekts sind Henry David Thoreaus Hütte am Walden Pond und Le Corbusiers Cabanon ... In beiden Fällen handelt es sich um Studien zu Mindestanforderungen ans Wohnen. Darüber hinaus sind es Beispiele für Gebäude, die auf gelungene Weise in Beziehung zu ihrem Standort und ihrer Umwelt stehen. Beide Gebäude wurden zudem unter erheblicher finanzieller Zurückhaltung gebaut – ein Konzept, das in den Entwurfsateliers unserer Universitäten nur selten berücksichtigt wird."

Die Vorstellung, dass unmittelbare Nähe zur Natur ein Quell der Inspiration ist, lässt an gewisse religiöse Überzeugungen denken. Während bei Le Corbusier „allergrößter Komfort" auf gerade einmal 13 m² Platz fand, veranschlagte der Architekt Kim Hee Jun für die Monk's Cabin (Pyeongchang, Südkorea, 2009, Seite 268) seines Auftraggebers, bei dem es sich um einen in Korea bekannten Mönch handelt, zwar ganze fünf Quadratmeter mehr. Dafür misst der zentrale Raum oder „bang" lediglich 2,7 m im Quadrat. Bei einer Deckenhöhe von 5,5 m und geöffneten Türen wird er „zu einem Teil der Landschaft", so der Architekt, „während die Formen der Natur bei geschlossenen Türen im Spiel des Lichts zu erkennen sind".

## FRAGILITÄT IM WINTERWALD

Anhand eines weiteren Beispiels aus Asien werden die verschiedenen Absichten deutlich, die Architekten mit hüttenähnlichen Projekten verfolgen. Gerade einmal 27 Jahre alt war der „Umweltkünstler" Hidemi Nishida, als er sein 20 m² großes Fragile Shelter (Sapporo, Japan, 2010–11, Seite 172) entwarf, einen Bau, der zum Schutz vor extremen Witterungsbedingungen aufgeständert ist und dem Gefälle des Geländes folgend gleichsam organisch auf seinen Standort reagiert. Das Projekt befindet sich, so Nishida, in einem „unberührten Winterwald" und soll die Grenzen dessen ausloten, was in der Begegnung von Natur und Architektur möglich ist. Materiell und konzeptuell „fragil" berührt die Konstruktion nur ganz leicht den Boden, eine Eigenschaft, die den meisten der in diesem Band gezeigten Projekten eigen ist.

Architekten, vor allem die jungen, bekunden immer wieder aufs Neue Interesse an kleinen, in der Natur gelegenen Häusern, wobei es dabei natürlich Ausnahmen gibt. Ein interessanter Fall ist das 21 m² große Eiland Huis (Breukelen, Niederlande, 2011–12, Seite 220) von 2by4-architects aus Rotterdam. Das auf einem schmalen Inselgrundstück gelegene Projekt „soll die Interaktion mit der natürlichen Umgebung je nach Bedürfnislage ermöglichen". Kaum ein Kunde würde davon ausgehen, dass auf derart wenig Raum eine Dusche, eine Toilette, eine Küche, Schränke, Aufbewahrungsmöglichkeiten und ein Schlafbereich Platz finden. Die Fassade des Eiland Huis öffnet sich vollständig auf eine hölzerne Terrasse, der Bau scheint über dem Standort am Wasser zu schweben und ermöglicht es den Nutzern, bei nur wenig Schutz, aber natürlich einigem Komfort, Sonnenaufgang und Sonnenuntergang zu erleben.

## KOMPLEXE ERFAHRUNG, EINFACHE FORM

Die geringe Größe von Le Corbusiers Cabanon wird von Nido (Sipoo, Finnland, 2011, Seite 290) noch unterschritten. Zum Zeitpunkt des

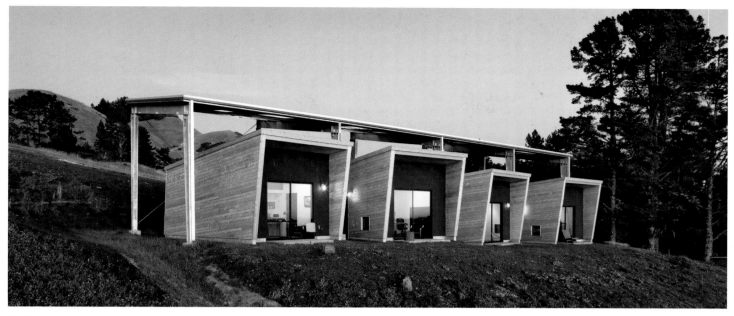

DIANE MIDDLEBROOK STUDIOS → 108

Entwurfs im Jahr 2009 war Robin Falck gerade einmal 19 Jahre alt. Mit dem 9 m² großen Projekt verfolgte er die „maximale Ausnutzung eines Raums, der nur mit dem Notwendigsten ausgestattet und von allem Überflüssigen befreit ist". Der Einsatz von Restmaterialien und Holz aus der Region sowie die Flachsdämmung stehen für einen Trend, der im Zusammenhang mit Entwürfen kleinerer, in der Natur gelegener Projekte in den letzten Jahren allgemein zu verzeichnen ist, ein Trend, der sich sowohl als ernstzunehmende Sorge um die Natur als auch in dem Wunsch äußert, Umweltverschmutzung weitgehend auszuschalten. Es versteht sich von selbst, dass Kunden und Architekten allein durch den Entwurf von Häusern mit kleiner Grundfläche Umweltbewusstsein demonstrieren wollen.

Ebenfalls in Nordeuropa (Ingarö, Schweden, Seite 66) befindet sich mit Sovhus 4:12 ein 12 m² kleiner Bau von Joakim Leufstadius, dem Mitbegründer der Stockholmer Firma Imanna Arkitekter. Sovhus 4:12 hat nicht weniger als vier verschiedene Wohnbereiche und spiegelt damit den Wunsch des Architekten wider, „mit einer einfachen Form eine komplexe Erfahrung zu schaffen". Mit einer Seitenwand, die sich vollständig öffnen lässt, und Glasflächen, die einen Ausblick in den Wald gewähren, experimentiert Sovhus 4:12 bewusst mit sehr reduzierten Wohnbedingungen und ermöglicht gleichzeitig, die Natur auf eine Art zu erleben, wie sie intensiver kaum denkbar ist.

Die Grundfläche des Dovecote Studio (Snape Maltings, Snape, Suffolk, GB, 2009, Seite 122) der Architekten Haworth Tompkins misst 29 m², bei einem Kostenpunkt von 155 000 £. Das Studio ist für die Nutzung durch einen einzelnen Künstler vorgesehen und gehört zu dem von Benjamin Britten an der Küste von Suffolk gegründeten Musikcampus Snape Maltings. In konzeptioneller Hinsicht ist das Dovecote Studio aufwendiger als manch anderes Projekt in diesem Band. Es besteht aus verschweißtem Cor-Ten-Stahl und ist mit Fichtensperrholz ausgekleidet. Das Studio wurde in unmittelbarer Nähe vorgefertigt und mithilfe eines Krans in der Ruine eines Taubenhauses aus dem 19. Jahrhundert platziert. Vom Studio blickt man auf die Nordsee, schon deshalb handelt es sich mit Sicherheit um einen Ort, an dem es sich gut arbeiten und nachdenken lässt – eine Eigenschaft, über die Entwürfe verfügen sollten, die sich dem Erbe der historischen Vorläufer von Thoreau und Le Corbusier als würdig erweisen wollen.

In diesem Band finden sich noch weitere Beispiele für Künstlerstudios. Die Diane Middlebrook Studios (Woodside, Kalifornien, 2011, Seite 108) setzen sich aus vier 26 m² großen Einheiten der Firma Cass Calder Smith (CCS Architecture) zusammen. Sie sind der Nutzung durch Schriftsteller im Rahmen des Djerassi Resident Artists Pro-

gram vorbehalten und verfügen über eine freistehende Überdachung in Fertigbauweise samt Solarkollektoren. Der Standort soll eine möglichst weite Sicht auf die Santa Cruz Mountains und den Pazifik gewähren. Die Einheiten sind mit unbehandelten Brettern aus Zedernholz verkleidet, verfügen über große Gleittüren aus Glas und einen kleinen privaten Außenbereich. Oben angeordnete Fenster auf der Nordostseite sind zu den Hügelkämmen und Bäumen der Umgebung orientiert. Die rechteckigen Aussparungen in der Überdachung erzeugen Muster aus Licht und Schatten; sie sind über den Oberlichtern der Hütten angebracht, sodass jede Einheit ein Fenster zum Himmel hat.

## OHNE WERTVOLLE MATERIALIEN

In Zeiten der Sorge um Umweltbelange und im Zuge wirtschaftlicher Krisen sind hüttenähnliche Architekturen auch außerhalb von Europa wieder in Mode gekommen. Für gerade einmal 20 000 $ hat Dan Molenaar von Mafcohouse (Toronto) das Franke-Mirzian Bunkhouse (Haliburton, Ontario, 2013, Seite 178) entworfen und gebaut. Das Haus verfügt über eine Nutzfläche von nur 9,3 m² und ist mit einem hocheffizienten Holzofen sowie Solarkollektoren für die Beleuchtung ausgestattet. Der Innenbereich ist mit Douglasienholz verschalt. Das Bunkhouse befindet sich unweit des Drag Lake (Haliburton), hat eine Wellblechfassade und eine Veranda aus Zedernholz. Am anderen Ende der Welt befindet sich die Zig Zag Cabin (Wollombi, New South Wales, Australien, 2002, Seite 444) von Drew Heath. Auch in diesem Fall handelt es sich um einen Versuch, herauszufinden, wie wenig zum Leben genügt. In dem Haus mit einer Grundfläche von 10 m² sind zwei Schlafbereiche im Erdgeschoss und ein Bett in einem abgehängten Mezzaningeschoss untergebracht. Der gebogene Holzrahmen des Hauses, das von einem Sperrholzbalken zusammengehalten wird, ermöglicht Fenster- und Türöffnungen an jeder Ecke des Baus. Da der Architekt „wertvolle Materialien" ablehnt, fiel die Wahl auf Masonitplatten und Kiefernholz.

## AUF EINEM BERG SITZEND, VON BÄUMEN HÄNGEND

Hütten dienen meist der Flucht in die Natur, um Zeit zum Nachdenken zu haben und von Frieden umgeben zu sein. Sie können aber auch ganz anderen Zwecken vorbehalten sein, wie mehrere Beispiele in diesem Band zeigen. So entstehen beispielsweise in Bäumen oder

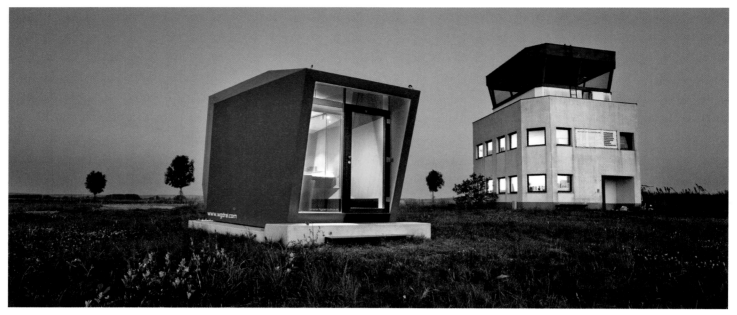

HYPERCUBUS → 214

an anderen ungewöhnlichen Standorten wie auf Berggipfeln immer mehr Hotelanlagen. Darüber hinaus haben sich verschiedenste Künstler und Designer der Hüttenarchitektur zugewandt, um Aussagen zu treffen, die vor dem Hintergrund unserer Gegenwart ihre jeweils ganz eigene Dringlichkeit haben.

Andreas Wenning, der deutsche Gründer von baumraum, einer namhaften, auf Baumhäuser spezialisierten Firma, hat sich mit dem Baumhausresort in einem alten Steinbruch im Osten der österreichischen Stadt Schrems (2013) an ein größeres Projekt gewagt. Der Komplex besteht aus jeweils 20 m² großen Baum- und Klippenhäusern, die lediglich einen Teil der Anlage ausmachen. Eine ähnliche, wenn auch in ganz anderer Weise realisierte Idee lag dem Treehotel im schwedischen Harads zugrunde. Nachdem die Eigentümer verschiedene Architekten konsultiert hatten, fiel ihre Wahl auf das Osloer Büro Rintala Eggertsson. Mit Dragonfly (2013, Seite 128) hat das Team seine jüngste und bisher größte Baumhaus-Suite entworfen. Der an acht Kiefern und Fichten aufgehängte Bau kann mit seinen insgesamt drei Schlafzimmern bis zu sechs Gäste beherbergen, hat eine Fassade aus verwittertem Stahl, ist im Innenbereich mit Sperrholz verschalt und bringt die Gäste mit bemerkenswertem Komfort der Natur näher. In gewisser Weise stellen Baumhäuser den ultimativen Hüttentypus dar, jedenfalls solange die Bäume, an denen sie befestigt sind, entsprechend geschont werden. Neben der Erfahrung, im wahrsten Sinne des Wortes von der Natur umgeben zu sein, bieten sie zudem die ungewöhnliche und möglicherweise beunruhigende Erfahrung, vom Wind bewegt zu werden.

Auf dieselben Architekten geht das Projekt Hut to Hut zurück (Kagala, Karnataka, Indien, 2012). Der 27 m² große Bau wurde für 75 000 $ mit Studenten von der Technisch-Naturwissenschaftlichen Universität Trondheim im Rahmen eines Workshops entworfen und gebaut, der im Anschluss an ein internationales Seminar zur Zukunft des Ökotourismus in den Westghats stattgefunden hatte. Dabei war vorgesehen, regional hergestellte Materialien und erneuerbare Energiequellen zu nutzen. Die Architekten: „Für die lokale Bevölkerung stellt die Hütte eine Möglichkeit dar, in den wachsenden Bereich umweltsensiblen Tourismus' zu investieren und gleichzeitig ihre traditionelle Kultur und Lebensweise beizubehalten."

Noch weiter abseits von ausgetretenen Pfaden, in einer Höhe von 3912 m über dem Meeresspiegel, liegt auf den Hängen des Elbrus das bemerkenswerte LEAPrus Hotel (Kaukasus, Russland, 2013, Seite 242). Insgesamt fünf Einzelgebäude aus aluminiumbeschichtetem Fiberglas bzw. Verbundplatten sind mit 49 Betten, Toiletten, einer Rezeption, Mitarbeiterunterkünften sowie einem Restaurant samt Küche ausgestattet. Insgesamt verfügt das LEAPrus Hotel über eine Nutzfläche von 106 m². Es handelt sich um ein Projekt der im italienischen Turin ansässigen LEAPFactory, die zudem in 2835 m Höhe auf den Hängen des Mont Blanc, dem höchsten Gipfel Westeuropas, mit dem Rifugio Gervasutti (Mont Blanc, Courmayeur, Italien, 2011) auch eine 30 m² große Berghütte realisiert hat. Die mithilfe von Helikoptern aus 600 kg schweren Verbundmodulen aus Schichtlaminat errichteten Herbergen können ggf. demontiert werden, ohne dass der empfindliche Gebirgsstandort in Mitleidenschaft gezogen wird. Zwar fügt sich das Rifugio Gervasutti visuell ganz und gar nicht in seine Umgebung ein, dafür machen es seine reversiblen Eigenschaften und minimalen Umweltfolgen zu einem Vorbild für zukünftige alpine Architektur.

## MODULE UND WINZERHÄUSER

Auch das DROP Eco-Hotel (2012, Seite 134) von In-Tenta, Barcelona, besteht aus 25 m² großen, aus Holz, Stahl und Polycarbonat gefertigten Modulen. Die röhrenförmigen Einheiten mit den blasenförmigen Fenstern können problemlos per Lastkraftwagen transportiert und auf justierbaren Stahlstützen errichtet werden. Fotovoltaikmodule auf dem Dach und eine Regenwassersammelanlage für den sanitären Wasserverbrauch halten die Umweltbelastungen so gering wie möglich. Das Konzept ermöglicht die Kombination mehrerer Module, sodass an jedem beliebigen Standort ganze Hotelanlagen entstehen können. Einer ähnlichen Grundidee folgt Studio WG3 aus dem österreichischen Graz mit dem 19 m² großen Hypercubus (Graz, Österreich, Seite 214). Bei Kosten in Höhe von 63 500 € verfügen die mobilen Einheiten über Stahlbetonfundamente, auf denen ein Rahmentragwerk aus Schichtholz mit Sperrholzwänden ruht. Es war die Absicht von WG3, „ein kleines Apartment für zwei Personen zu entwickeln. Auf den Tourismus ausgerichtet, schließt der Entwurf industrielle Fertigung, Transportmöglichkeit, die Optimierung des Innenraums, Selbstversorgung, eine wiedererkennbare Architektur und ökonomische Effizienz ein." Der Prototyp kann vertikal angeordnet werden, sodass „hotelähnliche Anlagen" entstehen. Einem traditionelleren Konzept folgen die 20 neuen Winzerhäuser des Weinkulturguts Longen-Schloeder (Longuich, Deutschland, 2011–12, Seite 256), deren Entwurf auf den Architekten Matteo Thun zurückgeht. Die im Moseltal gelegenen Häuser haben jeweils eine Grundfläche von 20 m² und sind, formal von der Architektur der Region inspiriert, aus dem Gestein eines nahegelegenen Steinbruchs errich-

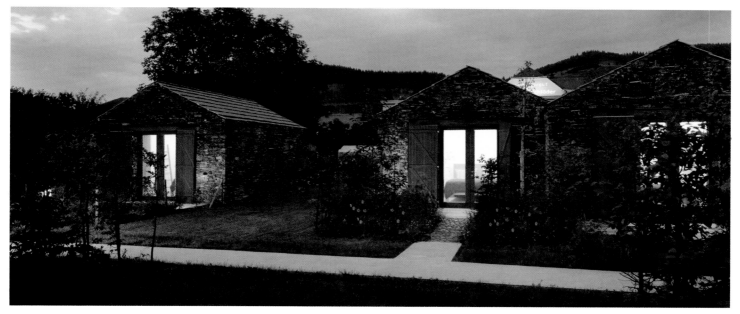

LONGEN-SCHLOEDER WINERY → 256

tet. Holz sowie „natürliche Stoffe und Materialien" zeichnen die Innenräume aus. Große Glastüren verbinden Innen- und Außenbereiche.

## GEH MIR AUS DER SONNE

Sehr viel näher am Geist dessen, was einen Architekten wie Le Corbusier einst beschäftigte, hat auch der Italiener Renzo Piano in jüngerer Vergangenheit mit „minimalen" Wohnverhältnissen experimentiert. Sein Projekt Diogene (Weil am Rhein, Deutschland, 2013, Seite 118) verfügt, bei Kosten von etwa 20 000 €, über eine Grundfläche von 7,5 m². Renzo Piano zufolge basiert dieses Projekt auf der Idee, „eine minimalistische Unterkunft für Notfälle, sehr klein, energieautark und nachhaltig, zu realisieren; eine kleine Wohneinheit also, die ausschließlich natürliche Energiequellen nutzt". Diogene wurde für den Möbelfabrikanten Vitra entworfen, kann problemlos transportiert werden und ist aus XLAM-Platten gefertigt (bestehend aus drei kreuzweise zusammengeleimten Zedernholzschichten). Vakuumplatten und Fenster mit Dreifachverglasung sorgen für die Isolierung, darüber hinaus sind Fotovoltaikmodule, eine geothermische Wärmepumpe, eine Regenwassersammelanlage und energiearme Beleuchtung Teil des ökologischen Konzepts. Im Inneren bilden ein zusammenklappbares Sofa, leichte Aufbewahrungskisten aus Aluminium sowie ein Holztisch einen spartanischen, aber zweckmäßigen Wohnraum. Das Projekt ist nach dem griechischen Philosophen Diogenes benannt, auf den folgender Ausspruch zurückgeht: „Der Mensch hat jedes Geschenk Gottes kompliziert gemacht." Der Überlieferung zufolge hauste der Philosoph in einem Holzfass und zerstörte seinen allerletzten Besitz, ein kleines Holzgefäß, nachdem er beobachtet hatte, wie ein Junge Wasser aus seinen Händen trank. Eine Legende besagt zudem, dass Alexander der Große dem Philosophen begegnete. Er fragte ihn, welchen seiner Wünsche er am ehesten erfüllt sehen wolle, worauf Diogenes geantwortet haben soll: „Geh mir nur ein wenig aus der Sonne." Die Antwort des Eroberers – Ausdruck seiner Toleranz und seines Verständnisses – soll gelautet haben: „Wäre ich nicht Alexander, ich wollte Diogenes sein."[3]

Zwar gibt dieser Band Projekten in freier Natur und mit geringer Größe den Vorzug, hüttenartige Konstruktionen finden sich aber auch in Städten. Shelter ByGG (Porto, Portugal, 2012, Seite 328) von Gabriela Gomes ist eine 11 m² große Unterkunft und hat 36 500 € gekostet. Die Außenhaut dieser kleinen „bewohnbaren Skulptur" besteht aus Holz, OSB-Platten (Oriented Strand Board), Blähkork und CORKwall. Gomes: „Es handelt sich um ein experimentelles Ob-

jekt, das Bildhauerei, Design und Architektur verbindet, ein neuartiges Raumerleben herausfordert und die Beziehung von künstlerischem Vergnügen und Wohnraumproblematiken infrage stellt." Zum Einsatz kamen umweltfreundliche und recycelte Materialien sowie Solarenergie. Keine Frage: Ebenso gut wie in ein urbanes Umfeld würde dieses Objekt auch an einen Standort außerhalb der Stadt passen.

## ERUPTIONEN DER UNVEREINBARKEIT

Die „Tree Huts in Paris" (2008–13, Seite 390) des japanischen Künstlers Tadashi Kawamata sind sehr eng an ihren französischen Standort gebunden. Schon im Vorfeld seiner jüngsten Installation auf der Place Vendôme (2013) hat Kawamata seit 2008 sowohl in Paris als auch andernorts auf ähnliche Weise gearbeitet, so in den Jardins des Tuileries (2008), in der Monnaie de Paris (2008) und im Centre Pompidou (2010). Kawamata vergleicht seine Arbeiten mit Stammeshütten, den Verschlägen von Obdachlosen oder gar Taubenhäusern. So wie Hütten in einem „natürlichen" Umfeld lassen auch diese Gebilde an Zuflucht denken, wenngleich in starkem Kontrast zu ihrer urbanen Umgebung. Anders als fast alle anderen Projekte in diesem Band sind Kawamatas Arbeiten nicht bewohnbar. Sie verkörpern vielmehr „Eruptionen" der Unvereinbarkeit im räumlichen Kontext klassischer oder, wie im Fall des Centre Pompidou, moderner Architektur. Tatsächlich sind die anderen Häuser in diesem Band, selbst solche mit sehr beschränktem Platzangebot, vor allem für wohlsituierte Menschen gedacht. Indem Kawamata für seine Objekte ausschließlich Restmaterialien verwendet und außer der Sehnsucht, der Geschwindigkeit städtischen Lebens zu entkommen, auch Elend und Not evoziert, geht er mit seinen Hütten-Interpretationen ganz andere Wege. Zwar haben Tadashi Kawamatas Installationen oft die Größe von Bauwerken, sie zeichnen sich jedoch immer durch eine scheinbar ungeordnete Ansammlung wiederverwendeter Materialien aus. Ein weiterer, für regellos anmutende Hausbauten bekannt gewordener Künstler ist der Kanadier Richard Greaves.

## IN DIE WILDNIS VERSCHWINDEN

Wer den Westen der USA oder andere unberührte Gegenden dieses Landes besucht hat, kann bestätigen: Die USA sind reich an gewaltigen Naturräumen fern der Städte und der meisten Formen unmittelbarer

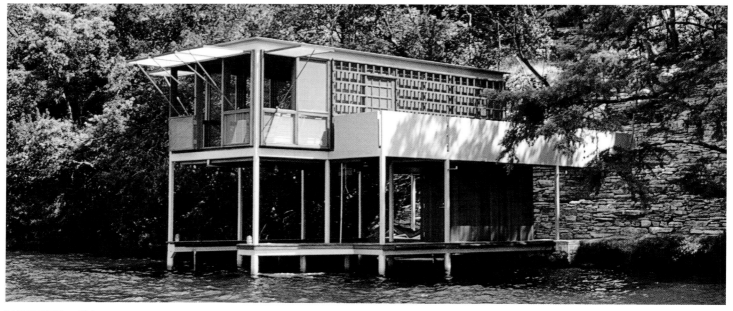

**LAKE HOUSE** → 234

Umweltverschmutzung. Das Land hat zudem eine Form des Individualismus hervorgebracht, die Thoreau und andere Künstler inspirierte. Und hier ist es auch, wo viele Menschen über einen finanziellen Hintergrund verfügen, von dem benachteiligte Bevölkerungsgruppen nur träumen können, ohne den außergewöhnliche Projekte inmitten der Natur aber nicht realisiert werden könnten. Einige davon mögen die Größe dessen übersteigen, was strenggenommen noch als kleines Haus oder Hütte gelten kann, zeichnen sich aber durch ihre Einbindung in ein natürliches Umfeld aus, wenn auch hier und da mit einem Maß an Komfort ausgestattet, das Le Corbusier sicher nicht für zweckmäßig gehalten hätte.

Olson Kundig Architects in Washington – allen voran Tom Kundig – waren gewissermaßen Vorreiter in der Entwicklung von Unterkünften, die trotz ausgeklügelter Architektur für Robustheit und Unabhängigkeit stehen. Das Delta Shelter (Mazama, Washington, 2005) misst großzügige 93 m² und ist auf Pfeilern errichtet worden, an einem Standort, der hin und wieder überflutet wird. Das Projekt ist mit vier Schiebefensterläden aus Stahl versehen, die über die Höhe beider Geschosse reichen und sich mithilfe eines Handkurbelmechanismus schließen lassen, um das Haus bei Unwetter oder Abwesenheit zu sichern. Aufgrund der abgeschiedenen Lage wurde das Delta Shelter vorgefertigt und am Standort zusammengebaut. Die relativ schlichte Sperrholzverkleidung im Innenbereich nimmt Bezug auf den unbehandelten Stahl der Fassaden. Die Architekten: „Das Delta Shelter bietet Nutzern unvergleichliche Ausblicke auf die majestätische Landschaft des ländlichen Washington. Inmitten eines Espenwalds wirkt das Haus bei geschlossenen Läden wie ein Wachposten." Die Vorstellung, von einem geschützten Standort aus die Natur übersehen zu können, liegt dem Bau kleiner Hütten als Ideal zugrunde und ist das Bedürfnis ihrer (zeitweiligen) Bewohner. Die Tye River Cabin von Kundig (Skykomish, Washington, 2005, Seite 414) hat eine Fläche von 116 m² und wurde mit Holzbeständen aus einem alten Lagerhaus sowie Spritzbeton und Stahl gebaut. Das Gebäude verfügt über zwei Schlafzimmer, ein Badezimmer und eine geothermische Wärmepumpe. Mit Blick auf das Erscheinungsbild heißt es bei den Architekten: „Nach und nach wird das Haus einen immer gedeckteren Farbton annehmen und schließlich im Wald verschwinden." Diese Aussage ist bemerkenswert. Sie steht für den Wunsch vieler Architekten und vieler Bewohner von in der Natur gelegenen Hausprojekten, auf die ein oder andere Art und Weise eins zu werden mit der Natur – und dies nicht notwendigerweise durch „organische" Architekturformen, sondern durch den Versuch, ein symbiotisches Verhältnis mit der Natur herzustellen. Die Olson

Cabin (Longbranch, Washington, 1959/2003) geht auf Kundigs Partner Jim Olson zurück, der sein Projekt in eine alte Familienhütte ein- und um diese herumbaute. Olson verwandte Pfeiler aus galvanisiertem Stahl und Balken aus Schichtholz, um den bestehenden Bau mit den Anbauten eins werden zu lassen. Das Wohnzimmer verfügt über eine raumhohe verglaste Fensteröffnung, die den Eindruck erweckt, zwischen innen und außen bestehe keine Grenze. Teile der Originalhütte sind als Wände innerhalb des Neubaus, für den ausschließlich zertifiziertes Bauholz zum Einsatz kam, erhalten geblieben. Während es sich bei den meisten hier publizierten Projekten um komplette Neubauten handelt, fügen sich in diesem Fall die bestehende Architektur und die dazugebauten Gebäudeteile mit der Natur zu einem stimmigen neuen Ganzen.

Ein weiteres namhaftes US-amerikanisches Büro, Andersson-Wise aus Austin, Texas, ist in dem vorliegenden Band mit zwei Projekten vertreten. Die Gründer, Arthur Andersson und F. Christian Wise, begannen ihre Tätigkeit nach längerer Zusammenarbeit mit Charles Moore, einem der bekanntesten Architekten der Postmoderne. Ihr Projekt am Flathead Lake (Polson, Montana, 2007, Seite 80) misst bescheidene 56 m² Grundfläche. Das Haus mit Seeblick im Westen von Montana wurde so platziert, dass Nutzer die Natur und die Tierwelt, zu der auch Fischadler und Adler gehören, beobachten können. Das Gebäude ist auf sechs in Betonblöcken verankerten Stahlpfeilern an einem Standort mit Gefälle errichtet worden und verfügt weder über Heizung noch Klimaanlage. Fließendes Wasser wird aus dem See heraufgepumpt. Das Lake House (Austin, Texas, 2002, Seite 234) von Andersson-Wise ist mit 121 m² mehr als doppelt so groß. Dieser nicht ans Versorgungsnetz angeschlossene Bau liegt auf einem Grundstück in steiler Hanglage am Ufer von Lake Austin und ist so konzipiert, dass er „im Umfeld möglichst wenig Spuren hinterlässt". Das Projekt verfügt über raumhohe Öffnungen und wird auf diese Weise natürlich durchlüftet.

Ein Beispiel für den wachsenden Trend zur architektonischen Umnutzung von Schiffscontainern ist das 30 m² große Container Guesthouse (San Antonio, Texas, 2009–10, Seite 102) des Architekten Jim Poteet aus San Antonio. Das Projekt soll „einen größtmöglichen Effekt durch eine minimale architektonische Geste" erzielen. Das Gästehaus ist mit einer Dusche, einer Komposttoilette, einer großen Glasschiebetür und einem Fenster am Ende des Containers ausgestattet. Der leicht erhöhte Dachgarten ermöglicht ungehinderten Luftstrom. Der Innenraum ist isoliert und mit Bambussperrholz verschalt, die Containerrückseite mit immergrünem, schattenspendendem Wein bedeckt. Für das Fundament wurden Telefonmasten und für

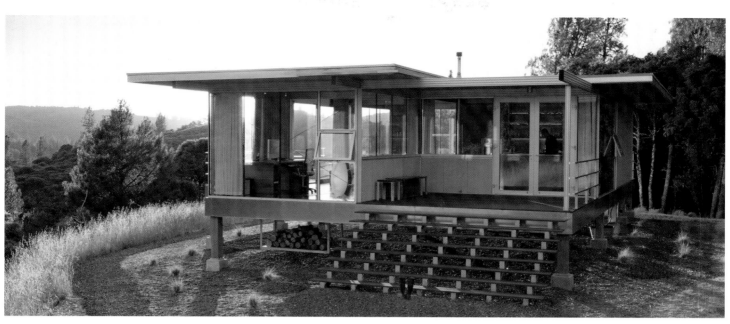

CLEARLAKE IT CABIN → 96

dem Wein bedeckt. Für das Fundament wurden Telefonmasten und für die Außenleuchten alte Scheiben eines Häufelpflugs wiederverwertet. Die Wiederverwertung von Materialien, vor allem des Containers selbst, sowie Maßnahmen zur Energieeinsparung machen das ökonomische, effiziente und sicher sehr wohnliche Container Guesthouse zu einem Prototyp für ähnliche Projekte in der Zukunft.

## TRAUTES HEIM IN HANGLAGE

Die kalifornischen Architekten von Taalman Koch haben viel Erfahrung mit „intelligenten" Häusern, die oft weit entfernt von städtischen Siedlungsräumen stehen. Die Clearlake IT Cabin (Clearlake, Kalifornien, 2010–11, Seite 96) ist zugleich das Wohnhaus und das Büro eines Lichtdesigners, der Los Angeles hinter sich lassen wollte. Das Projekt hat eine Grundfläche von 74 m² und wurde auf einer 1,2 m hohen Fertigbauplattform aus galvanisiertem Leichtstahl an einem Standort mit Gefälle errichtet. Pfeiler und Träger aus Leichtaluminium wurden vor Ort auf der Plattform zusammengesetzt. Der Grundriss ist reduziert und offen, große Glasflächen gewähren Ausblicke in die Natur. Außer für die Fußböden wurde auch für die Veranden, die Schränke und die maßgefertigten Möbel Zypressenholz wiederverwertet. Eine netzunabhängige Solaranlage befindet sich weiter oben auf dem Hang und versorgt das Haus mit Energie.

Auf eine junge Firma in Seattle, zeroplus, geht die Sneeoosh Cabin zurück (La Conner, Washington, 2006–07, Seite 334), ein Bau mit einer Grundfläche von 106 m², der in jeglicher Hinsicht auf sein Umfeld Rücksicht nimmt. Die ältesten Bäume vor Ort wurden erhalten und bestimmten den exakten Standort, an dem das Haus leicht erhöht steht, um den Boden möglichst zu schonen. Das verglaste Erdgeschoss ermöglicht eine Rundumsicht auf die Umgebung und „hebt die Grenze zwischen innen und außen auf". Auf der Westseite des Wohnraums befindet sich eine Schiebetür, die sich auf eine Terrasse öffnet, von dieser wiederum führt ein Treppenabgang auf einen gepflasterten Sitzbereich. Unterhalb des ausladenden Dachs befindet sich in einem „kokonartigen Gehäuse" der Schlafbereich. Ein Rahmensystem aus Stahlstreben und Brettschichtbalken widersteht extremer Witterung und möglichen Erdbeben.

Architektonische Eigenschaften wie diese können stellvertretend für einige der wichtigsten Ziele beim Bau von Häusern in ähnlichen Kontexten stehen: Standortschutz, die Verbindung von innen und außen bzw. der Bewohner mit ihrer Umgebung sowie Sicherheit inmitten der Wildnis. Wie lässt sich die Natur und wie lassen sich

Menschen vor den Unbilden derselben am besten schützen – das sind relevante Fragen für alle Architekten, die Projekte wie die in dem vorliegenden Band vorgestellten realisieren.

## UMWELTFREUNDLICH ODER UMWELTFEINDLICH

Der Bau von Hütten kann, abgesehen von den bereits erwähnten künstlerischen Intentionen, noch anderen Zwecken als der Schaffung von Wohnraum dienen. Die ungewöhnliche Outlandia Fieldstation (Glen Nevis, Lochaber, GB, 2008–10, Seite 296) des Architekten Malcolm Fraser aus Edinburgh hat eine Grundfläche von nur 7 m². Die nicht ans Versorgungsnetz angeschlossene Beobachtungsstation in Form eines Baumhauses sollte London Fieldworks, einem Zusammenschluss der Künstler Bruce Gilchrist und Jo Joelson, als flexibel einsetzbarer Treffpunkt für kreative künstlerische Zusammenarbeit und Recherche dienen. Das Projekt wurde auf einem Hang mit 45°-Gefälle errichtet und besteht teilweise aus vor Ort gefällten Bäumen. Der Architekt: „Der sanfte und umweltfreundliche Einsatz vor Ort gefällter Bäume war das ganze Gegenteil des invasiven, umweltschädlichen Absetzens der Betonfundamente per Helikopter." Die Klarheit dieser Äußerung zeigt einen Umstand, der für die meisten „umweltfreundlichen" Projekte in vergleichbaren Kontexten gilt: Die Materialien müssen oft über große Entfernungen angeliefert werden. Das mag angesichts moderner Bauverfahren zwar unvermeidlich sein, ist allerdings schädlich für die Umwelt. Ganz abgesehen davon, dass die Gegenwart von Menschen in der Natur die empfindliche Flora und Fauna stören kann. Anders als es sich so mancher wünschen mag, geht es bei vielen Projekten dieser Art eben doch nicht ganz ohne die Störung der Idylle zu.

Als Wohnraum konzipiert, aber aus behördlichen Gründen unbewohnt ist die Welcome Bridge (Tilburg, Niederlande, 2011–13, Seite 432) des Architekten und Künstlers John Körmeling. Die 112 m² große Kabine ist an einer Zugbrücke befestigt und hängt bei deren Öffnung 4,5 m über dem Boden. Körmeling gewann mit seinem Entwurf einen niederländischen Wettbewerb. Schon zuvor war er bekannt für durchaus kontroverse, besser noch: humorvolle, Projekte, darunter das Rotating House (Tilburg, 1999–2008) oder „Echt iets voor u", „die kürzeste überdachte Brücke der Welt" (Van Abbemuseum, Eindhoven, 2006). Im Fall der Welcome Bridge befände sich der jeweilige Brückenbewohner bzw. -meister nicht etwa abgeschieden inmitten der Natur, sondern im Luftraum, und könnte von hier, wie aus der Perspektive eines Außerirdischen, vorbeifahrende

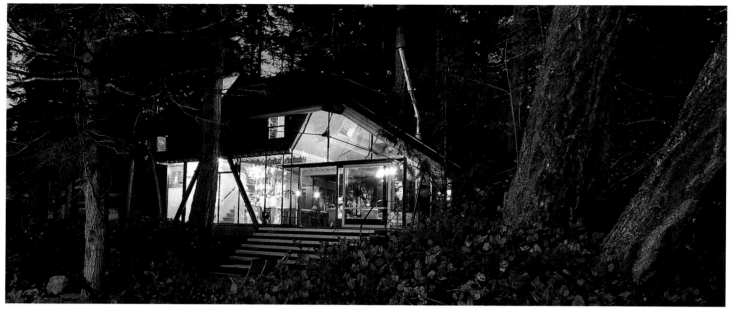

SNEEOOSH CABIN → 334

## ZURÜCK ZU DEN ALPEN

Eine Zusammenschau zeitgenössischer Hüttenarchitektur wäre unvollständig ohne Projekte, die der klassischen Almhütte, wie sie zahlreich in den schweizerischen oder österreichischen Bergen zu finden ist, ihre Reverenz erweisen. Die für diesen Band ausgewählten Beispiele fallen allerdings weniger traditionell aus. Der Umbau der Clavo Lain (Lain, Schweiz, 2011–12, Seite 88) durch das Team um Hans-Jörg Ruch hat wenig mit einer Almhütte zu tun. Vielmehr handelt es sich um eine vortrefflich umgebaute und durchaus großzügige (175 m²) Heu- und Viehscheune. In dem Wissen, dass die Abstände zwischen den Holzstämmen des ursprünglichen Gebäudes Luftaustausch gewährleisten, hat sich Ruch dafür entschieden, dieses wesentliche Gestaltungselement nicht aus Bequemlichkeit aufzugeben. Der Architekt: „Die Herausforderung bestand darin, Licht in die Räume zu lenken, ohne Fensteröffnungen in die Holzkonstruktion zu schneiden." In die bestehende Scheune wurde ein Gehäuse gesetzt, das Licht einlässt und den Bewohnern gleichzeitig Schutz vor Wind und Wetter bietet. Ein schwarzer Betonsockel wurde hinzugefügt, ohne die Scheune hierfür abzubauen. Der Architekt: „Das Gehäuse besteht aus gedämmten Holzrahmenelementen, die durch das Dach gelassen und vor Ort zusammengesetzt wurden. Der neue Baukörper ist mit einer Teerschicht überzogen, wodurch sich ein faszinierender Kontrast zur ursprünglichen Holzkonstruktion ergibt. In allen Phasen waren die architektonischen Eingriffe von allergrößtem Respekt gegenüber dem historischen Gebäude geleitet." Wie im Zusammenhang mit anderen Umbauprojekten auch, so zum Beispiel im Dorf Zuoz, beherrscht Hans-Jörg Ruch die Kunst, alte Holz- und Steinbauten auf eine Art und Weise umzubauen, die entschiedene Modernität ins Spiel bringt, ohne jedoch den traditionellen Kern der Originalarchitektur anzutasten. Das von Ruch in Lain hinzugefügte Fenster und die schräg einfallenden Sonnenstrahlen, die es ins Gebäude lässt, erinnern an die „Skyspaces" des Künstlers James Turrell, mit dem der Architekt bekannt ist.

Eine weitere Interpretation der Almhütte, deren Formensprache noch offenkundiger zeitgenössisch anmutet, geht zurück auf die österreichischen Architekten von Marte.Marte. Ihre Hütte (Laterns, Österreich, 2010–11, Seite 282) hat eine Grundfläche von 87 m². Der aus „sorgsam bearbeitetem Beton" bestehende Bau hat eine Eingangstür aus unbehandeltem Eichenholz und verschieden große quadratische Fenster, deren Rahmen ebenfalls aus massivem Eichenholz gearbeitet sind. Innerhalb des Gebäudes verbindet eine Wendeltreppe den Wohnbereich im Obergeschoss mit den beiden Privatbe-

reichen im Untergeschoss, wo Schlafzimmer und Entspannungsräume „wie bei einem Puzzle ineinandergreifen". Der gesamte Entwurf vermittelt einen Eindruck von Robustheit, der in vielerlei Hinsicht die durchaus raue Schönheit der Natur widerspiegelt. Das Projekt ist zwar nicht unmittelbar von traditionellen Almhütten inspiriert, stellt aber dennoch einen Versuch dar, dieses architektonische Genre neu zu interpretieren. Das Projekt als „Hütte" zu klassifizieren, legt der offizielle Name des Projekts eher nahe als seine Erscheinung.

In großer Entfernung von den Alpen liegt die Alpine Cabin (Vancouver Island, Kanada, 2008–13, Seite 34) der Architekten Scott & Scott. Es handelt sich um eine nicht ans Versorgungsnetz angeschlossene Unterkunft für Snowboarder am nördlichen Ende von Vancouver Island. Verwendet wurden Stützen aus regionalem Douglasienholz, sägeraues Tannenholz, Zedernholz für die Außenverkleidung und gehobeltes Tannenholz für den Innenbereich. Der Entwurf sollte ohne maschinellen Aushub auskommen sowie schweren Schneefällen und starken Winden standhalten. In der Hütte gibt es keinen Strom, geheizt wird mit einem Holzofen. Wasser wird von einer Quelle vor Ort ins Haus geholt. Die Hütte liegt 1300 m über dem Meeresspiegel und ist fünf Monate im Jahr über eine Schotterstraße zugänglich. Den Rest des Jahres werden Ausrüstung und Materialien per Schlitten angeliefert. Wegen der eingeschränkten Erreichbarkeit und des fehlenden Anschlusses ans Versorgungsnetz kann diese Hüttenvariante in all ihrer Modernität im Vergleich mit Betonbauten, die über fließend Wasser und Breitbandinternet verfügen, als „authentischer" gelten.

## WÄHREND DIE WIRKLICHKEIT EINE FABEL IST

Hütten und Häuser, die sich an Standorten in der Natur befinden, sind derart weit verbreitet, dass noch mehr Beispiele in diesen Band hätten einfließen können. Wie auch bei den anderen Bänden der Reihe *Architecture Now!* wurde sehr bewusst eine große Bandbreite an Projekten ausgewählt, um einen Eindruck davon zu vermitteln, wie vielgestaltig diese Architekturform im Hinblick auf Erscheinungsbild, Verwendungszweck und Größe ist. Als Hütte wurde hier vor allem ein Gebäude aufgefasst, das für das Leben inmitten der Wildnis dient. Vor dem Hintergrund zunehmenden Umweltbewusstseins tendieren Verantwortliche von Neubauprojekten in den letzten Jahren dazu, Wege ausfindig zu machen, die jeweiligen Standorte zu schonen und ggf. einen unkomplizierten Rückbau zu gewährleisten. In diesem Zusammenhang ist es erwähnenswert, dass die Hütten von früher, die

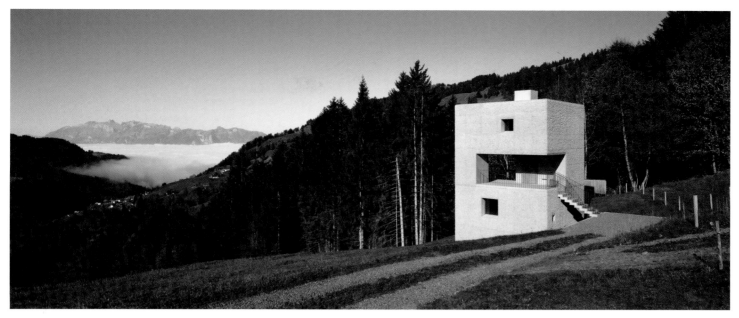

MOUNTAIN CABIN → 282

so gut wie immer aus Holz- und Steinmaterialien errichtet wurden, keine mit der Architektur von heute vergleichbaren Probleme mit sich brachten, was die Schädigung der Umwelt oder einen etwaigen Abriss angeht. In den Alpen beispielsweise verfallen aufgelassene Hütten. Holz und Stein gehen wieder ein in die Natur, aus der sie stammen. Stahl und Kunststoff dagegen werden nicht ohne Weiteres von der Erde wiederaufgenommen. In Zeiten wirtschaftlicher Krisen und immer größer werdender Zweifel an einem auf Konsum basierenden Gesellschaftsmodell sind Hütten auch deshalb beliebt, weil sie für die Suche nach einem weniger beschwerlichen und zerstörerischen Lebensstil stehen. Le Corbusiers Nachkriegsstudie, in der er seine ganz eigenen Mindestanforderungen ans Wohnen untersuchte, war zwar durchaus intellektueller Natur, fand aber vollständigen Eingang in sein Leben. Das Cabanon gleicht einer an der Küste von Roquebrune-Cap-Martin abgeworfenen Mönchszelle. Wenn die Proportionen stimmen (Stichwort Modulor) und für die grundlegenden Dinge des Lebens gesorgt ist, brauchen wir in unseren modernen Häusern dann tatsächlich immer mehr Platz? Steht nicht möglicherweise ein Weniger an Wohnraum eher im Einklang mit der Welt, in der wir leben? Renzo Pianos Diogene-Entwurf für Vitra dagegen formuliert Mindestanforderungen ans Wohnen auf andere Weise, lässt an Katastrophenszenarien und, wenigstens im Hinblick auf unseren materiellen Konsum, an eine Philosophie des Weniger-ist-mehr denken. Interessant ist auch folgende Tatsache: Im Fall von Thoreaus Hütte am Walden Pond, dem ersten hier angeführten Beispiel, stand die Lebensphilosophie ihres Erbauers in enger Verbindung mit einem Minimum an Bequemlichkeit und Größe. In Abkehr von „Blendwerk und Betrug" wollte Thoreau eine einfache Hütte, die geeignet sein sollte, „einem wandernden Gotte Obdach zu bieten".

*Blendwerk und Betrug werden als unerschütterliche Wahrheiten angesehen, während die Wirklichkeit eine Fabel ist. Wenn die Menschen ruhig nur die Wirklichkeit beobachten und sich nicht blenden lassen wollten, so würde ihnen das Leben, um es mit etwas, das wir kennen, zu vergleichen, wie ein Feenmärchen, wie Erzählungen aus „Tausendundeine Nacht" erscheinen. Wenn wir nur das achten wollten, was unvermeidlich ist und ein Recht auf Existenz hat, so würden die Straßen von Musik und Poesie erklingen. Wenn wir weise und ohne Eile sind, so sehen wir, dass nur große und würdige Dinge eine ewige und absolute Dauer haben, dass kleine Sorgen und kleine Freuden nur Schatten der Wirklichkeit sind. Dies ist immer erfreulich und erhebend. Indem sie ihre Augen schließen und schlummern und sich durch den Schein betrügen lassen, setzen die Menschen überall ihre tägliche Lebens- und Gewohnheitsroutine, die stets auf rein illusorischem Grunde aufgebaut ist.*[4]

Henry David Thoreau, *Walden oder Leben in den Wäldern*, 1845

Philip Jodidio
Grimentz, Schweiz

**1**  Henry David Thoreau, *Walden oder Leben in den Wäldern*, Zürich 1979, S. 98
**2**  http://eileengray-etoiledemer-lecorbusier.org/le-cabanon/, Zugriff am 11. November 2013
**3**  Projektdokumentation zur Verfügung gestellt von RPBW, dem Büro von Renzo Piano
**4**  Henry David Thoreau, *Walden oder Leben in den Wäldern*, Zürich 1979, S. 102 ff.

# FAITE POUR RECEVOIR UN DIEU EN VOYAGE

*Je gagnai les bois parce que je voulais vivre suivant mûre réflexion, n'affronter que les actes essentiels de la vie, et voir si je ne pourrais apprendre ce qu'elle avait à enseigner, non pas, quand je viendrais à mourir, découvrir que je n'avais pas vécu. Je ne voulais pas vivre ce qui n'était pas la vie, la vie est si chère ; plus que ne voulais pratiquer la résignation, s'il n'était tout à fait nécessaire. Ce qu'il me fallait, c'était vivre abondamment, sucer toute la moelle de la vie, vivre assez résolument, assez en Spartiate, pour mettre en déroute tout ce qui n'était pas la vie, couper un large andain et tondre ras, acculer la vie dans un coin, la réduire à sa plus simple expression.*

Henry David Thoreau, ***Walden ou la vie dans les bois,*** *1854, trad. Louis Fabulet*

La cabane construite en 1845 par le poète et philosophe américain Henry David Thoreau près de Concord, Massachusetts, dans laquelle il vécut 14 mois incarne à bien des égards les motifs qui poussent des hommes et des femmes à chercher refuge dans de minuscules domiciles, loin du stress et de la pollution des villes. L'idée du retour à la nature est d'autant plus répandue aujourd'hui que les derniers vestiges des déserts sont gravement menacés par l'urbanisation ou les « impuretés » que la vie moderne répand dans l'air et l'eau. Si l'excès et le « luxe » sont les forces motrices de certaines sociétés, de plus en plus de gens ressentent le besoin de redescendre à un minimum absolu, de vivre face au soleil levant ou d'écouter tous les jours les bruits de la nature. Cela ne veut pas dire que les cabanes ne peuvent offrir le moindre confort – la majeure partie de celles présentées ici disposent de tous les agréments de la « civilisation » – mais le raisonnement qui pousse certains à en construire pourrait bien les amener à oublier la forte empreinte carbone de la vie quotidienne dans les sociétés industrialisées.

Bien que la description par Thoreau de sa cabane au bord de l'étang de Walden évoque fortement le XIX^e siècle, nombre de ceux qui se construisent une petite maison dans le désert s'y réfèrent encore pour expliquer leur quête. Par exemple en ces termes :

*Lorsque pour la première fois je fixai ma demeure dans les bois, c'est-à-dire commençai à y passer mes nuits aussi bien que mes jours, ce qui, par hasard, tomba le jour anniversaire de l'Indépendance, le 4 juillet 1845, ma maison, non terminée pour l'hiver, n'était qu'une simple protection contre la pluie, sans plâtrage ni cheminée, les murs en étant de planches raboteuses, passées au pinceau des intempéries, avec de larges fentes, ce qui la rendait fraîche la nuit. À mon imagination elle conservait au cours de la journée plus ou moins de ce caractère auroral, me rappelant certaine maison sur une montagne, que j'avais visitée l'année précédente. C'était, celle-ci, une case exposée au grand air, non plâtrée, faite pour recevoir un dieu en voyage, et où pouvait une déesse laisser sa robe traîner. Les vents qui passaient au-dessus de mon logis, étaient de*

*ceux qui courent à la cime des monts, porteurs des accents brisés, ou des parties célestes seulement, de la musique terrestre. Le vent du matin souffle à jamais, le poème de la création est ininterrompu ; mais rares sont les oreilles qui l'entendent. L'Olympe n'est partout que la capsule de la terre* [1].

## J'AI UN CHÂTEAU SUR LA CÔTE D'AZUR

Là où le raisonnement de Thoreau se rapproche d'une philosophie de vie, c'est dans sa tentative de revenir à l'essentiel, une motivation qui semble aussi avoir présidé à la construction du Cabanon de vacances par Le Corbusier entre 1951 et 1952 à Roquebrune-Cap-Martin. Commencée dès 1948, alors que l'architecte travaillait aux projets de villégiatures voisins Roq et Rob, qui n'ont jamais été réalisés, c'est la seule et unique structure que Le Corbusier ait jamais construite pour lui-même, une cabane de tout juste 3,66 x 3,66 x 2,26 mètres. Le Cabanon, préfabriqué en Corse, est situé à proximité de la célèbre maison construite par son amie Eileen Gray (Villa E.1027, 1924) et juste à côté d'un bar appelé L'Étoile de mer qui appartenait au client de Roq et Rob, Thomas Rebutato. Construit en matériaux industriels et doté d'une apparence rude, ou rustique, en bois, le Cabanon expérimente la notion de modulor, le système de proportions humaines mis au point par Le Corbusier en 1943, et malgré une simplicité apparente, il est le résultat d'une réflexion minutieuse, on le voit notamment au mobilier disposé en spirale. En 1954, Le Corbusier achète 1290 mètres carrés de terrain à Rebutato, dont le Cabanon, et construit en échange cinq « unités de camping » pour son client [2]. Il aimait manifestement beaucoup Roquebrune-Cap-Martin et sa cabane. Il en disait : « J'ai un château sur la Côte d'Azur, qui fait 3,66 mètres par 3,66 mètres. C'est pour ma femme, c'est extravagant de confort, de gentillesse. » C'est certainement un endroit « où pouvait une déesse laisser sa robe traîner ». Ironie du destin, Le Cor-

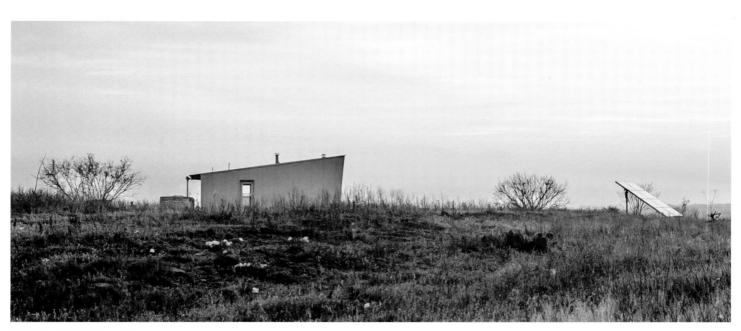

SUSTAINABLE CABIN → 366

busier se noiera dans la mer à Roquebrune le 27 août 1965. André Malraux, alors ministre de la Culture, prononça l'éloge funèbre dans la cour du Louvre le 1er septembre et l'architecte fut enterré comme il le voulait à Roquebrune-Cap-Martin, à côté de sa femme.

Les exemples de Thoreau et Le Corbusier n'ont, bien sûr, pas été choisis au hasard, ils sont tous les deux profondément révélateurs de l'attrait exercé par les cabanes, en termes de philosophie comme d'architecture. L'un des projets publiés ici, la Cabane durable (Sustainable Cabin, Crowell, Texas, 2010, page 367), construite par des étudiants et professeurs de l'université Texas Tech, fait expressément référence à ces deux exemples historiques. Elle a été construite avec l'équivalent actuel de ce que la sienne avait coûté à Thoreau (28 dollars et 12,5 cents, ce qui correspond aujourd'hui à 683,08 $) et selon le professeur qui a dirigé le programme, Upe Flueckiger : « Les précédents historiques sont la cabane de Henry David Thoreau au bord de l'étang de Walden... et le Cabanon du Corbusier... Les deux projets sont des études des besoins d'espace minimaux pour vivre. Ils sont également des exemples de structures qui entretiennent une relation réussie avec l'environnement et les sites sur lesquels elles sont construites. Enfin, ils ont tous les deux été réalisés avec des contraintes budgétaires significatives, rarement prises en compte dans les studios de design de nos écoles d'architecture. »

Bien sûr, l'idée de la proximité avec la nature comme source d'inspiration n'est pas sans évoquer certaines croyances religieuses. Le « confort extravagant » du Corbusier n'excédait pas 13 mètres carrés d'espace habitable. L'architecte Kim Hee Jun en propose cinq de plus dans sa cabane destinée à un célèbre moine bouddhiste coréen (Pyeongchang, Corée du Sud, 2009, page 268), mais l'espace central ou « bang » n'occupe qu'un carré de 2,7 mètres sur 2,7 (7,29 mètres carrés), avec un plafond de 5,5 mètres, il « devient une partie du paysage lorsque les portes sont ouvertes, tandis qu'elles permettent à la lumière de faire écho aux traces de la nature lorsqu'elles sont fermées », selon les termes de l'architecte.

## FRAGILE, DANS LA SAUVAGE FORÊT HIVERNALE

Un autre exemple venu d'Asie montre la diversité des effets et des buts recherchés par les architectes qui créent des cabanes. L'« artiste environnemental » Hidemi Nishida, âgé de seulement 27 ans, a imaginé l'Abri fragile (Sapporo, Japon, 2010–11, page 172) de 20 mètres carrés : destiné à accueillir des réunions ou des fêtes, il est surélevé

pour le protéger des conditions météorologiques extrêmes en hiver mais suit aussi la courbe de niveau du sol comme s'il réagissait au terrain de manière organique. Située dans ce que l'architecte appelle une « forêt hivernale sauvage », la structure semble vouloir définir les limites de la rencontre entre architecture et nature : physiquement et mentalement « fragile », elle ne touche que légèrement le sol – une caractéristique de la plupart des cabanes publiées ici.

Les toutes petites cabanes situées dans des régions sauvages ou désertiques attirent souvent l'intérêt des architectes, surtout les plus jeunes d'entre eux, même si cette règle connaît aussi ses exceptions. La Maison sur une île (Breukelen, Pays-Bas, 2011–12, page 220) de 21 mètres carrés conçue par 2by4-architects de Rotterdam est un exemple intéressant. Elle vise à « créer une interaction sur commande avec le décor naturel environnant » sur une île étroite. Peu de clients pourraient s'imaginer disposer d'une douche, de toilettes, d'une cuisine, de placards et de rangements sur un espace aussi réduit, sans oublier le lit. Avec ses façades entièrement ouvertes sur une terrasse en bois, la maisonnette semble flotter sur l'eau et permet à ses habitants d'admirer le lever et le coucher du soleil sous un abri réduit au minimum et, bien sûr, dans un confort relatif.

## DES FORMES SIMPLES COMPLEXES À VIVRE

D'une taille encore plus réduite que le Cabanon, Nido (Sipoo, Finlande, 2011, page 290) a été créé par Robin Falck alors qu'il avait 19 ans (2009). Il a voulu « optimiser l'usage de l'espace, se contenter de l'essentiel et se débarrasser de tout ce qui n'est pas nécessaire » avec sa cabane de 9 mètres carrés. Son choix d'utiliser des matériaux de récupération, du bois d'origine locale ou du lin pour l'isolation souligne une tendance très nette des cabanes créées par des architectes ou des designers depuis quelques années : un souci réel de la nature et une volonté de minimiser les sources de pollution. Il semble logique, en effet, que les propriétaires et les architectes, lorsqu'ils imaginent un espace de vie réduit, cherchent aussi à afficher leur responsabilité envers l'environnement.

Toujours dans un pays nordique (Ingarö, Suède, 2002, page 66), la Cabane 4:12 par Joakim Leufstadius de l'agence Imanna Arkitekter basée à Stockholm est une structure de 12 mètres carrés qui se targue de posséder pas moins de quatre espaces différents, en écho au désir de l'architecte de « créer une complexité avec une forme simple ». Avec sa façade qui peut être entièrement ouverte et des

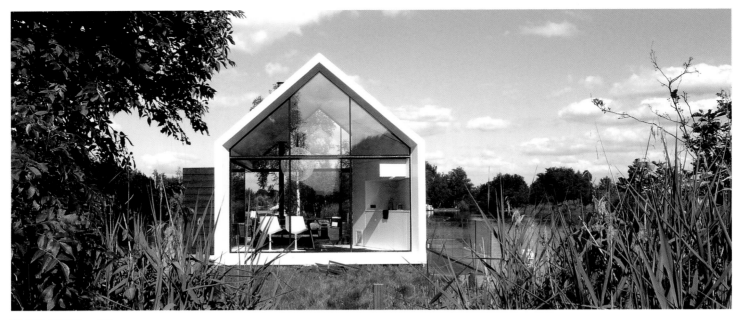

ISLAND HOUSE → 220

vitrages disposés en fonction des vues de la forêt environnante, elle permet d'expérimenter délibérément la vie dans des conditions minimales et de vivre le plus pleinement possible dans la nature.

Le studio Dovecote (Snape Maltings, Snape, Suffolk, GB, 2009, page 122) des architectes Haworth Tompkins présente une surface au sol de 29 mètres carrés et sa construction a coûté 155 000 £. Destiné à accueillir un artiste célibataire, il fait partie du campus de musique de Snape Maltings, fondé par Benjamin Britten sur la côte anglaise du Suffolk. Plus raffiné dans sa conception que certaines des autres cabanes publiées ici, il est fait d'acier Corten soudé doublé de contreplaqué d'épicéa. Fabriqué sur le site même, il a été mis en place à l'aide d'une grue dans les ruines d'un colombier du XIXᵉ siècle. Face à la mer du Nord, c'est sans aucun doute un endroit idéal pour le travail et la contemplation – une autre des vertus souvent recherchées dans toute cabane digne d'être racontée par Thoreau, Le Corbusier et leurs semblables.

D'autres exemples de studios d'artistes de type cabane sont publiés ici. Les studios Diane Middlebrook (Woodside, Californie, 2011, page 108) comprennent quatre unités de 26 mètres carrés créées par Cass Calder Smith (CCS Architecture). Réservées aux écrivains en résidence dans le cadre du programme Djerassi, ces «cabanes de sommeil/travail» ont été dotées d'une toiture préfabriquée indépendante en acier qui porte des panneaux solaires et disposées de manière à optimiser la vue sur les monts Santa Cruz qui dominent le Pacifique. Elles sont revêtues de panneaux de thuya géant brut avec de larges baies vitrées coulissantes et des espaces extérieurs privés. Leurs faces nord-est sont percées de fenêtres à claire-voie orientées vers les lignes de crête et les arbres environnants. Des ouvertures rectangulaires dans l'auvent d'acier créent des motifs d'ombre et de lumière et sont placées directement au-dessus des lucarnes dans le toit des cabanes de manière à ouvrir à chacune une fenêtre sur le ciel.

## PAS DE MATÉRIAUX PRÉCIEUX

Bien évidemment, la mode des cabanes n'est pas limitée à l'Europe en cette période d'inquiétudes environnementales et de difficultés économiques. Pour à peine 20 000 $, Dan Molenaar de Mafcohouse (Toronto) a conçu et construit le «baraquement» Franke-Mirzian (Franke-Mirzian Bunkhouse, Haliburton, Ontario, Canada, 2013, page 178) dont la surface utile atteint tout juste 9,3 mètres carrés. Le

chauffage est assuré par un poêle à bois à très bon rendement, des panneaux photovoltaïques fournissent l'éclairage et les finitions intérieures sont en sapin de Douglas. Proche du lac Drag (Haliburton), l'extérieur est bardé d'acier ondulé avec un revêtement en cèdre pour la véranda. À l'autre bout du monde, la cabane Zig Zag (Zig Zag Cabin, Wollombi, Nouvelle-Galles-du-Sud, Australie, 2002, page 444) de Drew Heath représente une autre tentative de définir les exigences minimales de vie. Avec une surface habitable de 10 mètres carrés, elle contient deux lits au rez-de-chaussée et une couchette sur une mezzanine suspendue. La charpente torsadée en bois, assemblée et maintenue par une poutre en contreplaqué, permet d'ouvrir la fenêtre et la porte aux coins. Du masonite et du cyprès ont été utilisés, conformément au refus par l'architecte de tout «matériau précieux».

## SUSPENDU À UN ARBRE OU PERCHÉ AU SOMMET D'UNE MONTAGNE

Bien sûr, les cabanes servent en premier lieu à fuir dans le désert pour trouver le temps de penser et de se laisser gagner par la paix. Mais les petites structures peuvent aussi avoir d'autres objectifs, plusieurs exemples publiés ici le montrent. Les hôtels sont ainsi de plus en plus nombreux à être composés de cabanes – perchées dans des arbres ou placées à des endroits inhabituels comme le sommet d'une montagne. De même, de nombreux artistes et designers se sont emparés de ce mode d'expression pour mettre en avant différents points qui présentent souvent un caractère d'urgence dans le contexte actuel.

L'Allemand Andreas Wenning, fondateur de baumraum et célèbre créateur de maisons dans les arbres, s'est lancé dans une entreprise plus vaste avec l'ensemble Tree House Resort (Schrems, Autriche, 2013) qui occupe une carrière à l'Est de la ville. Trois maisons et habitations dans la falaise de chacune 20 mètres carrés environ forment ce complexe dont les cabanes ne sont qu'une partie. La même idée a été reprise, dans un esprit assez différent, pour l'hôtel dans les arbres de Harads, en Suède. Après avoir fait appel à de nombreux autres architectes, les propriétaires ont demandé à l'équipe de Rintala Eggertsson, basée à Oslo, de créer la dernière et la plus grande des suites dans les arbres, baptisée Libellule (Dragonfly, 2013, page 128). Suspendue à huit pins et épicéas, la cabane de trois chambres peut loger jusqu'à six personnes. Revêtue d'acier patinable

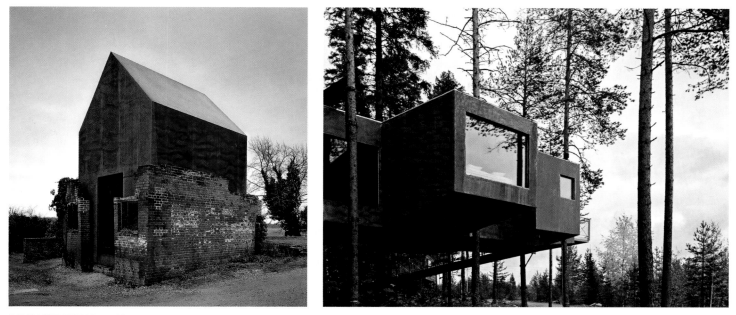

DOVECOTE STUDIO → 122                         DRAGONFLY → 128

et doublée de contreplaqué, la structure rapproche indéniablement les clients de la nature tout en leur offrant un confort relativement élevé. Les maisons dans les arbres sont, en un sens, la cabane ultime, au point que les arbres auxquels elles sont suspendues sont protégés. En plus du sentiment de faire littéralement partie du cadre naturel, elles offrent aussi la sensation inattendue, et éventuellement déstabilisante, de souffler avec le vent.

Les mêmes architectes sont les auteurs du projet Hut to Hut (Kagala, Karnataka, Inde, 2012), une structure de 27 mètres carrés développée pour un budget de 75 000 $ dans le cadre d'un atelier de conception et réalisation regroupant des étudiants de l'Université des sciences et technologies de Trondheim qui suivaient un séminaire international consacré à l'avenir de l'écotourisme dans la région des Ghâts occidentaux, en Inde. Il s'agissait d'utiliser des matériaux produits sur place et des sources d'énergie renouvelables. Les architectes expliquent que «cela incarne une possibilité pour la population locale d'investir dans le secteur en expansion du tourisme sensibilisé aux questions d'environnement, tout en conservant sa culture et son style de vie traditionnels.»

Encore plus loin des sentiers battus, l'étonnant hôtel LEAPrus est situé à 3912 mètres d'altitude, sur les pentes de l'Elbrouz (Caucase, Russie, 2013, page 242). Cinq constructions en fibre de verre ou panneaux sandwich recouverts de feuilles d'aluminium contiennent 49 lits, des toilettes, une réception et des logements de service, ainsi qu'un restaurant avec cuisine, le tout sur une surface utile au sol de 106 mètres carrés. Les auteurs du projet, l'agence LEAPFactory basée à Turin, ont également créé le refuge Gervasutti (Mont Blanc, Courmayeur, Italie, 2011), un bivouac de 30 mètres carrés construit à 2835 mètres d'altitude sur les pentes du Mont Blanc. Assemblés par hélicoptère avec des modules de stratifié composite de 600 kilos, ces refuges peuvent aussi être démontés sans causer le moindre dommage au site montagneux sensible. Et si le refuge Gervasutti évite résolument toute tentative de «se fondre» dans le paysage, sa nature réversible et son impact minimal sur l'environnement n'en font pas moins véritablement un modèle pour le design d'altitude du futur.

## DES MODULES ET DES PAVILLONS

Le DROP Eco-Hotel (2012, page 134) des architectes In-Tenta de Barcelone lui aussi est composé de modules de 25 mètres carrés en bois, acier et polycarbonate. En forme de tubes avec des fenêtres bulle, ils peuvent facilement être transportés par camion et posés sur des pattes en acier réglables. Des panneaux photovoltaïques sur le toit et un système de récupération de l'eau de pluie pour la salle de bains permettent de diminuer encore l'impact sur l'environnement. Le concept prévoit de réunir un certain nombre de modules pour créer des hôtels à divers emplacements. Une logique similaire a été appliquée par l'agence de Graz (Autriche) Studio WG3 pour son Hypercubus de 19 mètres carrés (Graz, 2010, page 214). Ces structures mobiles d'un coût de 63 500 € l'unité possèdent des fondations en béton armé surmontées d'une ossature en bois de charpente lamellé et de murs en contreplaqué. Selon les architectes, le but était «de développer un logement minimal pour deux personnes. Destiné au secteur touristique, l'ensemble associe la fabrication industrielle, la transportabilité, l'optimisation de l'espace intérieur, l'autosuffisance, une architecture originale et facilement reconnaissable et l'efficacité économique». Le module prototype peut être empilé verticalement afin de créer une «structure de type hôtel». De conception plus traditionnelle, les 20 pavillons du domaine viticole Longen-Schloeder (Longuich, Allemagne, 2011-12, page 256) par l'architecte Matteo Thun disposent chacun d'une surface habitable de 20 mètres carrés. Situés dans la vallée de la Moselle, leurs formes sont inspirées de l'architecture locale et ils sont construits avec des pierres extraites à proximité. Les intérieurs en sont marqués par le bois, «les étoffes d'origine et les matériaux naturels»; ils sont reliés à l'extérieur par de larges portes vitrées.

## ÔTE-TOI DE MON SOLEIL

Plus proche de l'esprit qui a pu animer un Le Corbusier, l'Italien Renzo Piano s'est récemment essayé à l'idée de conditions d'habitat «minimales». Sa cabane Diogene (Weil-am-Rhein, Allemagne, 2013, page 118) présente une surface habitable de 7,5 mètres carrés pour un coût approximatif de 20 000 €. Le projet est basé, selon Piano, sur «l'idée d'un refuge minimaliste pouvant être utilisé en cas d'urgence, à petite échelle, autosuffisant et durable. Une petite unité résidentielle qui a uniquement recours à des sources d'énergie naturelles». La cabane créée pour le fabricant de mobilier design Vitra et construite en panneaux XLAM (trois couches de cèdre croisées et collées) peut facilement être transportée. Des panneaux sous vide et des fenêtres à triple vitrage garantissent l'isolation, tandis que des

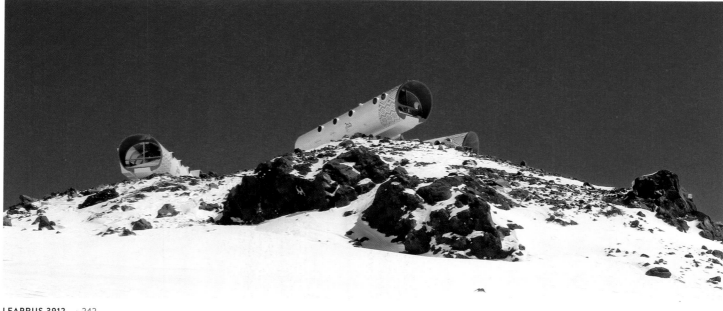

LEAPRUS 3912 → 242

modules photovoltaïques, une pompe à chaleur géothermique, la récupération de l'eau de pluie et l'éclairage faible consommation contribuent à la stratégie écologique du projet. À l'intérieur, un canapé-lit repliable, une table en bois et des caisses de rangement légères en aluminium forment un environnement spartiate, mais pratique. Le projet doit son nom au philosophe grec Diogène qui considérait que «l'homme a compliqué chaque cadeau des dieux». On raconte qu'il vivait dans un tonneau et aurait brisé le dernier objet qu'il possédait, un petit récipient en bois, après avoir vu un jeune garçon boire dans ses mains. La légende veut aussi qu'Alexandre le Grand ait rencontré le philosophe et lui ait demandé quel souhait il voudrait voir exaucé, ce à quoi Diogène aurait répondu : «Ôte-toi de mon soleil.» Faisant preuve à la fois de tolérance et de compréhension, l'empereur aurait alors déclaré : «Si je n'étais pas Alexandre, je voudrais être Diogène [3].»

Si la définition des cabanes choisie ici a tendance à préférer les emplacements isolés et les tailles réduites, le genre fait aussi son apparition dans les environnements urbains. L'abri ByGG (Porto, Portugal, 2012, page 328) créé par Gabriela Gomes est une construction de 11 mètres carrés qui coûte 36 500 €. Cette petite «sculpture habitable» est faite de bois, d'OSB (panneaux à copeaux orientés), d'aggloméré de liège expansé et de CORKwall en couverture extérieure. Selon Gomes : «Il s'agit d'un objet expérimental qui associe sculpture, design et architecture, tel un défi aux nouvelles expériences de l'espace et une remise en question des liens entre plaisir artistique et problèmes de logement.» Les matériaux utilisés sont non polluants et recyclés, et le projet fait appel à l'énergie solaire. Cet objet est clairement autant à sa place dans un environnement urbain que plus loin des villes.

## UNE FLORAISON INCONGRUE

À l'opposé, les Trois huttes à Paris (2008–13, page 390) de l'artiste japonais Tadashi Kawamata sont intimement liées à leurs emplacements. Kawamata a commencé son travail à Paris et ailleurs en 2008. Après le jardin des Tuileries (2008), la Monnaie de Paris (2008) et le Centre Pompidou (2010), il a choisi la place Vendôme pour sa dernière installation (2013). Il compare ses cabanes à des huttes tribales, des refuges pour sans-abris, ou même des pigeonniers. À l'instar des cabanes dans des décors «plus naturels», ces structures évoquent l'idée de refuge, mais dans un esprit de contradiction délibérée avec leur environnement urbain. Contrairement à la plupart des autres cabanes publiées ici, les huttes de Kawamata ne sont pas destinées à être habitées, mais plutôt à «fleurir» de manière incongrue sur des architectures classiques – ou plus modernes pour le Centre Pompidou. De même, si les autres maisonnettes sont construites dans l'ensemble pour des gens aisés, même celles aux dimensions les plus réduites, Kawamata fait appel à une autre interprétation de la cabane, faite ici exclusivement de matériaux réutilisés, qui évoque la misère autant que le désir d'échapper au rythme effréné de la vie citadine. Si ses installations prennent souvent des dimensions architecturales, elles ont aussi toutes en commun une accumulation dans un désordre apparent de matériaux réutilisés. Un autre créateur s'est fait connaître pour ses cabanes d'apparence chaotique, le Canadien Richard Greaves.

## DISPARAÎTRE DANS LE DÉSERT

Tous ceux qui ont visité l'Ouest des États-Unis ou leurs autres régions sauvages pourront le confirmer, le pays a la chance de posséder d'immenses territoires à l'abri de toute urbanisation et de la plupart des formes de pollution immédiate. C'est aussi le pays où est né l'individualisme qui a inspiré Thoreau et d'autres artistes. Enfin, au-delà d'une population réellement défavorisée, on y trouve un grand nombre de gens qui ont les moyens de construire des structures originales en pleine nature. La taille de certaines est supérieure à ce qu'on pourrait, techniquement parlant, appeler cabane, mais elles ont en commun l'immersion dans la nature, même si c'est parfois avec un confort que Le Corbusier n'aurait sans doute pas jugé recommandable dans de telles circonstances.

Les architectes de Washington Olson Kundig, et en particulier Tom Kundig, sont en un sens des pionniers des abris à l'architecture complexe qui donnent malgré tout une impression d'autonomie et de rudesse. Le refuge Delta (Mazama, Washington, 2005) dispose d'une généreuse surface de 93 mètres carrés. Surélevé sur des pilotis en raison des inondations régulières sur ce site, il possède quatre volets coulissants double hauteur en acier qui s'ouvrent avec un mécanisme à manivelle et le protègent des intempéries ou en l'absence du propriétaire. Le refuge est situé à un emplacement très isolé, de sorte qu'il a été préfabriqué et assemblé sur place. Le choix de l'acier non traité soumis à la rouille pour le revêtement extérieur trouve un écho dans les finitions intérieures en contreplaqué plutôt

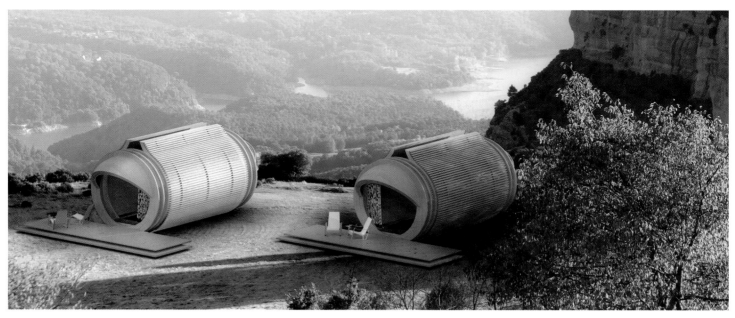

DROP ECO-HOTEL → 134

brutes. L'architecte explique : « Lorsqu'il est utilisé, le refuge offre des vues incomparables des majestueux paysages de l'État rural de Washington et lorsqu'il est fermé, la cabane se dresse comme une sentinelle dans la forêt de trembles. » L'idée d'observer une région désertique en restant protégé correspond parfaitement à la philosophie de la cabane ou de ses habitants (à temps partiel). La cabane de la Tye River (Skykomish, Washington, 2005, page 414), également construite par Kundig, est une structure de 116 mètres carrés en bois récupéré sur un vieil entrepôt, béton coulé en place et acier. Avec deux chambres et une salle de bains, elle est dotée d'une pompe à chaleur géothermique. Quant à son esthétique, les architectes expliquent : « Avec le temps, la cabane va prendre une teinte de plus en plus sourde et finira par disparaître dans la forêt. » La remarque est intéressante car elle révèle mieux que toute autre le souhait des créateurs de cabanes, et certainement aussi de leurs habitants, de devenir en quelque sorte une partie de l'environnement naturel – pas forcément par le biais d'architectures « organiques », mais au prix d'un réel effort pour entrer en symbiose avec la nature. La cabane Olson (Longbranch, Washington, 1959/2003) a été imaginée par le partenaire de Kundig Jim Olson à l'intérieur et autour d'une vieille cabane familiale. Olson a cherché à unifier la construction d'origine et les ajouts ultérieurs au moyen de colonnes en acier galvanisé et de poutres en bois lamellé. Le salon ouvre par une baie vitrée sur toute sa hauteur pour donner l'impression que toute barrière a disparu entre intérieur et extérieur. Des éléments de la cabane d'origine restent visibles sous forme de parois intérieures dans le nouveau bâtiment, dont tout le bois de construction est certifié. Ainsi dans cet exemple, et même si la plupart des cabanes publiées ici sont des constructions nouvelles, le cadre naturel et l'architecture ancienne sont associés pour former un tout cohérent.

Deux cabanes d'une autre agence connue d'Austin (Texas) – Andersson-Wise – sont présentées ici. Les fondateurs de l'agence, Arthur Andersson et F. Christian Wise, ont repris le travail après une longue collaboration avec Charles Moore, l'un des architectes postmodernes les plus remarqués. Leur cabane du lac Flathead (Cabin on Flathead Lake, Polson, Montana, 2007, page 80) est de dimensions modestes avec une surface habitable de 56 mètres carrés. Elle domine le lac Flathead, dans l'Ouest du Montana, et occupe un emplacement idéal pour l'observation de la nature, de la faune et de la flore, notamment des balbuzards et des aigles. La structure est posée sur six piliers en acier ancrés dans des blocs de béton sur le site en pente. La cabane ne possède ni chauffage, ni climatisation, et

l'eau courante est pompée dans le lac en contrebas. La Maison du lac (Austin, Texas, 2002, page 234) par les mêmes architectes occupe une surface plus de deux fois supérieure (121 m²). Non raccordée au réseau électrique, elle est construite sur une berge escarpée du lac Austin et a été conçue pour « avoir un impact minimal sur les alentours ». Elle est ouverte sur toute sa hauteur et ventilée naturellement.

La maison d'hôtes conteneur (Container Guesthouse, San Antonio, Texas, 2009-10, page 102) de 30 mètres carrés créée par l'architecte de San Antonio Jim Poteet est un exemple représentatif d'une autre tendance croissante, la réutilisation de conteneurs maritimes en architecture. Destinée à « produire l'effet maximal avec une intervention architecturale minimale », elle possède une douche et des toilettes à compost, ainsi qu'une large porte vitrée coulissante et une fenêtre à son extrémité. Le jardin sur le toit est surélevé pour permettre à l'air de circuler librement. L'intérieur isolé est revêtu de contreplaqué de bambou, tandis que l'arrière du conteneur est garni de panneaux de treillis couverts de vigne à feuilles persistantes qui l'ombragent. Des poteaux de téléphone recyclés ont été utilisés pour les fondations et les luminaires extérieurs sont faits avec les lames d'une charrue à disques de tracteur. La réutilisation de matériel existant, parmi lequel en tout premier lieu le conteneur lui-même, et les stratégies d'économie d'énergie adoptées donnent à cette réalisation un caractère de prototype pour de futures cabanes – économique, efficace et potentiellement attirante pour y vivre.

## COCOONING À FLANC DE COLLINE

Les architectes californiens Taalman Koch ont beaucoup travaillé dans le domaine des maisons « intelligentes », souvent loin de tout cadre urbain ou suburbain. Leur IT Cabin de Clearlake (Californie, 2010-11, page 96) de 74 mètres carrés sert de résidence et de bureau à un ingénieur-éclairagiste qui souhaitait fuir Los Angeles. La maison est surélevée à 1,2 mètre par une fine plate-forme préfabriquée en acier galvanisé sur un terrain en pente. Au-dessus de la plate-forme, les légères colonnes et poutres d'aluminium ont été assemblées sur place. Le plan ouvert et minimaliste comporte de vastes surfaces vitrées avec vue sur la nature environnante. Du cyprès récupéré a été utilisé pour les sols, ainsi que pour les terrasses, placards et meubles sur mesure. Un système à panneaux solaires hors réseau situé plus haut sur la pente fournit toute l'énergie de la maison.

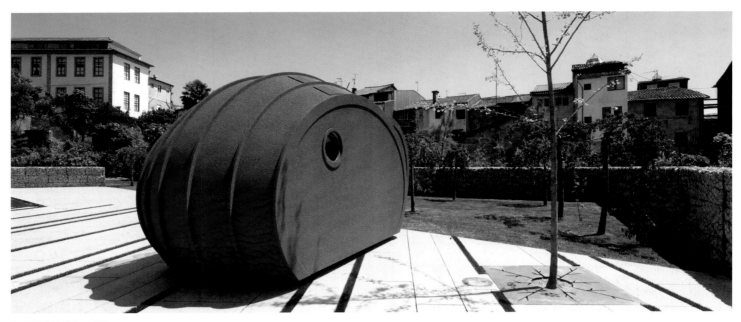

SHELTER BYGG → 328

Une jeune agence de Seattle, zeroplus, a créé la cabane Sneeoosh (Sneeoosh Cabin, La Conner, Washington, 2006–07, page 334) de 106 mètres carrés qui tente de respecter parfaitement le site sur lequel elle est construite. Les arbres les plus âgés ont été préservés et ont déterminé l'emplacement exact de la cabane qui est surélevée pour protéger le sol. Au niveau principal, un volume en verre transparent permet une vue complète des alentours et «fait disparaître les frontières entre dedans et dehors». Une large porte coulissante du côté ouest du salon ouvre sur une terrasse et un escalier qui mène à un patio au sol de pierre. Un «enrobage de type cocon» sous un large toit contient les espaces de couchage. Un système de charpente contreventée et de poutres en acier et lamellé-collé permet à la structure de résister aux éléments et aux tremblements de terre – des aspects de la conception architecturale qui correspondent clairement à certains des objectifs les plus significatifs de l'architecture moderne des cabanes. Là encore, la protection du site, l'absence de transition entre intérieur et extérieur – ou plutôt le lien entre les habitants et leur environnement naturel – et un certain sentiment de protection malgré le caractère sauvage du lieu sont autant de motivations et de réussites de ces projets. Comment protéger au mieux le terrain et les hommes en ces endroits où la nature est parfois très rude, telles sont les questions que se posent les architectes lorsqu'ils créent une cabane.

## RESPECTUEUX OU REDOUTABLE POUR L'ENVIRONNEMENT

Outre les buts artistiques déjà cités, les cabanes peuvent aussi avoir d'autres fonctions que la seule résidence. L'étrange station Outlandia (Glen Nevis, Lochaber, GB, 2008–10, page 296) par l'architecte d'Édimbourg Malcolm Fraser mesure tout juste 7 mètres carrés au sol. L'observatoire dans les arbres et station de recherches non raccordé au réseau électrique a été conçu par le collectif artistique London Fieldworks (Bruce Gilchrist et Jo Joelson) comme un lieu de réunion flexible destiné à la collaboration artistique et à la recherche. Érigé sur une pente à 45 degrés en pleine forêt, il a été en partie construit avec des arbres abattus sur place. L'architecte déclare: «Le faible impact et l'utilisation écologique du bois d'œuvre obtenu sur le site même est à l'opposé exact des héliportages de béton pour les fondations, redoutables pour l'environnement sur lequel ils ont un fort impact.» Cette lucidité est ici révélatrice d'une simple vérité

concernant même la cabane la plus «respectueuse de l'environnement»: les matériaux sont souvent transportés sur de grandes distances par des moyens mécaniques – c'est peut-être inévitable avec les méthodes de construction modernes, mais aussi potentiellement nuisible à l'environnement. Sans compter que la présence humaine dans un cadre sauvage risque de troubler la vie animale ou la flore parfois fragile. On le voit, tout n'est peut-être pas aussi romantique que certains pourraient le faire croire au pays des cabanes en montagne.

Destiné en principe à être habité, mais toujours inoccupé pour des raisons administratives, le Welcome Bridge (Tilburg, Pays-Bas, 2011–13, page 432) par l'architecte et artiste John Körmeling est une cabane de 112 mètres carrés accrochée à un pont à bascule qui se trouve suspendue à 4,5 mètres au-dessus du sol lorsqu'il est ouvert. Vainqueur d'un concours néerlandais de design, Körmeling était déjà connu pour ses réalisations quelque peu controversées, ou plutôt humoristiques, telles la Maison rotative (Tilburg, 1999–2008) ou «Echt iets voor u», le «pont couvert le plus court du monde» (Van Abbemuseum, Eindhoven, 2006). L'isolement de l'occupant de la cabane, en principe le pontier, n'a ici rien à voir avec le désert, mais avec le fait qu'il vit en l'air, observant le mouvement des bateaux et des voitures presque comme le ferait un spectateur extraterrestre.

## RETOUR AUX ALPES

Aucune étude des cabanes contemporaines ne saurait être complète sans une référence à celle qui est sans doute la plus typique dans cette catégorie, la cabane des Alpes telle qu'on en voit tant dans les montagnes suisses ou autrichiennes. Les exemples choisis ici ne sont délibérément pas aussi caractéristiques. Ainsi la rénovation Clavo Lain (Lain, Suisse, 2011–12, page 88) par l'équipe de Hans-Jörg Ruch ne comporte-t-elle pas de cabane de montagne à proprement parler, mais plutôt une grange et étable plutôt spacieuse (175 mètres carrés) et magnifiquement restaurée. Après avoir réalisé que les espaces entre les poutres en bois emboîtées qui formaient la structure d'origine avaient été conservés à des fins d'aération, Ruch décida de ne pas modifier cet élément essentiel pour le seul confort immédiat. L'architecte déclare: «Le plus grand défi a consisté à faire entrer la lumière du jour dans les pièces sans découper de fenêtres dans la construction en bois d'œuvre.» Une coque intérieure a été placée

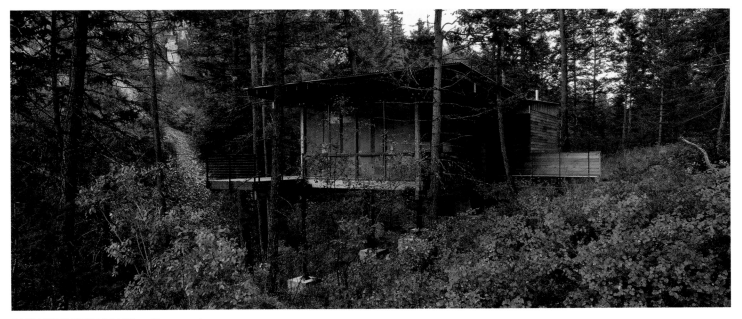

CABIN ON FLATHEAD LAKE → 80

dans la structure existante, elle laisse entrer la lumière, mais protège les habitants des intempéries. Une nouvelle base en béton noir percée d'une large fenêtre supplémentaire a également été ajoutée sans qu'il soit nécessaire de démanteler la construction existante en bois. L'architecte explique : « La coque intérieure est faite d'éléments de charpente en bois isolés qui ont été introduits par le toit et assemblés sur place. Le nouveau volume est couvert d'une couche de goudron, ce qui crée un fascinant contraste avec la construction historique en bois. À chaque phase du projet, notre intervention a été guidée par un immense respect pour le bâtiment historique. » Comme il l'avait déjà montré dans d'autres projets de rénovation, notamment à Zuoz, Hans-Jörg Ruch a maîtrisé ici l'art de restaurer des bâtiments anciens en bois ou pierre en y introduisant une touche résolument moderne sans en éliminer le cœur traditionnel. La fenêtre qu'il a ajoutée à Lain et les rayons lumineux obliques qu'elle laisse pénétrer à l'intérieur de la maison rappelle les *Skyspaces* de l'artiste James Turrell, bien connus de l'architecte.

Les architectes autrichiens Marte.Marte donnent une autre interprétation encore plus ouvertement contemporaine de la cabane des Alpes. Leur Cabane de montagne (Laterns, Autriche, 2010–11, page 282) mesure 87 mètres carrés au sol. La maison en « béton brut soigneusement taillé » possède des portes de devant en chêne, des planchers de chêne brut et des fenêtres carrées de différentes tailles aux solides cadres de chêne. À l'intérieur, un escalier en colimaçon relie le séjour de l'étage aux deux espaces privés du niveau inférieur où les chambres et salles de relaxation « s'emboîtent comme un puzzle ». L'ensemble donne une impression de solidité qui reflète à bien des égards la beauté plutôt rude du cadre naturel. Pas inspirée directement des anciennes cabanes de montagne, la maison exprime clairement un effort pour réinterpréter le genre — et doit sans doute autant au nom officiel du projet qu'à son apparence d'être classée parmi les « cabanes ».

Loin des Alpes, la Cabane alpine (Alpine Cabin, Vancouver Island, Canada, 2008–13, page 34) des architectes Scott & Scott est un refuge pour skieurs à l'extrémité nord de l'île de Vancouver. Les architectes ont utilisé des colonnes en sapin de Douglas d'origine locale, du bois de charpente en sapin scié brut, un revêtement extérieur en cèdre et des finitions intérieures en sapin raboté. Il s'agissait d'éviter toute excavation à la machine et de résister aux fortes chutes de neige et aux vents dominants. La cabane n'a pas l'électricité et est chauffée par un poêle à bois. L'eau captée à une source voisine n'est pas courante. Située à 1300 mètres d'altitude, la cabane est accessible par une route caillouteuse cinq mois par an, et sinon par traîneau. Du fait de son accès difficile et de l'absence de raccordement au réseau électrique, ce type de cabane est bien évidemment susceptible d'être considéré comme « plus authentique » dans toute sa modernité que les constructions en béton dotées de l'eau courante froide et chaude et de connexions Internet haut débit.

## LA RÉALITÉ EST FABULEUSE

Les cabanes jouissent aujourd'hui d'une telle popularité qu'on aurait pu en sélectionner beaucoup plus pour ce livre. Comme pour les autres volumes d'*Architecture Now!*, nous en avons délibérément choisi une variété très large afin de donner une idée de l'ampleur du genre, en termes d'aspect, d'usage, ou encore de taille. Il en ressort qu'une cabane est sans doute en premier lieu une structure de petite taille destinée à la vie au cœur d'une région sauvage et désertique. Avec les questions environnementales qui se posent depuis quelques années, les nouvelles cabanes cherchent le meilleur moyen de construire sans abîmer un site naturel, et peut-être aussi en permettant une démolition facile. On pourrait remarquer que les bâtiments plus anciens, inévitablement construits presque toujours en pierre ou bois local, n'ont jamais posé les problèmes de pollution ou de démolition que connaît l'architecture moderne. Dans les Alpes notamment, les vieilles cabanes abandonnées ont tendance à se délabrer d'abord pour disparaître ensuite entièrement dans leur milieu naturel, le bois et la pierre retournant à la terre d'où ils sont venus. Malheureusement, l'acier et les polycarbonates ne sont pas aussi facilement absorbés. Par ailleurs, avec les crises économiques et la remise en question par certains du modèle de la société de consommation, les cabanes sont aussi populaires parce qu'elles représentent la recherche d'un mode de vie moins onéreux et moins destructeur. L'étude par Le Corbusier de ses propres conditions de vie minimales après la guerre était une recherche intellectuelle qu'il a pleinement assumée toute sa vie. Le Cabanon a quelque chose de la cellule monastique. Si les proportions sont exactes (le modulor) et l'essentiel est fourni, est-il nécessaire de disposer de toujours plus d'espace comme c'est le cas dans les maisons contemporaines, ou un petit espace serait-il plus en accord avec le monde tel qu'il est aujourd'hui ? Le projet Diogene de Renzo Piano pour Vitra aborde la question des conditions de vie minimales sous un autre angle et évoque le soulagement de l'après-guerre autant qu'une attitude phi-

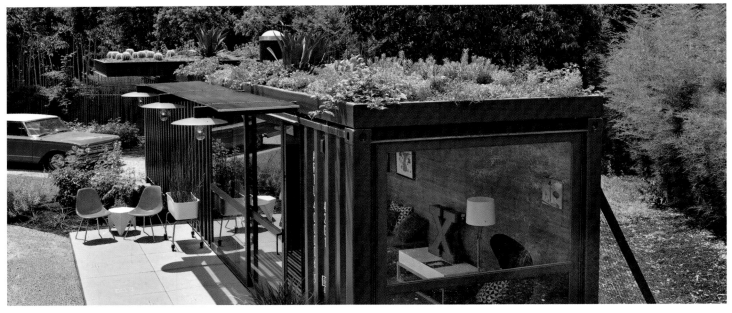

CONTAINER GUESTHOUSE → 102

losophique qui tend à chercher plutôt moins que plus, au moins en termes de consommation matérielle. On notera avec intérêt que dans le premier exemple cité ici, celui d'Henry David Thoreau et de sa cabane au bord de l'étang de Walden, les aspects philosophiques de son mode de vie sont étroitement liés au confort minimal et à la taille de l'abri. Se détournant des « feintes et illusions », il cherchait plus une cabane simple « faite pour recevoir un dieu en voyage ».

*Impostures et illusions passent pour d'incontestables vérités, tandis que la réalité est fabuleuse. Si les hommes s'attachent à observer seulement les réalités, sans se laisser bercer d'illusions, la vie, pour la comparer à des choses connues de nous, ressemblerait à un conte de fées et aux Mille et une nuits. Si nous respections seulement ce qui est inévitable et a droit d'être, alors la musique et la poésie résonneraient dans toutes les rues. Quand nous sommes sages et peu pressés, nous percevons que seules les choses grandes et dignes ont une existence permanente et absolue, que les peurs mesquines et les plaisirs mesquins ne sont que l'ombre de la réalité. Cette constatation est toujours exaltante et sublime. En fermant les yeux, en s'abandonnant à la somnolence et en consentant à se laisser duper par toutes sortes de spectacles, les hommes établissent et confortent partout leurs routines et leurs habitudes quotidiennes, qui sont pourtant construites sur des fondations purement illusoires. »*[4]

Henry David Thoreau, **Walden ou la vie dans les bois,** *1854, trad. Louis Fabulet*

Philip Jodidio
Grimentz, Suisse

1   Henry David Thoreau, *Walden ou la vie dans les bois, http://ece2.carnot.free.fr/Carnot_ CG_theme_files/Thoreau%20Walden%20.pdf,* accédé le 16 juillet 2014.
2   http://eileengray-etoiledemer-lecorbusier.org/le-cabanon/, accédé le 16 juillet 2014.
3   Documentation fournie par RPBW, le bureau de Renzo Piano.
4   Henry David Thoreau, *Walden ou la vie dans les bois, Où je vécus, et ce pour quoi je vécus. http://ece2.carnot.free.fr/Carnot_CG_theme_files/Thoreau%20Walden%20.pdf,* accédé le 16 juillet 2014.

# CABINS

# ALPINE CABIN

Area: 100 m² | Clients: Susan and David Scott

The architects designed their own off-grid snowboard cabin, located on the northern end of Vancouver Island. Locally sourced Douglas fir columns, rough-sawn fir lumber, cedar cladding for the exterior, and a planed fir interior finish were used. The cabin was designed to avoid machine excavation, and to withstand heavy snowfalls and strong winds. It has no electricity and is heated with a wood stove. Water is brought from a local source and carried in. The cabin is located at 1300 meters above sea level and is accessible by gravel road five months of the year, whereas during the other months, equipment and materials are carried by toboggan to the site.

—

Bei diesem Projekt am nördlichen Ende von Vancouver Island handelt es sich um eine nicht ans Versorgungsnetz angeschlossene Snowboardhütte, die den Architekten gehört. Verbaut wurden Stützen aus lokalem Douglasienholz, sägeraues Tannenholz, Zedernholz für die äußere Verschalung sowie gehobeltes Tannenholz für das Innere. Der Entwurf sollte ohne maschinellen Aushub auskommen und schweren Schneefällen sowie starken Winden standhalten. In der Hütte gibt es keinen Strom, ein Holzofen sorgt für Wärme. Wasser wird von einer Quelle geholt. Die Hütte befindet sich 1300 m über dem Meeresspiegel und fünf Monate im Jahr über eine Schotterstraße erreichbar. Den Rest des Jahres werden Ausrüstung und Materialien per Schlitten antransportiert.

—

C'est pour leur usage personnel que les architectes ont créé ce refuge hors réseau pour skieurs à l'extrémité nord de l'île de Vancouver. Le bois domine avec des colonnes en sapin de Douglas d'origine locale, du bois de charpente en sapin scié brut, un revêtement extérieur en cèdre et des finitions intérieures en sapin raboté : il s'agissait d'éviter toute excavation à la machine et de résister aux fortes chutes de neige et aux vents dominants. La cabane n'a pas l'électricité et est chauffée par un poêle à bois. L'eau captée à une source voisine n'est pas courante. Située à 1300 mètres d'altitude, la cabane est accessible par une route caillouteuse cinq mois par an, et sinon par traîneau.

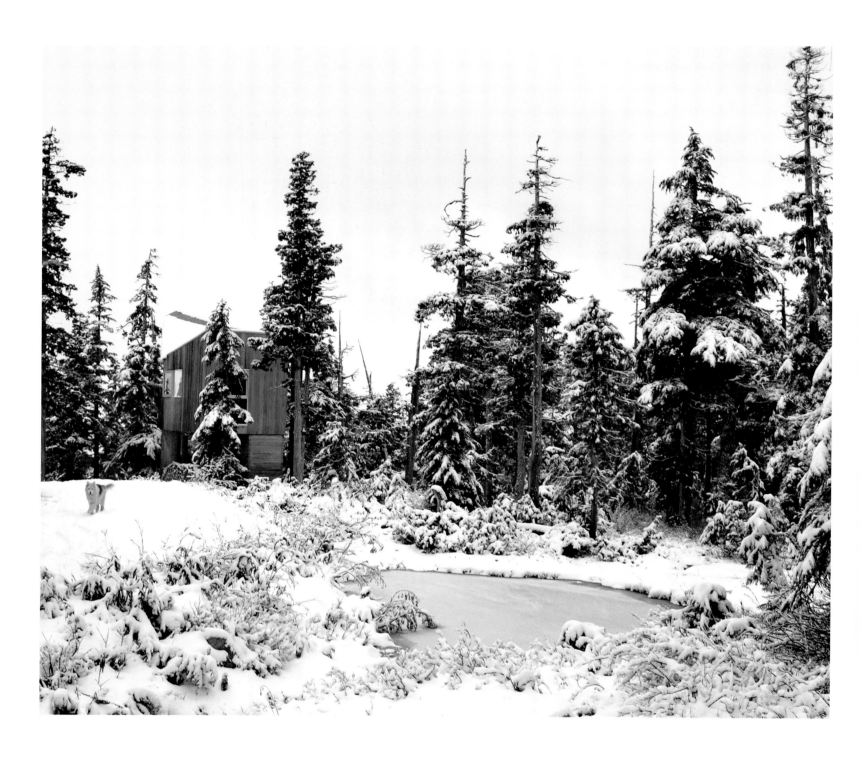

In the winter season, the cabin's gray cedar cladding blends almost seamlessly into the woods. The plan of the ground floor, bottom left, shows the covered entry in light brown. The upper floor consists of two bedrooms separated by an office.

Im Winter verschmilzt die Zedernholzverkleidung der Hütte nahezu mit dem Wald. Der Grundriss links unten zeigt das Erdgeschoss mit der geschützten Terrasse in Hellbraun. Im Obergeschoss liegen zwei durch ein Arbeitszimmer getrennte Schlafräume.

En hiver, le cèdre gris qui recouvre la cabane la fait se fondre tout en douceur dans les bois. En bas à gauche, le rez-de-chaussée et l'entrée couverte en brun clair. L'étage contient deux chambres séparées par un bureau.

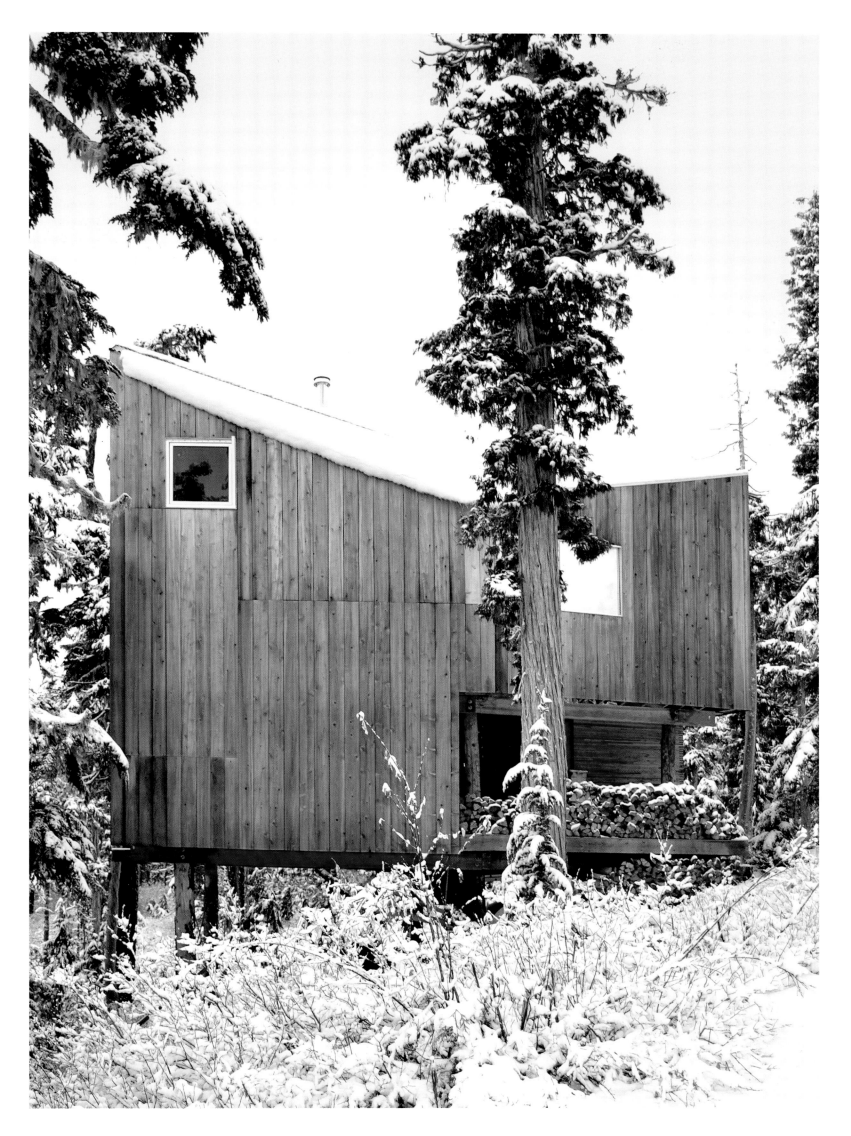

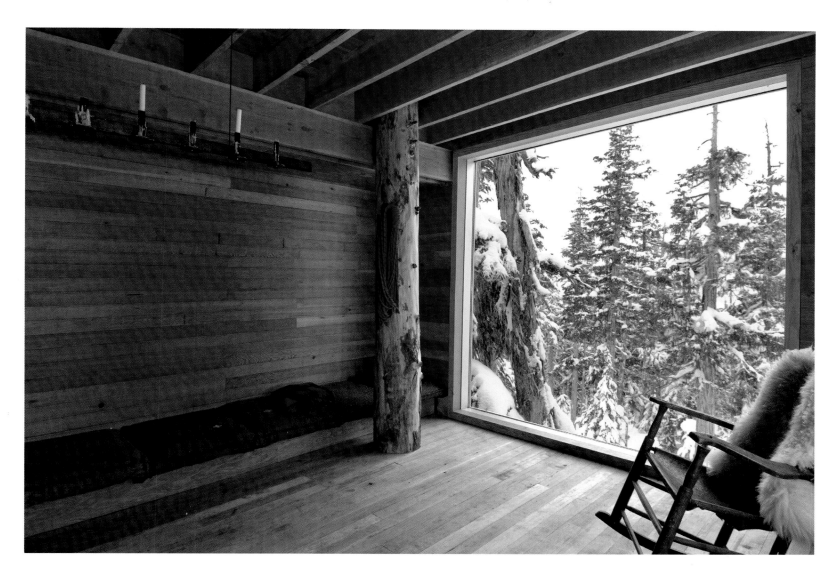

The interiors are marked by Douglas fir columns and planed fir surfaces, contrasting with such modern features as the very large window seen in the image above.

Stützen aus Douglasienholz sowie Oberflächen aus gehobeltem Tannenholz zeichnen die Innenräume aus und kontrastieren mit modernen Ausstattungsmerkmalen wie dem sehr großen Fenster im Bild oben.

L'intérieur est marqué par des colonnes en sapin de Douglas et de grandes surfaces en sapin raboté qui contrastent avec des éléments modernes comme les très grandes fenêtres ci-dessus.

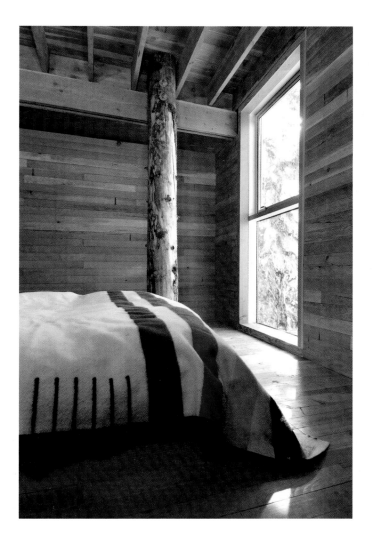

# BOATHOUSE

Area: 77 m² | Client: Stein Erik Sørstrøm | Cost: €4634
Collaboration: Marianne Løbersli Sørstrøm

This boathouse was built on the site of an 18th-century structure having the same function. The architects state: "It was in such a bad state that the owner decided to tear it down and build it anew. The simplicity of the old building, its good placement, and honest use of materials, would become key sources of inspiration for the design of the new building." Old windows from a nearby farmhouse were incorporated into the building, which is made of Norwegian pine, with materials from the old boathouse used to clad some interior surfaces. The architects explain: "Rational choices with regard to material use, method of construction, and detailing have given this boathouse its distinguished architectural features. The building remains true to the historical and cultural heritage of Norway's coastal regions, while catering to new modes of usage."

———

Dieses Bootshaus wurde anstelle eines Vorgängers aus dem 18. Jahrhundert errichtet. Die Architekten: „Das alte Bootshaus war in einem derart schlechten Zustand, dass sich der Eigentümer für Abriss und Neubau entschied. Die Einfachheit des alten Gebäudes, sein günstiger Standort und der ehrliche Materialeinsatz sollten zu einer wesentlichen Inspirationsquelle für den Neubau werden." Für das Projekt aus Norwegischer Kiefer kamen Fenster eines in der Nähe gelegenen Bauernhauses zum Einsatz und für einen Teil der Verkleidung im Inneren Materialien des alten Bootshauses. Die Architekten: „Den ausgezeichneten architektonischen Eigenschaften des Bootshauses liegen rationale Entscheidungen im Hinblick auf verwendete Materialien, Baumethoden und Gestaltungsdetails zugrunde. Das Gebäude bleibt dem historischen und kulturellen Erbe des norwegischen Küstenregion treu und eröffnet gleichzeitig neue Nutzungsmöglichkeiten."

———

Ce hangar à bateaux a été construit sur le site d'une structure du XVIIIᵉ siècle qui avait déjà cette fonction. Les architectes ont expliqué qu'« elle était dans un état tellement mauvais que le propriétaire a préféré la raser et reconstruire. La simplicité de l'ancienne construction, son orientation favorable et l'usage sans fioritures des matériaux sont devenus des sources d'inspiration essentielles pour le nouveau bâtiment ». Des fenêtres d'une ferme voisine ont été réutilisées, les murs sont en épicéa et des éléments de l'ancien hangar à bateaux ont été repris pour revêtir certaines surfaces intérieures. Les architectes constatent : « Des choix rationnels en ce qui concerne l'emploi des matériaux, les méthodes de construction et les détails confèrent son caractère architectural distingué au hangar à bateaux. Il reste fidèle à l'héritage historique et culturel des régions côtières norvégiennes, tout en apportant de nouveaux usages. »

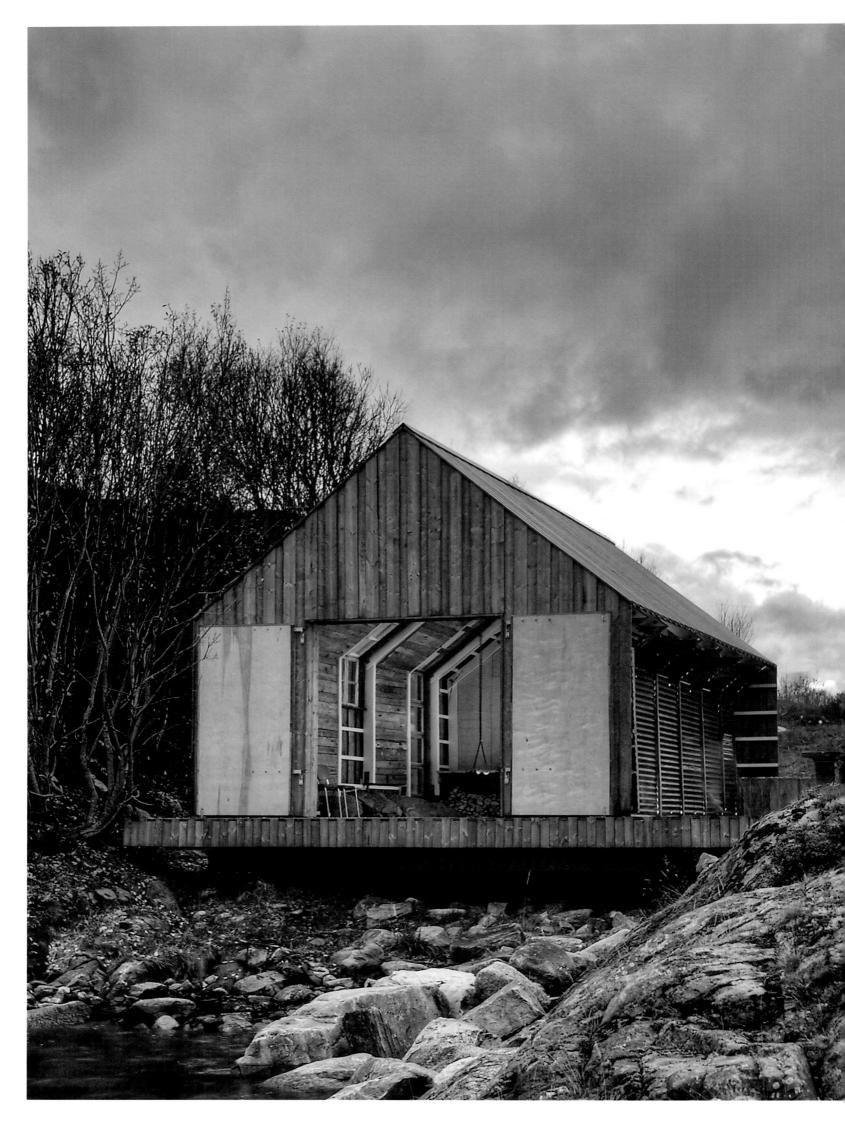

Although modern in its rough simplicity, the Boathouse is based on an older structure and employs Norwegian pine as its main material.

In seiner rauen Schlichtheit wirkt das Boots-haus zwar modern, es geht jedoch auf ein älteres Gebäude zurück und besteht vor allem aus norwegischer Kiefer.

Bien que moderne dans sa simplicité brute, la Boathouse est basée sur une structure ancienne et l'épicéa en est le principal matériau de construction.

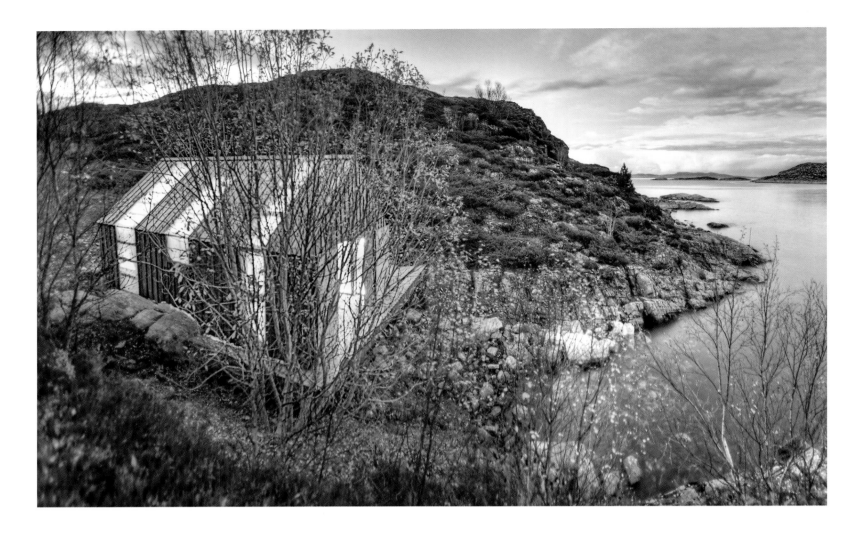

Above, band windows running down the roof and walls bring natural light into the structure. Below, a drawing shows how the Boathouse sits comfortably in its ravine site on H-profiles eight meters in length.

Oben die Bandfenster, die sich über Dach und Wände ziehen, und natürliches Licht ins Gebäude lassen. In der Zeichnung unten die 8 m langen H-Profile, auf denen das Bootshaus zwischen Felsenhängen ruht.

Ci-dessus, des fenêtres en bande descendent du toit le long des murs et font pénétrer la lumière du jour à l'intérieur. Ci-dessous, le schéma montre la Boathouse confortablement posée au-dessus du ravin, sur des profilés en H de 8 m de long.

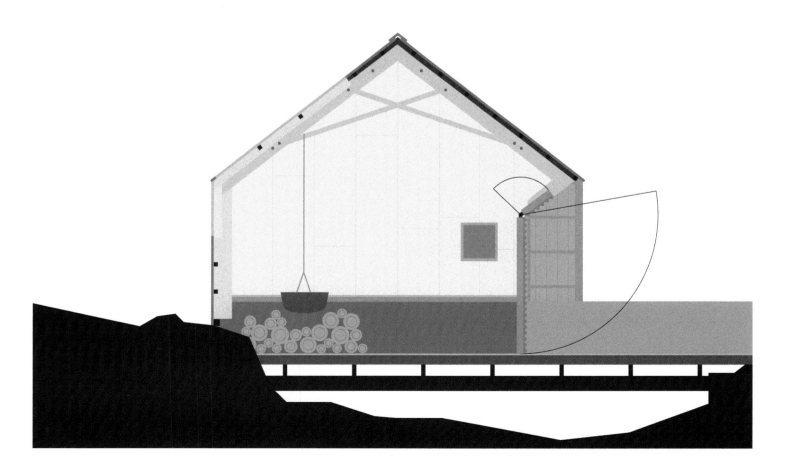

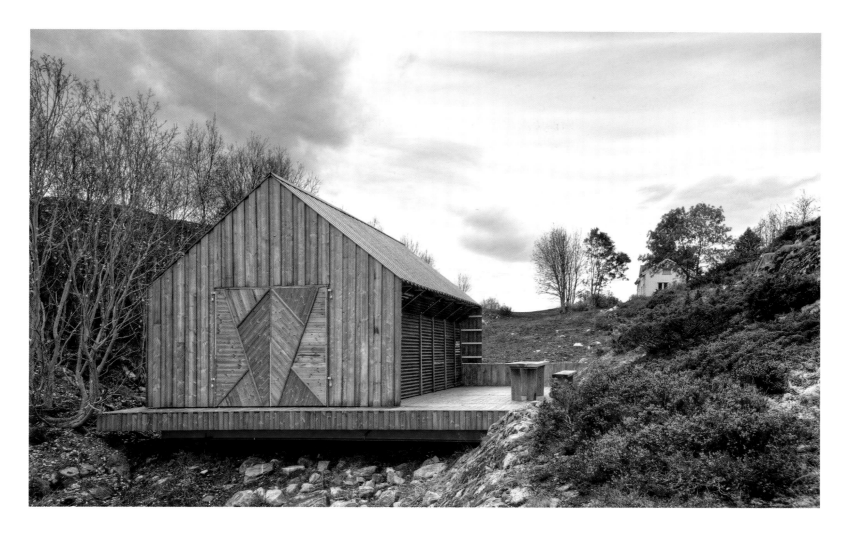

Sitting flush with the earth on the inland side, the Boathouse has a comfortable wooden terrace and appears quite closed from most angles, despite its large opening facing the water on the south façade.

Das Bootshaus steht auf der seeabgewandten Seite direkt auf dem Erdboden, hat eine bequeme Holzterrasse und wirkt aus fast allen Blickwinkeln relativ geschlossen, trotz der großen wasserseitigen Öffnung in der Südfassade.

Posée de plain-pied avec le sol vers l'intérieur des terres, la Boathouse dispose d'une agréable terrasse de bois et montre une apparence plutôt fermée sous la plupart des angles, malgré la vaste ouverture face à l'eau dans le mur sud.

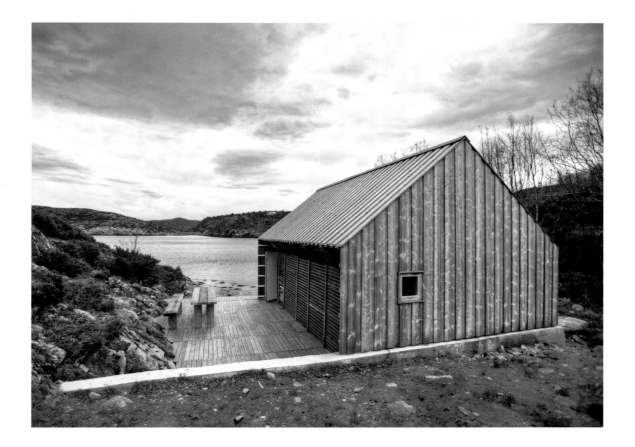

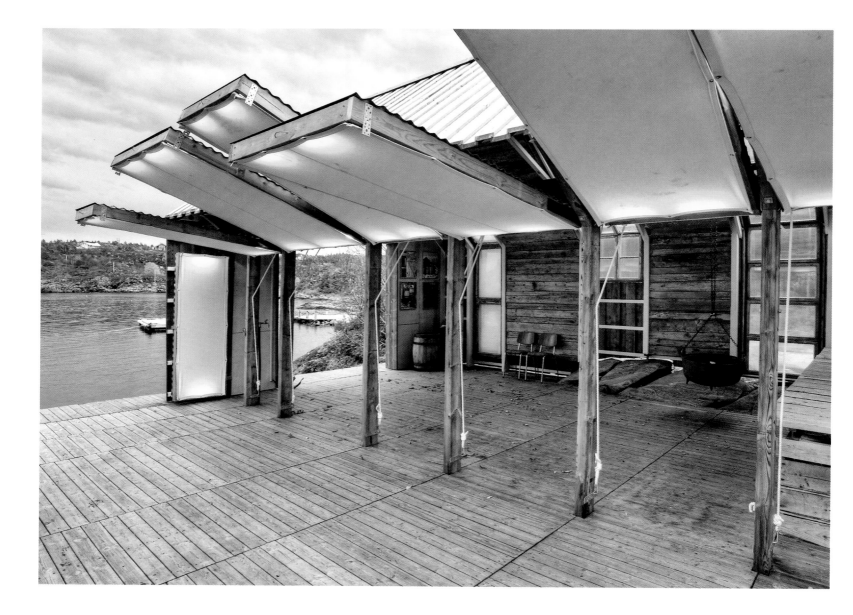

The façades of the house, lined with back-lit cotton
canvas, open vertically, leaving only the supports of the
house between the interior and the terrace.

Die mit hinterleuchtetem Baumwollstoff bespannten
Wände lassen sich vertikal öffnen, sodass nur noch
Stützpfeiler den Innenraum von der Terrasse trennen.

Les façades, doublées de toile de coton rétroéclairée,
s'ouvrent verticalement, l'intérieur n'est alors plus
séparé de la terrasse que par les appuis de la maison.

The cladding is made from Norwegian pine, which was pressure-treated using a product based on environmentally friendly biological waste derived from the production of sugar (Kebony).

Die Verschalung besteht aus dem Holz der Norwegischen Kiefer, das mit umweltfreundlichem, organischem Abfallmaterial aus der Zuckerherstellung (Kebony) druckimprägniert wurde.

Le bardage des murs est en épicéa imprégné sous pression d'un produit à base de déchets biologiques de la production écologique de sucre (Kebony).

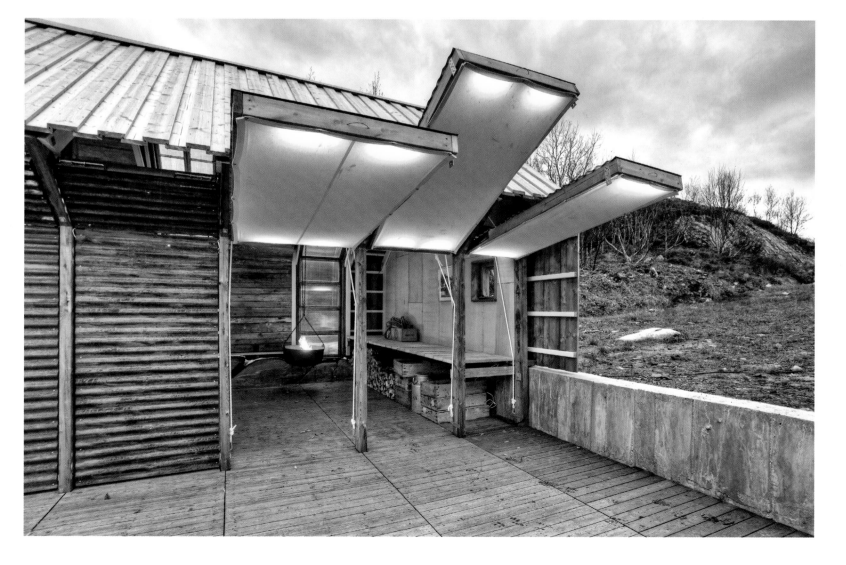

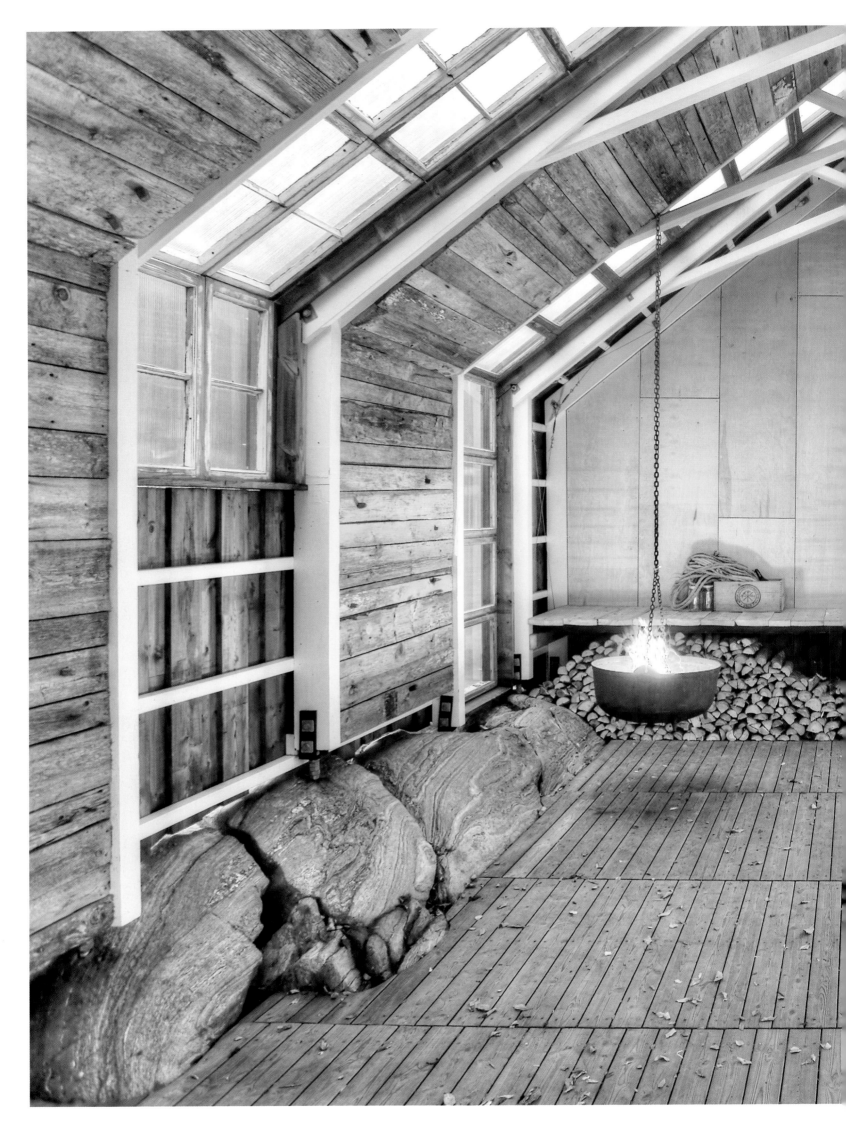

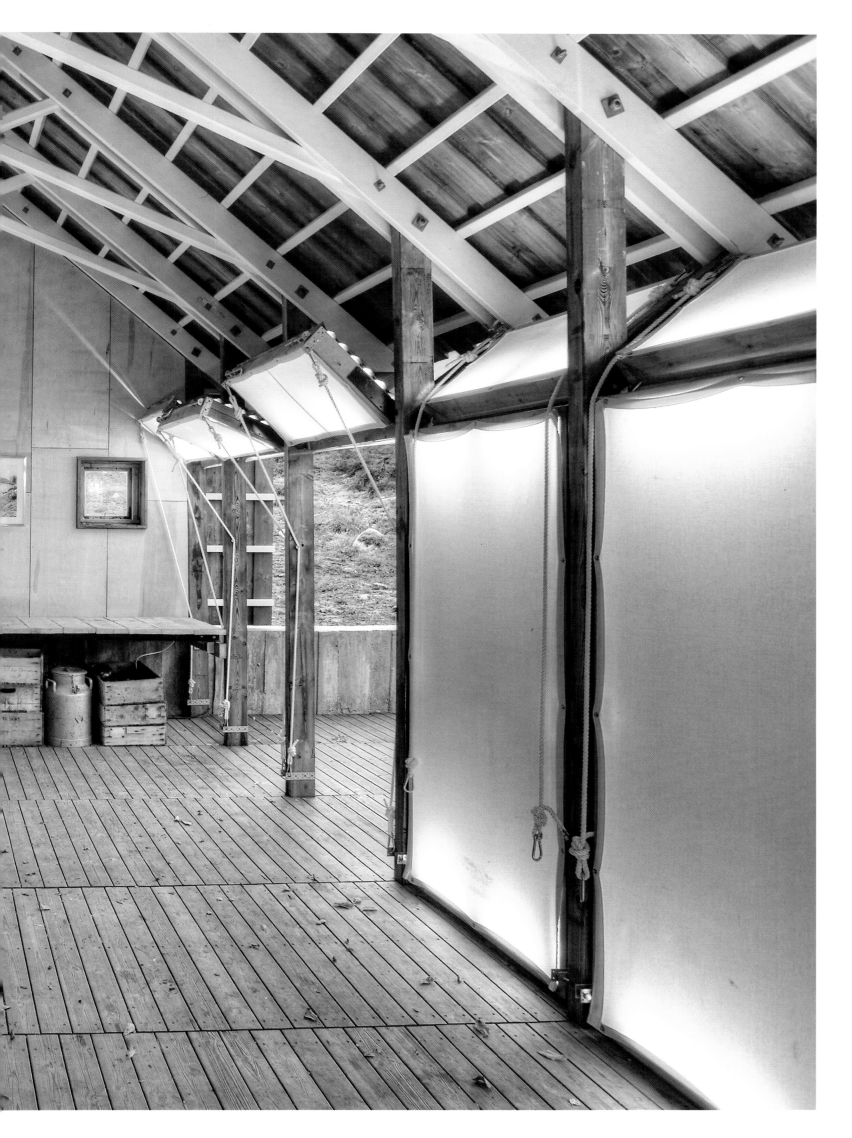

# BOWEN MOUNTAIN RESIDENCE

Area: 210 m²

Built in dense bushland near Blue Mountains National Park with a view toward Sydney, this house was erected with a slender steel structure on the site of an existing timber hut. The roof is angled to catch the afternoon sun in winter, while courtyards and a pool provide "framed views through to the east and allow breezes to penetrate the building." Glazed sliding doors open onto the terrace, where the Brazilian slate used for the interior floors extends outside. A large open fireplace is at the heart of the design and a "bedroom loft" with a private terrace is provided. A 110 000-liter water tank is buried on the site, and a sauna and 25-meter-long pool are also part of the design. The architect states: "The structural steel frame was on-site welded prior to shot blasting and finishing in a two-part epoxy coating. Both new and recycled Australian hardwoods were then used to frame the steel structure, with western red cedar doors and windows used extensively to complete the space."

———

Dieses Haus wurde mit einer schlanken Stahlkonstruktion im dichten Busch-land des Blue Mountains National Park mit Blick auf Sydney gebaut, an einem Standort, an dem sich bereits eine Holzhütte befand. Das angewinkelte Dach lässt im Winter Nachmittagssonne ein, während Außenbereiche und Pool „gerahmte Aussichten gen Osten bieten und dem Wind ermöglichen, durchs Haus zu streichen". Glasschiebetüren führen auf die Terrasse, die wie das Innere mit brasilianischem Schieferboden gepflastert ist. Ein großer offener Kamin bildet den Mittelpunkt des Projekts, das über ein „Schlafzimmerloft" mit eigener Terrasse verfügt. Ein 110 000 l großer Wassertank ist in die Erde eingelassen. Es gibt eine Sauna und einen Pool von 25 m Länge. Der Architekt: „Die Stahlkonstruktion wurde vor Ort zusammengeschweißt, sandgestrahlt und mit einer doppelten Epoxidbeschichtung versehen. Anschließend wurde die Konstruktion mit neuwertigen und recycelten australischen Harthölzern eingefasst. Türen und viele Fenster aus Rotzedernholz komplettieren den Bau."

———

Construite dans une zone de bush très dense à proximité du parc national des Blue Mountains, avec vue sur Sydney, cette maison occupe le site d'une autre maison en bois à fine structure d'acier. Le toit est incliné pour capter le soleil de l'après-midi en hiver, tandis que les cours et une piscine ouvrent des «vues encadrées vers l'est et permettent à la brise de pénétrer à l'intérieur». Des portes coulissantes vitrées ouvrent sur la terrasse où l'on retrouve l'ardoise brésilienne des sols intérieurs. Le cœur du concept est un vaste foyer ouvert, avec une «chambre loft» à terrasse privée. Un réservoir à eau de 110 000 l est enterré sur le site, qui comprend aussi un sauna et une piscine de 25 m. L'architecte explique que «la charpente structurelle en acier a été soudée sur place avant le grenaillage et les finitions par un revêtement époxy à deux composants. Des bois australiens durs, neufs et recyclés, ont ensuite été utilisés pour encadrer la structure en acier, tandis qu'un grand nombre de portes et fenêtres en thuya géant complètent l'espace».

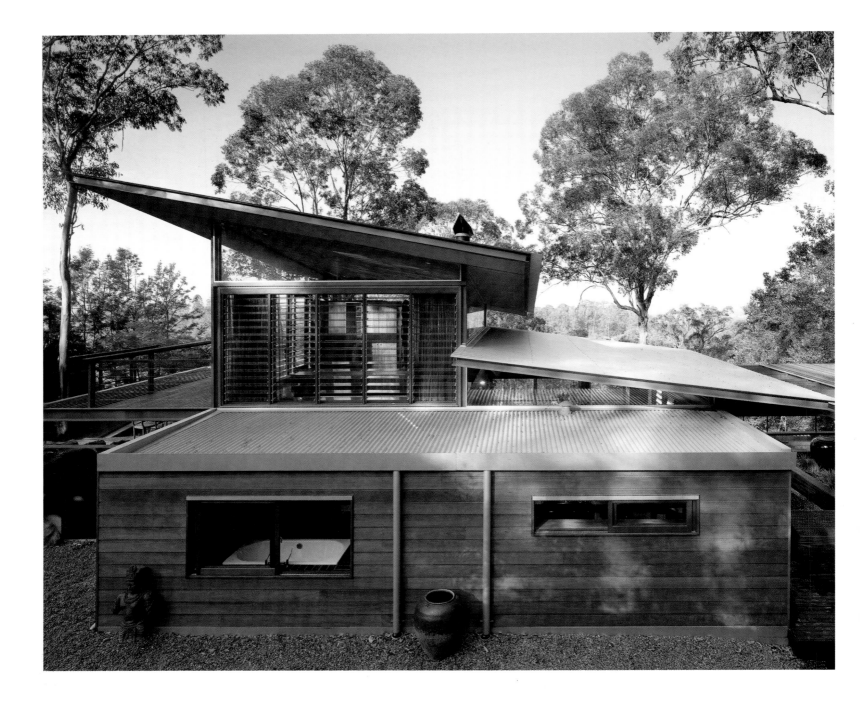

The light, planar design appears to sit weightlessly in its natural setting, with open terraces and windows offering the fullest possible contact with nature.

Die leichte, flächige Konstruktion erscheint in ihrem natürlichen Umfeld nahezu gewichtslos und verfügt über offene Terrassen sowie Fenster für einen möglichst intensiven Bezug zur Natur.

La conception plane et aérienne semble posée en toute légèreté dans le cadre naturel, les terrasses ouvertes et les fenêtres offrant le contact le plus absolu possible avec la nature.

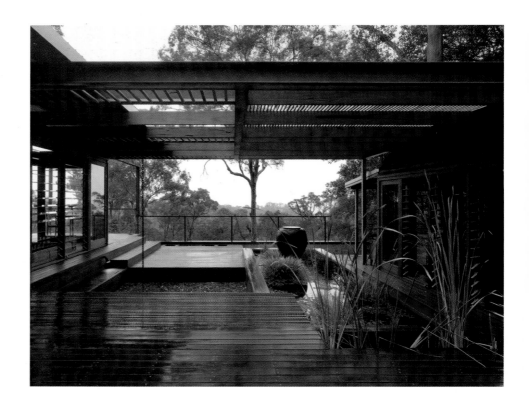

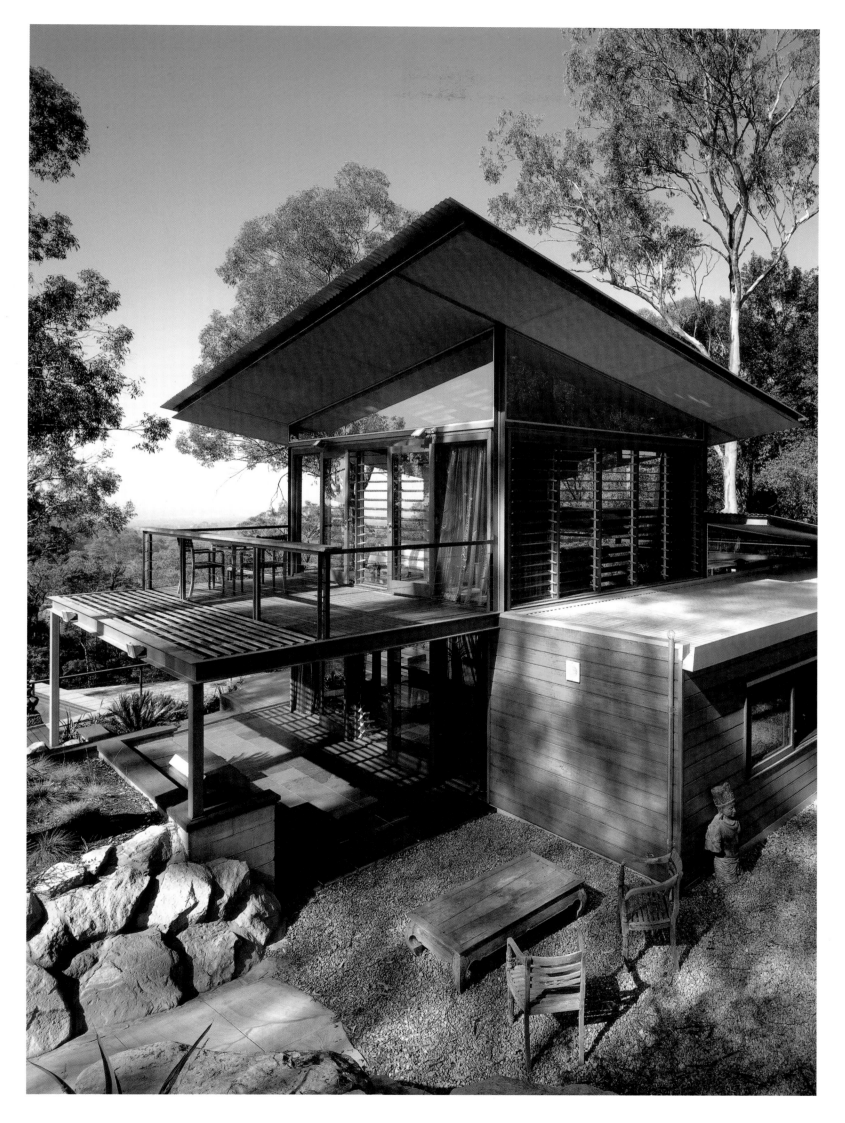

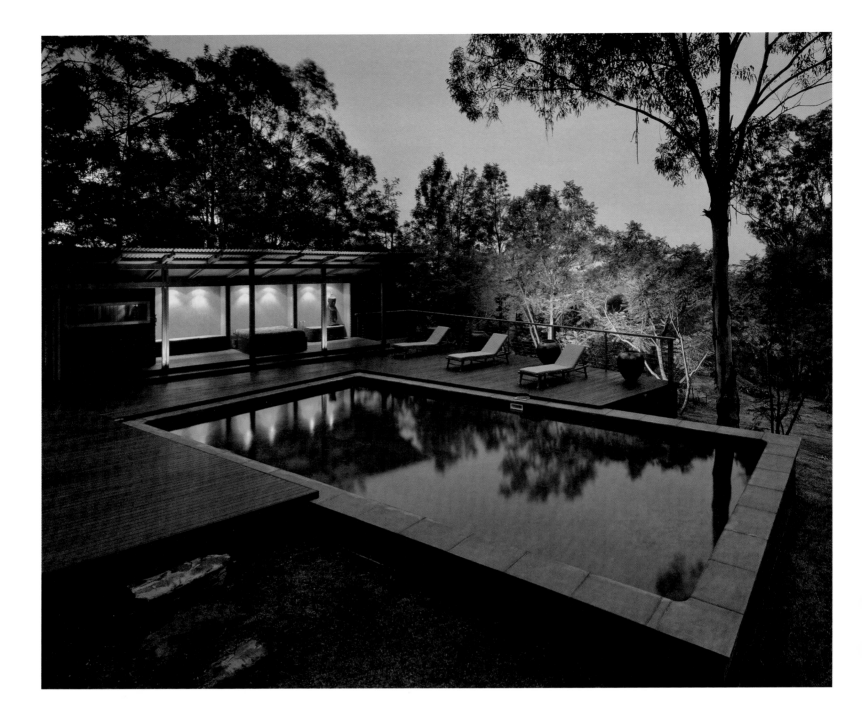

A sauna and daybed look out onto the terrace
and swimming pool, which are located near
an outdoor living and dining area, situated to the
left of the image above (not seen in picture).

Sauna und Bettcoach sind zur Terrasse und zum
Swimmingpool ausgerichtet, die in der Nähe eines im
Freien gelegenen Wohn- und Essbereichs liegen.
Dieser befindet sich links außerhalb des obigen Bildes.

Le sauna et la banquette-lit ouvrent sur la terrasse
et la piscine, elles-mêmes situées non loin d'un
espace séjour et repas extérieur, à gauche sur la
photo ci-dessus (non visible sur l'image).

Left, plans of the house show the bedroom suite and terrace on the upper level. The lower level includes the angled pool and terrace, a large sundeck, and a sunken living room, with the form of the existing hut also visible.

Die Pläne links zeigen Schlafzimmer und Terrasse im Obergeschoss. Im unteren Geschoss befinden sich der schräg eingepasste Pool und die Terrasse, ein großes Sonnendeck und das abgesenkte Wohnzimmer. Auch die Form der bestehenden Hütte ist zu sehen.

À gauche, les plans de la maison montrent la chambre et la terrasse à l'étage. Le niveau inférieur comprend la piscine en biais et la terrasse, ainsi qu'un vaste ponton et un salon en contrebas, tandis que la forme de la première maison reste visible.

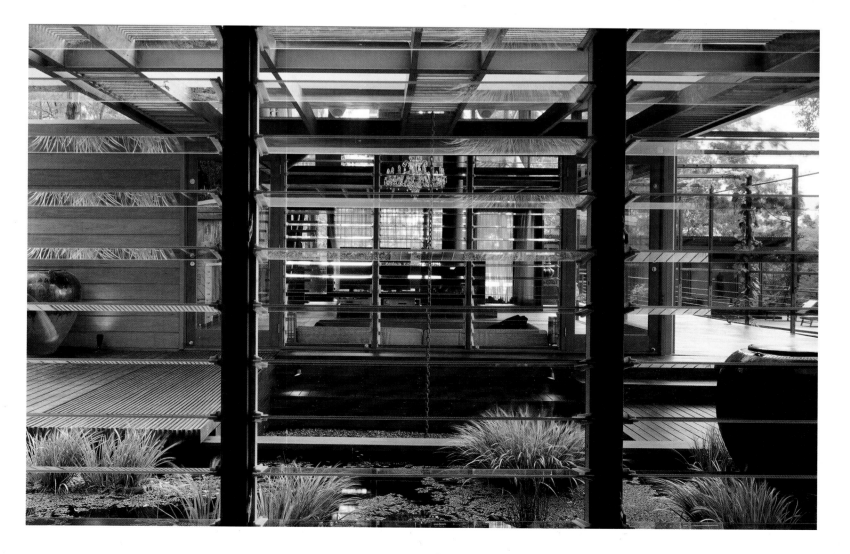

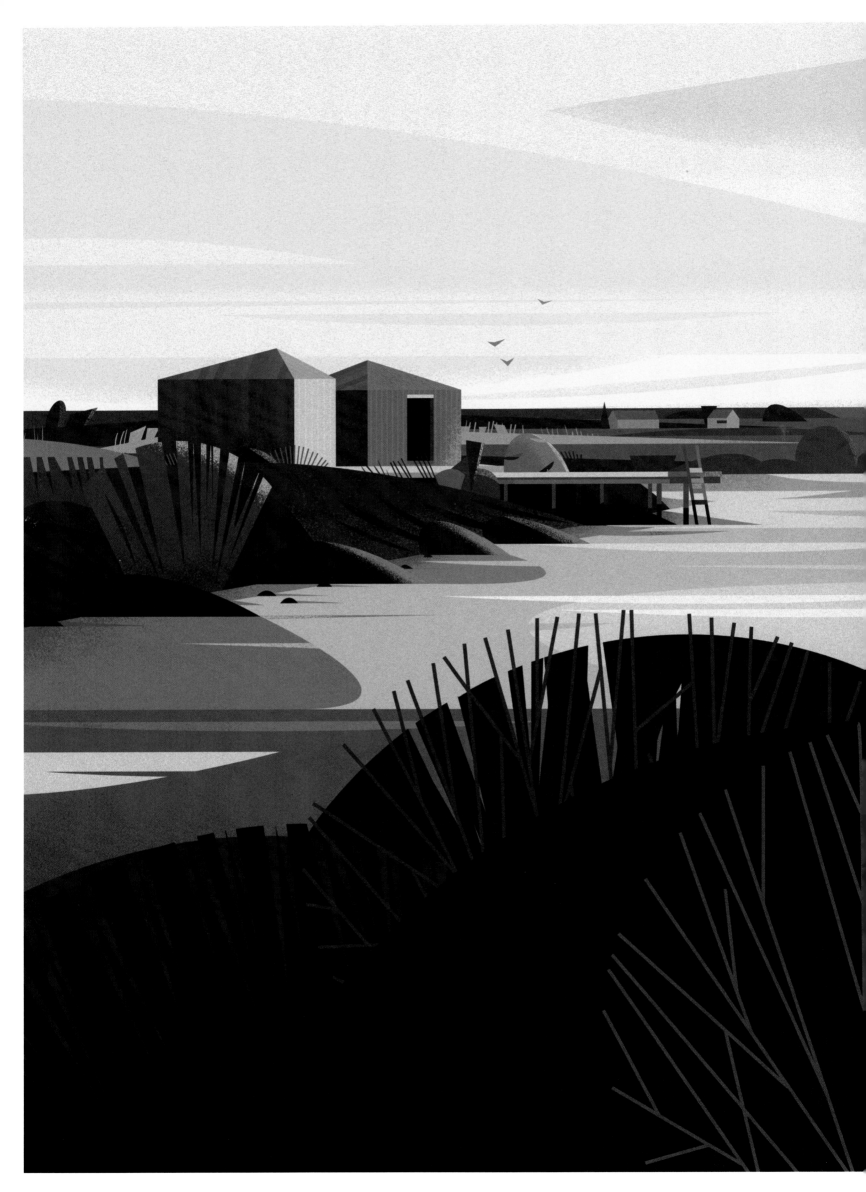

**AIRES MATEUS**
Alcácer do Sal [Portugal]
2013

# CABANAS NO RIO HUTS

Area: 26 m² | Client: Cabanas no Rio | Cost: €40 000

Entirely finished in recuperated scrap wood, these cabins have two different functions—one is intended as a kitchen and place to rest, the other as a sleeping space with a small bathroom and shower. The architects deliberately chose "archetypical forms", which can be seen in slightly less sophisticated variants in nearby fishermen's huts. Seen from certain angles, the Cabanas no Rio appear to be in splendid isolation opposite the water—a kind of minimal living space that nonetheless holds numerous surprises. They emphasize that wood allows for change and replacement while still retaining underlying values, in this instance, the elevations and angled ceiling and rooflines. Subjected to the weather, the wood is grayed, but it resists well over time. These are at once transient objects and representatives of an architectural type that has lasted over a very long period of time.

———

Diese Hütten sind ausschließlich aus Holzabfällen gefertigt und erfüllen jeweils unterschiedliche Funktionen, die eine als Küche und Ruhebereich, die andere als Schlafraum mit kleinem Bad und Dusche. Die Architekten wählten bewusst „archetypische Formen", die sich in etwas weniger eleganter Ausführung auch bei nahegelegenen Fischerhütten wiederfinden. Aus bestimmten Blickwinkeln gesehen, scheinen die Hütten in malerischer Abgeschiedenheit mit Blick aufs Meer zu liegen, eine Art Minimalwohnräume, die gleichwohl einige Überraschungen bereithalten. Sie verdeutlichen, dass Holz Veränderung und Erneuerung zulässt und zugleich grundlegende Werte bewahrt – wie in diesem Fall den Aufriss, die abgeschrägten Decken und Dachlinien. Das Holz hat witterungsbedingt eine graue Farbe angenommen, bleibt aber auch längerfristig widerstandsfähig. Es handelt sich sowohl um temporäre Objekte als auch um Vertreter einer sehr alten Architekturtyps.

———

Entièrement finies en retailles de bois récupérées, ces cabanes partagent deux fonctions – l'une sert de cuisine et lieu de repos, l'autre de chambre avec une petite salle de bains et douche. Les architectes ont délibérément choisi des « formes archétypiques » dont on retrouve des variantes moins raffinées dans les cabanes de pêcheurs voisines. Vues sous certains angles, les Cabanas no Rio apparaissent dans un splendide isolement au bord de l'eau – un espace de vie minimal qui réserve néanmoins de nombreuses surprises. Ils soulignent que le bois permet des changements et remplacements, tout en conservant des valeurs fondamentales, ici les hauteurs et angles des plafonds et des lignes de toits. Le bois prend une teinte grisée sous l'effet des intempéries mais n'en résiste pas moins bien au temps. Ces constructions sont donc à la fois temporaires et représentatives d'un type d'architecture qui existe depuis très longtemps.

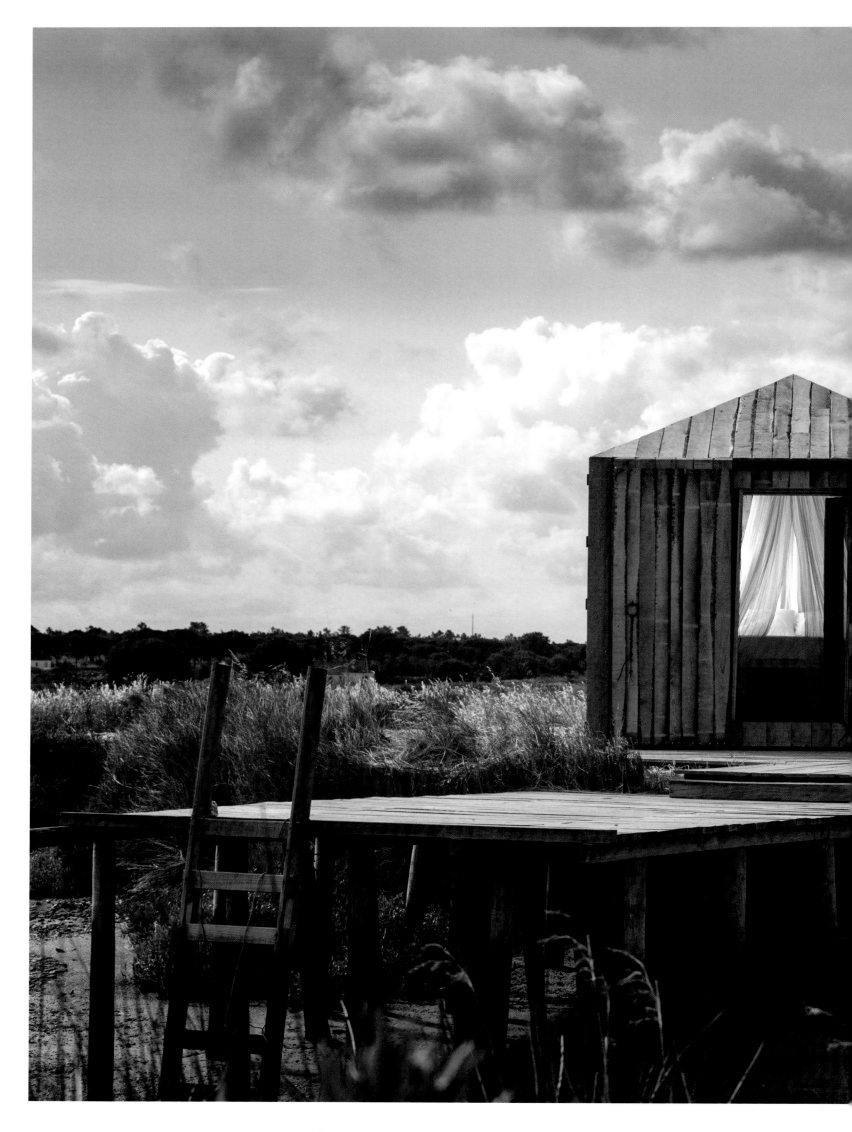

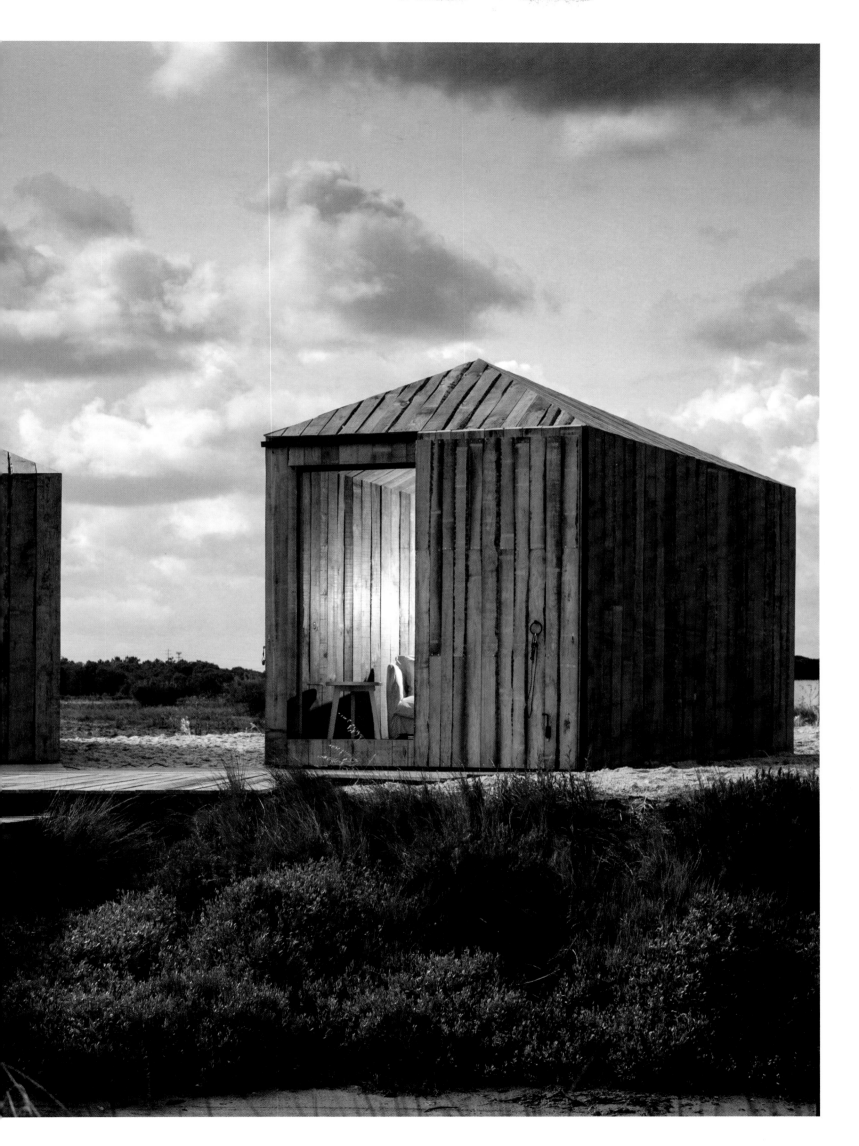

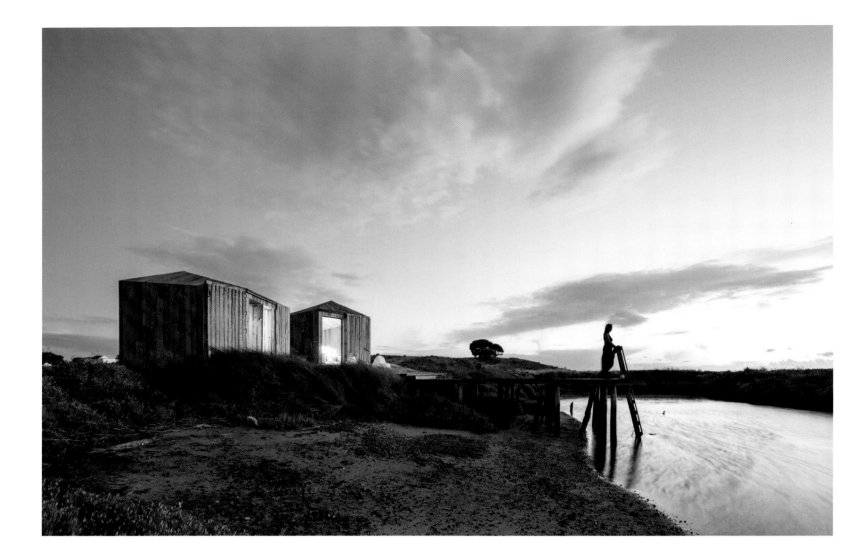

Although the Cabanas no Rio were conceived as a single, small seaside residence, the architects have divided it in two, retaining above all the form of traditional local fishermen's huts.

Zwar wurden die Cabanas no Rio als einzige kleine Strandunterkunft entworfen, die Architekten haben sie dennoch zweigeteilt und vor allem die Form regionaler Fischerhütten beibehalten.

Bien que conçues comme une petite résidence individuelle en bord de mer, les architectes ont divisé en deux leurs Cabanas no Rio pour conserver avant tout la forme des cabanes de pêcheurs traditionnelles de la région.

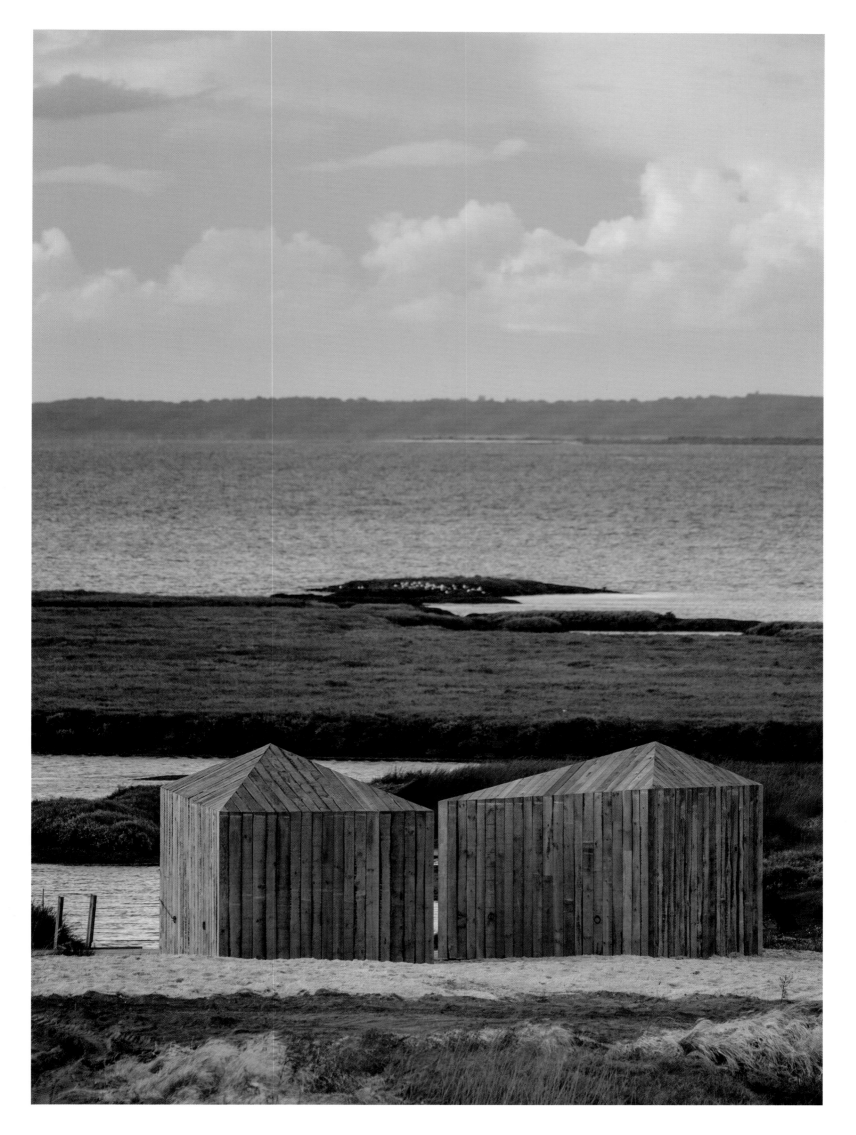

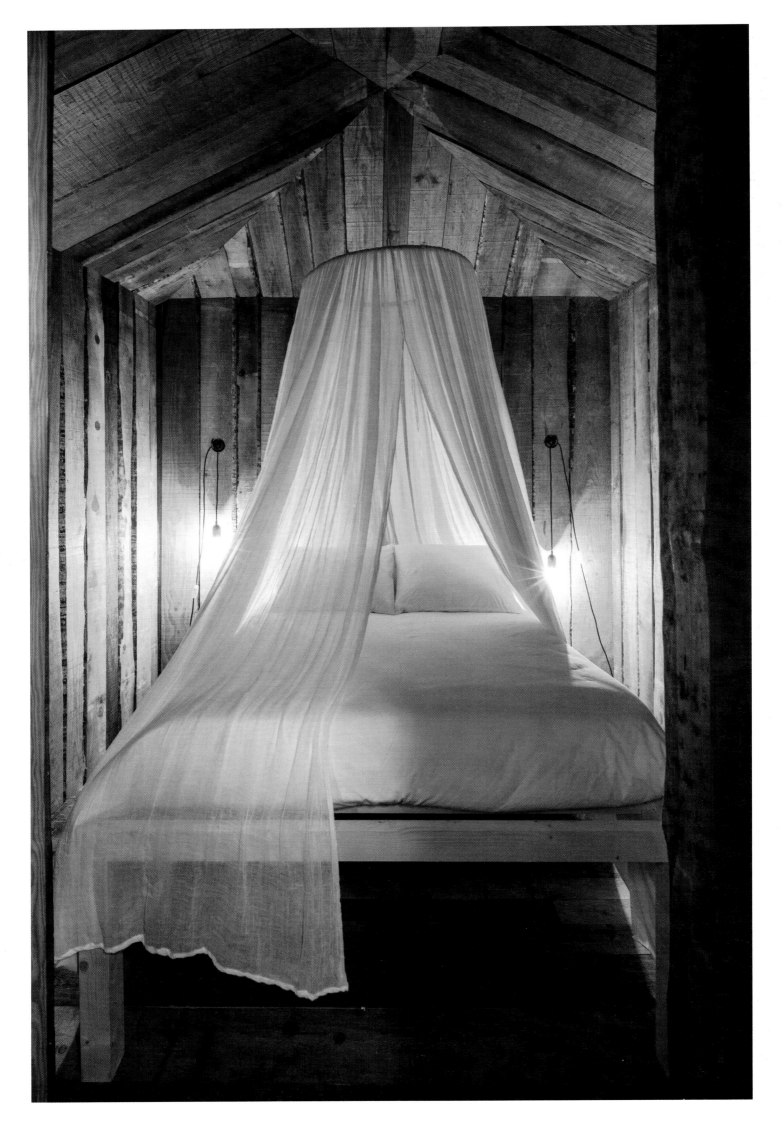

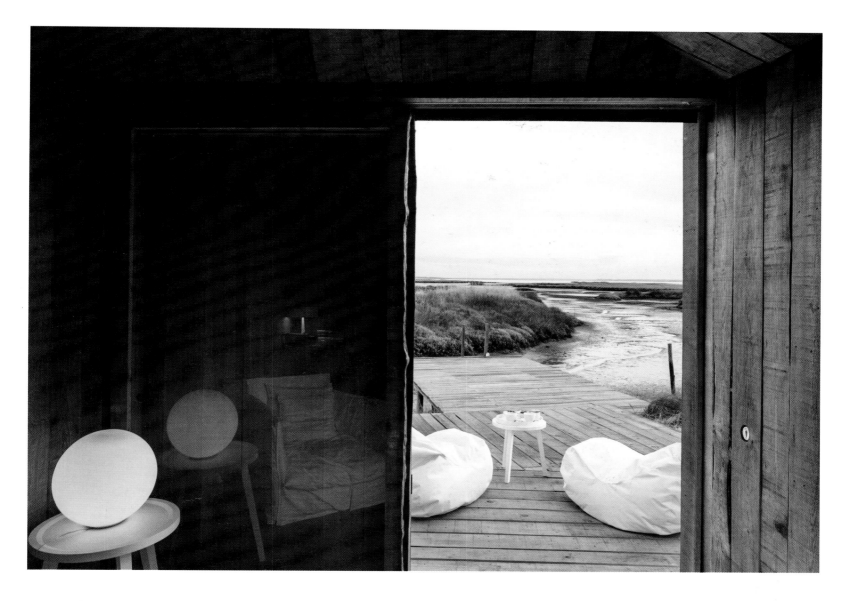

The bedroom has a closed and protected atmosphere (opposite and drawing left), but the huts open onto completely unbounded terraces that nearly touch the water.

Der Schlafraum ist geschützt und geschlossen (links sowie linke Zeichnung). Die Hütten öffnen sich jedoch auf gänzlich offene Terrassen, die fast bis ans Wasser reichen.

La chambre forme un cadre clos et protecteur (page et schéma de gauche), mais les cabanes ouvrent sur des terrasses entièrement dégagées qui touchent presque l'eau.

The architects contrast the closed design of the huts themselves with such features as this overtly open shower, with nothing to separate the user from the sand, grasses, and water other than a small terrace.

Die Architekten kontrastieren die Geschlossenheit der Hütten mit Ausstattungsmerkmalen wie dieser völlig offenen Dusche, die den Nutzer nur durch eine kleine Terrasse von Sand, Gras und Wasser trennt.

Les architectes ont opposé la conception fermée des cabanes à des éléments délibérément ouverts comme cette douche où rien sauf une petite terrasse ne sépare l'utilisateur du sable, des herbes et de l'eau.

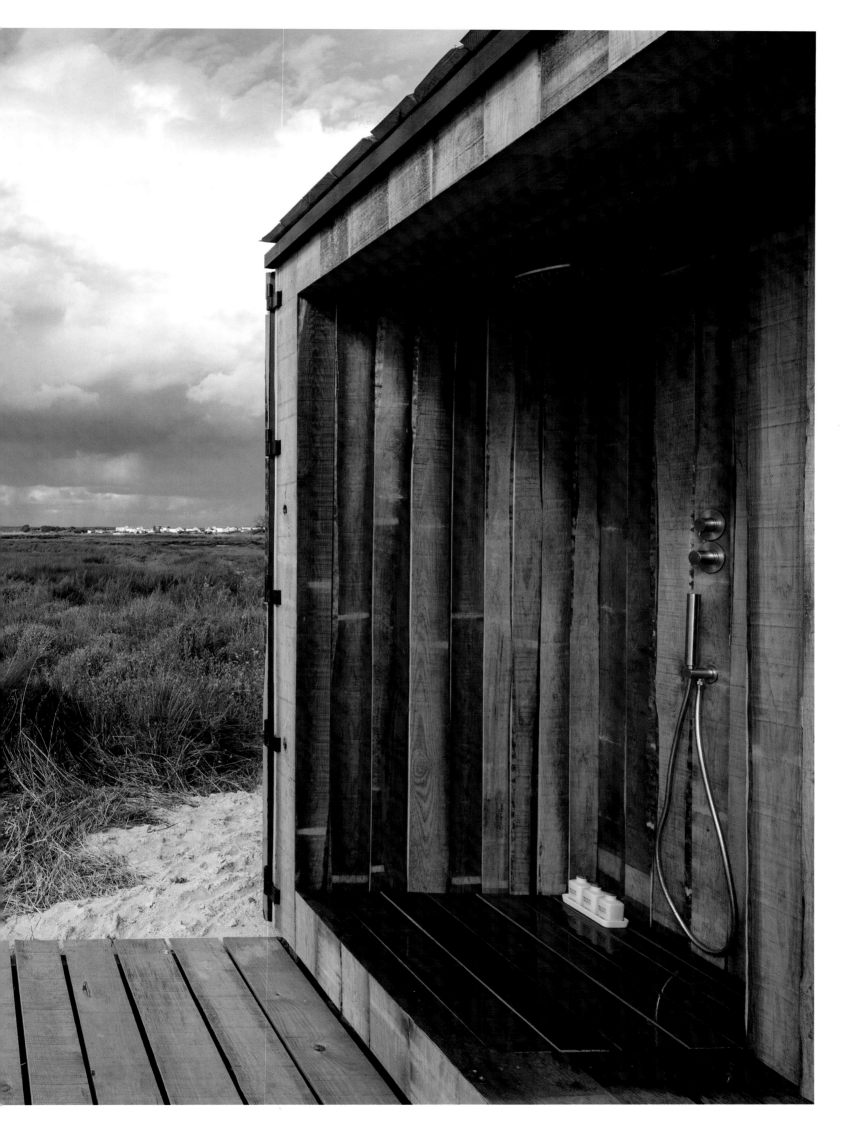

# CABIN 4:12

Area: 12 m² | Cost: €5000

The idea of the architect was to "create a complex experience through a simple form." With just 12 square meters, he has created four different spaces, three of which face in different directions with the fourth in the middle. One façade can be opened completely in each space. Glass surfaces are calculated to emphasize the relationship between interior spaces and the natural forest setting.

———

Der Architekt wollte „mittels einer einfachen Form eine komplexe Erfahrung schaffen". Auf nur 12 m² ließ er vier verschiedene Raumbereiche entstehen, von denen drei in unterschiedliche Richtungen orientiert sind. Der vierte ist mittig gelegen. Für jeden Bereich lässt sich ein Teil der Fassade vollständig öffnen. Glasflächen sind so angeordnet, dass sie die Verbindung zwischen Innenraum und Waldkulisse verstärken.

———

Le projet de l'architecte était de « créer une complexité avec une forme simple ». Dans seulement 12 m², il a imaginé quatre espaces différents, dont trois font face à une direction différente, tandis que le quatrième est au centre. L'une des façades de chaque espace peut être entièrement ouverte et les surfaces vitrées sont calculées pour mettre en valeur les liens entre les espaces intérieurs et le décor naturel de la forêt environnante.

The simple wooden volume is entirely closed on two sides. On the other two façades, large windows have horizontal bands that frame the forest setting.

Der schlichte Holzbau ist auf zwei Seiten ganz geschlossen. Die beiden anderen Seiten verfügen über horizontale Bandfenster, die den Wald einrahmen.

Le volume simple de bois est entièrement fermé de deux côtés, tandis que sur les deux autres façades, de larges fenêtres forment des bandes horizontales qui encadrent la forêt environnante.

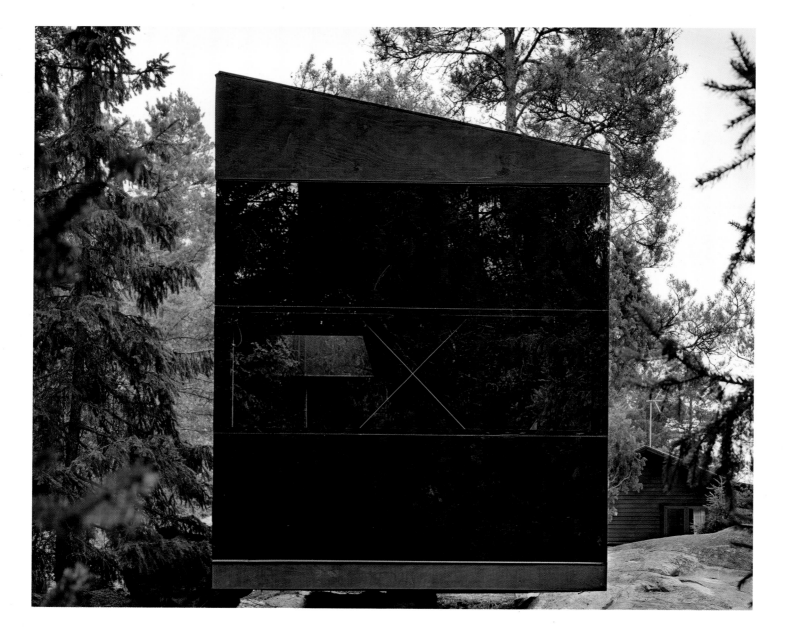

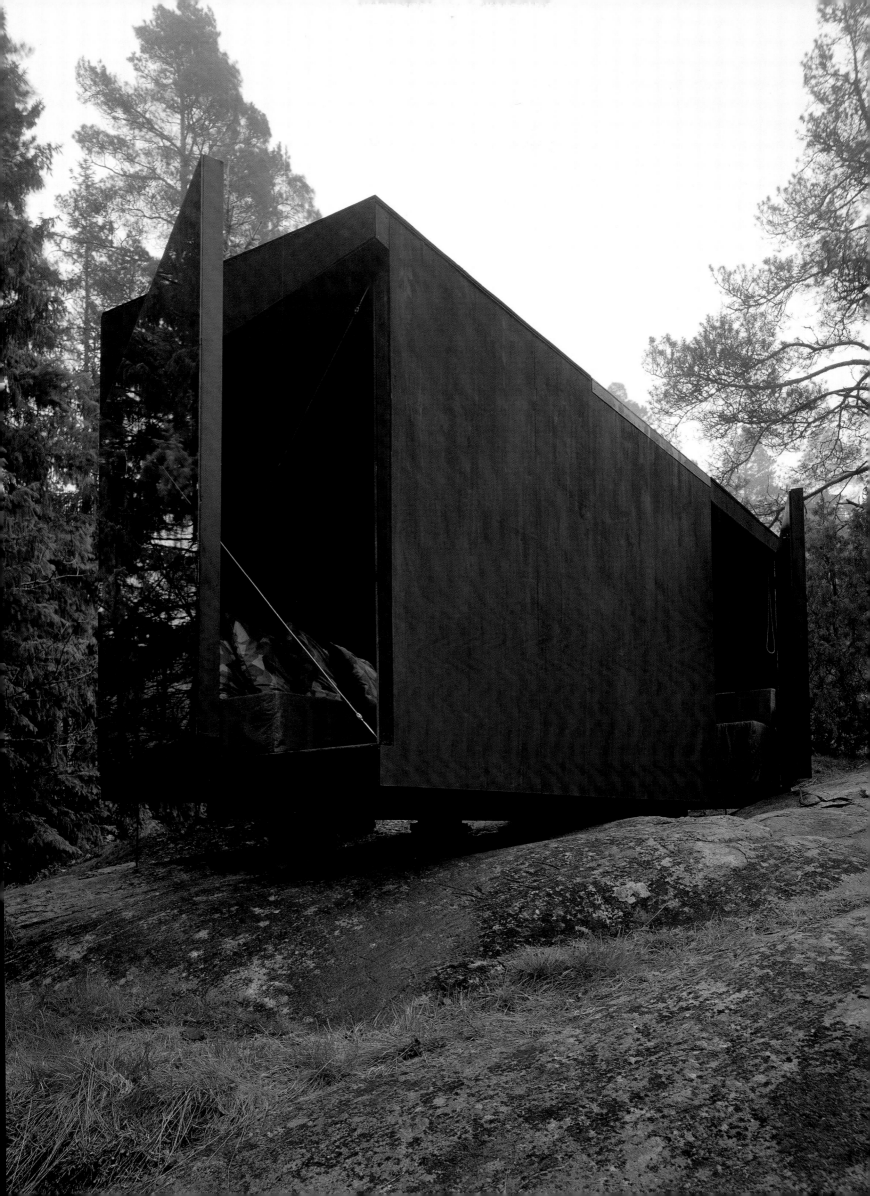

The wood interiors are painted in red and black, emphasizing the protected aspect of the forest hut, with wide windows enabling visitors to see out.

Das rot und schwarz lackierte Holzinterieur betont den behütenden Charakter der Waldhütte mit ihren breiten Fenstern, die dem Besucher den Ausblick gewähren.

Le bois de l'intérieur a été peint en rouge et noir pour mettre en valeur le caractère protecteur de cette cabane dans la forêt, les larges fenêtres ouvrant des vues sur l'extérieur.

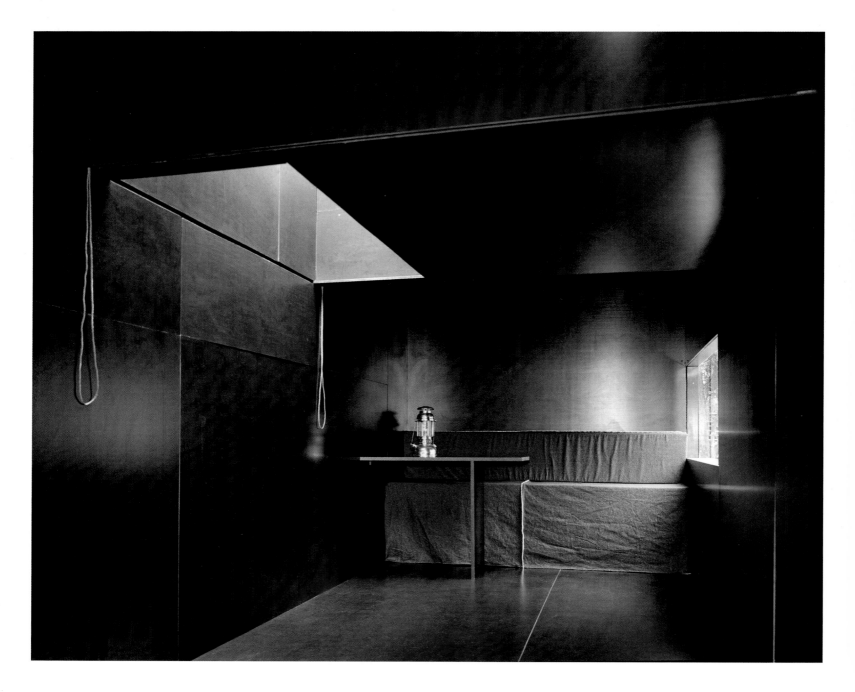

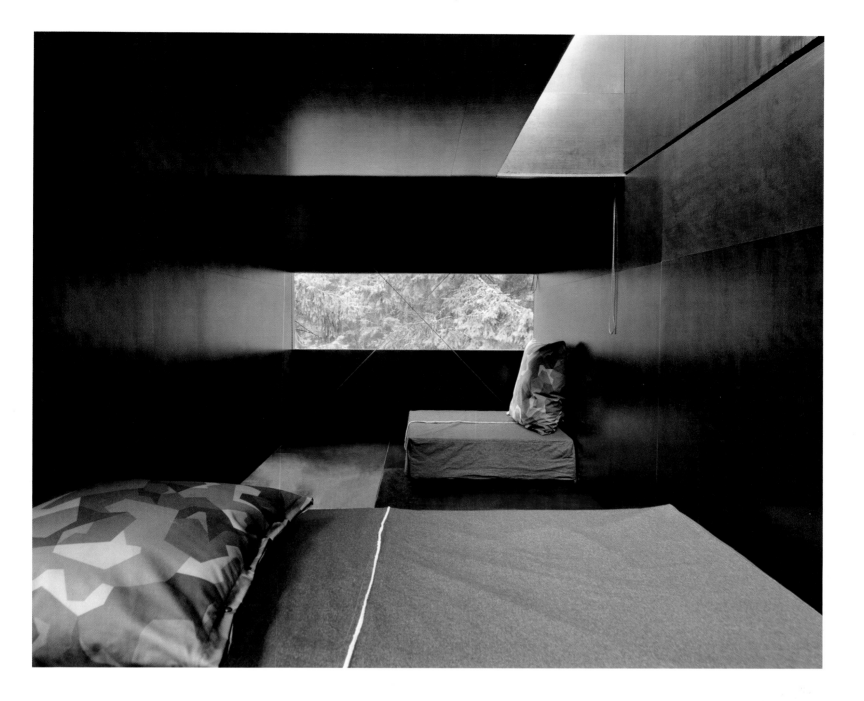

The mattresses are piled up and used as a sofa in the daytime; in the evening, they are spread out to form beds. Left, a drawing of the 12-square-meter space.

Aufeinandergestapelte Matratzen werden tagsüber zum Sofa, abends dienen sie ausgebreitet als Bett. Links eine Zeichnung des 12 m² großen Raums.

Les matelas sont empilés pendant la journée pour servir de sofa et étalés le soir pour former les lits. À gauche, un schéma de l'espace de 12 m².

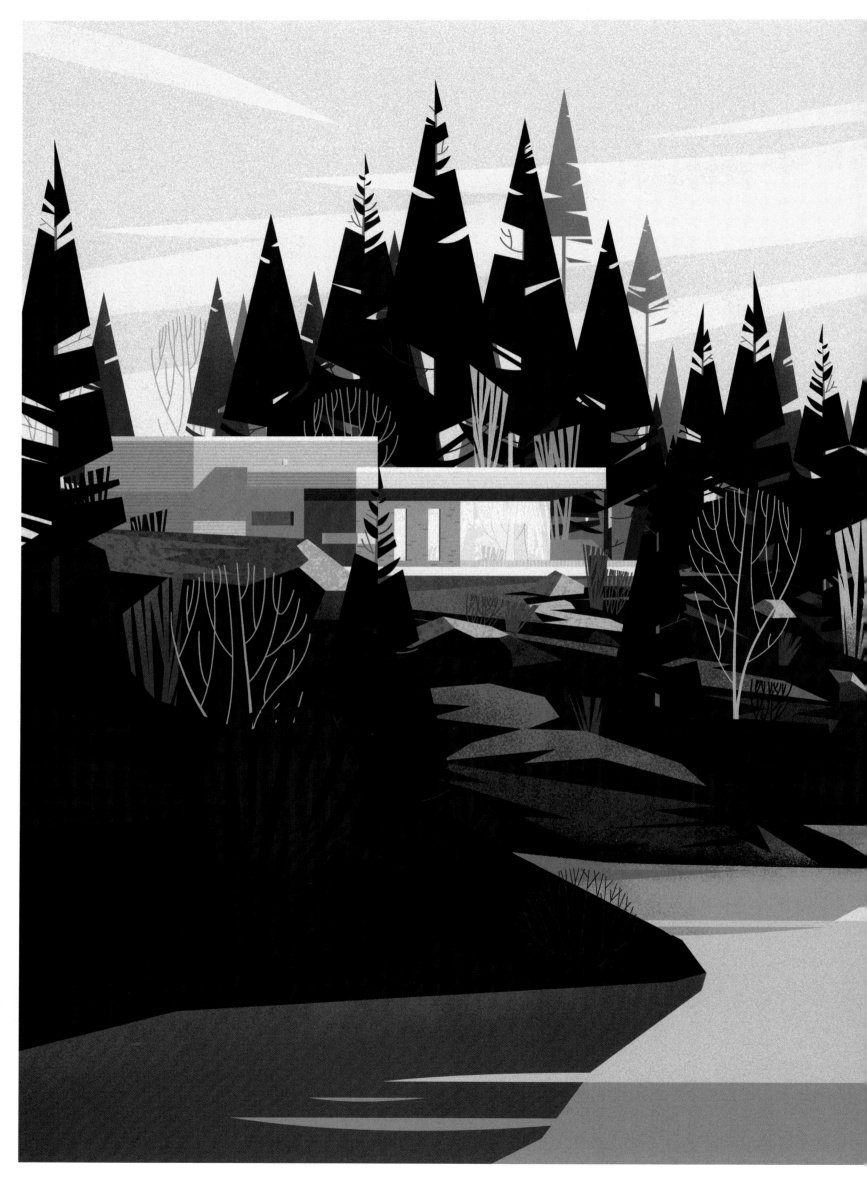

**GUDMUNDUR JÓNSSON**
Bjergøy [Norway]
2010–11

# CABIN GJ-9

Area: 100 m² | Client: Herlige Hus as | Cost: €322 000

This cabin was intended for use in various locations, preferably with a good view, and for mass-production. Two volumes, one containing bedrooms and the other a service area, are joined by the living and dining-room space in the form of a glazed pavilion in between, "producing contact to nature in all directions." A large roof serves to cover the cabin but also its terrace, "giving the impression that the cabin's space is larger when experienced from the inside," according to the architect. The terrace and the roof comprise a unit, extending the space with the glazed façade and the sliding doors. The cabin could also be outfitted with a roof terrace.

———

Dieses Haus war zur Serienfertigung und zur Nutzung an verschiedenen Standorten vorgesehen, die idealerweise über eine gute Aussicht verfügen. Zwei Baukörper, in denen sich die Schlafzimmer und der Versorgungsbereich befinden, sind derart miteinander verbunden, dass dazwischen ein Glaspavillon mit Wohn- und Essbereich entsteht, der die Bewohner „in alle Richtungen mit der Natur in Berührung bringt". Das Hausdach ragt bis über die Terrasse „und erweckt den Eindruck, der Innenbereich des Hauses sei größer". Terrasse und Dach bilden eine Einheit, Glasfassade und Schiebetüren erweitern den Raum. Das Haus kann auch mit einer Dachterrasse ausgestattet werden.

———

Cette cabane a été prévue pour pouvoir être utilisée à des emplacements divers, de préférence avec une belle vue, et pour une production de masse. Deux volumes contenant des chambres et un espace technique sont associés pour créer les espaces salon et salle à manger, sous la forme d'un pavillon vitré entre eux, « en contact avec la nature dans toutes les directions ». Le large toit couvre aussi la terrasse et « donne l'impression que l'espace est plus grand lorsqu'il est vu depuis l'intérieur », selon les termes de l'architecte. La terrasse et le toit forment une unité et accroissent l'espace, avec la façade vitrée et les portes coulissantes. La cabane pourrait donc aussi être dotée d'une terrasse sur le toit.

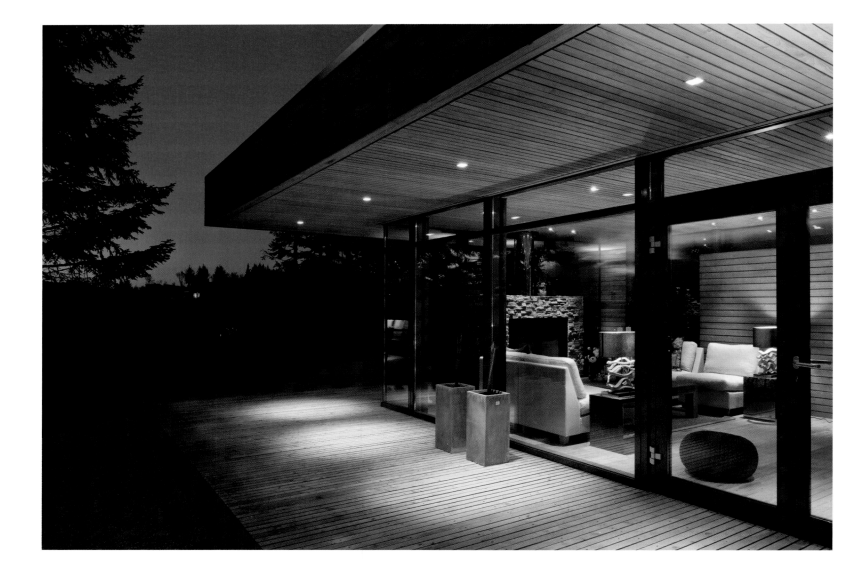

Playing on a modern recti-
linear archetype that consists in
concrete slabs and full-height
windows, the architect here
replaces concrete with wood.

Der Architekt nimmt Bezug auf
einen modernen, aus Betonplat-
ten gefertigten Archetyp mit
geraden Linien und raumhohen
Fenstern, ersetzt hier jedoch
Beton durch Holz.

Jouant sur un modèle rectiligne
moderne composé de dalles de
béton et de façades vitrées sur
toute leur hauteur, l'architecte
a remplacé le béton par du bois.

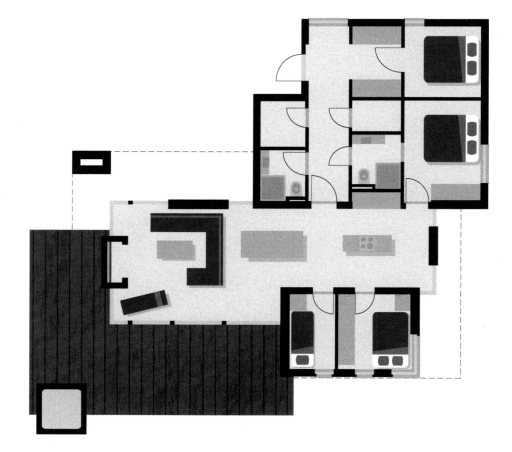

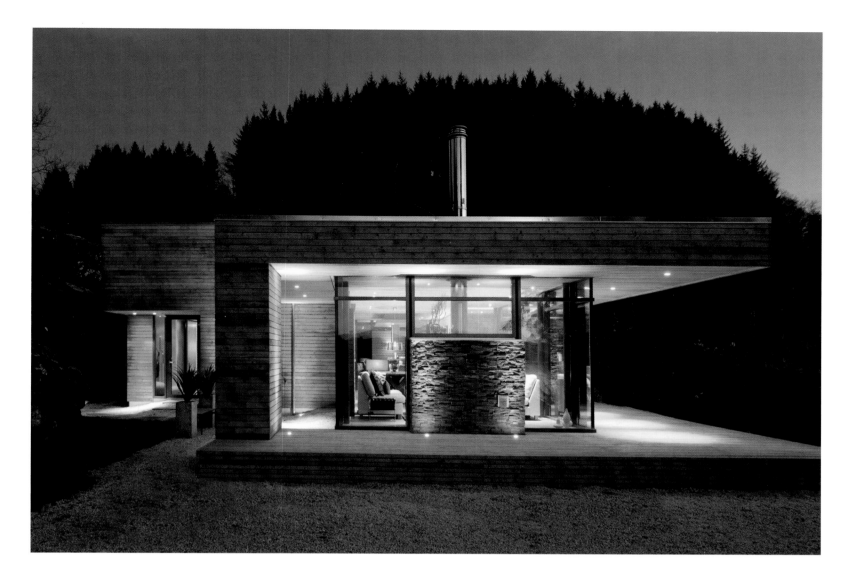

With its wooden platform and roof framing the central glass volume, the house glows from within at night, rendered distinct from the natural setting by its orchestration of straight lines.

Holzterrasse und Dach bilden den Rahmen des zentralen, gläsernen Teils des Gebäudes, das bei Nacht von innen leuchtet und sich von seiner natürlichen Umgebung durch das Zusammenspiel gerader Linien abhebt.

Avec sa plate-forme et son toit en bois qui encadrent le volume central vitré, la maison brille de tous ses feux la nuit, l'orchestration de lignes droites dont elle est formée la fait ressortir dans le décor naturel.

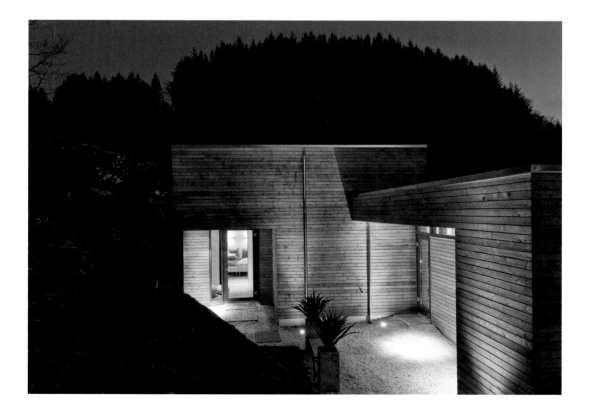

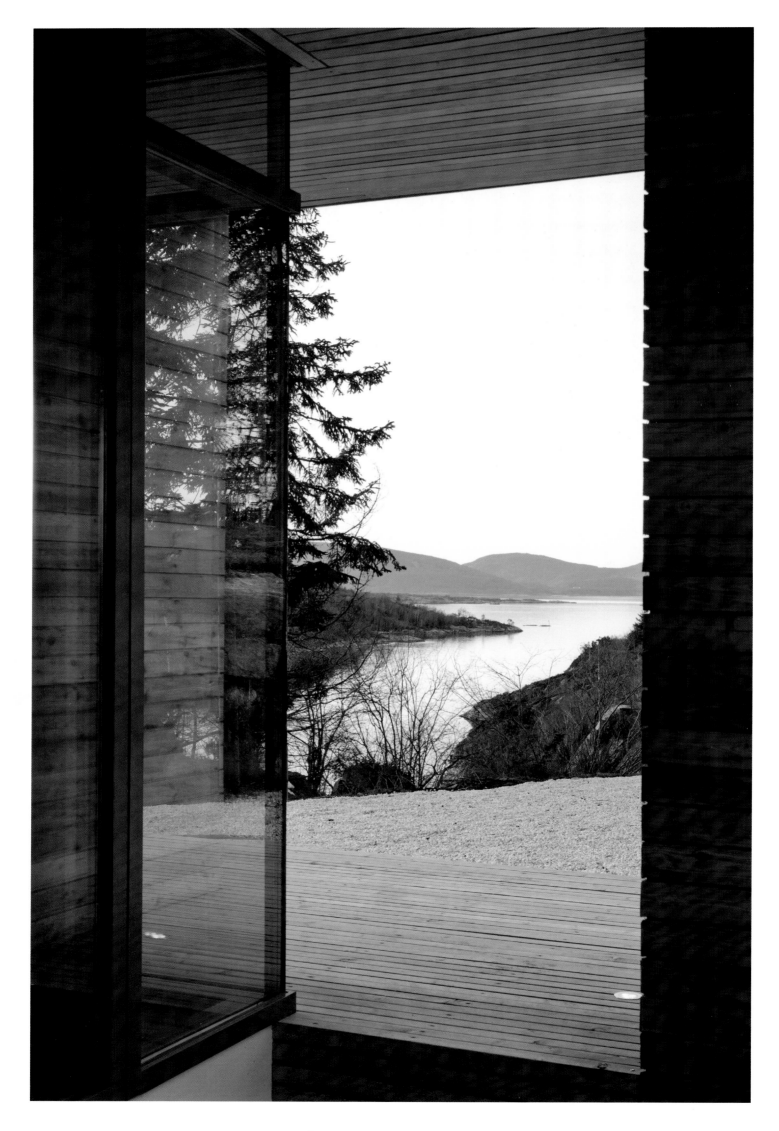

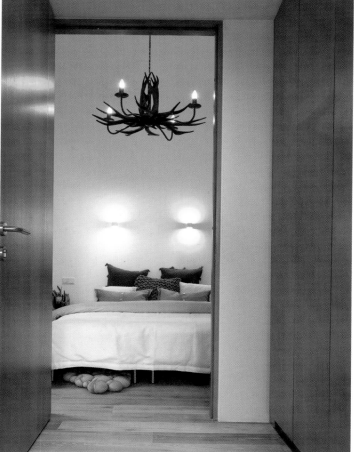

The glazed living and dining-room space is located between two volumes, one containing the bedrooms and the other a service area. Left, a terrace marks the transition to the beautiful natural setting.

Der verglaste Wohn- und Essraum liegt zwischen zwei Gebäudeteilen mit Schlafzimmern und Versorgungsbereich. Die Terrasse links markiert den Übergang in die schöne natürliche Umgebung.

Deux volumes contenant des chambres et un espace technique sont séparés par l'espace salon et salle à manger vitré. À gauche, la terrasse marque la transition vers le superbe cadre naturel.

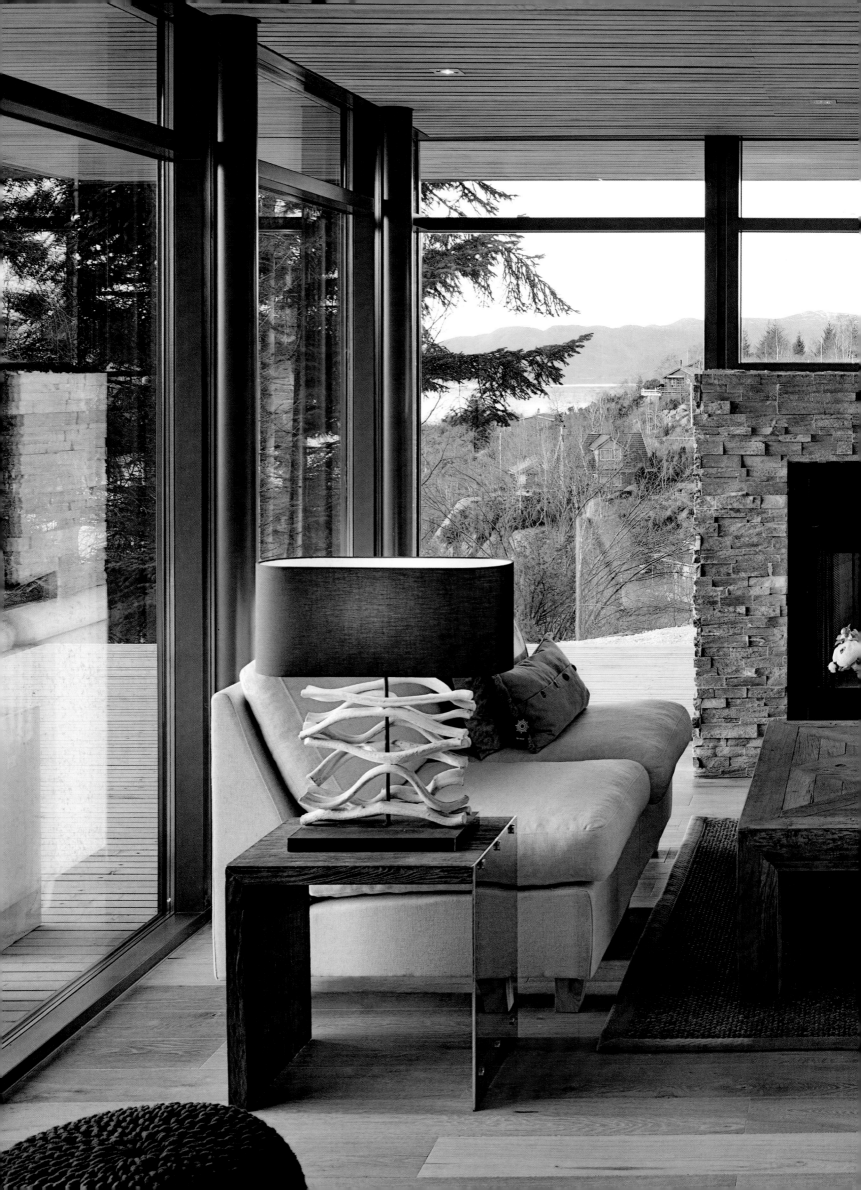

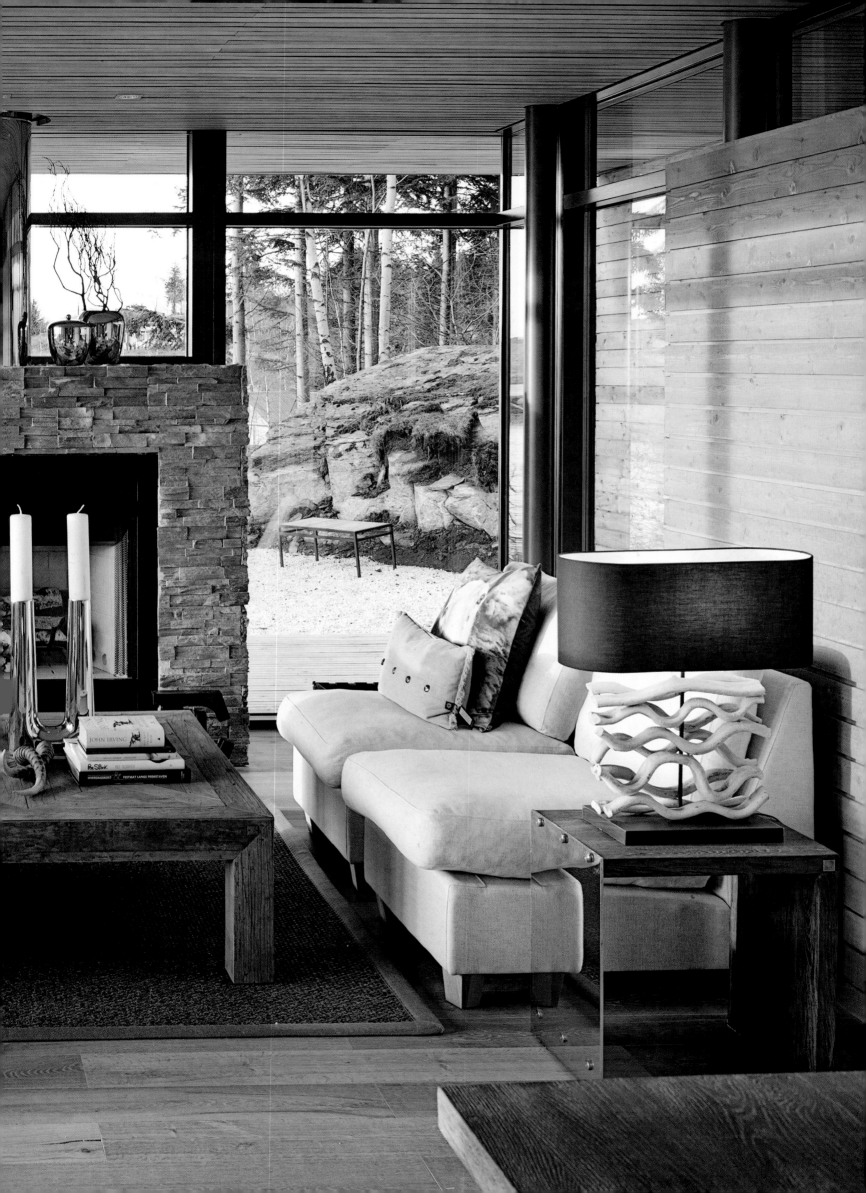

**ANDERSSON-WISE**
Polson, Montana [USA]
2007

# CABIN ON FLATHEAD LAKE

Area: 56 m²

Located on a site overlooking Flathead Lake in Western Montana, this cabin is ideally suited as a place from which to observe the natural setting and wildlife, which includes ospreys and eagles. The structure rests on six steel piers that are anchored in concrete blocks on the sloped site. The architects explain: "Screened walls enclose a living area, which has an open floor plan and wood slat floors that extend outside. Amenities are sparse but not neglected: a small kitchen, bathroom, and shower allow guests an overnight stay. The cabin has no heating or cooling system and running water is pumped from the lake below."

———

Das Projekt befindet sich im Westen Montanas auf einem Grundstück mit Blick auf den Flathead Lake und ist ideal gelegen, um die Naturkulisse und Tierwelt vor Ort, darunter Adler und Seeadler, zu beobachten. Der Bau ruht auf sechs Stahlpfeilern, die in Betonblöcken auf dem Hanggrundstück verankert sind. Die Architekten: „Die abgeschirmten Wände umschließen einen Wohnraum mit offenem Grundriss und einem Dielenfußboden, der sich bis in den Außenbereich zieht. Die Ausstattung ist sparsam, wurde aber nicht vernachlässigt: Es gibt eine kleine Küche, ein Bad und eine Dusche, sodass Gäste über Nacht bleiben können. Das Haus verfügt weder über eine Heizung noch über eine Klimaanlage. Fließendes Wasser wird aus dem See heraufgepumpt.

———

Cette cabane qui domine le lac Flathead, dans l'Ouest du Montana, occupe un emplacement idéal pour l'observation de la nature, de la faune et de la flore, notamment des balbuzards et des aigles. La structure est posée sur six piliers en acier ancrés dans des blocs de béton sur le site en pente. Les architectes expliquent : « Des murs écrans enclosent un espace de séjour au plan ouvert et aux sols en lattes de bois qui se prolongent à l'extérieur. Le confort est sommaire, mais pas négligé : une petite cuisine, une salle de bains et une douche permettent aux hôtes de passer la nuit. La cabane ne possède cependant ni chauffage, ni climatisation, et l'eau courante est pompée dans le lac en contrebas. »

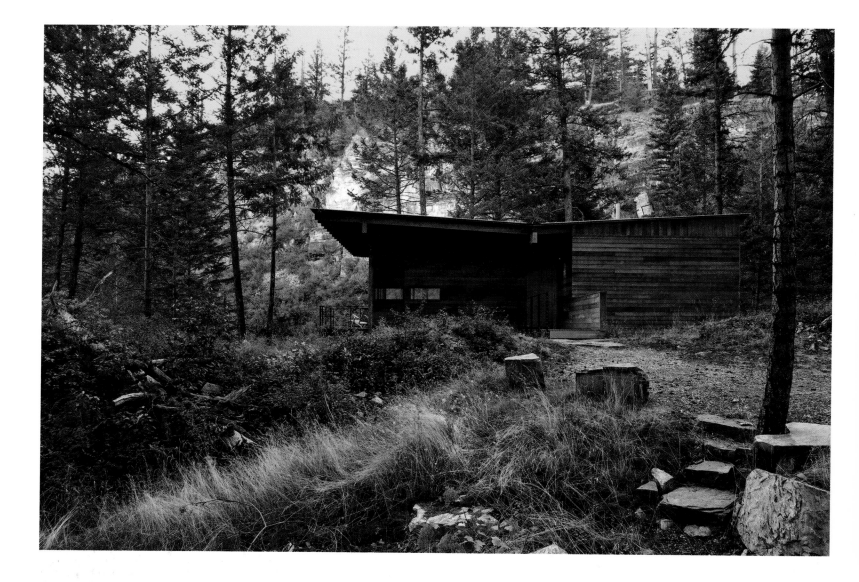

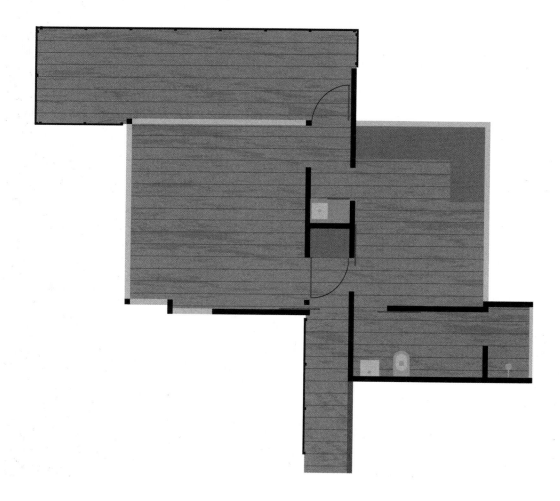

The cabin is set on six steel piers that are anchored to concrete blocks set into the sloped site. The wooden slat floors extend outdoors to create terraces.

Die Hütte ruht auf sechs in Betonblöcken auf dem Hang-grundstück verankerten Stahlpfeilern. Holzdielen ziehen sich bis in den Außenbereich und bilden eine Terrasse.

La structure est posée sur six piliers en acier ancrés dans des blocs de béton sur le site en pente. Les sols en lattes de bois se prolongent à l'extérieur pour former les terrasses.

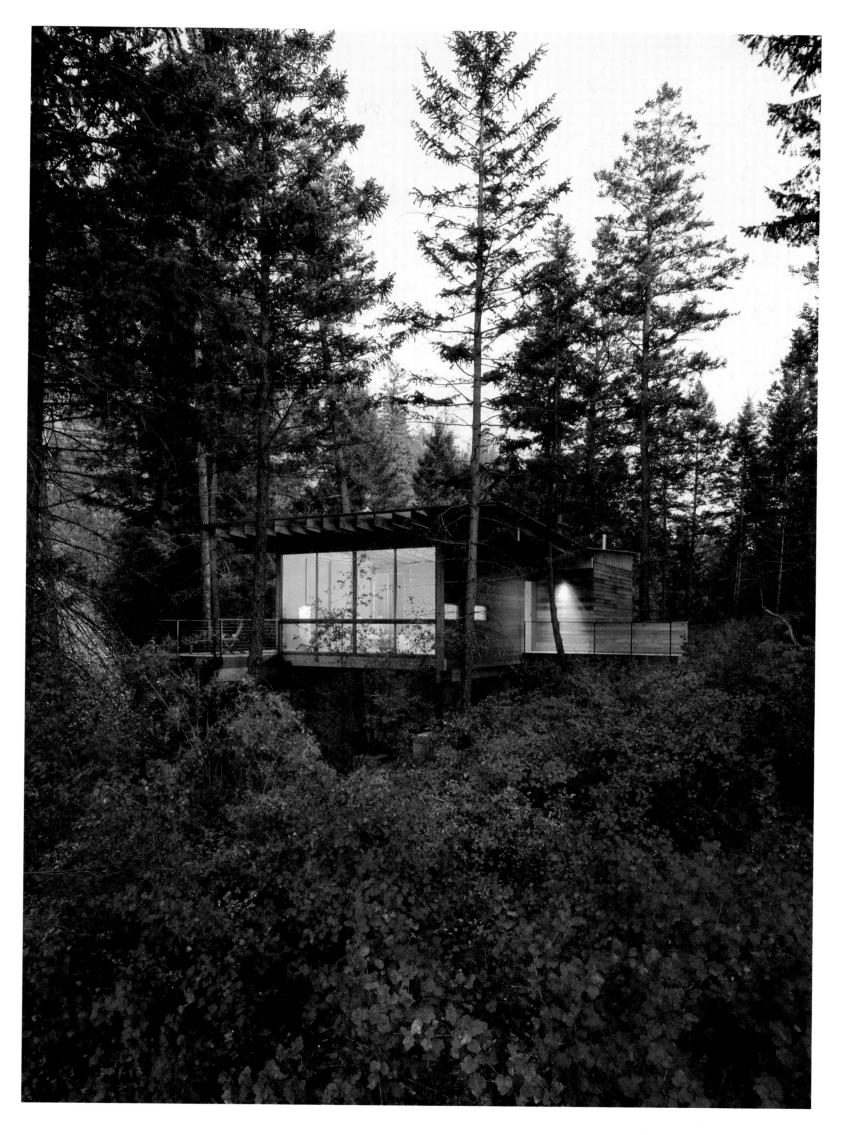

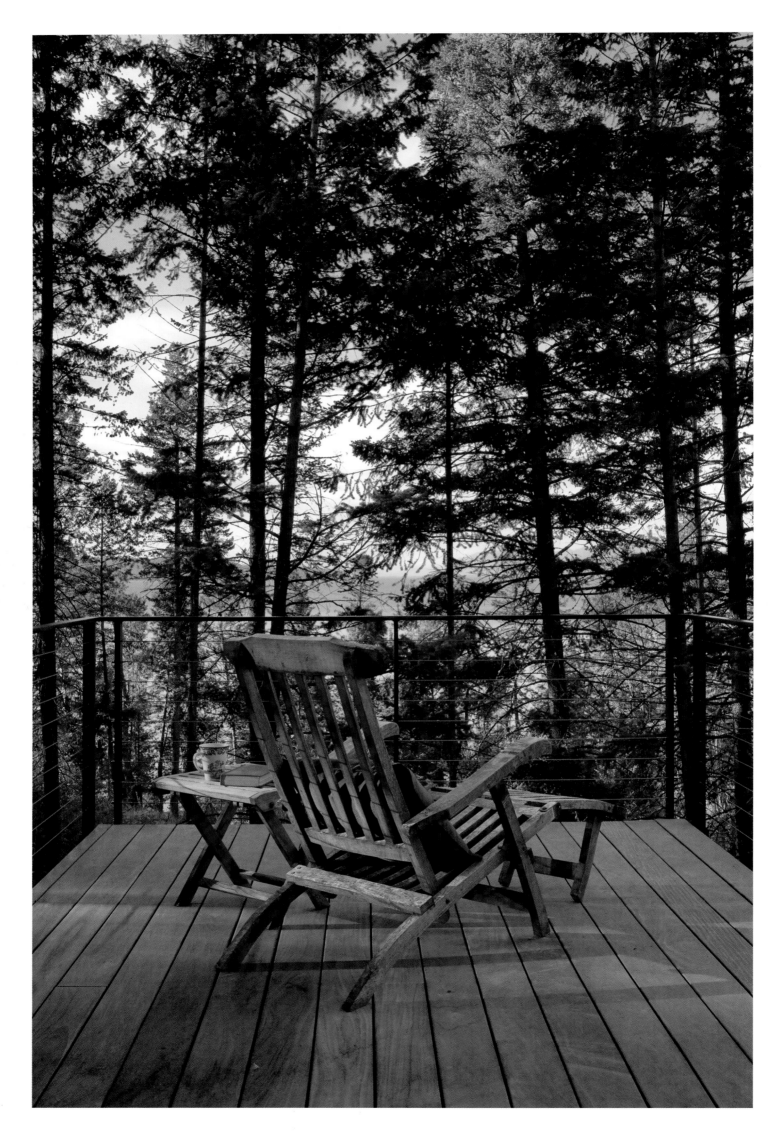

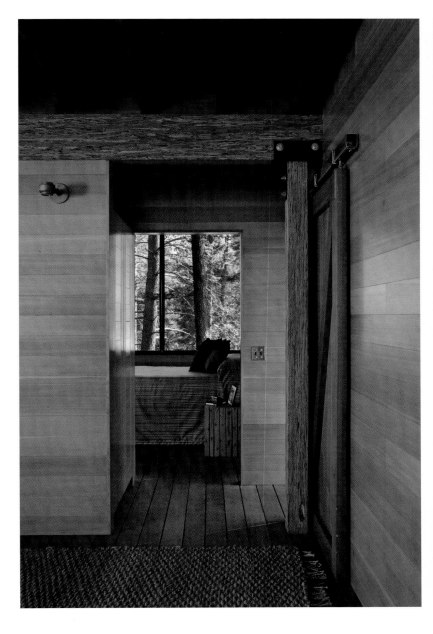

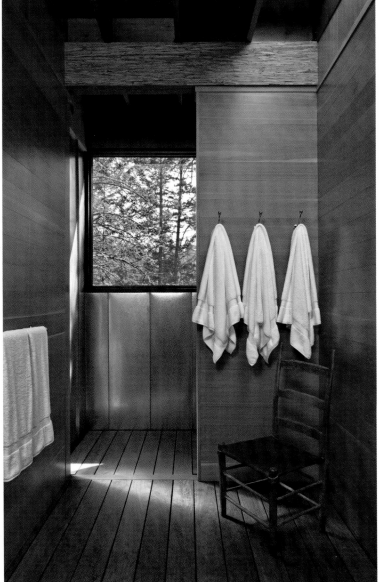

A small kitchen, bathroom, and shower are included in the cabin, which has no heating or cooling system. Water is pumped up from the lake below the site.

Die Hütte verfügt über Küche, Badezimmer und Dusche und verfügt weder über Heizung noch Klimaanlage. Wasser wird aus dem See unterhalb des Grundstücks heraufgepumpt.

La cabane comprend une petite cuisine, une salle de bains et une douche, mais ni chauffage, ni climatisation. L'eau est pompée dans le lac en contrebas.

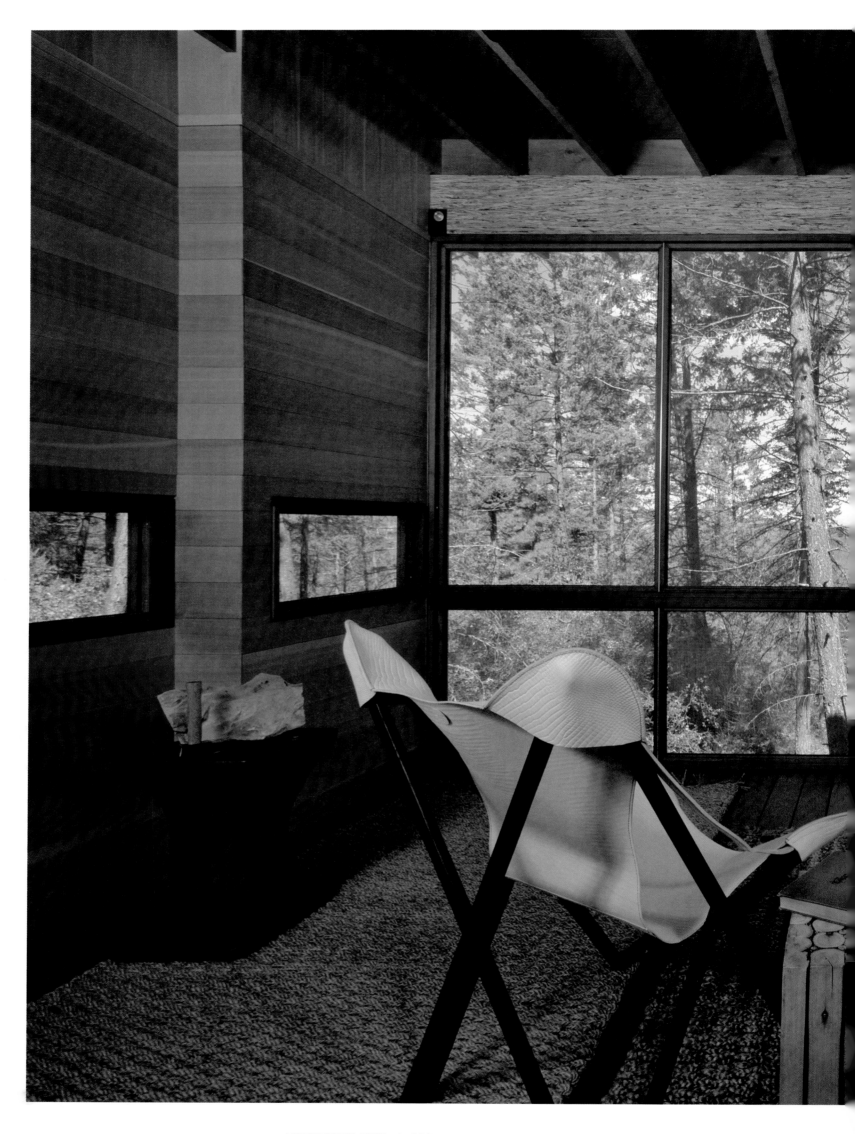

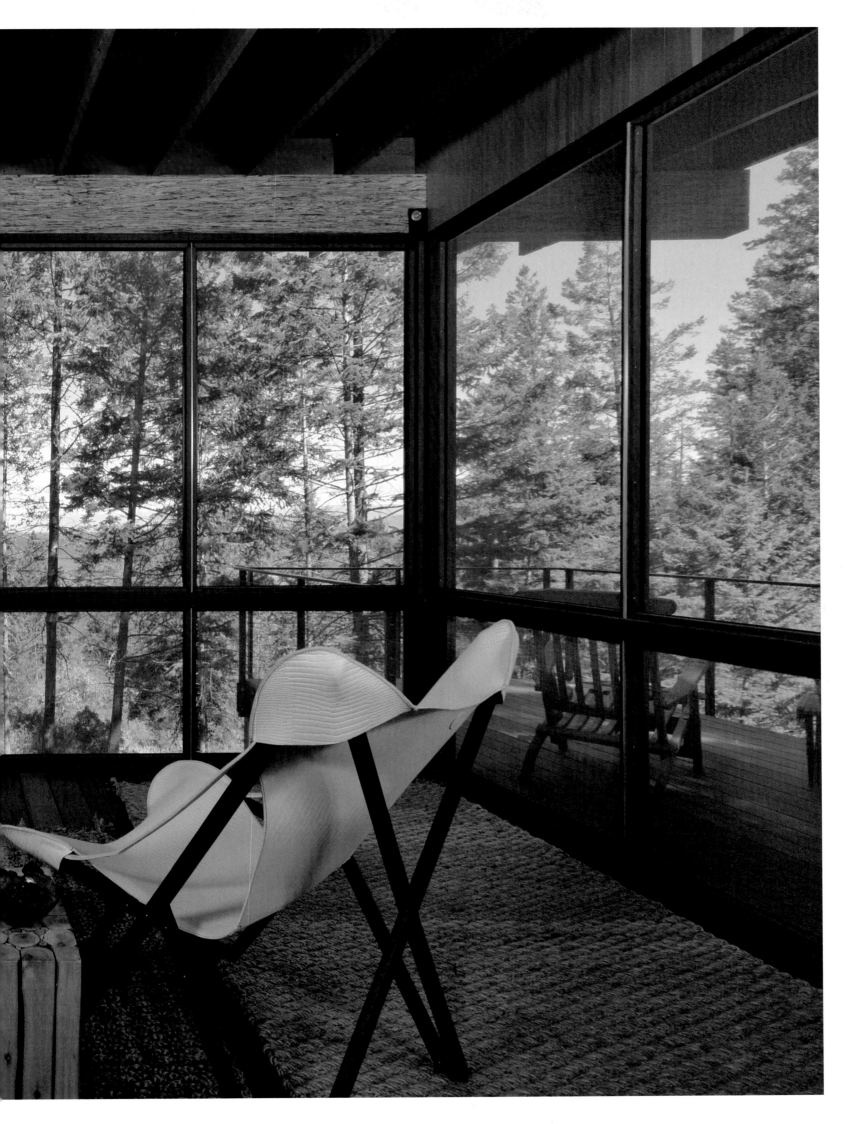

**HANS-JÖRG RUCH**
Lain [Switzerland]
2011–12

# CLAVO LAIN RENOVATION

Area: 175 m²

This hay and cattle barn was made of interlocked timber beams with air allowed in for ventilation. The architect states: "The challenge was to bring daylight into the rooms without cutting windows into the timber construction." An inner shell was placed inside the existing structure—allowing light in but protecting the residents from the elements. A new base in black concrete and with a large window was added in a manner that did not require the original wooden building to be dismantled. The architect explains: "The inner shell is constructed out of insulated wood-frame elements which were inserted through the roof and were put together on site. The new volume is covered with a layer of tar, which creates a fascinating contrast with the historical timber construction. In each phase, the architectural interventions were driven by a strong respect for the historical building."

———

Diese Heu- und Viehscheune wurde aus ineinander verschränkten Holzstämmen errichtet und erlaubt eine natürliche Luftzirkulation. Der Architekt: „Die Herausforderung bestand darin, Licht in die Räume zu lenken, ohne Fensteröffnungen in die Holzkonstruktion zu schneiden." In die bestehende Scheune wurde ein Gehäuse gesetzt, das Licht einlässt und die Bewohner vor den Elementen schützt. Ein schwarzer Betonsockel mit einem großen Fenster wurde hinzugefügt, ohne die Holzscheune hierfür abzubauen. Der Architekt: „Das Gehäuse besteht aus gedämmten Holzrahmenelementen, die durch das Dach gelassen und vor Ort zusammengesetzt wurden. Der neue Baukörper ist mit einer Teerschicht überzogen, wodurch sich ein faszinierender Kontrast zur ursprünglichen Holzkonstruktion ergibt. In allen Phasen waren die architektonischen Eingriffe von allergrößtem Respekt gegenüber dem historischen Gebäude geleitet.

———

Cette grange et étable était faite de poutres en bois emboîtées qui permettaient volontairement à l'air de pénétrer à des fins d'aération. L'architecte déclare : « Le plus grand défi a consisté à faire entrer la lumière du jour dans les pièces sans découper de fenêtres dans la construction en bois d'œuvre. » Une coque intérieure a été placée dans la structure existante – laissant entrer la lumière, mais protégeant les habitants des intempéries. Une nouvelle base en béton noir percée d'une large fenêtre supplémentaire a été ajoutée sans qu'il soit nécessaire de démanteler la construction existante en bois. L'architecte explique : « La coque intérieure est faite d'éléments de charpente en bois isolés, qui ont été introduits par le toit et assemblés sur place. Le nouveau volume est couvert d'une couche de goudron, ce qui crée un contraste fascinant avec la construction historique en bois. À chaque phase du projet, notre intervention a été guidée par un immense respect pour le bâtiment historique. »

This former hay and cattle barn was built from interlocked timber. The architect sought to bring daylight into the renovated residence without cutting into the timber structure.

Die einstige Vieh- und Heuscheune wurde aus ineinander verschränkten Holzstämmen errichtet. Dem Architekten war daran gelegen, Licht ins umgebaute Wohnhaus zu leiten, ohne in die Holzkonstruktion zu schneiden.

Cette ancienne grange et étable était faite de poutres en bois emboîtées. L'architecte a essentiellement cherché à faire entrer la lumière du jour à l'intérieur de la résidence rénovée sans découper de fenêtres dans la construction en bois d'œuvre.

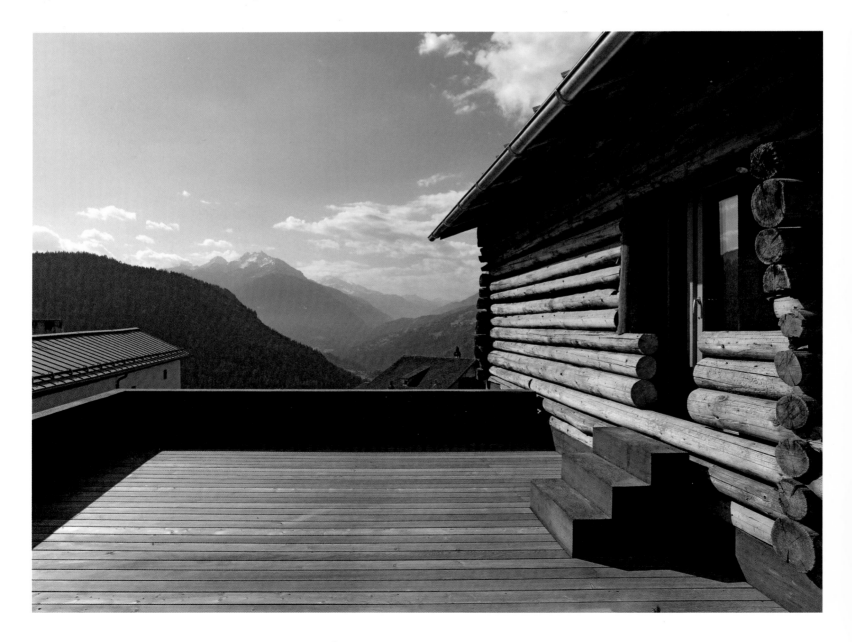

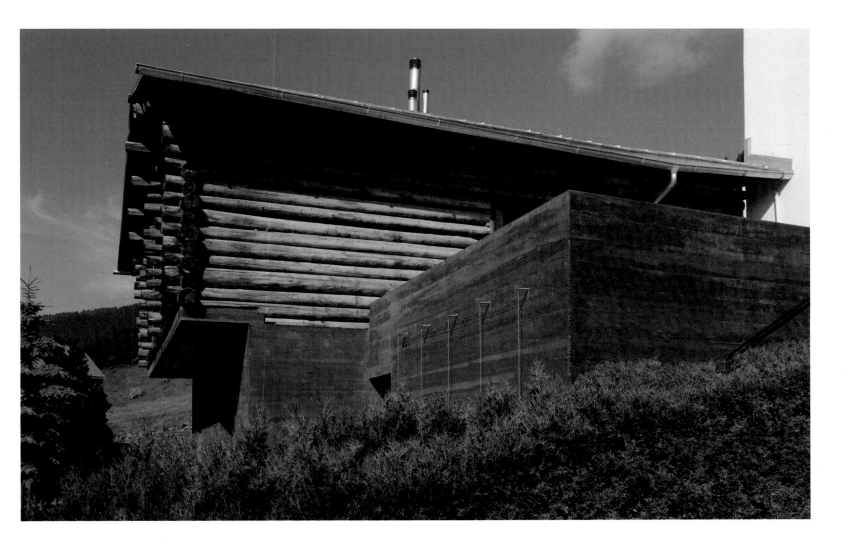

A new base of black concrete supports the old wooden structure, which was not dismantled during construction. Below, plans of the residence.

Die alte Holzkonstruktion ruht auf einem neuen schwarzen Betonsockel und wurde im Verlauf der Bauarbeiten nicht zerlegt. Unten sind Grundrisse des Wohnhauses abgebildet.

Une nouvelle base en béton noir porte l'ancienne structure en bois qu'il n'a pas été nécessaire de démanteler pendant la construction. Ci-dessous, plans de la maison.

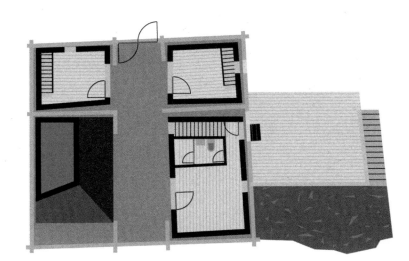

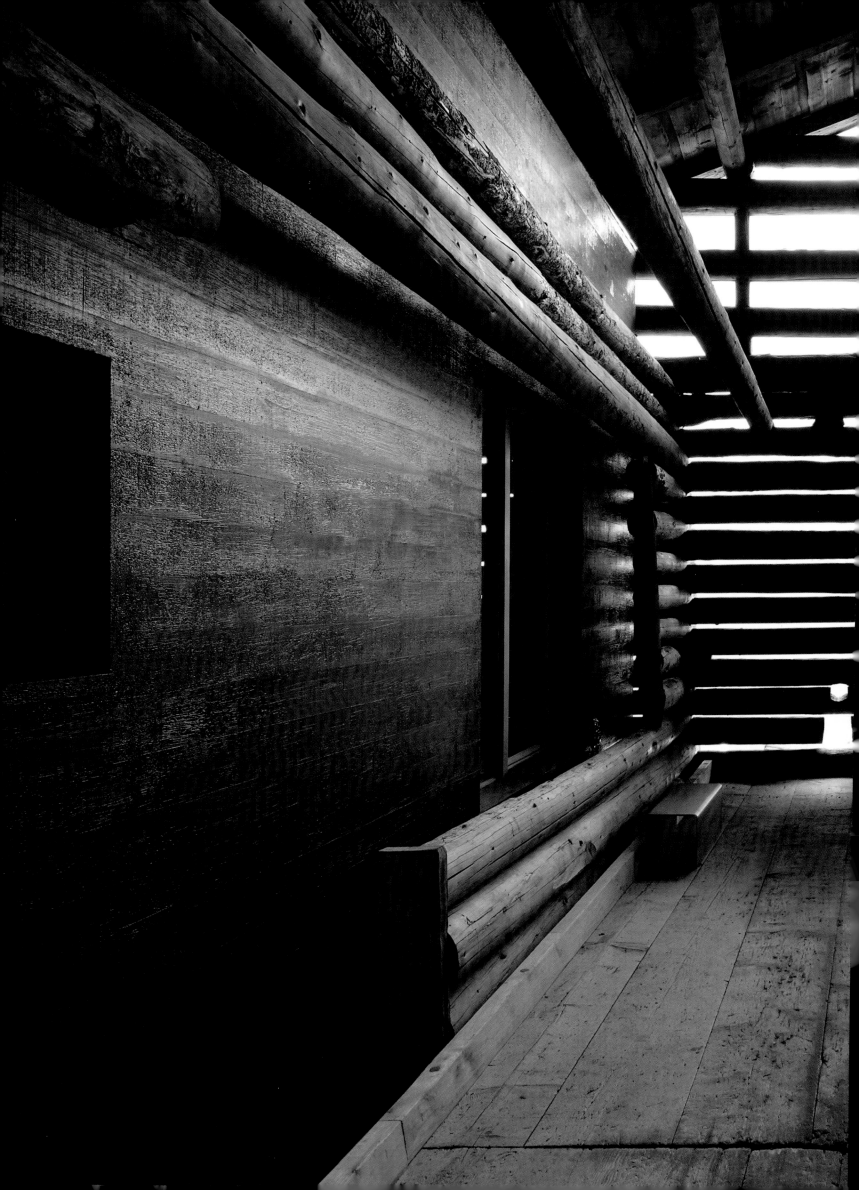

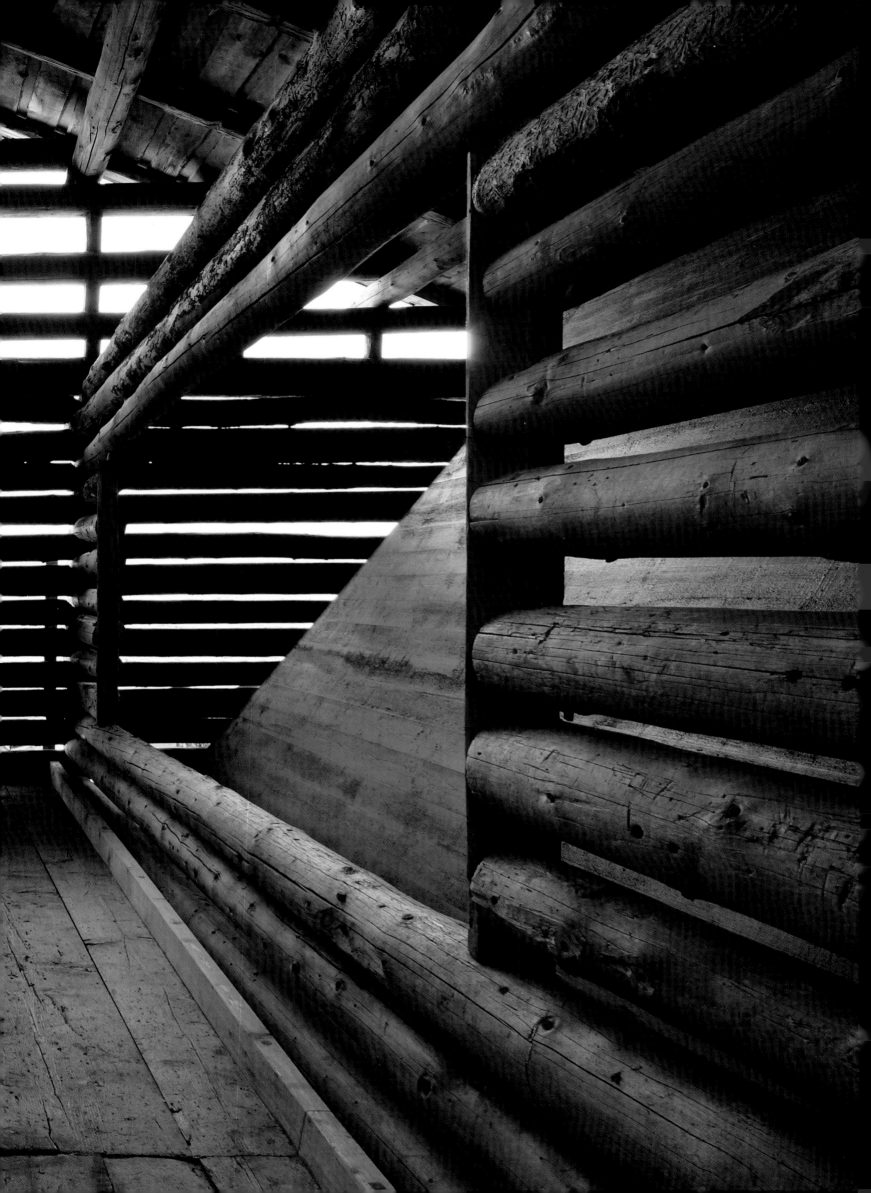

The inner shell is built with an insulated wood frame whose elements were brought in through the roof. Right, an elevation drawing; below, a roof opening allows light directly into the interior.

Das Gehäuse im Inneren besteht aus gedämmten Holzrahmenelementen, die durchs Dach eingebracht wurden. Rechts ein Aufriss und unten die Dachöffnung, durch die direktes Licht einfällt.

La coque intérieure est faite d'éléments de charpente en bois isolés qui ont été introduits par le toit. À droite, plan en élévation et ci-dessous, une ouverture dans le toit laisse pénétrer la lumière directe.

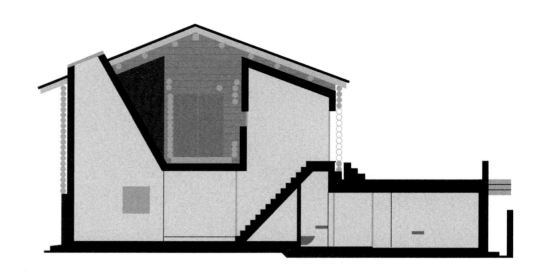

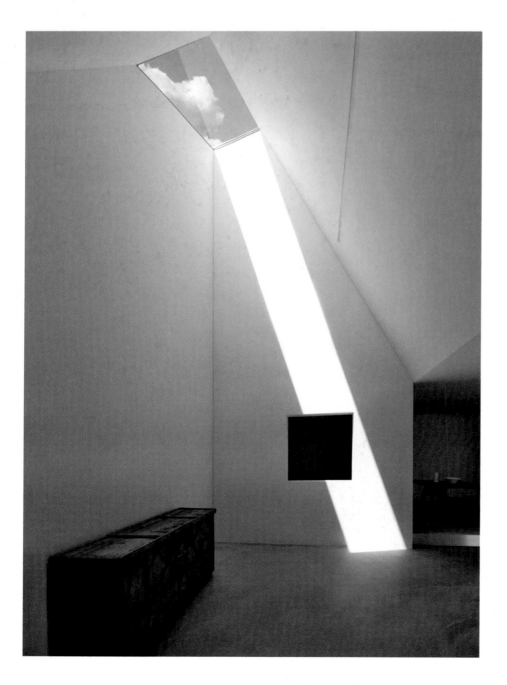

Right page, the interior volumes might be characterized as minimalist, with an emphasis on the contrast between light, dark, and shadow.

Die Innenräume auf der rechten Seite können als minimalistisch beschrieben werden und betonen den Kontrast zwischen Licht, Schatten und Dunkelheit.

Page de droite, les volumes intérieurs peuvent être qualifiés de minimalistes et insistent sur le contraste entre la lumière, l'obscurité et l'ombre.

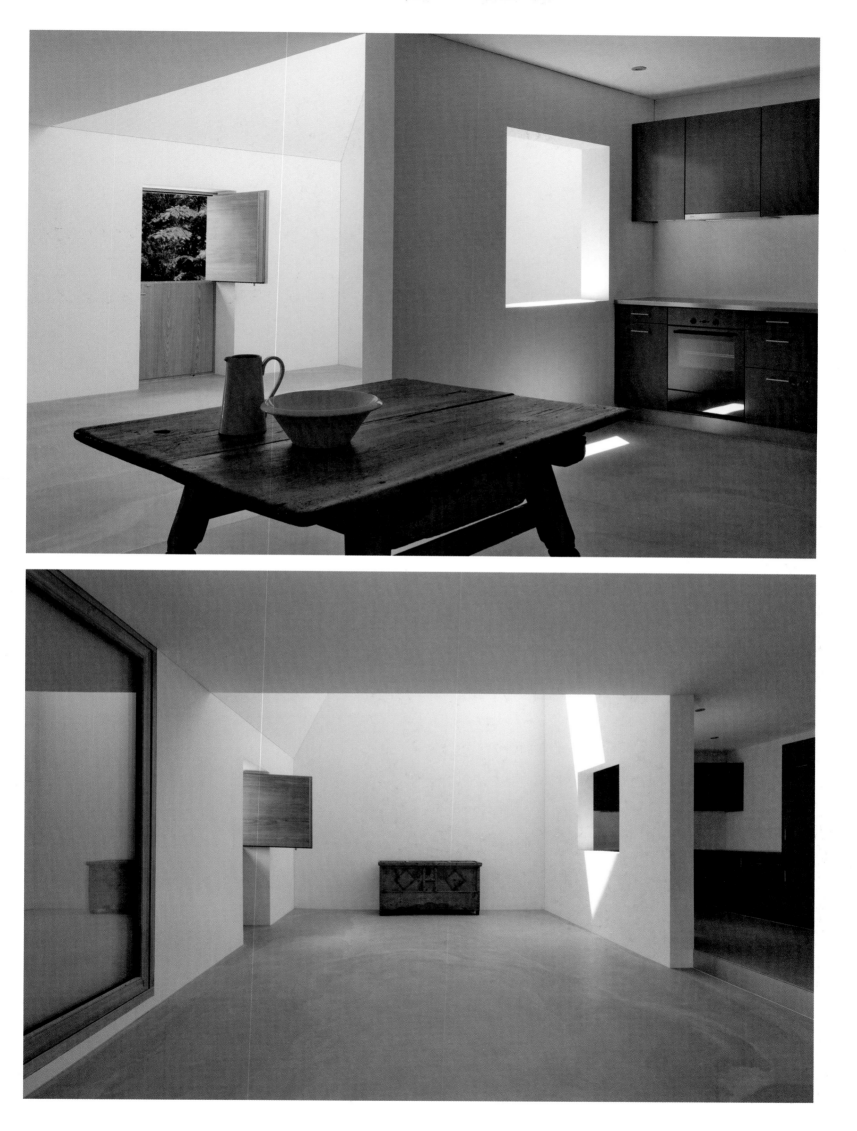

# CLEARLAKE IT CABIN

Area: 74 m² | Client: Terry Ohm | Cost: $280 000
Collaboration: Ryan Whitacre

This remote cabin serves as a home and an office for a lighting designer seeking to escape the city. Lifted 1.2 meters into the air, this prefabricated, light-gauge, galvanized-steel, platform structure is on a sloped site. Above the platform, lightweight aluminum columns and beams were assembled on site. A minimal, open plan has been combined with large areas of glazing to provide views of the natural setting. Reclaimed cypress was used for the floors, as well as for the outdoor terraces, cabinetry, and custom-made furniture. An off-grid solar-panel system is located higher on the same slope to provide all energy for the house.

———

Dieses abgelegene Haus ist das Wohn- und Bürogebäude eines Lichtdesigners, der die Stadt hinter sich lassen wollte. Es wurde auf einer 1,2 m hohen, vorgefertigten Plattform aus galvanisiertem Leichtstahl an einem Standort mit Gefälle errichtet. Pfeiler und Träger aus Leichtaluminium wurden vor Ort auf der Plattform zusammengesetzt. Der Grundriss ist reduziert und offen, große Glasflächen gewähren einen Ausblick auf die Natur. Außer für die Fußböden wurde auch für die Terrassen, die Schränke und die maßgefertigten Möbel Zypressenholz wiederverwendet. Eine netzunabhängige Solaranlage befindet sich weiter oben auf demselben Hang und versorgt das Haus mit Energie.

———

Cette cabane isolée sert de résidence et de bureau à un ingénieur-éclairagiste qui souhaitait fuir Los Angeles. Elle est surélevée à 1,2 m par une fine plateforme préfabriquée en acier galvanisé sur un terrain en pente. Au-dessus de la plate-forme, les légères colonnes et poutres d'aluminium ont été assemblées sur place. Le plan ouvert et minimaliste comporte de vastes surfaces vitrées avec vue sur la nature environnante. Du cyprès récupéré a été utilisé pour les sols, ainsi que pour les terrasses, placards et meubles sur mesure. Un système à panneaux solaires hors réseau situé plus haut sur la pente fournit toute l'énergie de la maison.

The frame of the house, made of prefabricated,
light-gauge, galvanized steel, is lifted 122 centimeters
off the ground. Aluminum columns and beams are
held together by aluminum clip angles, stainless-steel
bolts, and cable braces.

Die vorgefertigte Rahmenkonstruktion aus galvanisiertem
Leichtstahl wurde 122 cm über dem Boden errichtet.
Die Aluminiumträger und -pfeiler werden von Befesti-
gungswinkeln aus Aluminium, Edelstahlschrauben und
Drahtseilverstrebungen zusammengehalten.

La charpente légère en acier galvanisé préfabriqué est
surélevée à 122 cm au-dessus du sol. Les colonnes et
poutres d'aluminium sont assemblées par des cornières
en aluminium, des boulons en acier inoxydable et des
supports de câbles.

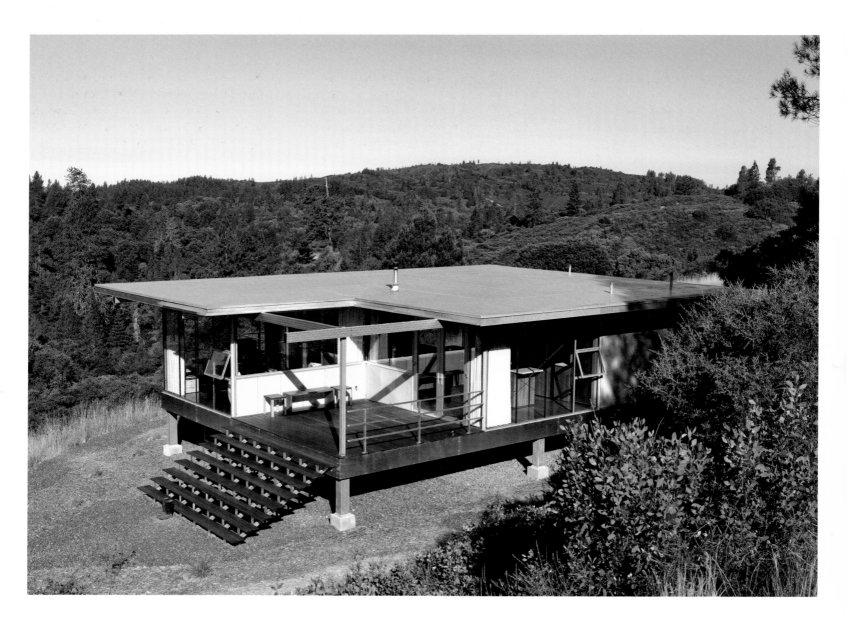

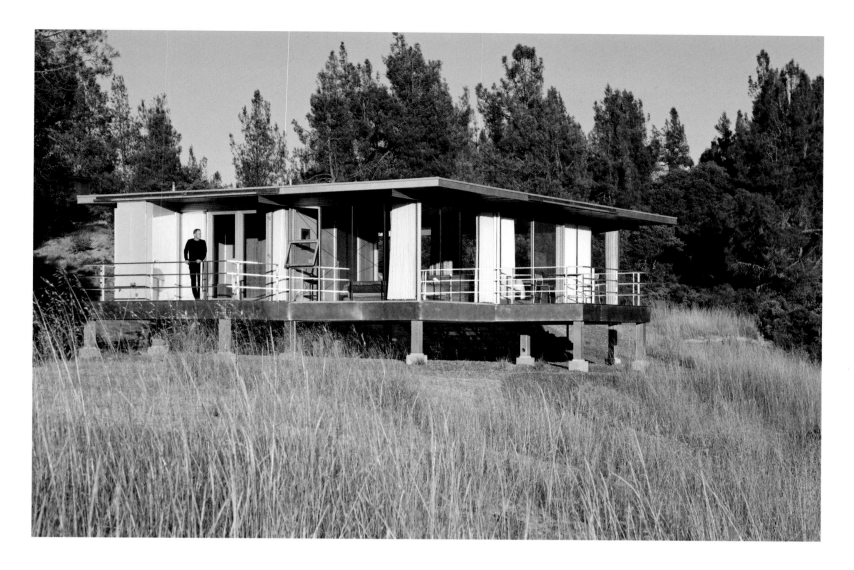

The minimal, open plan has large spans of glass that provide generous views of the surrounding countryside. The interior is marked by the exposed aluminum members, glass, and reclaimed Monterey cypress.

Der Grundriss ist reduziert und offen, große Glasflächen ermöglichen eine gute Aussicht auf die Landschaft. Das Interieur zeichnet sich durch freiliegende Aluminiumelemente, Glas und recyceltes Monterey-Zypressenholz aus.

Le plan ouvert et minimaliste comporte de vastes surfaces vitrées pour des vues généreuses du paysage. L'intérieur est surtout marqué par les éléments en aluminium apparent, le verre et le cyprès de Monterey récupéré.

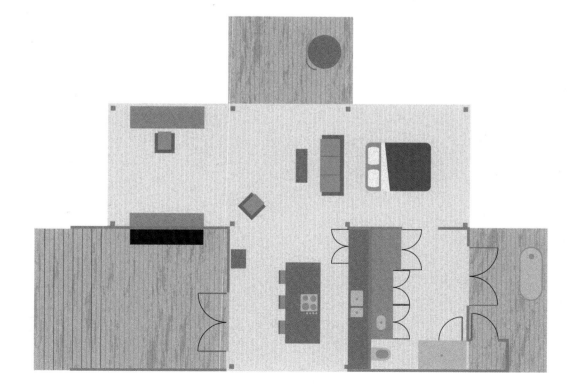

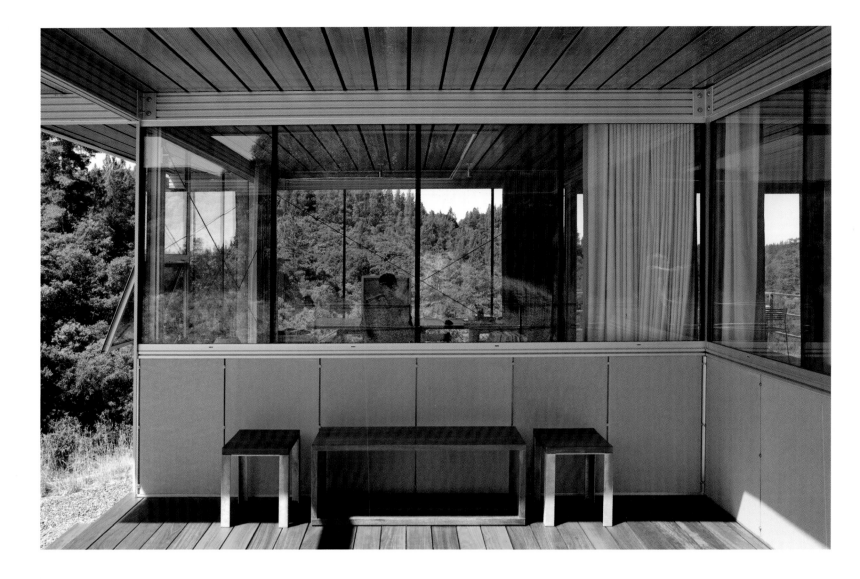

The house uses an off-grid solar-panel system that
provides all energy, including lighting, which is
integrated into the steel ceiling panels and custom-
designed cabinets.

Eine netzunabhängige Solaranlage versorgt das Haus
mit Energie unter anderem für die Beleuchtung,
die in die Deckenplatten aus Stahl und die nach Kunden-
wunsch angefertigten Regale integriert wurde.

La maison dispose d'un système à panneaux solaires
hors réseau qui fournit toute l'énergie nécessaire,
y compris l'éclairage – intégré aux panneaux d'acier
du plafond et aux placards sur mesure.

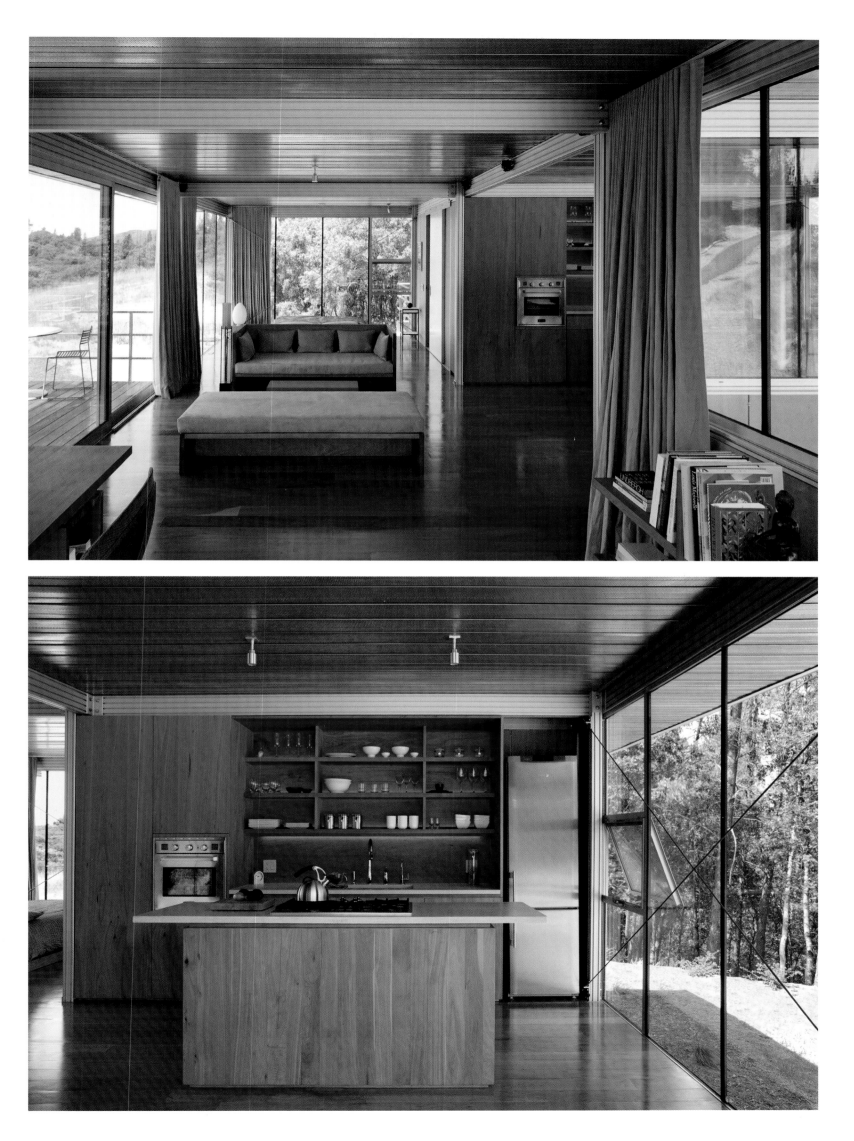

**JIM POTEET**
San Antonio, Texas [USA]
2009–10

# CONTAINER GUESTHOUSE

Area: 30 m² | Client: Stacey Hill | Collaboration:
Brett Freeman, Isadora Sintes, Shane Valentine

The architect has made considerable efforts to investigate the "repurposing of existing structures for new uses." Comparing the Container GuestHouse to an "art project," Jim Poteet sought to "create the maximum effect with the minimum of architectural gesture." The client was interested in experimenting with shipping containers because she lives in a warehouse located in a former industrial site. The guesthouse has a shower and composting toilet, and a large glazed sliding door and end window. A garden on the roof is elevated to allow free airflow. The insulated interior is lined with bamboo plywood, while the rear of the container has mesh panels that are covered with evergreen vines for shading. Recycled telephone poles were used for the foundation, and exterior light fixtures were made with blades from a tractor disk plow.

Der Architekt hat sich eingehend mit der „Umnutzung bestehender Konstruktionen" auseinandergesetzt und vergleicht sein Container GuestHouse mit einem „Kunstprojekt". Jim Poteet war daran gelegen, „einen größtmöglichen Effekt durch eine minimale architektonische Geste" zu erzielen. Die Kundin wollte gern mit Schiffscontainern experimentieren, da sie ein Lagergebäude auf einem ehemaligen Industriegelände bewohnt. Das Gästehaus ist mit einer Dusche, einer Komposttoilette, einer großen Glasschiebetür und einem Fenster an der Endseite des Containers ausgestattet. Der Dachgarten wurde etwas angehoben, damit die Luft zirkulieren kann. Die isolierten Innenräume sind mit Bambussperrholz verschalt, an der Containerrückseite befinden sich Maschengitter, die mit schattenspendendem, immergrünem Wein bedeckt sind. Für das Fundament wurden Telefonmasten wiederverwendet. Die Außenleuchten sind aus den Scheiben eines Häufelpflugs gefertigt.

L'architecte s'est ici efforcé d'explorer « la nouvelle conception de structures existantes pour de nouveaux usages ». Comparant sa maison d'hôtes à un « projet artistique », Jim Poteet a cherché à « produire l'effet maximal avec une intervention architecturale minimale ». La cliente était intéressée par une expérimentation avec des conteneurs maritimes car elle habite un hangar dans un ancien site industriel. La chambre d'hôtes possède une douche et des toilettes à compost, ainsi qu'une large porte vitrée coulissante et une fenêtre à son extrémité. Un jardin sur le toit est surélevé pour permettre à l'air de circuler librement. L'intérieur isolé est revêtu de contreplaqué de bambou, tandis que l'arrière du conteneur est garni de panneaux de treillis couverts de vigne à feuilles persistantes qui l'ombragent. Des poteaux de téléphone recyclés ont été utilisés pour les fondations et les luminaires extérieurs sont faits avec les lames d'une charrue à disques de tracteur.

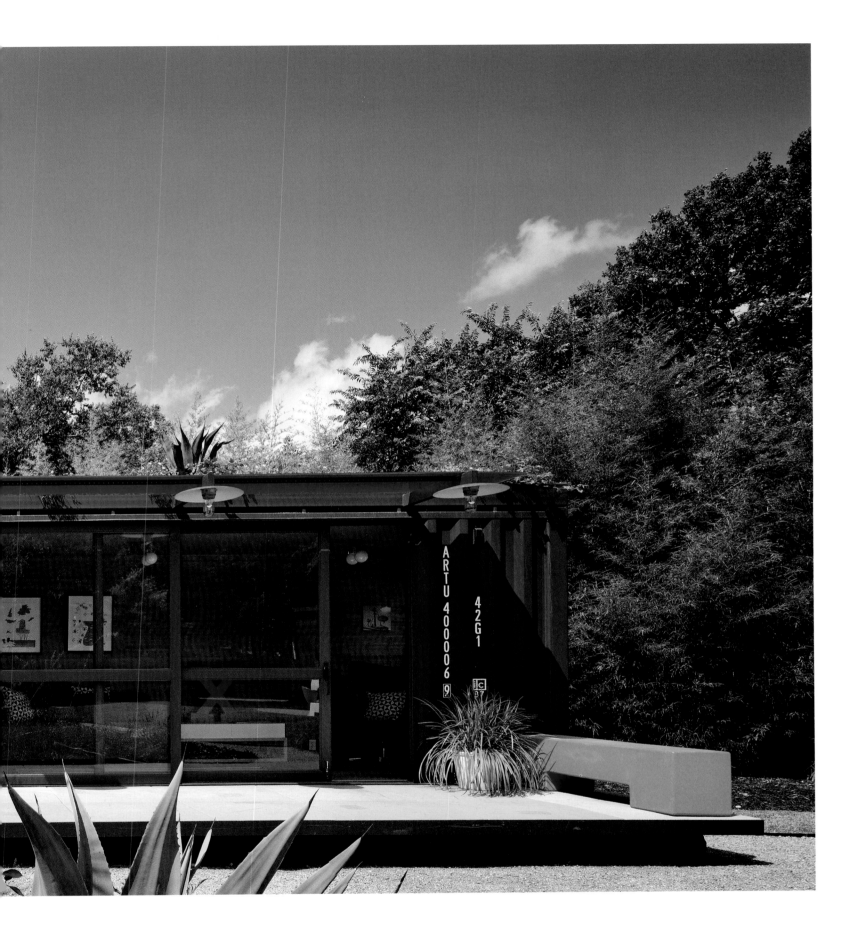

Though made with a shipping container, the dark blue house, with a garden on the roof, has all the attributes of a modern cabin: it's easy to transport, requires very little construction work, and is ready to go.

Das dunkelblaue Haus mit Dachgarten besteht aus einem Frachtcontainer, verfügt aber über alle Eigenschaften einer modernen Hütte. Es ist leicht zu transportieren, kann mit wenig Aufwand aufgebaut werden und ist schnell zur Nutzung bereit.

Bien que constituée d'un conteneur maritime, la maison peinte en bleu foncé avec un jardin sur le toit présente toutes les caractéristiques d'une cabane moderne, facile à transporter, ne nécessitant que très peu de travaux de construction et prête à l'emploi.

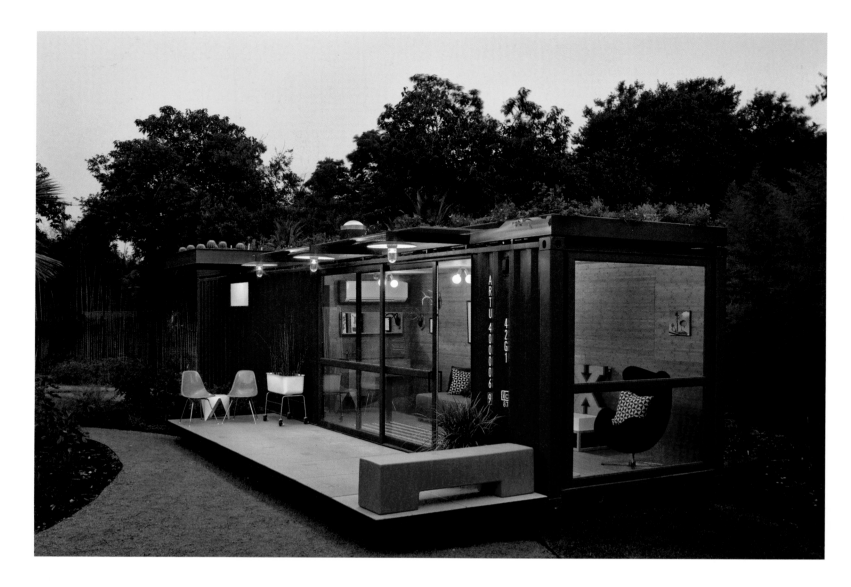

The interior is insulated with spray foam and lined with bamboo plywood on both the floor and walls. The deck consists of HVAC equipment pads made of recycled soda bottles set in a steel frame.

Böden und Wände des sprühschaumisolierten Innenbereichs wurden mit Bambussperrholz ausgekleidet. Die Terrasse auf dieser Seite ist mit HVAC-Equipment-Pads aus recycelten Getränkeflaschen gefertigt, die in einem Stahlrahmen sitzen.

L'intérieur a été isolé avec de la mousse expansée puis revêtu de contreplaqué de bambou sur les murs et le sol. La terrasse sur cette page est faite de panneaux d'équipement CVC à base de bouteilles de soda dans un cadre en acier.

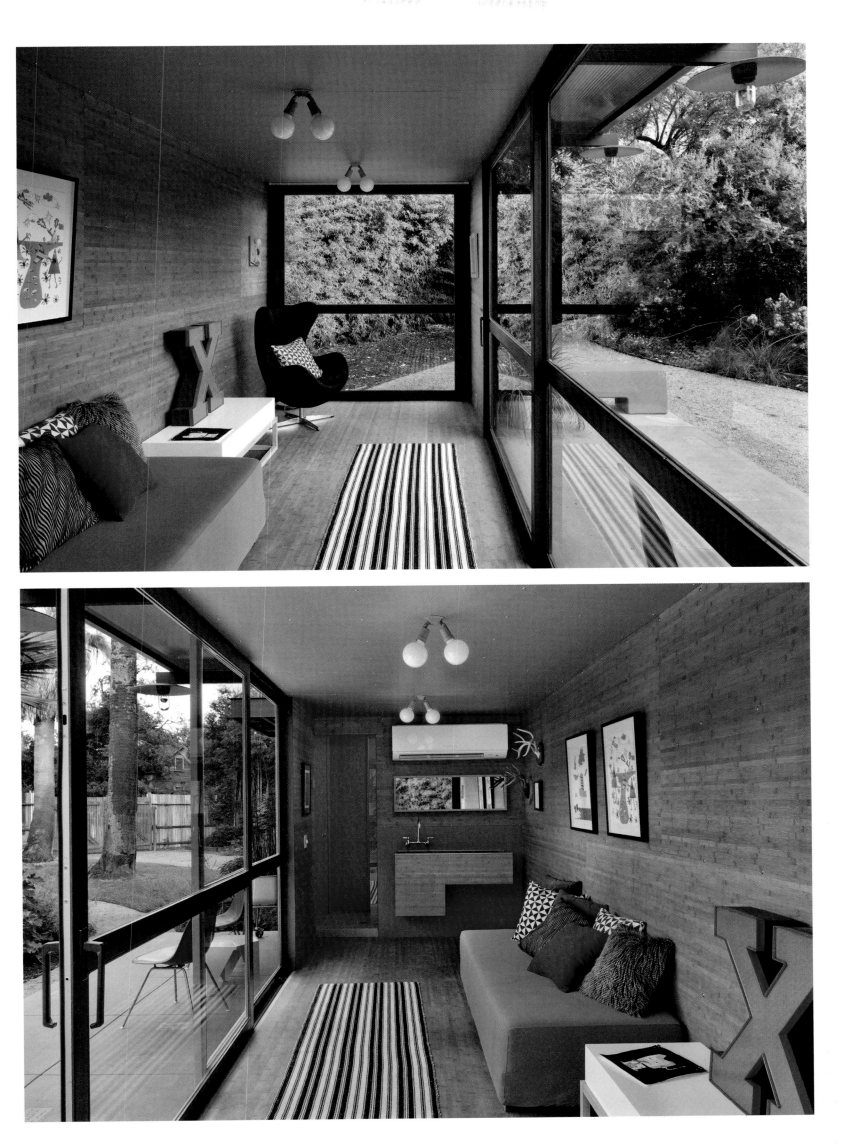

# DIANE MIDDLEBROOK STUDIOS

Area: 26 m² (each) | Client: Djerassi Resident Artists Program
Cost: $550 000 | Collaboration: Timothy Quayle

The Djerassi Resident Artists Program was founded in 1979 by Stanford University Professor Carl Djerassi. His wife, Diane Middlebrook, a Professor of English at Stanford, passed away in 2007. CCS Architecture completed four writers' cabins, collectively called the Diane Middlebrook Memorial Writers' Residence, at the Djerassi Resident Artists Program in Woodside, California. The sleep/work cabins were designed with a freestanding, pre-engineered steel roof that carries solar panels. The location of the cabins is intended to maximize views of the Santa Cruz Mountains overlooking the Pacific. Clad in unfinished red cedar boards, the cabins include large, sliding glass doors and private outdoor spaces. The northeast-facing sides contain clerestory windows angled toward the surrounding ridgelines and trees. Rectangular holes in the steel canopy create patterns of light and shade while aligning with skylights in the cabins, giving each unit a window to the sky.

---

Das Djerassi Resident Artist Program wurde 1979 durch den Stanford-Professor Carl Djerassi ins Leben gerufen. Dessen Ehefrau Diane Middlebrook, Professorin für Englisch in Stanford, starb im Jahr 2007. CCS Architecture hat vier Häuser für Schriftsteller ausgeführt, die als Teil des Djerassi Resident Artists Program im kalifornischen Woodside den Namen Diane Middlebrook Memorial Writers' Residence tragen. Die Schlaf- und Arbeitsunterkünfte wurden mit einer freistehenden Überdachung in Fertigbauweise samt Solarkollektoren konzipiert. Der Standort soll einen möglichst weiten Ausblick auf die Santa Cruz Mountains und den Pazifik ermöglichen. Die Hütten sind mit roten, unbehandelten Zedernholzbrettern verkleidet, verfügen über große Schiebetüren aus Glas und private Außenbereiche. Auf der Nordseite sind die Hütten mit hoch sitzenden Fenstern ausgestattet, die auf die umgebenden Bergkämme und Bäume ausgerichtet sind. Rechteckige Aussparungen in der Stahlüberdachung erzeugen ein Spiel aus Licht und Schatten; sie sind über den Oberlichtern der Hütten angebracht, sodass jede Wohneinheit ein Fenster zum Himmel hat.

---

Le programme Djerassi de résidence d'artistes a été créé en 1979 par le professeur de Stanford Carl Djerassi. Sa femme, Diane Middlebrook, professeur d'anglais à Stanford, est décédée en 2007. CCS Architecture a réalisé quatre logements pour écrivains, baptisés Diane Middlebrook Memorial Writers' Residence, à Woodside, en Californie, et destinés aux écrivains en résidence dans le cadre du programme. Ces « cabanes de sommeil/travail » ont été dotées d'une toiture préfabriquée indépendante en acier qui porte des panneaux solaires et sont disposées de manière à optimiser la vue sur les monts Santa Cruz qui dominent le Pacifique. Elles sont revêtues de panneaux de thuya géant brut avec de larges baies vitrées coulissantes et des espaces extérieurs privés. Leurs faces nord-est sont percées de fenêtres à claire-voie orientées vers les lignes de crête et les arbres environnants. Des ouvertures rectangulaires dans l'auvent d'acier créent des motifs d'ombre et de lumière et sont placées directement au-dessus des lucarnes dans le toit des cabanes de manière à ouvrir à chacune une fenêtre sur le ciel.

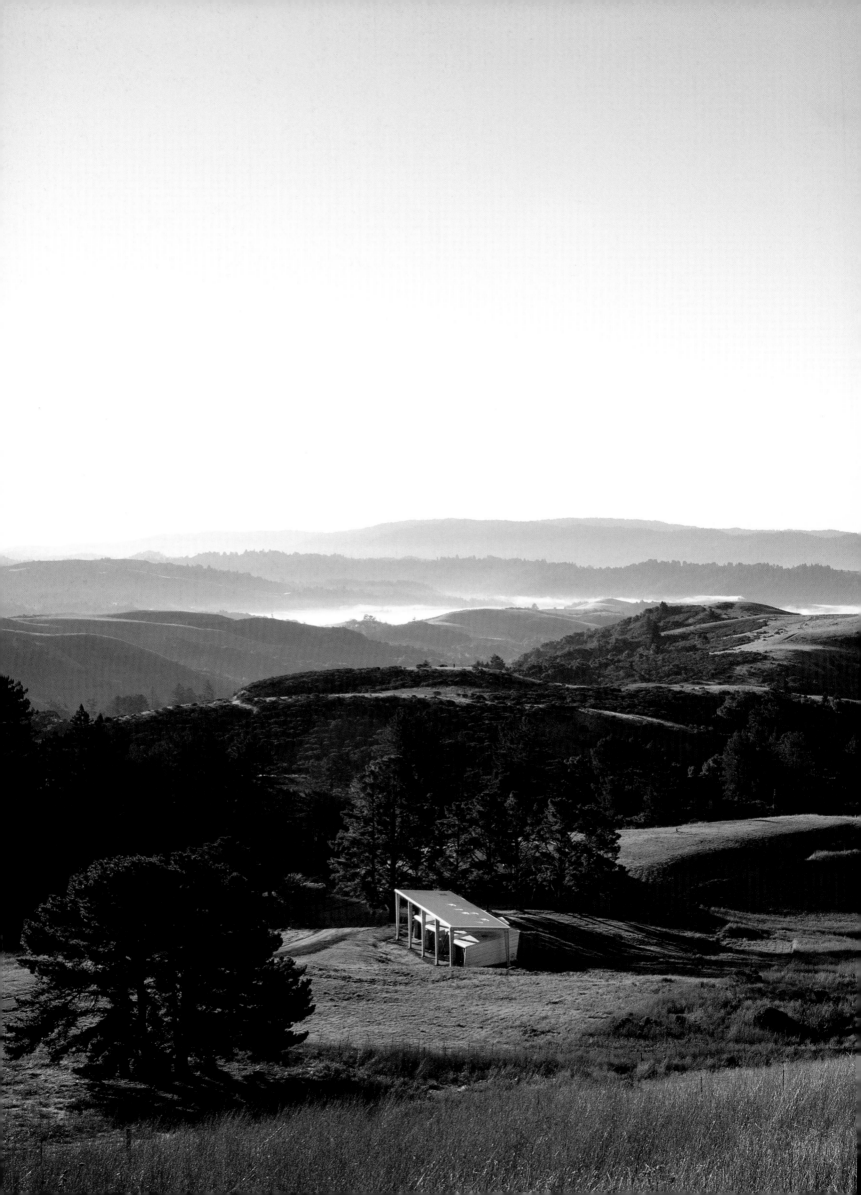

The building consists of four
separate one-room studios
grouped together under a
freestanding steel canopy that
supports a solar panel array.

Das Projekt besteht aus
einer Gruppe von vier einzel-
nen Ein-Zimmer-Studios unter
einem freistehenden Stahldach
mit Solarkollektoren.

Les quatre studios distincts
sont regroupés sous une toiture
indépendante en acier qui
porte des panneaux solaires.

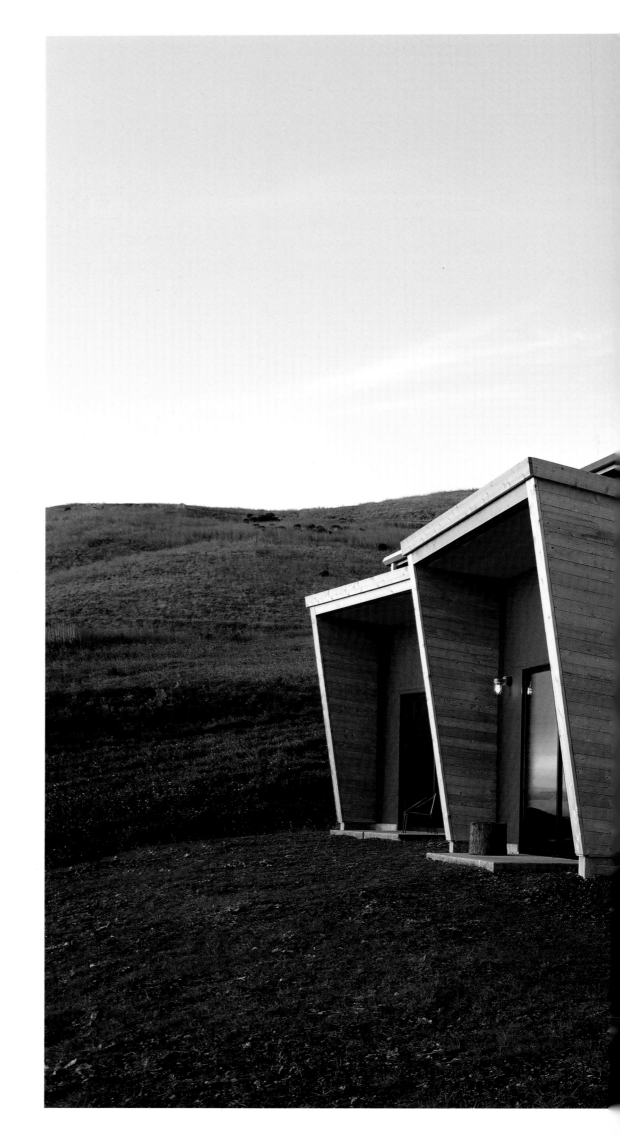

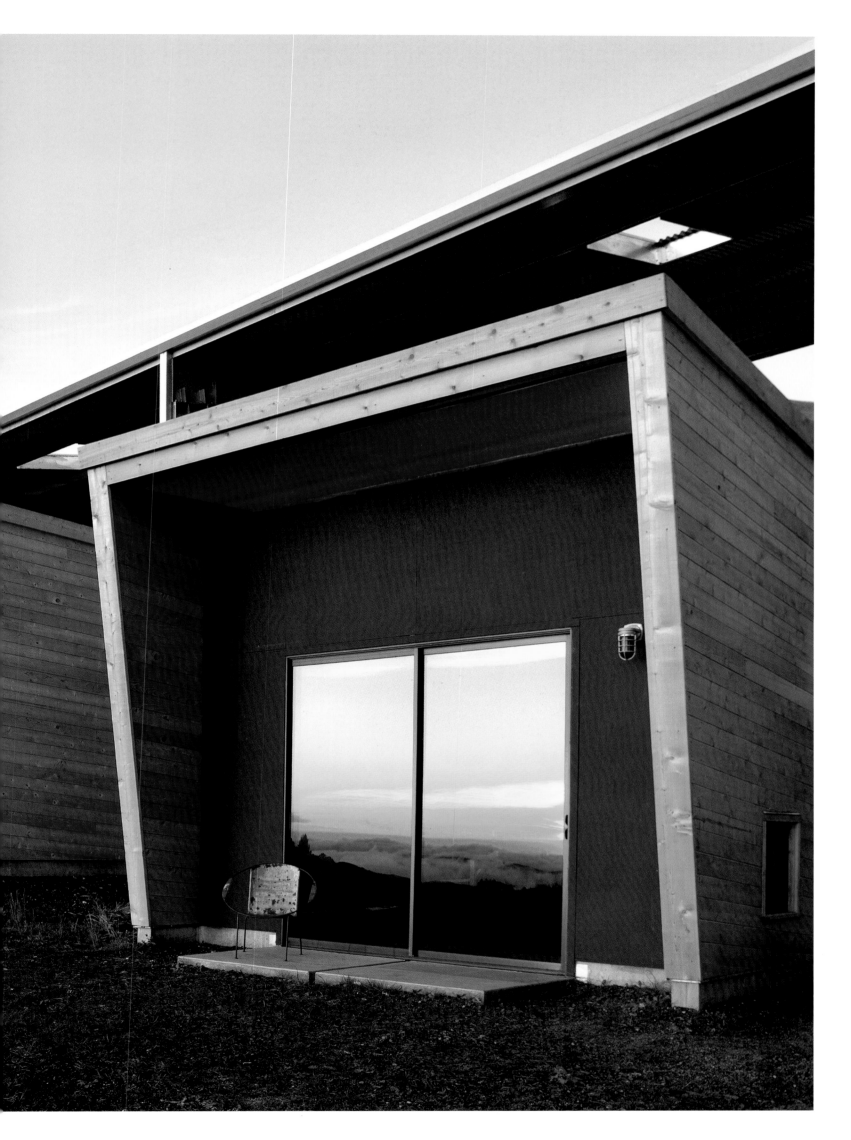

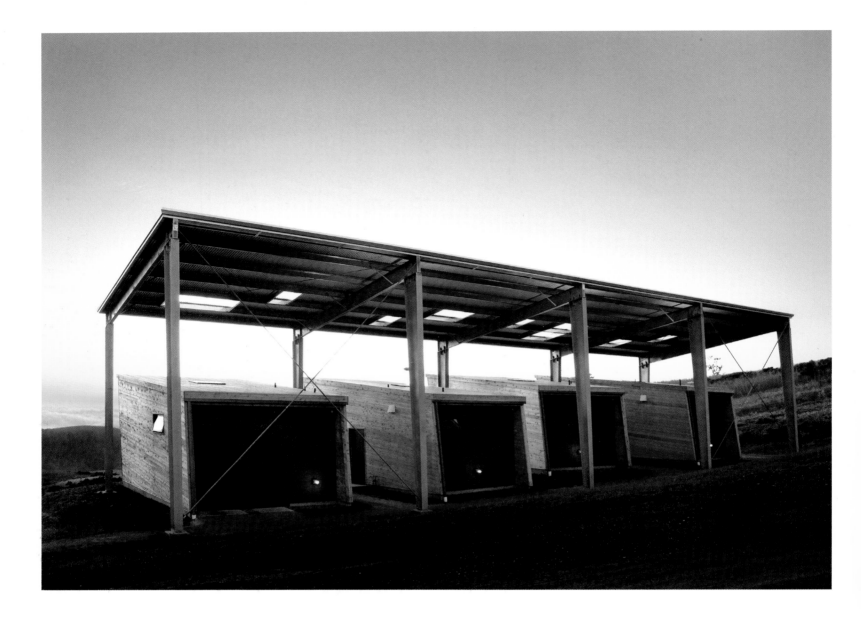

The cabins are placed slightly at an angle under the unifying canopy to provide a bit more privacy. Angled forward, they project beyond the canopy in the front.

Für mehr Privatsphäre sind die Hütten unter dem Einheit stiftenden Dach leicht versetzt angeordnet. Auf der Vorderseite ragen sie unter dem Dach hervor.

Les cabanes sont disposées légèrement de biais sous leur auvent commun pour plus d'intimité. Elles dépassent de l'auvent à l'avant.

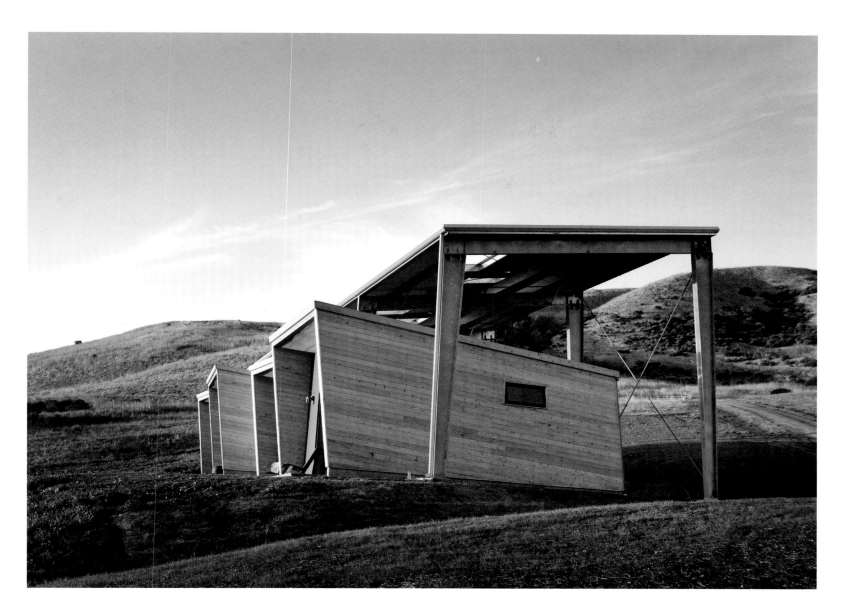

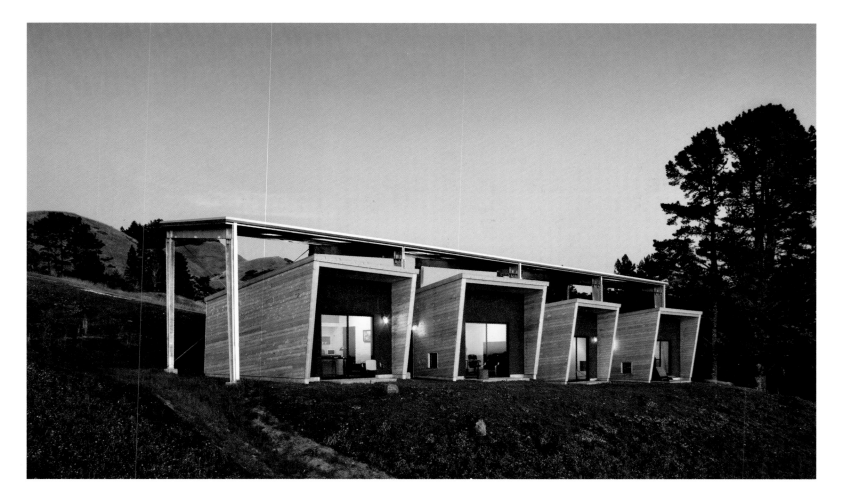

Living and sleeping space are juxtaposed in this image, where recessed openings in the walls provide space for hanging clothes, and for the kitchen area.

Der Wohn- und Schlafbereich liegen einander gegenüber; in die Wände sind Öffnungen für den Küchenbereich sowie für die Unterbringung von Kleidung eingelassen.

Cette photo montre les espaces de séjour et de repos contigus où des ouvertures en renfoncement ménagent des espaces pour une penderie et le coin cuisine.

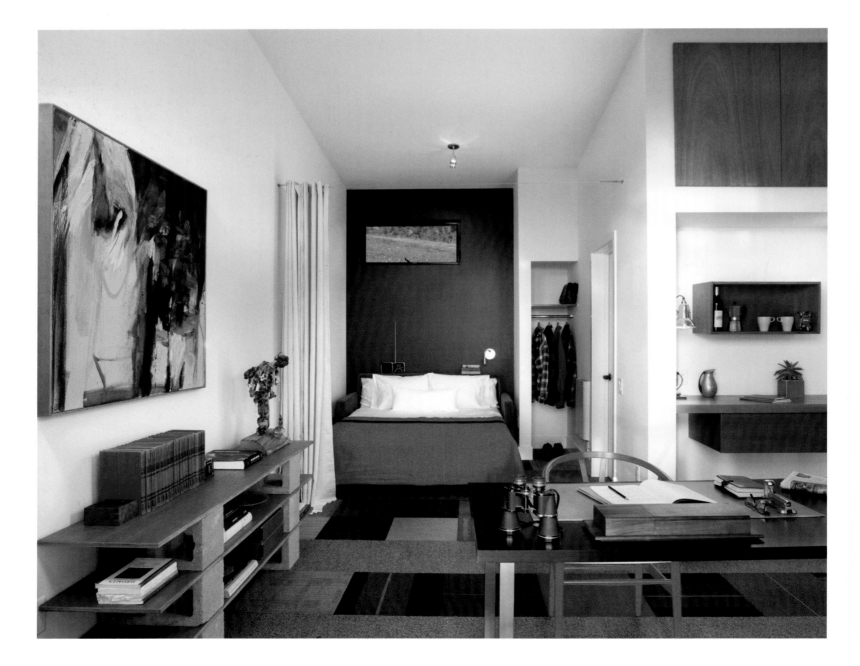

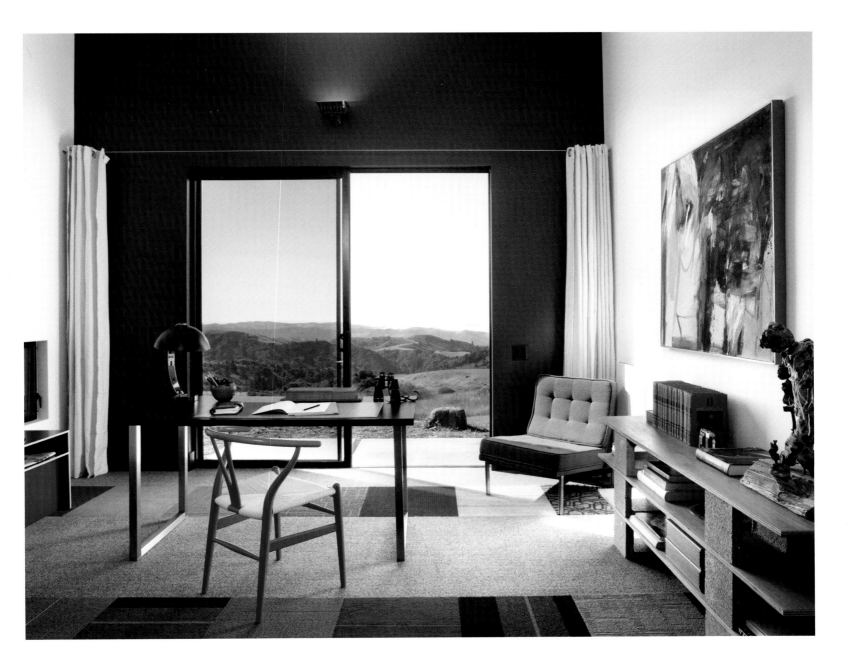

The interior décor is modern and efficient, with a large sliding glass door providing an uninterrupted view of the countryside and easy access to a small front terrace.

Die Inneneinrichtung ist modern und funktional. Eine große Glasschiebetür bietet freie Sicht auf die Landschaft und Zugang zu einer kleinen Terrasse.

L'aménagement intérieur est moderne et rationnel avec une large baie vitrée coulissante qui permet une vue parfaitement dégagée sur le paysage et un accès facile à la petite terrasse à l'avant.

# DIOGENE

Area: 7.5 m² | Client: Vitra | Cost: €20 000

According to Renzo Piano, this project is based on "the idea of realizing a minimum refuge which can be used for emergencies, working in a small scale, and being self-sufficient and sustainable. A small residential unit using only natural energy sources." Easily transported, the cabin is made with XLAM panels (three intersecting, glued layers of cedar). Vacuum panels and triple-glazed windows ensure insulation, while photovoltaic panels, a geothermal heat pump, a rainwater collection system, and low-energy lighting are also part of the ecological strategy of Diogene. Inside, a foldable sofa bed, a wooden table, and lightweight aluminum boxes for storage form a spartan but practical living environment. The project is named after the Greek philosopher Diogenes, who said: "I am a citizen of the world."

———

Renzo Piano zufolge basiert dieses Projekt auf der Idee, „eine minimalistische Unterkunft für Notfälle, sehr klein, energieautark und nachhaltig, zu realisieren; eine kleine Wohneinheit also, die ausschließlich natürliche Energiequellen nutzt". Diogene kann problemlos transportiert werden und ist aus XLAM-Platten gefertigt (bestehend aus drei kreuzweise zusammengeleimten Zedernholzschichten). Vakuumplatten und Fenster mit Dreifachverglasung sorgen für die Isolierung, zudem sind Fotovoltaikmodule, eine geothermische Wärmepumpe, eine Regenwassersammelanlage und energiearme Beleuchtung Teil des ökologischen Konzepts von Diogene. Im Inneren bilden ein zusammenklappbares Schlafsofa, ein Holztisch sowie leichte Aufbewahrungskisten aus Aluminium einen spartanischen, aber zweckmäßigen Wohnraum. Das Projekt ist nach dem griechischen Philosophen Diogenes benannt, der einst sagte: „Ich bin ein Weltbürger.

———

Selon Renzo Piano, le projet est basé sur « l'idée d'un refuge minimaliste pouvant être utilisé en cas d'urgence, à petite échelle, autosuffisant et durable. Une petite unité résidentielle qui a uniquement recours à des sources d'énergie naturelles ». La cabane construite en panneaux XLAM (trois couches de cèdre croisées et collées) peut facilement être transportée. Des panneaux sous vide et des fenêtres à triple vitrage garantissent l'isolation, tandis que des modules photovoltaïques, une pompe à chaleur géothermique, la récupération de l'eau de pluie et l'éclairage faible consommation contribuent à la stratégie écologique du projet. À l'intérieur, un canapé-lit repliable, une table en bois et des caisses de rangement légères en aluminium forment un environnement spartiate, mais pratique. Le projet doit son nom au philosophe grec Diogène qui se disait « citoyen du monde ».

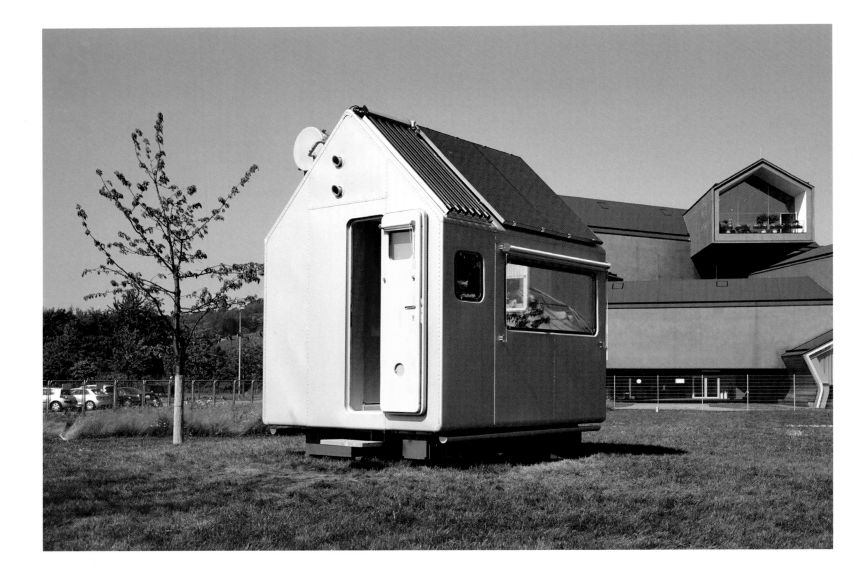

Placed on the grounds of the Vitra complex (Weil am Rhein, Germany), Diogene stands close to the VitraHaus building designed by Herzog & de Meuron (above).

Diogene steht auf dem Gelände der Firma Vitra (Weil am Rhein, Deutschland) unweit des von Herzog & de Meuron entworfenen VitraHauses (oben).

Installé sur le terrain du complexe Vitra (Weil-am-Rhein, Allemagne), Diogene se dresse à côté de la VitraHaus conçue par Herzog & de Meuron (ci-dessus).

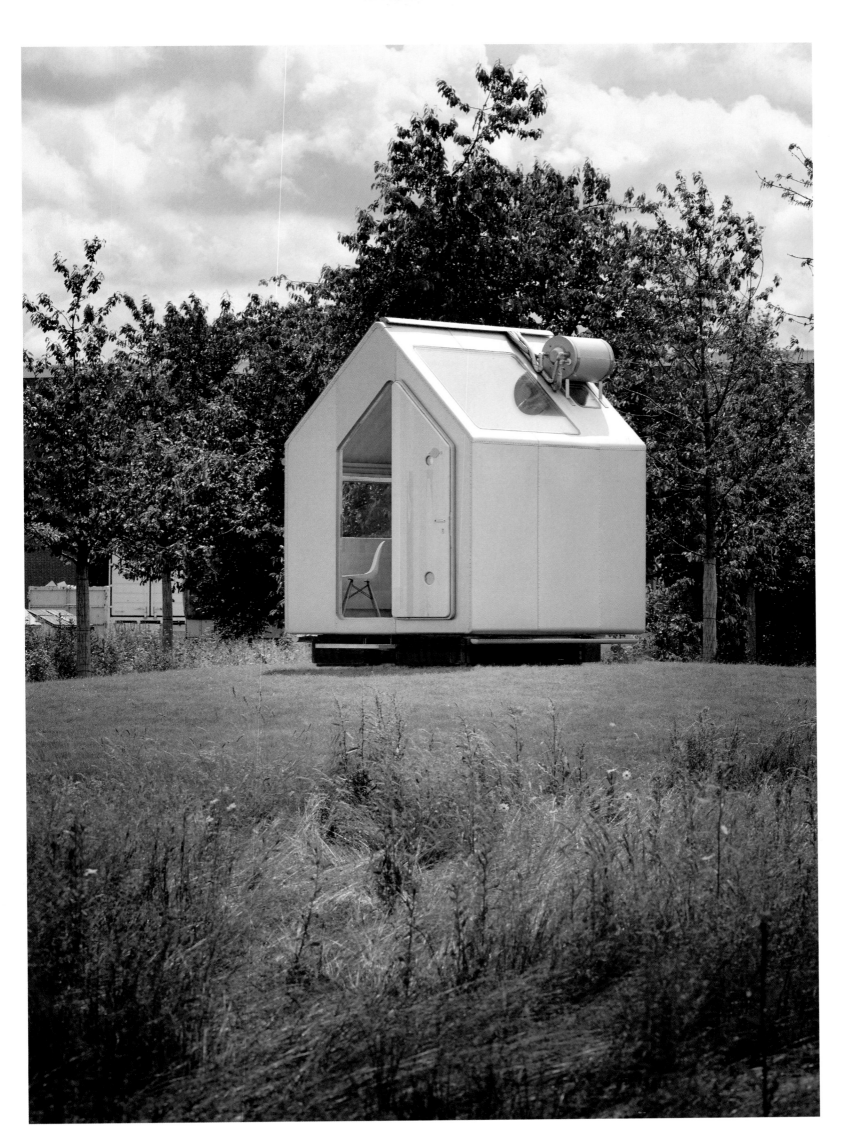

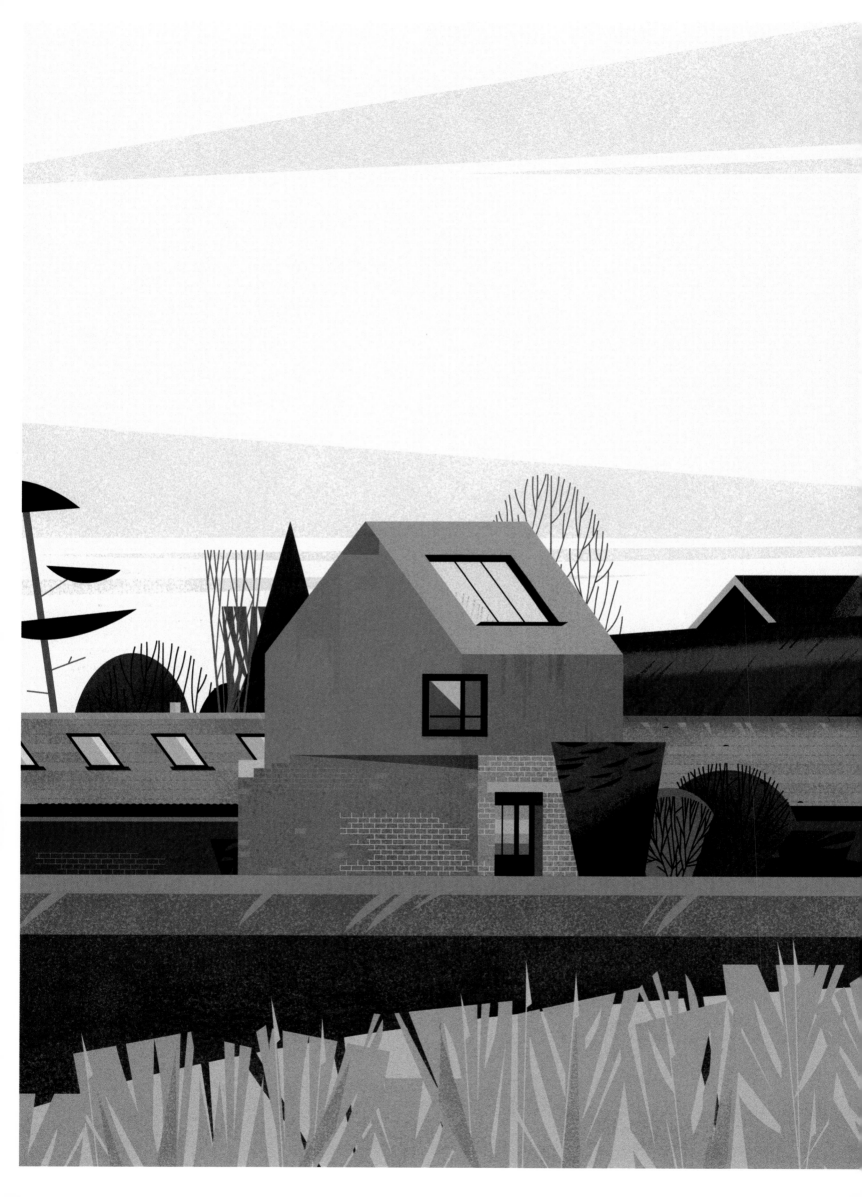

# DOVECOTE STUDIO

Area: 29 m² | Client: Aldeburgh Music | Cost: £155 000

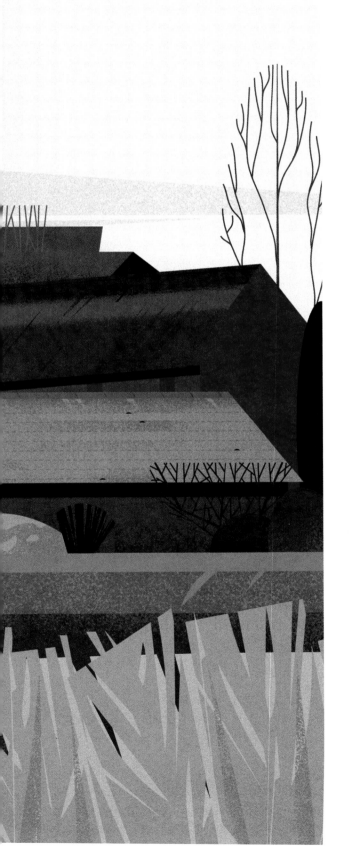

Converted from the ruins of a 19th-century dovecote (home for domesticated pigeons), this studio is intended for a single artist and forms part of the music campus at Snape Maltings, founded by Benjamin Britten in a group of former industrial buildings on the Suffolk coast of England. The studio is made with a welded Cor-ten steel monocoque shell, which was lined in spruce plywood. It was fabricated on site and then placed in its final location with a crane to avoid undue disturbance to the vegetation. The architects state: "A large north-facing roof window, ground-floor double doors, and a small mezzanine workspace enable the studio to be used for writing, music, visual arts, or performance. A corner window from the mezzanine gives long views over the reed beds to the North Sea."

———

Dieses in den Ruinen eines Taubenhauses aus dem 19. Jahrhundert errichtete Studio ist für einen einzelnen Künstler konzipiert und gehört zu dem von Benjamin Britten gegründeten Musikcampus Snape Maltings, der in einer Reihe von Industriebauten an der Küste von Suffolk untergebracht ist. Das Studio besteht aus einer geschweißten, einschaligen Hülle aus Cor-Ten-Stahl und ist mit Fichtensperrholz ausgekleidet. Es wurde vor Ort gefertigt und mithilfe eines Krans platziert, um die Vegetation nicht in Mitleidenschaft zu ziehen. Die Architekten: „Wegen eines großes Dachfensters auf der Nordseite, Doppeltüren im Erdgeschoss und einen kleinen Mezzanin-Arbeitsplatz eignet sich das Studio sowohl für Autoren als auch bildende Künstler und Performancekünstler. Ein Eckfenster im Mezzaningeschoss gewährt einen weiten Ausblick über das Röhricht hin zur Nordsee.

———

Issu de la reconversion des ruines d'un colombier du XIXᵉ siècle, le studio est destiné à accueillir un artiste célibataire, il fait partie du campus de musique de Snape Maltings fondé par Benjamin Britten dans un ensemble d'anciens bâtiments industriels sur la côte anglaise du Suffolk. Il est fait d'une monocoque en acier Corten soudé doublée de contreplaqué d'épicéa. Fabriqué sur le site même, il a été mis en place à l'aide d'une grue afin de ne pas détruire indûment la nature. Les architectes expliquent: « Une large fenêtre dans le toit face au nord, les doubles portes du rez-de-chaussée et un petit espace de travail sur une mezzanine permettent au studio d'être utilisé pour l'écriture, la musique, les arts plastiques ou les performances. Une fenêtre dans l'angle de la mezzanine offre des vues très larges des roselières vers la mer du Nord. »

The new structure has been inserted into the remains of the brick walls of a 19th-century dovecote. Its Cor-ten steel outline seems to blend easily with the ruins.

Der Neubau wurde in die Überreste der Backsteinmauern eines Taubenhauses aus dem 19. Jahrhundert gesetzt. Die Hülle aus Cor-Ten-Stahl fügt sich offenbar gut in die Ruine ein.

La nouvelle construction a été insérée dans les murs de briques en ruines d'un colombier du XIXᵉ siècle avec lesquels sa silhouette en acier Corten se fond aisément.

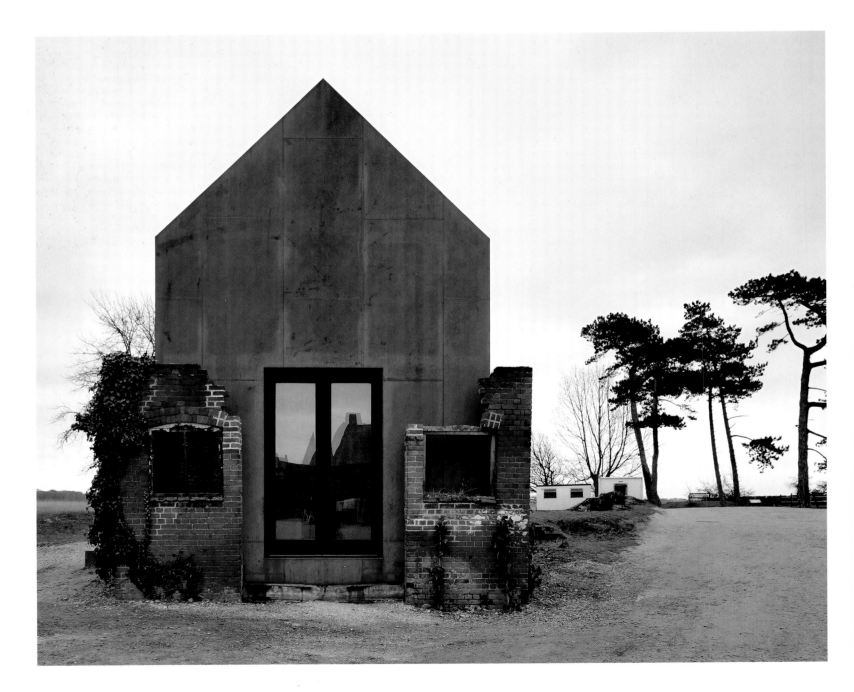

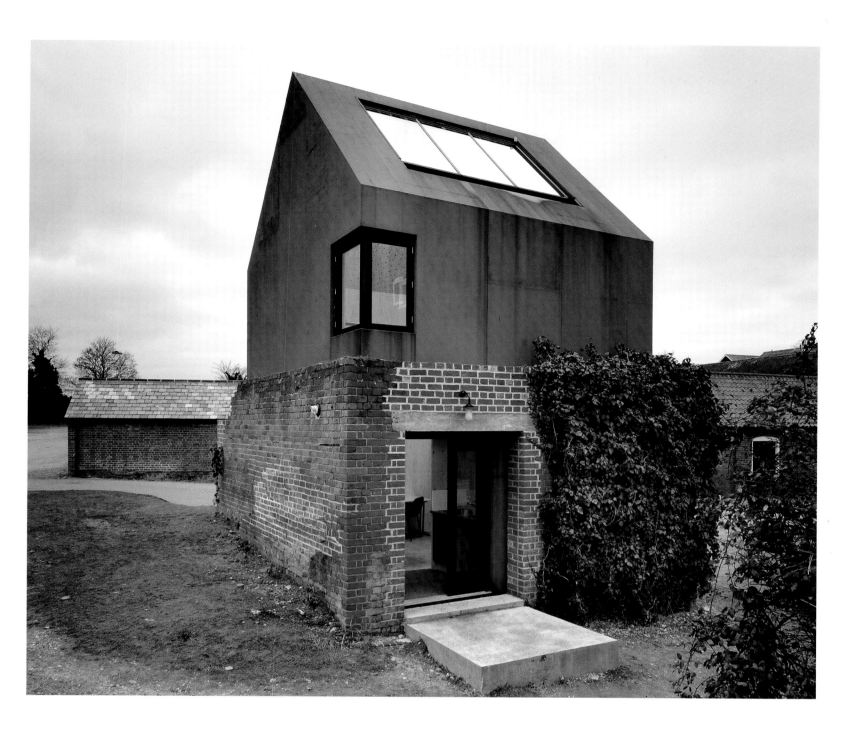

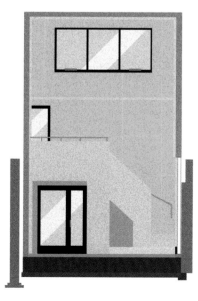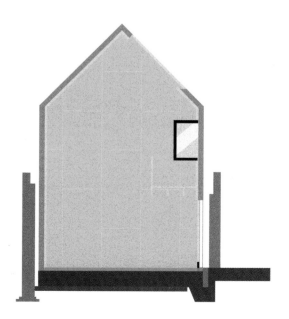

The double-slope roof has a generous skylight on one side that compensates for the relatively closed steel façades.

Auf einer Seite des Spitzdachs befindet sich ein großes Dachfenster und gleicht die relative Geschlossenheit der Stahlfassade aus.

Le toit à double pente est percé d'une généreuse lucarne sur un côté qui compense le caractère sinon assez clos des façades en acier.

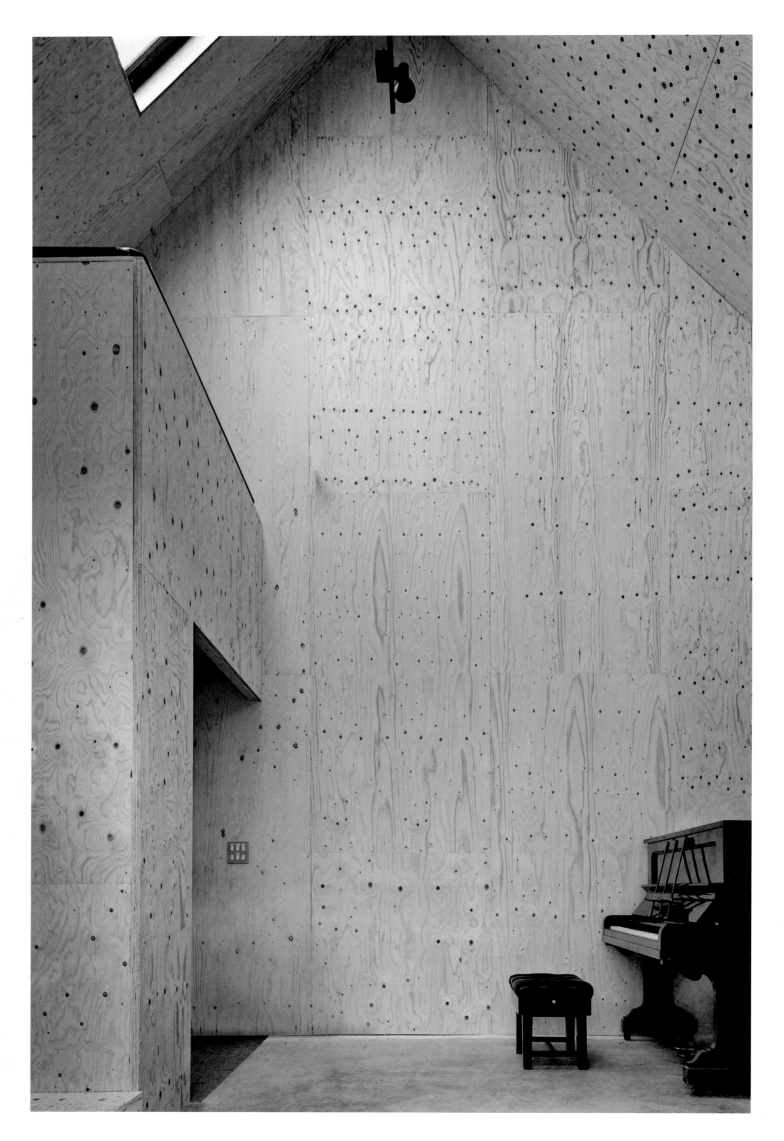

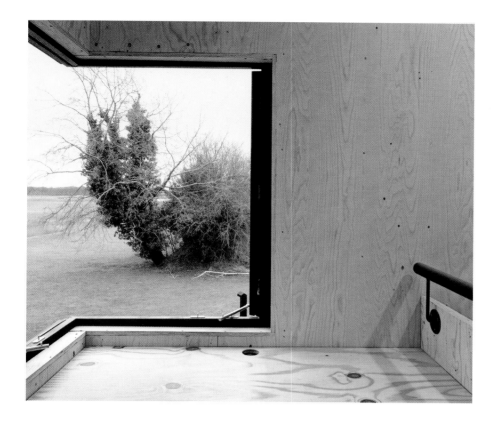

A corner window gives an unexpectedly generous view of the surroundings. The interior forms of the building are very much in harmony with the exterior, though lighter colors predominate.

Das Eckfenster bietet eine überraschend großzügige Aussicht auf die Umgebung. Die Formen im Innern des Gebäudes stimmen mit dem Äußeren überein, wobei hellere Farben dominieren.

Une fenêtre d'angle ouvre une vue étonnamment large des alentours. Les formes intérieures du bâtiment sont très largement harmonisées avec l'extérieur, mais les couleurs dominantes sont plus claires.

Left page, full spruce plywood surfaces on the interior correspond to the relatively closed and blank exterior Cort-ten walls. The roof opening nonetheless floods the space with natural light.

Die Oberflächen aus Fichtensperrholz im Innenbereich (linke Seite) korrespondieren mit der eher geschlossenen und rohen Außenwand aus Cor-Ten-Stahl. Dafür taucht die Dachöffnung den Raum in natürliches Licht.

Page de gauche, les surfaces intérieures entièrement couvertes de contreplaqué d'épicéa font pendant aux murs extérieurs en acier Corten relativement fermés et nus. L'ouverture dans le toit suffit à inonder l'espace de lumière naturelle.

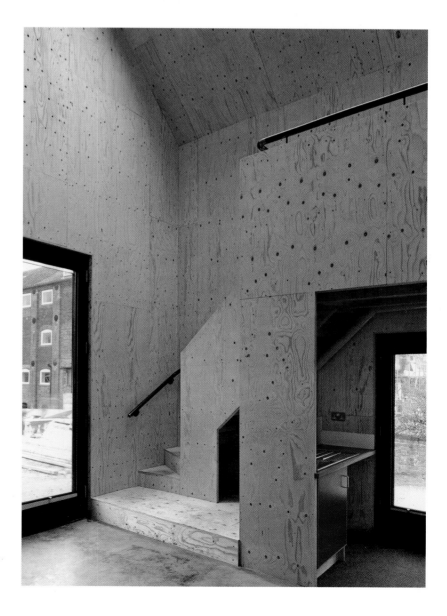

# DRAGONFLY

Area: 30 m² | Client: Harads Treehotel

This new structure joins others designed by talented architects at the Treehotel in Harads, northern Sweden. The largest of the six existing tree houses on the site, the structure is suspended above the ground on eight pine and spruce trees. Conceived as a suite with three bedrooms to sleep up to six guests, the structure can also be used as a conference room for up to 12 people. The Dragonfly is clad in weathered steel and lined with plywood.

———

Dieses neue Projekt befindet sich neben einer Reihe weiterer Bauten begabter Architekten im Treehotel in Harads, Nordschweden. Es handelt bei dem an acht Kiefern und Fichten aufgehängten Bau um das größte der sechs Baumhäuser vor Ort. Es wurde als Suite mit drei Schlafzimmern konzipiert und kann bis zu sechs Gäste beherbergen. Dragonfly ist zudem als Konferenzraum für bis zu zwölf Gäste einsetzbar. Das Projekt ist mit verwittertem Stahl und im Innenbereich mit Sperrholz verschalt.

———

Cette nouvelle construction en rejoint d'autres créées par des architectes de talent pour l'hôtel dans les arbres de Harads, dans le Nord de la Suède. C'est la plus grande des six cabanes dans les arbres déjà présentes sur le site. Elle est suspendue à huit pins et épicéas. Conçue comme une suite de trois chambres pouvant loger jusqu'à six personnes, elle peut aussi servir de salle de réunion et accueillir jusqu'à douze personnes. La «Libellule» (Dragonfly) est revêtue d'acier patinable et doublée de contreplaqué.

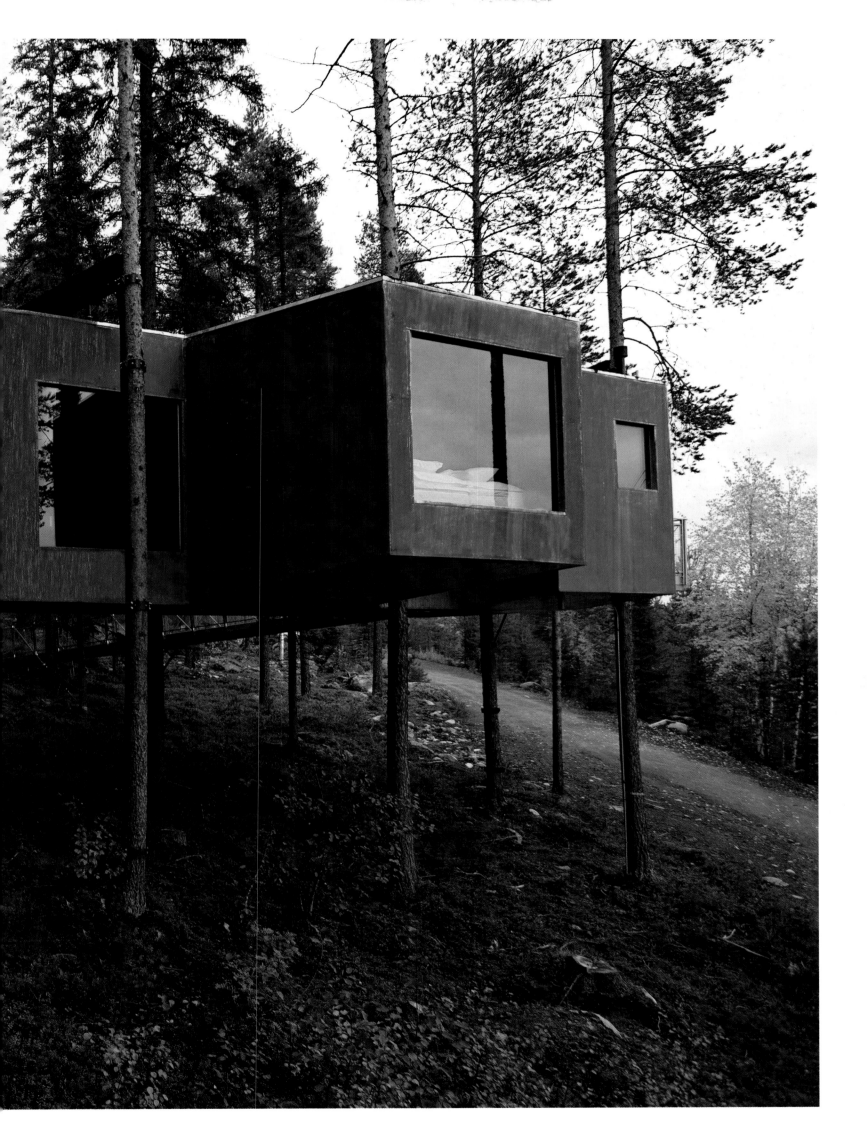

The Dragonfly has an area of 30 square meters and weighs 22 metric tons. Dark plywood interiors offer generous openings onto the natural setting.

Dragonfly ist 30 m² groß und wiegt 22 t. Die Innenräume aus dunklem Sperrholz verfügen über großzügige Öffnungen in die Natur.

Dragonfly a une surface de 30 m² et pèse 22 tonnes métriques. Les intérieurs en contreplaqué sombre offrent des vues généreuses sur le décor naturel.

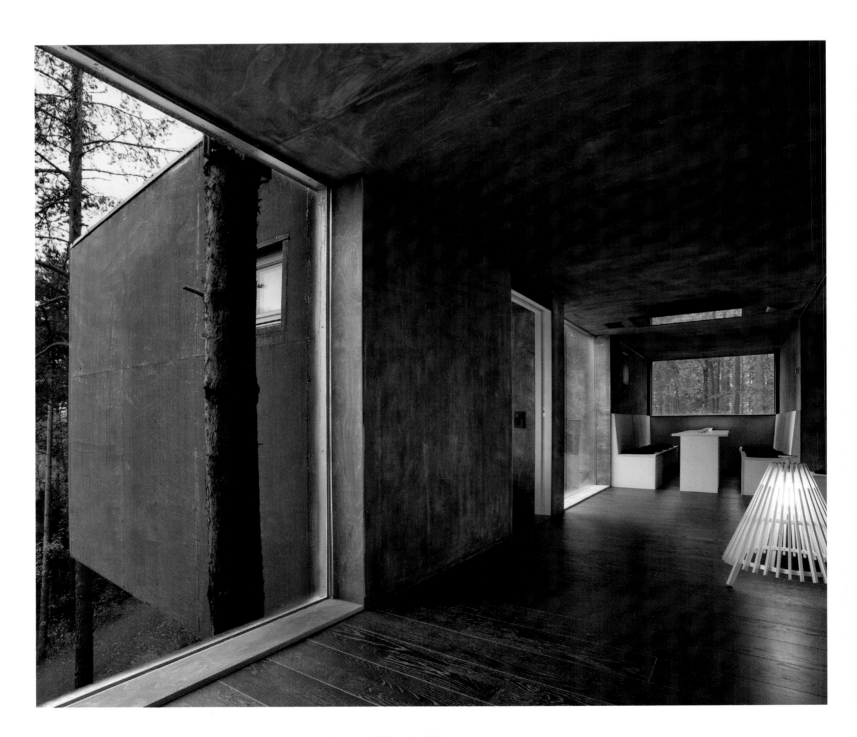

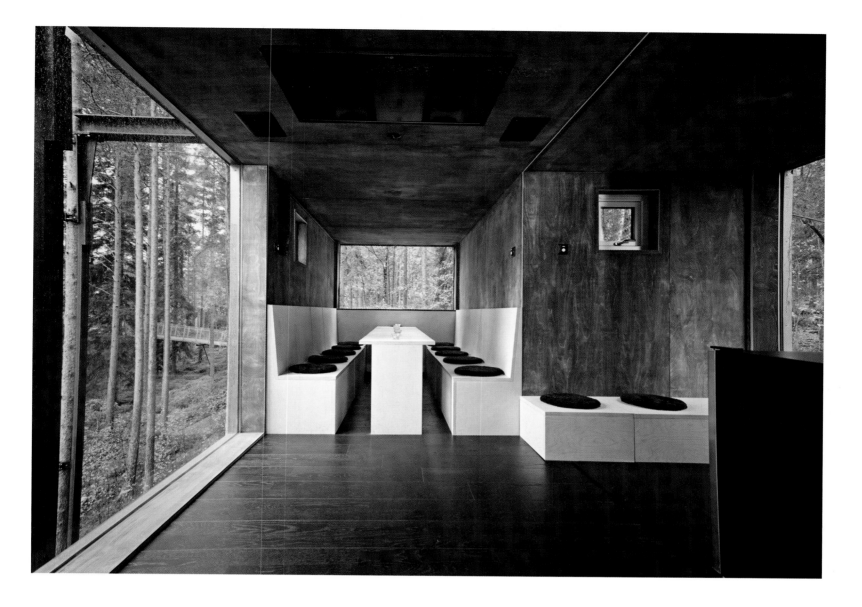

The size and unexpected configuration of the Dragonfly are visible in the plan to the left, but also in the photos on this double page, where the conference configuration is visible.

Die Größe und die überraschende Raumanordnung von Dragonfly sind auf dem Plan links und auf den Bildern dieser Doppelseite zu sehen, die die Anordnung für Konferenzen zeigen.

La taille et la surprenante configuration de Dragonfly sont mises en valeur sur le plan à gauche, mais aussi sur les photos de cette double page où l'espace est aménagé en « mode réunion ».

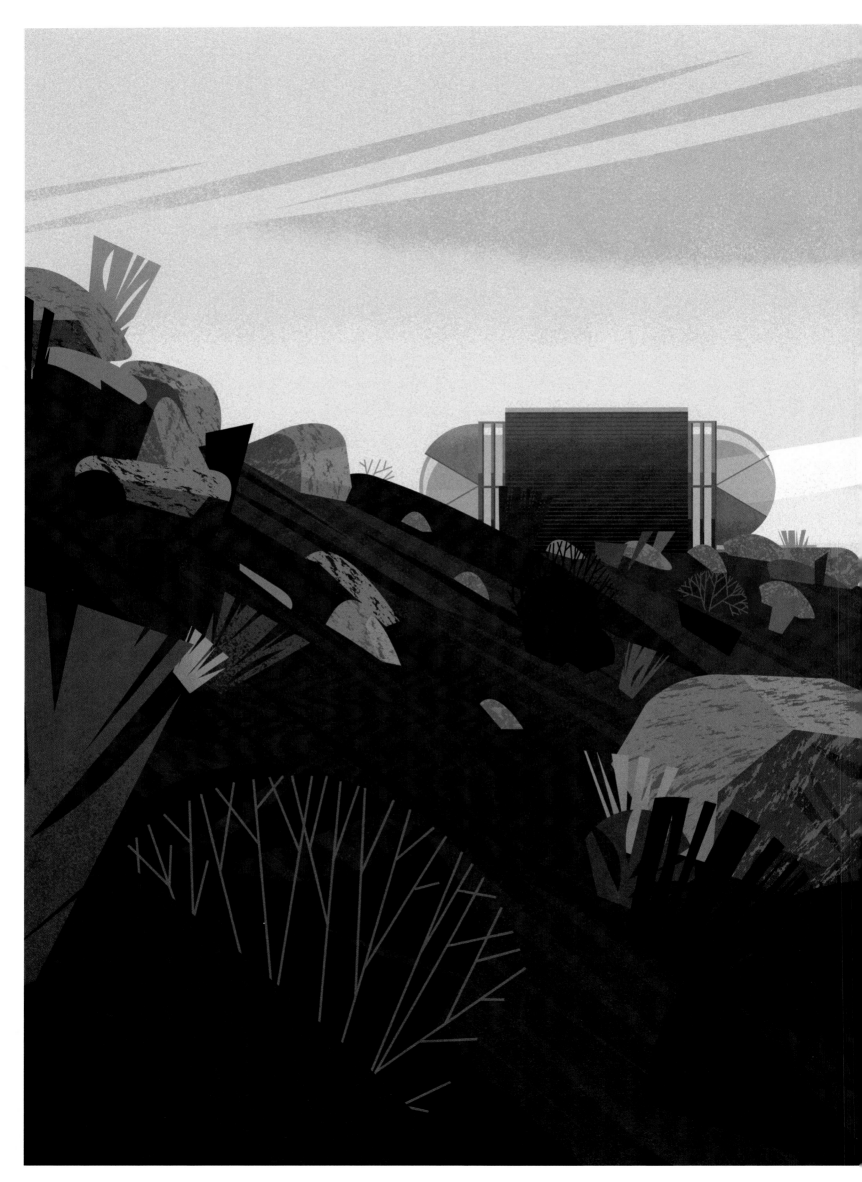

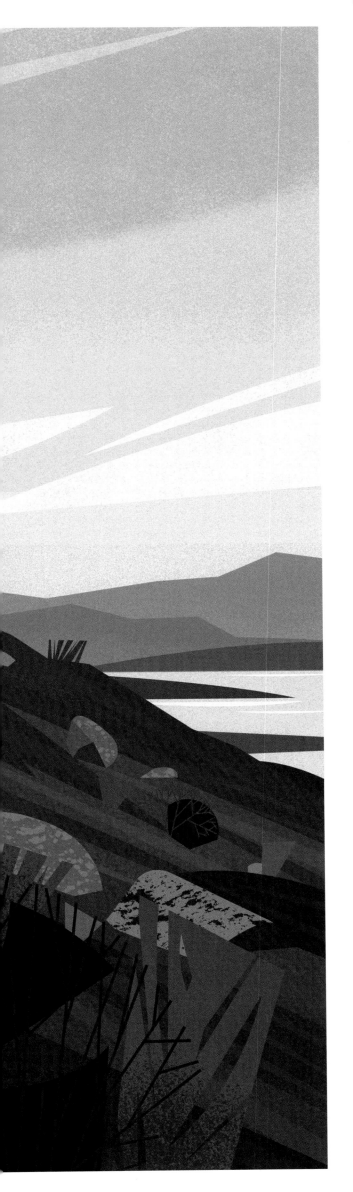

# DROP
# ECO-HOTEL

Area: 25 m² | Client: Urban Square (manufacturer)

Made with wood, steel, and glass, the DROP Eco-Hotel was designed as a removable modular hotel room. The designers explain: "The idea is that this unit can be placed in a beautiful spot, but then easily removed without any ecological damage as a result of its presence. Its design draws inspiration from organic shapes found in nature." The lightweight units are made with modular, prefabricated wooden and steel elements in a factory and can be transported to their final location by truck. They are put in place on adjustable steel legs. Large operable bubble windows at the ends of the cylindrical tube forms allow users to fully appreciate their setting. A skylight runs the entire length of the pod, which can accommodate two adults. Photovoltaic panels on the roof and a rainwater collection system for use in the bathroom reduce environmental impact.

———

Das aus Holz, Stahl und Glas gefertigte DROP Eco-Hotel wurde als transportables Hotelzimmer konzipiert. Die Designer: „Die Einheit kann an einem schönen Standort aufgestellt und ohne Umweltfolgen mühelos wieder entfernt werden. Der Entwurf bezieht seine Inspiration aus organischen, in der Natur vorgefundenen Formen." Die leichten Einheiten werden aus modularen Holz- und Stahlelementen in einer Fabrik gefertigt, können per Lkw an den jeweiligen Standort gebracht und dort auf justierbare Stahlstützen gestellt werden. Dank großer blasenförmiger Funktionsfenster an den Enden der zylindrischen Röhren können Nutzer die Umgebung genießen. Ein Oberlicht erstreckt sich auf ganzer Länge der Module, in denen zwei Erwachsene Platz finden. Fotovoltaikpaneele auf dem Dach und eine Regenwassersammelanlage für den sanitären Wasserverbrauch reduzieren die Umweltbelastung.

———

Fait de bois, d'acier et de verre, le DROP Eco-Hotel a été conçu comme une chambre d'hôtel modulable et mobile. Ses auteurs expliquent : « L'idée est de pouvoir placer l'unité sur un site, puis de pouvoir l'en retirer facilement sans que sa présence ne nuise en rien à l'environnement. Nous avons puisé notre inspiration dans les formes organiques qu'on trouve dans la nature. » Les unités légères sont construites en usine à l'aide d'éléments modulaires préfabriqués en bois et acier et peuvent être transportées par camion jusqu'à leur destination finale. Elles sont ensuite posées sur des pieds en acier réglables. De grandes fenêtres bulle peuvent être ouvertes aux extrémités du tube pour permettre aux occupants d'apprécier pleinement la vue sur l'environnement décor. Une lucarne court sur toute la longueur de la cabine qui peut loger deux adultes. Des panneaux photovoltaïques sur le toit et un système de récupération de l'eau de pluie pour la salle de bains permettent de diminuer encore l'impact sur l'environnement.

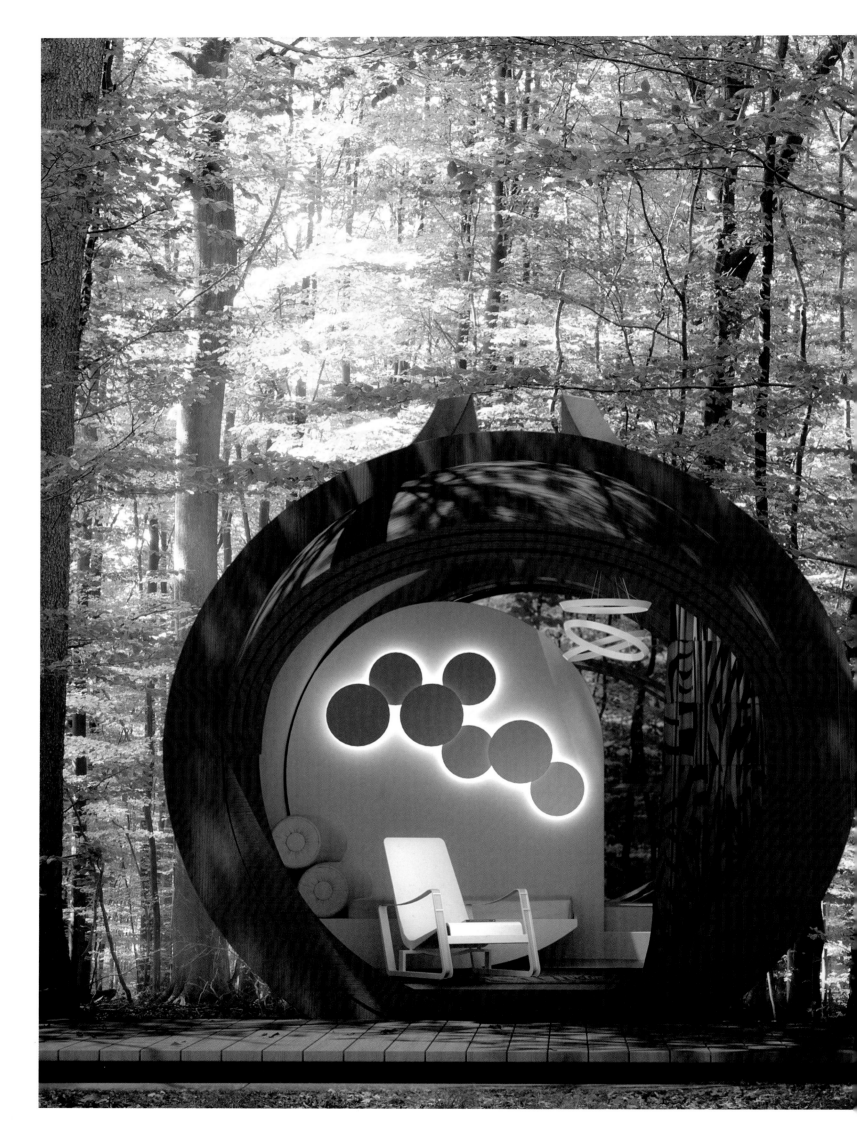

Made of modular, prefabricated wooden and steel elements, the structure sits on adjustable steel legs that can be adapted to an irregular site.

Die aus vorgefertigten Holz- und Stahlelementen bestehende Konstruktion ruht auf justierbaren Stahlstützen, die an unebene Bodenverhältnisse angepasst werden können.

Faite d'éléments modulaires préfabriqués en bois et acier, la structure est posée sur des pieds en acier qui peuvent être adaptés aux irrégularités du terrain.

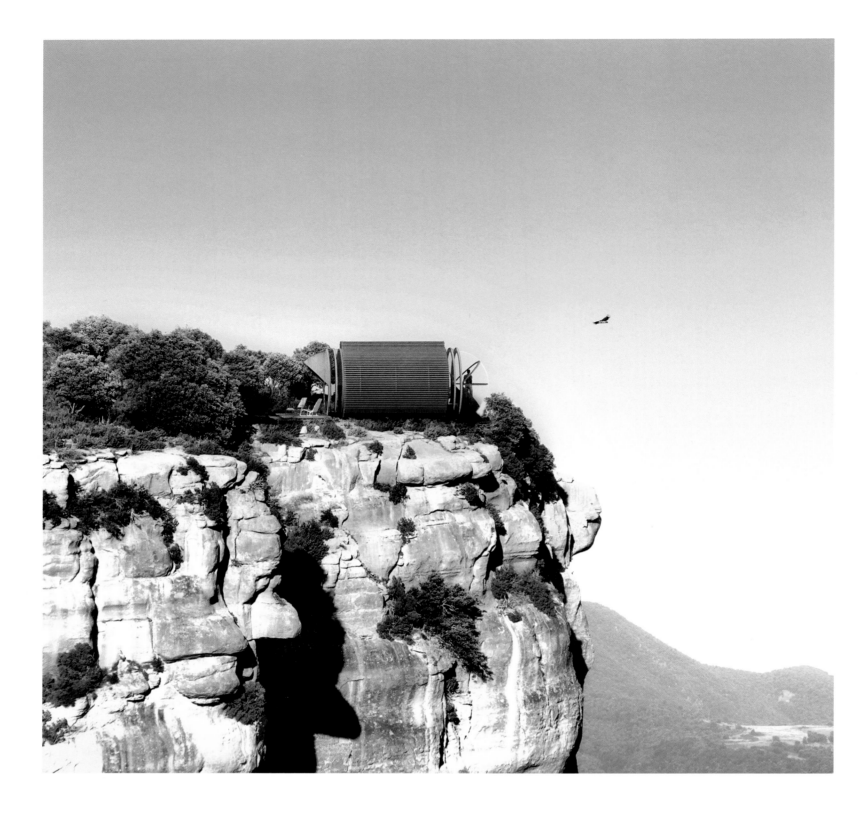

The DROP Eco-Hotel concept was the winner of a competition organized by Urban Square, O-cults, and the Ricardo Bofill Taller de Arquitectura.

Das Konzept für das DROP Eco-Hotel gewann einen von Urban Square, O-cults und Ricardo Bofill Taller de Arquitectura ausgerichteten Wettbewerb.

Le DROP Eco-Hotel a gagné un concours organisé par Urban Square, O-cults et Ricardo Bofill Taller de Arquitectura.

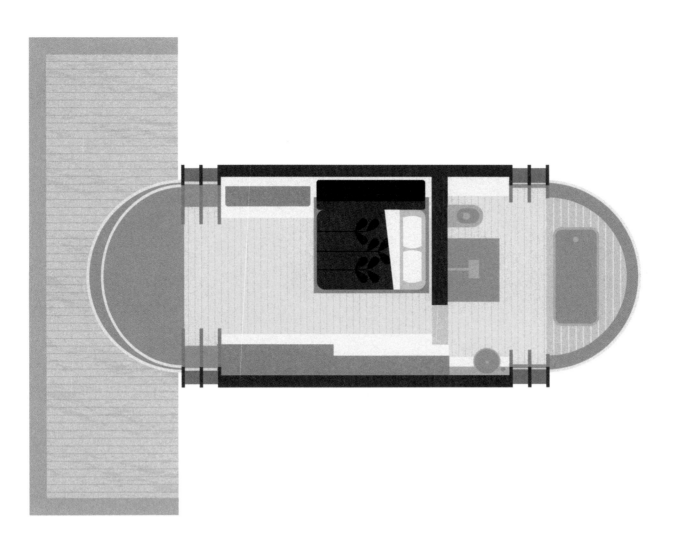

The small structure has operable spherical windows at either end that can be opened to allow direct contact with nature as well as natural ventilation.

Die halbkugelförmigen Funktionsfenster an beiden Enden der Konstruktion lassen sich öffnen – für direkten Kontakt mit der Natur und natürliche Belüftung.

La petite structure est dotée de fenêtres bulle aux deux extrémités qui peuvent être ouvertes pour un contact direct avec la nature et pour une ventilation naturelle.

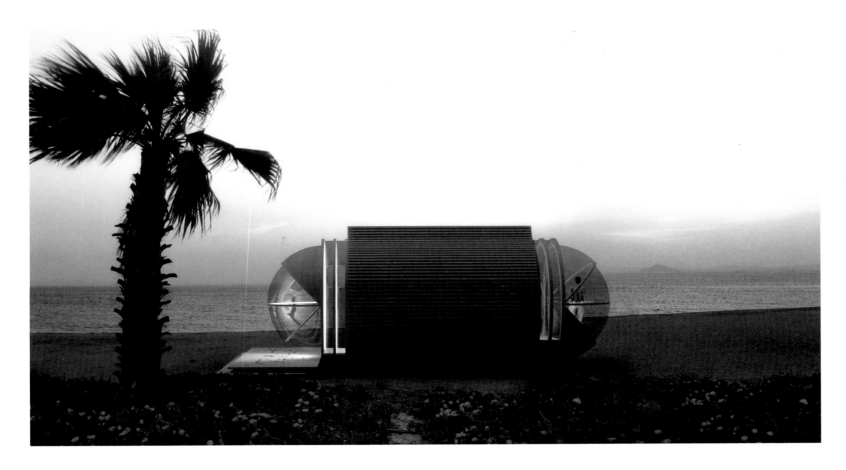

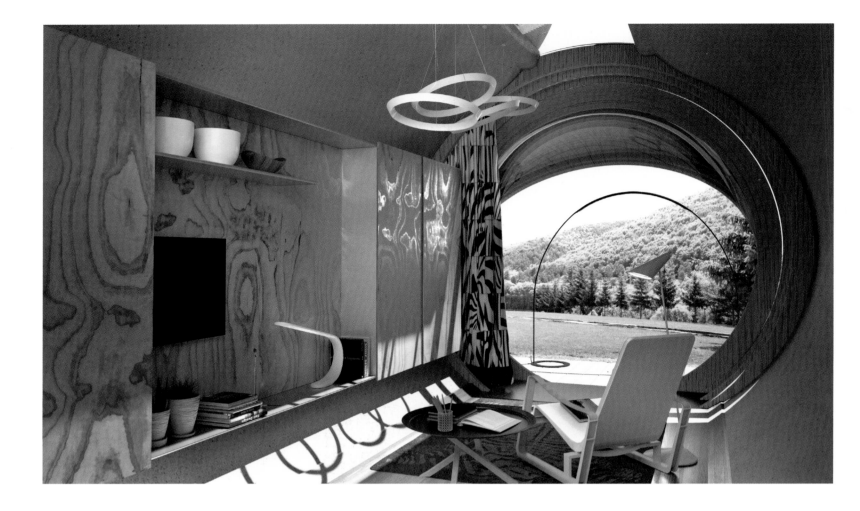

A skylight runs the entire length of the pod, which is designed to accommodate two adults. A lounge area shares space with the bedroom while a separate bathroom with toilet, bath, and shower are also included.

Ein Oberlicht zieht sich über die gesamte Länge der Kabine, in der zwei Erwachsene Platz finden. Lounge- und Schlafbereich sind in einem Raum untergebracht, zudem gibt es ein separates Bad mit Toilette, Badewanne und Dusche.

Une lucarne court sur toute la longueur de la cabine qui peut loger deux adultes. Le salon partage son espace avec la chambre à coucher et une salle de bains séparée avec toilettes, baignoire et douche est également comprise.

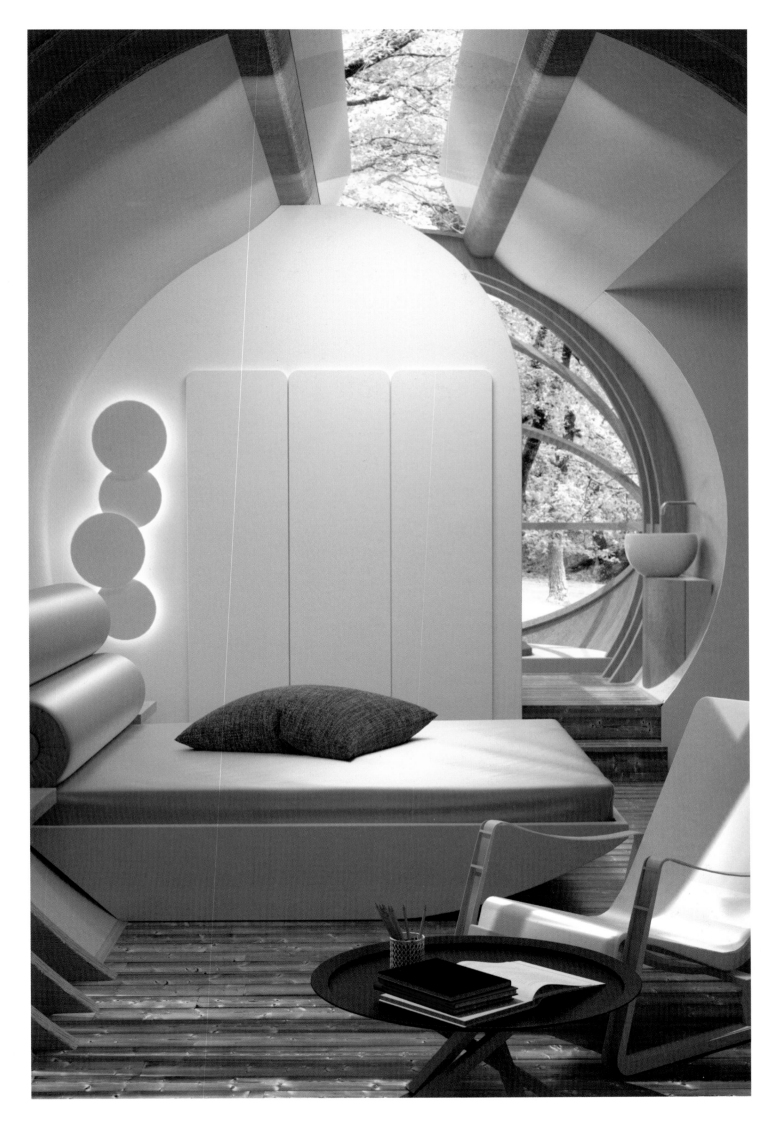

**NAREIN PERERA**
Mathugama [Sri Lanka]
2007–09

# ESTATE BUNGALOW

Area: 120 m² | Client: Steffan de Rosairo | Collaboration: Dilshan Weerarathne,
Keerthi Ratnayake (Structural Engineer)

Set on a raised site between a rubber plantation and the jungle, this bungalow offers a view of a 17-hectare estate being developed by the client. Three bedrooms with bath, a multifunction space, and a pantry make up the essential elements of the interior design of the steel, timber, and bamboo structure. The architect took his formal inspiration from local Chena "watch huts" used by farmers to keep an eye on their land at night. Narein Perera sought to create a building that would "touch the earth lightly," set up on thin, steel supports on its sloping site. The asymmetrical roof covering an outdoor terrace contributes to the "fragile" appearance of the bungalow, which is nonetheless firmly anchored on concrete supports.

———

Von diesem zwischen einer Kautschukplantage und dem Urwald auf einer Anhöhe gelegenen Bungalow blickt man auf einen 17 ha großen Landbesitz, der von dem Bauherrn erschlossen wird. Drei Schlafzimmer mit Bad, ein Multifunktionsraum und eine Vorratskammer bilden die wesentlichen Elemente des Baus aus Stahl, Holz und Bambus. Der Architekt ließ sich für die Erscheinungsform seines Projekts von den Chena-Aussichtshütten inspirieren, die von den Bauern der Gegend genutzt werden, um bei Nacht ihr Land zu bewachen. Narein Perera wollte, dass das Haus den Boden des abschüssigen Standorts auf dünnen Stahlpfeilern nur „leicht berührt". Das asymmetrische Dach überspannt eine Außenterrasse und trägt zur „fragilen" Erscheinung des gleichwohl fest auf Betonstützen verankerten Bungalows bei.

———

Construit en hauteur entre une plantation d'hévéas et la jungle, ce bungalow a vue sur un domaine de 17 hectares exploité par le client. Trois chambres avec bain, un espace multifonctions et un garde-manger composent l'essentiel de l'intérieur dans cette structure d'acier, bois et bambou. L'architecte s'est inspiré pour la forme des cabanes Chena locales utilisées par les paysans pour veiller sur leurs terres la nuit. Narein Perera a voulu créer un bâtiment qui « toucherait légèrement la terre », perché sur de fins supports en acier plantés dans le terrain en pente. Le toit asymétrique au-dessus d'une terrasse contribue à la « fragilité » apparente du bungalow, qui est néanmoins solidement ancré dans des supports de béton.

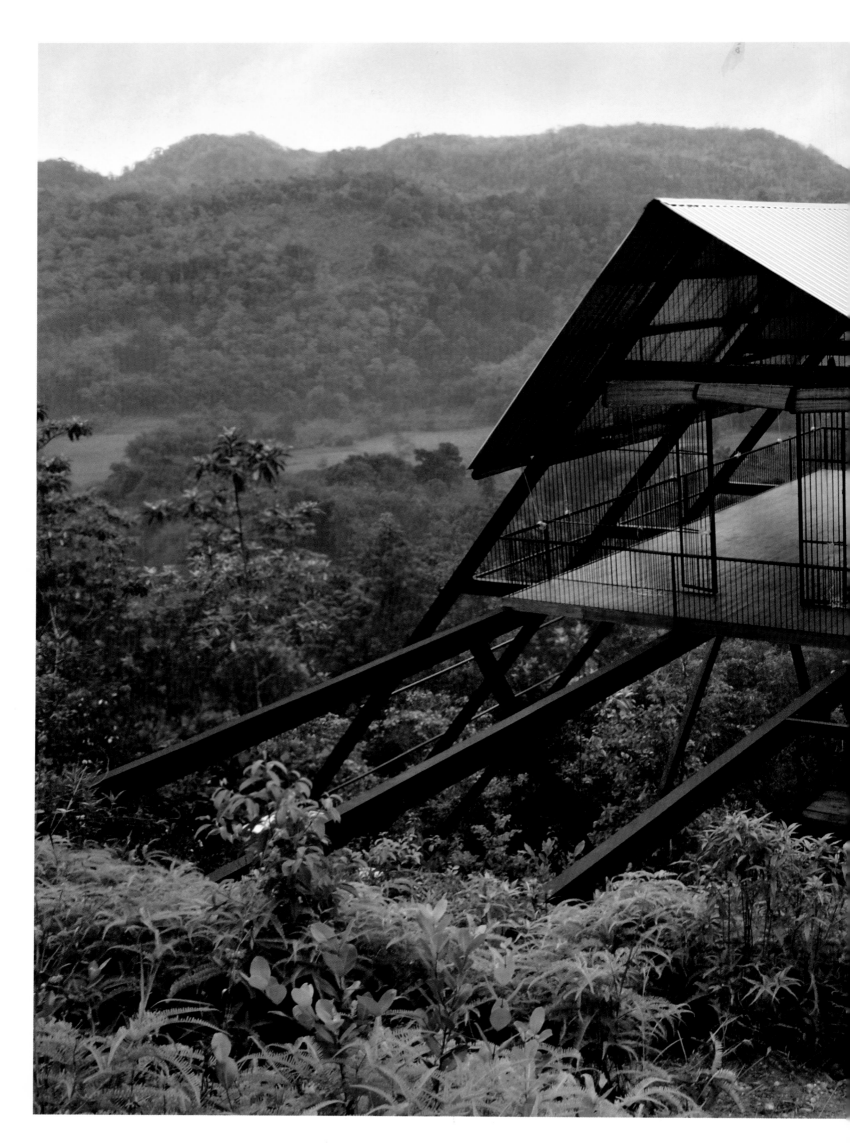

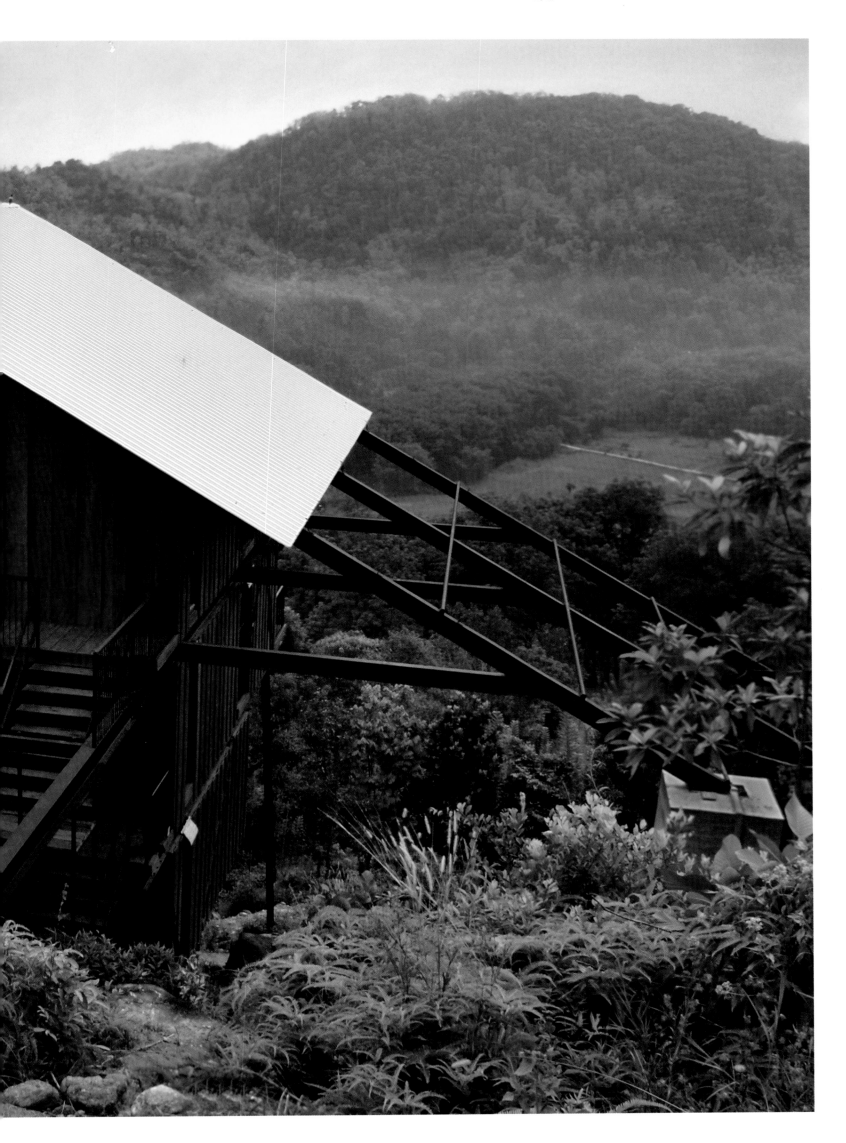

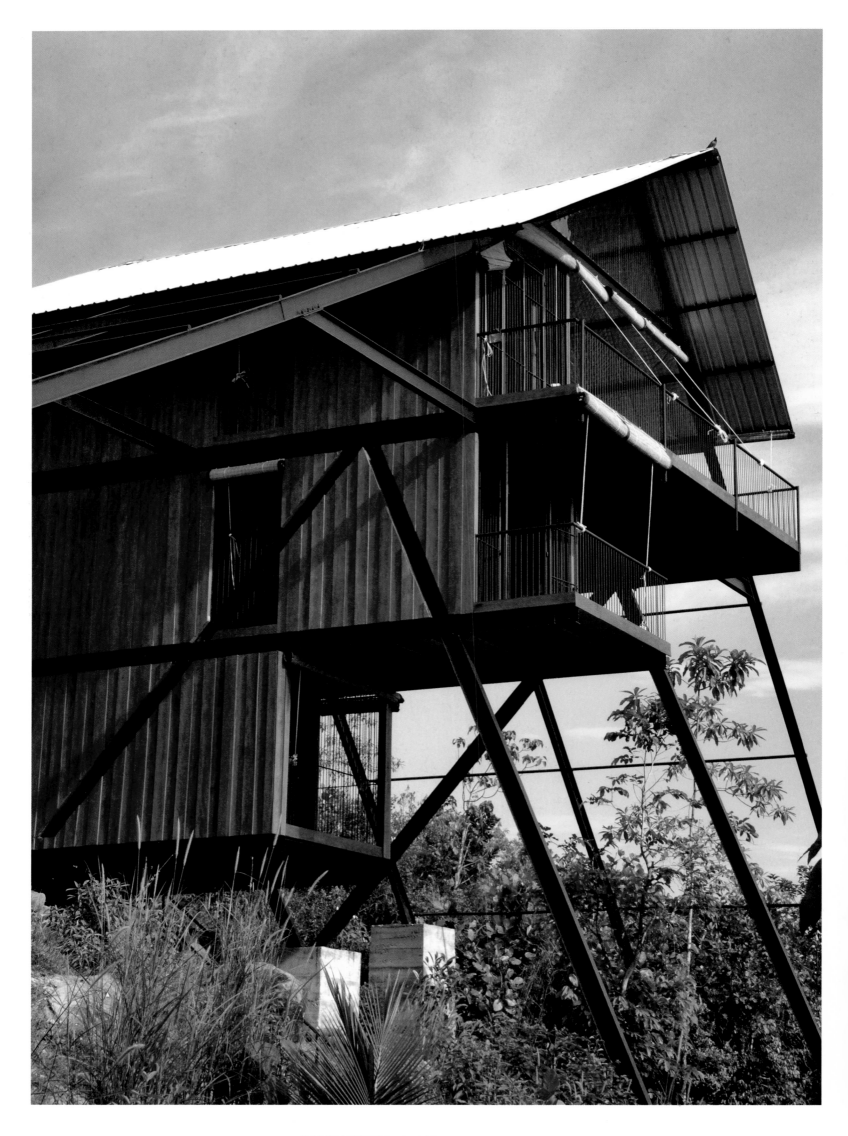

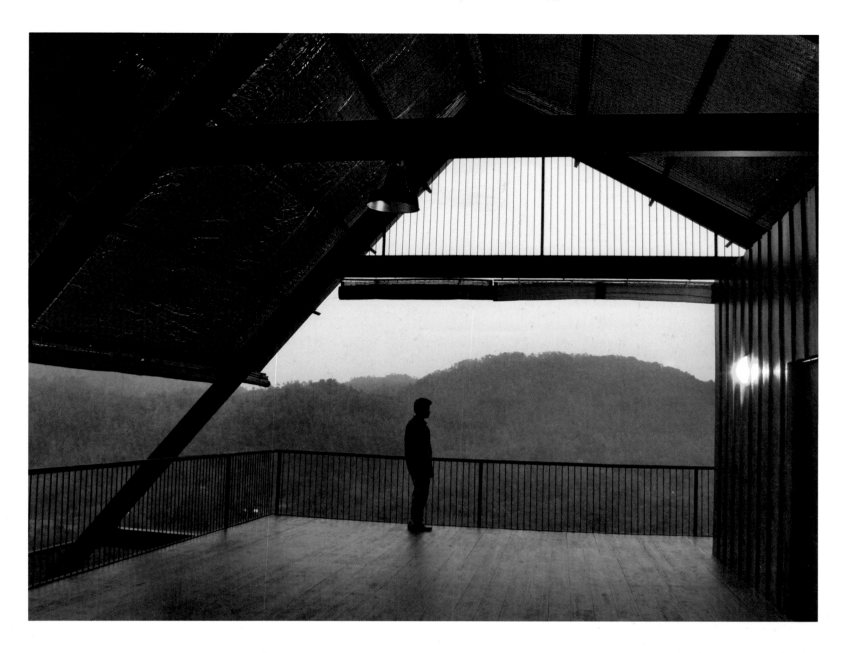

The structure is perched on
a raised site between a rubber
plantation and the jungle. Its
form is derived from the Chena
"watch huts" used by Sri Lankan
farmers to look after their
crops at night.

Das Gebäude liegt auf einer
Anhöhe zwischen einer
Kautschukplantage und dem
Urwald. Die Form beruht auf
Chena-Beobachtungshütten,
die von sri-lankischen Bauern
genutzt werden, um nachts
über ihr Land zu wachen.

La structure est perchée sur
un site en hauteur entre une
plantation d'hévéas et la jungle.
Sa forme est dérivée des
cabanes Chena utilisées par les
paysans sri-lankais pour veiller
sur leurs cultures la nuit.

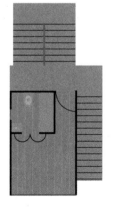
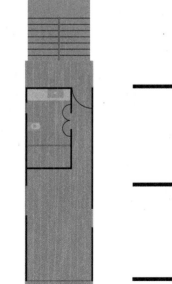
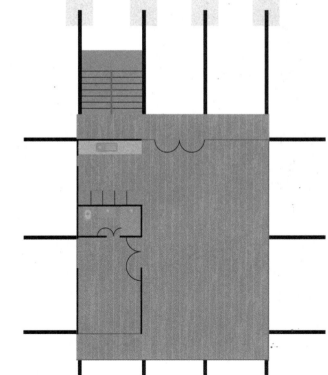

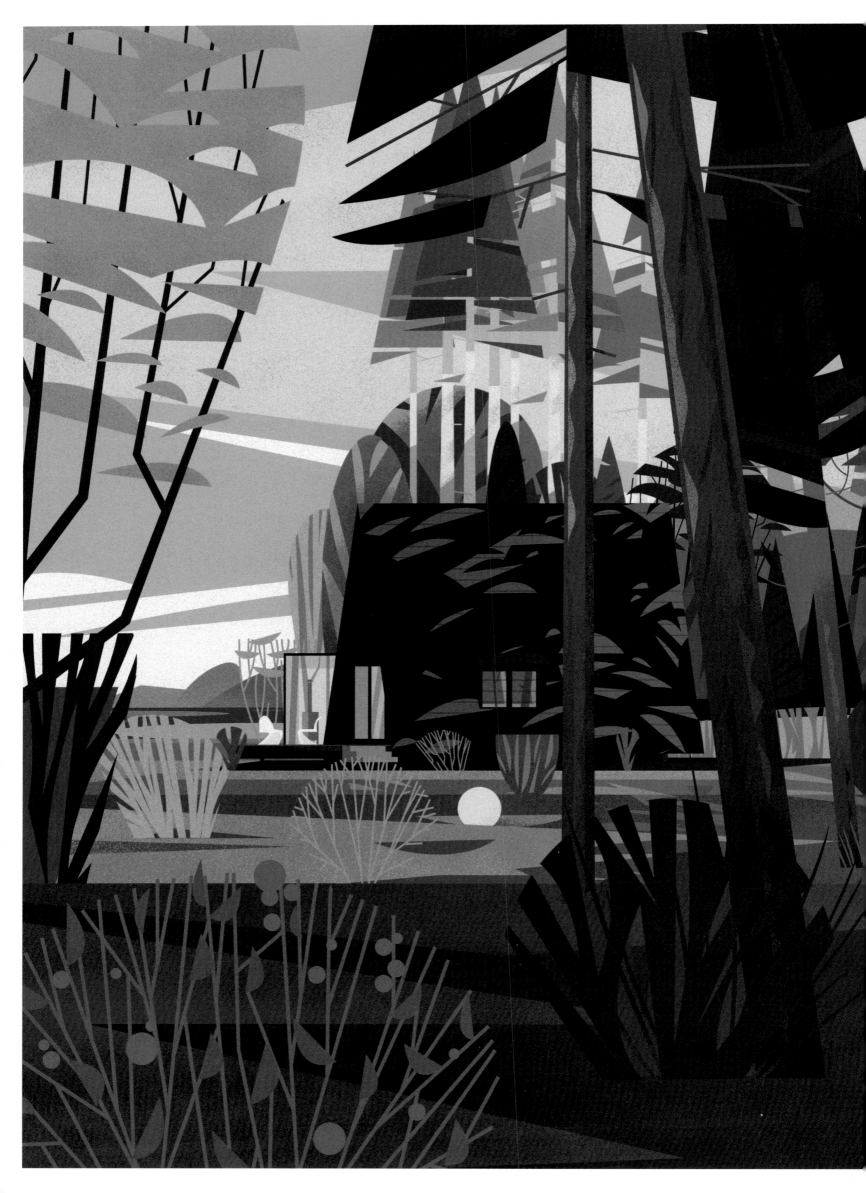

**DMVA**
Brecht [Belgium]
2010–11

# EXTENSION VB4

Area: 50 m² + 25 m² extension | Client: Rini van Beek | Cost: €50 000

dmvA was asked to extend an old A-frame house to make it into a "comfortable contemporary house." Local authorities rejected an "organic lobate" design, which led the architects to create their mobile Blob vB3. They returned to the project with a trapezoidal wooden "tunnel," adding a library, bathroom, and entrance. The back and front of the new structure are completely glazed. Porches are made of laminated lumber and the façade is covered with fiber-cement siding.

———

dmvA wurden damit beauftragt, ein altes Nurdachhaus in ein „komfortables, zeitgenössisches Haus" umzuwandeln. Die Behörden lehnten den ersten, „organischen" Entwurf mit Klappendesign ab. In der Folge entwickelten die Architekten ihre mobile Wohneinheit Blob vB3. Sie wandten sich dem Projekt erneut mit einem Entwurf zu, der einen trapezförmigen hölzernen „Tunnel" vorsah, in dem Bibliothek, Badezimmer und Eingang untergebracht sind. Hinter- und Vorderseite des Anbaus sind vollständig verglast. Die Veranden bestehen aus Brettschichtholz. Die Fassade ist mit Faserzement verkleidet.

———

Pour ce projet, dmvA devait agrandir une ancienne maison aux pans de toit descendant jusqu'au sol et en faire une « habitation contemporaine confortable ». Les autorités locales ont refusé un design « organique lobé », ce qui a donné aux architectes l'idée du Blob vB3 mobile. Ils sont ensuite revenus au premier projet avec une proposition de « tunnel » trapézoïdal en bois qui ajoute une bibliothèque, une salle de bains et un vestibule à la structure d'origine. L'avant et l'arrière de la nouvelle construction sont entièrement vitrés, les porches sont en bois de charpente lamellé et la façade est recouverte d'un bardage en fibre-ciment.

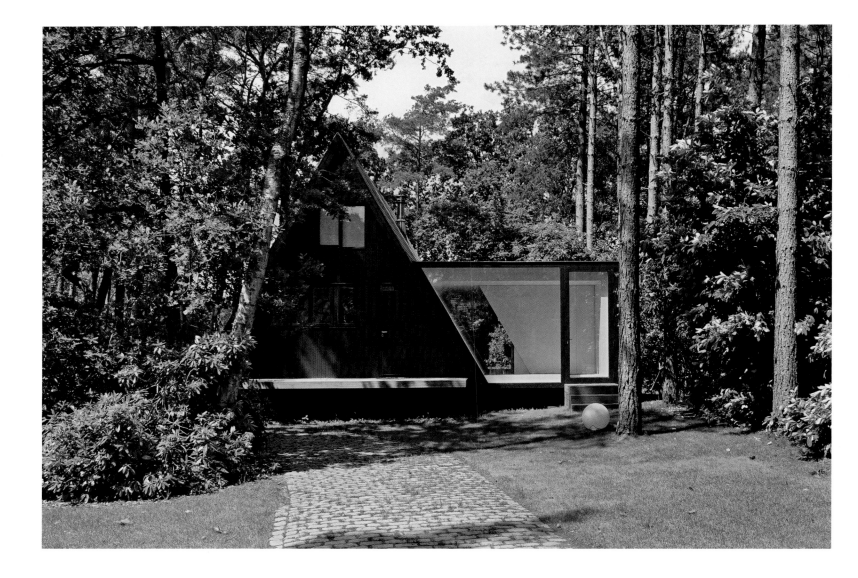

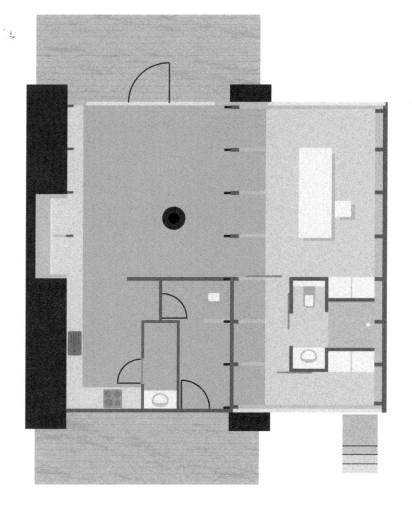

The design is the result of a careful study of local building regulations subsequent to the rejection of an organic form. The addition is made of wood and glass.

Der Entwurf resultiert aus der eingehenden Prüfung örtlicher Baubestimmungen im Zuge der Ablehnung einer organischen Form. Der Anbau besteht aus Holz und Glas.

Le design est issu d'une étude approfondie des règlements locaux en matière de construction, après le refus d'une forme organique. L'extension est en bois et verre.

The architects state: "The architectural concept is based on a dialogue between old and new, coziness and openness, glass and wood, and linked by materiality and details."

Die Architekten: „Das architektonische Konzept basiert auf einem Dialog zwischen Alt und Neu, Gemütlichkeit und Offenheit, Glas und Holz, und wird durch die Materialität und Details zusammengehalten."

Les architectes déclarent : « Le concept architectural est fondé sur un dialogue entre l'ancien et le nouveau, l'intimité et l'ouverture, le verre et le bois, reliés par la matérialité et de nombreux détails. »

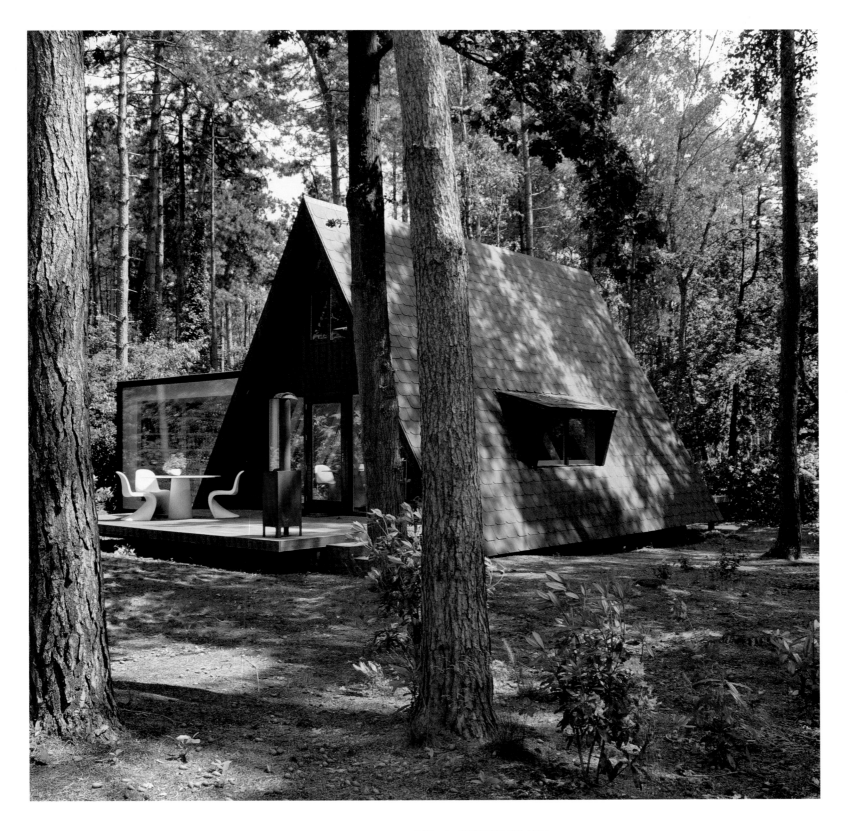

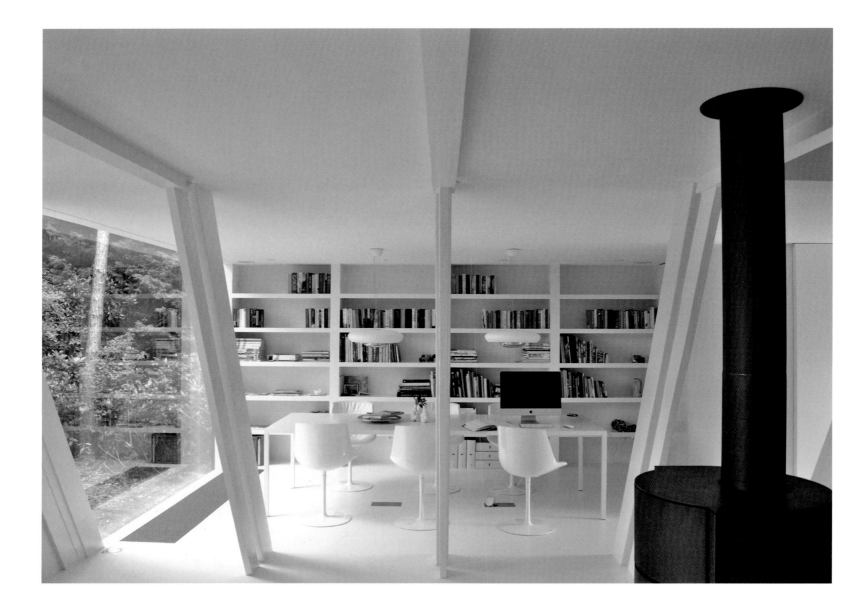

The floor has a polyurethane finish, while ceilings and walls are in plasterboard. Bookshelves and sliding doors with timber profiles and double glazing complete the white interior design, along with a contrasting black wood-burning stove.

Der Boden ist mit Polyurethan beschichtet, Decken und Wände bestehen aus Gipsplatten. Bücherregale und Schiebetüren mit Holzprofil sowie Doppelverglasung komplettieren die weiße Inneneinrichtung samt Holzofen in kontrastierendem Schwarz.

Le sol est recouvert d'un enduit de polyuréthane, les murs et les plafonds sont en placoplâtre. Les étagères de livres et les portes coulissantes aux profilés en bois et double vitrage apportent la touche finale à l'intérieur conçu en blanc, qui contraste avec un poêle à bois noir.

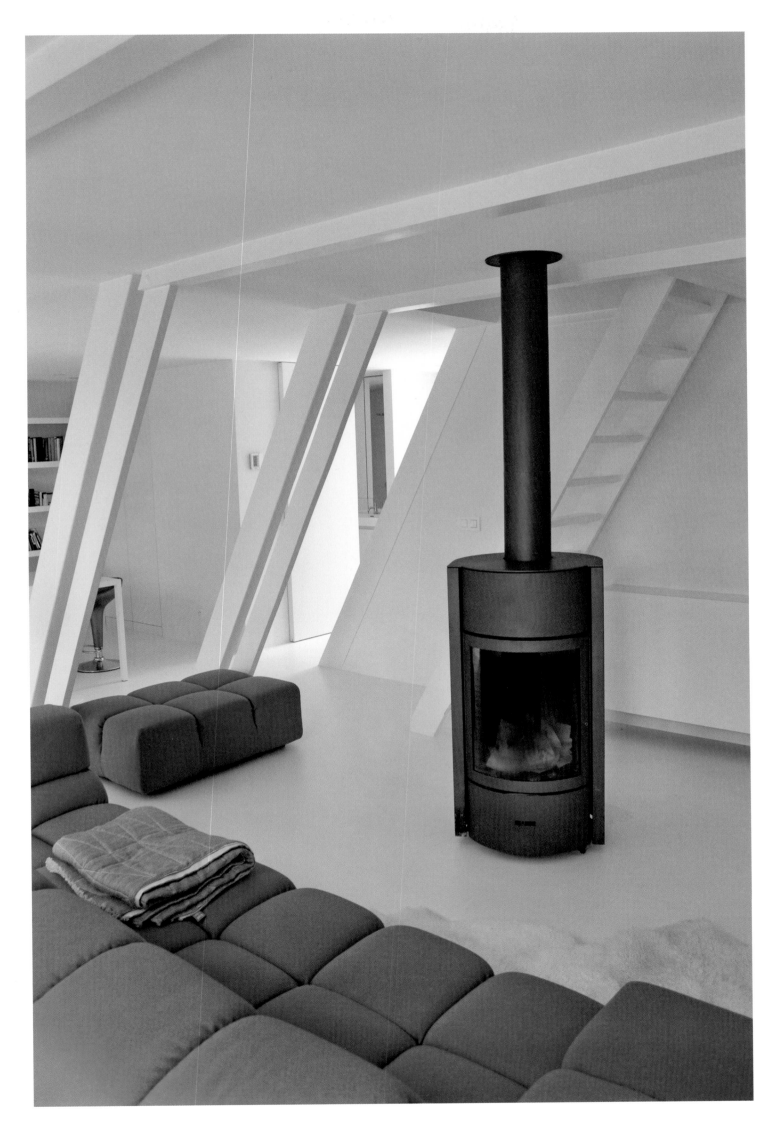

# FLAKE HOUSE

Area: 22 m² | Client: Le Lieu Unique | Cost: €21 000

The architects describe this "nomadic dwelling" as a "poetic shelter, a "folly" that "merges how-tech and high tech." The Flake House was created in 2006 as part of a competition called "Petites machines à habiter" held by the CAUE 72 organization in the Sarthe départment of France. The house was set up in Nantes (June 5—August 16, 2009) at the Festival Estuaire Nantes/St. Nazaire, organized by Le Lieu Unique.

———

Die Architekten bezeichnen diese „Nomadenbehausung" als „poetische Zufluchtsstätte", als „verrückten Einfall", der „How-Tech und Hightech miteinander verbindet". Das Flake House wurde ursprünglich 2006 im Rahmen des von der Organisation CAUE 72 im Département Sarthe ausgeschriebenen Wettbewerbs „Petites machines à habiter" entworfen. Gebaut wurde es in Nantes, im Rahmen des von Le Lieu Unique ausgerichteten Festivals Estuaire Nantes/St. Nazaire (5. Juni–16. August 2009).

———

Les architectes décrivent leur « habitat nomade » comme un « refuge poétique, une "folie" où fusionnent how-tech et high-tech ». La maison Flake a été créée en 2006 dans le cadre d'un concours intitulé « Petites machines à habiter » organisé par CAUE 72 dans la Sarthe. Elle a été montée à Nantes (5 juin–16 août 2009) au festival Estuaire Nantes/Saint-Nazaire, organisé par le lieu unique.

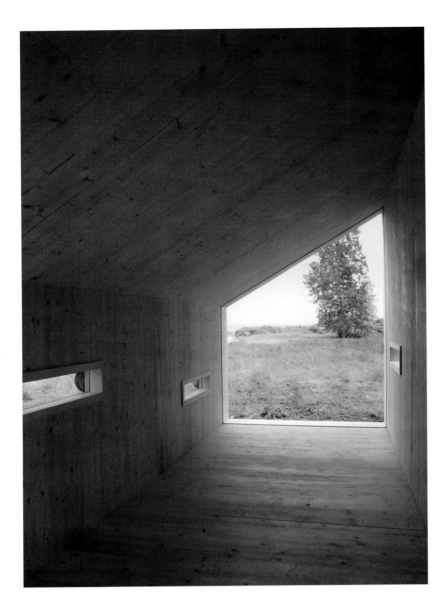

The 22-square-meter design was built for a budget of €21 000. The architects deliberately contrasted the smooth and simple interiors with the rough log exterior walls.

Der 22 m² große Entwurf wurde für 21 000 € realisiert. Die Architekten wollten das ebenmäßige und einfache Innere von den unbearbeiteten Holzaußenwänden absetzen.

Le projet de 22 m² a été construit pour un budget de 21 000 €. Les architectes ont délibérément opposé l'intérieur simple et lisse aux murs extérieurs en rondins bruts.

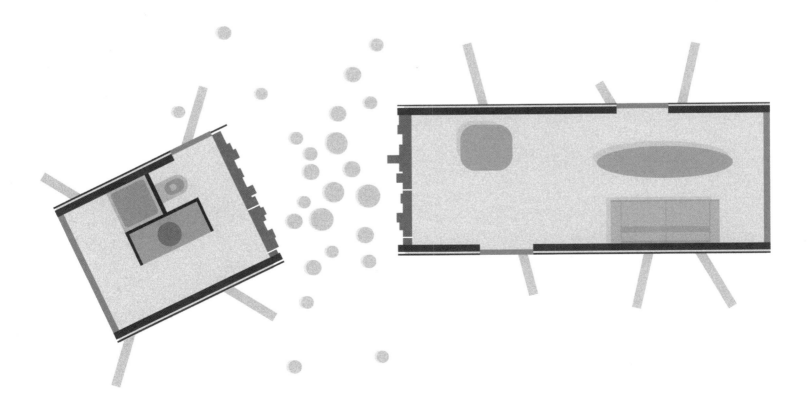

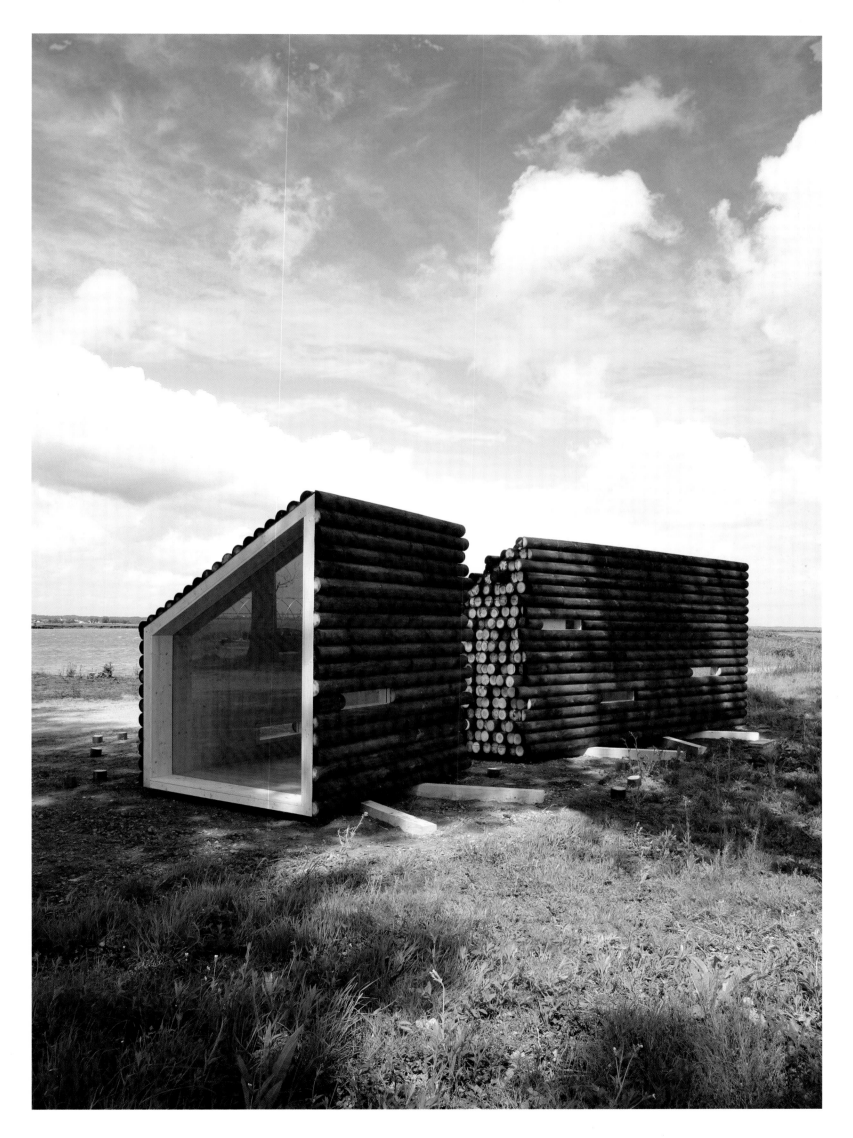

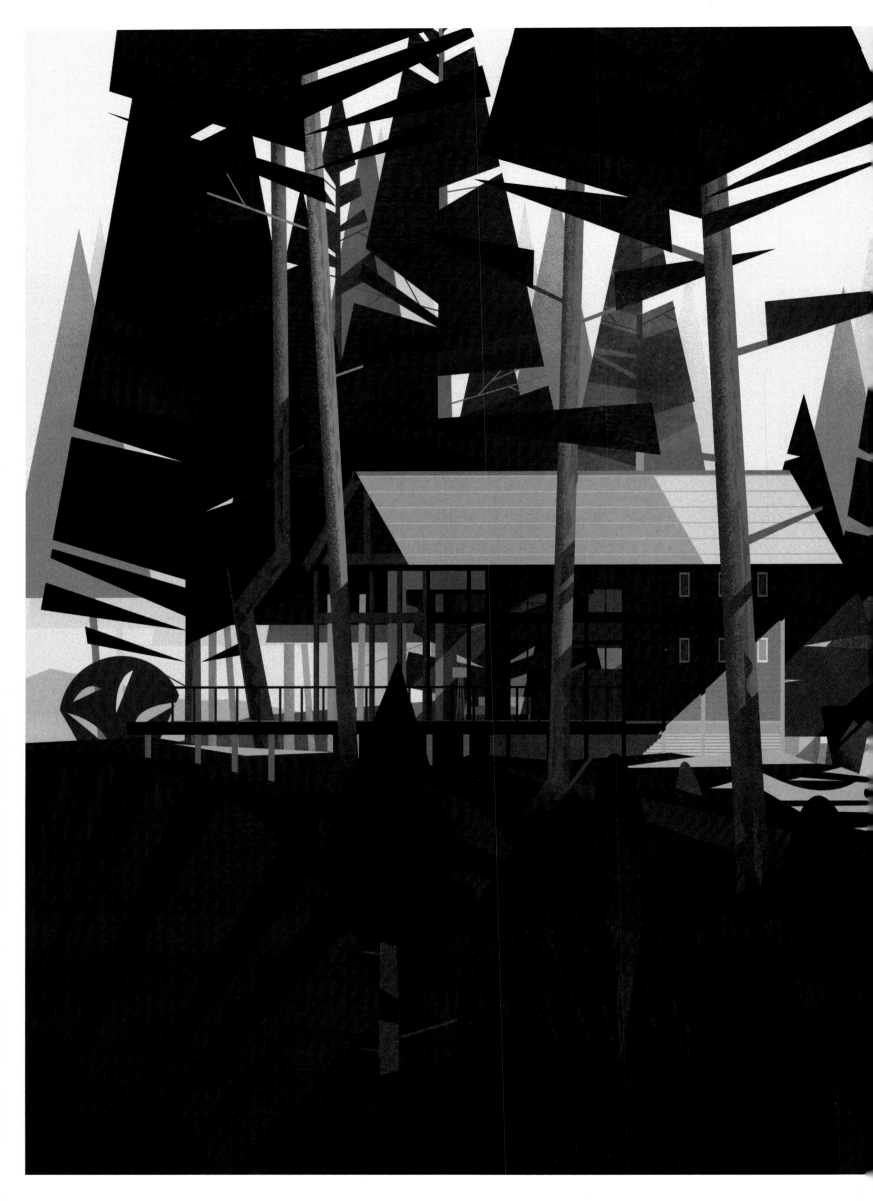

# FOSTER LOOP CABIN

Area: 153 m² | Collaboration: Kyle Zerbey

Built on a 1.2-hectare site, parts of this cabin are lifted off the ground on concrete piers to minimize environmental damage. The one-and-a-half-story living space is accessed via the entrance. A central fireplace and stairway mark this area. Bedrooms with a low-walled, "tent-like" design are on the upper floor. A roof deck and an elevated catwalk leading to the former campground of the owners (whence the idea of the tents for the bedrooms) further permit the integration of the structure into its natural environment.

———

Teile dieses Gebäudes, das auf einem 1,2 ha großen Grundstück liegt, sind auf Betonsäulen aufgeständert, um die Umweltbelastung so gering wie möglich zu halten. Die Eingangstür führt direkt in den anderthalbgeschossigen Wohnraum, der sich durch einen zentral platzierten Kamin und einen Treppenaufgang auszeichnet. Die Schlafzimmer mit „zeltartig" anmutenden, niedrigen Decken befinden sich im Obergeschoss. Eine Dachterrasse und ein erhöhter Steg, der zum einstigen Campinggrundstück der Eigentümer führt (daher die Idee für die zeltartigen Schlafbereiche), erlauben darüber hinaus die Verbindung des Gebäudes mit seiner natürlichen Umgebung.

———

Construite sur un terrain de 1,2 hectares, cette petite maison est en partie surélevée par des piliers de béton afin de réduire les risques pour l'environnement. L'entrée donne directement accès à l'espace à vivre d'un étage et demi, marqué par un foyer central et la présence de l'escalier. Les chambres à coucher aux murs bas «type tente» sont à l'étage. Un toit en terrasse et une passerelle surélevée qui mène à l'ancien terrain de camping des propriétaires (d'où l'idée des tentes pour les chambres) contribuent à intégrer encore davantage la construction dans son cadre naturel.

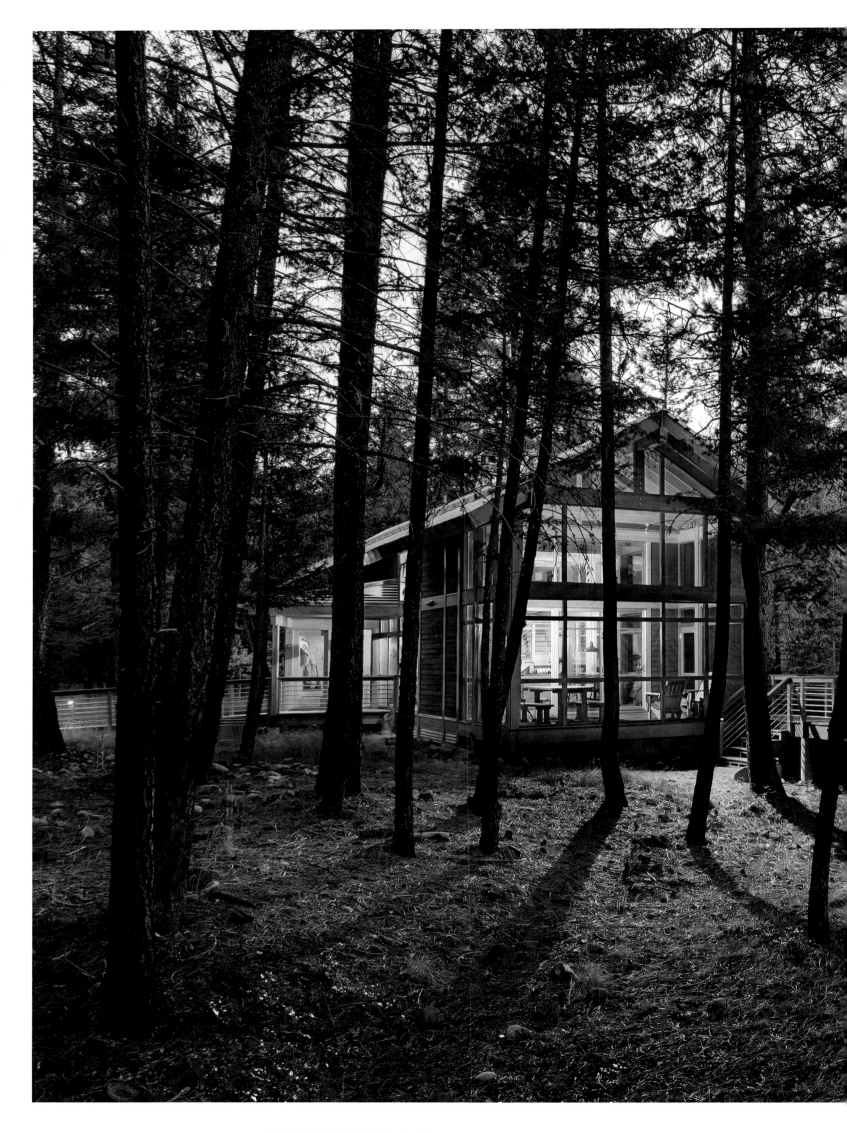

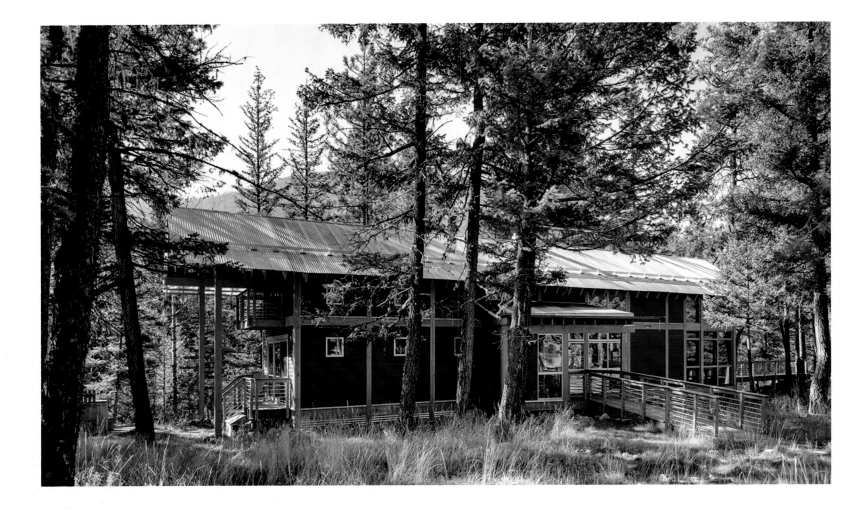

The house has western red cedarwood siding and a corrugated galvanized roof with transparent corrugated roofing over the decks.

Das Haus verfügt über eine Verkleidung aus dem Holz der Riesen-Thuja, ein galvanisiertes Wellblechdach und eine lichtdurchlässige Terrassenüberdachung.

La maison est bardée de thuya géant avec un toit en acier ondulé galvanisé, translucide et ondulé au-dessus des galeries extérieures.

The one-and-a-half-story living space and kitchen are close to a central fireplace and stairway that leads to the "tent-like" upper-level bedrooms.

Der anderthalbgeschossige Wohnraum samt Küche ist nahe des zentralen Kamins und einer Treppe gelegen, die zu den „zeltartigen" Schlafzimmern im Obergeschoss führt.

L'espace séjour et cuisine d'un étage et demi est marqué par un foyer central et la présence de l'escalier qui mène aux chambres à coucher « type tente » à l'étage.

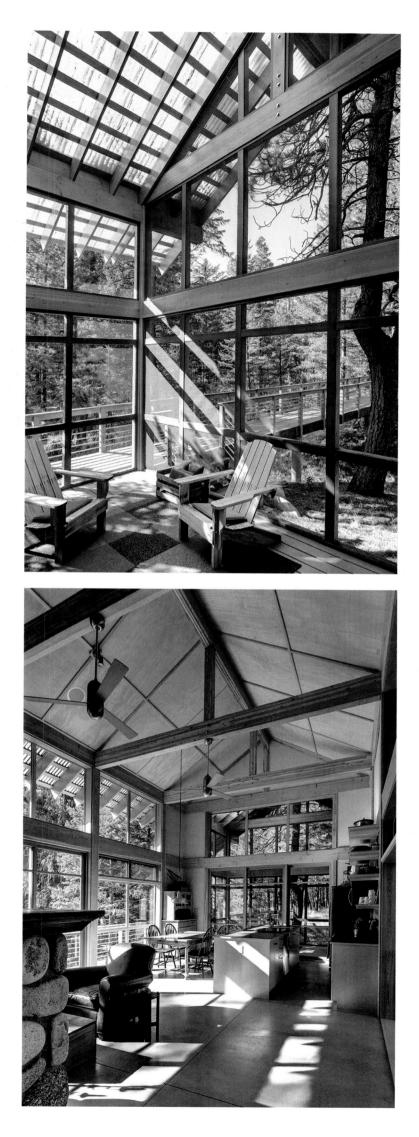

**AVANTO ARCHITECTS**
Virrat [Finland]
2009–10

# FOUR-CORNERED VILLA

Area: 64 m² + 19 m² sauna | Cost: €180 000

The island site of this house inspired the architects to seek out four different views—three toward the lake and the fourth in the direction of the forest to the west. They state: "You get morning light at the breakfast table, midday in the dining room, and evening in the sitting room. There is no direct sunlight in the bedroom so you don't need curtains. Terraces are covered to prevent the hot summer sun overheating the building but allowing passive solar energy in the winter." Double doors open onto the terraces of the dark-colored house, which seems to disappear when seen from the lake. The house has no running water and electricity "is provided by the sun." Only wood from the local forest is burned for heating.

————

Die Insellage dieses Hauses inspirierte die Architekten dazu, vier verschiedene Ausblicke zu betonen, drei davon zeigen den See, die vierte den Wald im Westen. Die Architekten: „Man hat Morgenlicht am Frühstückstisch, Mittagslicht im Esszimmer und Abendlicht im Wohnzimmer. Ins Schlafzimmer fällt kein direktes Sonnenlicht, Vorhänge sind also unnötig. Eine Terrassenüberdachung verhindert, dass die Sommersonne das Gebäude überhitzt und erlaubt im Winter eine passive Nutzung der Sonnenenergie." Auf die Terrasse des dunkel gestrichenen Hauses, das vom See aus nahezu unsichtbar ist, öffnen sich Doppeltüren. Es gibt im Haus kein fließendes Wasser; Elektrizität „liefert die Sonne". Zum Heizen wird ausschließlich Holz aus dem nahegelegenen Wald verwendet.

————

La situation insulaire de la maison a donné aux architectes l'idée d'ouvrir quatre vues différentes – trois vers le lac et la quatrième vers la forêt, à l'ouest. Ils expliquent qu'ainsi, « la lumière du matin éclaire la table du petit-déjeuner, celle de midi la salle à manger et celle du soir le salon. La chambre seule ne bénéficie d'aucun ensoleillement direct, de sorte qu'il n'est pas nécessaire d'y poser des rideaux. Les terrasses sont couvertes pour éviter toute surchauffe en été mais permettre l'exploitation de l'énergie solaire passive en hiver ». Des doubles portes ouvrent sur les terrasses de la maison à la teinte sombre, presque invisible depuis le lac. Il n'y a pas l'eau courante et la seule énergie électrique disponible « est fournie par le soleil ». Le bois brûlé pour le chauffage provient exclusivement de la forêt locale.

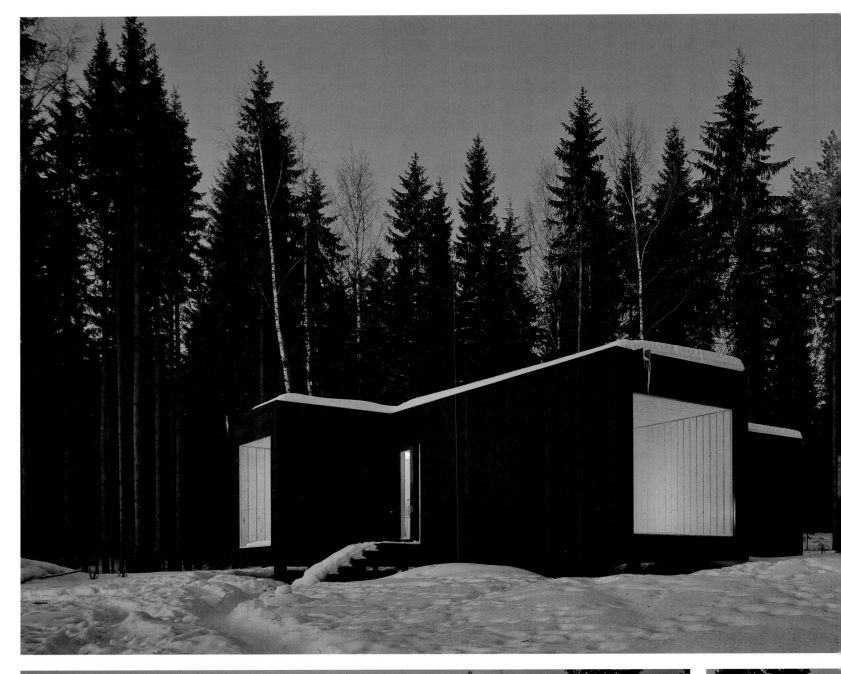

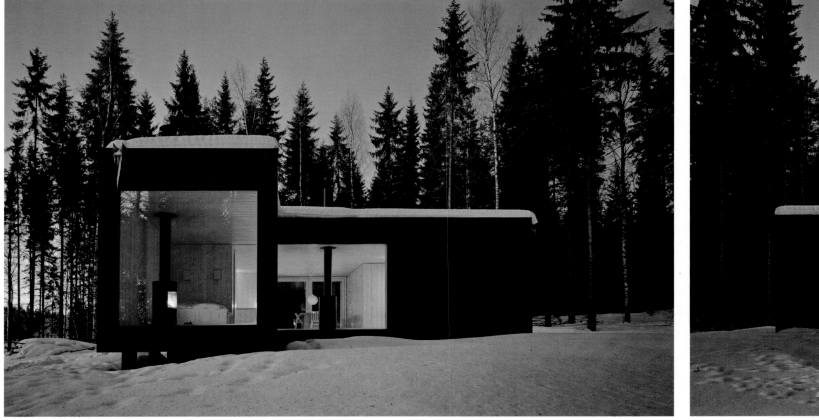

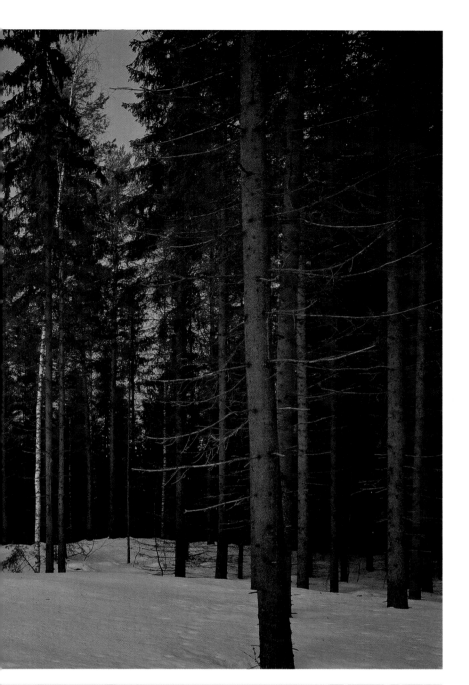

The cross-like shape of the house frames four very different views, with the lake on three sides and forest on the other. Double doors open out onto the terraces.

Aufgrund der Kreuzform bietet das Haus vier verschiedene Aussichten: auf drei Seiten den See und auf der vierten den Wald. Doppeltüren führen auf die Terrassen.

La forme en croix de la maison délimite quatre vues très différentes, trois vers le lac et la quatrième vers la forêt. Des doubles portes ouvrent sur les terrasses.

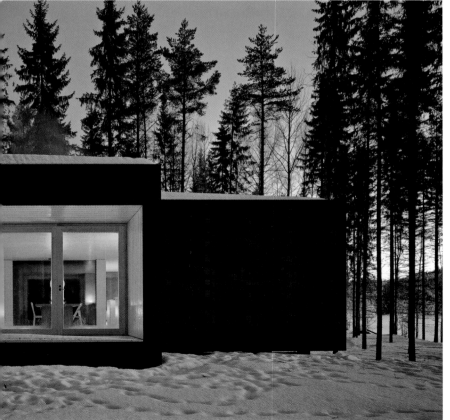

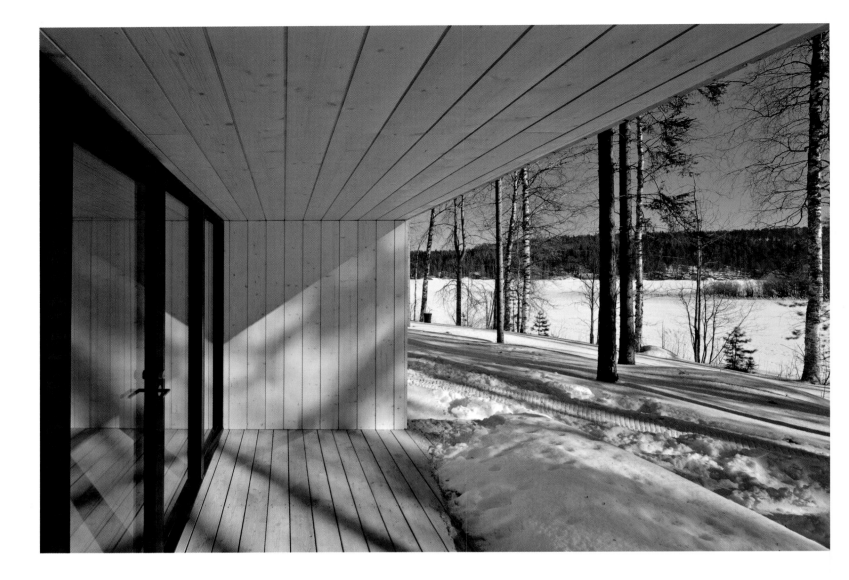

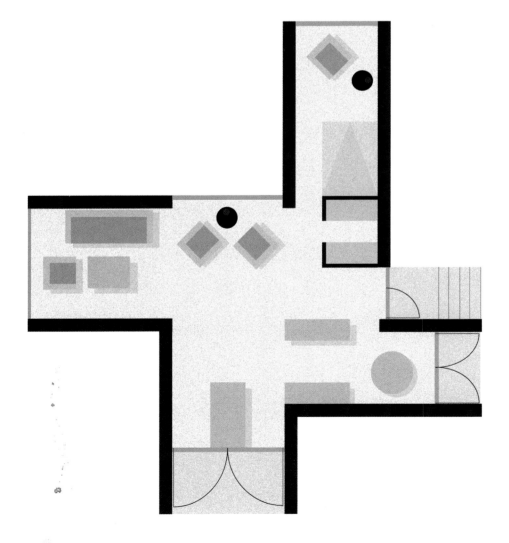

The well-insulated house has no running water and is heated by a wood stove. On the right, the 19-square-meter sauna.

In dem gut isolierten Haus gibt es kein fließendes Wasser, geheizt wird mit einem Holzofen. Rechts die 19 m² große Sauna.

La maison parfaitement isolée n'a pas l'eau courante et est chauffée par un poêle à bois. À droite, le sauna de 19 m².

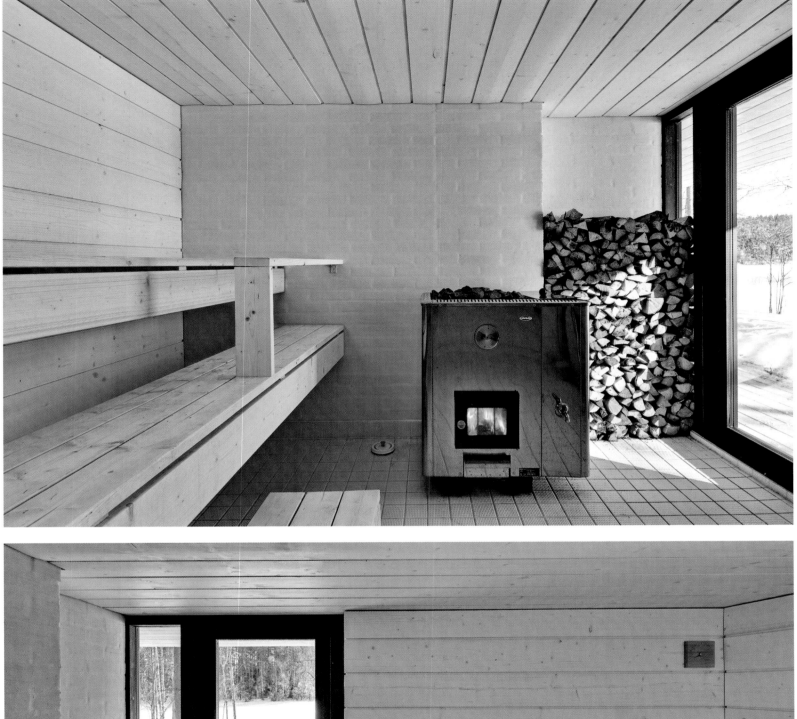

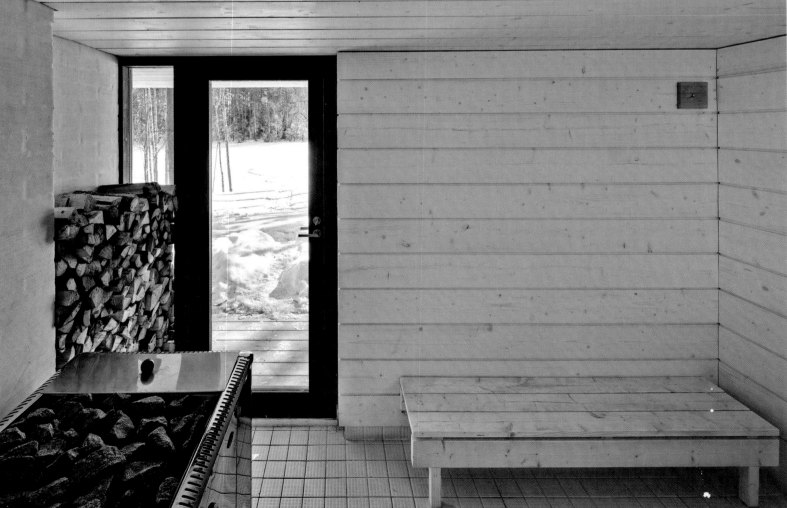

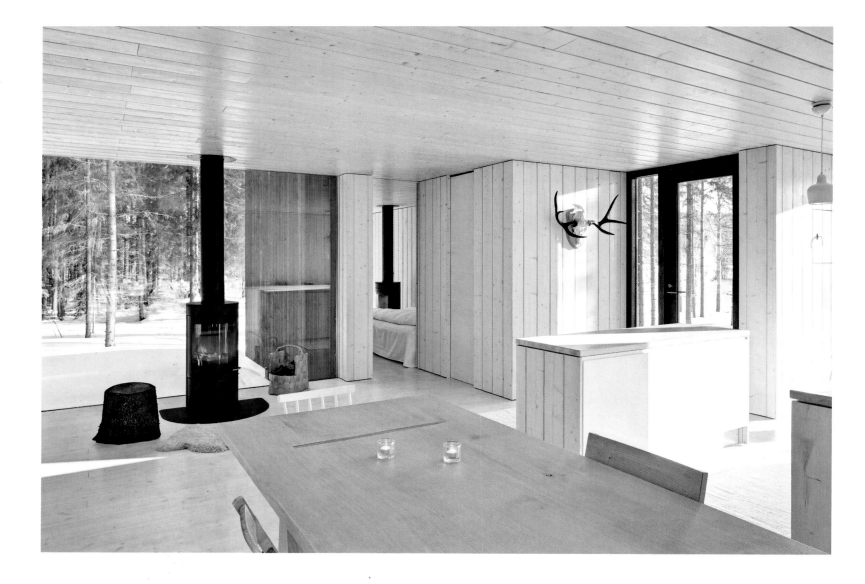

"The basic idea," state the architects, "is to provide an example of a sustainable cottage in contrast to normal Finnish cottages that are heated all year round with electricity to keep pipes from freezing."

„Grundidee war es", so die Architekten, „ein Beispiel für ein nachhaltiges Landhaus zu geben, das sich von normalen finnischen Landhäusern unterscheidet, die ganzjährig elektrisch beheizt werden, um das Einfrieren der Rohre zu verhindern".

« L'idée de base, expliquent les architectes, est de créer un exemple de maison durable, contrairement aux cottages finlandais qui sont normalement chauffés toute l'année à l'électricité afin d'éviter le gel des canalisations. »

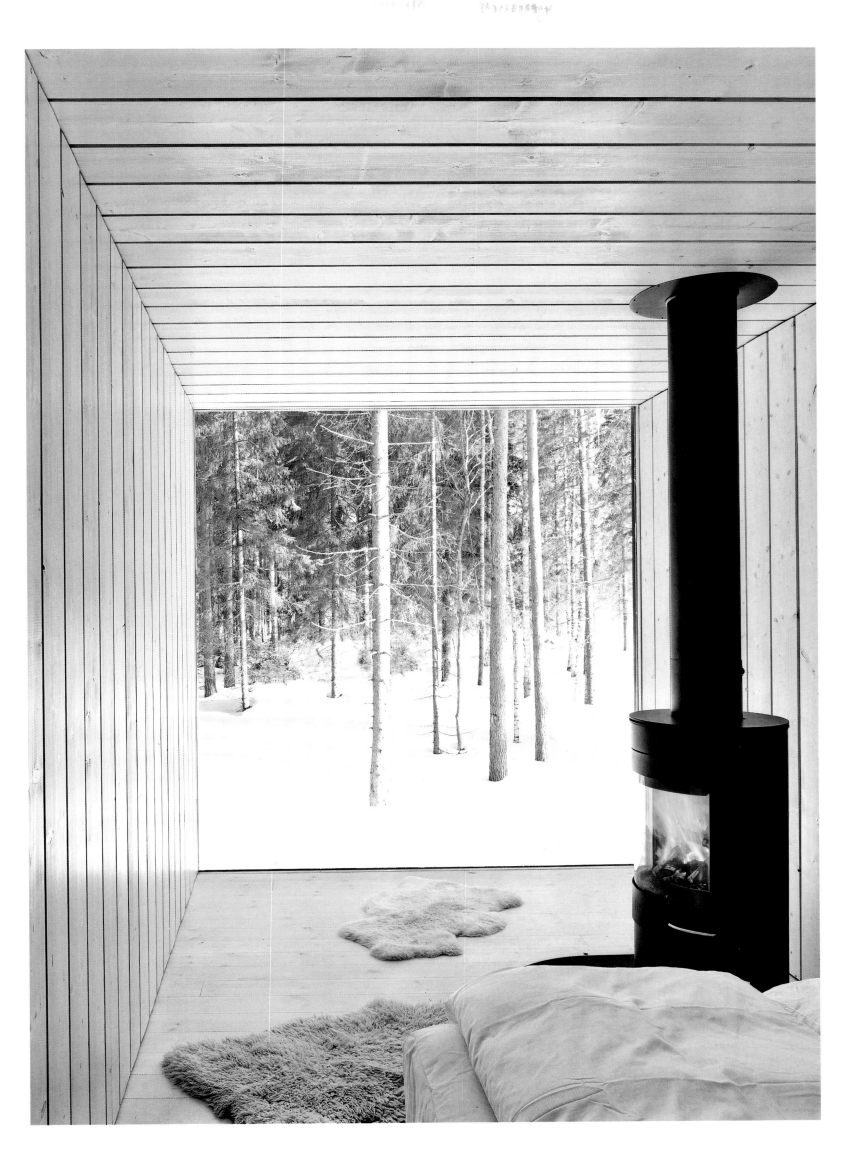

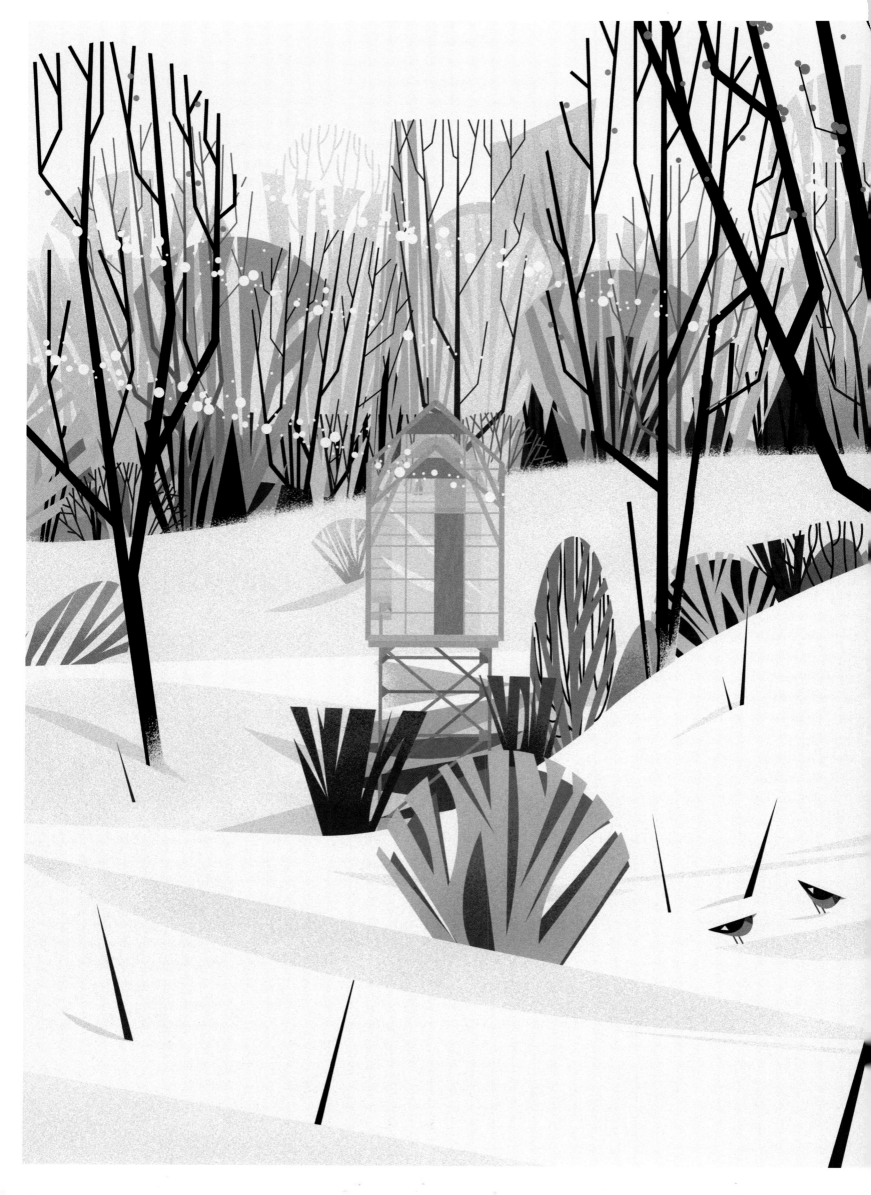

**HIDEMI NISHIDA**
Sapporo [Japan]
2010–11

# FRAGILE SHELTER

Area: 20 m² | Cost: ¥200 000

The designer explains: "This project is a temporary shelter in the wild winter forest. It leads people to gather, and a number of events happened there. Sometimes, local students had a party there, and sometimes local kindergarten children came and had lunch. This is a cozy base for winter activities." The structure is lifted off the ground to protect it from extreme winter weather conditions—it also follows the ground level of the site, as though reacting to it in an organic way.

———

Der Architekt: „Es handelt sich bei diesem Projekt um einen temporären Zufluchtsort in einem unberührten Winterwald, an dem Menschen zusammenkamen und gelegentlich auch Veranstaltungen stattfanden. Mal feierten Studenten aus der Gegend eine Party, mal aßen Kindergartenkinder hier zu Mittag. Ein gemütlicher Ort für winterliche Freizeitgestaltung." Der Bau ist zum Schutz vor den extremen Witterungsbedingungen im Winter aufgeständert, er folgt dabei dem Gefälle, als ob er organisch auf seinen Standort reagieren würde.

———

Le designer explique : « Il s'agit d'un abri temporaire dans la forêt hivernale sauvage. Il est conçu pour amener les gens à se réunir et a déjà accueilli de nombreuses manifestations. Les étudiants de la région y ont organisé des fêtes et les petits des jardins d'enfants voisins sont venus y déjeuner. C'est une base confortable et douillette pour les activités hivernales. » Le bâtiment est surélevé pour le protéger des conditions météorologiques extrêmes en hiver – mais suit aussi la courbe de niveau du sol comme s'il réagissait au terrain de manière organique.

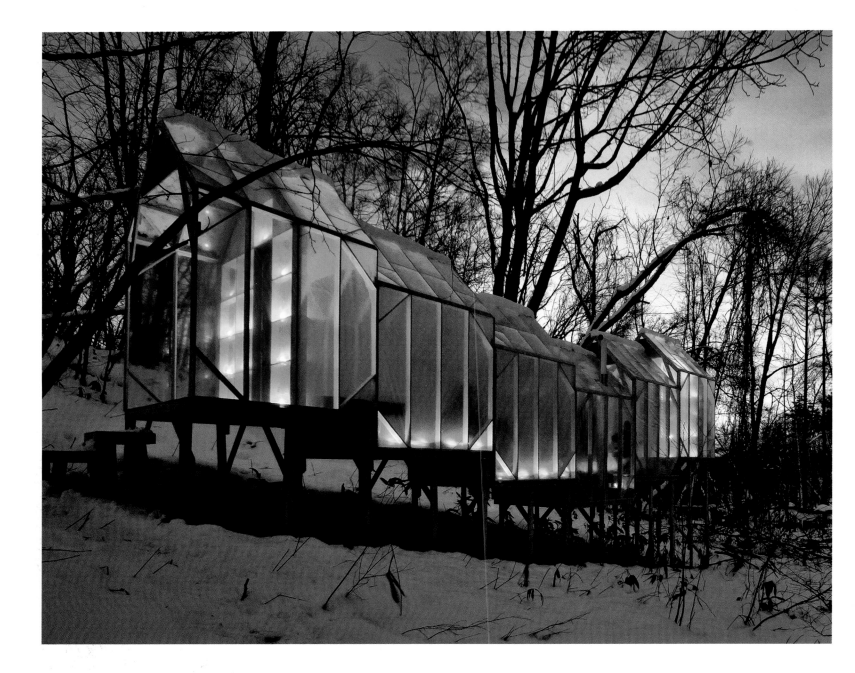

Located on the northern island of Hokkaido, this
temporary shelter was left in place for two months,
from November 2010 to January 2011.

Dieser temporäre Zufluchtsort befand sich
zwischen November 2010 und Januar 2011 zwei
Monate auf der nördlichen Insel Hokkaido.

Situé sur l'île septentrionale d'Hokkaido, cet abri
temporaire a été mise en place pendant deux mois,
entre novembre 2010 et janvier 2011.

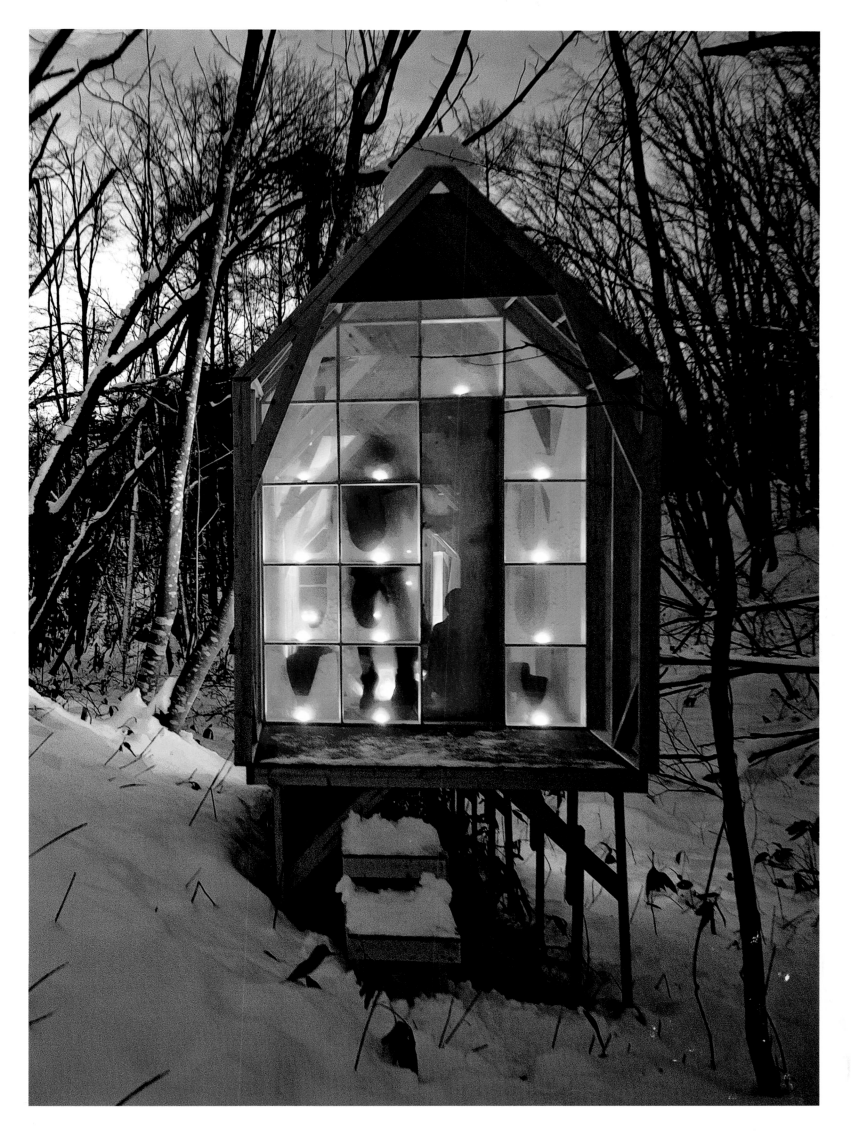

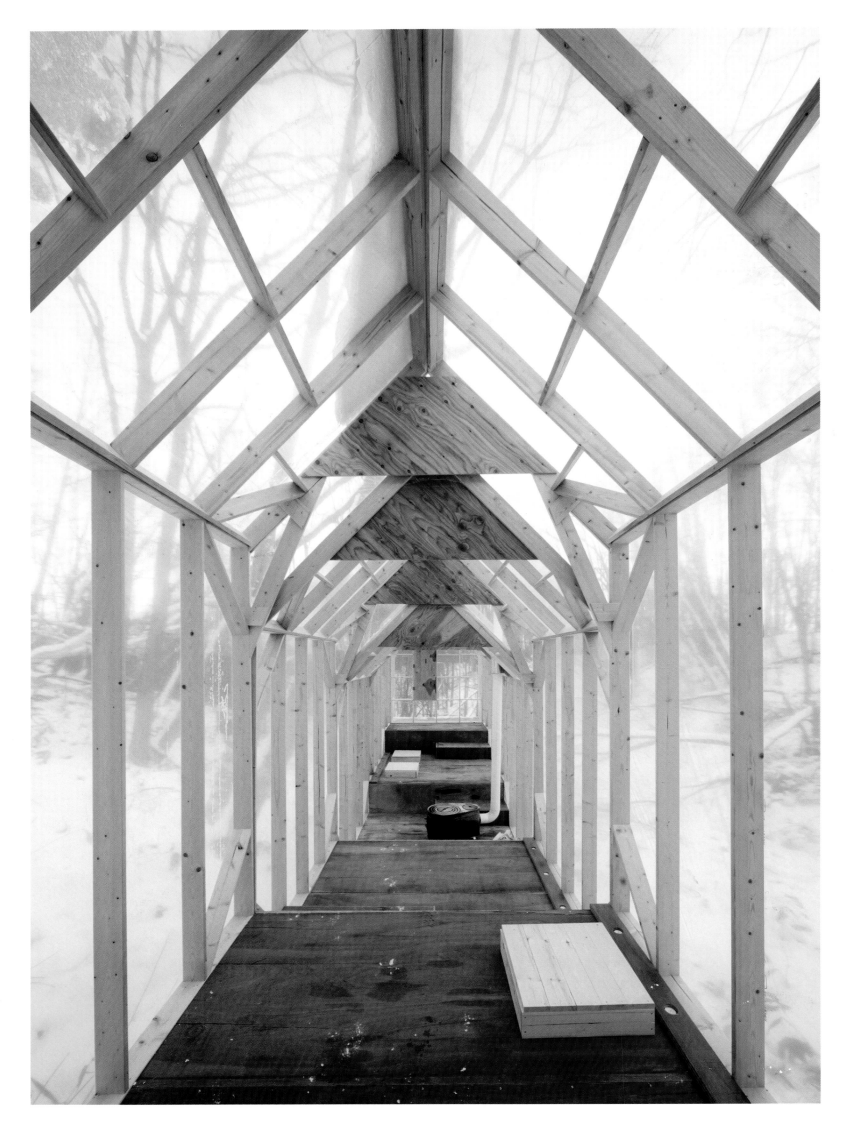

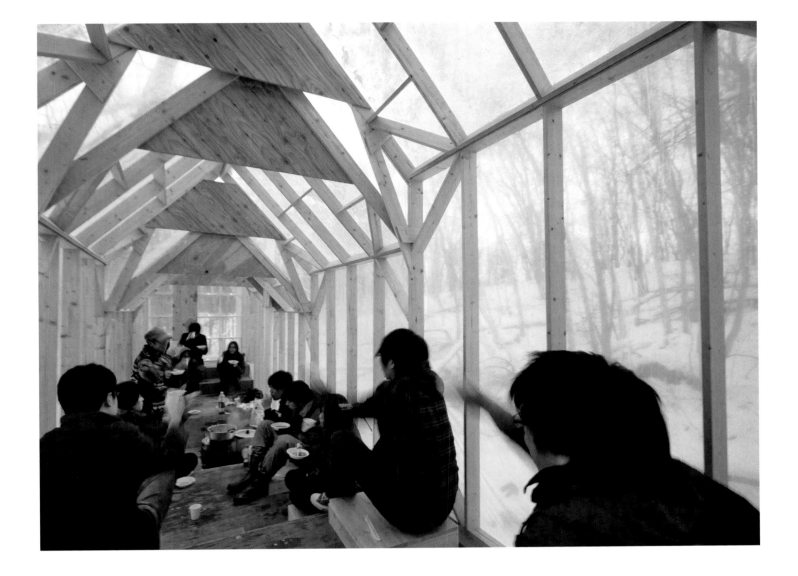

The architect states: "This fragile shelter in a wild environment is a wonderfully cozy, empathetic space when a number of people are gathered inside."

Der Architekt: „Der fragile Zufluchtsort inmitten der Wildnis ist ein herrlich gemütlicher, empathischer Raum, sobald sich Menschen in ihm versammeln."

L'architecte déclare : «Cet abri fragile dans un environnement rude et sauvage devient un espace merveilleusement sympathique et douillet lorsqu'un grand nombre y est réuni. »

# FRANKE-MIRZIAN BUNKHOUSE

Area: 9.3 m² | Clients: Joseph Franke, Carlo Mirzian | Cost: $20 000

The Franke-Mirzian Bunkhouse structure was designed and fabricated to be used as a Mafcohouse presentation booth for the Cottage Life trade show in Toronto. After the show, the structure was reused as a permanent cabin on Drag Lake, Haliburton. A flat 4.3-meter-square roof is cantilevered over the structure, which has large deck doors. The primary source of heat is a high-efficiency wood stove, and photovoltaic panels are used for lighting. The interior is finished in Douglas fir. For the outside, corrugated-steel siding and cedar decking are used.

—

Das Franke-Mirzian Bunkhouse wurde für einen Präsentationsstand von Mafcohouse anlässlich der Messe „Cottage Life" in Toronto entworfen und gebaut. Nachdem die Messe zu Ende war, kam das Haus als ständige Übernachtungsmöglichkeit am Drag Lake, Haliburton, erneut zum Einsatz. Das Flachdach kragt auf einer Fläche von 4,3 m² über den Bau hinaus, der über große Terrassentüren verfügt. Hauptwärmequelle ist ein hocheffizienter Holzofen. Eine Fotovoltaikanlage sorgt für Strom. Der Innenraum ist mit Douglasienholz verkleidet, für den Außenbereich kamen Wellblechverkleidung und für den Boden der Veranda Zedernholz zum Einsatz.

—

Le « baraquement » Franke-Mirzian a été conçu et fabriqué par Mafcohouse comme une cabine de présentation à la foire commerciale Cottage Life de Toronto et a ensuite été réutilisée comme chambre permanente au bord du lac Drag (Haliburton). Un toit plat carré de 4,3 m² est posé en encorbellement sur la structure aux larges portes-fenêtres coulissantes. Le chauffage est assuré principalement par un poêle à bois à haute efficacité, des panneaux photovoltaïques fournissent l'éclairage. Les finitions intérieures sont en sapin de Douglas. L'extérieur est bardé d'acier ondulé avec un revêtement en cèdre pour la véranda.

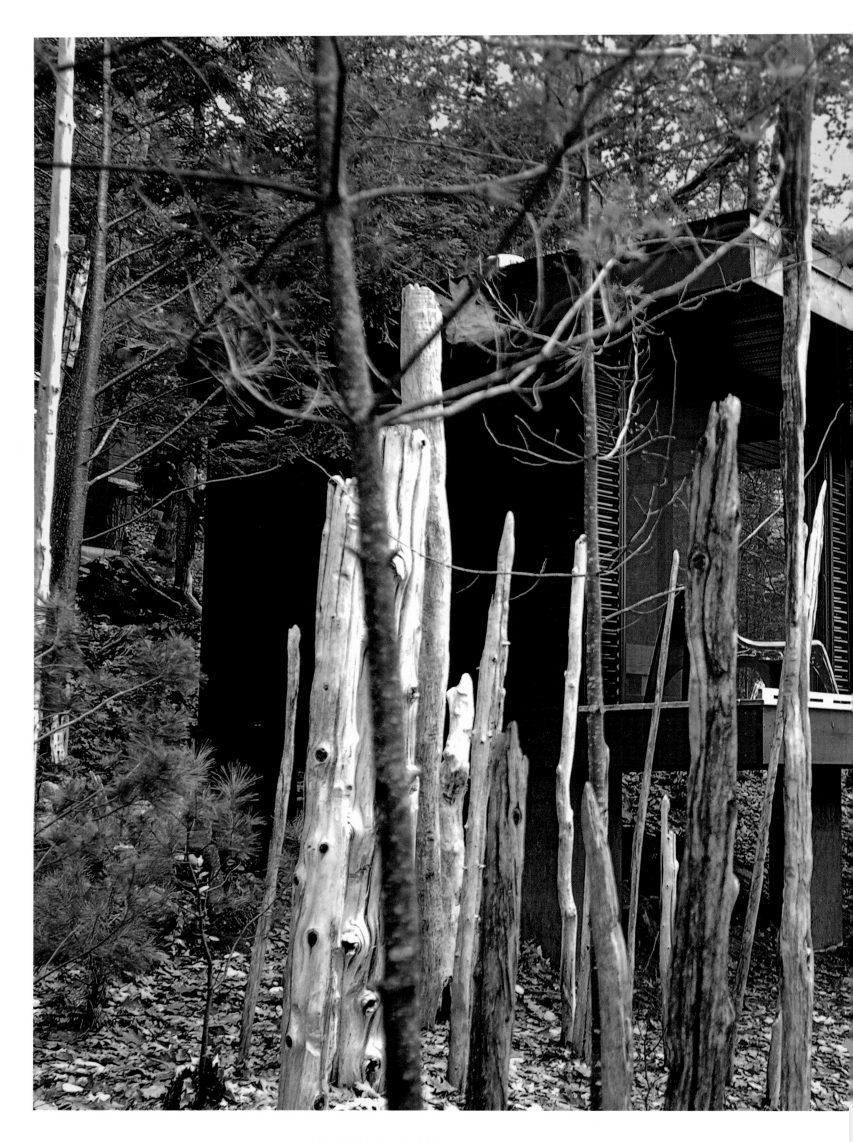

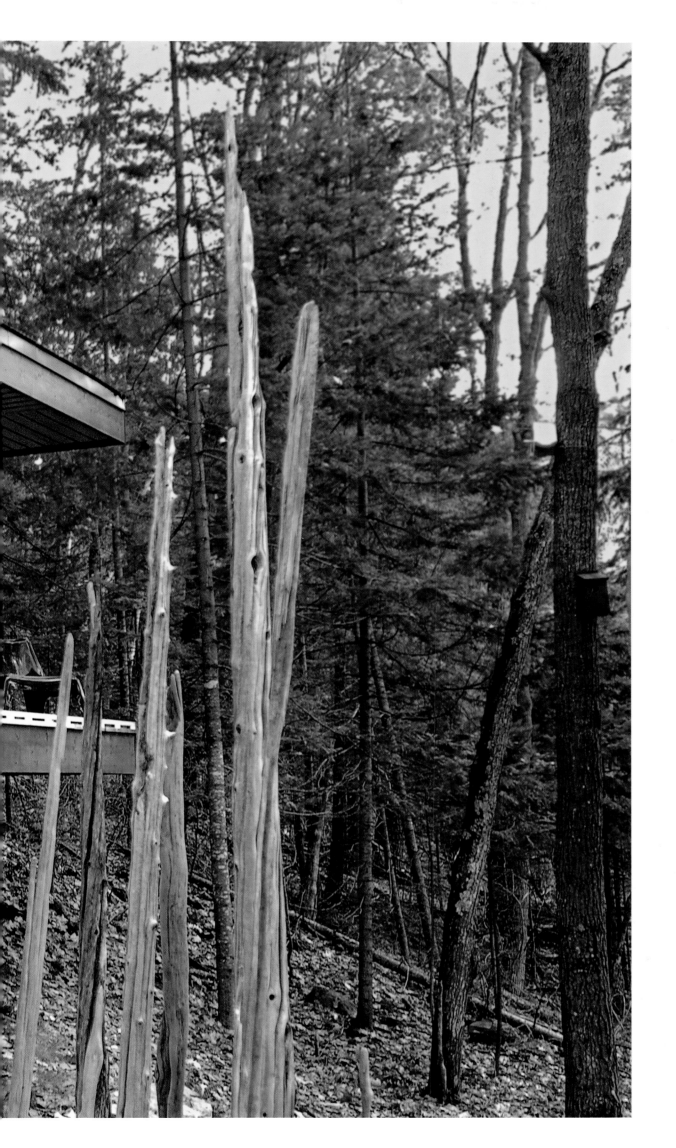

This house sits on four concrete piers with a post-and-beam super-structure. The exterior is in corrugated metal with a cedar deck.

Dieses Haus ruht auf vier Betonpfeilern mit einem Pfosten-Riegel-Aufbau und verfügt über eine Zedernholzterrasse und eine Wellblechfassade.

La maison est posée sur quatre piliers de béton avec une superstructure à poteaux et poutres. L'extérieur est en métal ondulé avec ue véranda en cèdre.

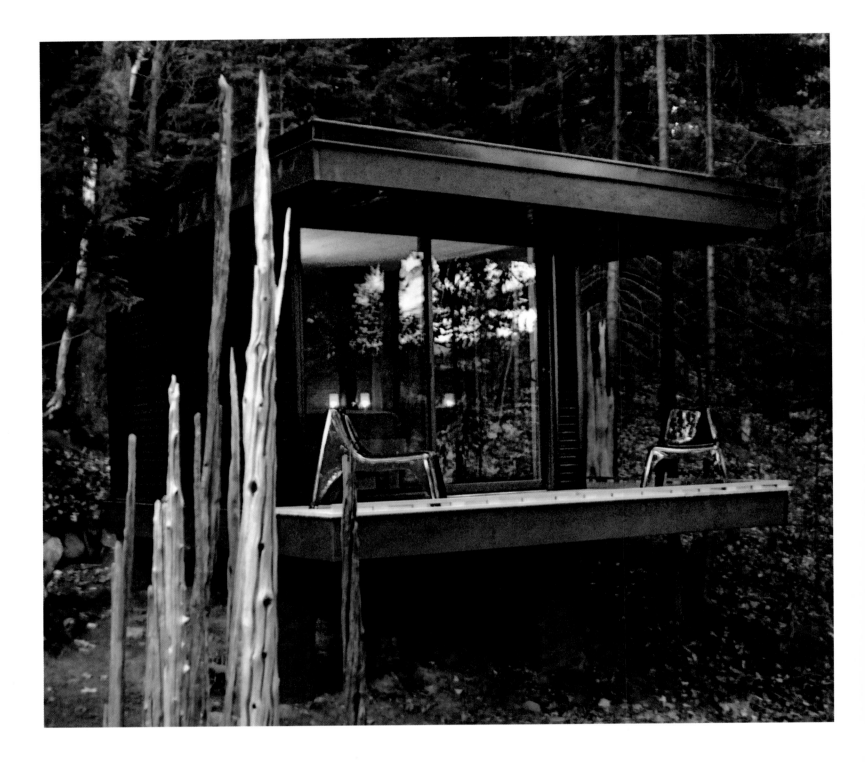

The plan is square with terraces on two sides that extend the square form. Right, interiors are in Douglas fir paneling.

Der Grundriss ist quadratisch mit Terrassen auf zwei Seiten, welche die quadratische Form erweitern. Der Innenraum rechts ist mit Douglasienholz verkleidet.

Le plan carré est prolongé par des terrasses sur deux côtés. À droite, l'intérieur est lambrissé en sapin de Douglas.

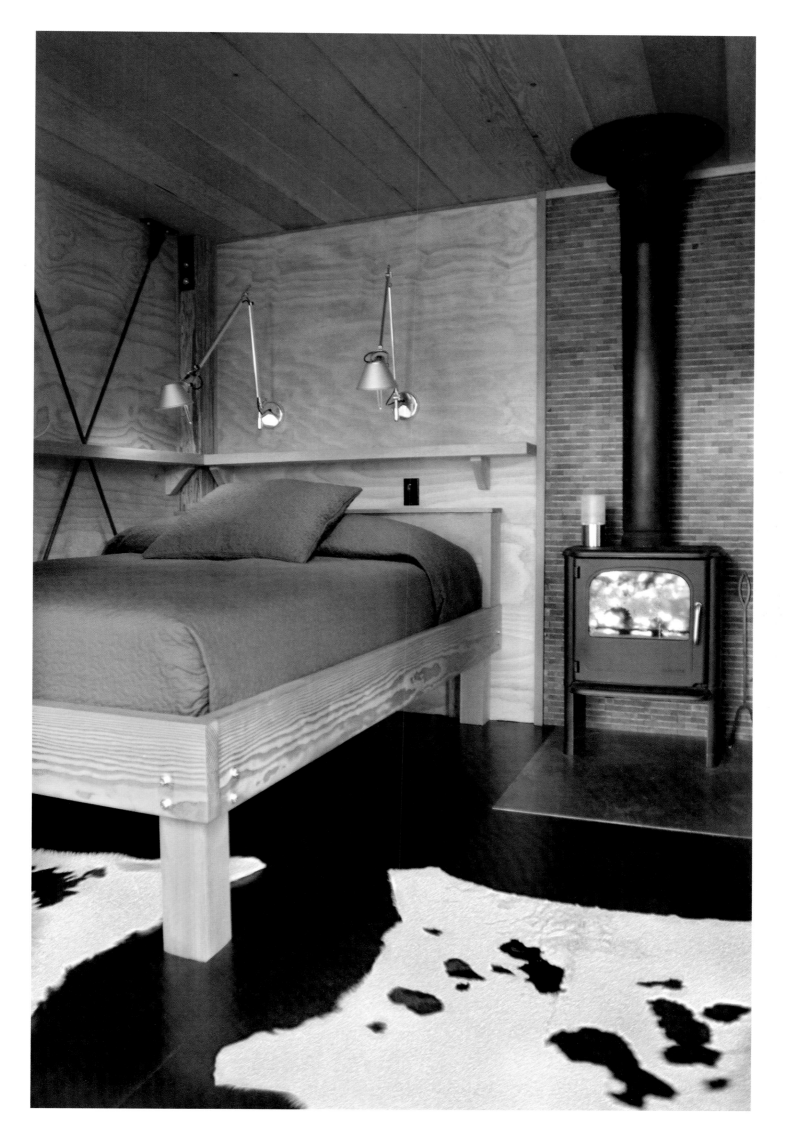

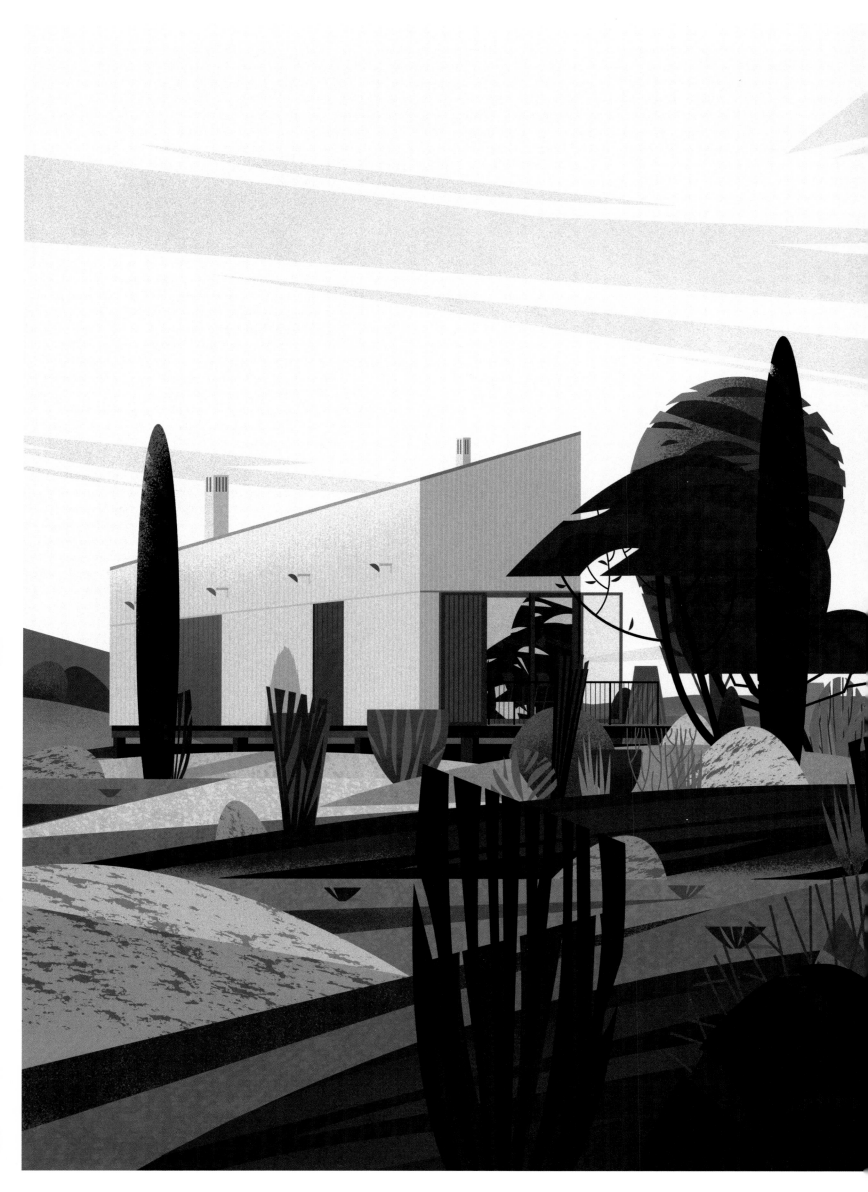

# GAROZA HOUSE

Area: 75 m² | Collaboration: Verónica Meléndez, Margarita Martínez, Paula Vega

According to the architect, Garoza House was "conceived as an industrialized, scalable, and growing prototype, which is adapted to its users´ basic and specific requirements, and that is ready to become larger as do their needs and interests." This first phase includes a double-height interior space for living, cooking, and eating. The corners, mezzanines, and transition spaces are presently being used for sleeping, work, and storage. A "non-proportional terrace" is imagined as a "piece of the artificial landscape created by the house." The house was manufactured at specialized factories using three-meter-wide modules. It is meant to have an "urban," technical quality with floor heating and home automation. "Conceiving an object according to contemporary aesthetics and technology, and placing it in nature, is a gesture that could be closer to art than to the tradition of building a house as the classic method of appropriating the place," according to the architect.

——

Dem Architekten zufolge wurde die Casa Garoza „als industrieller und skalierbarer Prototyp konzipiert, der sich an die grundlegenden und besonderen Anforderungen seiner Nutzer anpasst und mit ihren Bedürfnissen und Ansprüchen wächst". Die erste Phase des Projekts verfügt über einen Innenraum mit doppelter Raumhöhe zum Wohnen, Kochen und Essen. Die Ecken, Mezzaningeschosse und Übergangsbereiche werden derzeit zum Schlafen und Arbeiten sowie als Stauraum genutzt. Die „nicht proportionale Terrasse" stellen sich die Architekten als „Teil der künstlichen Landschaft, die das Haus bildet" vor. Die Casa Garoza wurde in einer Spezialfabrik aus 3 m breiten Modulen gefertigt. Mit Fußbodenheizung und Gebäudeautomation soll es eine „urbane", technische Qualität besitzen. „Ein Objekt zu entwerfen und in der Natur zu platzieren, das sich an zeitgenössischer Formensprache und Technologie orientiert, ist eine Geste, die der Kunst vielleicht näher ist als der traditionelle Bau eines Hauses als klassische Methode zur Aneignung eines Orts."

——

L'architecte explique que la maison Garoza a été « conçue comme un prototype industrialisé, modulable et évolutif, adapté aux besoins fondamentaux et spécifiques de ses utilisateurs et prêt à croître avec leurs exigences et leurs intérêts ». La première phase présentée ici comprend un espace intérieur double hauteur destiné au séjour, à la cuisine et aux repas. Les coins, les mezzanines et les espaces intermédiaires sont utilisés pour dormir, travailler et entreposer. Une « terrasse non proportionnelle » a été conçue comme un « élément du paysage artificiel créé par la maison ». L'ensemble a été fabriqué dans des usines spécialisées avec des modules larges de 3 m. La qualité technique se veut « urbaine » avec un chauffage au sol et un système domotique. « Le geste consistant à concevoir un objet fidèle à l'esthétique et à la technologie contemporaines pour le placer dans la nature est peut-être plus proche de l'art que de la tradition qui fait de la construction d'une maison la méthode par excellence pour s'approprier l'endroit », selon les termes de l'architecte.

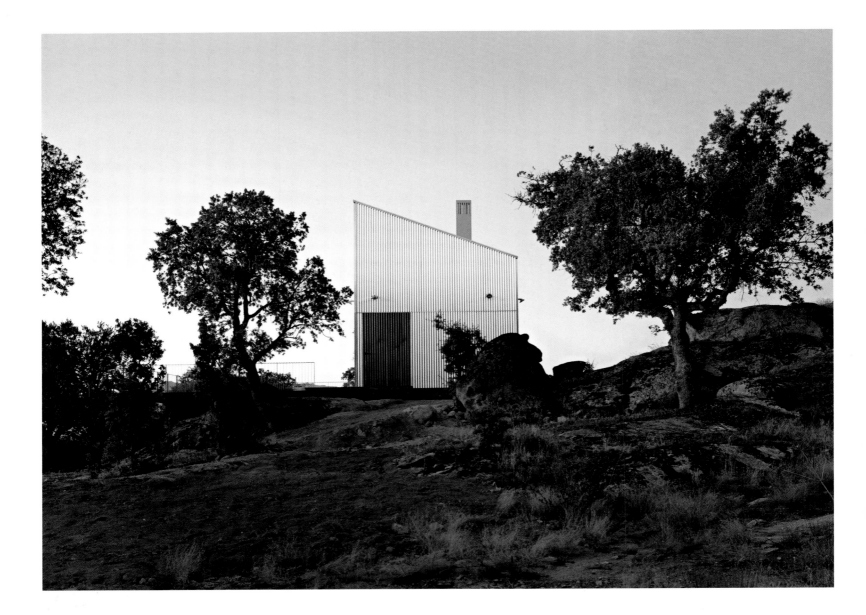

Intended as a prototype for residential construction, the house was manufactured in three-meter-wide modules to facilitate road transport. It sits lightly on the site, supported by adjustable pillars.

Dieses als Prototyp für den Wohnungsbau intendierte Haus wurde aus 3 m breiten Modulen gefertigt, um den Straßentransport zu erleichtern, und berührt auf justierbaren Stützen nur leicht seinen Standort.

Conçue comme un prototype de construction résidentielle, la maison a été fabriquée avec des modules de 3 m pour faciliter le transport par route. Elle est posée légèrement sur le sol, portée par des piliers réglables.

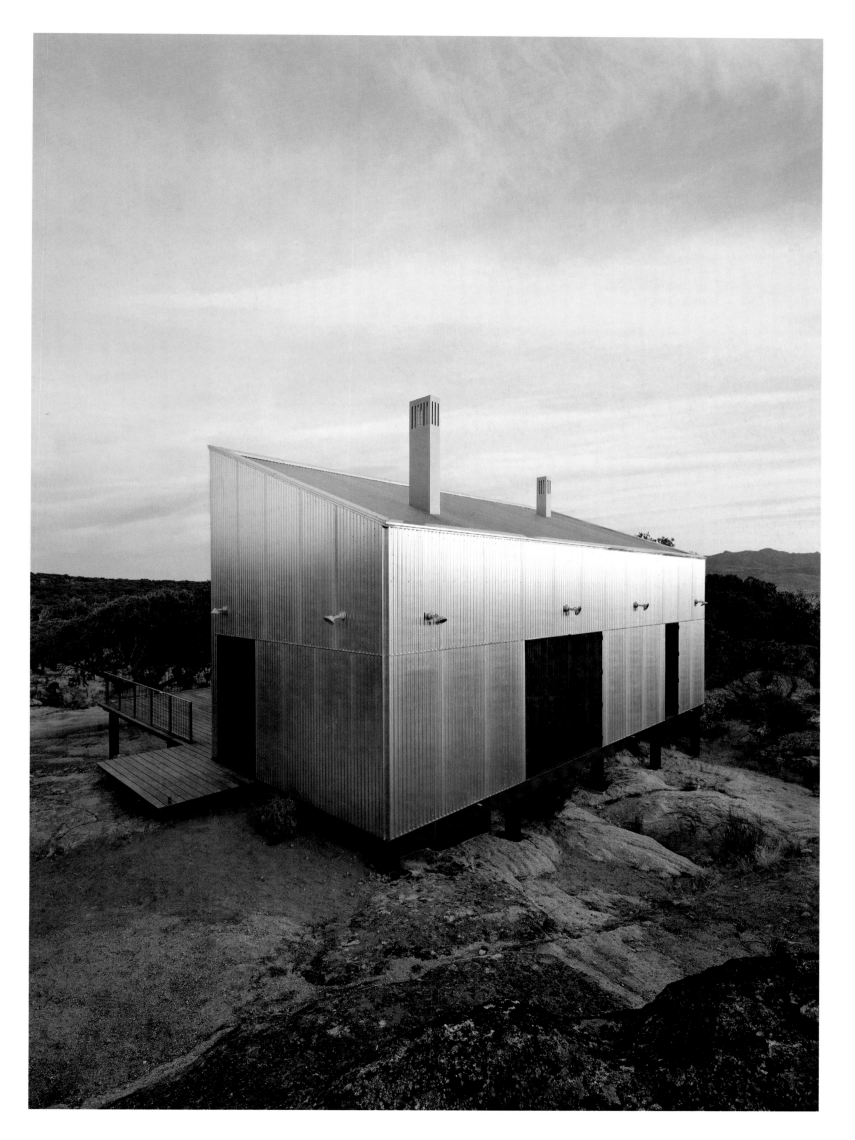

Interior partitions, storage spaces, and fixed furniture
are incorporated into the vertical walls. The basic
75-square-meter house costs €200 000.

Raumteiler, Stauraum und Einbaumobiliar sind in
die Wände integriert. Das einfache, 75 m² große Haus
kostet 200 000 €.

À l'intérieur, les cloisons, les espaces de rangement
et le mobilier fixe sont incorporés aux murs verticaux.
La maison de base, de 75 m², coûte 200 000 €.

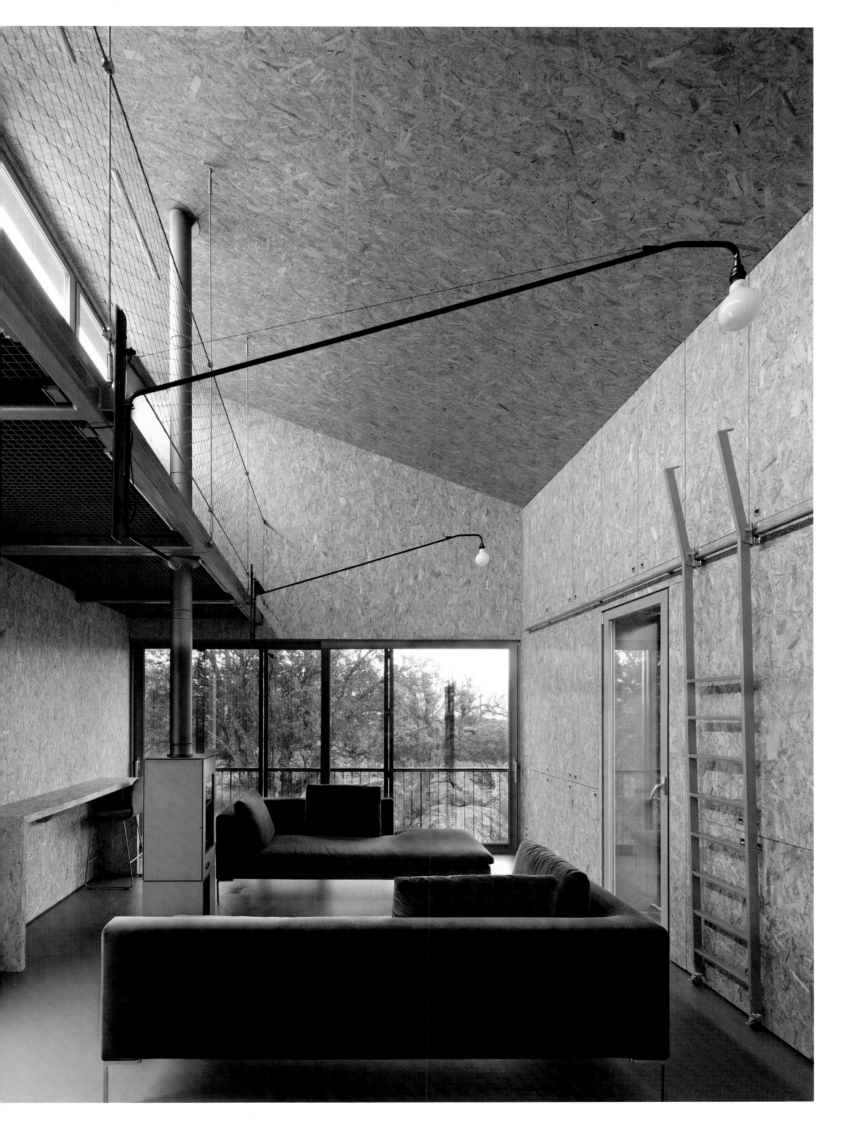

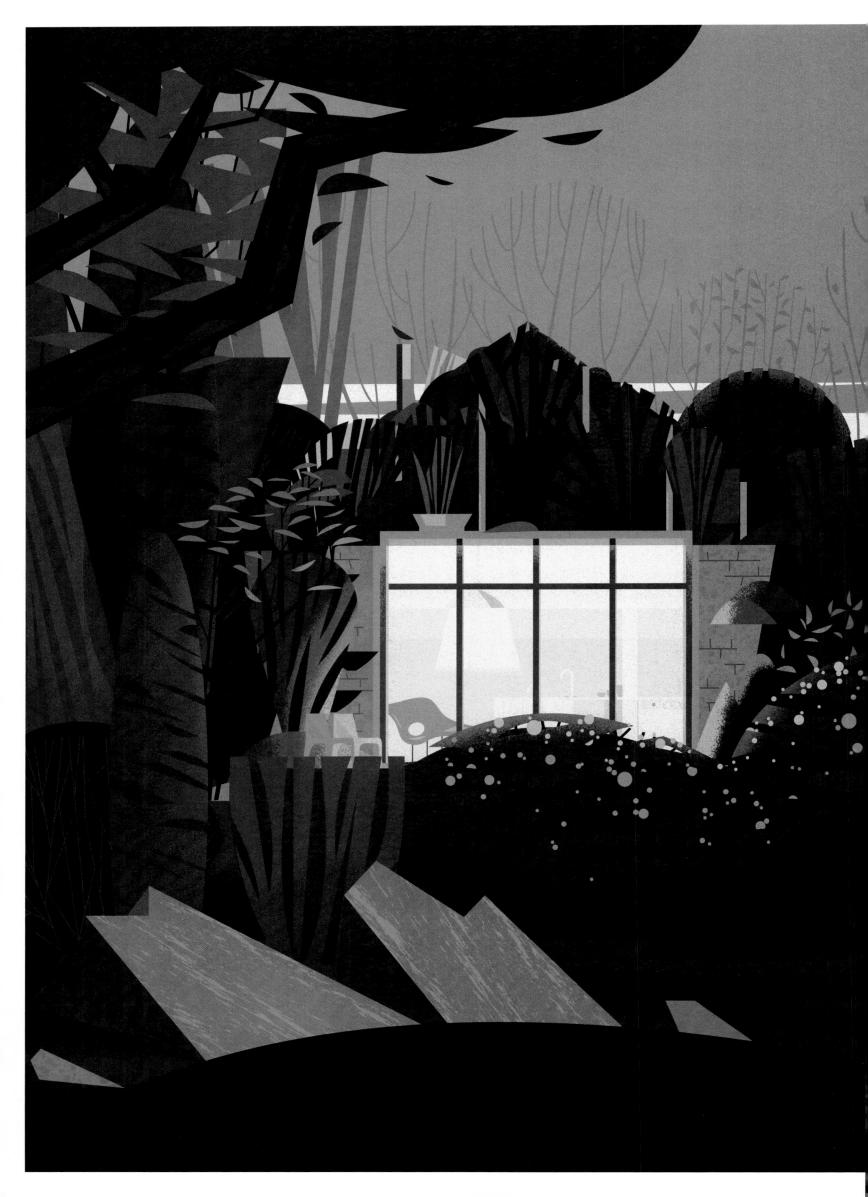

# GREEN BOX

Area: 40 m² | Cost: €48 000 | Collaboration: Erika Gaggia

This project involved the renovation of a small, unused garage, near a weekend house situated on the slopes of the Rhaetian Alps in north central Italy. Lightweight galvanized metal profiles and steel wires were wrapped around the existing volume, transforming it into a three-dimensional support for climbing vegetation. The varieties used are *Lonicera periclymenum* and *Polygonum baldshuanicum* for the main volume and *Humulus lupulus* with *Clematis tangutica* as secondary plantings. The pavilion contains a room for storing gardening tools. A galvanized steel kitchen is also part of the project with larch planks for flooring and large sliding doors. Windows are made with unpainted galvanized steel. The architects describe it as "a small green shelter in the vegetation, a privileged observation point of the changing of the seasons of the surrounding park."

Für dieses Projekt wurde eine kleine ungenutzte Werkstatt umgebaut, die in der Nähe eines Wochenendhauses auf den Hängen der Rätischen Alpen in Nordmittelitalien liegt. Der vorhandene Baukörper wurde rundum mit leichten, galvanisierten Metallprofilen und Stahldrähten versehen, sodass ein dreidimensionaler Klettergrund für verschiedene Pflanzen entstand. Verwendete Arten sind vor allem *Lonicera periclymenum* und *Polygonum baldshuanicum* für den größten Teil des Projekts und *Humulus lupulus* mit *Clematis tangutica* als Sekundärbepflanzung. In dem Pavillon befindet sich ein Lagerraum für Gartengerät. Außerdem ist das Projekt mit einer Küche aus galvanisiertem Stahl, Dielen aus Lärchenholz und großen Schiebetüren ausgestattet. Die Fenstereinfassungen bestehen aus unlackiertem, galvanisiertem Stahl. Die Architekten beschreiben die Green Box als „kleines, grünes, von Pflanzen umgebenes Refugium und günstig gelegenen Ort, um den Jahreszeitenwechsel im umgebenden Park zu beobachten".

Le projet comprend la rénovation d'un petit garage à l'abandon à côté d'une maison de campagne sur les flancs des Alpes rhétiques, dans le Nord de l'Italie centrale. Des profilés légers de métal galvanisé et des fils d'acier ont été enroulés autour du volume existant afin de le transformer en un support tridimensionnel pour plantes grimpantes. Les variétés utilisées sont *Lonicera periclymenum* et *Polygonum baldshuanicum* pour le volume principal, *Humulus lupulus* et *Clematis tangutica* en plantations secondaires. Le bâtiment abrite une pièce où ranger les ustensiles de jardinage. Il comprend également une cuisine en acier galvanisé, au sol en planches de mélèze et larges portes coulissantes. Les fenêtres sont en acier galvanisé sans peinture. Les architectes décrivent leur œuvre comme « un petit refuge vert au cœur de la végétation, un lieu privilégié pour observer le passage des saisons dans le parc environnant ».

This project is based on the reuse of an old garage. Light galvanized metal profiles and steel wire were used to turn the structure into a support for climbing vegetation.

Für dieses Projekt wurde eine alte Garage umgenutzt. Die Konstruktion besteht aus galvanisierten Leicht-metallprofilen sowie Stahldraht und dient als Kletterpflanzengerüst.

Le projet est basé sur la réutilisation d'un ancien garage. La structure consiste en profilés légers de métal galvanisé et fils d'acier qui ont été enroulés afin de servir de support aux plantes grimpantes.

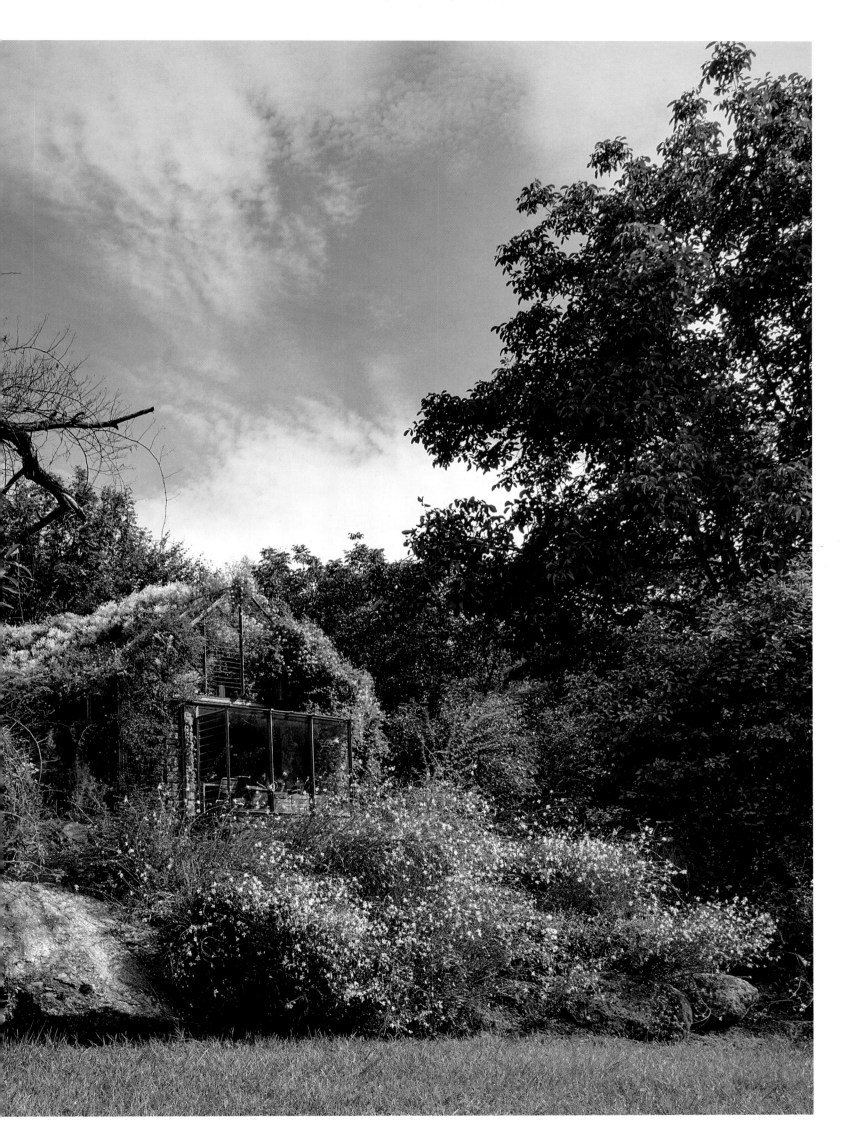

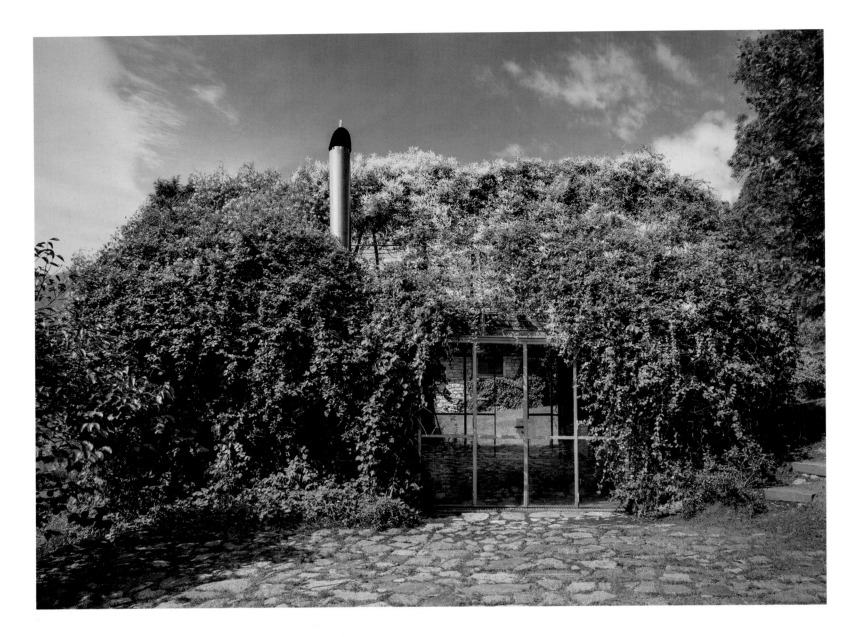

Interiors are used to store gardening tools but also include a kitchen and an area to receive guests. The flooring is made of larch planks in the spaces seen here.

In den Innenräumen lagert Gartengerät, es gibt aber auch eine Küche und einen Bereich für den Empfang von Gästen. Für Boden und Räume auf dieser Seite wurden Lärchenbretter verwendet.

L'intérieur sert à ranger les ustensiles de jardinage, mais comprend aussi une cuisine et un espace où recevoir des invités. Des planches de mélèze ont été utilisées pour les sols des espaces qu'on voit ici.

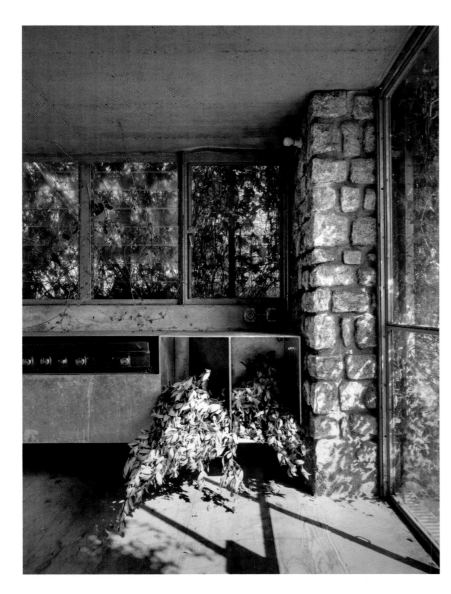

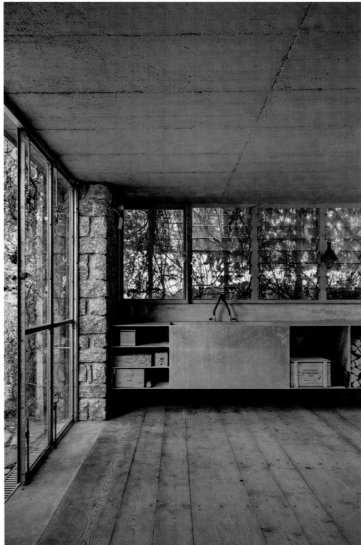

The architects state: "Materials are left rough and simple, galvanized steel for the kitchen … and large sliding doors, windows in unpainted galvanized steel, simple pipes for the water supply."

Die Architekten: „Die Materialien sind unbearbeitet und einfach: galvanisierter Stahl für die Küche… und große Schiebetüren, Fenster aus unlackiertem galvanisiertem Stahl, einfache Rohrleitungen für die Wasserversorgung."

Les architectes déclarent: « Les matériaux ont été laissés à l'état brut et simple, avec de l'acier galvanisé pour la cuisine… et de larges portes coulissantes, des fenêtres en acier galvanisé sans peinture et de simples tuyaux pour l'alimentation en eau. »

**AATA**
Navidad, Licancheu [Chile]
2006

# GUESTHOUSE

Area: 26 m² | Client: Mario Cerda Sepúlveda | Cost: €15 800

The basic form of this guesthouse is a two-story wooden cube with 5.4-meter-long sides. The intention of the architects was to create "an example of low-energy consumption and minimal carbon footprint." The orientation of the structure, location of its windows, solar gain, and insulation were all carefully studied. Windows allow as much sunlight in as possible during the winter months and are also situated to encourage natural airflow during the summer. Local bales of hay coated with mud were used for construction, for reasons of thermal efficiency and cost-cutting. The hay is protected from the rain by transparent polycarbonate. The roof of the building is covered with grass.

———

Dieses Gästehaus ist ein zweigeschossiger Holzkubus mit einer Seitenlänge von 5,4 m. Die Architekten wollten „ein Beispiel für niedrigen Energieverbrauch und eine gute $CO_2$-Bilanz" geben. Gebäudeausrichtung, Lage der Fenster, Sonnenerträge und Isolation wurden eingehend geplant. Die Fenster erlauben im Winter optimalen Lichteinfall und im Sommer natürliche Durchlüftung. Wegen des Wärmehaushalts und der geringen Kosten wurden für den Bau mit Lehm überzogene Heuballen aus der Region verwendet. Transparentes Polycarbonat schützt die Ballen vor Regen. Das Gebäudedach ist mit Gras bewachsen.

———

La maison d'hôtes présente la forme de base d'un cube en bois de 5,4 m à deux niveaux. Les architectes voulaient créer « un exemple de basse consommation énergétique et empreinte carbone minimale ». Pour cela, l'orientation du bâtiment, l'emplacement des fenêtres, l'apport solaire et l'isolation ont été soigneusement étudiés. Les fenêtres font entrer le plus de soleil possible pendant les mois d'hiver et sont situées de manière à favoriser la circulation de l'air en été. Pour des raisons de rendement thermique et de coût, des balles de chaume local recouvertes de boue et protégées de la pluie par un polycarbonate transparent ont été utilisées. Le toit est planté d'herbe.

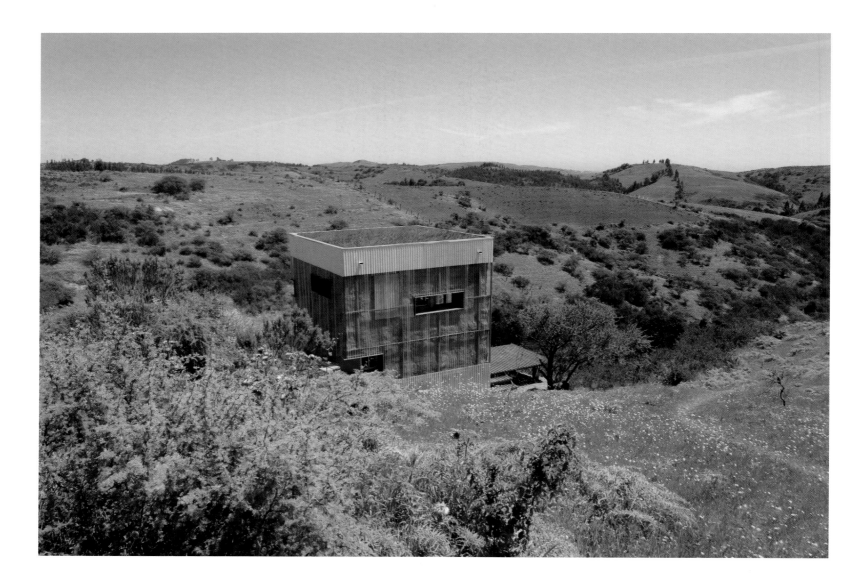

This small (26-square-meter) structure cost €15 800 to build. The two-story structure constitutes a wooden cube whose sides are 5.4 meters long.

Der Bau dieses kleinen Gebäudes (26 m²) kostete 15 800 €. Es handelt sich um einen zweigeschossigen Würfel mit einer Seitenlänge von 5,4 m.

Cette petite (26 m²) structure coûte 15 800 € à construire. L'ensemble à deux niveaux forme un cube en bois de 5,4 m.

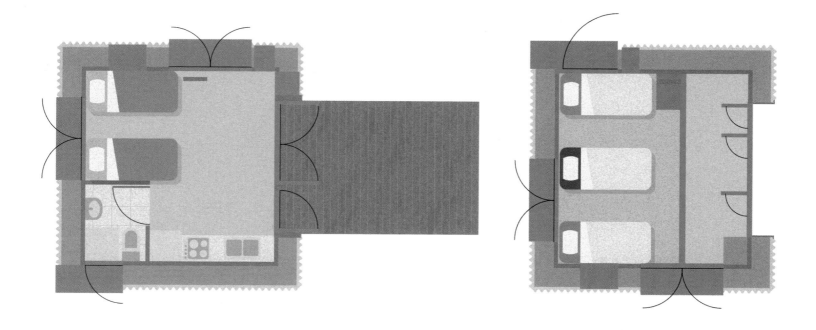

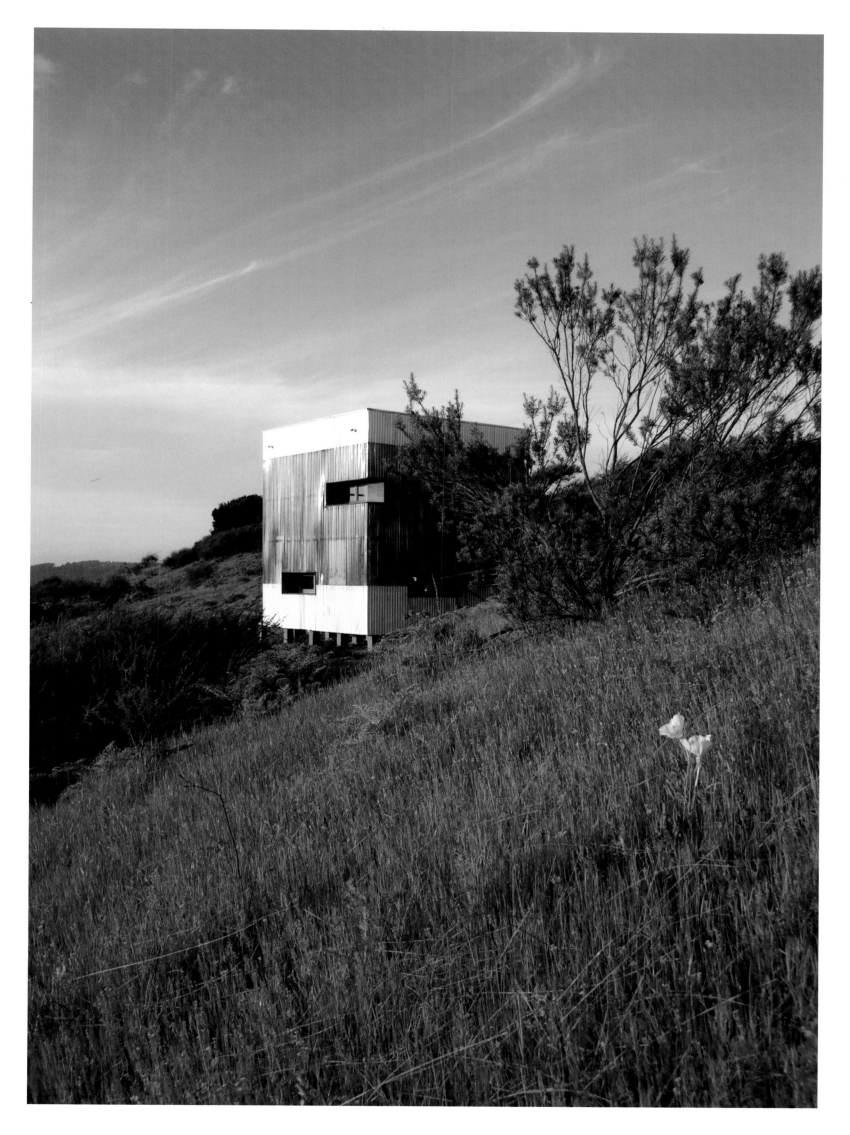

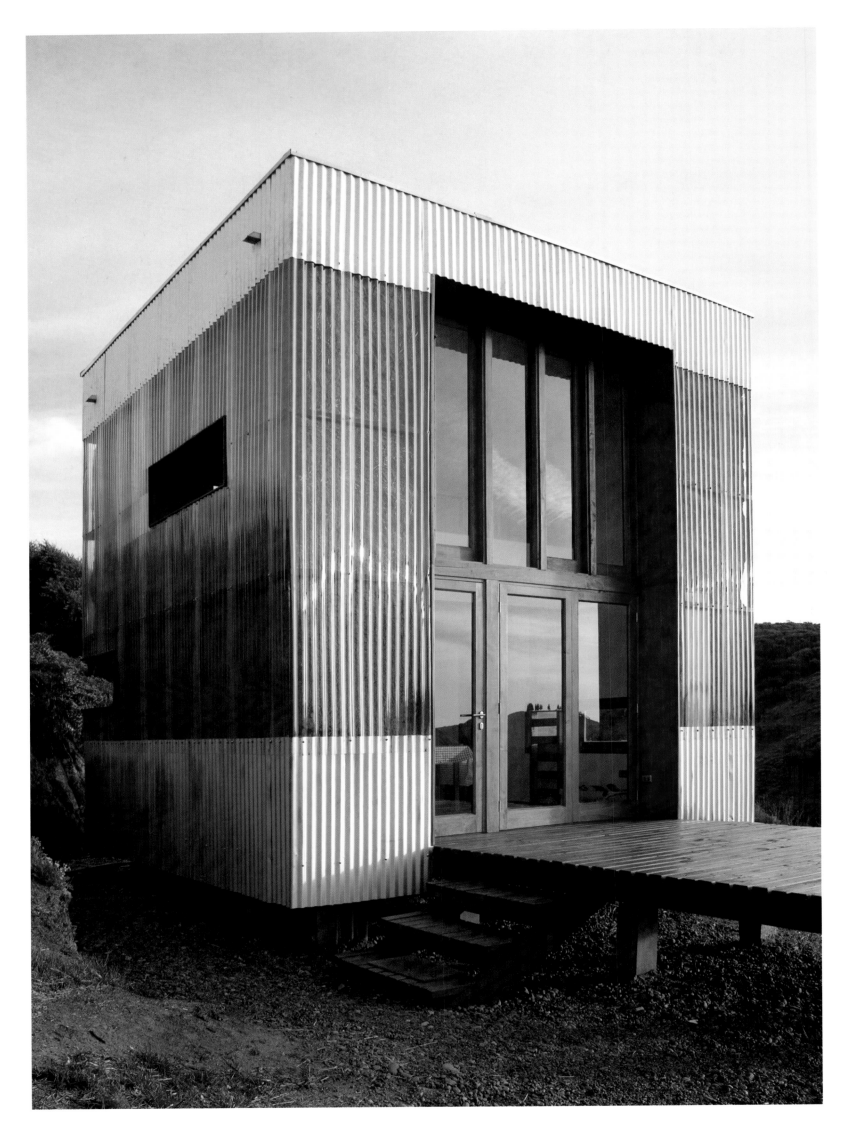

Transparent corrugated polycarbonate cladding covers straw and mud walls. Inside, window placement was studied to provide maximum winter light and cross-ventilation in summer.

Eine transparente Gebäudehülle aus gewelltem Poly-carbonat bedeckt die Stroh- und Lehmwände. Die Fenster wurden so platziert, dass im Winter möglichst viel Licht einfällt und im Sommer Durchzug gewähr-leistet ist.

Un revêtement de polycarbonate ondulé transparent recouvre des murs de chaume et de boue. À l'intérieur, l'emplacement des fenêtres a été étudié pour faire entrer le plus de soleil possible pendant les mois d'hiver et favoriser la circulation transversale en été.

**JOSEPH BELLOMO**
Kailua-Kona, Big Island, Hawaii [USA]
2011

# HOUSE ARC

Area: 23 m² | Client: Circle Palo Alto | Cost: $45 000

Assembled in just three days, this house was built using cold, rolled, galvanized steel, cedar and polycarbonate siding, aluminum doors and windows, as well as photovoltaic panels. The modular system uses bent-steel ribs in an "environmentally sensitive and affordable" design, which, in this instance, was assembled on an 8000-square-meter site on the western side of the Big Island of Hawaii. Raised above grade on piers, House Arc has large windows and was built near an existing swimming pool.

———

Montiert wurde dieses Haus innerhalb von nur drei Tagen mit kalt galvanisiertem Stahl, einer Verkleidung aus Zedernholz und Polycarbonat, Aluminiumtüren und -fenstern sowie einer Fotovoltaikanlage. Das modulare System besteht aus gebogenen Stahlrippen, denen ein „umweltfreundliches und kostengünstiges" Design zugrunde liegt. House Arc wurde auf einem 8000 m² großen Gelände im westlichen Teil der Insel Hawaii auf Stützen und mit großen Fenstern neben einem bestehenden Swimmingpool errichtet.

———

Assemblée en seulement trois jours, cette «maison» est en acier galvanisé laminé à froid, cèdre et bardage de polycarbonate, avec des portes et fenêtres en aluminium et des panneaux photovoltaïques. Le système modulaire utilisé applique des cintrages d'acier courbes à un design «respectueux de l'environnement et abordable» sur un terrain de 8000 m², du côté ouest de la grande île d'Hawaii. Surélevée hors sol par des piliers, House Arc possède de larges fenêtres et a été construite à côté d'une piscine.

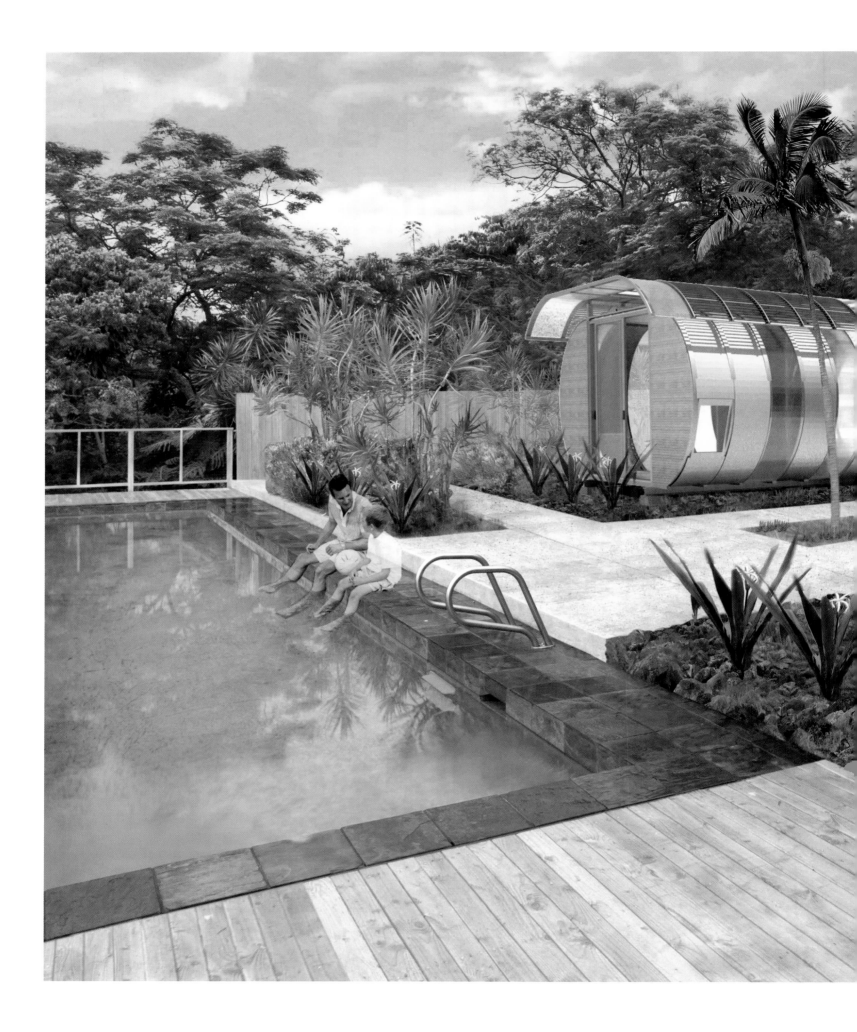

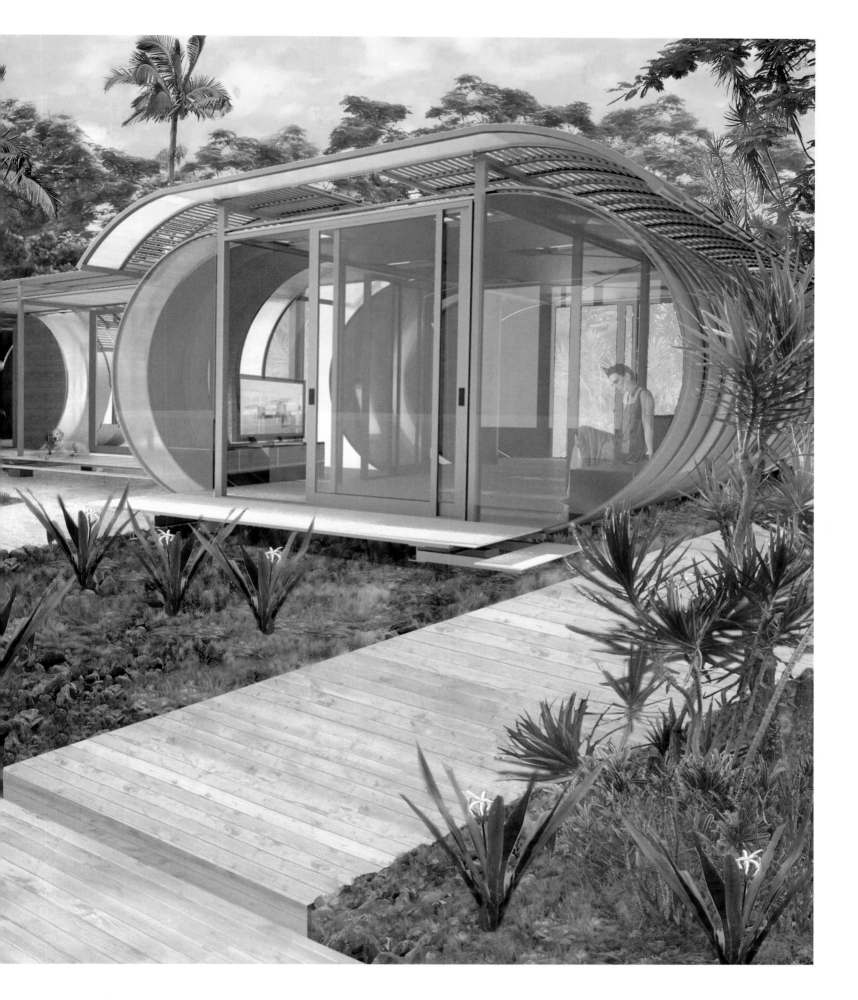

House Arc was designed with a modular system of bent-steel tubes, aiming to create "an environmentally sensitive and affordable method of housing people."

House Arc wurde als modulares System aus gebogenen Stahlröhren mit dem Ziel entworfen, eine „umweltfreundliche und kostengünstige Methode zur Schaffung von Wohnraum" zu entwickeln.

House Arc a été conçue avec un système modulaire de tubes d'acier courbes dans le but de créer «un moyen écologique et abordable de loger les gens».

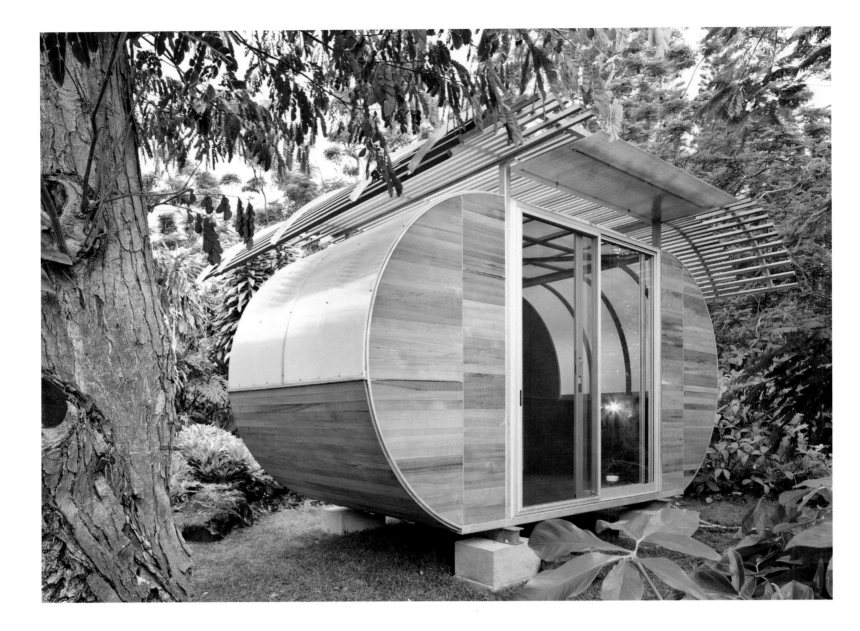

The Shelter Arc is envisaged as an accessory building standing apart from the larger structures.

Shelter Arc ist als freistehendes Nebengebäude für größere Bauten vorgesehen.

L'abri est prévu pour tenir lieu de bâtiment annexe à l'écart de structures plus importantes.

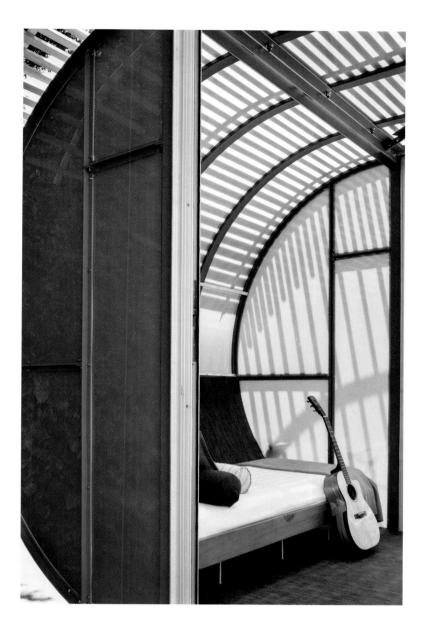

Solar panels and shading trellises line the outer part of the structures. The modular design would allow for the system to be used for emergency housing in natural-catastrophe areas.

Auf dem Dach der Gebäude befinden sich Solarkollektoren und Schattengitter. Das modulare Design ermöglicht eine Nutzung als Notunterkunft in Katastrophengebieten.

La structure est doublée à l'extérieur par des panneaux solaires et des treillages qui l'ombragent. La conception modulaire est censée permettre au système d'être utilisé comme logement d'urgence dans les régions touchées par des catastrophes naturelles.

# HUSTADVIKA TOOLS

Area: 15 m² | Clients: Tormod Nikkerud, Anne Felde | Cost: €24 500

The architects explain that the project was conceived "both as an answer to the clients' need for a wind-and-rain shelter at their outdoor summer house-piazza, and as a combined toolshed and special-occasion, sleep-under-the-stars facility." Located on the far northwestern coast of Norway, the structure is subjected to harsh weather conditions. Tar-coated wood panels, like those used for local boats, form the exterior of the structure. The rear walls of the shed are made of glass to provide an ocean view. The upper glass roof of the main part of the structure can be opened when weather permits.

———

Der Entwurf für dieses Projekt ist den Architekten zufolge „eine Antwort auf den Wunsch der Auftraggeber nach einem Unterstand zum Schutz vor Wind und Regen auf der Terrasse ihres Sommerhauses und nach einem Geräteschuppen, der bei besonderen Anlässen zugleich als Schlafmöglichkeit unter den Sternen dienen sollte". Das Projekt liegt an der Nordwestküste Norwegens und ist einer rauen Witterung ausgesetzt. Für die Außenwände kamen geteerte Holzplanken zum Einsatz, wie beim Bootsbau in der Region. Der Schuppen verfügt über gläserne Rückwände für einen freien Meerblick. Das Glasdach des Hauptbaus kann bei entsprechendem Wetter geöffnet werden.

———

Les architectes présentent leur projet « à la fois comme une réponse au besoin du client d'un abri du vent et de la pluie pour la terrasse de sa maison de vacances et comme une cabane à outils associée à un dortoir à la belle étoile occasionnel ». Située sur la côte de l'extrême Nord-Ouest de la Norvège, la construction est soumise à des conditions météorologiques très rudes. Des panneaux de bois goudronné, comme ceux qui sont utilisés dans la région pour les bateaux, en forment l'extérieur. Les parois arrière sont en verre pour la vue sur l'océan. Le toit en verre de l'élément principal peut être ouvert si le temps le permet.

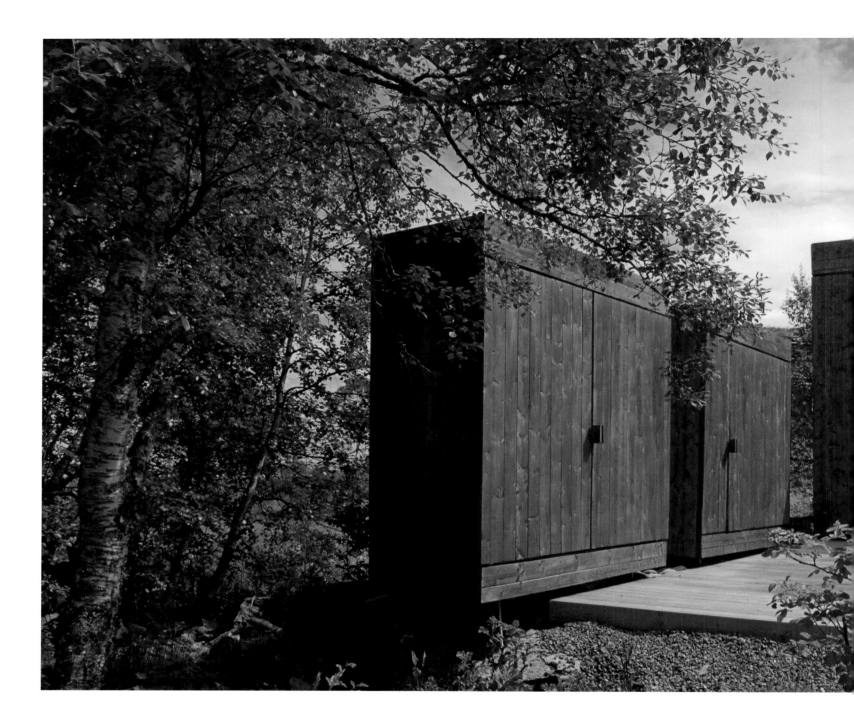

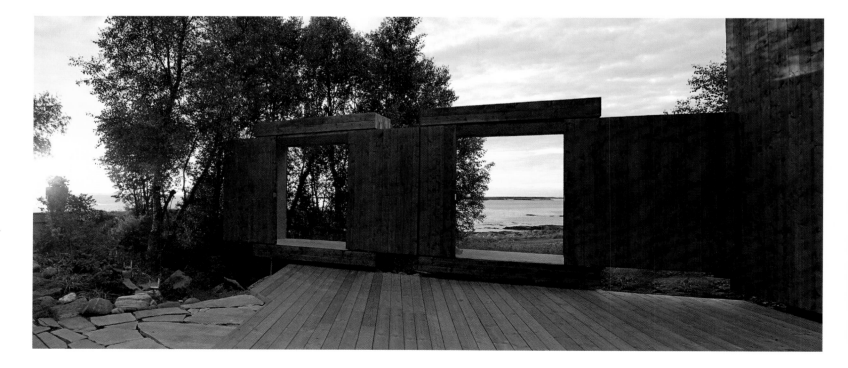

The architects explain that this is a "combined toolshed and special-occasion, sleep-under-the-stars facility."

Den Architekten zufolge handelt es sich um „eine Kombination aus Geräteschuppen und Schlafmöglichkeit unter den Sternen für besondere Anlässe".

Les architectes expliquent qu'ils ont construit une « cabane à outils combinée à un dortoir à la belle étoile occasionnel. »

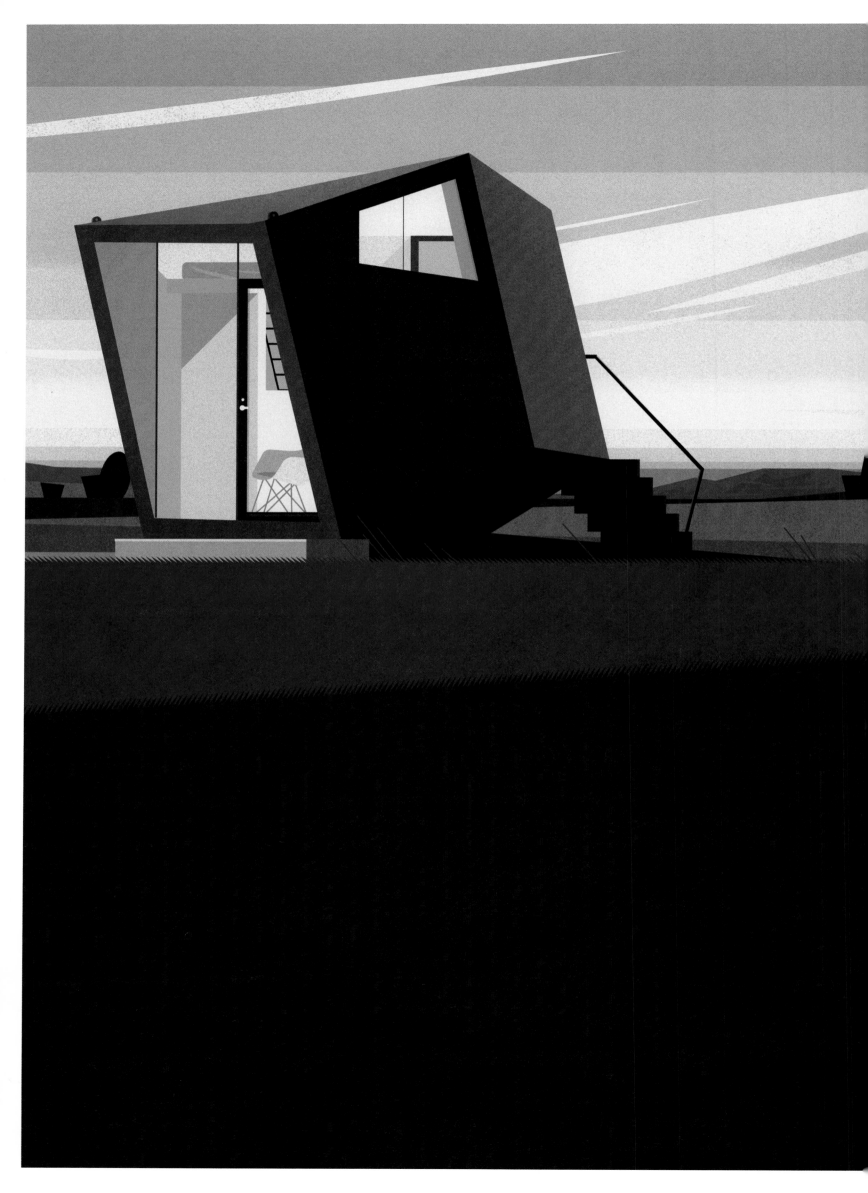

**STUDIO WG3**
Graz [Austria]
2010

# HYPERCUBUS

Area: 19 m² | Client: Studio WG3 | Cost: €63 500

The base of this mobile structure is a reinforced-concrete foundation. The box or framework on the concrete foundation is made of glued laminated timber, and the main material employed is plywood. The Hypercubus is a research project that is related to a thesis. The intention of WG3 was "to develop a minimal apartment intended for two people. Aimed at the area of tourism, the scheme entails industrial manufacturing, transport capability, interior space optimization, self-sufficiency, memorable and recognizable architecture, and economic efficiency." They began their work on this project in January 2010 and completed the prototype in May 2010. The prototype envisaged a module that can be vertically stacked to create a "hotel-like structure."

———

Das Fundament dieser mobilen Einheit besteht aus Stahlbeton, auf dem ein Rahmentragwerk aus Schichtholz ruht. Zum Einsatz kam vornehmlich Sperrholz. Bei dem Hypercubus handelt es sich um ein Forschungsprojekt im Rahmen einer Abschlussarbeit. Es war die Absicht von WG3, „ein kleines Apartment für zwei Personen zu entwickeln. Auf den Tourismus ausgerichtet, schließt der Entwurf industrielle Fertigung, Transportmöglichkeit, die Optimierung des Innenraums, Selbstversorgung, eine wiedererkennbare Architektur und ökonomische Effizienz ein." WG3 arbeiteten ab Januar 2010 an dem Projekt und stellten im Mai 2010 den Prototypen fertig, der vertikal angeordnet werden kann, um eine „hotelähnliche Anlage" entstehen zu lassen.

———

Des fondations en béton armé forment la base de cette structure mobile, surmontées du cube, ou ossature, en bois de charpente lamellé collé, le contreplaqué étant le principal matériau utilisé. L'Hypercubus est au départ un projet de recherche dans le cadre d'une thèse. L'intention de WG3 était « de développer un logement minimal pour deux personnes. Destiné au secteur touristique, l'ensemble associe la fabrication industrielle, la transportabilité, l'optimisation de l'espace intérieur, l'autosuffisance, une architecture originale et facilement reconnaissable et l'efficacité économique ». Les architectes ont commencé à travailler sur ce projet en janvier 2010 et le prototype a été achevé en mai 2010. Il prévoyait un module qui peut être empilé verticalement afin de créer une « structure de type hôtel ».

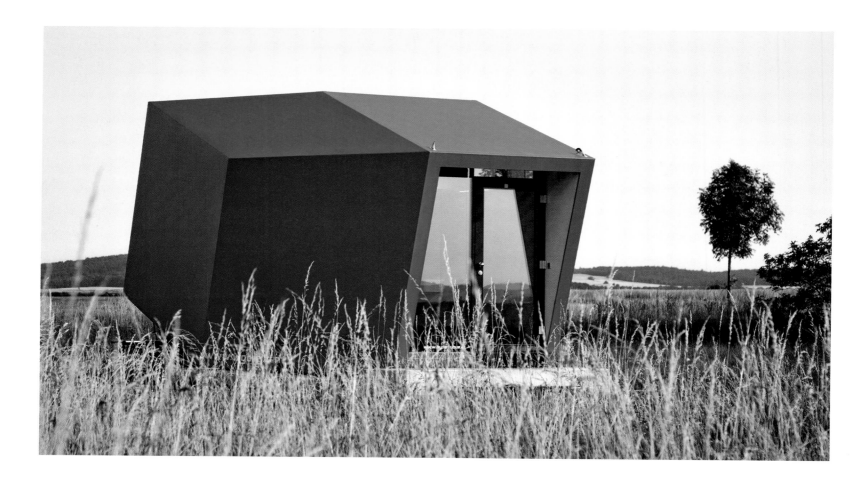

This project is based on a 3-D model created on a computer. The wood structure is then created on a CNC milling machine.

Das Projekt basiert auf einem 3D-Computermodell. Der Holzbau entstand mithilfe einer CNC-Fräse.

Le projet est basé sur un modèle 3D créé sur ordinateur. La structure de bois a ensuite été réalisée sur une fraiseuse à commande numérique.

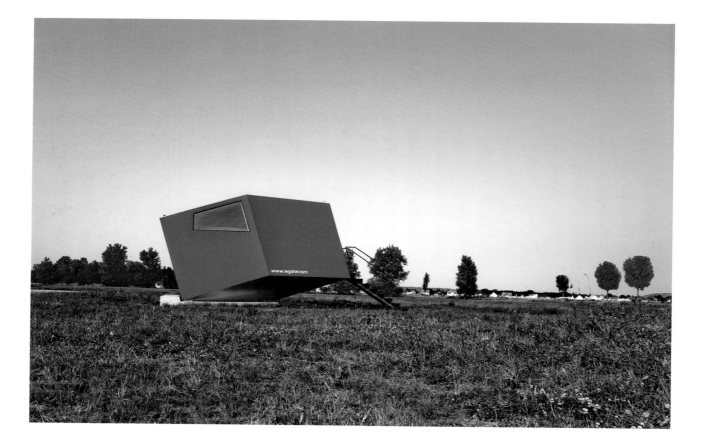

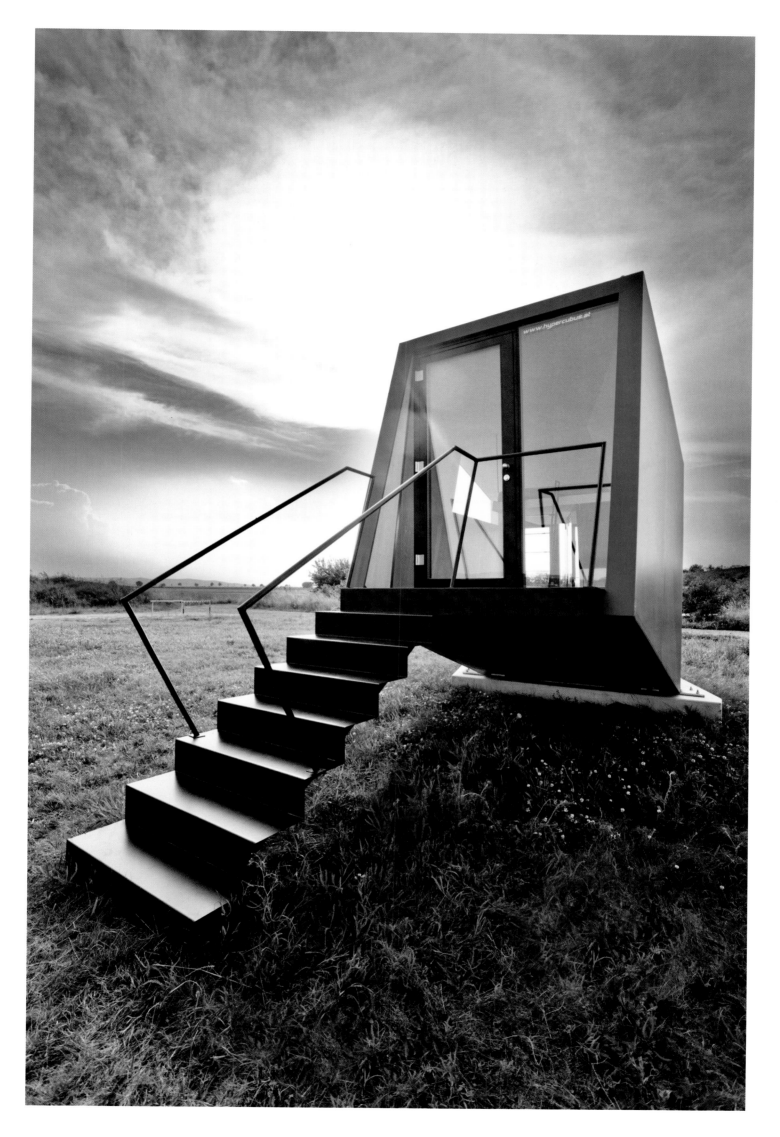

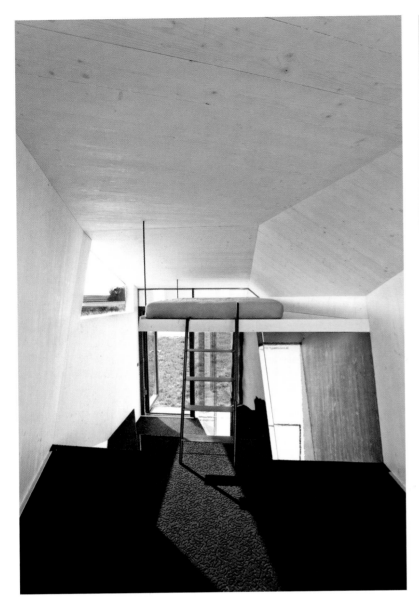

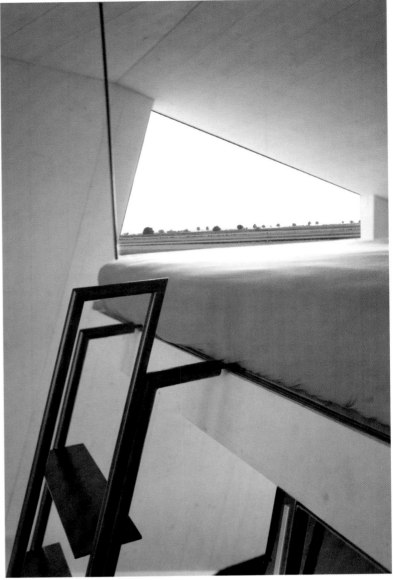

Interior floors are carpeted. Medium-density fiberboard is used for the kitchen furniture. The bathroom has a movable mirror box.

Die Böden sind mit Teppich ausgelegt, das Küchenmobiliar besteht aus Hartfaserplatten mittlerer Dichte und das Bad verfügt über eine bewegliche Spiegelbox.

À l'intérieur, les sols sont recouverts de moquette. Le mobilier de la cuisine est en panneaux de fibres de densité moyenne. La salle de bains est dotée d'un cube à miroirs mobile.

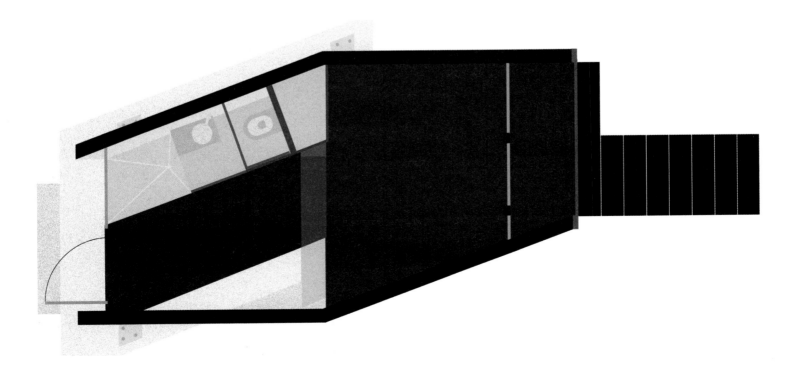

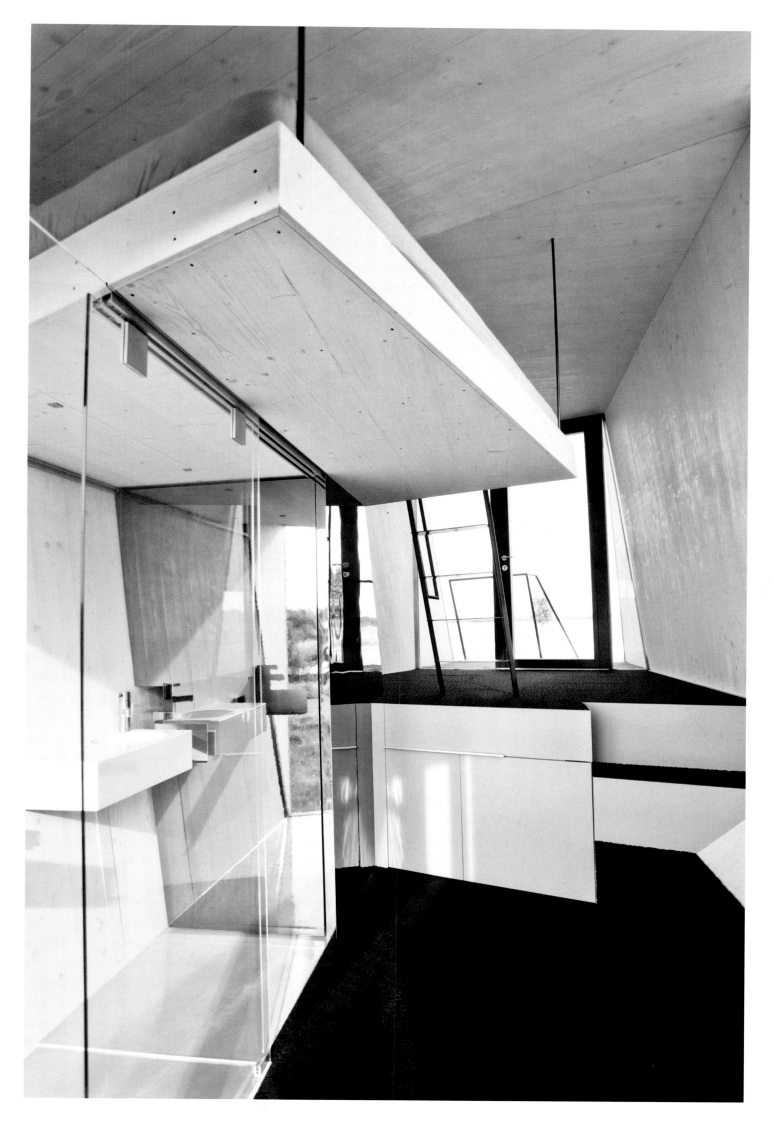

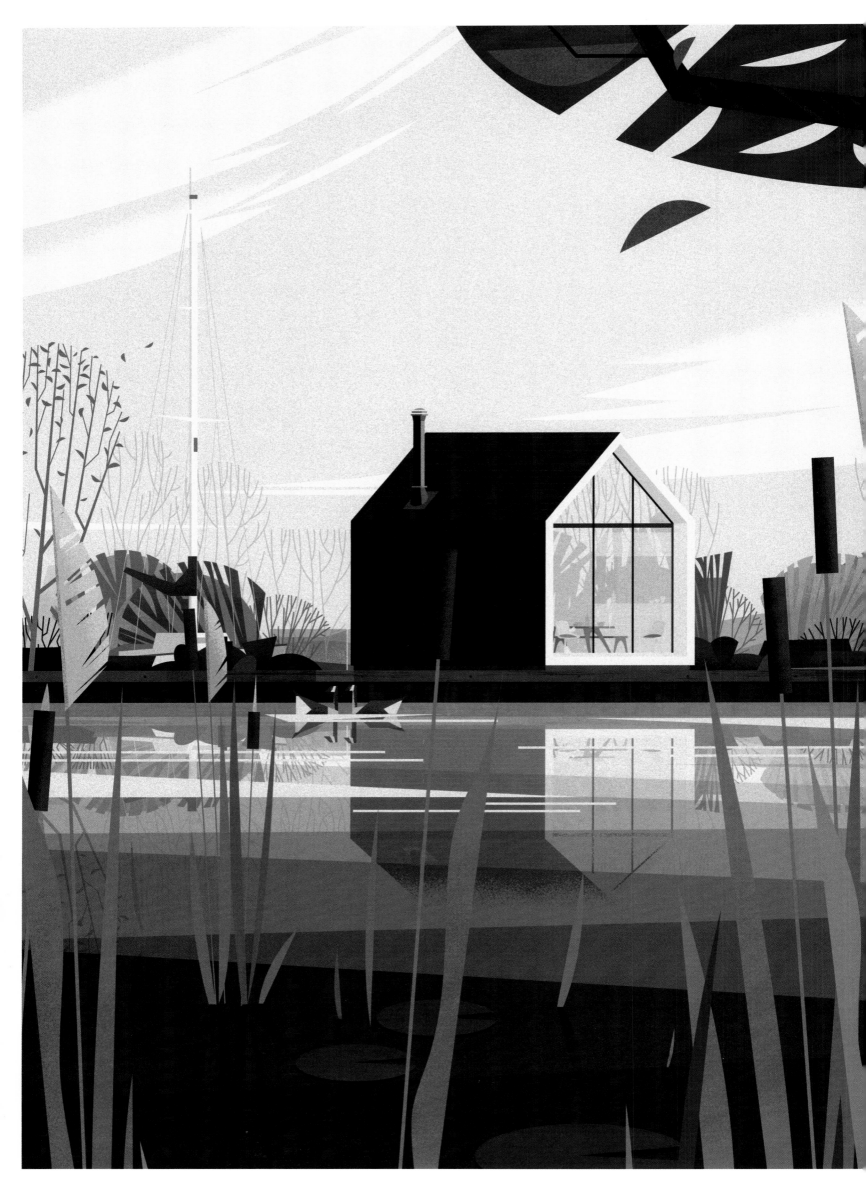

# ISLAND HOUSE

Area: 21 m² | Collaboration: Jille Koop, Isabel Rivas, Loenor Coutinho

Located on a narrow island in the lake district of Loosdrechtse Plas, this cabin is intended to "customize the interaction with the surrounding" natural setting. One glass façade and a dark-wood surface can be completely opened onto an outdoor wooden terrace. The folded wooden façade "becomes an abstract perpendicular element that floats above the water." Despite its very small size, the house includes a shower, toilet, kitchen, closets, storage, and other functions that are integrated into a double wall. A black, metal fireplace, which can be rotated, hangs from the ceiling. An east-west orientation allows the house to take in both sunrise and sunset. The steel-frame structure has wood and structural glass façades, wooden furniture, and a white epoxy floor.

———

Loosdrechtse Plas heißt die Seengegend, in der sich auf einem schmalen Inselgrundstück dieses Haus befindet, das „die Interaktion mit der natürlichen Umgebung je nach Bedürfnislage ermöglichen soll". Eine Glasfassade und eine dunkle Fläche aus Holz können vollständig auf eine Holzterrasse geöffnet werden. Die faltbare Holzfassade „wird zum abstrakten Element, das lotrecht über dem Wasser hängt". Trotz der geringen Größe verfügt das Haus über eine Dusche, ein WC, eine Küche, Schränke, Stauraum und weitere in eine zweischalige Wand integrierte Funktionen. Eine schwarze, drehbare Feuerstelle aus Metall hängt von der Decke. Die Ost-West-Ausrichtung ermöglicht es, Sonnenaufgang und Sonnenuntergang zu betrachten. Die Stahlrahmenkonstruktion verfügt über Holz- und tragende Glasfassaden, Holzmobiliar und einen weißen Boden aus Epoxid.

———

Située sur une île étroite dans la région lacustre de Loosdrechtse Plas, cette petite maison vise à « créer une interaction sur commande avec le décor naturel environnant ». Une façade vitrée et une autre face de bois sombre peuvent être entièrement ouvertes sur une terrasse en bois, la façade en bois repliée « devient alors un élément perpendiculaire abstrait qui flotte sur l'eau ». Malgré sa taille très réduite, la maison comporte une douche, des toilettes, une cuisine, des placards, des rangements et d'autres fonctions intégrées à un double mur. Une cheminée rotative de métal noir est suspendue au plafond. L'orientation est-ouest permet à la maison d'être éclairée à la fois par le lever et par le coucher du soleil. La structure à ossature d'acier est équipée de façades porteuses en bois et en verre, de mobilier en bois et d'un sol en époxy blanc.

The orientation of the house is based on the directions of the rising and setting sun. The steel-frame structure has two structural glass façades, and two Plato wood façades.

Das Haus ist nach der aufgehenden bzw. untergehenden Sonne ausgerichtet. Die Stahlrahmenkonstruktion verfügt über zwei tragende Außenwände aus Glas und zwei Außenwände aus Plato-Holz.

L'orientation de la maison suit les directions du soleil levant et couchant. La structure à ossature d'acier présente deux façades porteses en verre et deux en bois Plato.

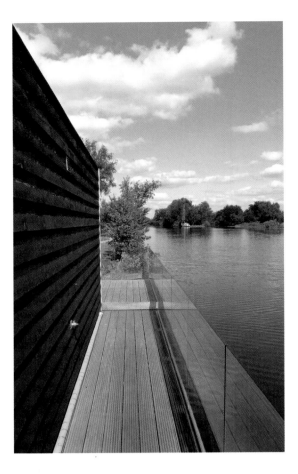

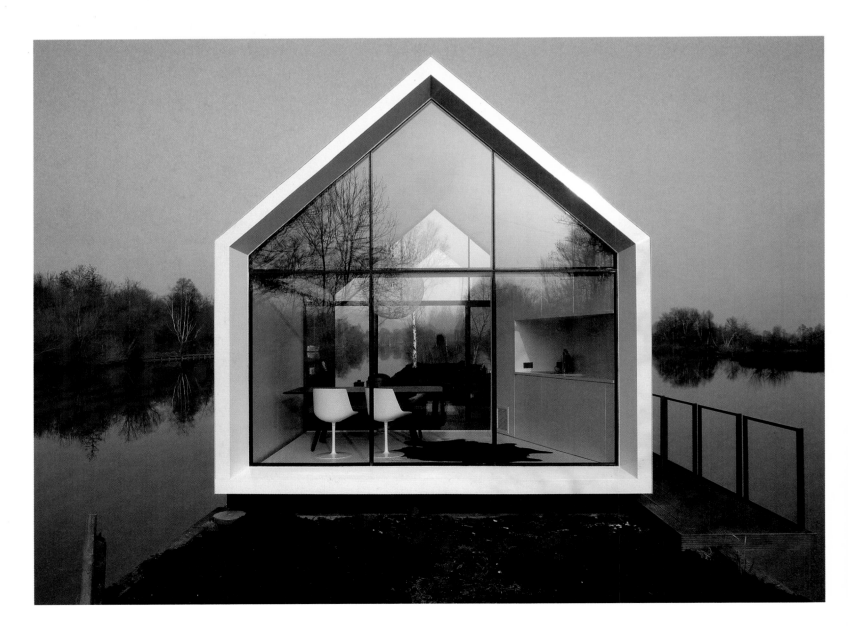

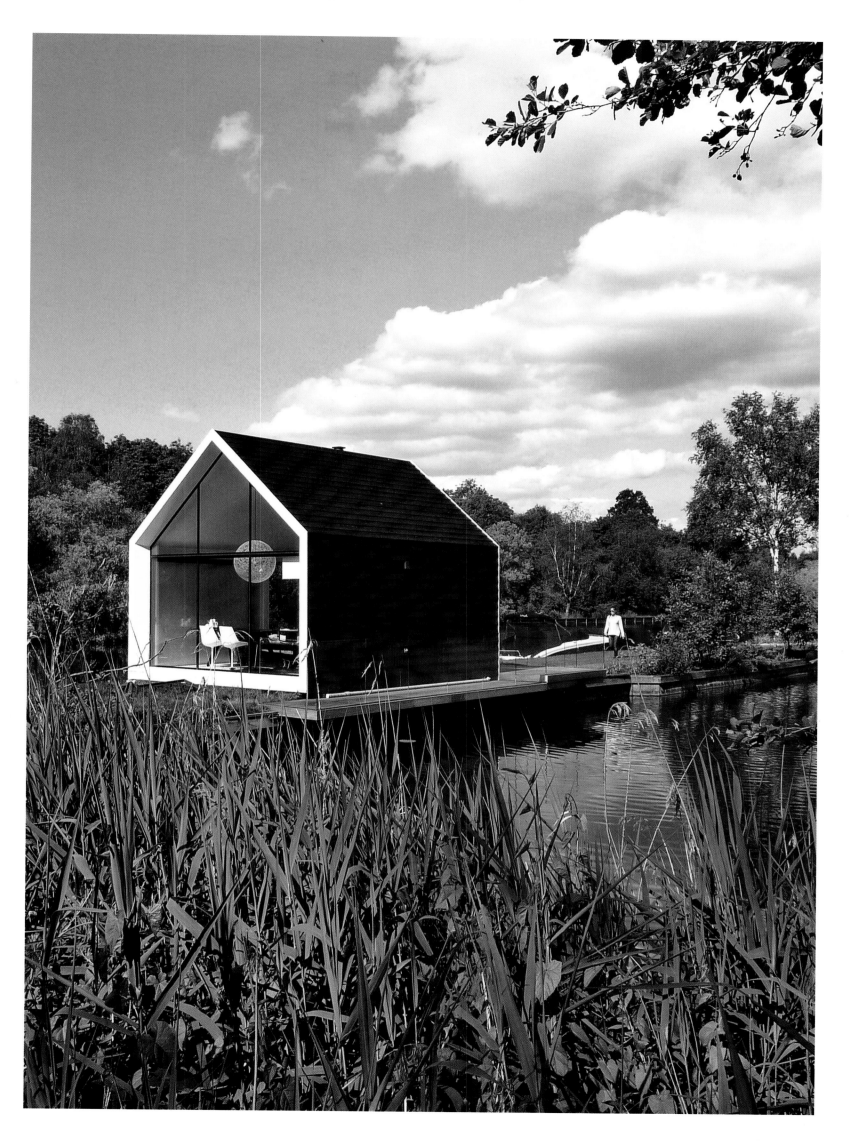

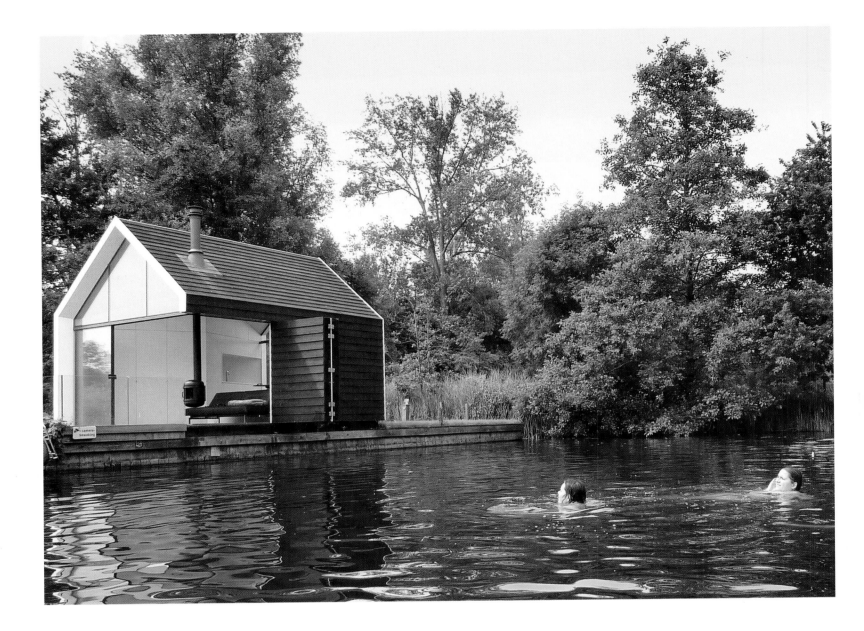

With one glass side and part of the wooden façade open, the entire house becomes a covered exterior space by the water.

Eine Glas- und ein Teil der Holzwand können geöffnet werden, sodass das gesamte Haus zu einem überdachten Freiluftareal am Wasser wird.

Une façade vitrée et une partie de la façade en bois peuvent être ouvertes pour transformer la maison en un espace extérieur couvert au bord de l'eau.

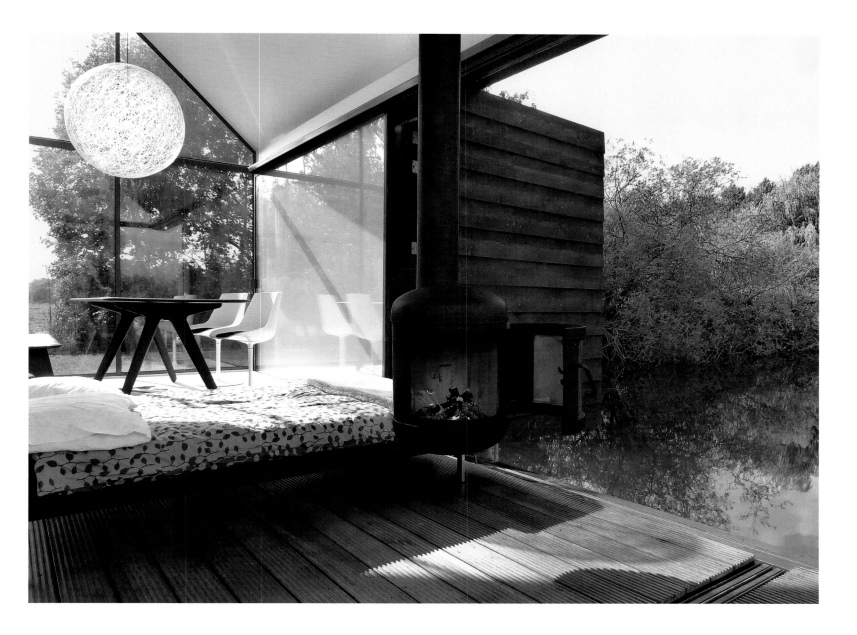

The architects explain that the wooden floor of the living area is directly adjacent to the water, so when the wooden façade is folded open, it "enables the inhabitants to access the lake from the living room."

Den Architekten zufolge grenzt der Holzboden des Wohnbereichs bei aufgeklappter Holzwand direkt ans Wasser und „ermöglicht Bewohnern den Zugang zum See vom Wohnraum aus".

Les architectes expliquent que, lorsque la façade de bois est repliée et ouverte, le sol en bois du séjour se trouve en contact direct avec l'eau, « ce qui permet à ses occupants d'accéder directement au lac depuis le salon ».

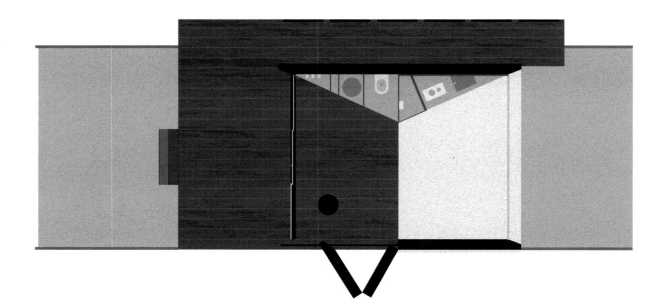

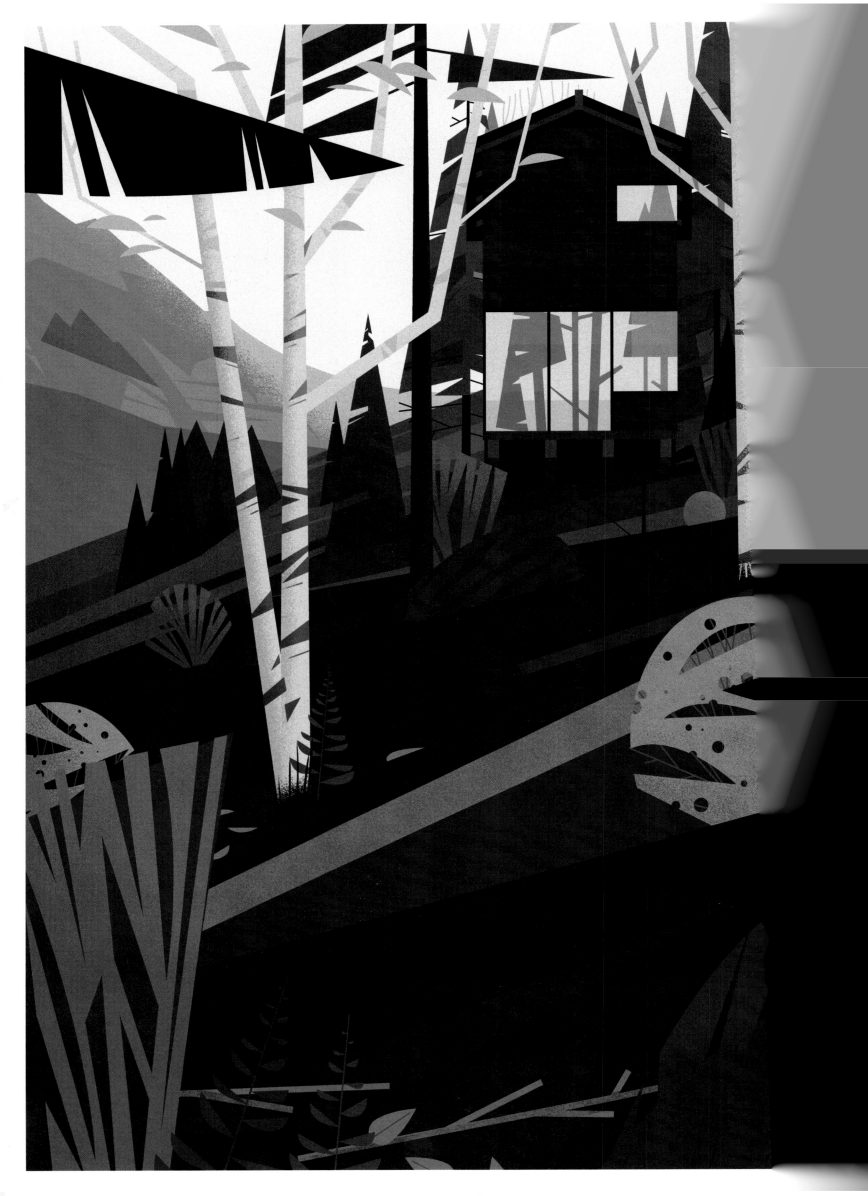

**JENSEN & SKODVIN ARCHITECTS**
Gudbrandsjuvet [Norway]
2012–13

# JUVET LANDSCAPE HOTEL

Area: 30 m² (each) | Client: Knut Slinning

The Juvet Landscape Hotel is located in Valldal, near the town of Åndalsnes in northwestern Norway. The architects completed the first phase with seven rooms designed to "exploit breathtaking scenery with minimal intervention" in 2009. The second phase involved the two new cabins published here. Designed along the lines of a traditional Norwegian log *stabbur*, the cabins are set on steeply sloped sites, and are lifted several meters off the ground on the low side by 30-millimeter steel poles intended to disturb the site as little as possible. Windows were located to frame specific views. The openings in the log walls where the windows were inserted were painted in different colors in collaboration with the artist Knut Wold. Jensen & Skodvin were also responsible for the landscape design near these two cabins.

———

Das Landschaftshotel Juvet befindet sich in Valldall, unweit von Åndalsnes im Nordwesten von Norwegen. Die Architekten brachten 2009 Phase 1 des Projekts zum Abschluss, „das bei minimalem Eingriff in die Umwelt voll und ganz von der atemberaubenden Kulisse profitieren sollte". Phase 2 schließt die beiden Hütten mit ein, die hier vorgestellt werden. Der Entwurf lehnt sich an traditionelle norwegische Stabbur-Hütten an. Die Bauten befinden sich an einem Standort mit starkem Gefälle und sind auf 30-Millimeter-Stahlposten mehrere Meter über dem Boden errichtet, um das Gelände möglichst zu schonen. Die Fenster sind so platziert, dass sie jeweils eine charakteristische Aussicht bieten. Die Fensteröffnungen in den Holzwänden wurden in Zusammenarbeit mit dem Künstler Knut Wold in verschiedenen Farben gestrichen. Jensen & Skodvin waren auch für die Landschaftsgestaltung im Umfeld der beiden Hütten verantwortlich.

———

L'hôtel paysager Juvet est situé à Valldal, près de la ville d'Åndalsnes, dans le Nord-Ouest de la Norvège. Les architectes ont d'abord réalisé une première phase en 2009, composée de sept chambres conçues pour « tirer parti du décor à couper le souffle en limitant au minimum toute intervention ». La seconde phase comprend les deux nouvelles cabanes publiées ici. Conçues sur le modèle des greniers norvégiens traditionnels en rondins, les *stabbur*, elles sont construites sur des terrains en pente raide et surélevées à plusieurs mètres au-dessus du sol du côté le plus bas sur des pieux en acier de 30 millimètres afin de perturber le moins possible le site naturel. Les fenêtres ont été disposées de manière à encadrer des vues précises et les ouvertures où elles ont été insérées dans les murs de rondins ont été peintes de différentes couleurs en collaboration avec l'artiste Knut Wold. Jensen & Skodvin a aussi été chargé de l'aménagement paysager à proximité des deux cabanes.

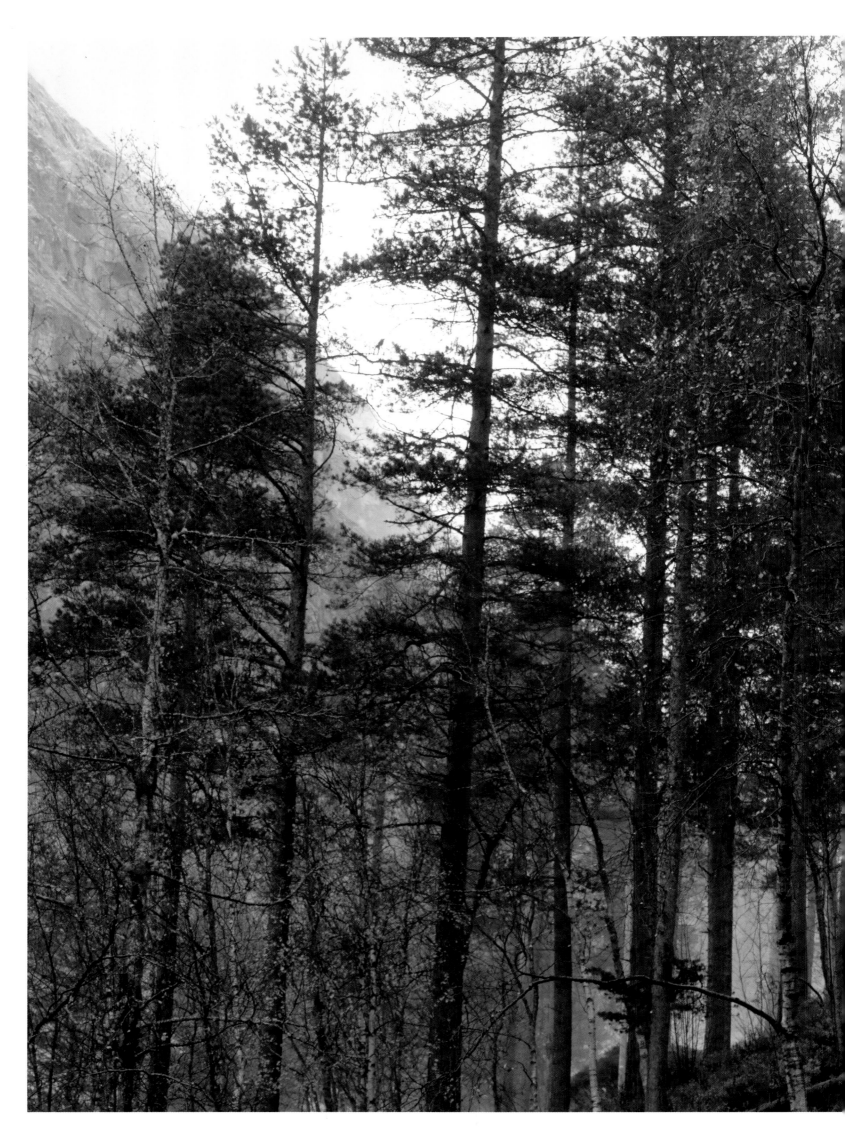

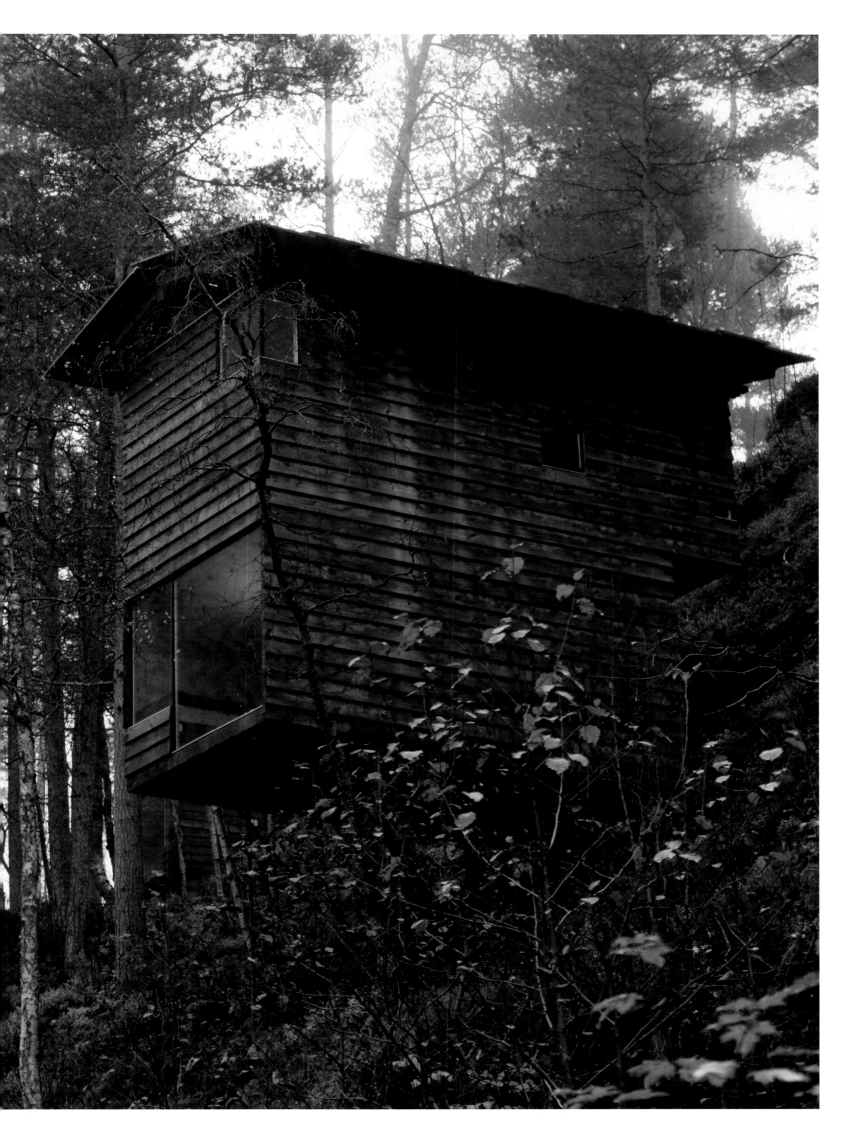

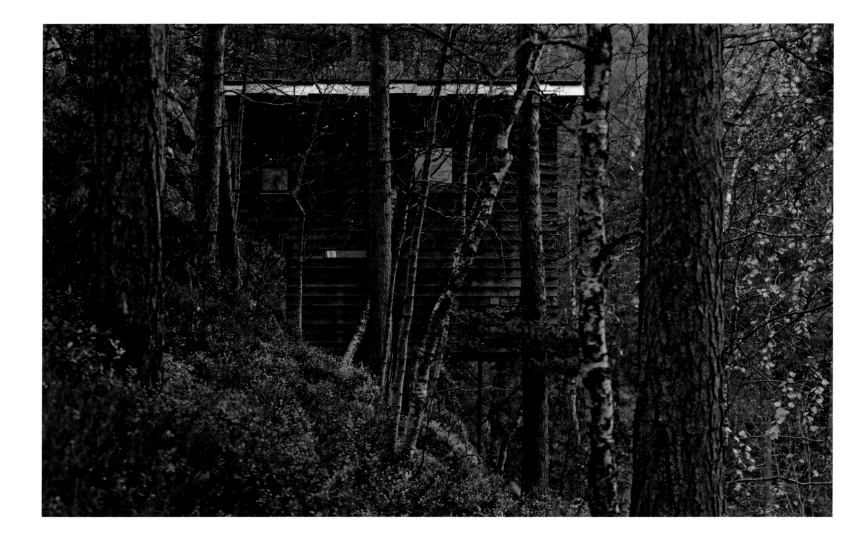

The two new cabins are designed along the lines of traditional Norwegian *stabbur* and set up off the ground on steel poles on the lower side of their sloped sites.

Die beiden neuen Hütten nehmen Bezug auf traditionelle norwegische Stabbur-Hütten und sind auf Stahlpfosten auf der tiefer gelegenen Seite ihrer Standorte in Hanglage errichtet.

Les deux nouvelles cabanes ont été conçues sur le modèle des greniers norvégiens traditionnels ou *stabbur* et surélevées sur des pieux en acier du côté le plus bas du terrain en pente.

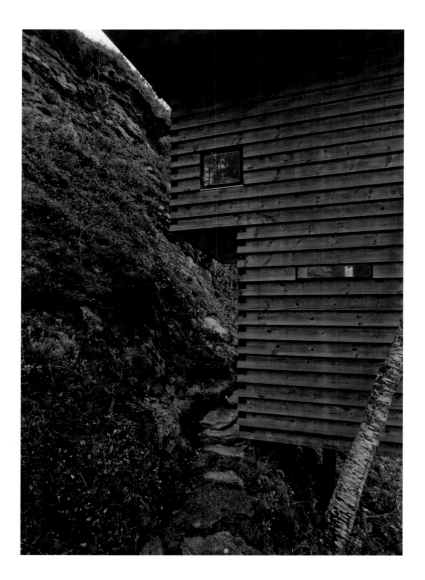

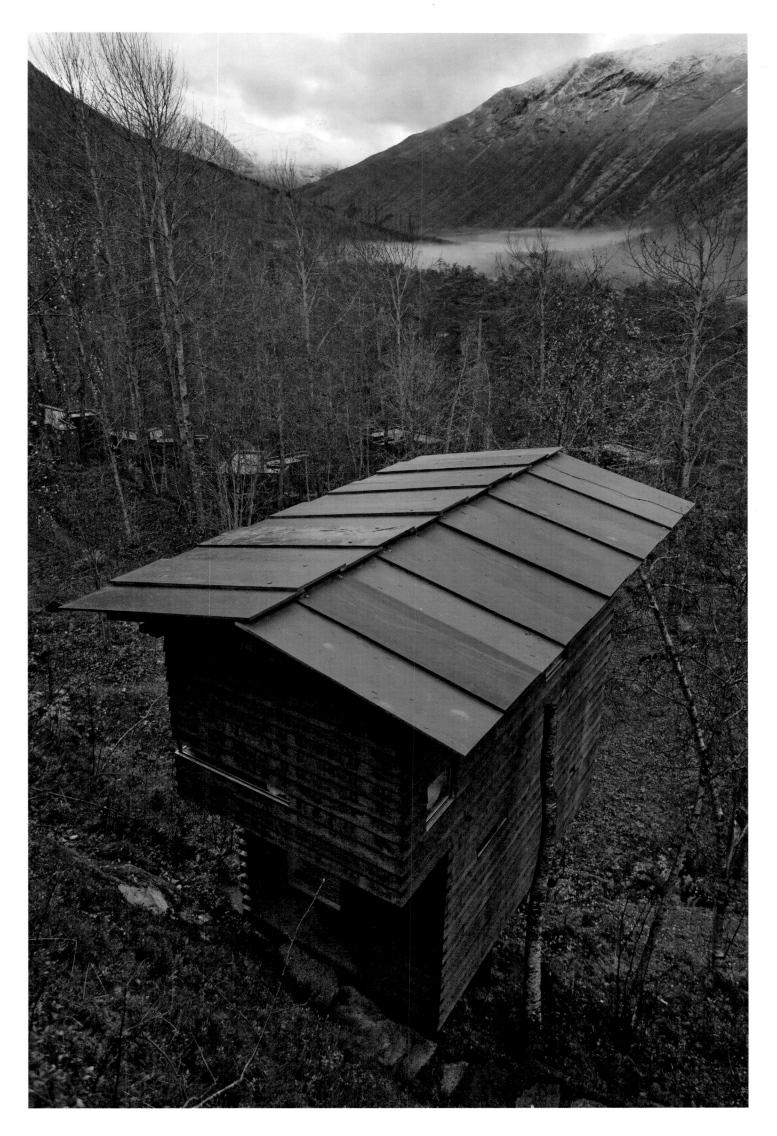

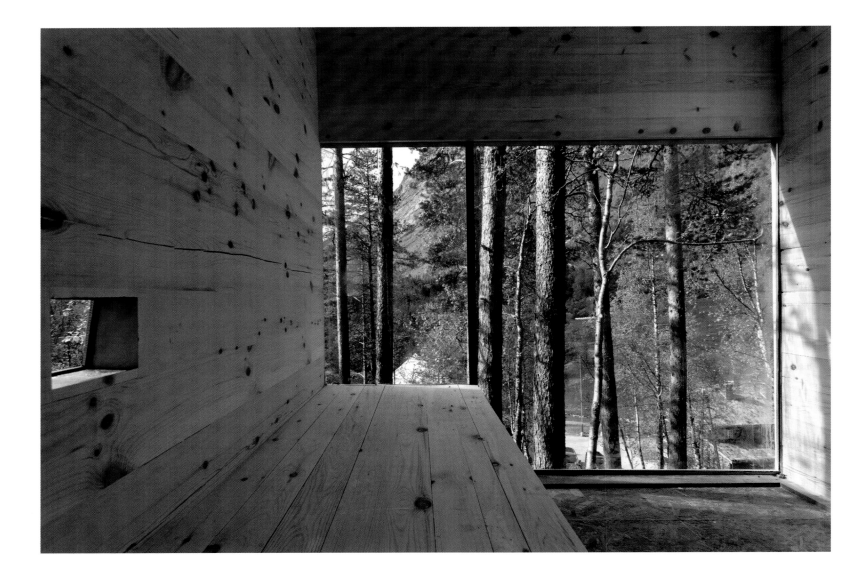

The relatively rough wood interior frames large windows that almost give guests the impression that they are in the natural setting.

Die relativ derbe Holzausstattung der Hütten bildet den Rahmen für die großen Fenster, die die Gäste beinahe glauben lassen, sie befänden sich draußen in der Natur.

L'intérieur en bois assez brut encadre de grandes fenêtres qui donnent l'impression aux habitants de se trouver comme en pleine nature.

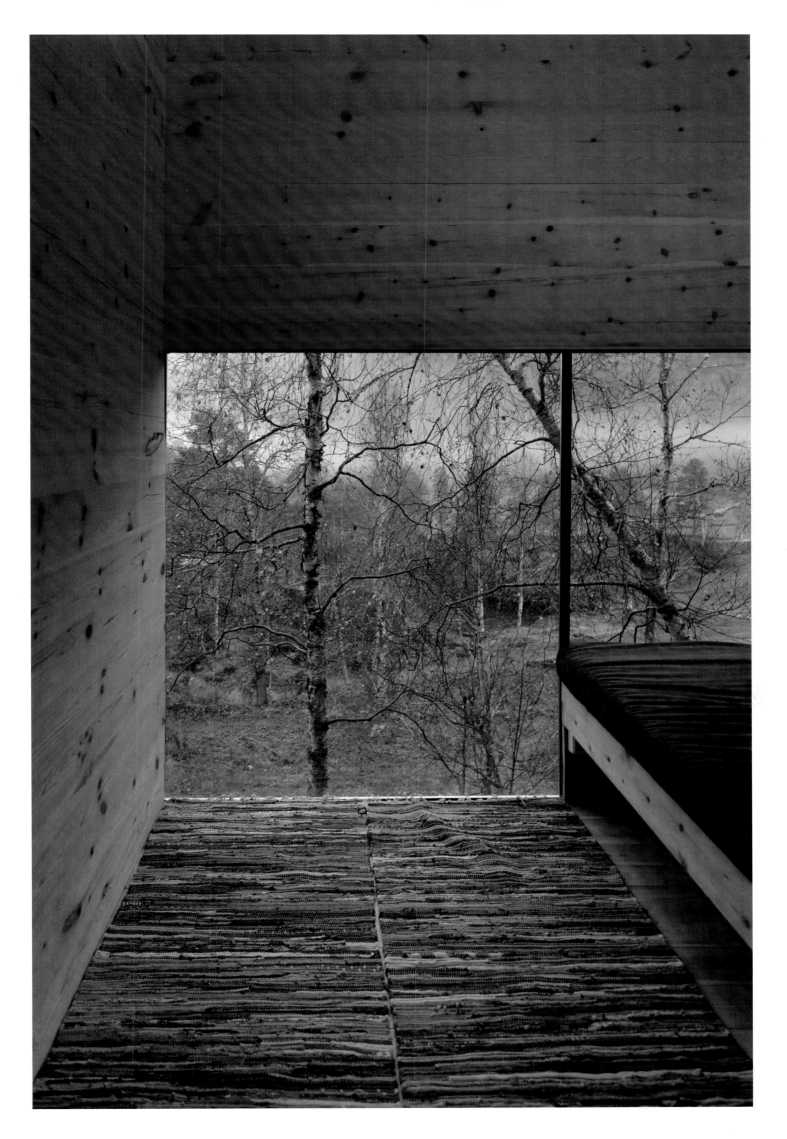

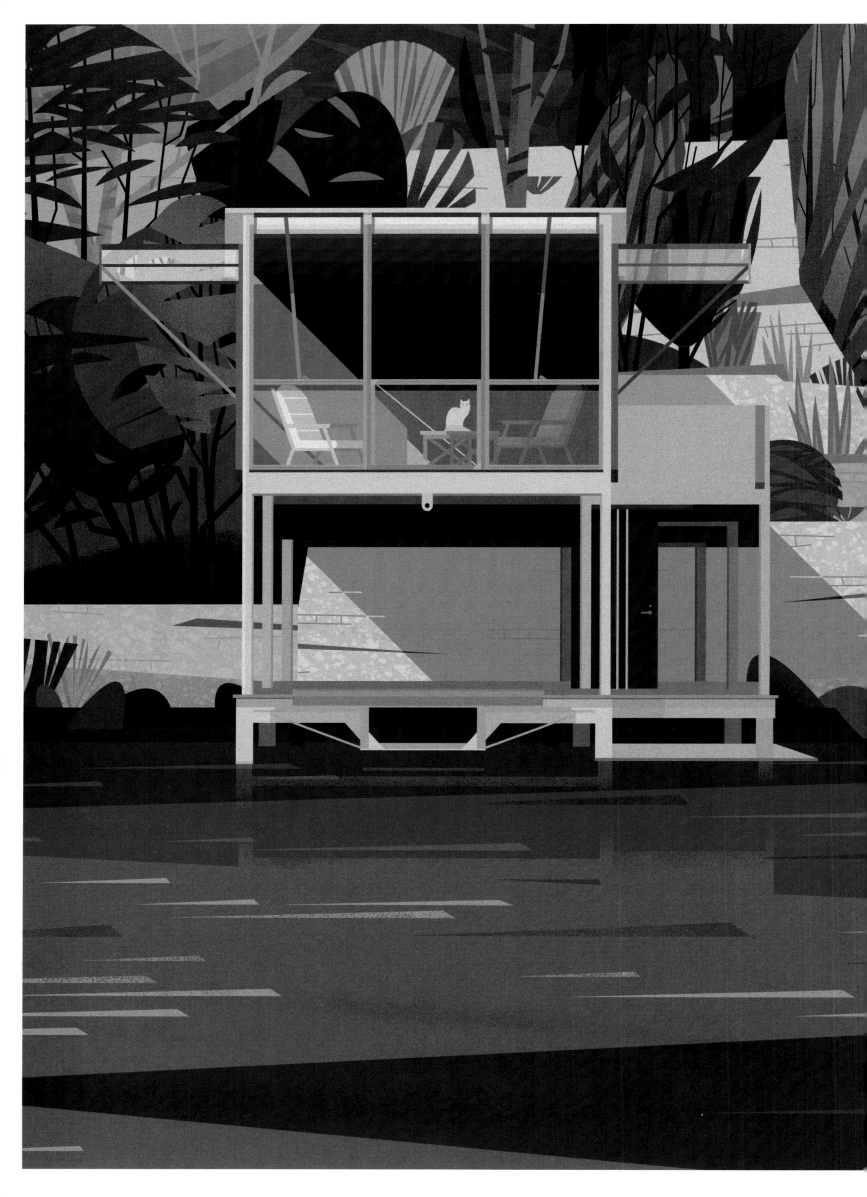

**ANDERSSON-WISE**
Austin, Texas [USA]
2002

# LAKE HOUSE

Area: 121 m²

Built on a steeply sloped bank of Lake Austin, the Lake House is reached by crossing a suspension bridge over a ravine at the end of a long footpath. The architects compare the structure to a water skater or a "surface-skimming insect." Off the local power grid, the structure is intended to "exert minimal impact on its surroundings." The steel-frame building was brought on a barge to the site and is anchored in rocks beneath the level of the water. A floating carpentry shop was used to complete construction without further damage to the site. Natural ventilation is encouraged by screens, while the proximity of the house to the water also cools it. The lower screens are designed to swing out on the north and east sides to create full-height openings, "making impromptu diving platforms."

—

Das Lake House wurde an einem steilen Uferhang des Lake Austin errichtet und ist nach einem längeren Fußmarsch über eine Hängebrücke erreichbar, die eine Schlucht quert. Die Architekten vergleichen den Bau mit einem Wasserläufer, einem „Insekt, das nur flüchtig die Wasseroberfläche berührt". Das Lake House ist nicht ans Versorgungsnetz angeschlossen und sollte „in seiner Umgebung möglichst wenig Spuren hinterlassen". Die Stahlrahmenkonstruktion wurde mit einem Lastschiff antransportiert und im Gestein unterhalb der Wasseroberfläche verankert. Die Bauarbeiten wurden mithilfe einer schwimmenden Holzbauplattform durchgeführt, ohne den Standort in Mitleidenschaft zu ziehen. Durchlässige Fenstergitter und die Nähe zum See sorgen für natürliche Durchlüftung und Kühlung. Nach Norden und Osten lassen sich die unteren Gitternetze vollständig aufklappen, „so dass spontan ein Badedeck entsteht".

—

La maison est construite sur une berge escarpée du lac Austin, on y accède par un pont suspendu au-dessus d'un ravin après avoir parcouru un long chemin à pied. Les architectes la comparent à une araignée d'eau ou un « insecte qui rase la surface de l'eau ». Non raccordée au réseau électrique, elle est conçue pour « avoir un impact minimal sur les alentours ». Le bâtiment à charpente en acier a été amené par barge sur le site et est ancré dans la roche sous l'eau. Une menuiserie flottante a été utilisée pour achever la construction sans causer de dommages supplémentaires au site. La maison est rafraîchie par la proximité de l'eau et des grillages favorisent la ventilation naturelle – ceux du bas sont battants et peuvent être ouverts sur toute leur hauteur au nord et à l'est pour « former des plongeoirs improvisés ».

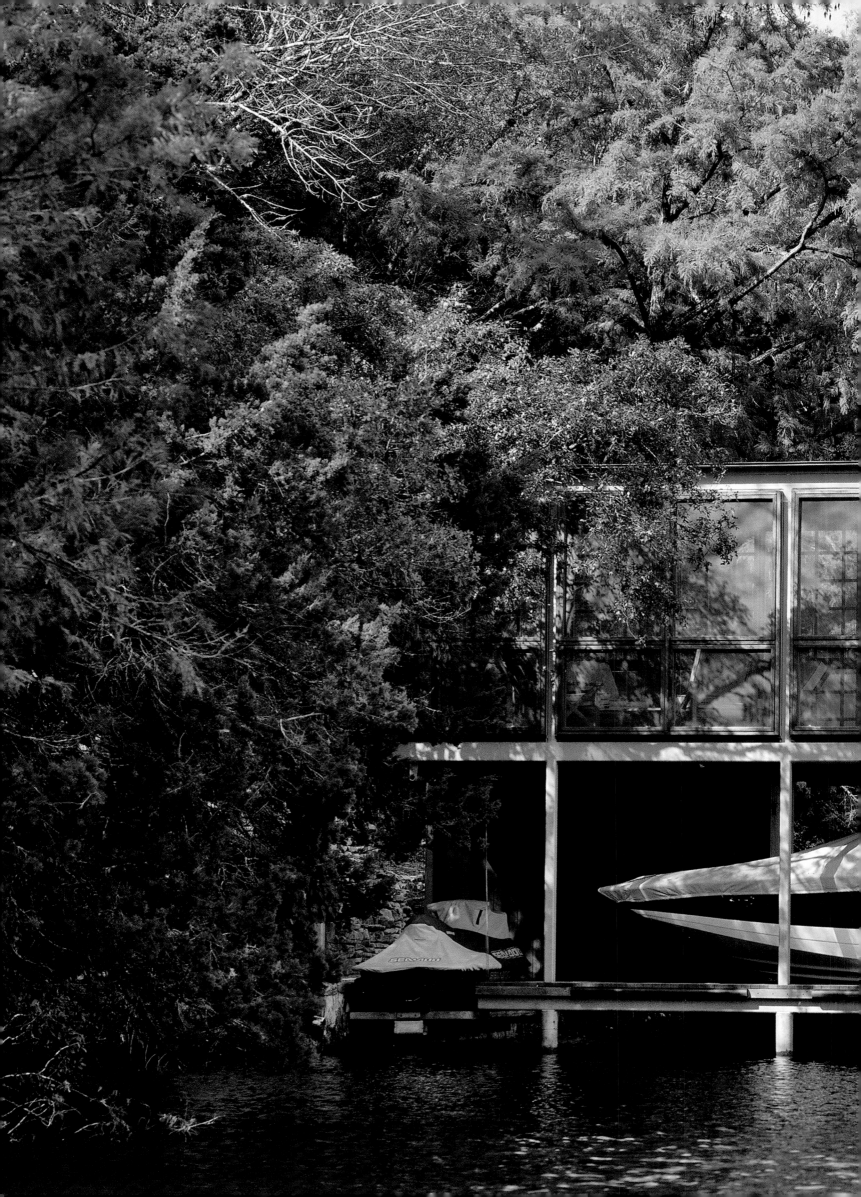

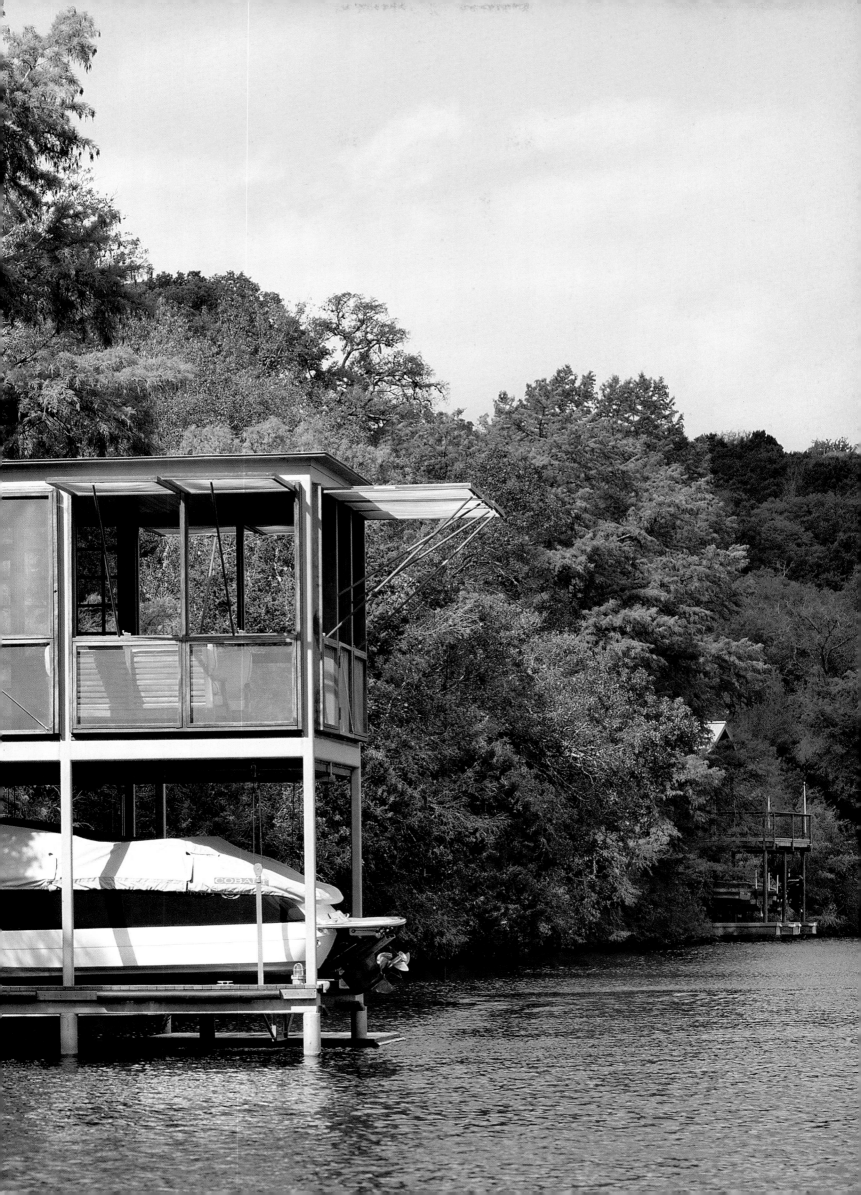

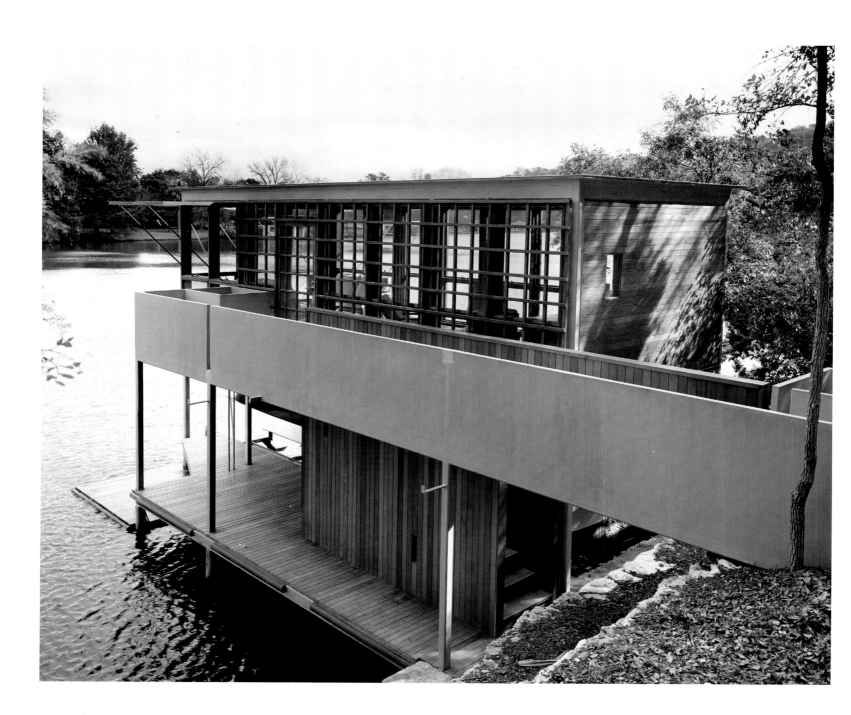

The structure is made with a single steel framework
that was brought by barge to the site. It is anchored in
rocks that lie below water level.

Der Bau besteht aus einer einzelnen Stahlrahmenkonst-
ruktion, die per Lastschiff an den Standort gebracht
wurde und ist unter dem Wasserspiegel im Fels verankert.

La structure est composée d'une simple charpente
en acier qui a été amenée par barge sur le site. Elle
est ancrée dans la roche sous-marine.

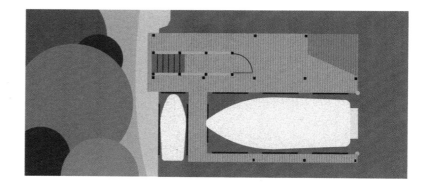

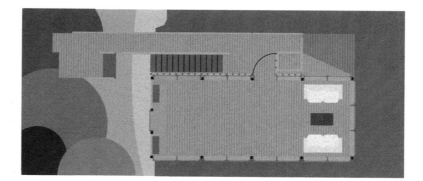

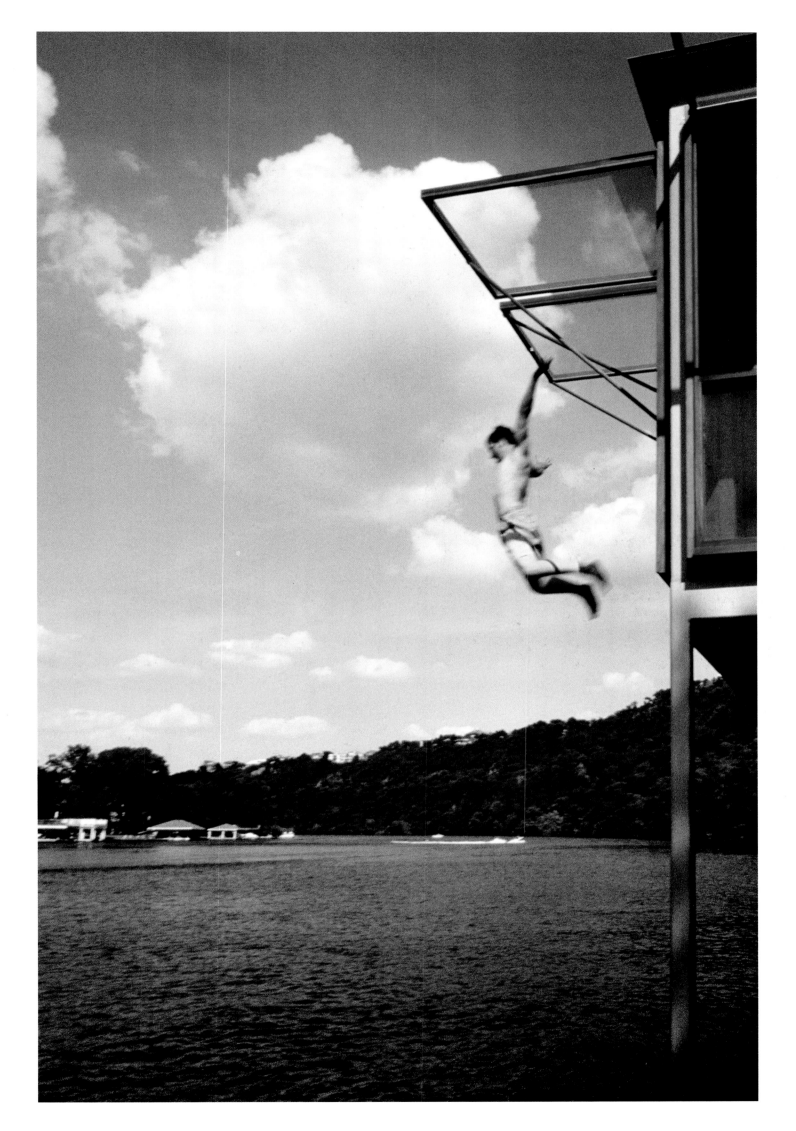

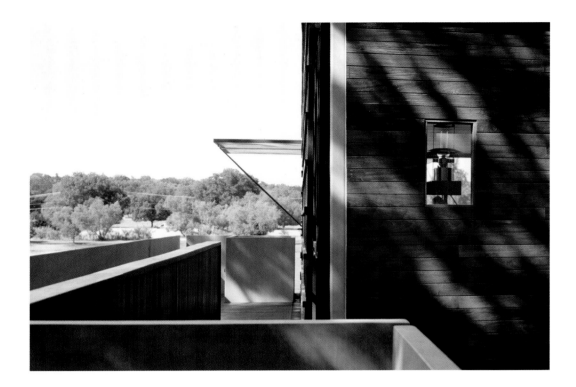

The rectangular volume of the house
juts out over the water at the base
of a steeply sloped site. A lantern in
the window (above) offers an inviting
note when the house is inhabited.

Der rechtwinklige Baukörper kragt
am unteren Ende eines steilen Hangs
übers Wasser. Wenn niemand im Haus
ist, strahlt die Laterne im Fenster
(oben) eine einladende Note aus.

Le volume rectangulaire de la maison
avance au-dessus de l'eau au pied
d'une berge escarpée. Une lanterne
dans l'embrasure de la fenêtre
(ci-dessus) apporte une note enga-
geante lorsque la maison est vide.

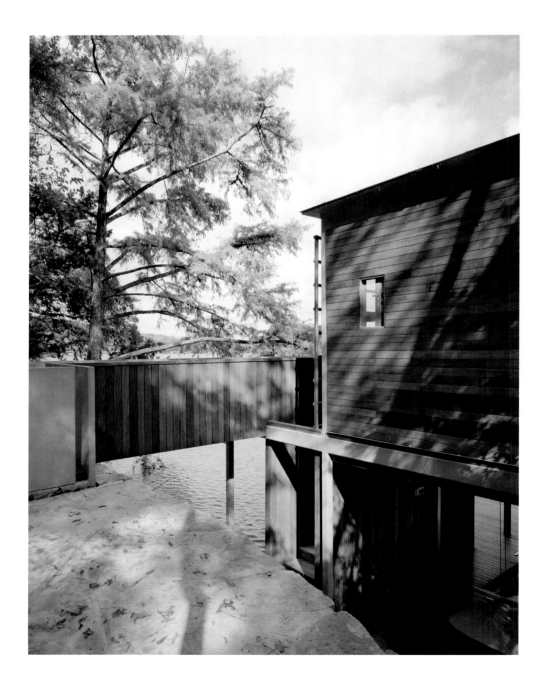

Screened panels are used to keep mosquitoes out of the house, with interiors emphasizing dark wood and a protected environment.

Durchlässige Fenstergitter halten Mücken davon ab, ins Haus zu gelangen. Im Innenbereich stehen dunkles Holz und Geborgenheit im Vordergrund.

Des panneaux grillagés empêchent les moustiques de rentrer à l'intérieur de la maison, qui met en valeur le bois sombre pour une atmosphère protectrice.

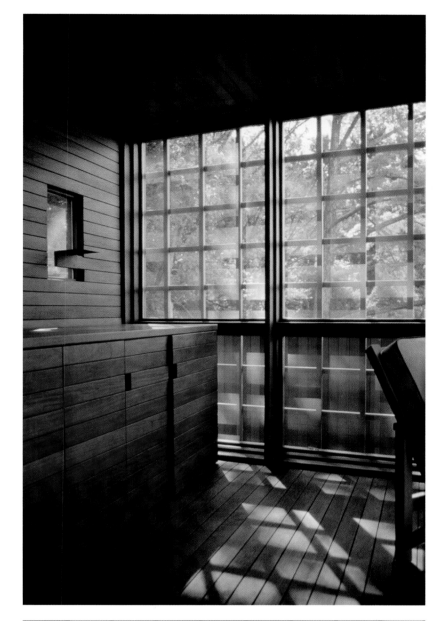

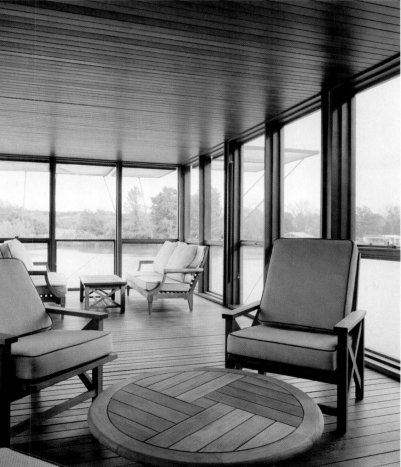

# LEAPRUS 3912

Area: 106 m² | Client: North Caucasus Mountain Club

This complex is made up of five prefabricated modular structures that were designed and manufactured in Italy. Three are made of white fiberglass and two of sandwich panel covered with aluminum sheet. The elements were carried by helicopter to the slopes of Mount Elbrus and assembled there at 3912 meters above sea level. The Eco-Hotel being built in this extreme location is to include 49 beds, toilets, reception, staff accommodations, and a restaurant with kitchen. The designers explain: "The structures of the new alpine station are made with durable materials of the highest quality, using cutting-edge technologies in the field of environmental sustainability." The complex includes a LEAPeco R sewage treatment plant.

———

Dieser Komplex besteht aus fünf in Italien entworfenen und produzierten Fertigbaumodulen. Drei Module sind aus weißem Fiberglas gefertigt, zwei weitere aus aluminiumbeschichtetem Verbundpaneel. Die Bauelemente wurden per Helikopter auf die Hänge des Elbrus transportiert und 3912 m über dem Meeresspiegel zusammengebaut. Das an diesem extremen Standort gelegene Öko-Hotel beherbergt 49 Betten, Toiletten, eine Rezeption, Mitarbeiterunterkünfte und ein Restaurant mit Küche. Die Architekten: „Die Bauten der neuen Hochgebirgsstation bestehen aus strapazierfähigen Materialien höchster Qualität und wurden mithilfe neuester, ökologisch nachhaltiger Technologien gefertigt." Der Komplex ist mit einer Abwasserreinigungsanlage vom Typ LEAPeco R ausgestattet.

———

Le complexe se compose de cinq structures modulaires préfabriquées, conçues et produites en Italie. Elles sont en fibre de verre blanche ou, pour deux d'entre elles, en panneaux sandwich recouverts de feuilles d'aluminium. Les éléments ont été amenés par hélicoptère sur les pentes de l'Elbrouz et assemblés à 3912 m d'altitude. L'éco-hôtel ainsi construit dans cet environnement extrême comprend 49 lits, des toilettes, une réception, des logements de service et un restaurant avec cuisine. Ses auteurs expliquent : « Les structures de la nouvelle station sont en matériaux durables de la meilleure qualité et font appel à des technologies de pointe en ce qui concerne la durabilité environnementale. » Le complexe comprend une station d'épuration des eaux usées LEAPeco R.

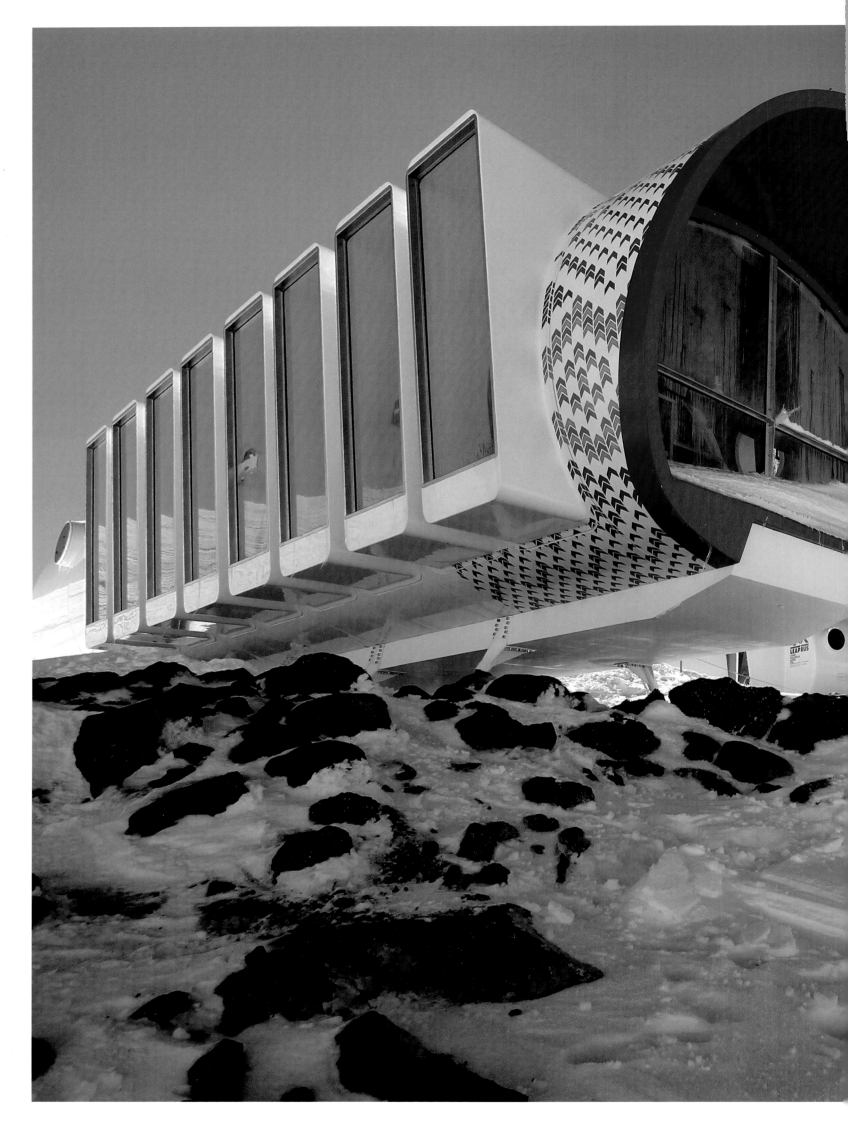

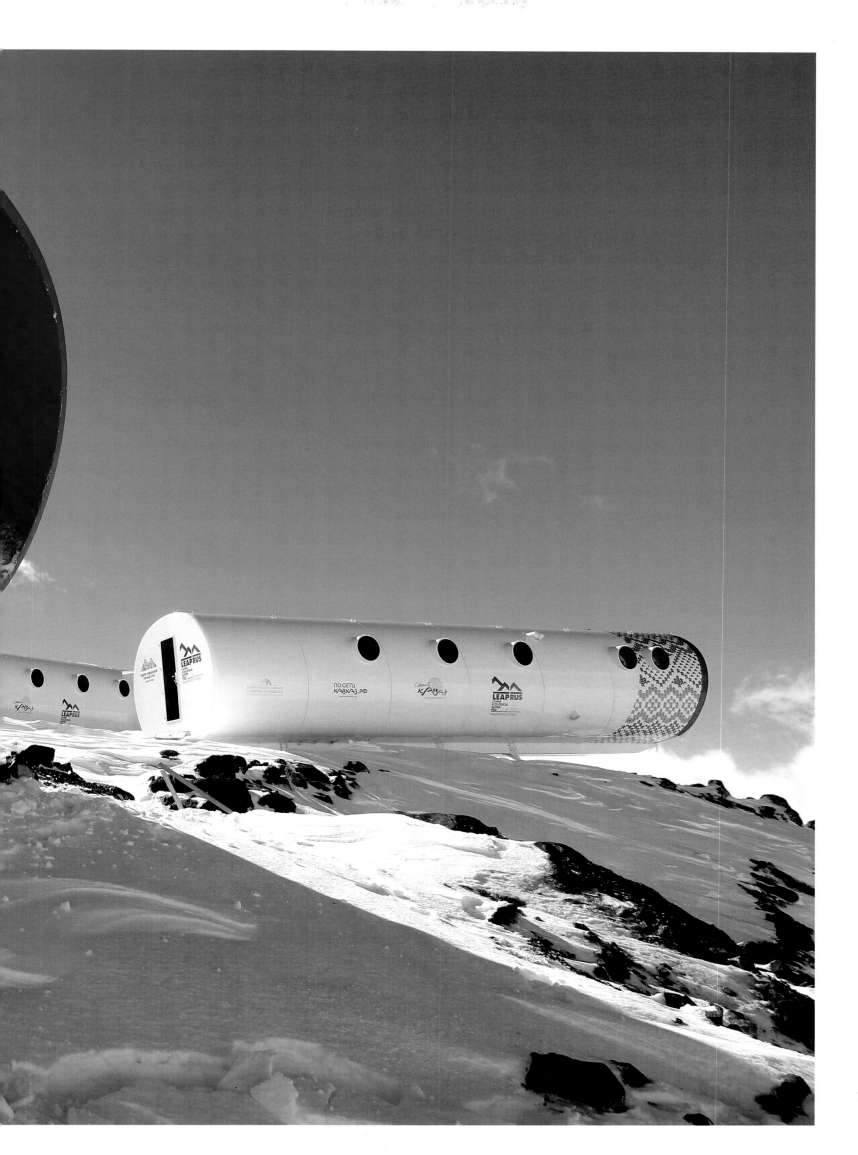

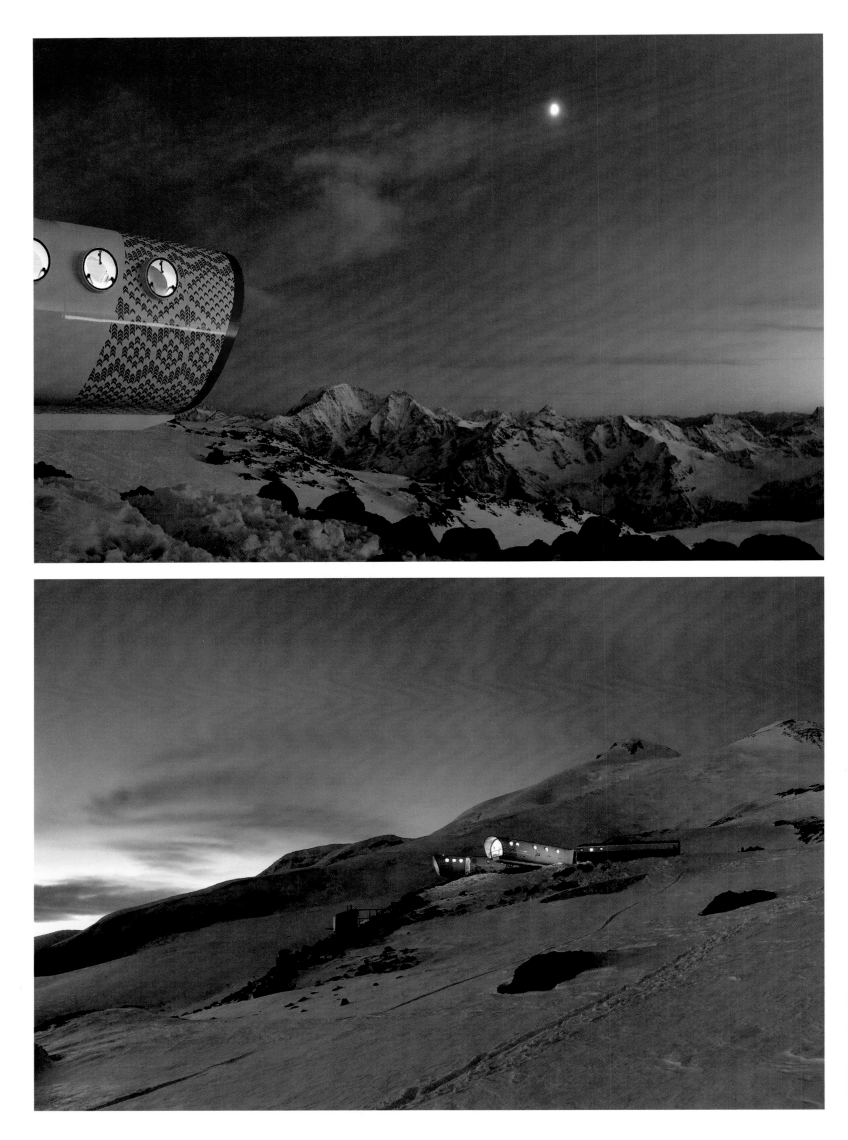

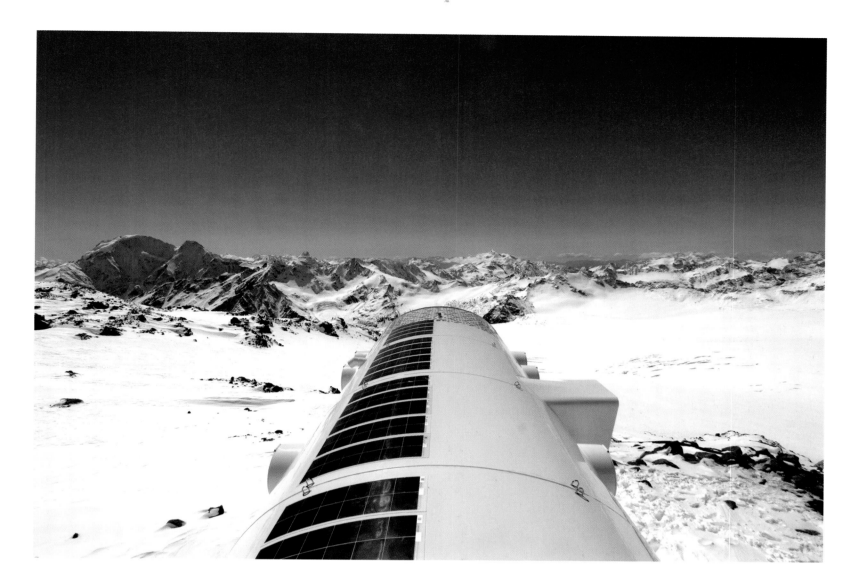

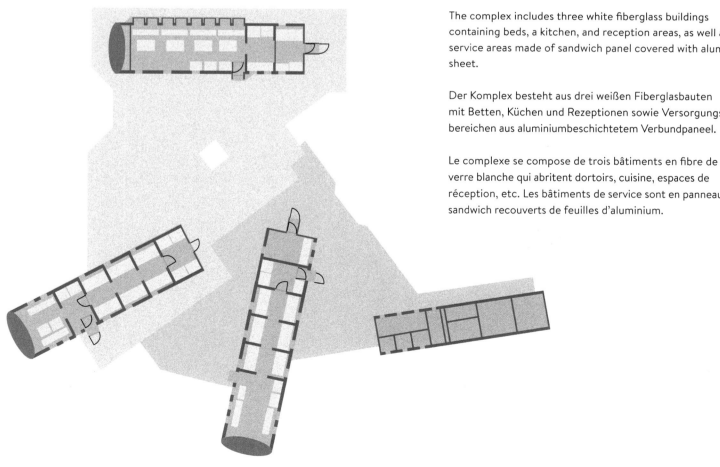

The complex includes three white fiberglass buildings containing beds, a kitchen, and reception areas, as well as service areas made of sandwich panel covered with aluminum sheet.

Der Komplex besteht aus drei weißen Fiberglasbauten mit Betten, Küchen und Rezeptionen sowie Versorgungsbereichen aus aluminiumbeschichtetem Verbundpaneel.

Le complexe se compose de trois bâtiments en fibre de verre blanche qui abritent dortoirs, cuisine, espaces de réception, etc. Les bâtiments de service sont en panneaux sandwich recouverts de feuilles d'aluminium.

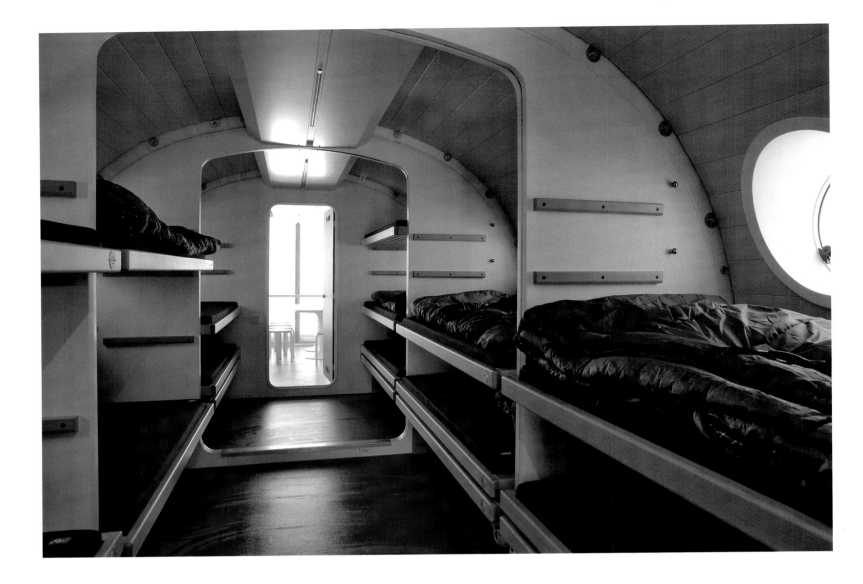

The high-efficiency structural shells feature an internal air circulation system with heat recovery and LED lighting, which contribute to low-energy usageas they.

Hocheffiziente Bauhüllen tragen zum niedrigen Energieverbrauch bei, wie auch die LED-Beleuchtung und das interne Luftzirkulationssystem samt Wärmerückgewinnung.

Les coques structurelles haute efficacité contribuent à une faible consommation d'énergie avec un système de circulation de l'air intérieur à récupération de chaleur et des LED pour l'éclairage.

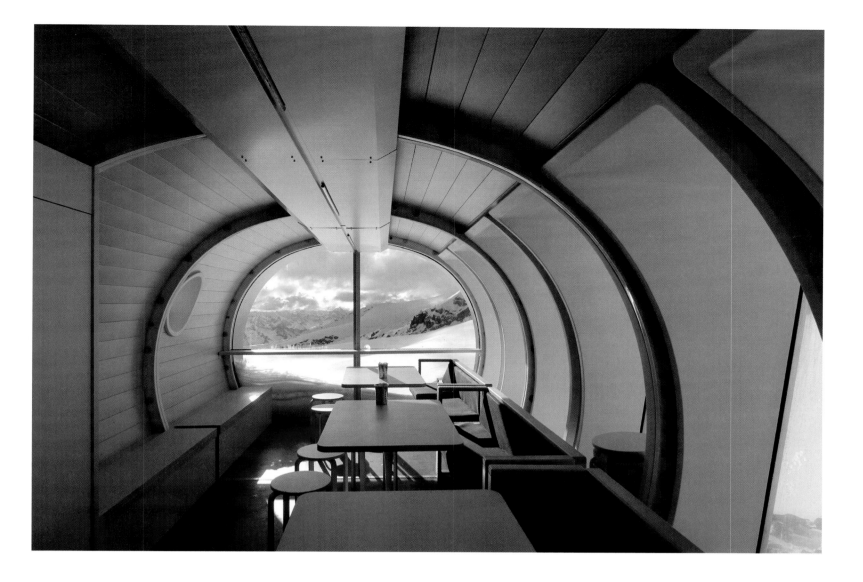

Despite the rather inhospitable exterior environment at an altitude of nearly 4000 meters above sea level, the structures offer a warm, inviting atmosphere with sweeping views of the mountain setting.

Trotz des unwirtlichen Umfelds in einer Höhe von knapp 4000 m über dem Meeresspiel ist die Atmosphäre in den Gebäuden, von denen sich ein weiter Blick über die Berge bietet, warm und einladend.

Malgré l'environnement extérieur plutôt inhospitalier à près de 4000 m au-dessus du niveau de la mer, l'hôtel offre une atmosphère chaleureuse et accueillante et ouvre généreusement la vue sur le décor de montagnes.

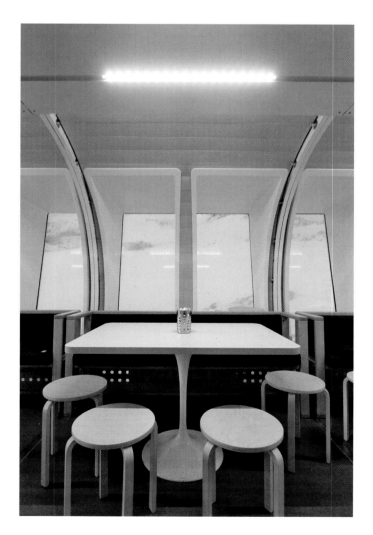

# LOFTCUBE

Area: 30 m² | Client: Hotel Château de la Poste
Manufacturer: loftcube GmbH, Munich | Cost: €120 000
Collaboration: Bracht Architects, Hamburg

Although the idea of mobile homes, even structures that can be carried and placed by helicopter, is far from new, Werner Aisslinger states: "What could a minimal home unit look like, a temporary retreat, where urban nomads in big cities and dense urban zones could find privacy?" The first experiment with these units was carried out at Berlin's first design festival, "DesignMai" (May 3–18, 2003), where two "Loftcube" prototypes (a "living" version and a "home office" version) were put in place. These prototypes were designed as honeycomb wooden modules with plastic laminate suitable for dismantling. Measuring 6.6 meters in width and length, the cubes are three meters high, and offer 36 square meters of interior space. For this special project in Belgium, the Loftcube was downsized to 30 square meters due to Belgian building laws. The client, who runs a well-known hotel, wanted the cube to be located in an isolated site in his large park. "We designed a special compact suite in a modern chalet style with an open view that remains cozy and private," says the designer.

Das Konzept mobiler Wohnmöglichkeiten – auch solcher, die per Hubschrauber transportiert und platziert werden können – ist zwar alles andere als neu, dennoch fragt Werner Aisslinger: „Wie könnte eine Kleinstwohneinheit aussehen, ein temporärer Rückzugsort, an dem urbane Nomaden in Großstädten und dicht besiedelten urbanen Räumen Privatsphäre finden?" Erstmals mit solchen Wohneinheiten experimentiert hat Aisslinger im Rahmen des ersten Berliner Designfestivals „DesignMai" (3.–18. Mai 2003), als er zwei Prototypen des „Loftcube" (eine Wohn- und eine Büroausführung) installierte. Diese Prototypen waren für einen leichten Wiederabbau aus Holzmodulen und Kunststofflaminat mit Wabenstruktur gefertigt. Die Cubes sind 6,6 m breit und lang, 3 m hoch und haben eine Grundfläche von 36 m². Für dieses in Belgien ausgeführte Projekt wurde der Loftcube örtlichen Baubestimmungen gemäß auf eine Grundfläche von 30 m² verkleinert. Der Kunde, Betreiber eines bekannten Hotels, wünschte sich den Cube an einem abgelegenen Standort innerhalb seines Parks. Der Architekt: „Wir haben eigens eine kompakte offene Suite im modernen Chalet-Stil entworfen, die dennoch behaglich und persönlich anmutet."

L'idée de logement mobile, et même de structures susceptibles d'être transportées et mises en place par hélicoptère, est loin d'être neuve, pourtant Werner Aisslinger se demande encore « à quoi pourrait ressembler une unité d'habitation minimale, une retraite temporaire où les nomades des grandes villes et zones d'urbanisation denses pourraient trouver un peu d'intimité ? » La première expérimentation de ces unités a eu lieu au premier festival de design de Berlin « DesignMai » (3–18 mai 2003) où deux prototypes de « Loftcubes » (une version « séjour » et une « bureau personnel ») avaient été installés. Ils étaient composés de modules en bois alvéolé et de stratifié permettant leur démantèlement. Les cubes sont larges et longs de 6,6 m, pour une hauteur de 3 m, et offrent un espace intérieur de 36 m² (réduit à 30 m² par le code de la construction belge pour le projet en Belgique présenté ici). Le client, qui tient un hôtel de renom, souhaitait placer le cube à un endroit isolé du grand parc. « Nous avons créé une suite spéciale très compacte dans un style chalet moderne avec une vue dégagée, qui conserve son caractère douillet et intime », explique le designer.

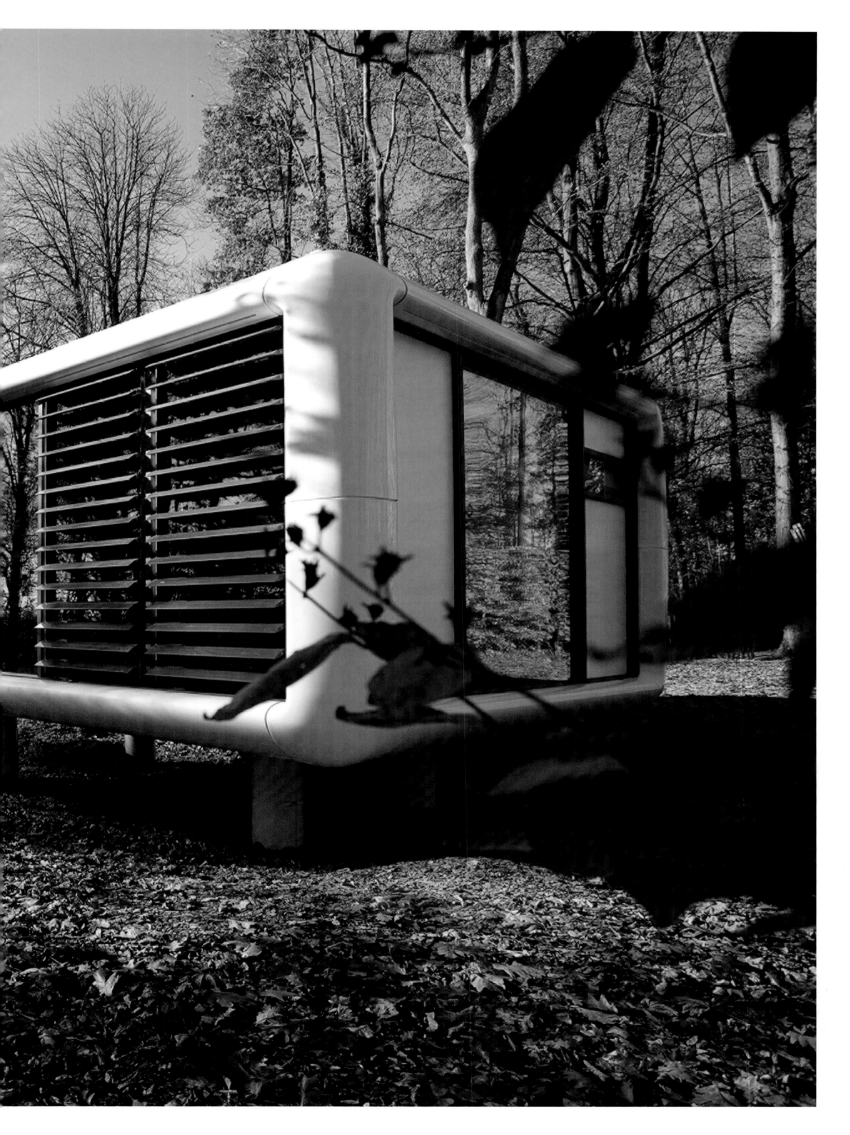

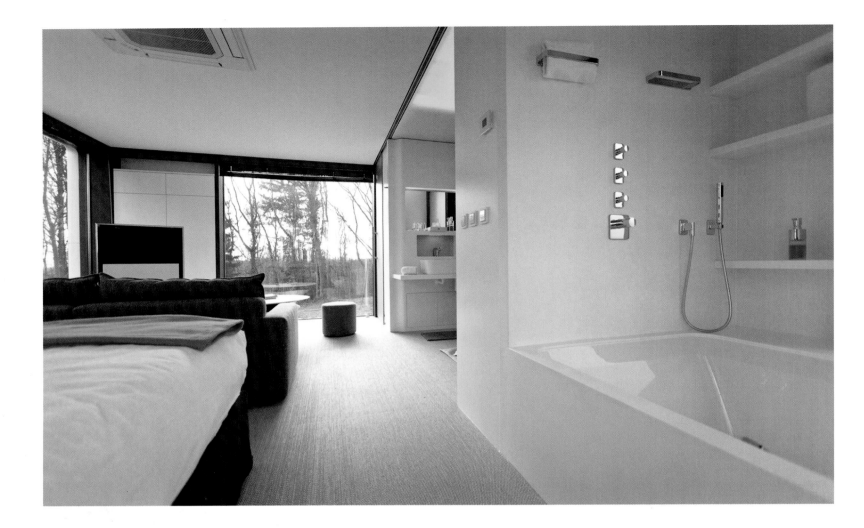

The architect describes the interior of this square cabin as being designed in a "modern chalet style." An open bathtub is seen above.

Das Innere dieses quadratischen Hauses ist laut Architekt im „modernen Chalet-Stil" gehalten. Oben die offen installierte Badewanne.

L'architecte qualifie l'intérieur de sa cabane carrée de « style chalet moderne ». Ci-dessus la baignoire ouverte.

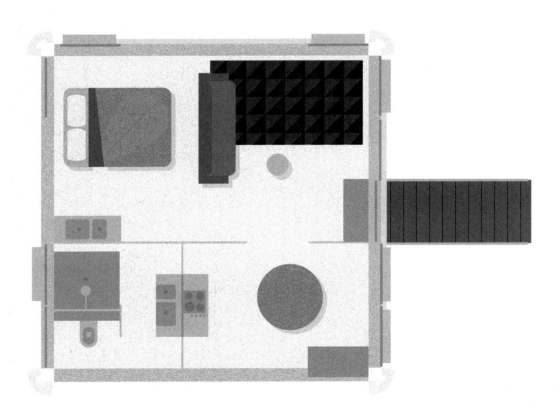

Living and sleeping areas are contiguous, as seen in
the image below and the plan on the left page.
Ample natural light is admitted by full-height glazing.

Der kombinierte Schlaf- und Wohnbereich ist im Bild
unten und auf dem Grundriss links zu erkennen.
Raumhohe Fenster lassen viel natürliches Licht ein.

Les espaces séjour et couchage sont contigus, comme
on le voit ci-dessous et sur le plan de la page de gauche.
Le vitrage sur toute la hauteur laisse abondamment
entrer la lumière du jour.

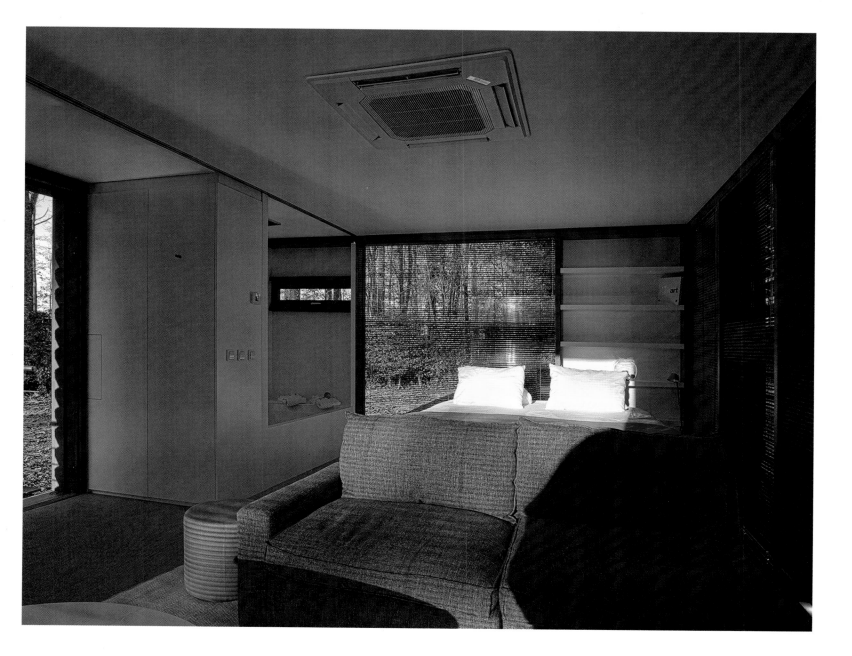

**MATTEO THUN**
Longuich [Germany]
2011–12

# LONGEN-SCHLOEDER WINERY

Area: 20 m² (each)
Client: WeinKulturgut Longen-Schloeder
Collaboration: Stein-Hemmes-Wirtz (Local Architect),
Johannes Cox (Landscape Design)

These small lodges in the Moselle River Valley are located on a 6500-square-meter, family-owned piece of property, where guests are able to "enjoy the structures of wine and fruit production as well as the setting of a village, and to experience a life in harmony with nature." Made with local stone, each of the 20 houses has a small wooden terrace and private garden. Wood, "original fabrics, and natural materials" mark the interiors, as do wooden floors. Large glass doors connect interior and exterior. The project received the 2013 Architekturpreis Wein conferred by the Department of the Environment, Agriculture, Nutrition, Viniculture, and Forestry of Rhineland-Palatinate, the Chamber of Architects of the same state, and the German Association of Viniculture.

———

Diese Winzerhäuser liegen im Moseltal auf einem 6500 m² großen Familiengrundstück und bieten Gästen die Möglichkeit, sich „an den Weinerzeugungs- und Obstbaustätten sowie einer dörflichen Szenerie zu erfreuen und im Einklang mit der Natur zu leben". Die 20 aus dem Gestein eines nahegelegenen Steinbruchs errichteten Häuser sind mit kleinen Holzterrassen und jeweils einem privaten Garten ausgestattet. Holz und Holzböden sowie „natürliche Stoffe und Materialien" zeichnen die Innenbereiche aus. Große Glastüren verbinden Innen und Außen. Das Projekt erhielt 2013 den Architekturpreis Wein 2013, der vom Ministerium für Umwelt, Landwirtschaft, Ernährung, Weinbau und Forsten des Landes Rheinland-Pfalz, der rheinland-pfälzischen Architektenkammer und dem Deutschen Weinbauverband e.V. verliehen wird.

———

Ces petits pavillons dans la vallée de la Moselle occupent une propriété familiale de 6500 m² et permettent à leurs occupants de «profiter des structures de production viticole et fruitière, d'un cadre villageois et d'une vie en harmonie avec la nature». Chacune des 20 maisonnettes en pierre locale possède une petite terrasse en bois et un jardin privatif. Les intérieurs en sont marqués par le bois, «les étoffes d'origine et les matériaux naturels», sans oublier les sols en bois. De larges portes vitrées relient intérieur et extérieur. Le projet a reçu le prix Architekturpreis Wein 2013 décerné par le ministère de l'Environnement, de l'Agriculture, de la Nutrition, de la Viticulture et de la Forêt de Rhénanie-Palatinat, la chambre des Architectes du Land et l'Association allemande de la viticulture.

Twenty small houses are located in relatively close
proximity. Their stone walls are pierced by windows
and large double doors.

Die zwanzig kleinen Häuser liegen relativ dicht
beieinander. Die Steinmauern sind von Fenstern und
großen Doppeltüren durchbrochen.

Vingt maisonnettes sont placées relativement
proches les unes des autres. Leurs murs de pierre sont
percés de fenêtres et de larges doubles portes.

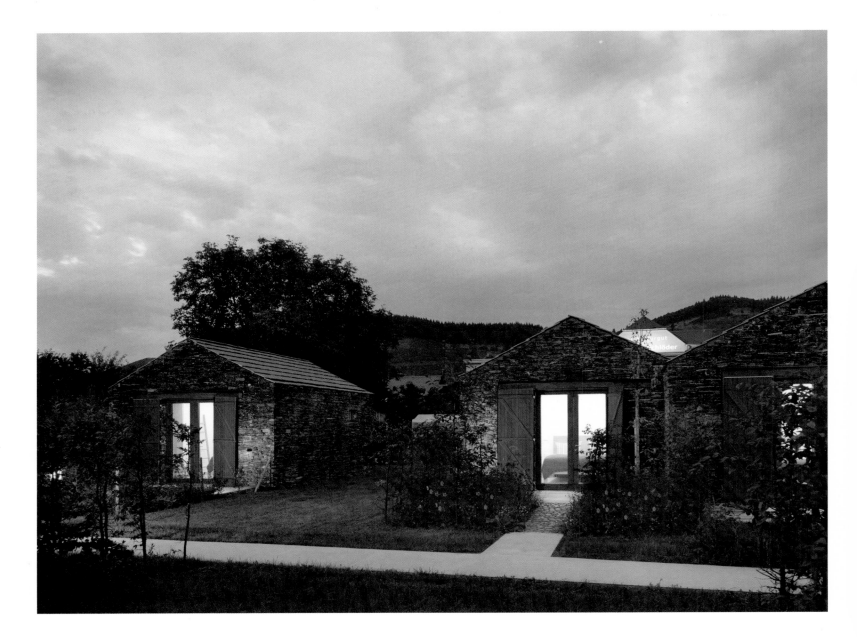

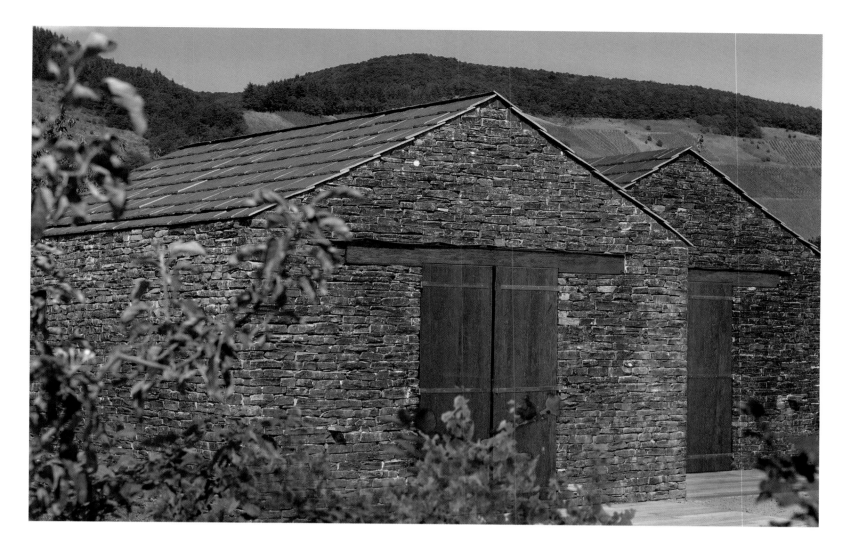

The space is devoted in good part to a bedroom, with a small bathroom just behind the bed (see plan below). When they are closed, the houses resemble agricultural buildings.

Der Schlafbereich nimmt den Großteil der Fläche ein. Hinter dem Bett (siehe unten) befindet sich das kleine Bad. In geschlossenem Zustand ähneln die Häuser Agrarbauten.

L'espace disponible est occupé en grande partie par une chambre à coucher, avec une petite salle de bains juste derrière le lit (plan ci-dessous). Fermées, les maisons pourraient ressembler à des bâtiments agricoles.

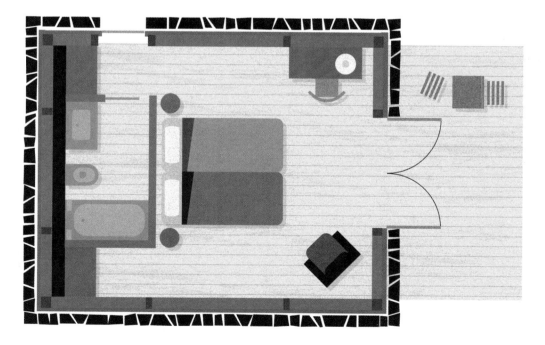

Interior spaces are modern and bright, with simple furnishings and smooth surfaces contrasting with the rough stone exteriors.

Das Interieur ist modern und hell, das Mobiliar schlicht. Glatte Oberflächen kontrastieren mit dem rauen Steinäußeren.

Les espaces intérieurs sont clairs et modernes, avec un mobilier simple et des surfaces lisses qui contrastent avec les pierres brutes de l'extérieur.

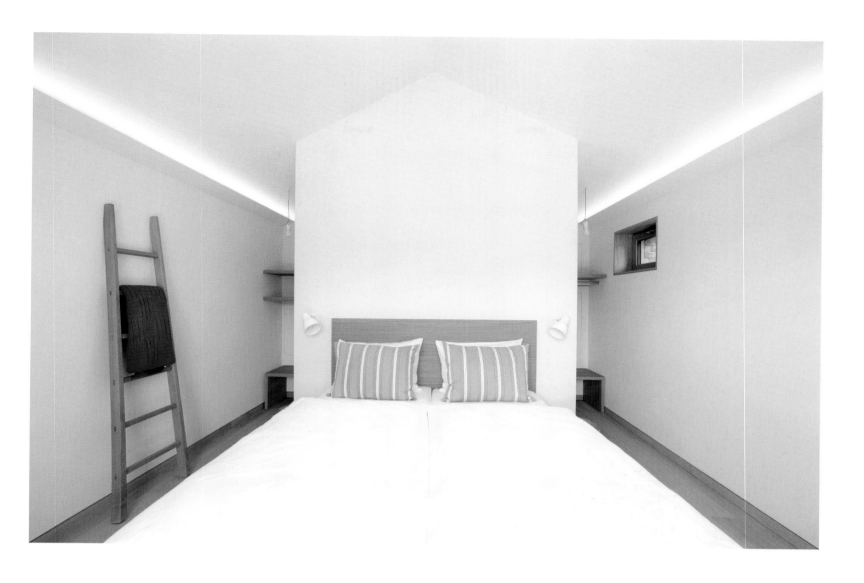

The bathroom and closet areas are placed behind the wall at the head of the bed. The efficient arrangement of the space makes these houses, which are essentially hotel rooms, quite comfortable.

Bad- und Schrankbereich liegen hinter der Wand am Kopfende des Bettes. Durch effiziente Raumnutzung sind die Häuser, bei denen es sich eigentlich um Hotelzimmer handelt, sehr komfortabel.

La salle de bains et les toilettes sont placées derrière le mur à la tête du lit. Un aménagement efficace et rationnel de l'espace rend les maisons, pour la plupart des chambres d'hôtel, assez confortables.

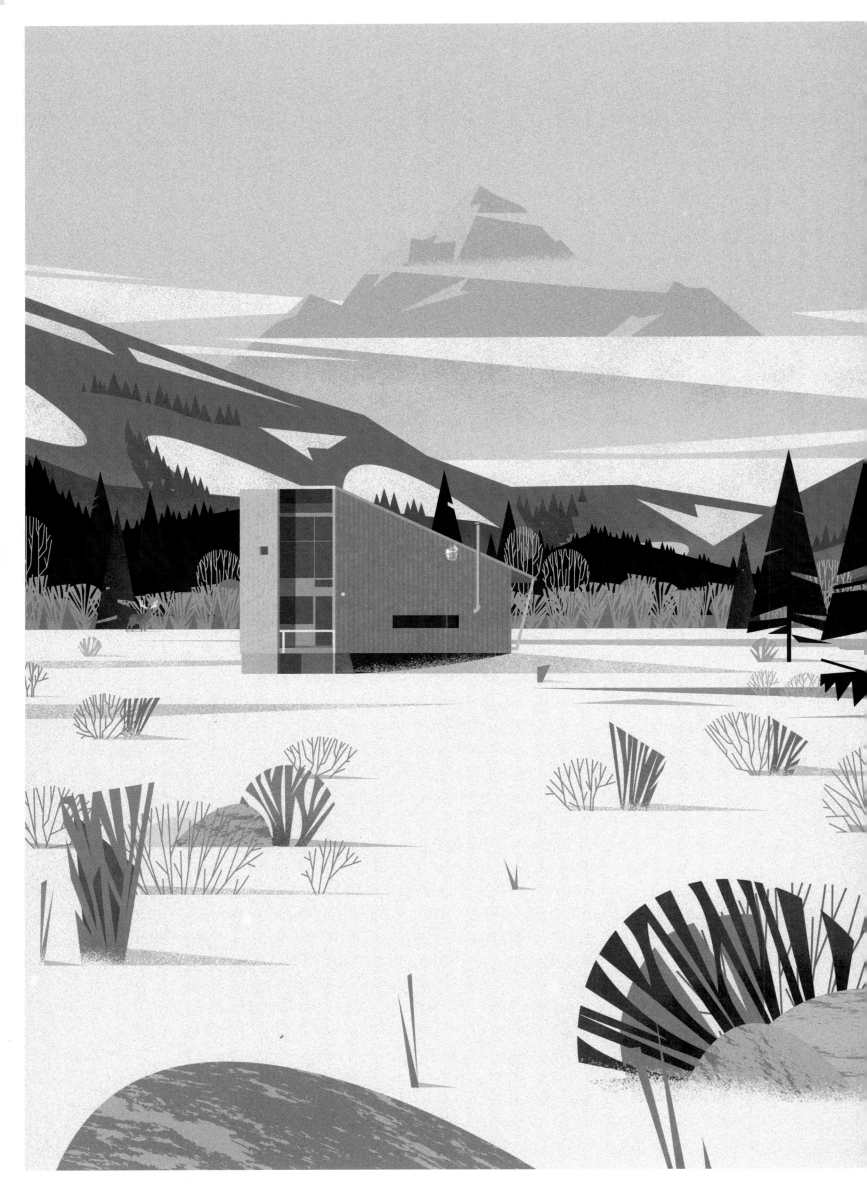

**EGGLESTON FARKAS**
Winthrop, Washington [USA]
2000

# METHOW CABIN

Area: 110 m$^2$

The Methow Cabin was designed as a small retreat used for cross-country skiing and mountain biking. The owners wished to accommodate six to eight people, with a communal area for gathering and dining. The structure opens at the ends to offer views up and down the valley and is anchored in a concrete base 122 centimeters deep, extending beneath the frost line. Glulam beams, cedar exterior siding, and steel details were used. The architects explain: "The shed roof echoes the slope of the hills beyond, while allowing snow to slide off easily. There are no roof penetrations, and the simple form eliminates ridges and valleys that would be susceptible to leaks."

———

Die Methow Cabin wurde als kleiner Rückzugsort nach dem Skilanglaufen und Mountainbiken entworfen. Die Eigentümer wünschten sich Unterbringungsmöglichkeiten für sechs bis acht Personen sowie einen Bereich für Zusammenkünfte und die gemeinsame Einnahme der Mahlzeiten. Das Gebäude gewährt an den beiden Enden einen Ausblick in tiefer und höher gelegene Tallagen und ist in einem 122 cm tiefen Fundament verankert, das bis unter die Frostgrenze reicht. Zum Einsatz kamen Balken aus Brettschichtholz, eine Außenverkleidung aus Zedernholz und Stahlelemente. Die Architekten: „Das schräge Dach nimmt Bezug auf die Hänge der Hügel im Hintergrund und erleichtert das Abrutschen des Schnees. Das Dach ist nicht durchbrochen, und die einfache Form verhindert Unebenheiten, die für undichte Stellen anfällig sind."

———

La Methow Cabin a été conçue comme un refuge aux dimensions réduites pour les skieurs de randonnée et les cyclistes tout-terrain. Les propriétaires souhaitaient pouvoir loger six à huit personnes et disposer d'un espace commun pour se réunir et prendre leurs repas. Le bâtiment est ouvert aux extrémités pour la vue vers le haut et vers le bas de la vallée. Il est ancré dans une base de béton profonde de 122 cm qui se déploie sous la profondeur de gel. Les poutres sont en lamellé-collé, le bardage extérieur en cèdre et les détails en acier. Les architectes expliquent : « Le toit en pente fait écho à la pente des collines environnantes, tout en permettant à la neige de glisser facilement. Il ne laisse rien pénétrer et sa forme simple ne comporte ni faîte, ni cornière susceptible de fuir. »

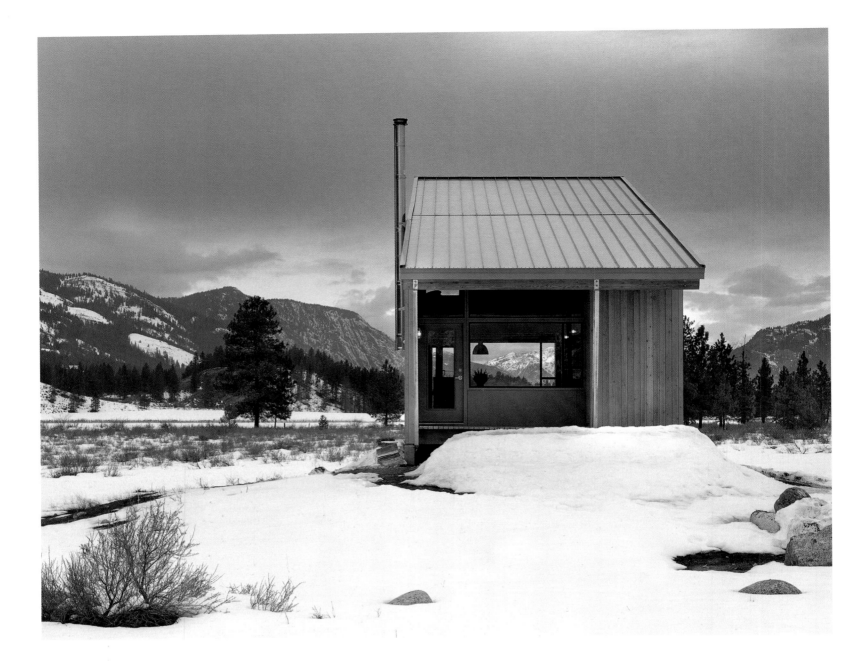

The cabin rises up to take in a
full-height view of the mountain
setting. Right, plans of each
level of the structure.

Die Raumhöhe nimmt zuguns-
ten der Aussicht auf die Berge
zu. Rechts Grundrisse der
einzelnen Ebenen des Baus.

La cabane offre une vue sur la
montagne de toute sa hauteur.
À droite, plans des différents
niveaux.

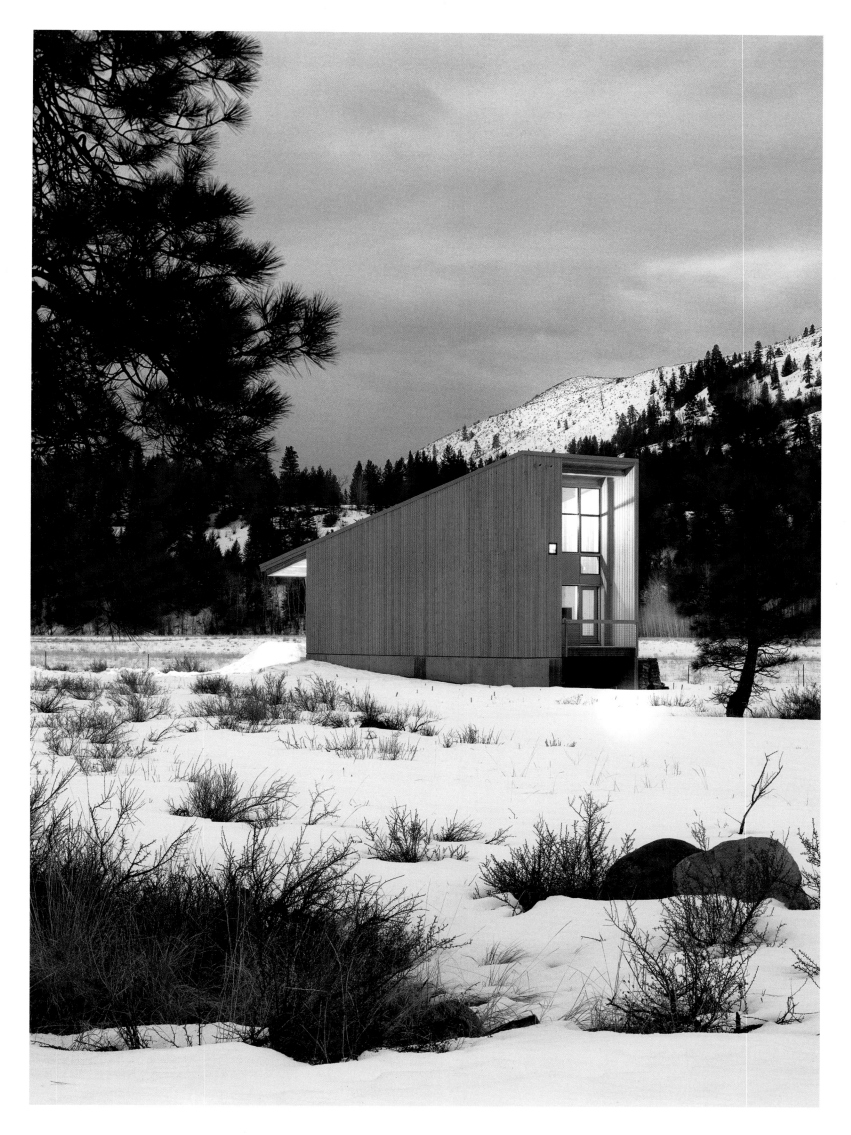

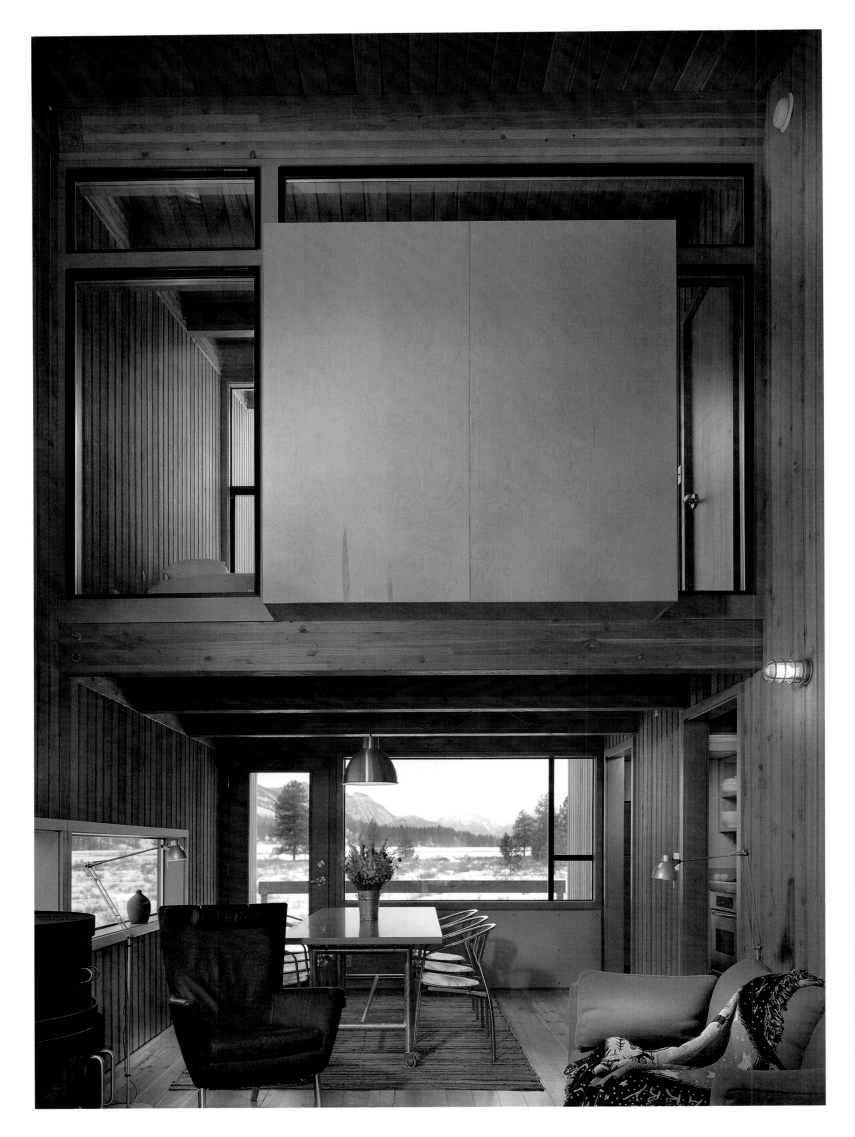

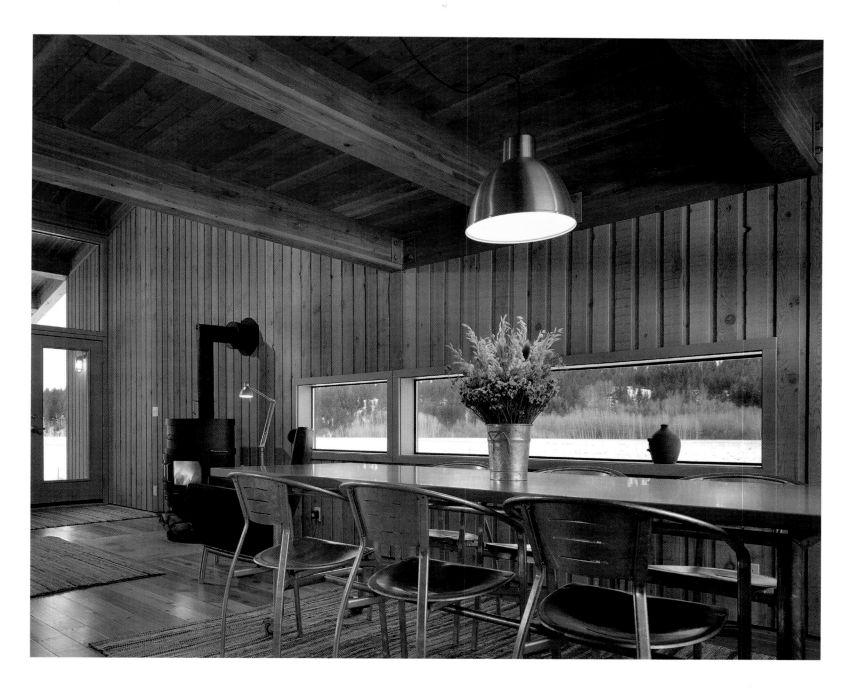

Cedar siding is used both for the exterior walls and for the interiors in order to "create a continuum" between outside and inside. Above, and left, a dining-room table sits below a mezzanine bedroom area.

Außen- und Innenwände sind mit Zedernholz verkleidet, um zwischen Außen- und Innenbereich „ein Kontinuum zu schaffen". Oben und links der Esstisch unter dem Schlafbereich im Mezzanin.

Le bardage en cèdre a été utilisé pour les murs extérieurs comme pour l'intérieur afin de « créer une continuité » entre extérieur et intérieur. Ci-dessus et à gauche, la table de la salle à manger est placée sous une chambre à coucher en mezzanine.

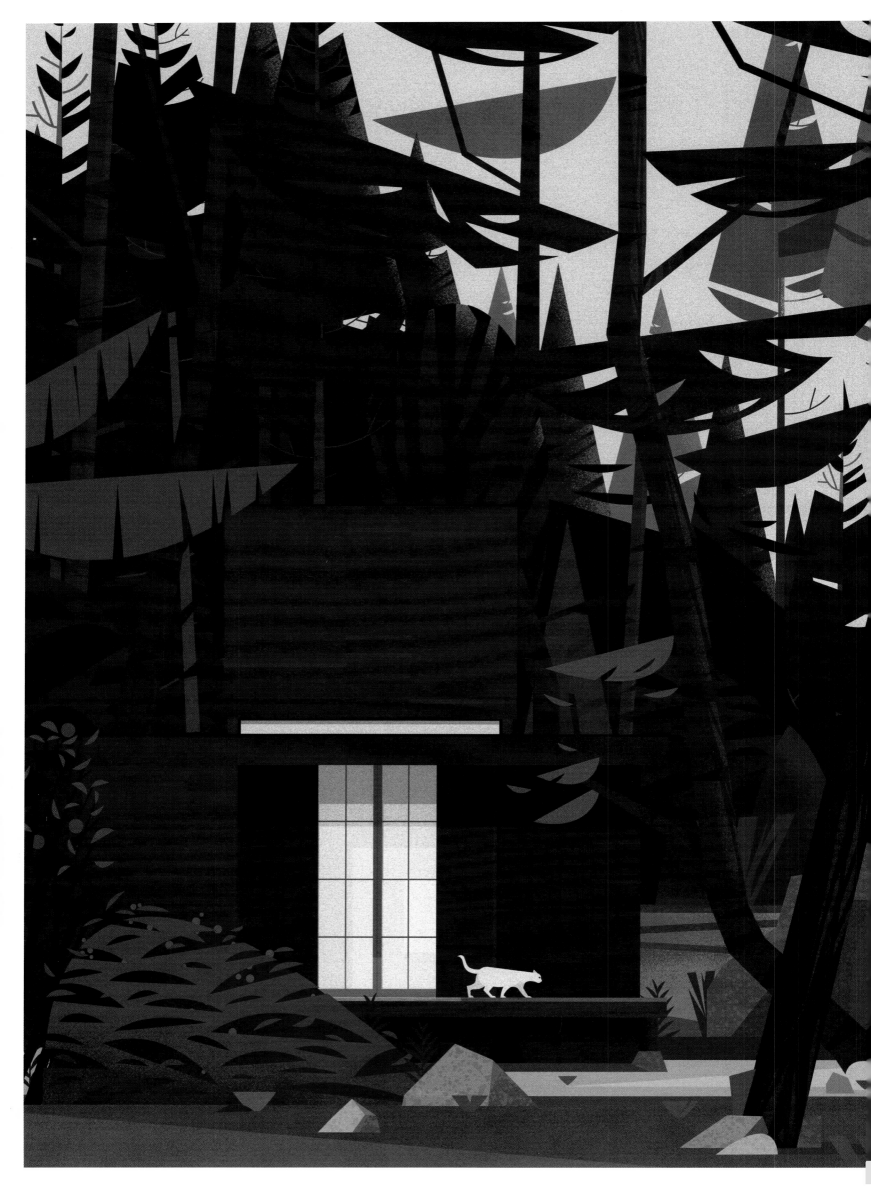

# MONK'S CABIN

Area: 18 m²

This small cabin was built amongst pine trees in the mountains in Korea. It was designed for a well-known Buddhist monk, who was a spiritual leader, philosopher, educator, best-selling author, and environmentalist. It is open to nature on all four sides and has a 2.7-square-meter room in the center with a 5.5-meter-high ceiling. The architect uses the Korean word *bang*, which refers in traditional architecture to a "room that varies depending on a change of surroundings." The architect explains: "The *bang* becomes a part of the landscape through open doors, while its closed doors allow light to resonate with the traces of nature. This cabin," he concludes, "is the reinterpretation of the traditional Korean *bang*, allowing the daily life of a Buddhist monk to become consolidated with nature."

———

Diese kleine Hütte wurde, von Kiefern umgeben, in den koreanischen Bergen für einen bekannten buddhistischen Mönch errichtet, ein spirituelles Oberhaupt, Philosoph, Lehrer, Bestsellerautor und Umweltschützer. Das Projekt öffnet sich nach allen Seiten zur Natur. Im Zentrum befindet sich ein 2,7 m² großer Raum mit einer Deckenhöhe von 5,5 m. Der Architekt verwendet das koreanische Wort „bang", das in der traditionellen Architektur einen Raum bezeichnet, der sich je nach den Umgebungsverhältnissen verändert. Der Architekt: „Das ‚bang' wird bei geöffneten Türen zu einem Teil der Landschaft. Bei geschlossenen Türen und im Spiel des Lichts sind die Formen der Natur zu erkennen." Der Architekt schließt: „Die Hütte ist eine Neuinterpretation des traditionellen koreanischen ‚bang' und ermöglicht einem buddhistischen Mönch, das alltägliche Leben mit der Natur zu vereinen."

———

Cette petite cabane au milieu des pins, dans les montagnes coréennes, a été conçue pour un célèbre moine bouddhiste à la fois chef spirituel, philosophe, enseignant, auteur de best-sellers et écologiste. Ouverte sur la nature par ses quatre côtés, elle présente une pièce de 2,7 m² sous un plafond de 5,5 m. L'architecte évoque à son sujet le mot coréen « bang » qui, dans l'architecture traditionnelle, désigne « un espace qui varie au gré des changements de l'environnement. Il devient une partie du paysage lorsque les portes sont ouvertes, tandis qu'elles permettent à la lumière de faire écho aux traces de la nature lorsqu'elles sont fermées. Cette cabane, conclut-il, réinterprète le "bang" coréen traditionnel en permettant à un moine bouddhiste de concilier quotidien et nature ».

This wooden cabin for a monk was built in an ideal location for contemplation and contact with nature.

Diese Holzhütte für einen Mönch wurde an einem idealen Ort für Kontemplation und den Kontakt mit der Natur erbaut.

Cette cabane en bois a été construite pour un moine à un emplacement idéal pour la contemplation et le contact avec la nature.

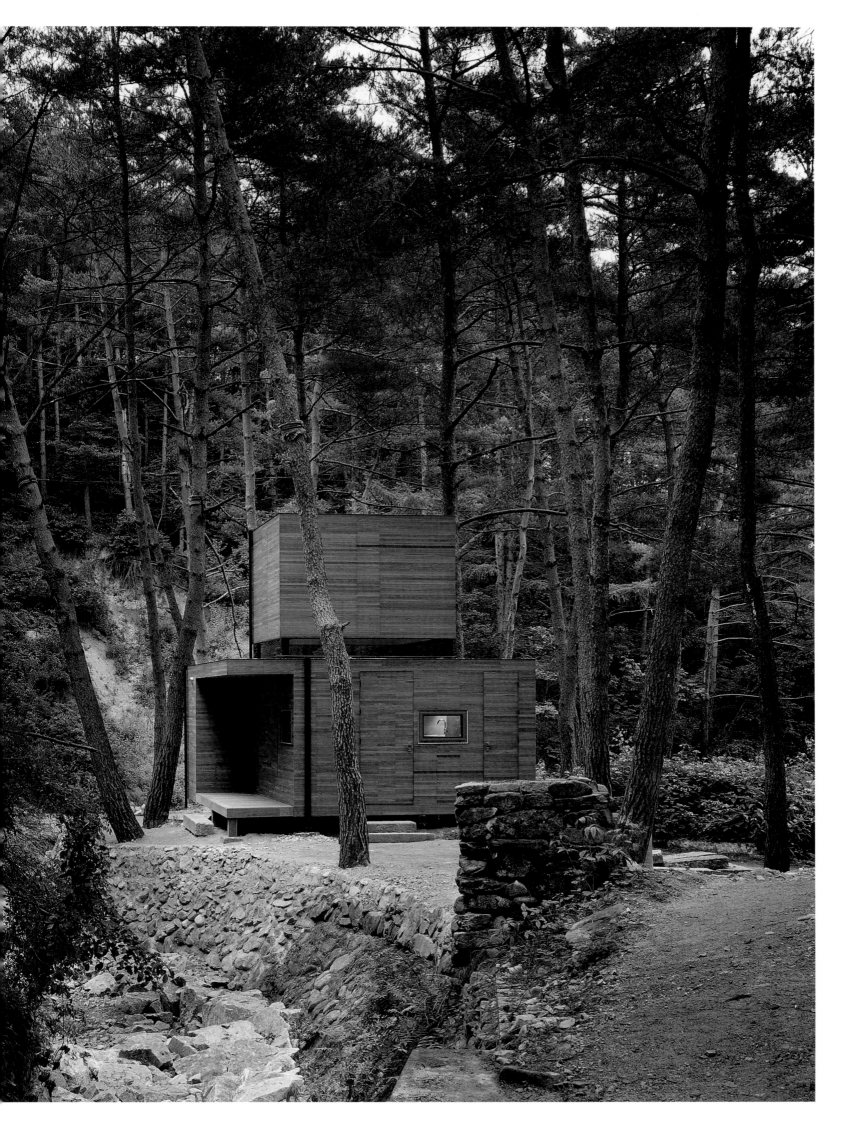

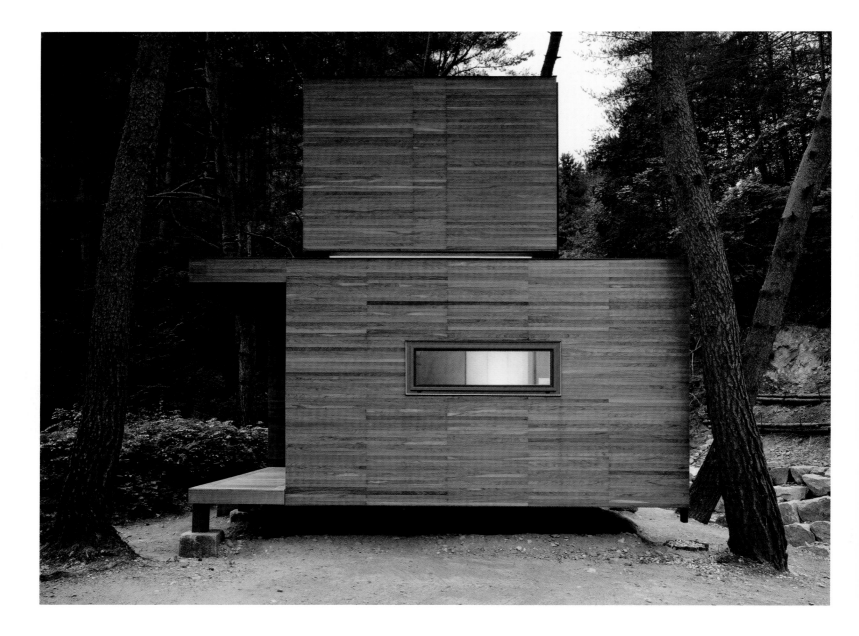

The cabin sits lightly on the ground, lifted up on thin pillars. The cubic design is a combination of straight lines and block-like forms.

Die Hütte ist auf schmalen Stützen aufgeständert und sitzt nur leicht auf dem Untergrund. Der würfelförmige Entwurf konzentriert sich auf die Verbindung gerader Linien und blockartiger Formen.

Elle repose légèrement sur le sol, surélevée par de fins piliers. La conception cubique tire le meilleur parti d'une combinaison de lignes droites et de formes cubiques.

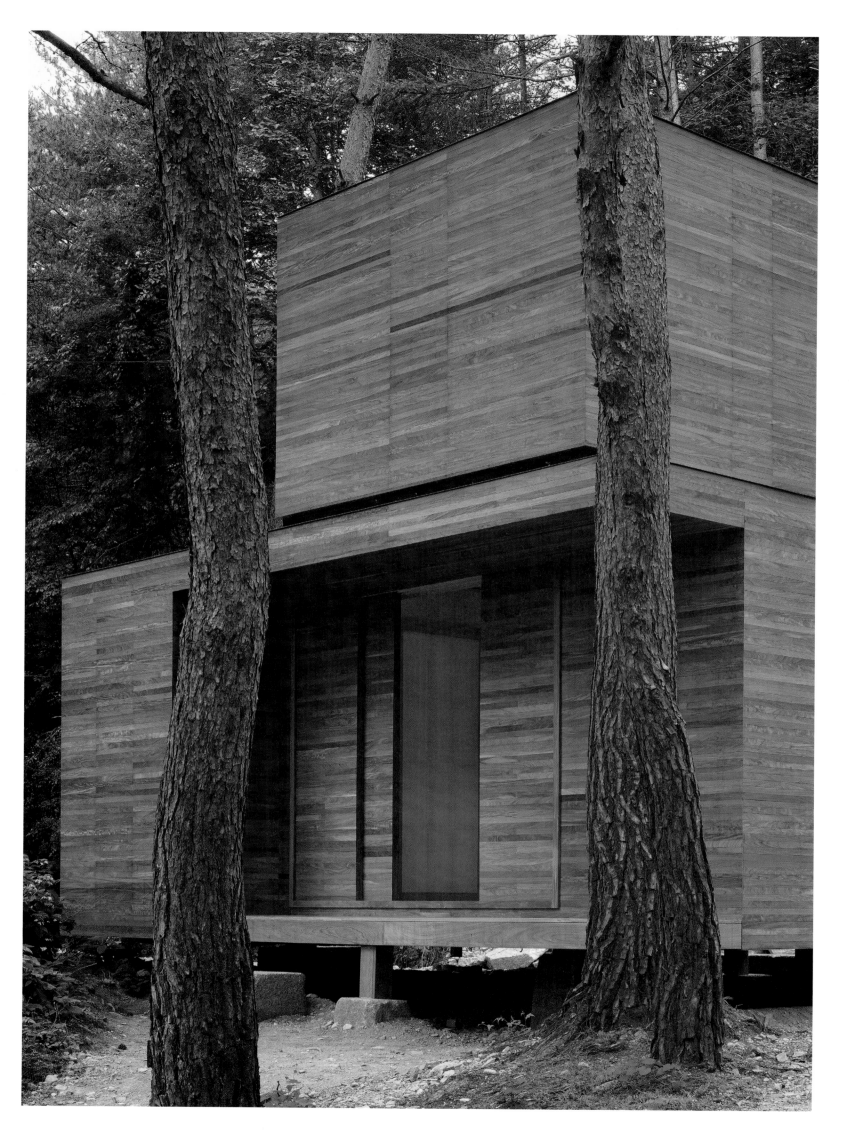

The central space is modeled on the traditional Korean *bang*, in this case 2.7 meters square with a maximum ceiling height of 5.5 meters.

Der zentrale Raum ist dem traditionellen koreanischen „bang" nachempfunden, misst 2,7 m² und hat eine Deckenhöhe von 5,5 m.

L'espace central est formé selon le « bang » coréen traditionnel, ici 2,7 m² et une hauteur de plafond maximale de 5,5 m.

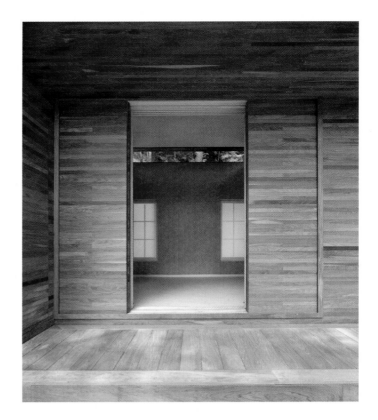

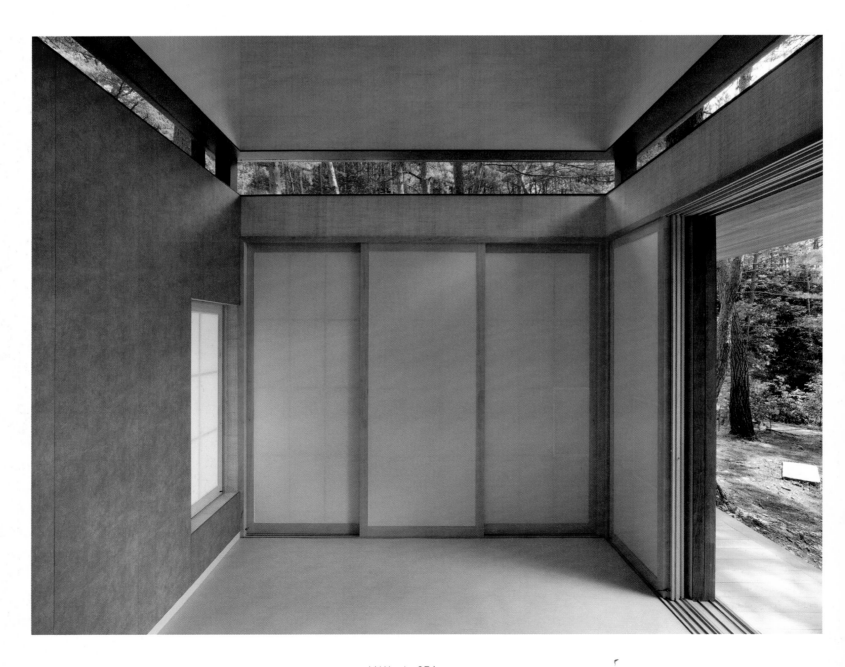

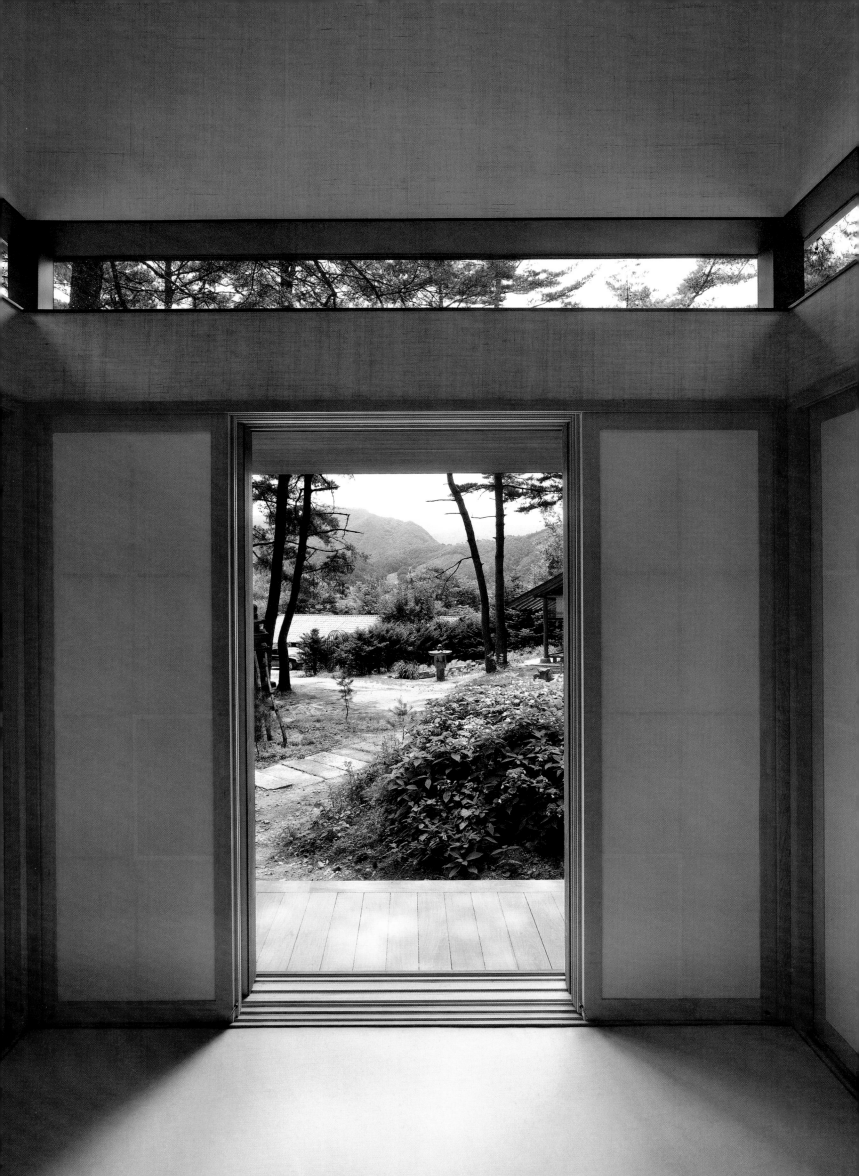

# MORERAVA COTTAGES

Area: 77 m² (each), including 17 m² of terrace area
Client: Turismo Morerava | Cost: $75 000 (each)

These four cottages were built at the initiative of the architects, who noted that "family-friendly" cabins of a certain quality were not being offered on Easter Island. They studied material sources and daily use of the cabins in order to have the least possible impact on the island's environment. The prefabricated design was created on the mainland and shipped to Easter Island by boat. The grid employed was selected to minimize waste of materials. The timber structure is left visible inside because the local climate does not require insulation. A gap was left between the ceiling panels and the zinc roof to allow for natural ventilation. The cabins are supported by single pillars to avoid damage to the terrain and prevent potential moisture problems. Local plants and shrubs were used for the landscaping. Windows were placed to provide for ample natural light and cross-ventilation, as well as to avoid views from cabin to cabin for the sake of privacy. Hot water is generated by solar-heating tanks, and solar panels provide the cottages with their own source of energy.

---

Diese vier Ferienhäuser wurden auf Initiative der Architekten gebaut, denen aufgefallen war, dass es auf der Osterinsel keine „familienfreundlichen" Unterkünfte eines gewissen Standards gab. Sie informierten sich eingehend über Materialbezugsquellen und die alltägliche Ferienhausnutzung, um die Natur auf der Insel möglichst wenig zu schädigen. Die Fertighäuser wurden auf dem Festland hergestellt und per Boot auf die Osterinsel transportiert. Das verwendete Bauraster soll die Verschwendung von Materialien weitgehend verhindern. Die Holzstruktur ist auch innen sichtbar, da wegen des Klimas keine Dämmung nötig ist. Zur natürlichen Belüftung wurde zwischen Decke und Zinkdach etwas Platz gelassen. Die Ferienhäuser sind aufgeständert, um das Gelände nicht zu beeinträchtigen und Feuchtigkeit zu verhindern. Für die Landschaftsgestaltung kamen heimische Pflanzen und Sträucher zum Einsatz. Die Fenster sind so platziert, dass sie viel natürliches Licht einlassen, Querlüftung ermöglichen und zum Schutz der Privatsphäre kein Blick von Ferienhaus zu Ferienhaus möglich ist. Warmwasser wird über Solartanks zur Verfügung gestellt. Eine Fotovoltaikanlage macht die Häuser unabhängig von anderen Energiequellen.

---

Ces quatre petites maisons ont été réalisées à l'initiative des architectes qui avaient noté l'absence de logements «familiaux» de qualité sur l'île de Pâques. Ils ont étudié avec soin les sources de matériaux et l'utilisation quotidienne des habitations afin de réduire le plus possible l'impact sur l'environnement de l'île. Le concept préfabriqué a été conçu sur le continent et acheminé par bateau. Le plan adopté l'a été pour gaspiller le moins possible de matériaux. La structure en bois a été laissée apparente car le climat local ne nécessite aucune isolation. Une ouverture entre les panneaux qui forment le plafond et la toiture en zinc permet une ventilation naturelle. Des piliers simples portent l'ensemble afin de ne pas abîmer le terrain et de prévenir les éventuels problèmes d'humidité. Des plantes et arbrisseaux locaux ont été utilisés pour l'aménagement paysager. Les fenêtres sont disposées de manière à laisser pénétrer la lumière naturelle en abondance et permettre une ventilation croisée, tout en fermant chaque unité à la vue des autres afin de préserver l'intimité des occupants. L'eau chaude est fournie par des réservoirs de chauffage solaire et des panneaux solaires permettent d'éviter le recours à toute autre source d'énergie.

The 77-square-meter cabins are made
of poplar timber and plywood boards.
The external cladding is in radiata pine,
and the roofing in corrugated zinc.

Die 77 m² großen Hütten bestehen
aus Pappelholz und Sperrholzplatten.
Für die Außenverkleidung kamen
Monterey-Kiefernholz, für das Dach
Wellblech aus Zink zum Einsatz.

Les cabanes de 77 m² sont en bois de
peuplier et panneaux de contreplaqué.
Le revêtement extérieur est en pin
Radiata et la toiture en zinc ondulé.

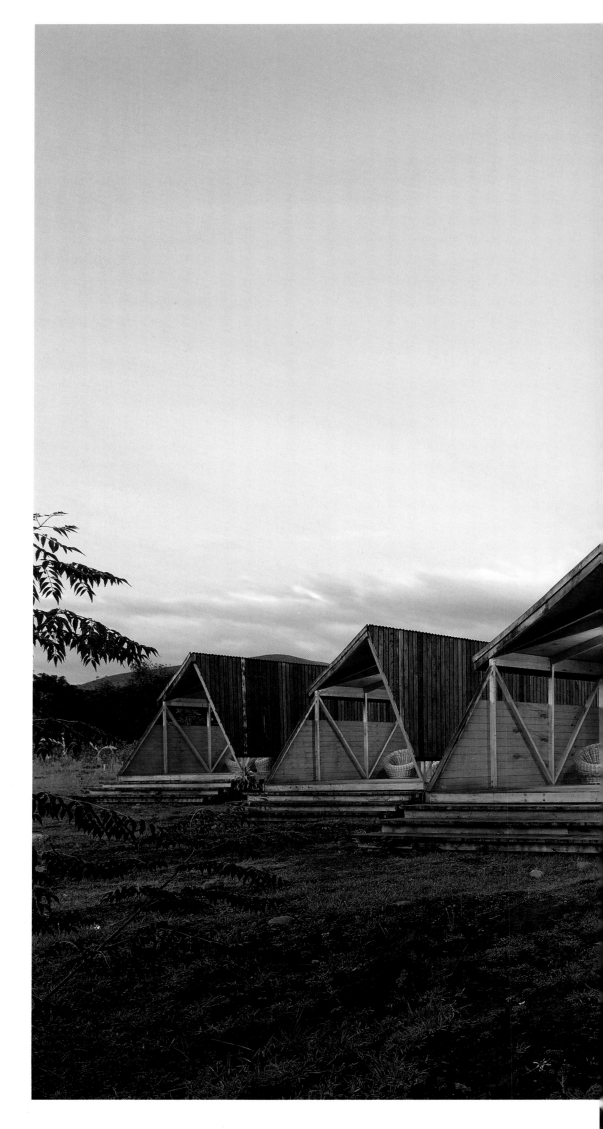

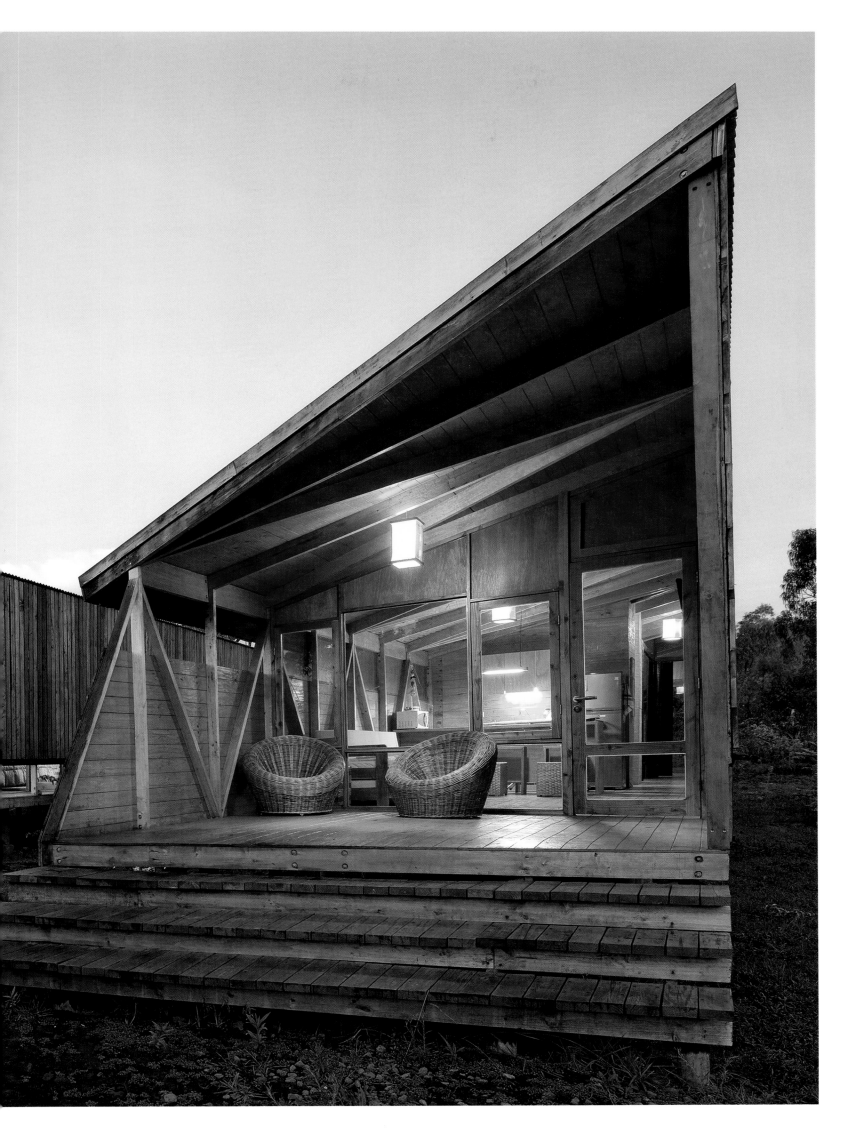

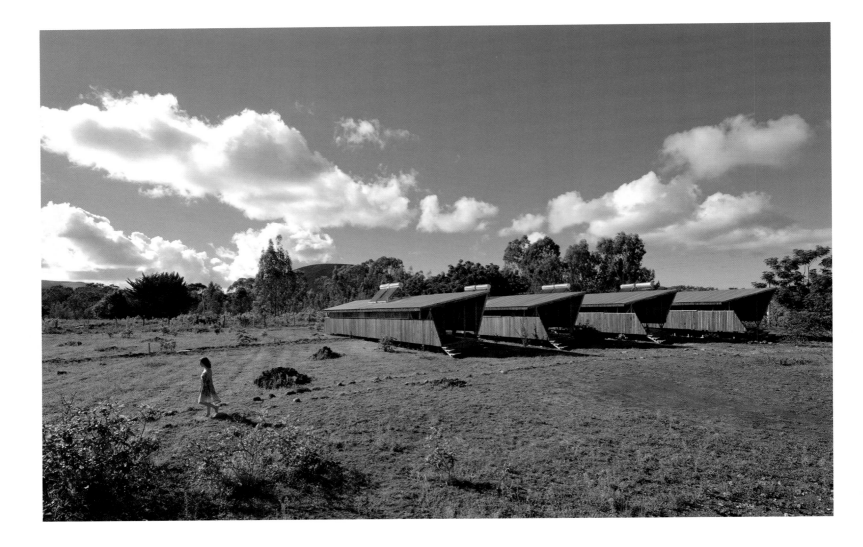

The architects noticed that "family-friendly cabins which meet certain quality standards" were not available on Easter Island. They sought to make a "minimal impact" on the delicate island environment.

Den Architekten war aufgefallen, dass auf der Osterinsel „familienfreundliche Unterkünfte eines gewissen Standards" fehlten. Sie wollten in der empfindlichen Insellandschaft „möglichst wenige Spuren" hinterlassen.

Les architectes avaient noté l'absence de «logements familiaux d'un certain niveau de qualité» sur l'île de Pâques. Ils ont cherché à créer un «impact minimal» sur l'environnement fragile de l'île.

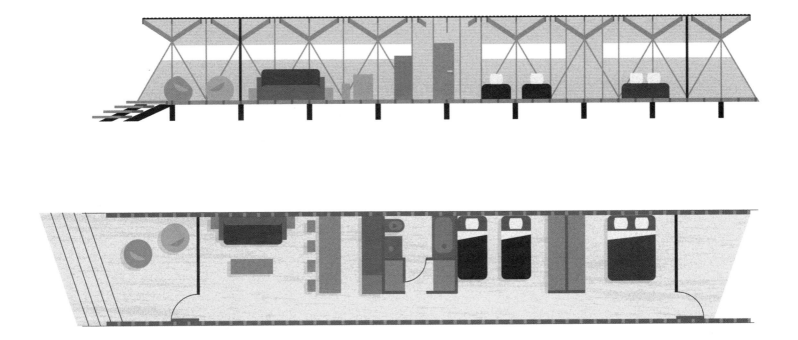

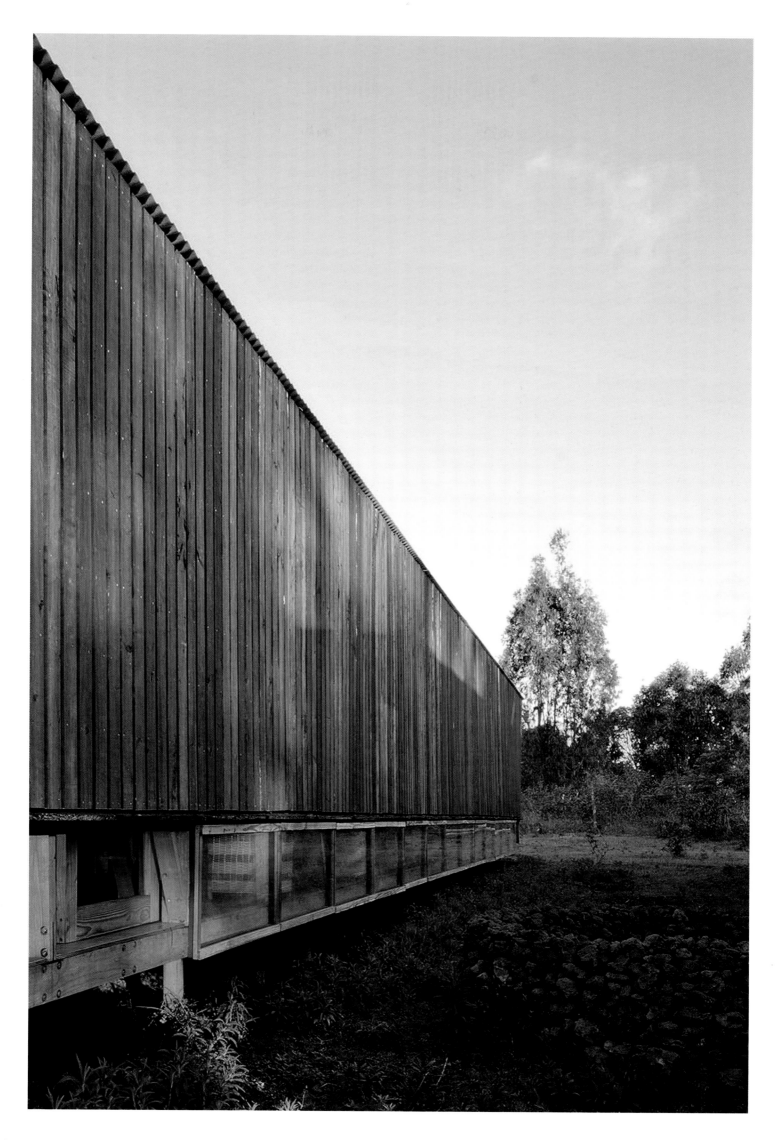

# MOUNTAIN CABIN

Area: 87 m²

 In their design, the architects used "carefully hewn rough concrete," oak front doors with anthracite-colored handrails, and untreated oak floors, as well as square windows of different sizes with solid oak frames. Inside the structure, a spiral staircase connects the living area on the upper level with the two private areas on the lower level, where the bedrooms and relaxation areas "are interlocked like a puzzle." The entire design gives an impression of solidity that is in many ways a reflection of the rather harsh beauty of the natural setting.

———

Die Architekten verwendeten für dieses Projekt „sorgsam bearbeiteten rauen Beton", Eingangstüren aus Eichenholz, anthrazitfarbene Handläufe und unbehandeltes Eichenholz für die Fußböden. Zudem kamen verschieden große quadratische Fenster mit massiven Eichenholzrahmen zum Einsatz. Innerhalb des Gebäudes verbindet eine Wendeltreppe den Wohnraum im Obergeschoss mit den beiden Privatbereichen im Untergeschoss, wo die Schlaf- und Entspannungsräume „wie bei einem Puzzle ineinandergreifen". Der gesamte Entwurf vermittelt einen Eindruck von Robustheit, der in vielerlei Hinsicht die durchaus raue Schönheit der Natur reflektiert.

———

Les architectes ont ici utilisé le « béton brut soigneusement taillé », avec des portes de devant en chêne aux rampes anthracite, des planchers de chêne brut et des fenêtres carrées de différentes tailles aux solides cadres de chêne. À l'intérieur, un escalier en colimaçon relie le séjour de l'étage aux deux espaces privés du niveau inférieur où les chambres et salles de relaxation « s'emboîtent comme un puzzle ». L'ensemble donne une impression de solidité qui reflète à bien des égards la beauté plutôt rude du cadre naturel.

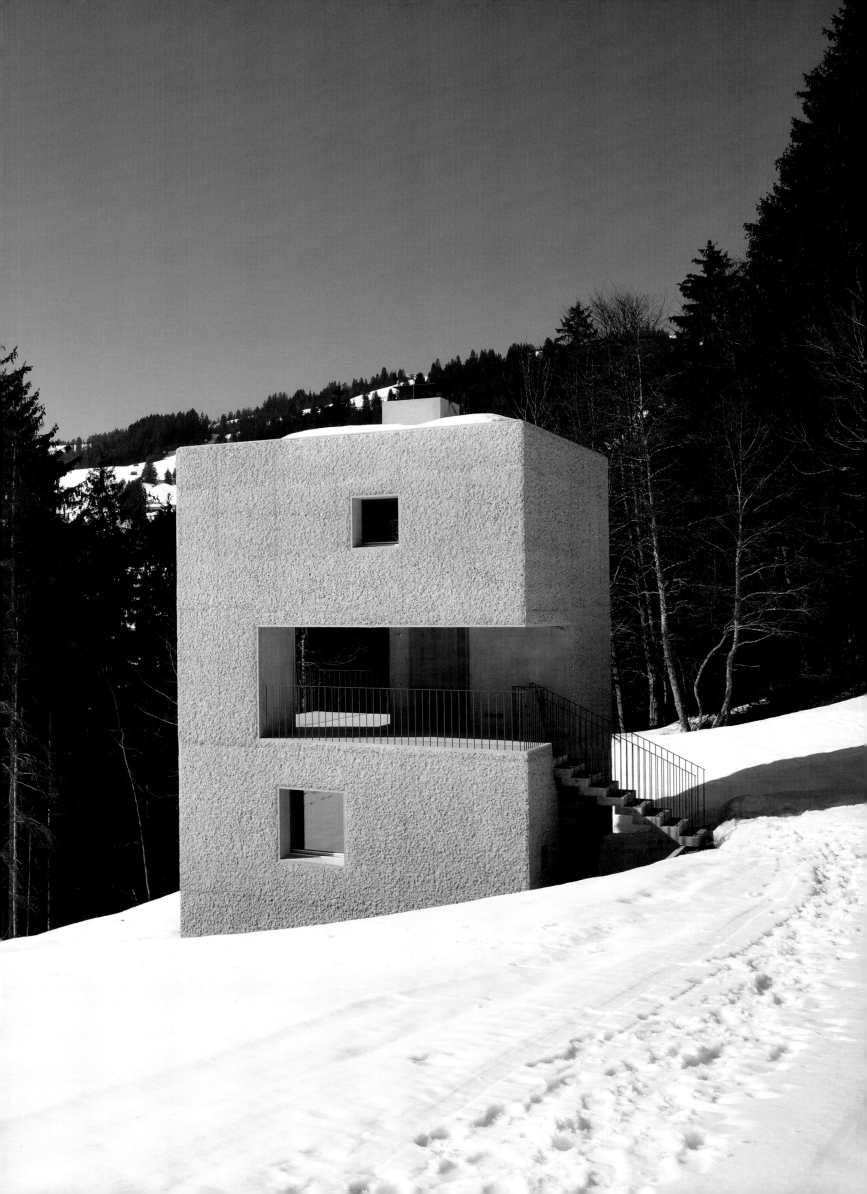

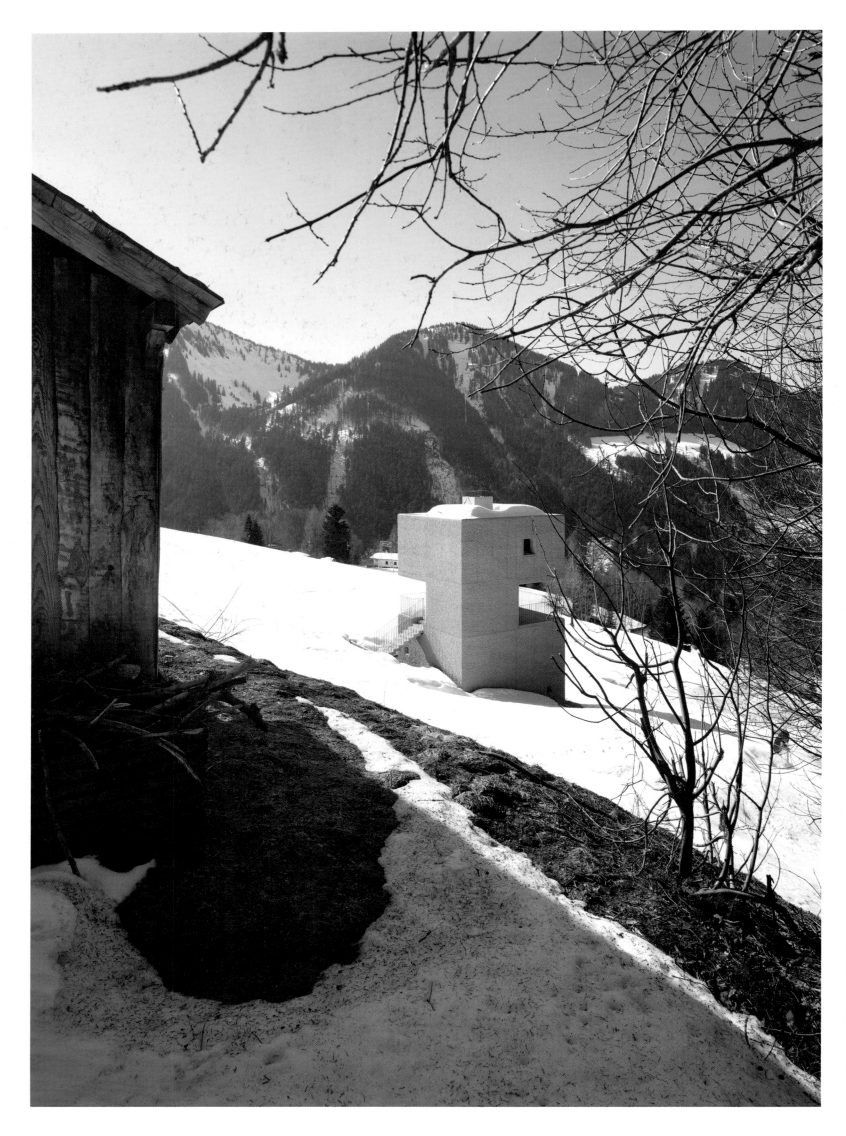

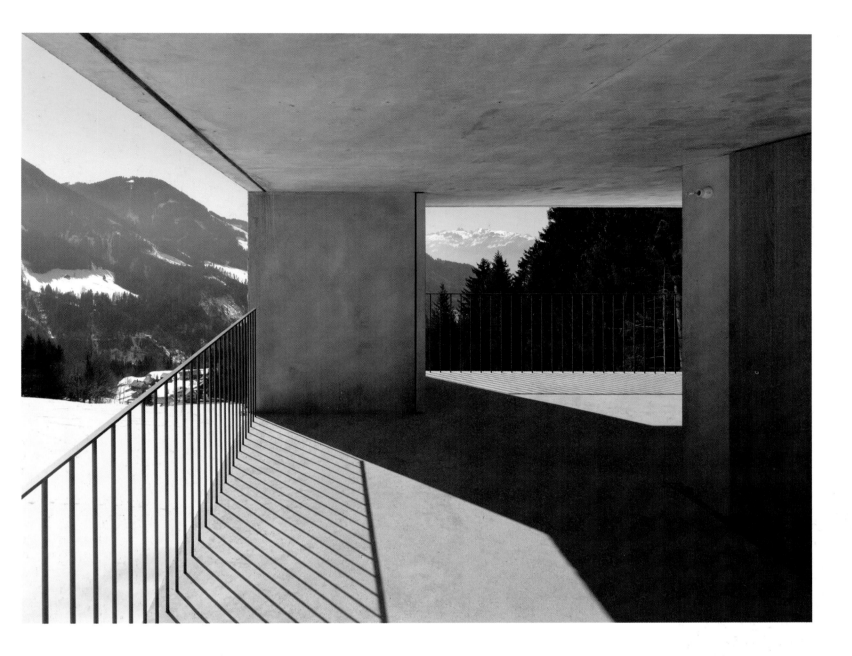

The square plan and concrete volumes of the house are enlivened by cutouts that leave spaces for outside terraces and views of the mountain setting.

Der quadratische Grundriss und der Betonkörper des Hauses werden durch Aussparungen aufgelockert, die Raum für eine Terrasse und den Blick in die Berglandschaft schaffen.

Le plan carré et les volumes en béton sont égayés par des découpures qui ouvrent des terrasses et des vues sur les montagnes environnantes.

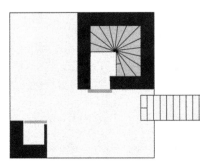
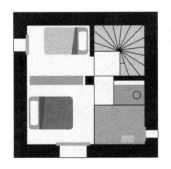
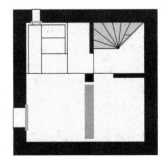

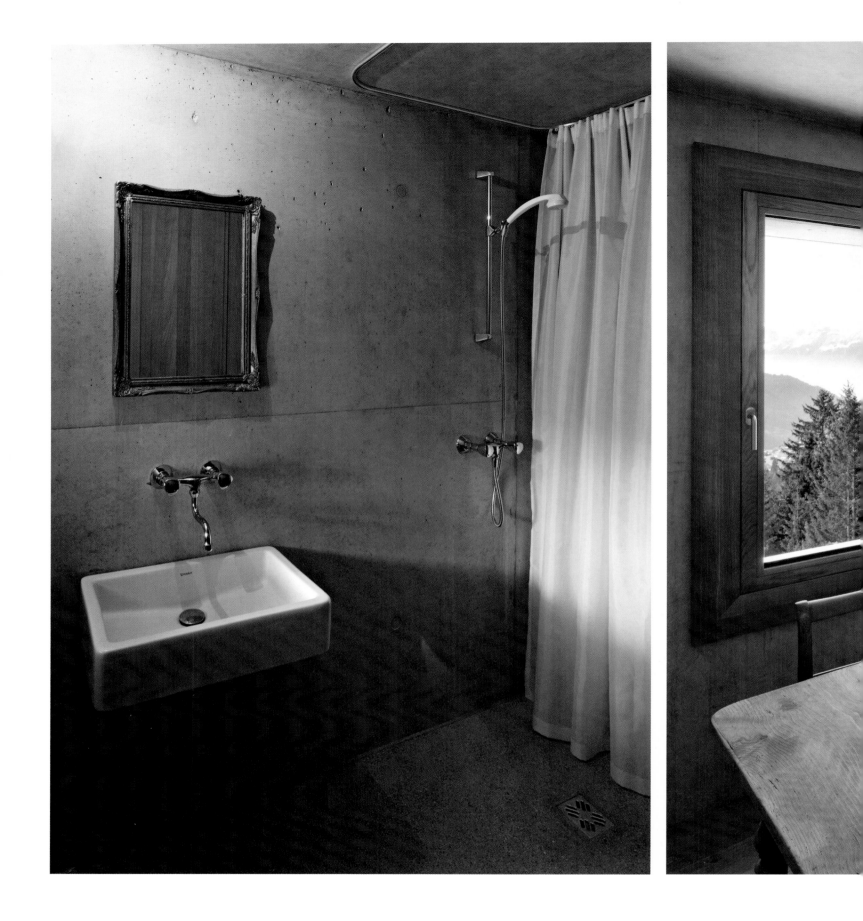

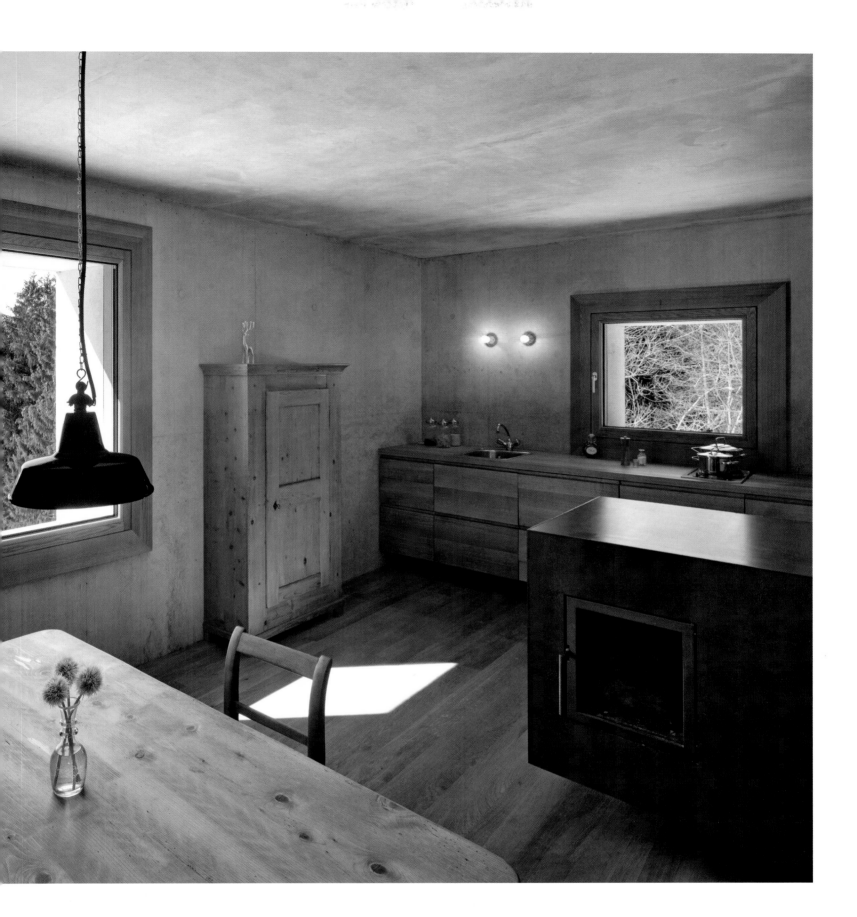

Wood finishing and some added wooden furniture make the interior of the house warmer than might be expected when it is seen from the outside.

Holzflächen und Holzmobiliar lassen das Innere des Hauses wärmer erscheinen als von außen zunächst vermutet.

Les finitions en bois et le mobilier en bois ajouté rendent l'intérieur de la maison plus chaleureux qu'on ne le penserait en la voyant de l'extérieur.

**ROBIN FALCK**
Sipoo [Finland]
2011

# NIDO

Area: 9 m² | Cost: €10 000

Nido was designed by Robin Falck in 2009 and built after his military service (2009–10), completed in 2011. This cabin was designed to be built without a permit. The designer states that he "wanted to maximize the use of this space, just having the essentials and stripping away all the unnecessary parts," a philosophy that he now follows as a designer. The top level has a bed and space to keep clothes and books. A table was made with left-over materials. Falck used locally sourced wood and enlisted the help of a local carpenter to build the window frame and door. The cabin is insulated with flax and is warmed during the winter with a small heat fan. Colors were chosen to "mimic a large boulder and let it melt into the surroundings easily." He called the cabin "Nido" (meaning "bird's nest" in Italian) because his own name, Falck, means "falcon" in Swedish.

———

Robin Falck entwarf Nido im Jahr 2009 und stellte das Projekt 2011 nach seinem Armeedienst (2009–10) fertig. Es sollte ohne Baugenehmigung errichtet werden können. Der Designer wollte die „maximale Ausnutzung eines Raums, der nur mit dem Notwendigsten ausgestattet und von allem Überflüssigen befreit ist" – eine Philosophie, der er auch weiterhin folgt. Im Obergeschoss befinden sich ein Bett sowie Stauraum für Kleidung und Bücher. Der Tisch wurde aus Ausschussmaterialien angefertigt. Robin Falck griff auf Holz aus der Region zurück und ließ sich von einem Tischler aus der Gegend beim Bau der Holzrahmen für Fenster und Türen helfen. Das Projekt verfügt über eine Flachsdämmung und wird im Winter mit einem kleinen Lüfter geheizt. Die Farbgebung sollte „einen großen Felsen nachahmen" und das Gebäude „mit der Umgebung verschmelzen". Falck nannte sein Projekt „Nido" (nach dem italienischen Wort für „Vogelnest"). Sein Nachname bedeutet auf Deutsch „Falke".

———

Robin Falck a dessiné Nido en 2009 et l'a construit après son service militaire (2009–10), puis achevé en 2011. La cabane devait pouvoir être bâtie sans permis de construire. Le designer explique qu'il «a voulu optimiser l'usage de l'espace, se contenter de l'essentiel et se débarrasser de tout ce qui n'est pas nécessaire», une philosophie qui est encore la sienne aujourd'hui. Le lit se trouve à l'étage, avec un espace de rangement pour des vêtements et des livres. Une table a été fabriquée avec des matériaux de récupération. Robin Falck a uniquement utilisé du bois d'origine locale et s'est assuré le concours d'un menuisier de la région pour l'encadrement de la fenêtre et la porte. La cabane est isolée avec du lin et chauffée par un petit radiateur soufflant en hiver. Les couleurs ont été choisies pour «imiter un gros rocher et permettre à la maison de se fondre facilement dans le décor». L'architecte l'a appelée «Nido» («nid» en italien) parce que son nom à lui, Falck, signifie «faucon» en suédois.

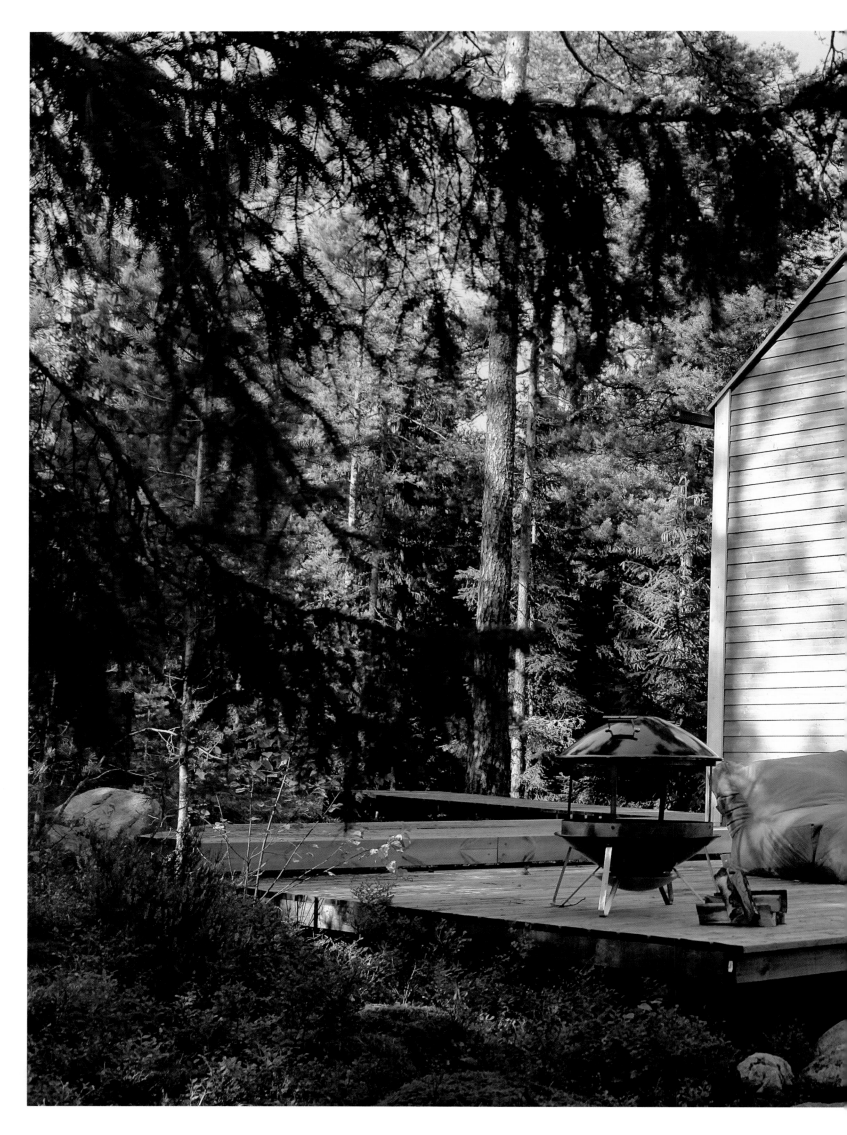

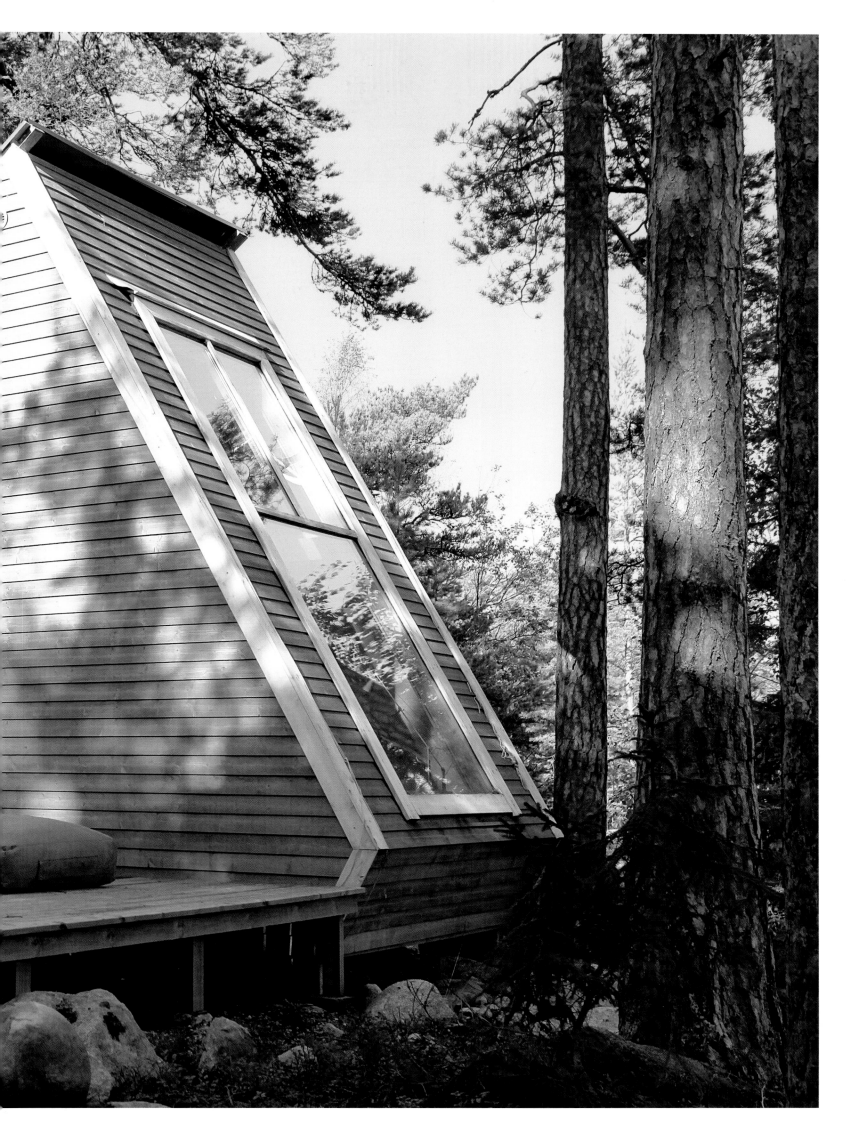

With its small, curved wooden ramp and very
modest profile, the Nido would almost appear to be
the prototypical cabin in this sylvan setting.

Mit der geschwungenen Holzrampe und dem
sehr schlichten Profil wirkt Nido an diesem waldigen
Standort wie eine prototypische Hütte.

Avec sa courte rampe d'accès courbe et son profil
très discret, Nido est presque l'archétype de la cabane
dans ce décor sylvestre.

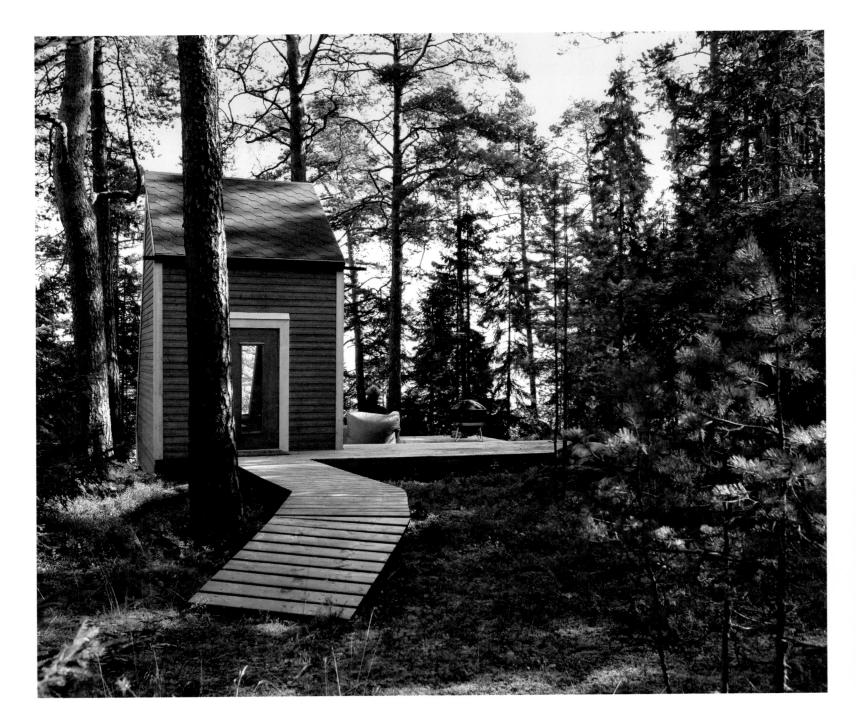

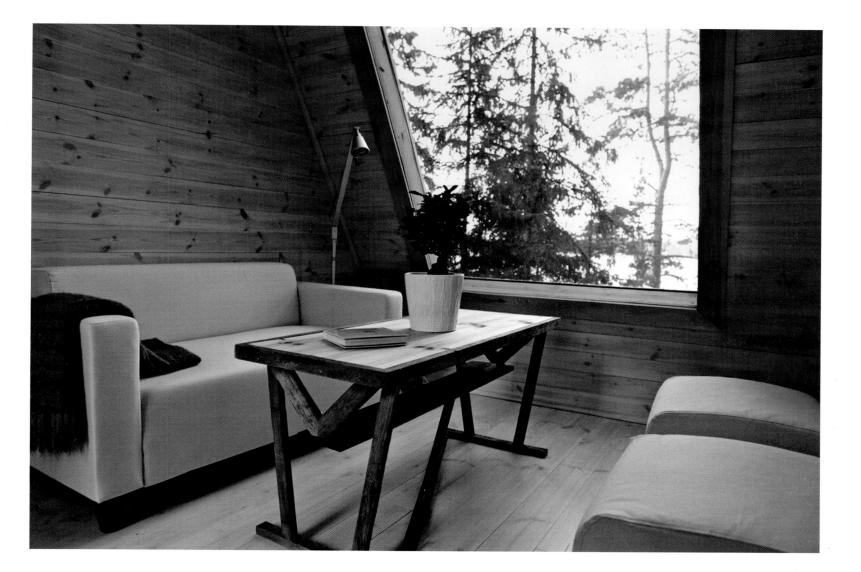

Although the design appears to be quite simple, it has a number of unexpected features, such as the very large inclined window seen in the image above.

Trotz seiner Einfachheit besitzt der Entwurf eine Reihe überraschender Merkmale, darunter das große Dachschrägenfenster (im Bild oben).

Malgré une conception d'apparence plutôt simple, la construction possède de nombreux éléments inattendus comme la très grande fenêtre inclinée que l'on voit ci-dessus.

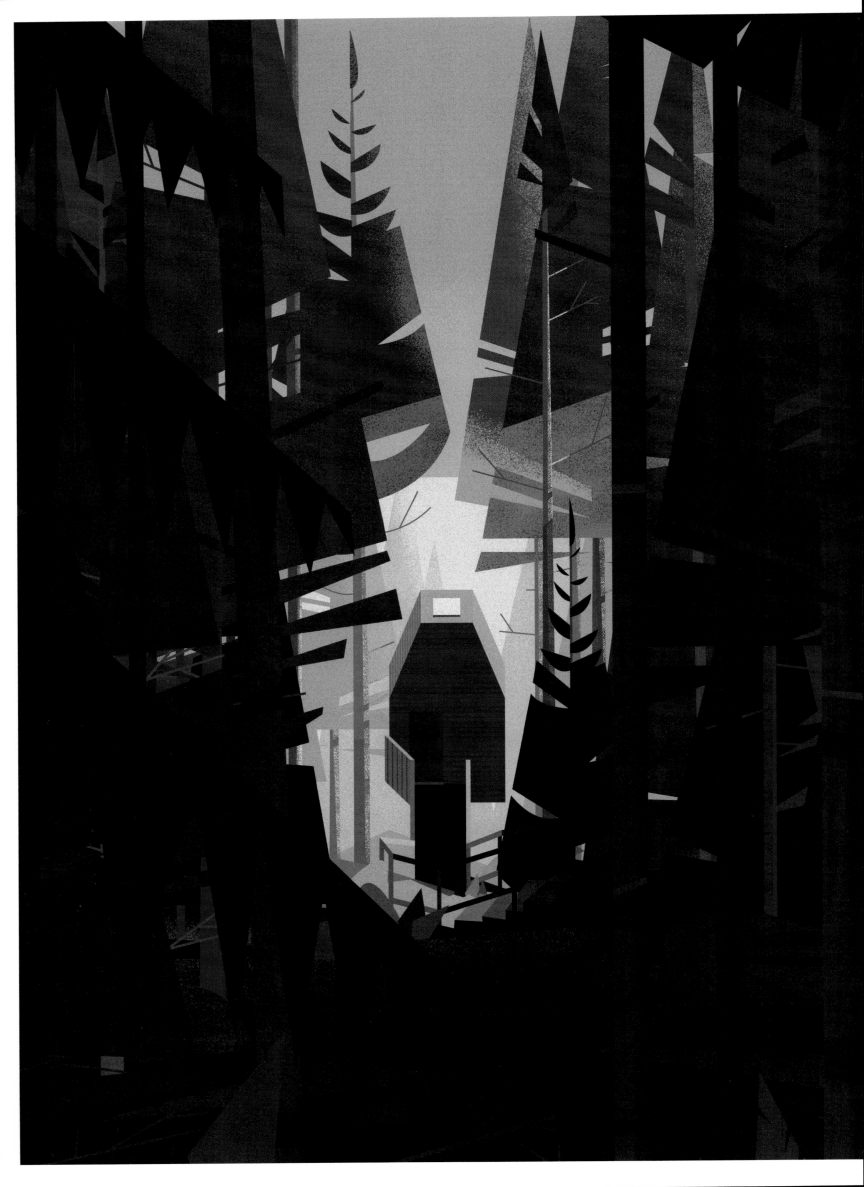

**MALCOLM FRASER**
Glen Nevis, Lochaber [UK]
2008–10

# OUTLANDIA FIELDSTATION

Area: 7 m² | Client: London Fieldworks | Cost: £20 000

Outlandia is an off-grid tree-house observatory and field station conceived by the art partnership London Fieldworks (Bruce Gilchrist and Jo Joelson) as a flexible meeting space for creative artistic collaboration and research. It was designed by Malcolm Fraser Architects (Niall Jacobson and Malcolm Fraser) and was built on a forested, 45-degree slope. It was partly built with trees cut down on the site. Entered from the rear via a bridge, it consists of "a simple box" with large windows opening onto the view. The architect states: "The low-impact, eco-friendly use of timbers recovered from the site was the opposite (of the) high-impact, eco-terrifying, helicoptered concrete drops for the foundations. Construction then was part-joinery, part-forestry, and part-mountain rescue, with a local contractor (Norman Clark) who nicely combined all three..." The design and construction of Outlandia was funded by the Calouste Gulbenkian Foundation, the Highland Council, the Highlands and Islands Enterprise, the Scottish Arts Council, and the Nevis Partnership.

---

Outlandia ist eine nicht ans Versorgungsnetz angeschlossene Beobachtungsstation in Form eines Baumhauses, die London Fieldworks, ein Zusammenschluss der Künstler Bruce Gilchrist und Jo Joelson, als flexibel einsetzbaren Treffpunkt für künstlerische Zusammenarbeit und Recherche geplant hatte. Entworfen wurde das Projekt von Malcolm Fraser Architects (Niall Jacobson und Malcolm Fraser) als „einfacher Kasten", der auf der Rückseite über eine Brücke im Wald betreten wird, über einen Hang mit 45 Grad Gefälle hinausragt und mittels der großen Fenster Ausblicke gewährt. Die Architekten: „Der sanfte und umweltfreundliche Einsatz vor Ort gefällter Bäume war das ganze Gegenteil des invasiven, umweltschädlichen Absetzens der Betonfundamente per Helikopter. Zu den Bauarbeiten gehörten Tischler-, Forst- und Bergwachttätigkeiten, die ein Bauunternehmer aus der Gegend (Norman Clark) bestens miteinander verband ..." Entwurf und Bau der Outlandia Fieldstation wurden gefördert von der Stiftung Calouste Gulbenkian, dem Highland Council, der Highlands and Islands Enterprise, der Forestry Commission Scotland und dem Scottish Arts Council und der Nevis Partnership.

---

Outlandia est un observatoire dans les arbres et une station de recherches non raccordée au réseau électrique qui a été conçue par le collectif artistique London Fieldworks (Bruce Gilchrist et Jo Joelson) comme un lieu de réunion polyvalent destiné à la collaboration artistique et à la recherche. Elle a été dessinée par Malcolm Fraser Architects (Niall Jacobson et Malcolm Fraser). Érigée sur une pente à 45 degrés en pleine forêt, elle a été en partie construite avec des arbres abattus sur place. On y accède par un pont à l'arrière. C'est « juste une boîte » avec de grandes fenêtres pour la vue. L'architecte déclare : « Le faible impact et l'utilisation écologique du bois d'œuvre obtenu sur le site même est à l'opposé exact des héliportages de béton pour les fondations, redoutables pour l'environnement sur lequel ils ont un fort impact. La construction a comporté une part de menuiserie, une part de foresterie et une part de sauvetage en montagne, avec un entrepreneur local (Norman Clark) qui a gentiment associé les trois... » La conception et la construction d'Outlandia ont été financées par la fondation Calouste Gulbenkian, le Highland Council, Highlands and Islands Enterprise, le Scottish Arts Council et Nevis Partnership.

In this image, the Outlandia Fieldstation almost appears to be hanging in empty space above the forest at the end of its access ramp.

Auf diesem Bild hat es den Anschein, als hänge die Outlandia Fieldstation am Ende der Zugangsrampe über dem Wald im Leeren.

Sur cette photo, Outlandia Fieldstation semble comme suspendue en l'air au-dessus de la forêt à l'extrémité de sa rampe d'accès.

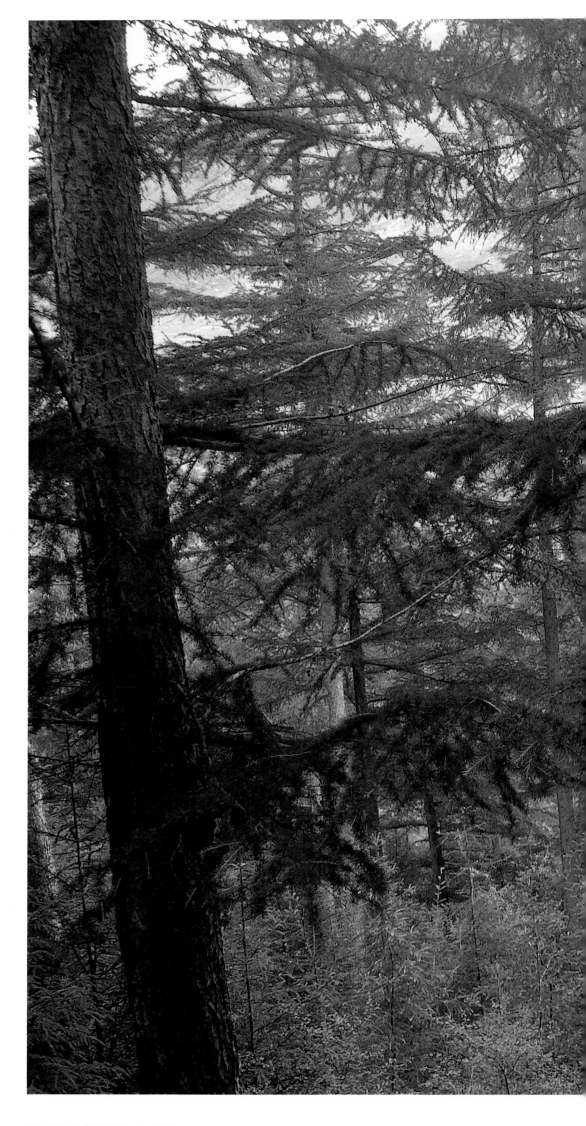

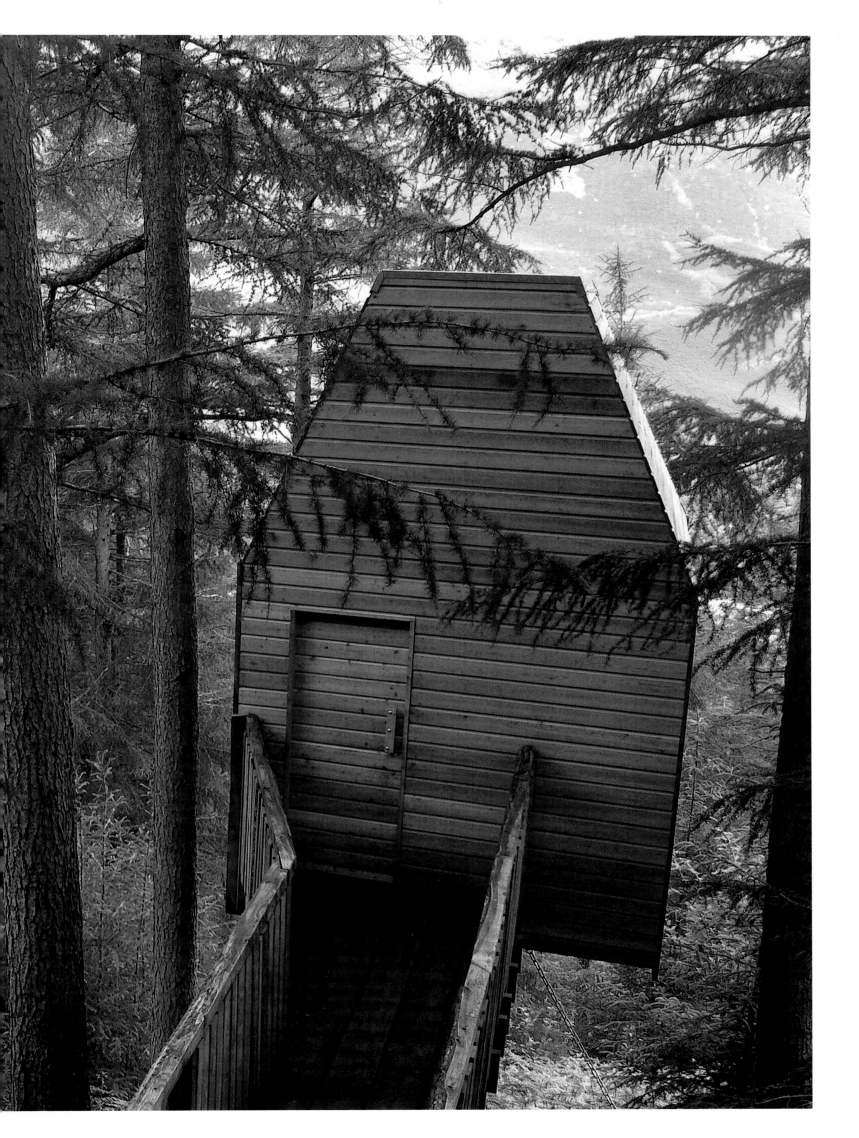

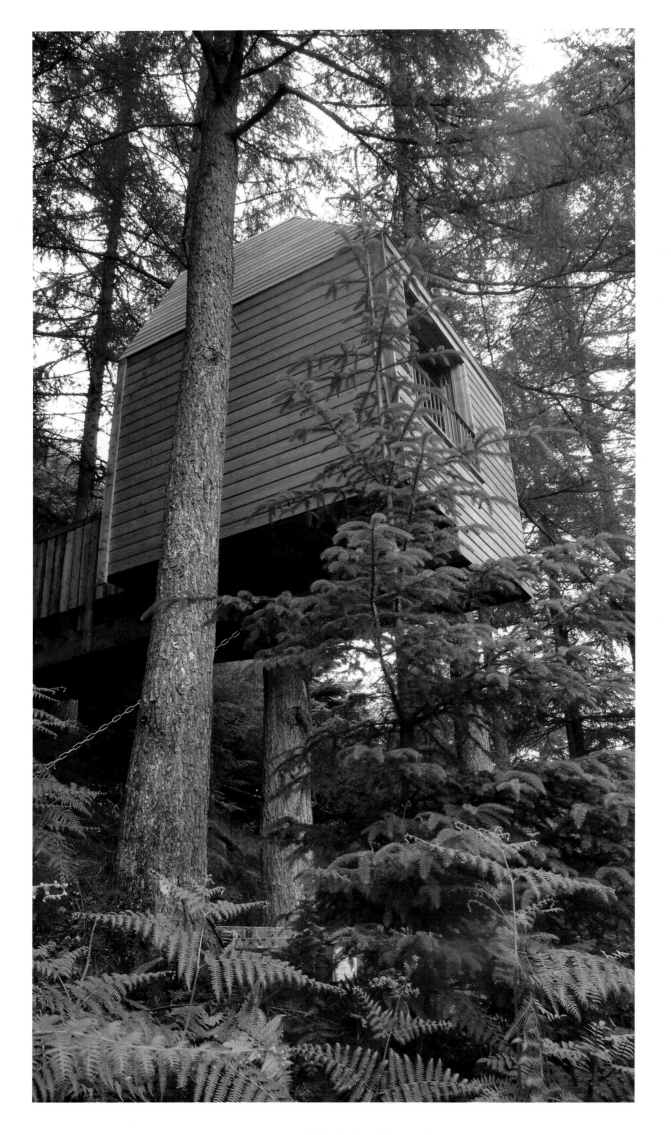

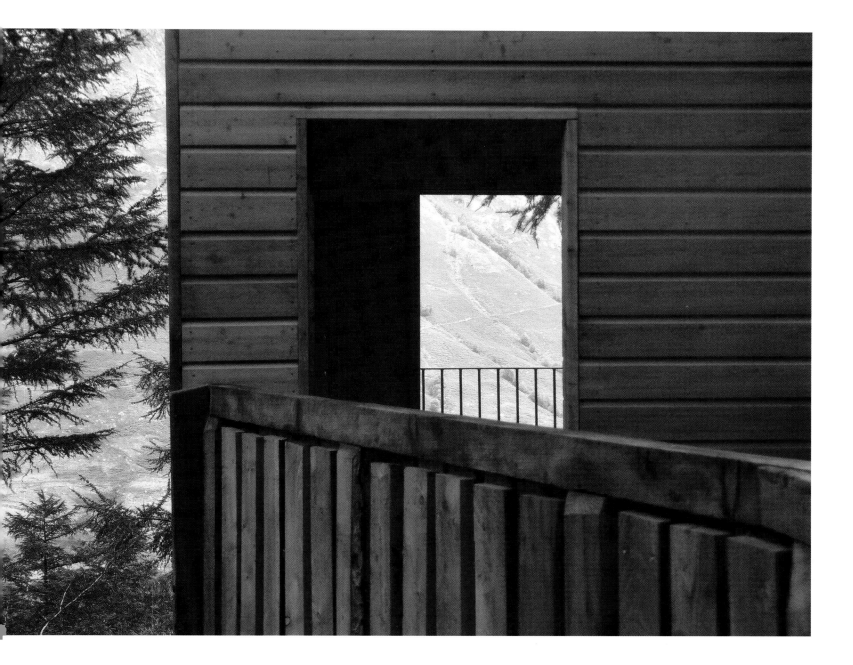

The plan below shows that the design is exceedingly simple. The large window seen in the image above through the doorway, and on the left side of the plan, allows observation of the forest.

Der Grundriss unten zeigt die äußerst einfache Bauweise. Durch das große Fenster hinter dem Durchgang im Bild oben und auf dem Plan zur Linken lässt sich der Wald beobachten.

Le plan ci-dessous montre une conception extrêmement simple, la grande fenêtre que l'on voit par la porte sur la photo ci-dessus et à gauche sur le plan permet d'observer la forêt.

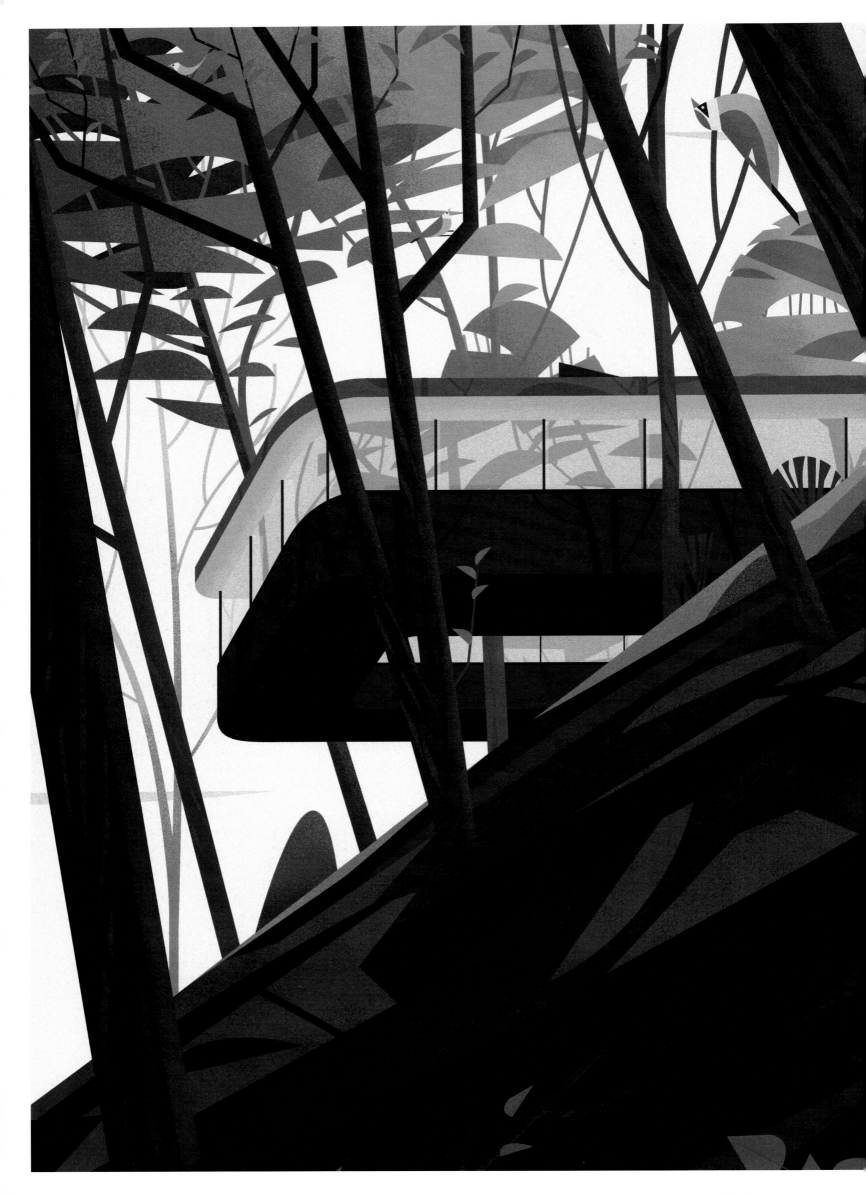

# PASSAGE HOUSE

Area: 105 m² | Collaboration: Akira Suzuki, Yasuhiro Kaneda

The roof and exterior of this house were built with FRP (fiber-reinforced plastics). Inside, plywood is used for the walls, and plastic board for the ceilings. Cantilevered over a steeply sloped forest site, the building has a hollow center and ample glazing, meaning that residents are quite literally surrounded by the natural setting. The architects explain: "The place where the building and the ground touch was made as small as possible, and it does not touch the slope." Describing their work more in aesthetic or poetic terms than in practical ones, they state: "Though it is open and bright, there is also a dark place. Although it is high, there is also a low place. There is a narrow place and a large place. The space with the real depth is this rich site itself. In this Passage House, the visitor will experience the scenery of the wonderful mountains, comfortably unaware."

———

Das Dach und die Außenwände dieses Haus bestehen aus einem FKV-Material (Faserverbundkunststoff). Die Wände im Innenbereich wurden mit Sperrholz und die Decken mit Plastikplatten verschalt. Das Haus kragt über einen steilen, bewaldeten Hang aus. Das Zentrum des Hauses mit seinen großen Glasflächen bildet ein Hohlraum, Bewohner sind also im Wortsinn von der Natur umgeben. Die Architekten: „Die Fläche, wo Gebäude und Boden aufeinandertreffen, wurde so klein wie möglich gehalten; den Hang selbst berührt der Bau nicht." In einer weniger konkreten als kunstvollen und poetischen Sprache heißt es weiter: „Zwar ist das Haus offen und hell, aber es gibt auch einen dunklen Ort. Zwar ist es hoch, aber es ist gibt auch einen tiefen Ort. Es gibt einen engen und einen weiten Ort. Der Ort wahrer Tiefe ist der prächtige Standort selbst. Im Passage House erleben Besucher die herrliche Gebirgskulisse auf angenehme Art wie nebenbei."

———

Cette maison est construite en FRP (plastique renforcé de fibres de verre) pour la toiture et l'extérieur, avec des parois intérieures en contreplaqué et des plaques de plastique au plafond. Placée en saillie au-dessus d'un terrain forestier en pente raide, elle présente un centre évidé et une abondance de vitrages, de sorte qu'elle est littéralement entourée de toutes parts par la forêt. Les architectes expliquent que « le contact entre le bâtiment et le sol a été réduit le plus possible et la maison ne touche pas la pente ». Ils poursuivent, décrivant leur œuvre en termes plus esthétiques ou poétiques que pratiques : « Bien qu'elle soit claire et ouverte, on y trouve aussi un endroit sombre. Elle est haute, mais on y trouve aussi un endroit bas. On y trouve un endroit étroit et un endroit large. L'espace réellement profond est le site lui-même, très riche. Dans cette maison appelée Passage, le visiteur profite du magnifique paysage montagnard dans un confort inconscient. »

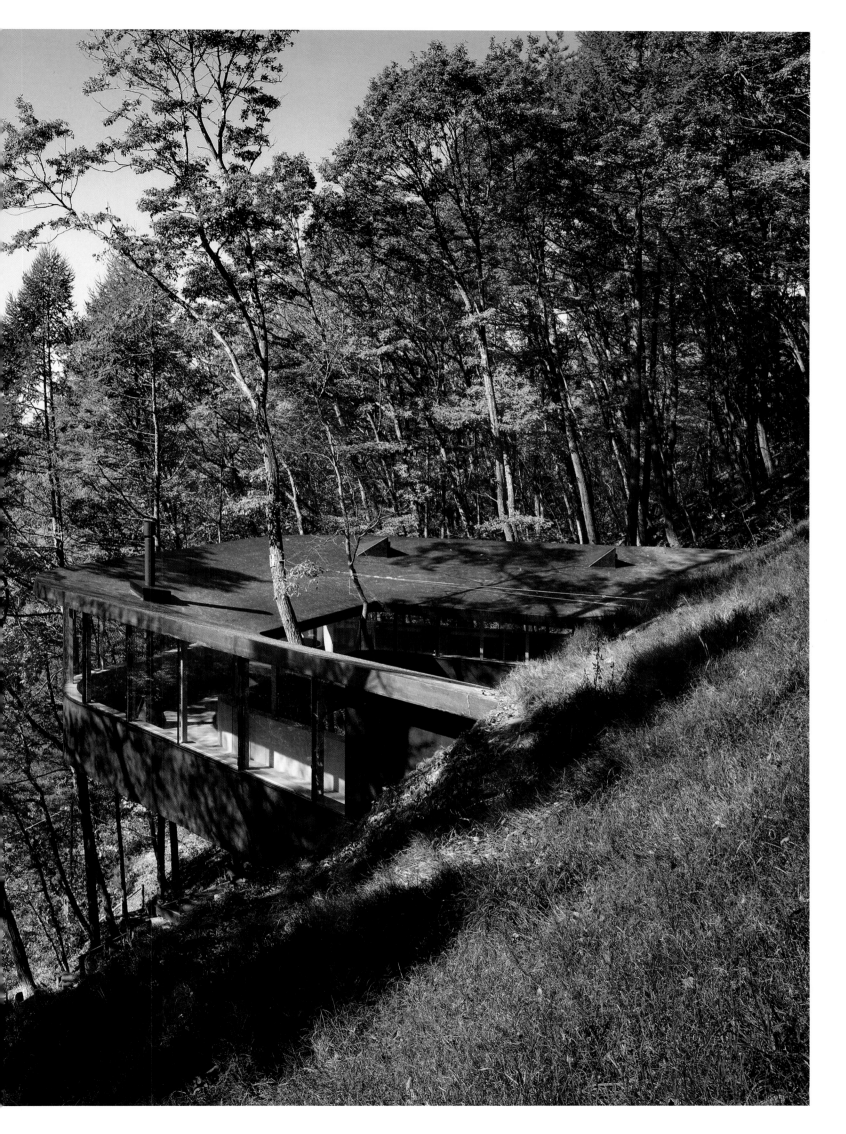

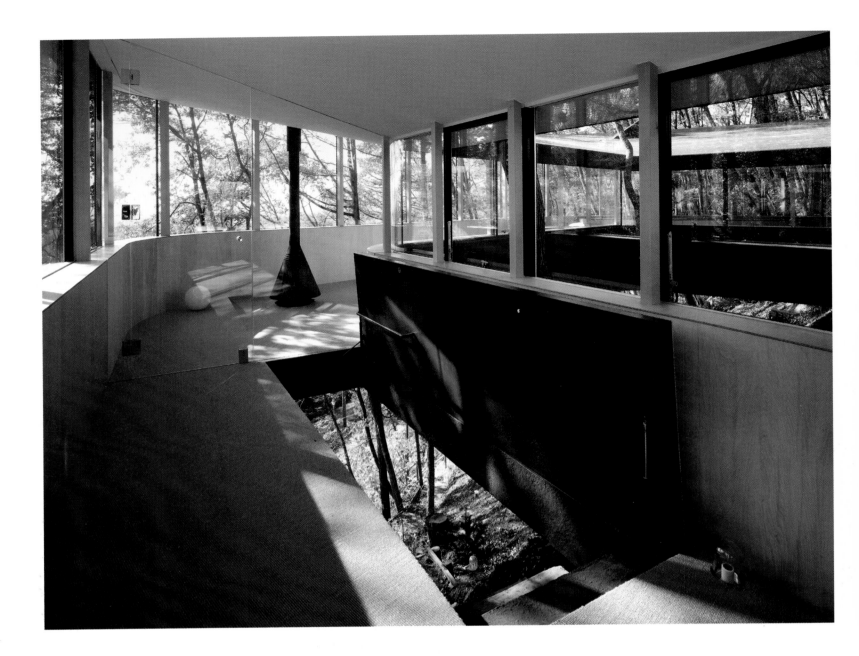

The unusual, partially elevated configuration of the house allows views of the forest from all sides, but also through the curving central opening.

Durch die ungewöhnliche Gestaltung des teilweise erhöht gelegenen Hauses ist von allen Seiten und durch die geschwungene zentrale Öffnung der Wald zu sehen.

La configuration inédite, en partie surélevée, de la maison permet d'admirer la forêt de tous les côtés, y compris par l'ouverture centrale arrondie.

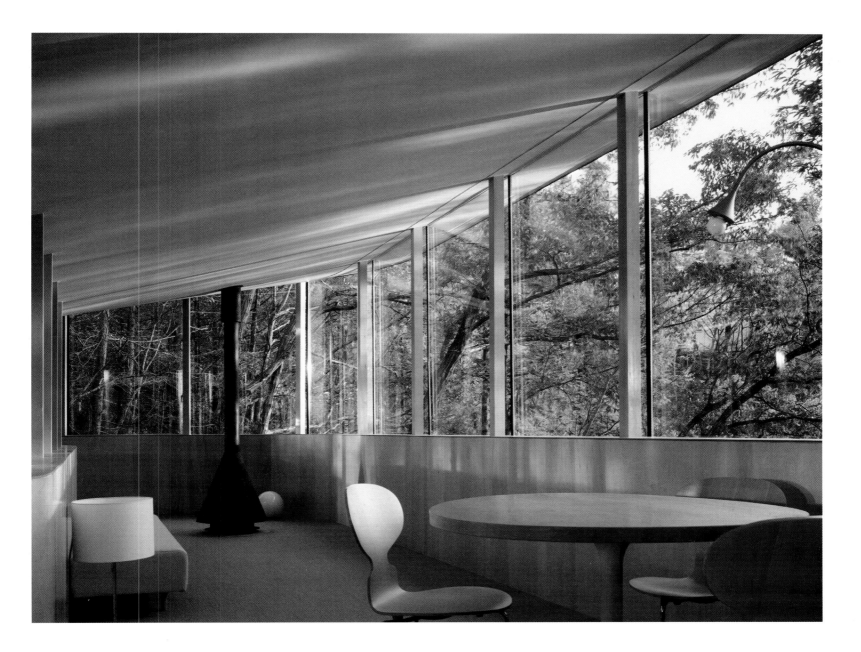

Nature and transparency are the key
words to describe this house,
where even the bathroom (right)
has glass walls on all sides.

Natur und Transparenz sind Schlüssel-
wörter für die Charakterisierung
des Hauses, in dem selbst das Bad
(rechts) auf allen Seiten über
Glaswände verfügt.

Nature et transparence sont les
mots-clés pour décrire cette maison
où même la salle de bains (à droite)
est vitrée sur trois côtés.

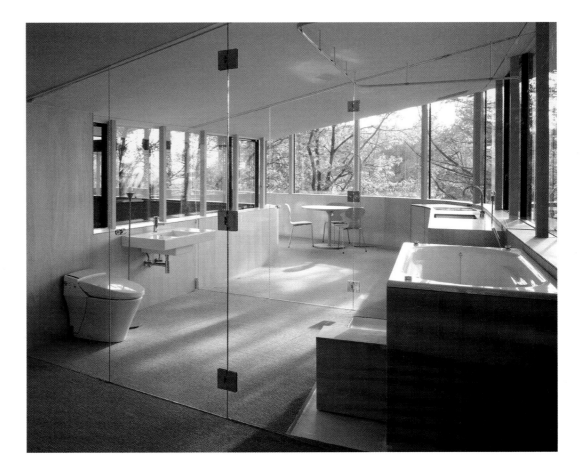

**PAUL HIRZEL**
Potlatch River, near Juliaetta, Idaho [USA]
2010–12

# RIVER STRUCTURES

Area: 106 m² (Lookout); 214 m² (Bridge) | Cost: $1 million (both structures)
Collaboration: Bob Wilson Construction (Contractor),
TD & H (Engineering Consultants)

At the end of an unpaved road cut into a hillside near Juliaetta, Idaho, the architect's clients wanted to create a live-work space for their vineyard. One structure is located above a flood plain and is called the "Bridge" while the other is on a narrow cliff overlooking a pool in the Potlatch River and is called the "Lookout". The "Lookout" houses a small event space, storage, and a studio, while the "Bridge" contains owner and guest quarters. The clients required minimum disturbance of the site and minimal energy consumption. The "Bridge" is elevated on four concrete piers above maximum flood levels. The architect describes the structures as "tough and utilitarian," made with local pine, galvanized metal, and exposed framing lumber. Paul Hirzel explains: "Because both structures have essentially 'scaffolding' as a part of their design, construction costs were kept to a minimum.„

———

Die Kunden wünschten sich auf ihrem Weingut am Ende eines unbefestigten Wegs in den Hügeln unweit von Juliaetta, Idaho, einen Ort zum Wohnen und Arbeiten. Eines der Gebäude, die sogenannte Bridge (Brücke) liegt oberhalb einer Flussniederung, das andere, „Lookout" (Ausguck) genannt, auf einem schmalen Felsen mit Blick auf eine Ausweitung des Potlach River. Der „Lookout" beherbergt einen kleinen Veranstaltungsraum, Lagermöglichkeiten und ein Studio. In der „Bridge" befinden sich Wohnräume für die Eigentümer und ihre Gäste. Die Kunden wollten den Standort so wenig wie möglich in Mitleidenschaft ziehen und den Energieverbrauch minimal halten. Die „Bridge" ist oberhalb des höchsten Wasserstands bei einer Flut auf vier Betonpfeilern errichtet. Die Architekten beschreiben den mit Kiefernholz aus der Region, galvanisiertem Metall und einem freiliegenden Holzrahmen errichteten Bau als „robust und zweckmäßig". Paul Hirzel erklärt: „Da in beiden Gebäuden ‚Gerüste' Teile des Entwurfs sind, wurden die Baukosten auf ein Minimum reduziert."

———

Les clients ont voulu créer un espace de vie et de travail pour leur vignoble à l'extrémité d'une route non goudronnée creusée à flanc de colline près de Juliaetta, dans l'Idaho. L'un des éléments est placé au-dessus d'une zone inondable et baptisé le « Pont », l'autre surplombe un bassin dans la rivière Potlatch en haut d'une étroite falaise et porte le nom de « Vigie ». La « Vigie » abrite un petit espace destiné à accueillir diverses manifestations, des rangements et un studio, tandis que le « Pont » contient les appartements du propriétaire et des hôtes. Les clients avaient exigé une perturbation minimale pour le site et une consommation énergétique minimale. Le « Pont » est surélevé sur quatre piliers de béton au-dessus du niveau maximal de crue. L'architecte décrit la structure créée comme « solide et fonctionnelle », faite de pin local, de métal galvanisé et d'une charpente apparente en bois. Paul Hirzel explique en outre : « Comme les deux éléments sont essentiellement conçus en "échafaudages", les coûts de construction sont restés très bas. »

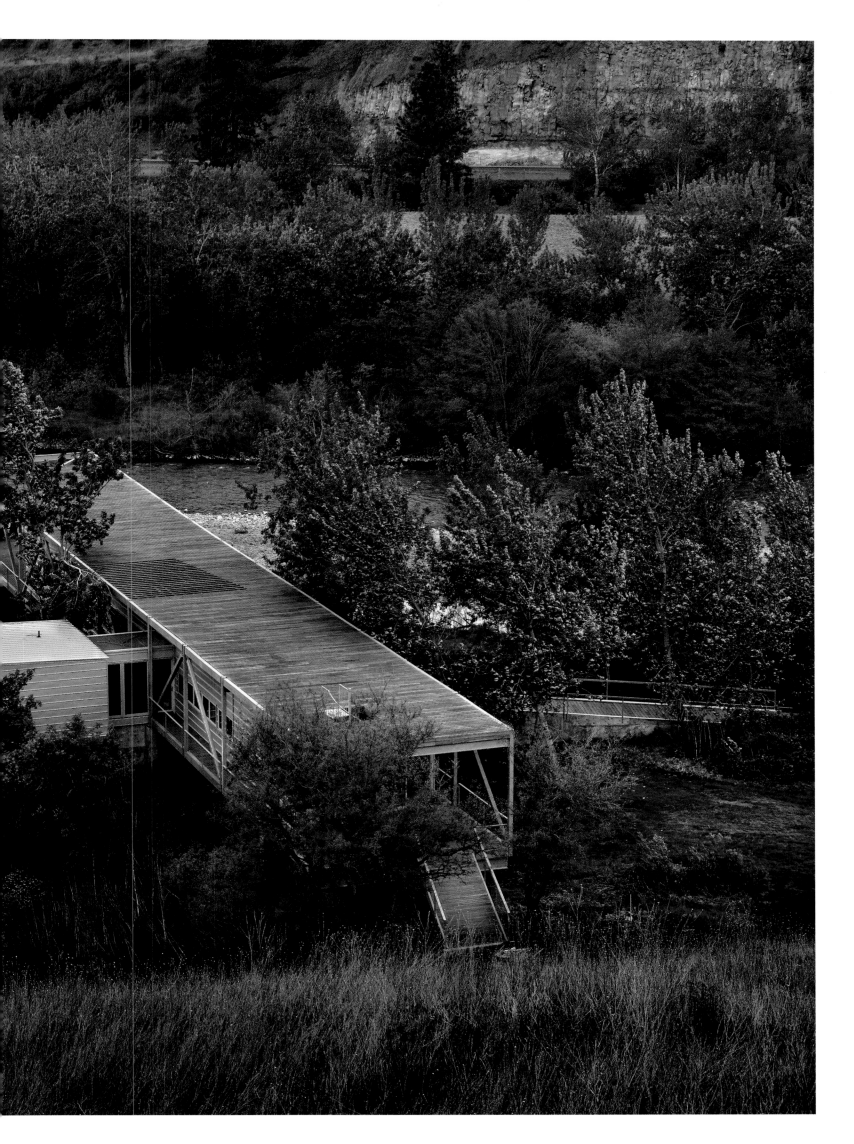

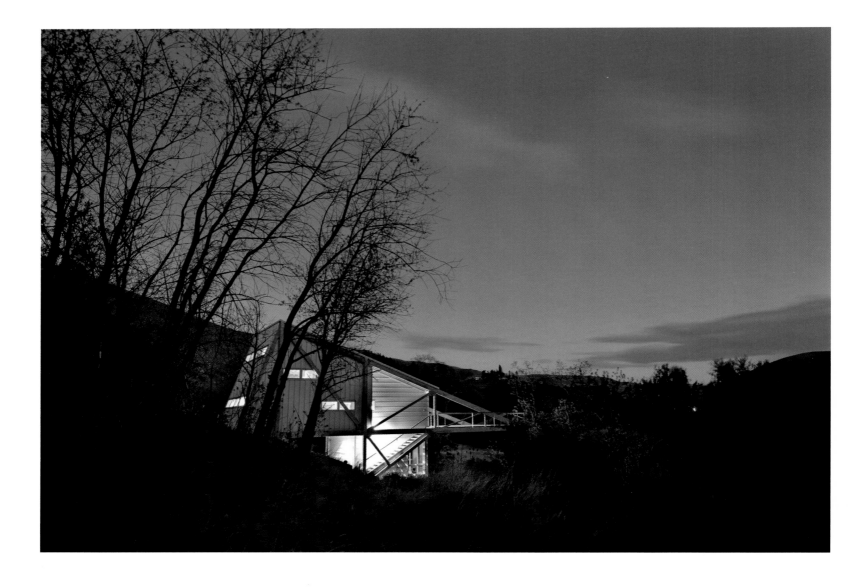

The Bridge Structure (below) has an area of 214 square meters while the Lookout Structure (above and right page) encloses 106 square meters of "conditioned space."

Die „Bridge" (unten) hat 214 m² Grundfläche, während der „Lookout" (oben und rechte Seite) 106 m² „regulierten Raum" umfasst.

L'élément Pont (ci-dessous) occupe une surface de 214 m², tandis que la Vigie (ci-dessus et page de droite) renferme 106 m² d'« espace conditionné ».

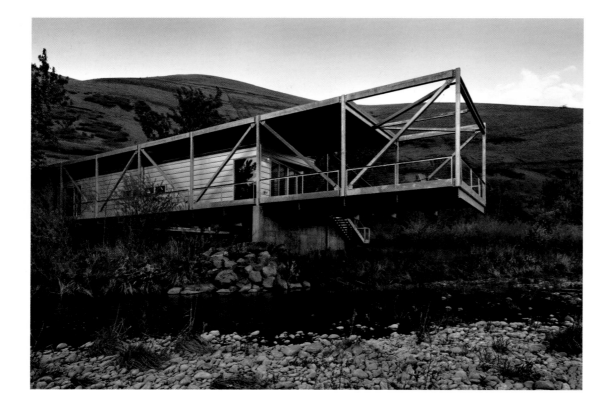

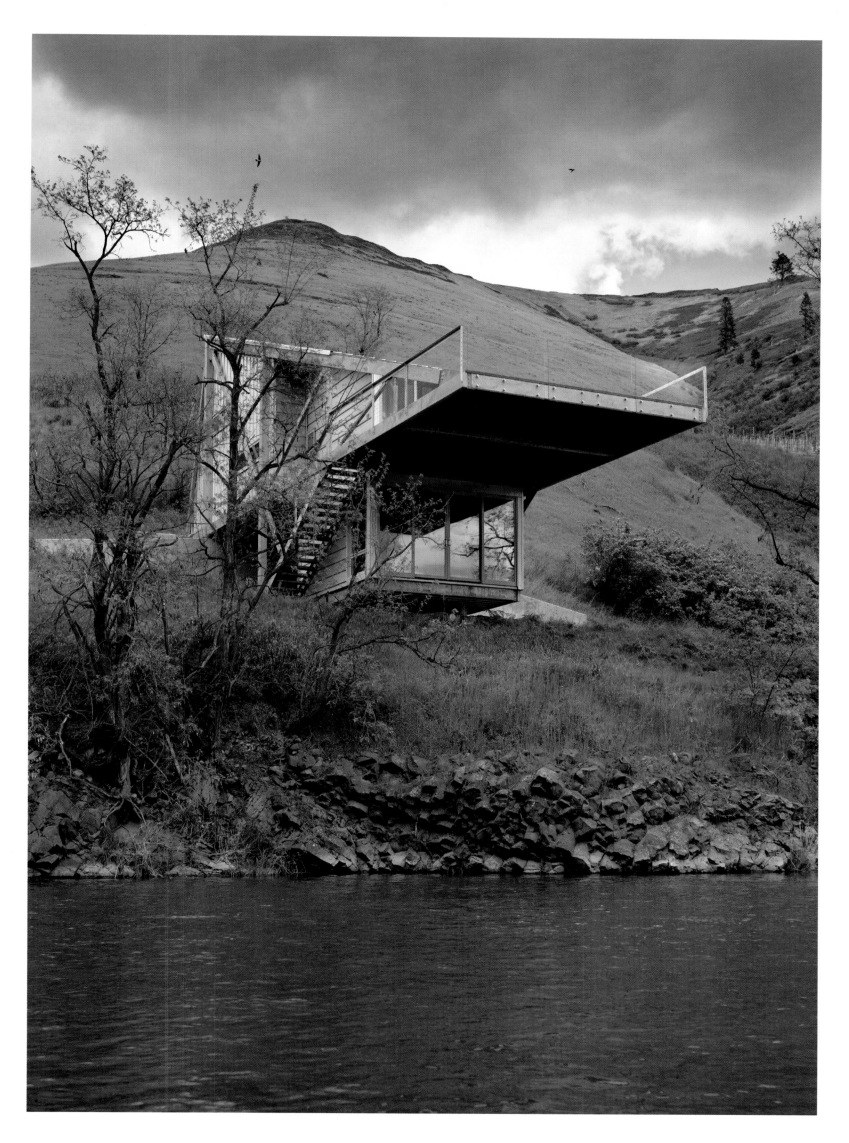

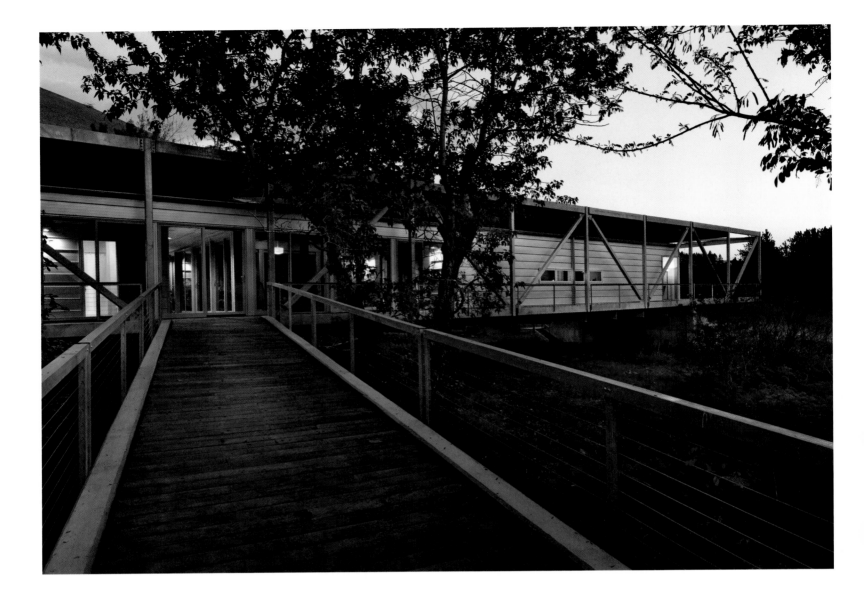

The Bridge Structure, which includes living and guest quarters, is set 3.7 meters off the ground, calculated to be above the 300 to 500-year flood level, and is supported by just four 20-centimeter-thick concrete piers.

Mit ihren Wohn- und Gasträumen schwebt die „Bridge" auf nur 20 cm schmalen Betonpfeilern 3,7 m über dem Boden und liegt damit Berechnungen zufolge oberhalb des alle 300 bis 500 Jahre bei Hochwasser erreichten Pegelstands.

Le Pont, qui abrite les espaces de séjour et les appartements des hôtes, est surélevé à 3,7 m au-dessus du sol, une hauteur calculée pour être supérieure à la crue qui se produit tous les 300 à 500 ans, et est porté par seulement quatre piliers de béton d'une épaisseur de 20 cm.

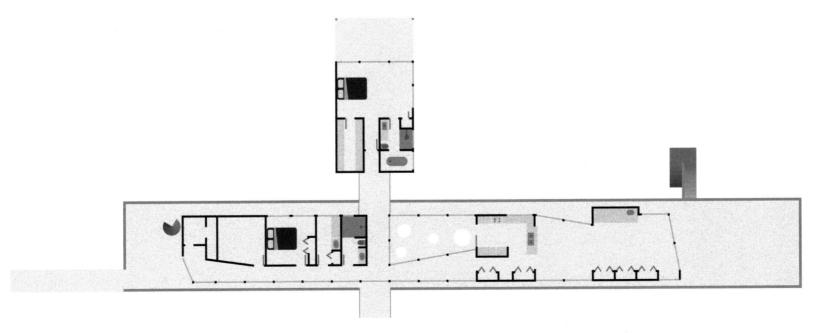

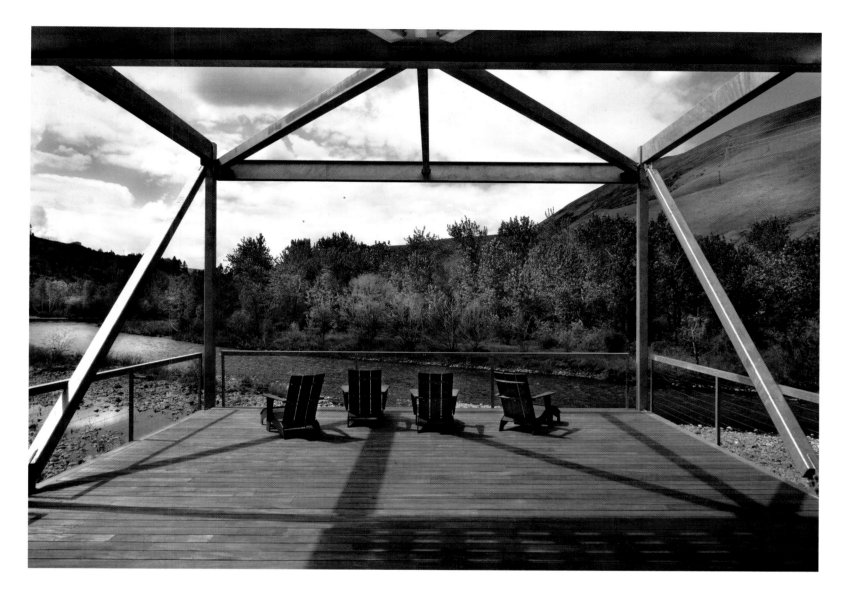

On this page, the exterior terrace and spiral stairway of the Bridge Structure. The open frame of the terrace provides a privileged view of the Potlatch River.

Auf dieser Seite sind die Außenterrasse und die Wendeltreppe der „Bridge" abgebildet. Von der Terrasse mit dem offenem Rahmengerüst ist die Aussicht auf den Potlach River hervorragend.

On voit sur cette page la terrasse et l'escalier en colimaçon du Pont. Le cadre ouvert de la terrasse fournit un point de vue exceptionnel sur la rivière Potlatch.

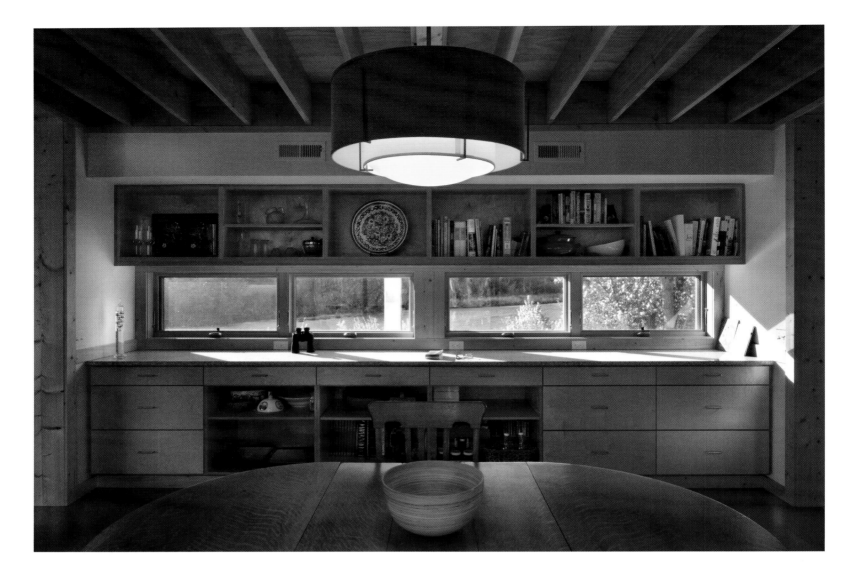

Interiors of the Bridge Structure are made warmer than the exterior might imply through the extensive use of wood, with generous glazing offering views of the natural site all around.

Das Interieur der „Bridge" mit viel Holz wirkt wärmer, als die äußere Erscheinung zunächst vermuten lässt. Große Glasflächen bieten ringsherum Ausblicke in die Natur.

L'intérieur du Pont est plus chaleureux que l'extérieur ne le suggère en raison de l'usage extensif du bois et des généreux vitrages qui donnent sur le cadre naturel alentour.

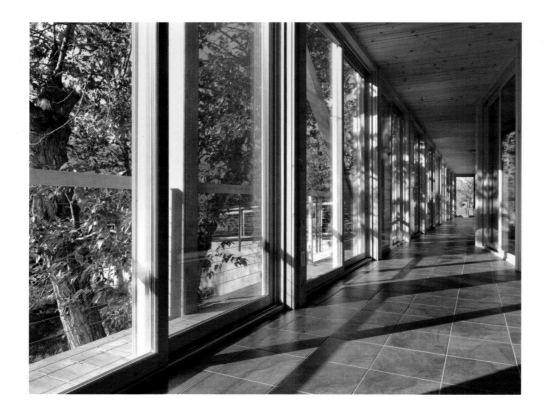

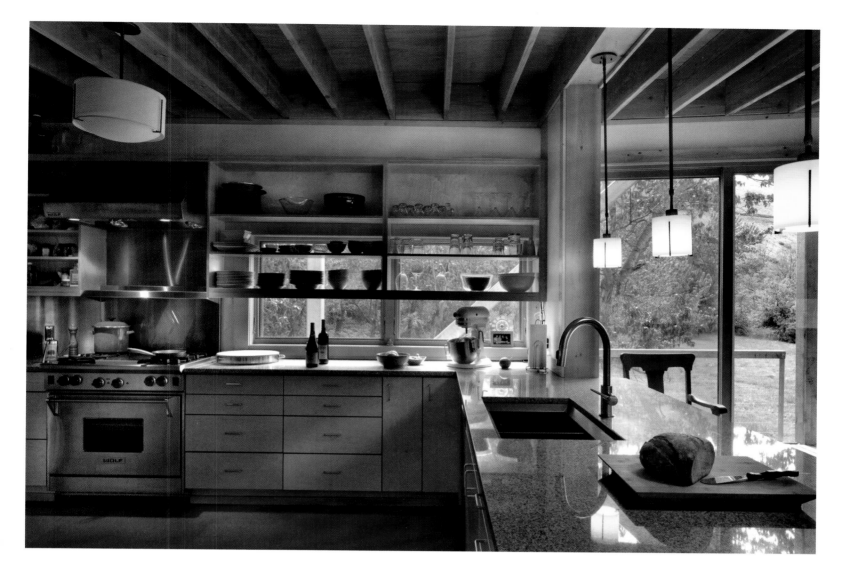

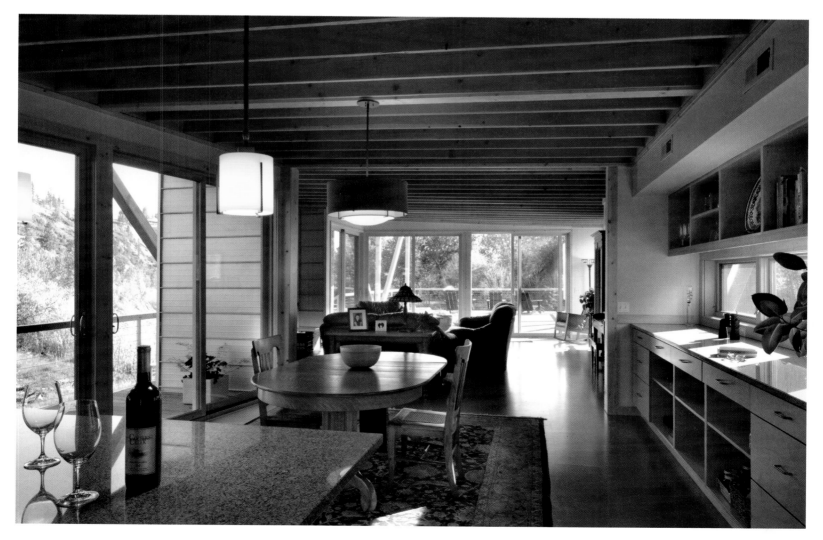

**TODD SAUNDERS**
Mount Tuam, Salt Spring Island [Canada]
2012

# SALT SPRING ISLAND CABIN

Area: 120 m² | Client: Nancy Krieg

This cabin has a concrete base and a wood frame. It employs structural steel, corrugated-steel panels, and secondary cedar wood cladding. Located in British Columbia, the site of this cabin is in a fir forest, with views toward the San Juan Islands and Olympic Mountains. The design includes "two little pods, related but also non-related," states the architect. The client decided with Saunders to create a cabin imagined as "an extension of the existing surrounding beauty," which includes waterfalls. The units are located on either side of a waterfall. One of them contains living space, while the other has an art studio and can be used as a guest room. Both stand on pillars. A light aluminum bridge connects the volumes. The atelier has an open plan, while the living unit contains spaces that "are placed vertically, so that they have different views and orientation (facing south and east, respectively), each offering a distinct experience."

———

Beim Bau dieses Holzrahmenhauses mit Betonfundament wurden Baustahl sowie eine Wellstahl- und eine zweite Verkleidung aus Zedernholz verwendet. Es steht in British Columbia in einem Tannenwald und bietet Ausblicke auf die San Juan Islands und die Olympic Mountains. Dem Architekten zufolge gehören zum Entwurf „zwei kleine Kapseln, die in Beziehung zueinander stehen und gleichzeitig unabhängig voneinander sind". Die Bauherrin und Saunders entschieden sich für ein Haus als „Erweiterung der schönen Umgebung", in der es auch Wasserfälle gibt. Die Einheiten liegen beiderseits eines Wasserfalls. Eine von ihnen beherbergt die Wohnräume, die andere ein Atelier, das auch als Gästezimmer genutzt werden kann. Beide Bauten sind auf Stützen errichtet und durch eine leichte Aluminiumbrücke verbunden. Das Atelier hat einen offenen Grundriss, die Räume des Wohngebäudes sind „zugunsten verschiedener Blickachsen und Ausrichtungen (süd- bzw. ostwärts) vertikal angeordnet, um jeweils unterschiedliche Eindrücke zu bieten".

———

La maison possède une base en béton et une charpente en bois. Elle comporte également de l'acier de construction, des panneaux d'acier ondulé et un second revêtement de cèdre. Elle se trouve en Colombie-Britannique, dans une forêt de sapins avec vue vers les îles San Juan et les monts Olympiques. L'ensemble comprend « deux unités, apparentées mais non raccordées », selon l'architecte. Le client a choisi avec Saunders de créer une cabane imaginée comme « une extension de la beauté environnante », et notamment des cascades. Placées de part et d'autre d'une cascade, l'une comprend un espace à vivre et l'autre un atelier d'art qui peut servir de chambre d'amis. Elles sont toutes les deux posées sur des piliers et reliées par une légère passerelle en aluminium. L'atelier présente un plan ouvert, tandis que les espaces de l'unité de séjour « sont disposés verticalement pour offrir des vues et orientations différentes (face au sud et à l'est) afin de procurer chacune un vécu spécifique ».

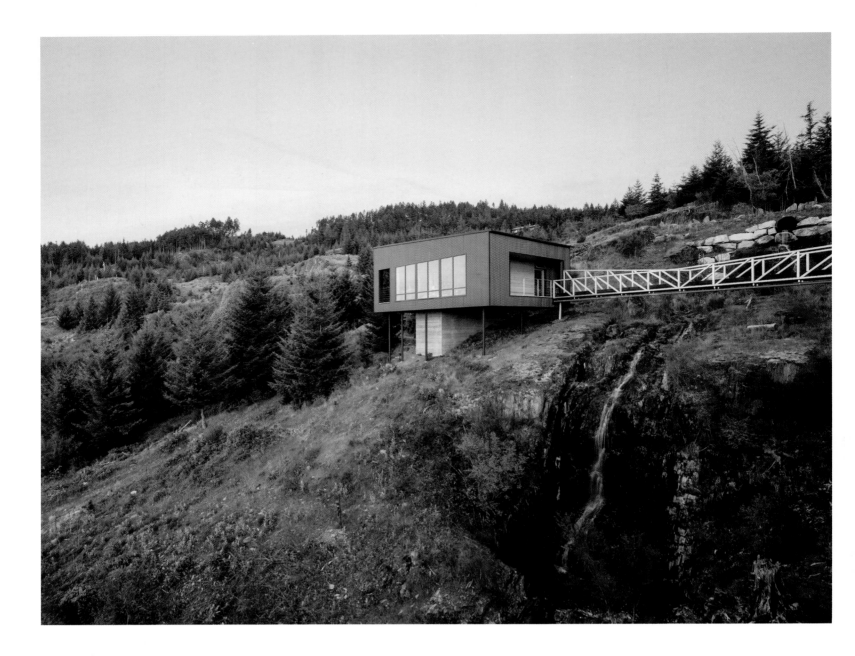

"It was important to me that the buildings did not
overshadow the landscape but, rather, become
an extension of the existing surrounding beauty,"
says architect Todd Saunders.

„Mir war es wichtig, dass die Gebäude die Landschaft
nicht in den Schatten stellen, sondern eine Fortsetzung
der sie umgebenden Schönheit werden", sagt Architekt
Todd Saunders.

« Il était important pour moi que les constructions
n'éclipsent pas le paysage mais, plutôt, deviennent une
extension de la beauté environnante », déclare l'archi-
tecte Todd Saunders.

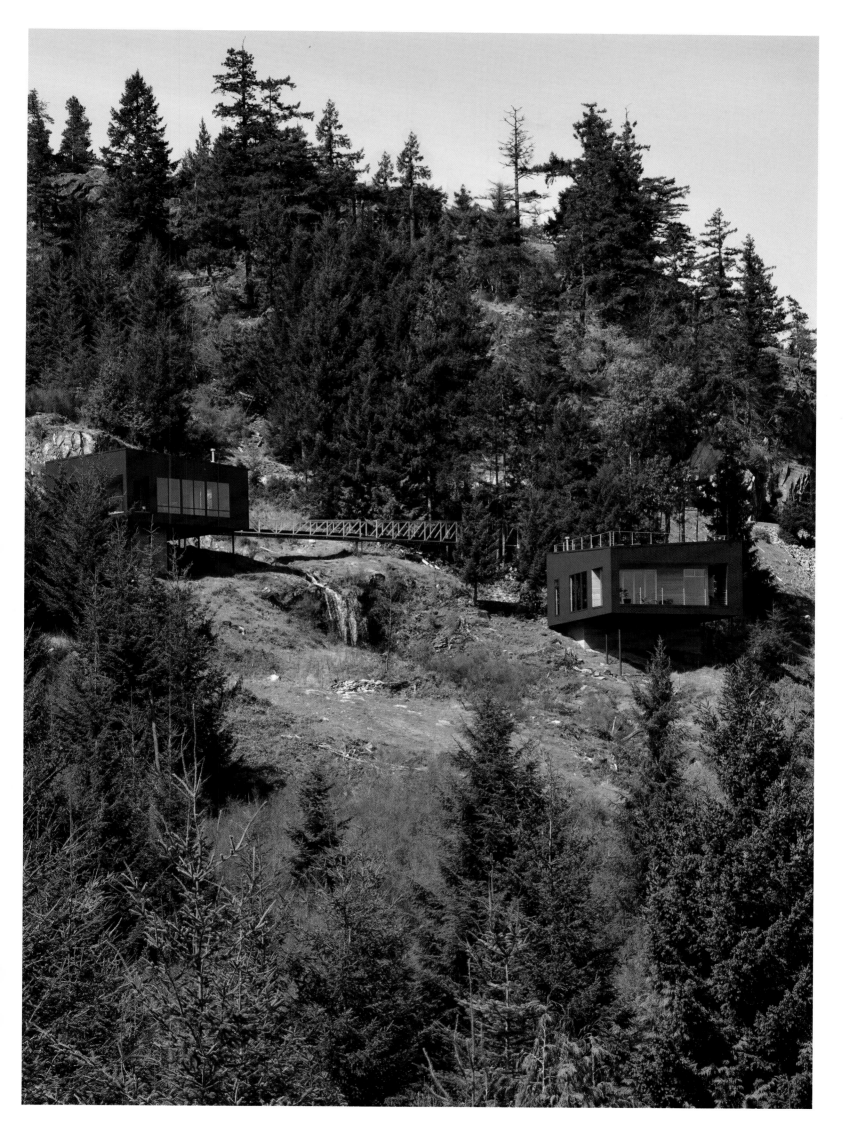

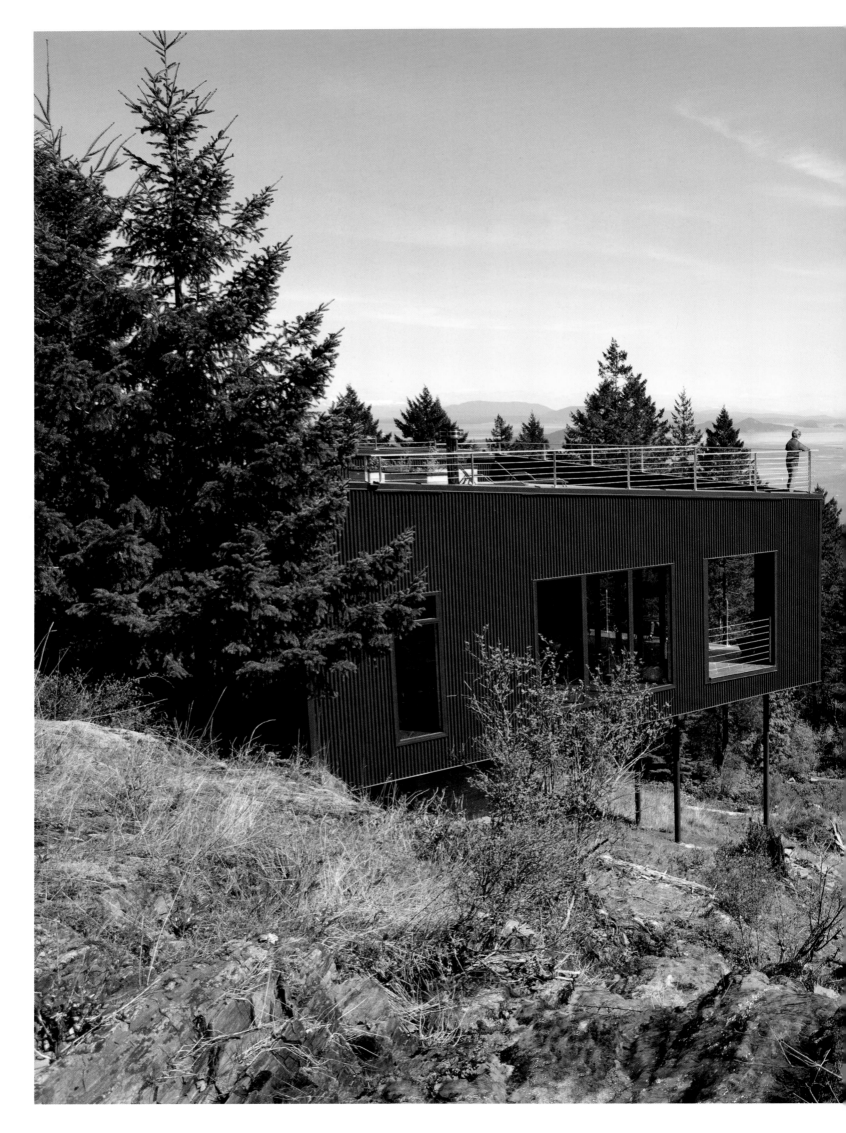

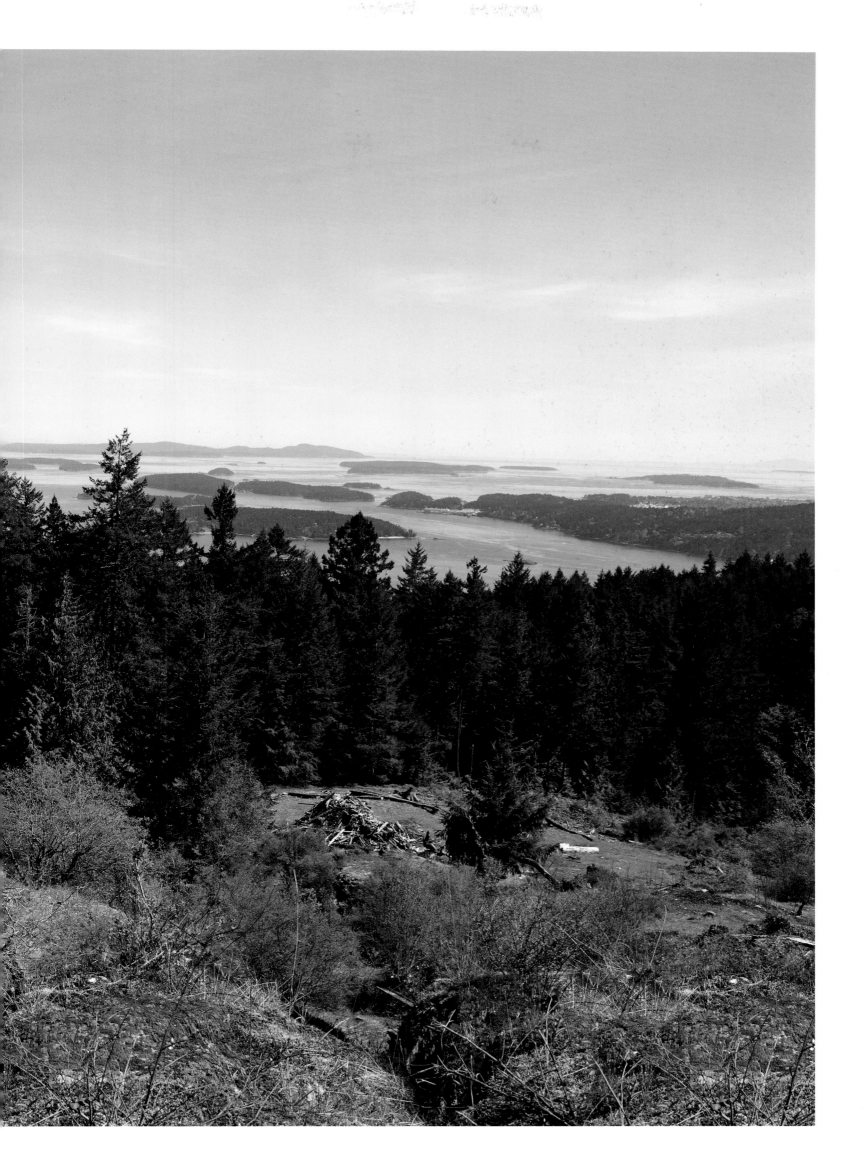

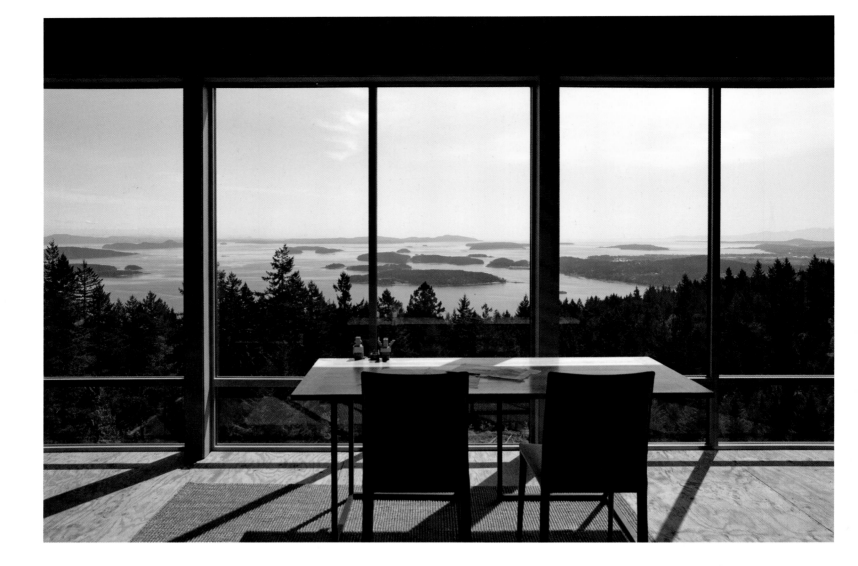

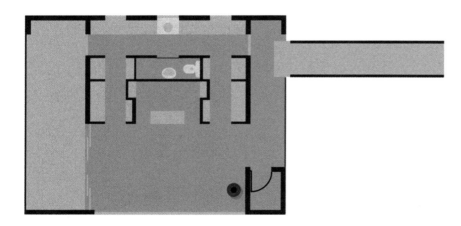

The two separate structures are located on either side of a waterfall. One contains a living unit and the other has studio space and can act as a guest room.

Die zwei separaten Gebäude liegen beiderseits eines Wasserfalls. In einem von ihnen befinden sich die Wohnräume, im anderen ein Atelier, das auch als Gästezimmer dienen kann.

Les deux structures séparées sont placées de chaque côté d'une cascade. L'une contient un espace à vivre et l'autre un atelier d'art qui peut servir de chambre d'amis.

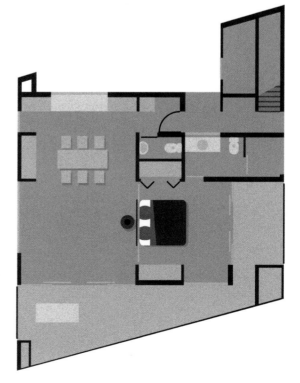

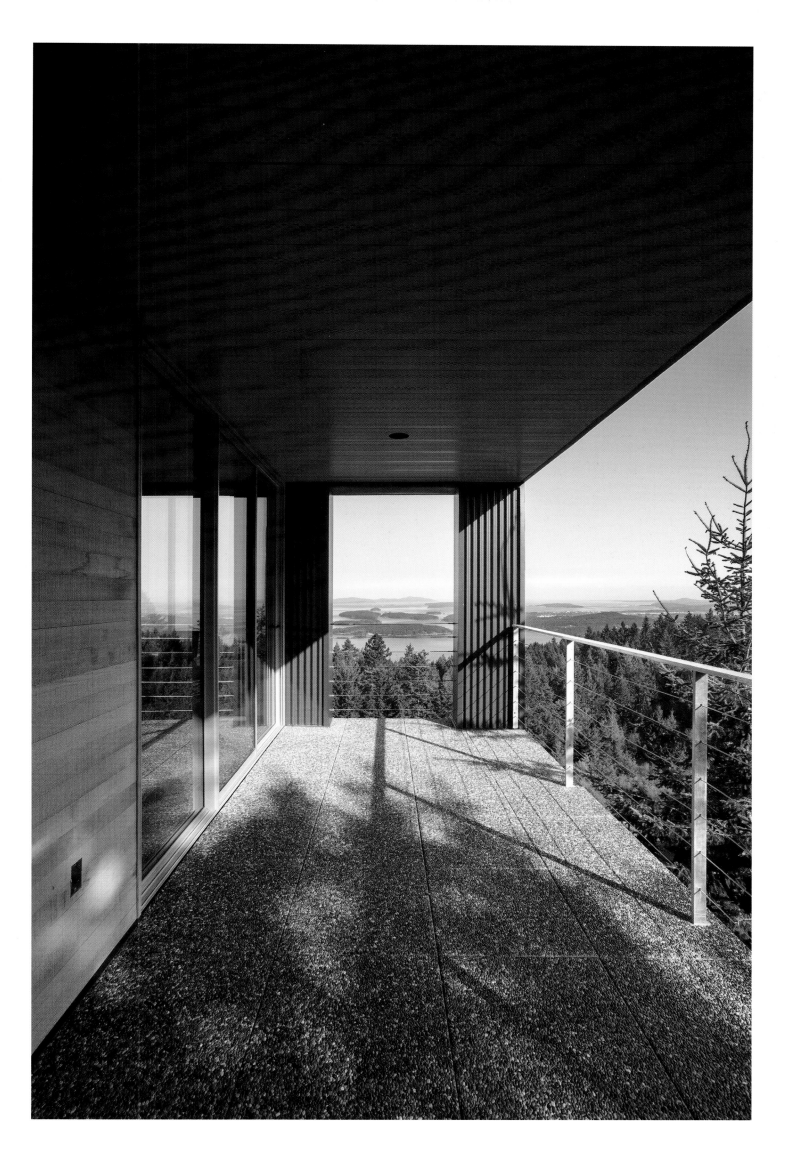

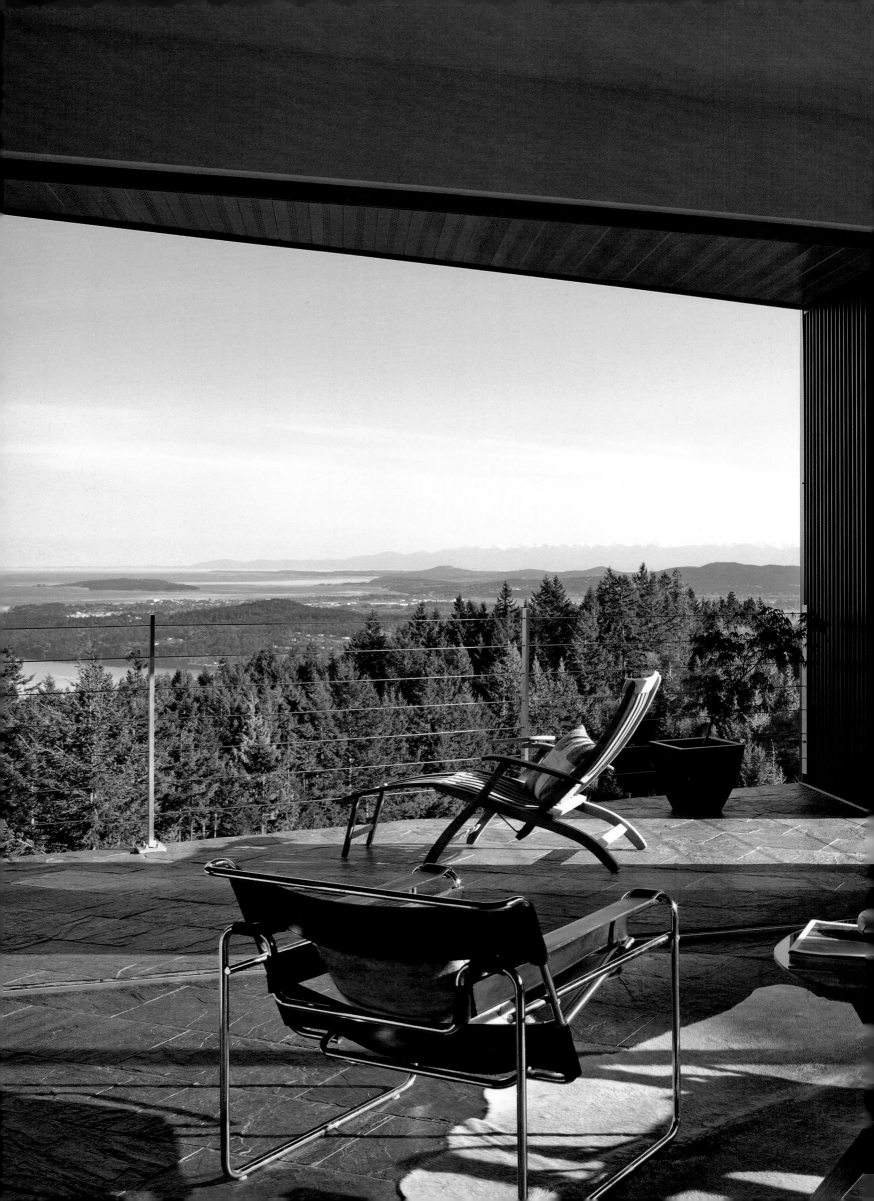

**GABRIELA GOMES**
Various locations / Porto [Portugal]
2012

# SHELTER BYGG

Area: 11 m² | Client: Guimarães European Capital of Culture 2012
Cost: €36 500 | Collaboration: Sergio Bessa

This small, "habitable sculpture" is made of wood, OSB (oriented strand board), Expanded Cork Agglomerate, and CORKwall for the external covering. Its concept fits in with the other work of Gabriela Gomes, who seeks to "convert sculptural objects into design objects." Intended to be seen in public spaces, the work is mobile. It has one double room with an integrated bathroom. According to the designer: "This is an experimental object that combines sculpture, design, and architecture, defying new experiences with space and questioning relations of artistic enjoyment and habitation issues." Non-polluting and recycled materials were used and solar energy is employed.

———

Die Außenhaut dieser kleinen „bewohnbaren Skulptur" besteht aus Holz, OSB-Platten, Korkdämmstoffen und CORKwall für die Außenhaut. Das Konzept erinnert an andere Arbeiten von Gabriela Gomes, die „skulpturale Objekte zu Designobjekten umfunktionieren" möchte. Da das Objekt im öffentlichen Raum gezeigt werden soll, ist es transportabel. Es verfügt über ein Doppelzimmer mit integriertem WC. Die Designerin erklärt: „Es handelt sich um ein experimentelles Objekt, das Bildhauerei, Design und Architektur verbindet, ein neuartiges Raumerleben herausfordert und die Beziehung von künstlerischem Vergnügen und Wohnraumproblematiken infrage stellt." Umweltfreundliche und recycelte Materialien und Solarenergie kommen zum Einsatz.

———

Cette petite « sculpture habitable » est faite de bois, d'OSB (panneaux à copeaux orientés), d'aggloméré de liège expansé et de CORKwall en couverture extérieure. Le concept rejoint d'autres réalisations de Gabriela Gomes qui cherche à « convertir des objets sculpturaux en objets design ». L'abri est destiné à être vu dans des espaces publics, il est mobile et renferme une chambre double avec WC intégré. Selon Gomes : « Il s'agit d'un objet expérimental qui associe sculpture, design et architecture, tel un défi aux nouvelles expériences de l'espace et une remise en question des liens entre plaisir artistique et problèmes de logement. » Les matériaux utilisés sont non polluants et recyclés, et le projet fait appel à l'énergie solaire.

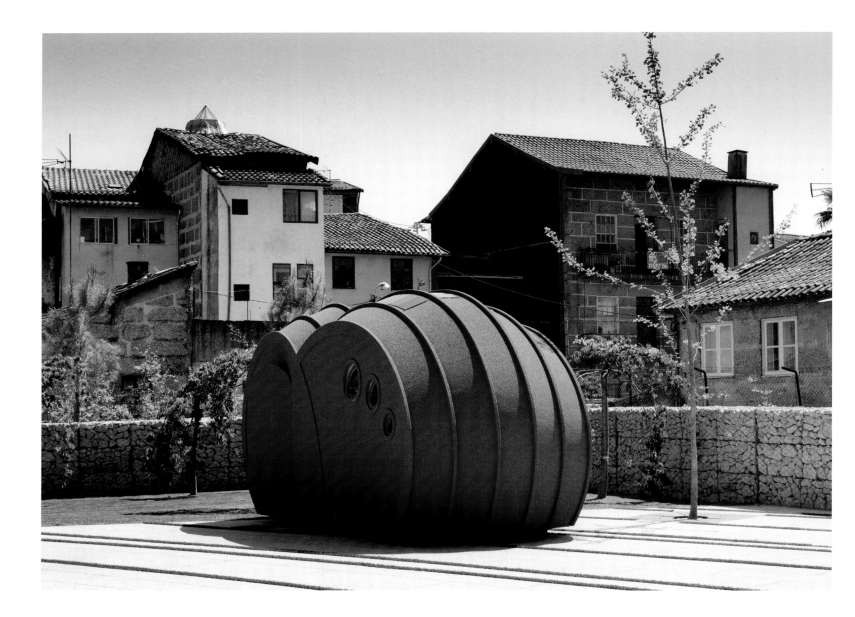

Gabriela Gomes calls this "an artistic manifestation that provides an innovative and unexpected experience as an accommodation space, associated with eco-sustainable solutions and mobility."

Gabriela Gomes bezeichnet das Projekt als „künstlerischen Ausdruck, der eine neuartige und ungewöhnliche Wohnerfahrung ermöglicht, verbunden mit ökologischer Nachhaltigkeit und Mobilität".

Gabriela Gomes définit sa construction comme « une manifestation artistique qui permet une expérience innovante et inédite en tant qu'espace de logement, associée à des solutions écologiques durables et à la mobilité ».

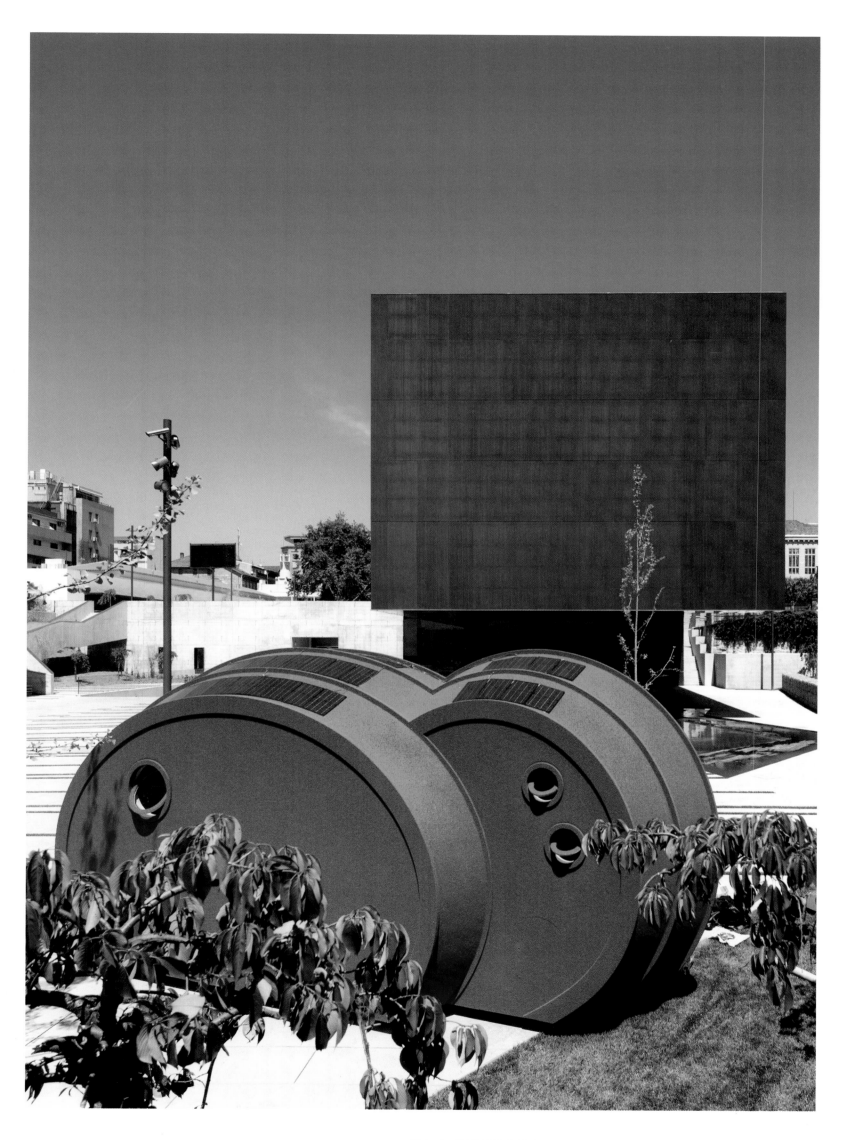

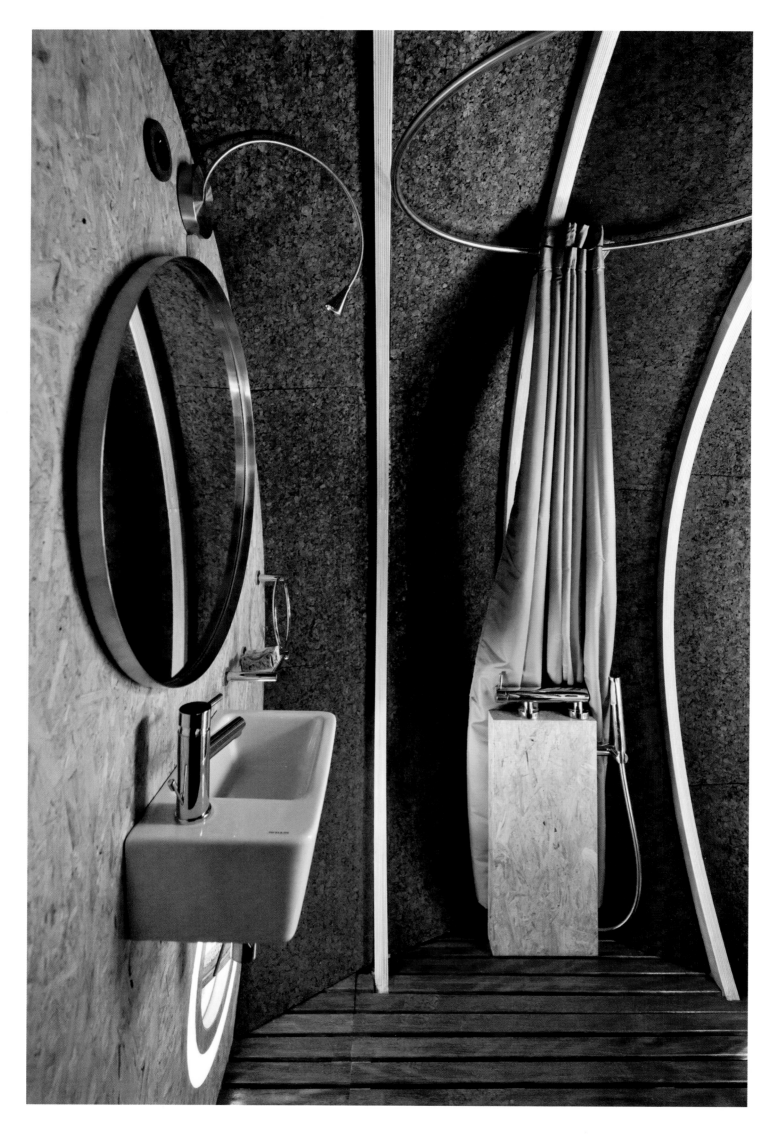

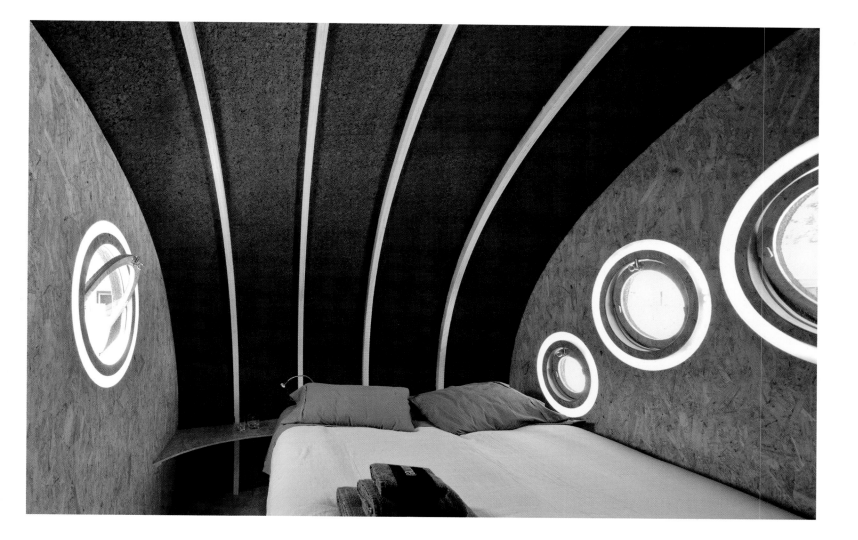

The work of the designer consists in "converting sculptural objects into design objects" that can be used as everyday products. Left page, the shower, which is also seen on the left in the plan below.

Die Arbeit der Designerin besteht darin, „skulpturale Objekte zu Designobjekten umzufunktionieren", die alltagstauglich sind. Die Dusche (linke Seite) ist auch im Grundriss (unten links) abgebildet.

Le travail du designer consiste à « convertir des objets sculpturaux en objets design » qui peuvent être utilisés au quotidien. Page de gauche, la douche qu'on voit aussi à gauche sur le plan ci-dessous.

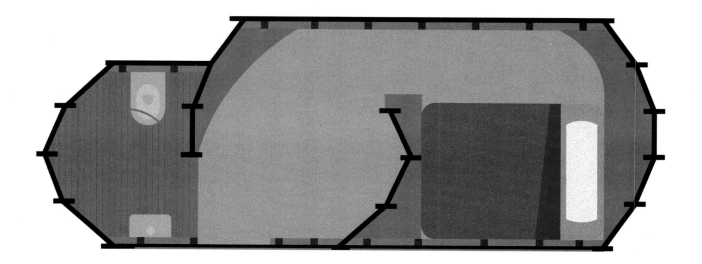

**ZEROPLUS**
La Conner, Washington [USA]
2006-07

# SNEEOOSH CABIN

Area: 106 m²

The architects placed the highest priority on reducing the impact of this cabin on its natural environment. The oldest trees on the site were intentionally preserved and the structure was lifted up to protect the ground beneath. Eight concrete pads were designed to support the cabin with minimal disturbance to the soil. The volume's transparent-glass main floor allows a full view of the setting, "dissolving the boundaries between inside and out." A large sliding door on the west face of the living room opens onto a deck and stairs that lead to a stone patio. Beneath a broad roof, a "cocoon-like encasement" contains the sleeping areas. A steel-brace frame and glulam beam system were used to ensure that the structure can withstand the elements and an earthquake.

---

Höchste Priorität für die Architekten dieses Projekts war es, Umweltschäden möglichst gering zu halten. Die ältesten Bäume am Bauplatz wurden bewusst erhalten und das Gebäude erhöht auf acht Betonstützen errichtet, um den Boden darunter zu schonen. Das vollständig transparente Erdgeschoss ermöglicht eine Rundumsicht auf die Umgebung und „hebt die Grenze zwischen innen und außen auf". Eine große Glasschiebetür auf der Westseite des Wohnraums öffnet sich auf eine Veranda, von der Stufen auf eine Steinterrasse führen. Unterhalb des ausladenden Dachs befindet sich ein „kokonartiges Gehäuse" mit den Schlafbereichen. Um den Elementen und möglichen Erdbeben standzuhalten, wurde für den Bau ein System aus Stahlrahmen und Balken aus Brettschichtholz verwendet.

---

Les architectes ont donné ici la priorité absolue à la réduction de l'impact sur le milieu naturel. Les arbres les plus âgés du site ont été volontairement préservés et la cabane est surélevée pour protéger le sol – les huit appuis en béton qui la portent ont été créés pour causer le moins de dégâts possible. Au niveau principal, un volume en verre transparent permet une vue complète des alentours et «fait disparaître les frontières entre dedans et dehors». Une large porte coulissante du côté ouest du salon ouvre sur une terrasse et un escalier qui mène à un patio au sol de pierre. Un «enrobage de type cocon» sous un large toit contient les espaces de couchage. Un système de charpente contreventée et poutres en acier et lamellé-collé permet à la structure de résister aux éléments et aux tremblements de terre.

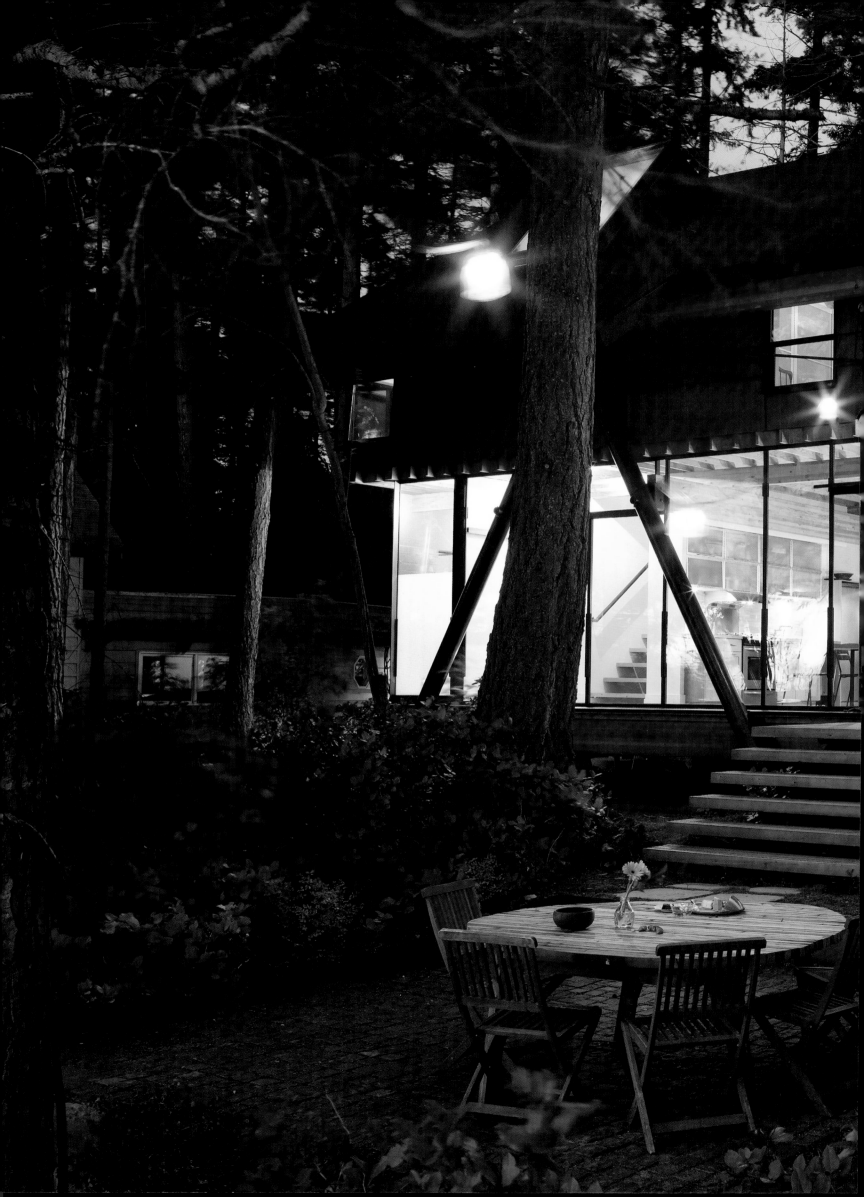

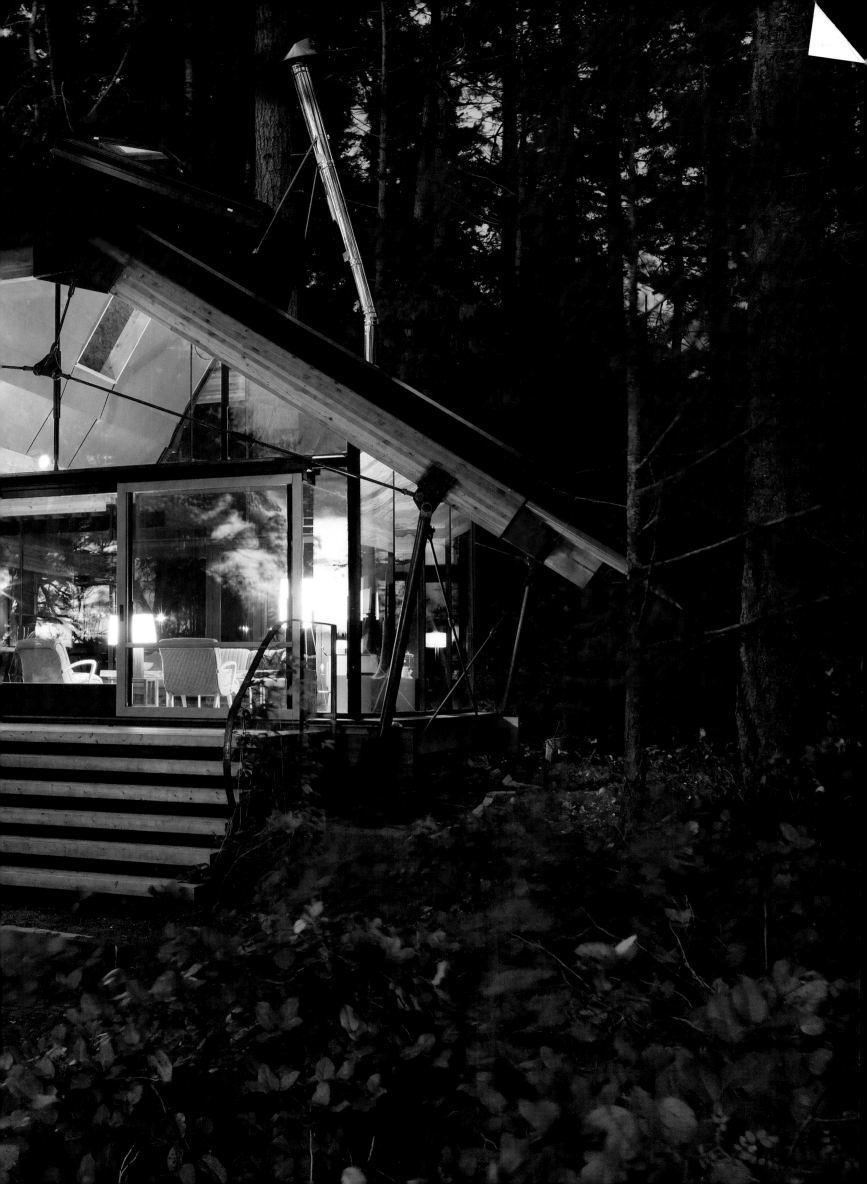

The west face of the living room has a large sliding door that opens onto a deck and a wide stairway that leads to a rough stone patio.

Die große Schiebetür auf der Westseite des Wohnzimmers öffnet sich auf eine Veranda sowie eine breite Treppe, die zu einer Steinterrasse führt.

Une large porte coulissante du côté ouest du salon ouvre sur une terrasse et un vaste escalier qui mène à un patio au sol de pierre brute.

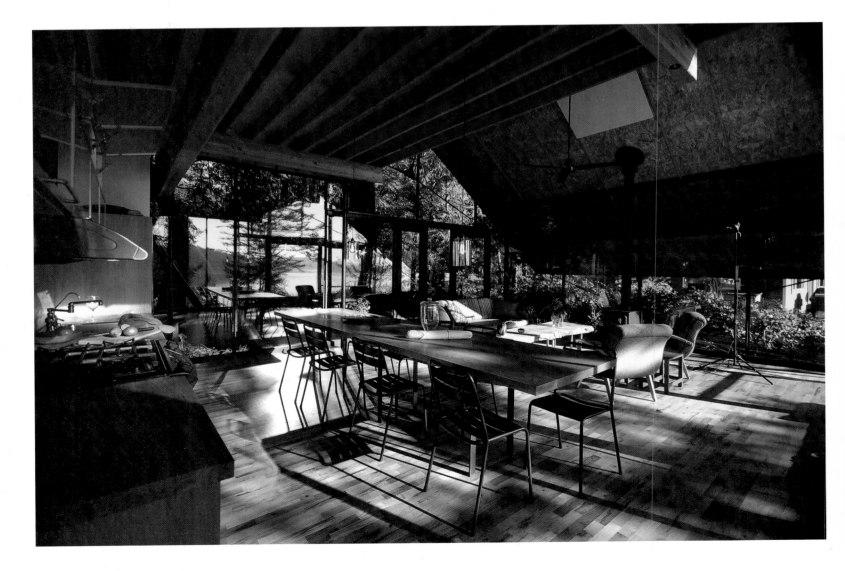

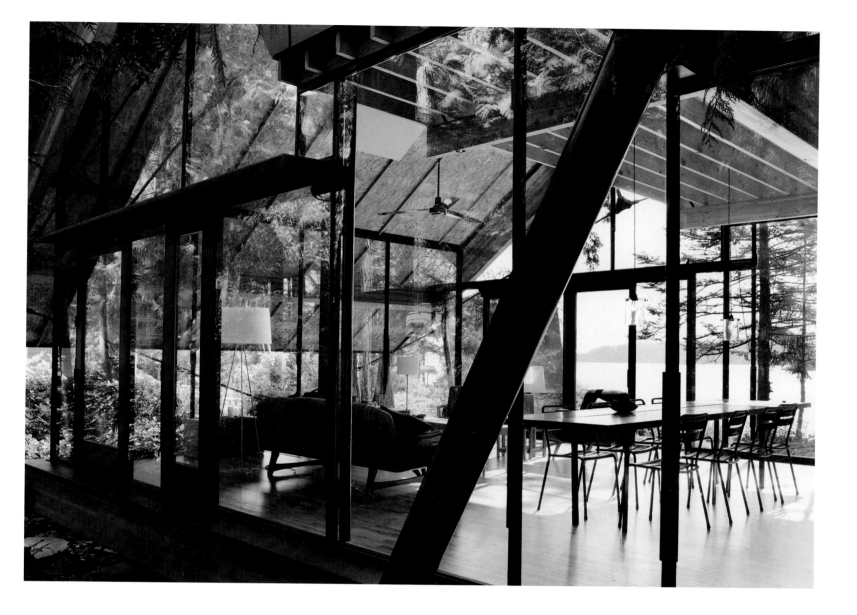

The "transparent glass enclosure" of the cabin seeks to dissolve "the boundaries between inside and out." Left, a plan shows the basic rectangular space, with the kitchen area on the left.

Die „transparenten Glaswände" des Hauses sollen „die Grenze zwischen innen und außen" aufheben. Der Grundriss (links) zeigt den einfachen rechteckigen Raum mit der Küche zur Linken.

L'« enceinte de verre transparente » de la cabane cherche à « faire disparaître les frontières entre dedans et dehors ». À gauche, le plan montre la forme de base rectangulaire de la structure avec l'espace cuisine à gauche.

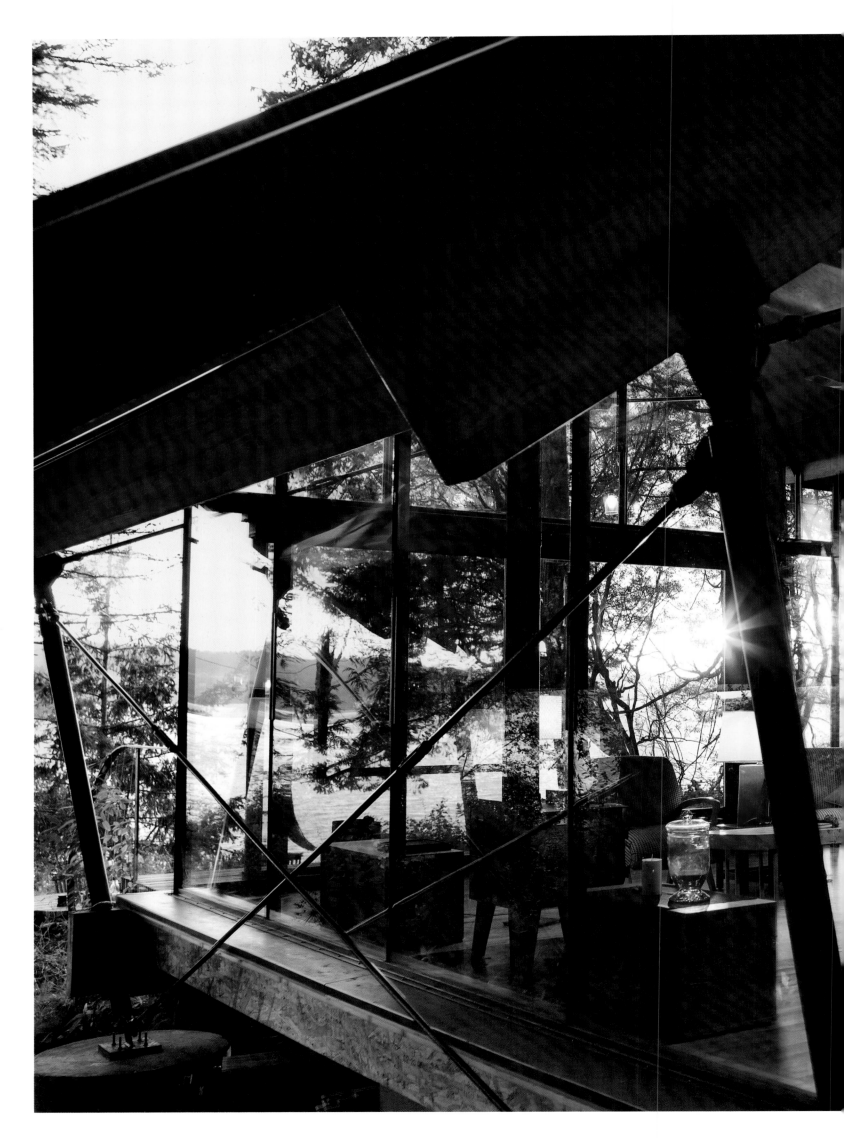

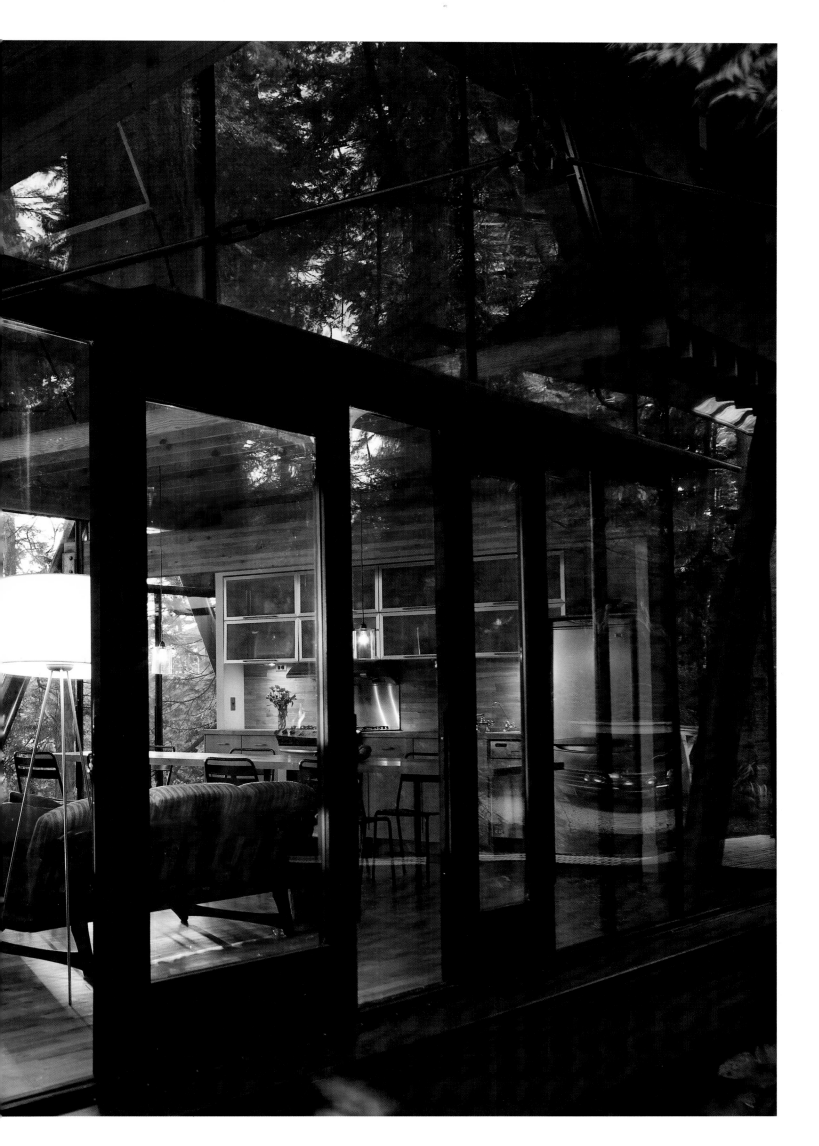

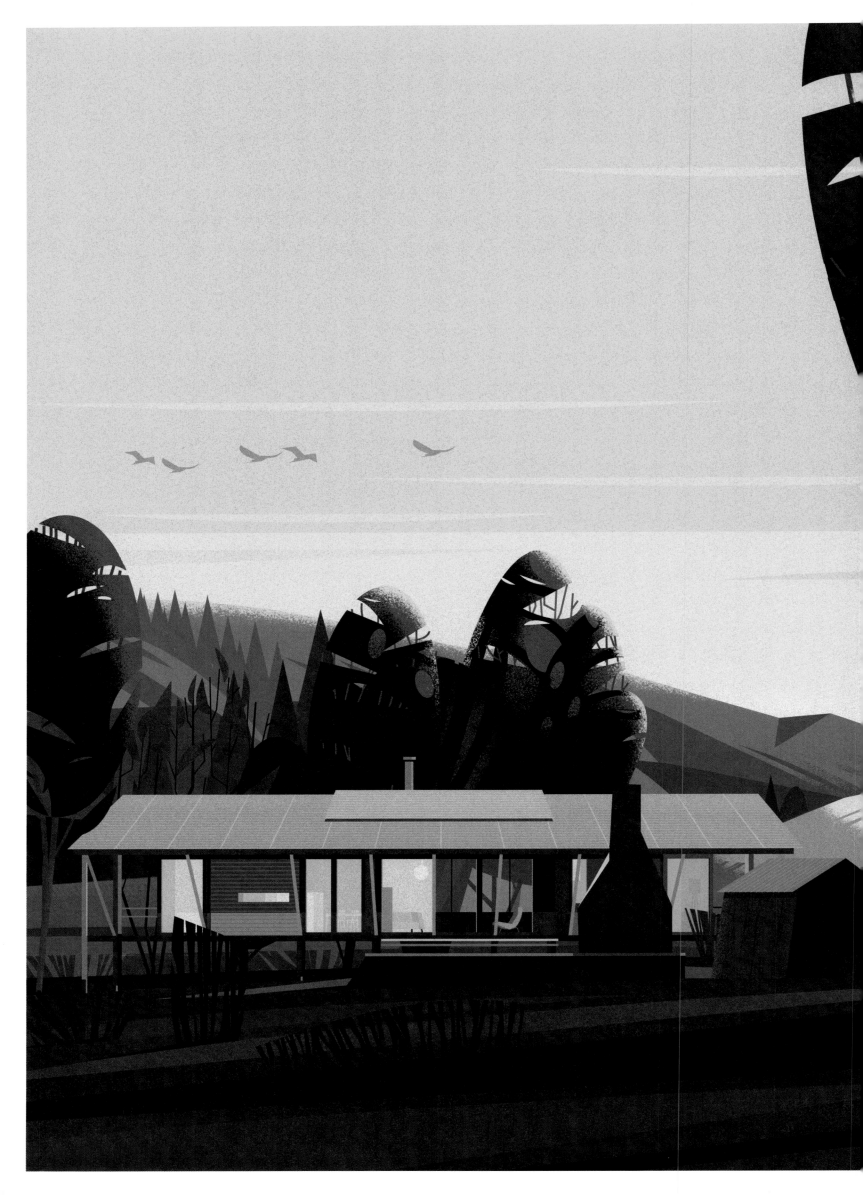

**CPLUSC**
St. Albans, New South Wales [Australia]
2002

# ST. ALBANS RESIDENCE

Area: 104 m²

Close to Sydney, but "reasonably remote," this residence was built on a 12-hectare site in part with old bridge timbers removed from the former St. Alban's Bridge. The structure was erected on the site of an existing timber cottage. The architect explains: "The construction technique of the building allowed it to look and feel elevated. The mass of the courtyard and stone fireplace grounds the work, contrasting and enhancing the light steel framing of the awning, and the sharp edges of corrugated roofing." Galvanized steel sections welded on site were employed, while hoop pine plywood was used for joinery, wall, and ceiling cladding. Karri (*Eucalyptus diversicolor*) flooring and decking, and cedar doors and windows are part of the material choices made by the architect, who explains that "with the exception of the flooring, all elements were prefabricated to aid in erection and possible disassembly." According to Clinton Cole: "Traditional materials of rural Australia have been used in conjunction with modern building techniques and systems to create a contemporary weekender, with an awareness of its environment, history, and place."

---

Dieses Wohnhaus liegt zwar in der Nähe von Sydney, ist aber dennoch „ausreichend weit weg". Es wurde auf einem 12 ha großen Gelände teils aus dem alten Bauholz der St. Alban's Bridge und am Standort einer früheren Holzhütte erbaut. Der Architekt: „Die Konstruktionsweise bewirkt, dass das Haus erhöht erscheint und sich erhöht anfühlt. Der massive Hof und der Steinkamin erden den Bau, kontrastieren und betonen den leichten Stahlrahmen des Vordachs und die scharfen Kanten des Wellblechdachs." Verwendet wurden vor Ort geschweißte Stahlprofile, während die hölzernen Bestandteile des Hauses sowie Wand- und Deckenverkleidung aus dem Holz der Neuguinea-Araukarie bestehen. Karribaumholz (Eucalyptus diversicolor) für Fußböden und Veranda sowie Zedernholz für Türen und Fenster gehören zur Materialwahl des Architekten, der erklärt, dass „mit Ausnahme der Böden alle Bauteile vorgefertigt wurden, um den Auf- und möglichen Abbau zu erleichtern". Clinton Cole: „Traditionelle Materialien des ländlichen Australien wurden mit modernen Bautechniken und -systemen verwendet, um ein zeitgemäßes Wochenendhaus mit Umwelt-, Geschichts- und Standortbewusstsein zu schaffen."

---

À proximité de Sydney mais néanmoins « à une distance raisonnable », cette résidence a été bâtie sur un terrain de 12 hectares, en partie avec du bois récupéré de l'ancien pont de Saint-Alban. Une petite maison en bois occupe déjà le site. L'architecte explique : « La technique de construction a permis de donner l'apparence et l'impression que le bâtiment est surélevé. La masse de la cour et de la cheminée en pierre forme la base de l'ensemble, contrastant avec la légèreté de la charpente en acier de l'auvent et les arêtes vives de la toiture ondulée qu'elle met ainsi en valeur. » Les éléments en acier galvanisé ont été soudés sur place et du contreplaqué d'araucaria a été utilisé pour la menuiserie, le mur et le revêtement du plafond. Le sol et la terrasse en karri (*Eucalyptus diversicolor*), comme les portes et fenêtres en cèdre, sont des choix de l'architecte qui explique qu'« à l'exception du sol, tous les éléments ont été préfabriqués pour faciliter la construction et l'éventuel désassemblage ». Clinton Cole résume le projet comme suit : « Des matériaux traditionnels de l'Australie rurale ont été utilisés et associés à des techniques de construction et à des systèmes modernes afin de créer une villégiature contemporaine, consciente de son environnement, de son histoire et de son emplacement. »

The house is set on a 12-hectare
site not far from Sydney, but
in an area considered "reason-
ably remote."

Dieses Haus liegt auf einem
12 ha großen Grundstück in der
Nähe von Sydney und dennoch
„ausreichend weit weg".

La maison occupe un site
de 12 hectares à proximité de
Sydney mais néanmoins
« à une distance raisonnable ».

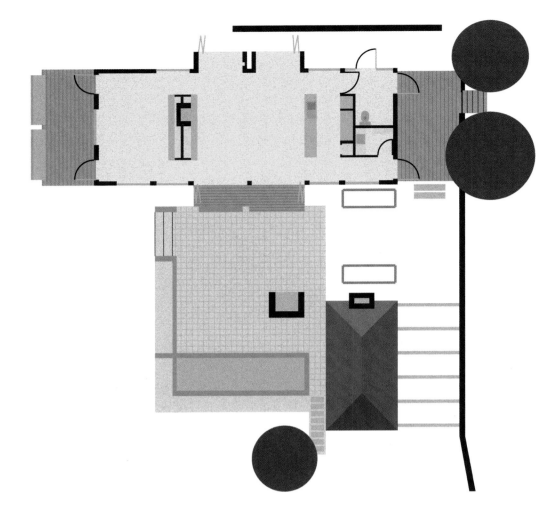

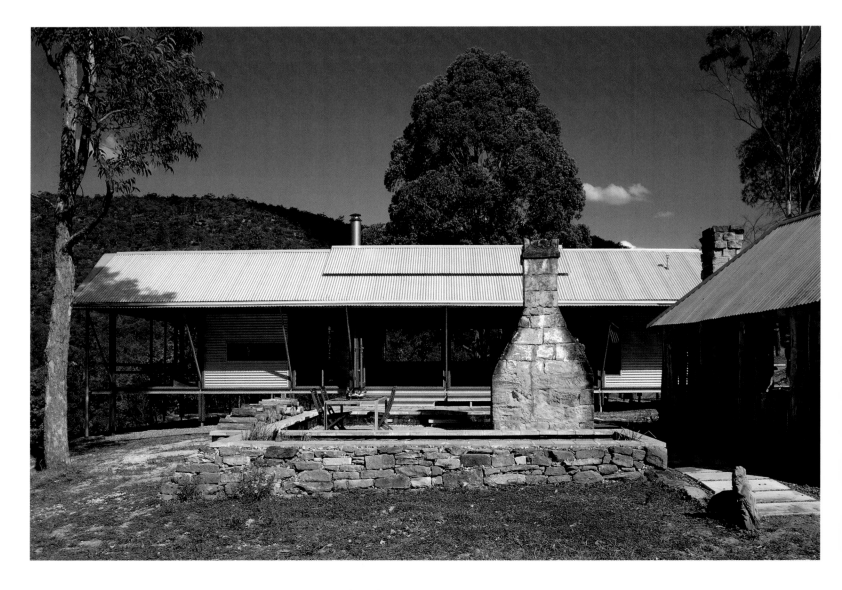

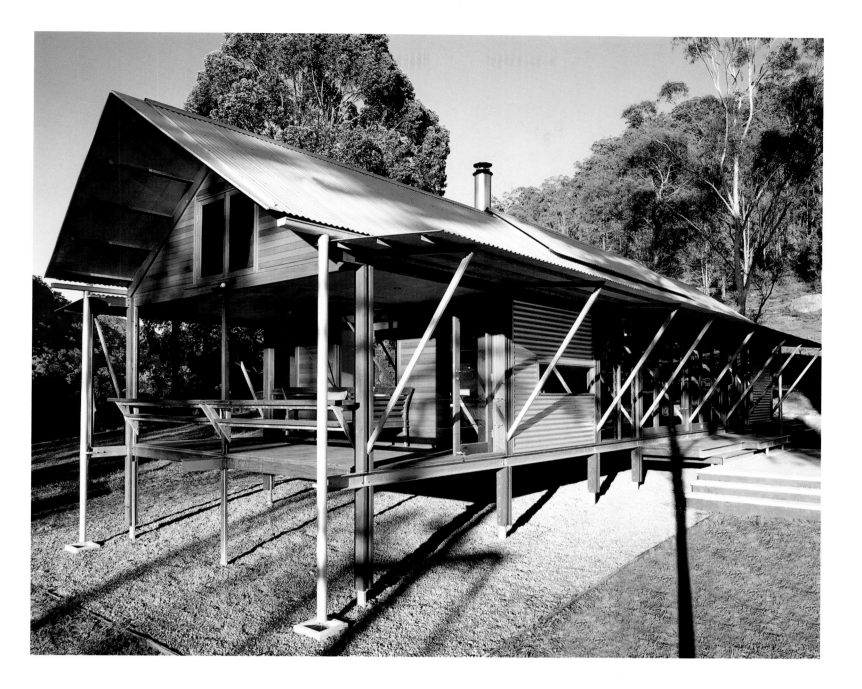

Light corrugated roofing contrasts with the stone
terrace and fireplace (left page). Out of respect for the
site and the environment, the house is in good part
lifted up off the ground.

Das leichte Wellblechdach steht im Kontrast zu Stein-
terrasse und Feuerstelle (linke Seite). Zum Schutz des
Bauplatzes und der Umwelt ist das Haus in großen
Teilen erhöht errichtet worden.

La légère toiture ondulée contraste avec la terrasse en
pierre et la cheminée (page de gauche). Par respect
pour le site et l'environnement, la maison est en grande
partie surélevée.

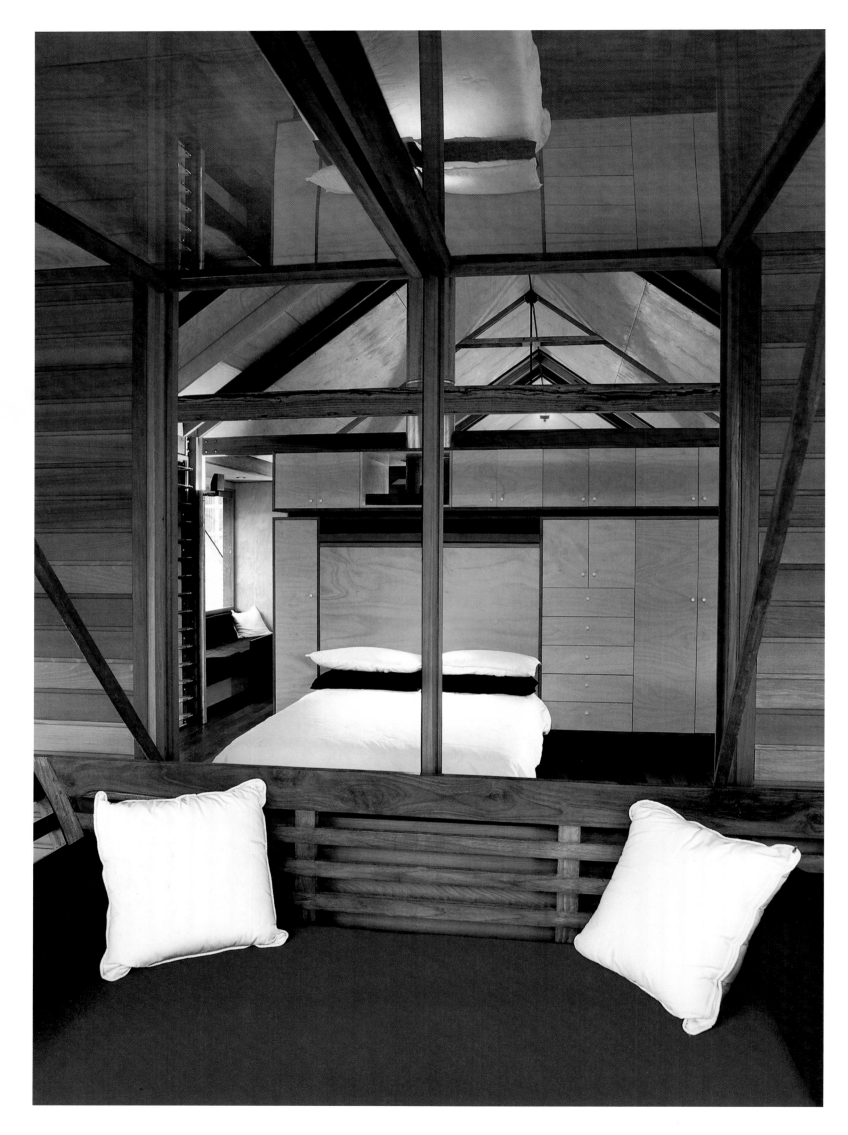

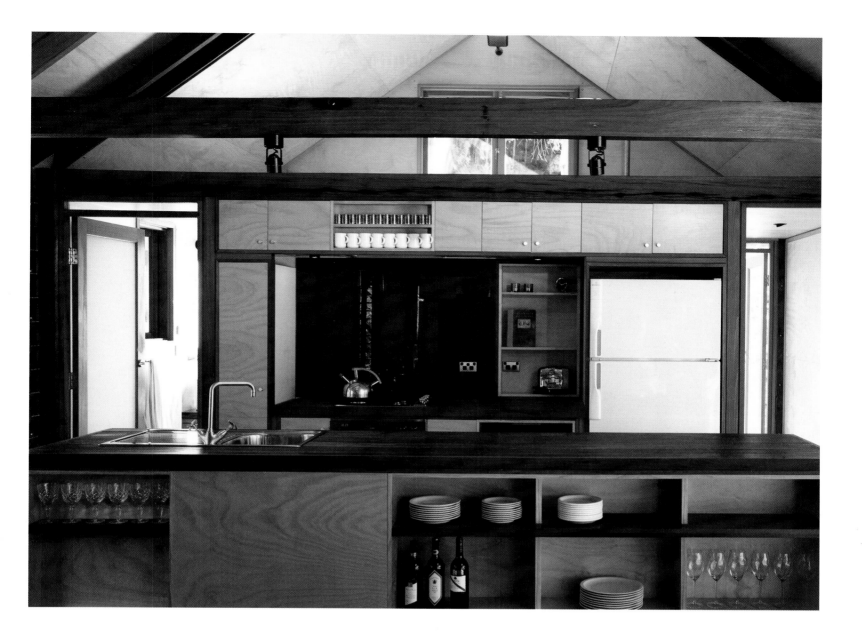

Hoop pine plywood was used for the joinery, wall, and ceiling cladding. All elements of the design were prefabricated with the exception of the flooring "to aid in erection and possible disassembly."

Für Verbindungselemente sowie Wand- und Deckenverkleidung wurde Sperrholz der Neuguinea-Araukarie verwendet. Außer den Böden sind alle Einzelteile vorgefertigt, „um den Auf- und möglichen Abbau zu erleichtern".

Du contreplaqué d'araucaria a été utilisé pour la menuiserie, le mur et le revêtement du plafond. À l'exception du sol, tous les éléments ont été préfabriqués « pour faciliter la construction et l'éventuel désassemblage ».

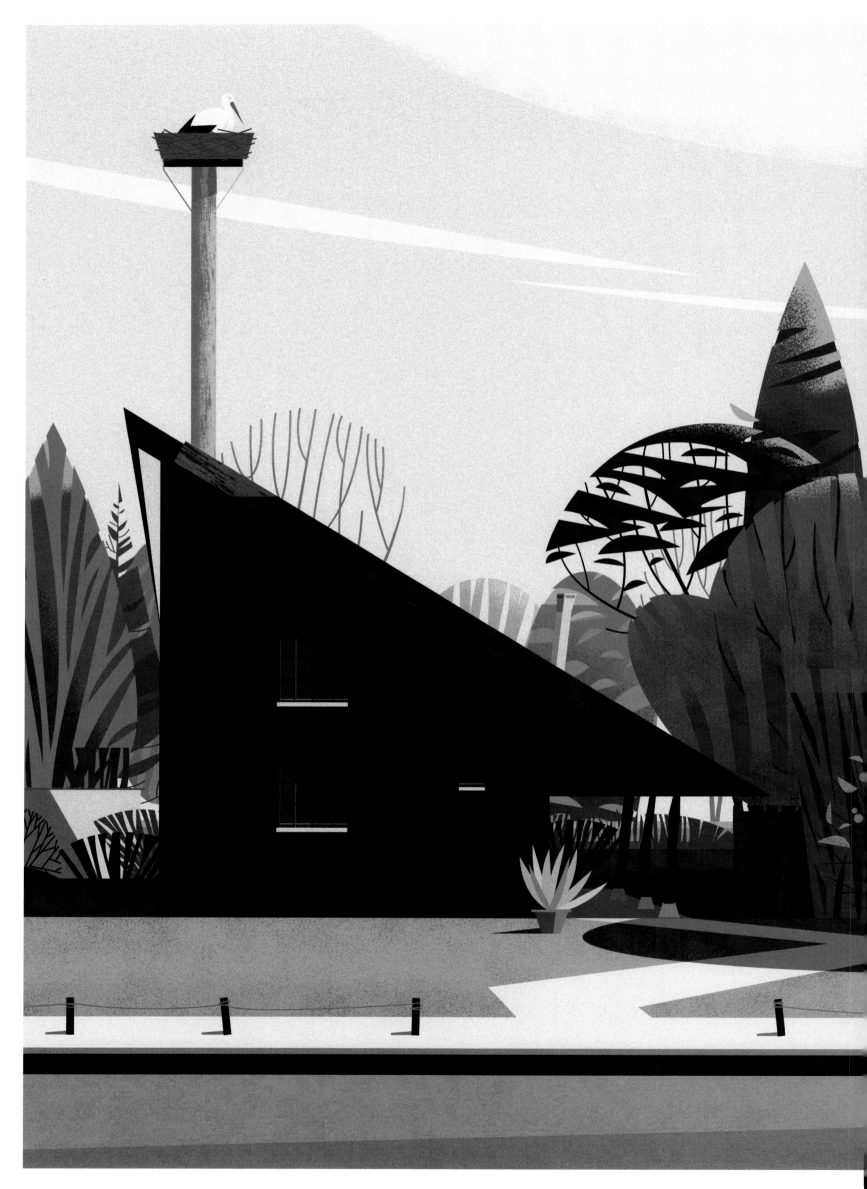

# STORKHOUSE

Area: 37 m² | Clients: Hagenberg Studio and Raiding Foundation
Collaboration: Richard Woschitz Engineering (Structural Engineering),
Dominik Petz (Carpentry) | Cost: €150 000

Built with oak, charred wood (*yakisugi*), reed, bricks, and concrete, this guest-house has been open to the public since April 2013. It is located in Raiding, south of Vienna, which is the birthplace of the composer Franz Liszt. Despite its small size, the house can actually accommodate four people, and includes a kitchenette, shower, toilet, and open fireplace. The name of the house comes from the fact that storks are meant to nest on its roof in the spring and summer months. Specially designed handmade furniture was created by the architect for this structure, which is part of the Raiding Project, in which Roland Hagenburg is bringing together similar structures by 13 noted Japanese architects, such as Kazuyo Sejima and Ryue Nishizawa (SANAA), Hiroshi Hara, and Toyo Ito. The Storkhouse is quite typical of the work of Terunobu Fujimori in that it makes reference to Japanese tradition, albeit in a somewhat quirky, modern way.

———

Dieses Gästehaus wurde mit Eichenholz, verkohltem Holz (Yakisugi), Ried, Ziegelsteinen sowie Beton gebaut und ist seit April 2013 der Öffentlichkeit zugänglich. Es befindet sich südlich von Wien in Raiding, dem Geburtsort des Komponisten Franz Liszt. Trotz der geringen Größe bietet das Haus Platz für vier Personen und ist mit einer kleinen Küche, Dusche, WC und einem Kamin ausgestattet. Es hat seinen Namen, „Storchenhaus", weil auf dem Dach in den Frühlings- und Sommermonaten Störche nisten sollen. Der Architekt hat eigens für dieses Projekt Holzmöbel entworfen. Das Haus ist Teil des Raiding Project, in dessen Rahmen Roland Hagenburg ähnliche Bauten von 13 bekannten japanischen Architekten zusammenbringt, darunter Kazuyo Sejima, Ryue Nishizawa (SANAA), Hiroshi Hara und Toyo Ito. Das Storchenhaus ist für den Architekten Fujimori insofern eine typische Arbeit, als dieser auch hier Bezug auf die japanische Tradition nimmt, wenn auch auf eigenwillige und moderne Art und Weise.

———

Cette maison d'hôtes en chêne, bois brûlé (*yakisugi*), roseaux, briques et béton est ouverte au public depuis avril 2013 à Raiding, au sud de Vienne, une ville connue pour être la ville natale du compositeur Franz Liszt. Malgré sa taille réduite, la maison peut parfaitement loger quatre personnes et comprend une kitchenette, une douche, des toilettes et un foyer ouvert. Elle doit son nom aux cigognes qui sont censées nicher sur son toit au printemps et en été. Le mobilier fait main spécialement conçu a été créé par l'architecte pour la structure qui fait partie du projet Raiding dans le cadre duquel Roland Hagenburg a réuni des structures similaires réalisées par 13 architectes japonais de renom tels que Kazuyo Sejima et Ryue Nishizawa (SANAA), Hiroshi Hara ou Toyo Ito. La Maison de la cigogne est assez caractéristique du travail de Terunobu Fujimori car elle fait référence à la tradition japonaise mais d'une manière originale et moderne, quelque peu excentrique.

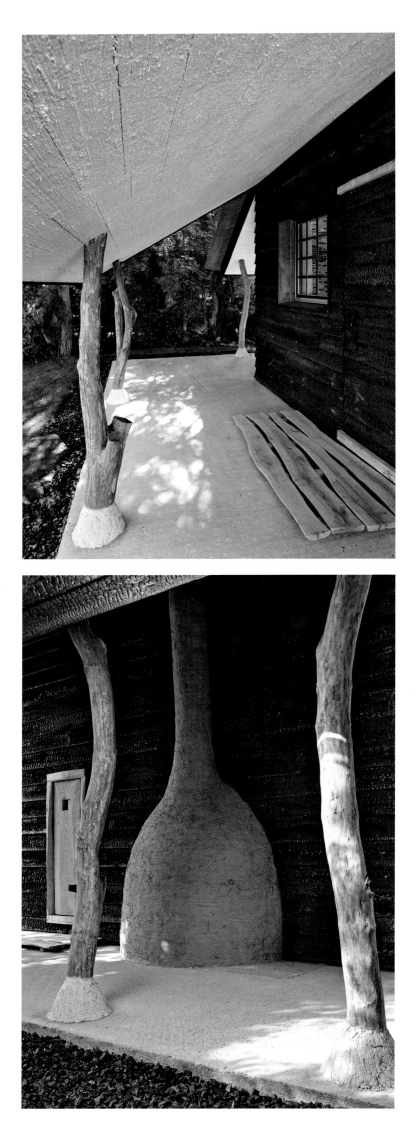

The façade of the house is made with *yakisugi*, a traditional Japanese technique consisting in charring the cedarwood cladding. A stork nest is set high above the house (right page).

Die Fassade ist mit der traditionellen japanischen Yakisugi-Technik entstanden, bei der die Zedernholzverschalung angekohlt wird. Auf der rechten Seite das Storchennest über dem Haus.

La façade de la maison est en *yakisugi*, une technique traditionnelle japonaise qui consiste à brûler le revêtement en bois de cèdre. Un nid de cigognes est installé haut au-dessus de la maison (page de droite).

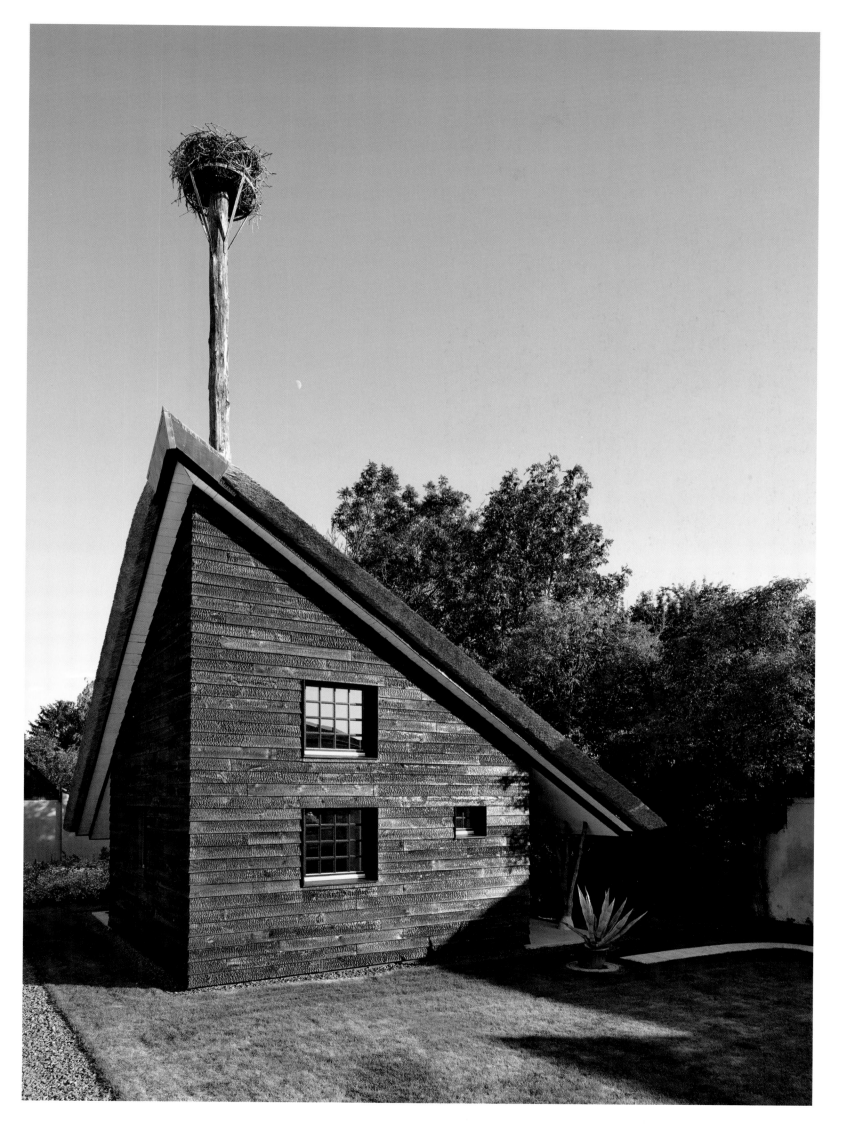

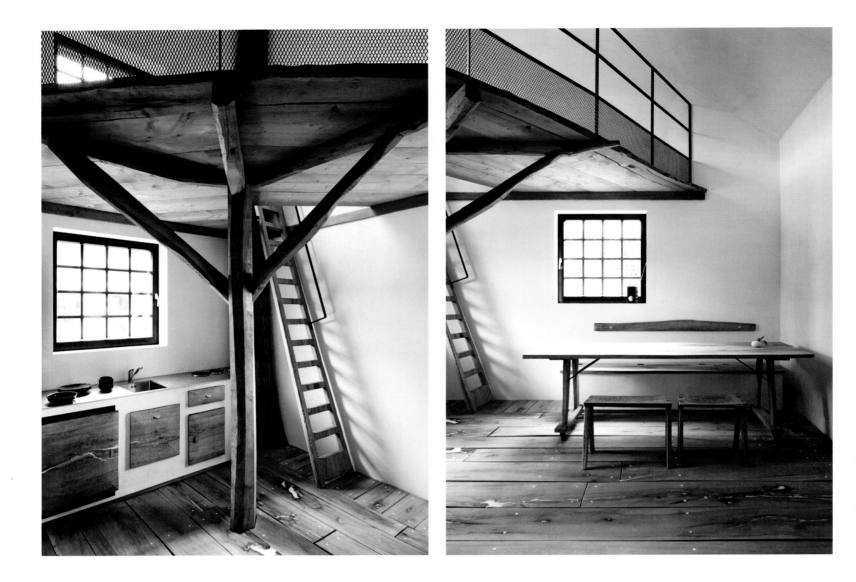

As the interiors of the house demonstrate, the architect draws on a most unexpected combination of Japanese tradition and a very personal sense of modernity. Rough wood planks are used for the floor, and the wood furnishings are also by Professor Fujimori.

Den Innenräumen ist anzusehen, dass der Architekt japanische Tradition und ein sehr persönliches Verständnis von Modernität auf überraschende Weise verbindet. Für den Boden kamen grobe Holzbohlen zum Einsatz. Auch das Holzmobiliar wurde von Professor Fujimori entworfen.

Comme le montre l'intérieur de la maison, l'architecte associe de manière extrêmement originale la tradition japonaise et un sens très personnel de la modernité. Des planches de bois brut ont été utilisées pour le sol et le mobilier en bois a également été créé par le professeur Fujimori

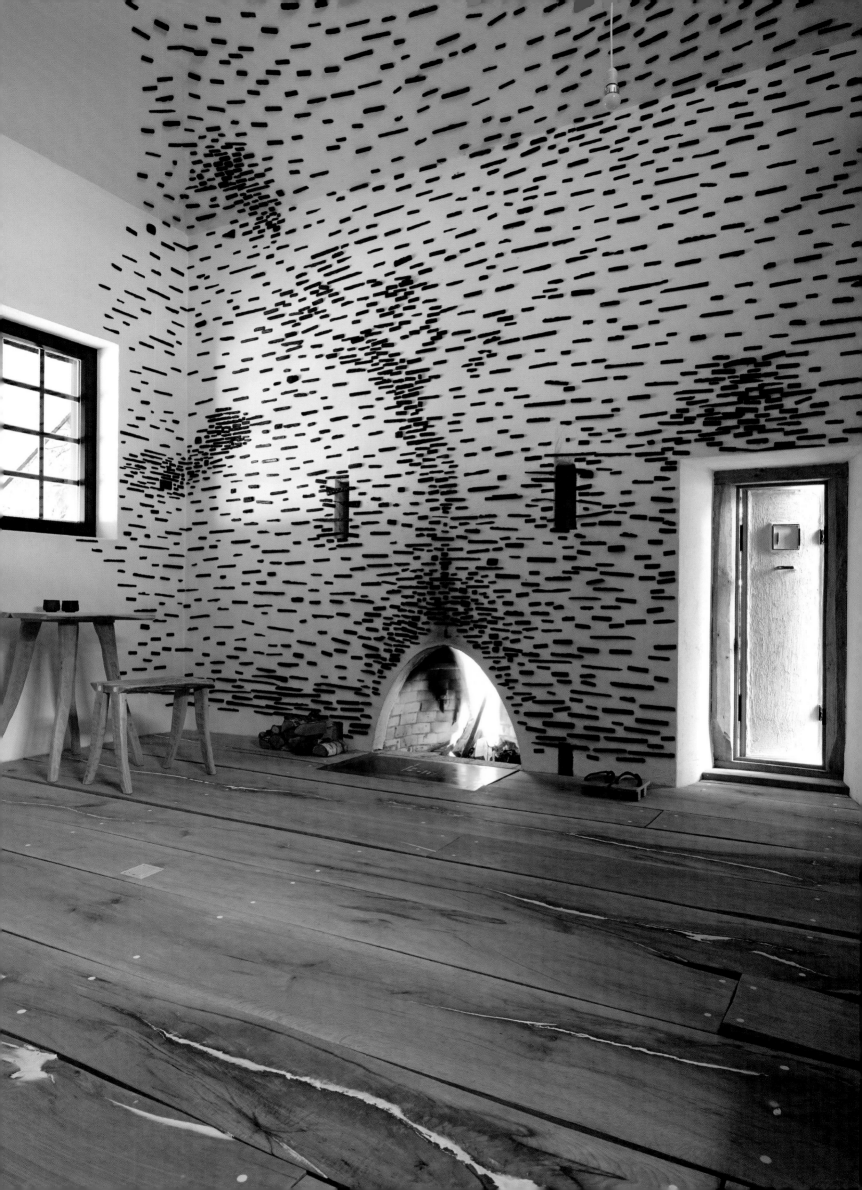

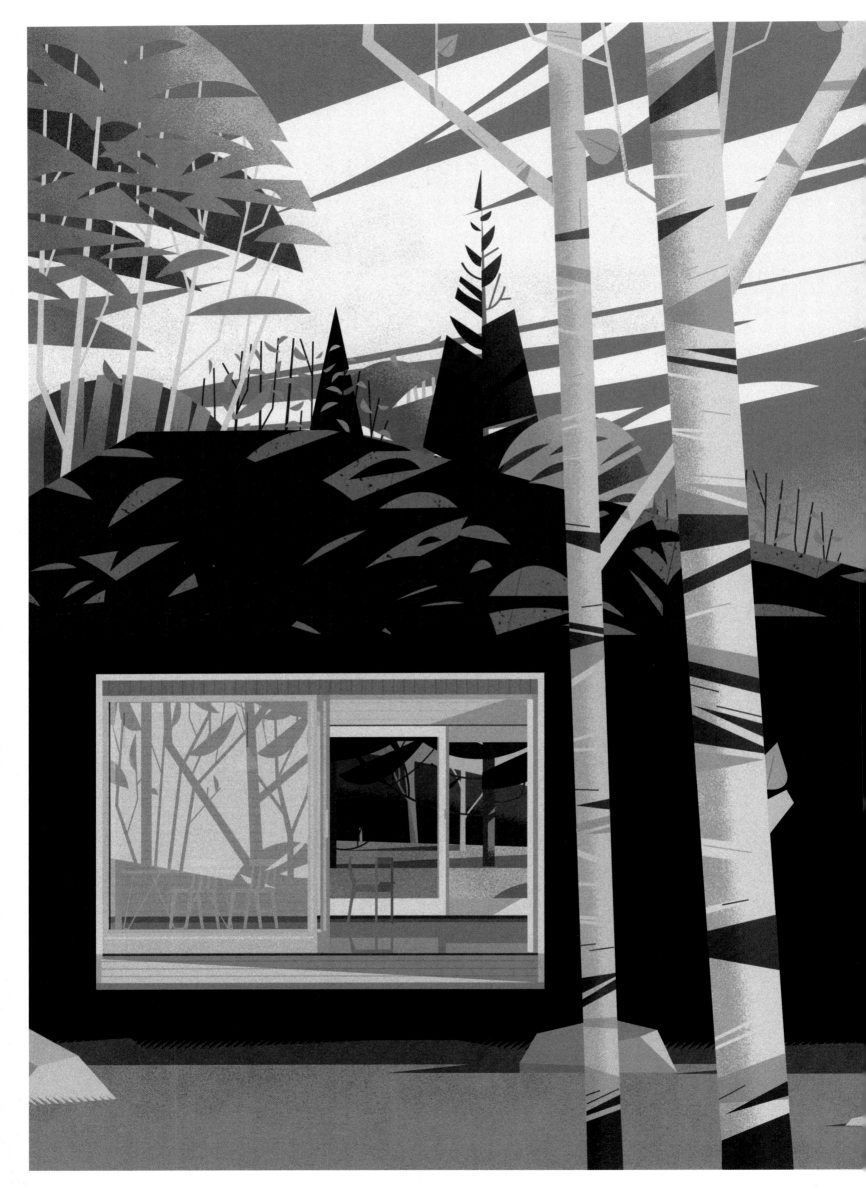

**THAM & VIDEGÅRD**
Söderöra Island, Stockholm Archipelago [Sweden]
2007–08

# SUMMER HOUSE

Area: 80 m²

Located on a remote island in the Stockholm Archipelago, this house cannot be reached by car. The design includes an open central space, two small bedrooms, storage, and a bath. A skylight and large glazed niches bring natural light into the central space. Sliding glass doors located in two of the niches allow access to an outdoor dining area and a protected entrance porch. The roof and façades are finished with a standard, black-slate, bitumen roofing product. The interiors are clad in natural and light-gray painted, sawed wood panels.

———

Dieses Haus befindet sich auf einer abgelegenen Schäre im Stockholmer Schärengarten und ist nicht per Auto erreichbar. Es verfügt über einen offenen zentralen Raum, zwei kleine Schlafzimmer, einen Lagerraum und ein Bad. Ein Dachfenster und großflächig verglaste Nischenbereiche lassen viel natürliches Licht in den zentralen Raum, Glasschiebetüren in zwei der Nischenbereiche öffnen sich auf einen Essbereich im Freien und eine geschützte Eingangsveranda. Dach und Fassade sind mit einem handelsüblichen Bedachungsmaterial aus schwarzem Schiefer und Bitumen verkleidet. Der Innenbereich ist mit naturbelassenen, hellgrau lackierten Brettern verkleidet.

———

Cette maison sur une île isolée de l'archipel de Stockholm est inaccessible en voiture. Le concept comprend un espace central ouvert, deux petites chambres, un espace de rangement et une salle de bains. Une lucarne et de grandes niches vitrées font entrer la lumière du jour dans l'espace central. Des portes vitrées coulissantes dans deux des niches donnent accès à un coin repas extérieur et à un porche d'entrée abrité. Le toit et les façades sont enduits d'un produit standard pour toiture à base de bitume et d'ardoise noire. L'intérieur est revêtu de panneaux de bois de sciage naturel peints en gris clair.

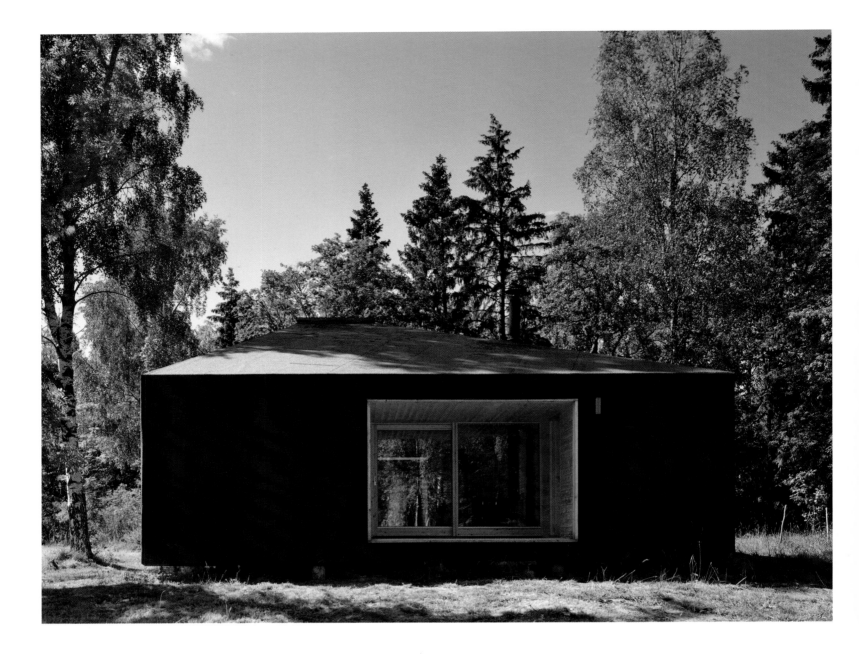

The roof and façades of the Summer House are finished with
a standard, slate-black, bitumen roofing product that contrasts
with the recessed windows and doors.

Dach und Außenwände sind mit einem handelsüblichen
Dachmaterial aus schwarzem Schiefer und Bitumen verkleidet
und heben sich von den tief eingelassenen Fenstern und
Türen ab.

Le toit et les façades de la Summer House sont enduits
d'un produit pour toiture à base de bitume et d'ardoise noire
qui contraste avec les portes et fenêtres encastrées.

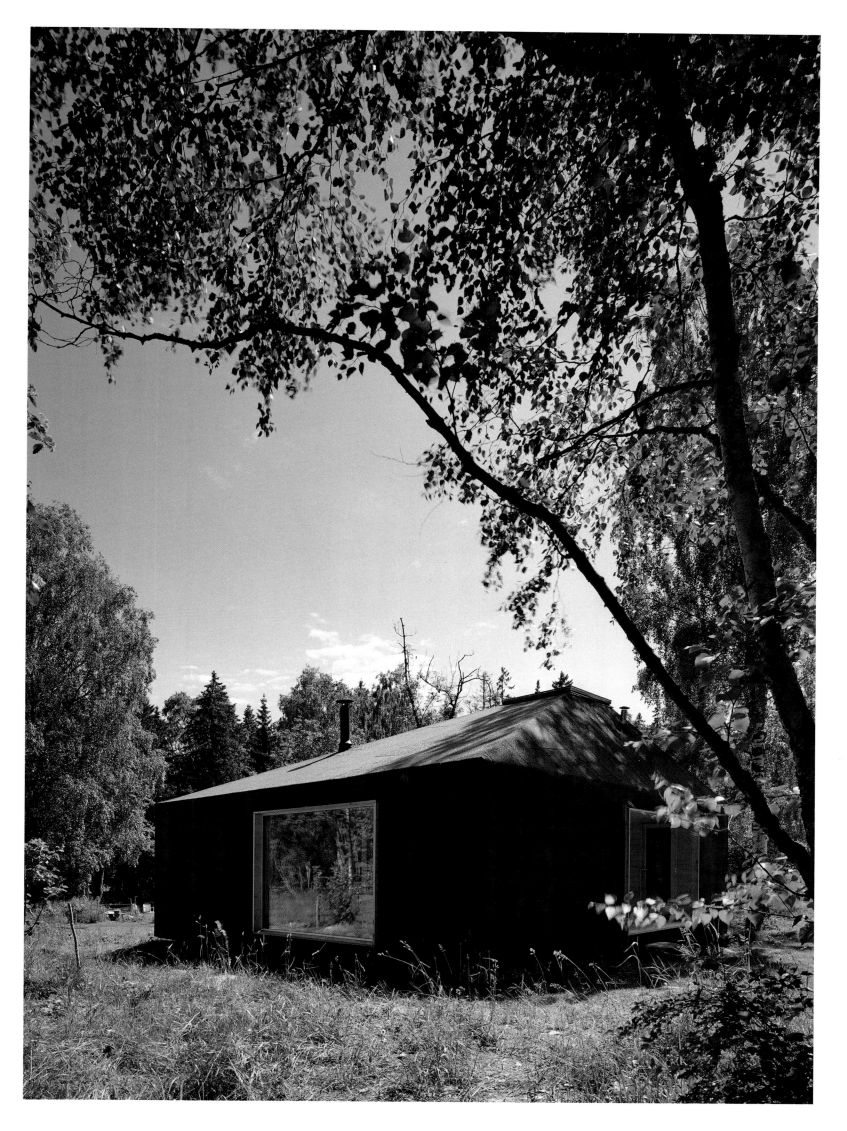

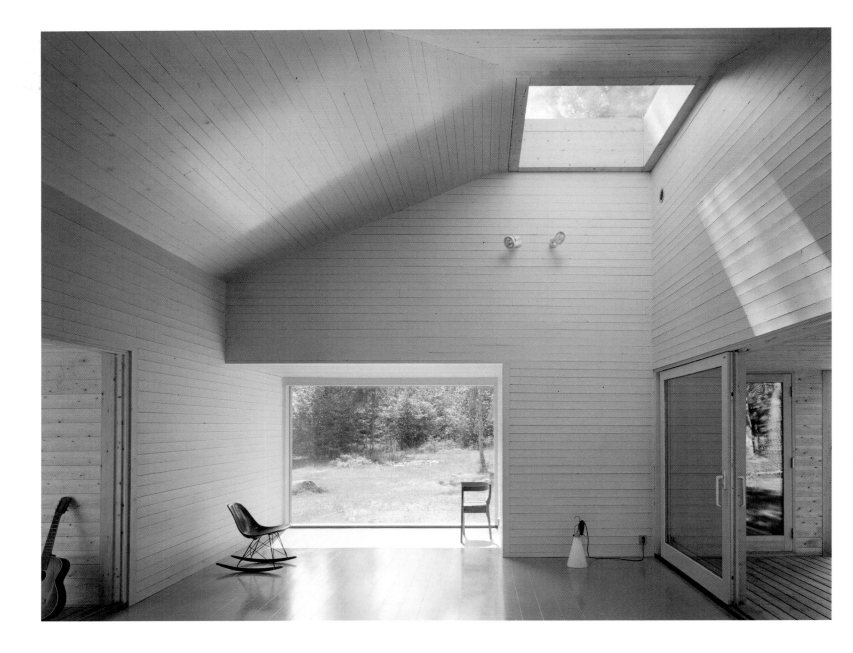

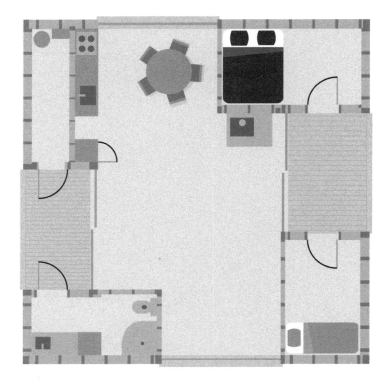

Indoor and outdoor "rooms" are finished with sawed wood paneling painted light gray. Light enters not only from the generous windows but also from a skylight, making the interior contrast with the dark exterior of the house.

Innen- und Außenräume sind mit hellgrau lackierten Brettern verkleidet. Licht fällt durch große Fenster sowie ein Oberlicht und kontrastiert mit dem dunklen Äußeren des Hauses.

Les « pièces » intérieures et extérieures sont revêtues de panneaux de bois de sciage peints en gris clair. La lumière pénètre par les grandes fenêtres, mais aussi par une lucarne, et contraste avec l'aspect extérieur sombre de la maison.

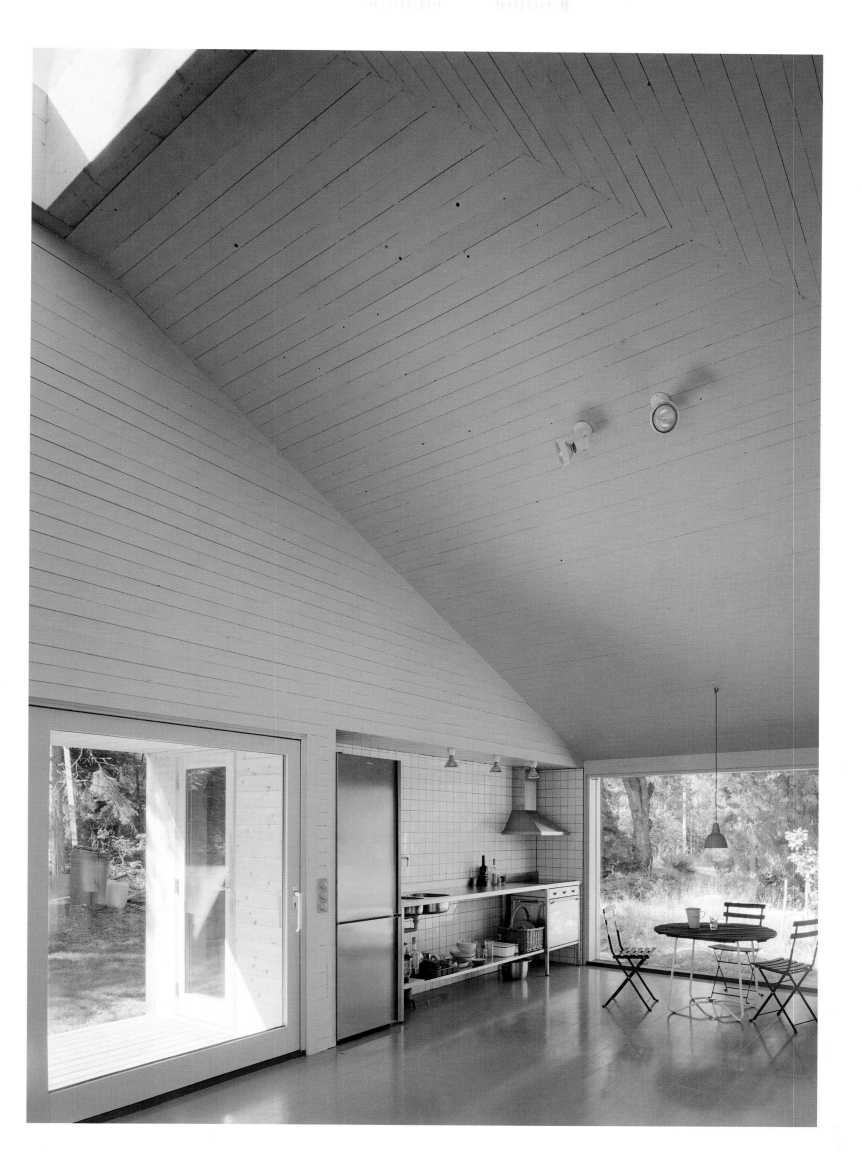

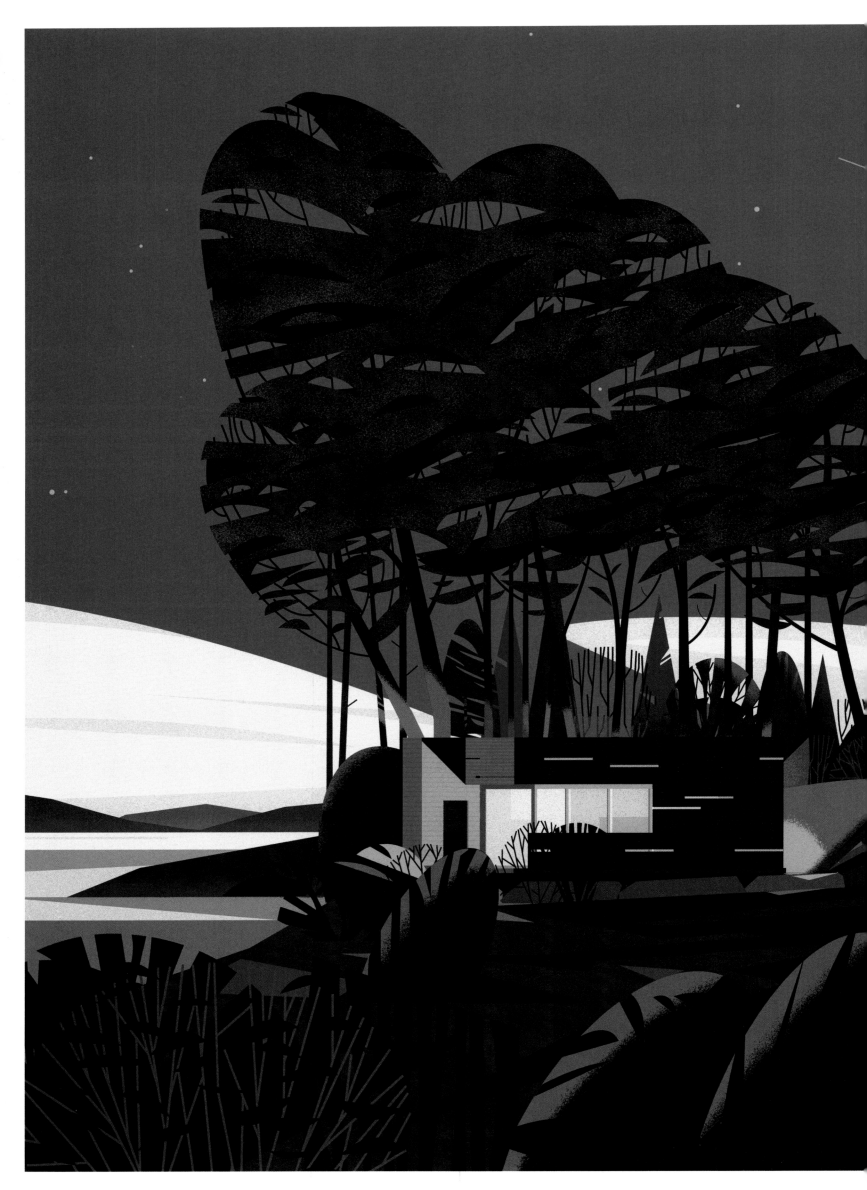

**TAYLOR SMYTH**
Lake Simcoe, Ontario [Canada]
2004

# SUNSET CABIN

Area: 26 m² | Cost: $80 000 | Collaboration: Mike Le Frerriere

This one-room sleeping cabin evokes "the original 'Primitive Hut' built of tree trunks and branches described by Laugier in the 18th century, combined with precise modern detailing that calls to mind Mies van der Rohe," according to the architect. The structure serves as a private retreat from the nearby main cottage. Three of its walls have full-height glazing, enabling the occupants to observe the sunset. An exterior horizontal cedar screen on two sides ensures privacy and protection from direct sunlight, although a cutout in the screen allows for views. The cabin has a green roof and minimal furnishings made of birch veneer plywood. Prefabricated in Toronto, the cabin was assembled on site over a ten-day period. Prefabrication was used to reduce labor costs and to avoid disturbing the natural setting.

---

Diese Ein-Zimmer-Schlafhütte bezieht sich den Architekten zufolge auf die von „Laugier im 18. Jahrhundert beschriebene, aus Baumstämmen und Zweigen errichtete ‚Urhütte', kombiniert mit präzisen modernen Details, die an Mies van der Rohe erinnern". Der Bau dient als Rückzugsort, das Haupthaus befindet sich in der Nähe. Drei Wände bestehen komplett aus Glas und bieten eine Aussicht auf den Sonnenuntergang. Außen ist an zwei Seiten ein horizontaler Sonnenschutz aus Zedernholz angebracht, der zur besseren Sicht über Aussparungen verfügt. Das Dach der Hütte ist begrünt. Das sparsame Mobiliar besteht aus Birkenfurniersperrholz. Die in Toronto vorgefertigte Hütte wurde innerhalb von zehn Tagen am Standort zusammengebaut. Die Fertigbauweise wurde gewählt, um die Arbeitskosten gering zu halten und die Umwelt so wenig wie möglich zu beeinträchtigen.

---

Cette cabane à pièce unique évoque pour l'architecte « la "hutte primitive" originelle en troncs d'arbres et branchages décrite par Laugier au XVIIIᵉ siècle, combinée à des détails modernes rappelant Mies van der Rohe ». Elle sert de refuge privé au cottage voisin. Trois de ses murs sont vitrés sur toute leur hauteur pour observer le soleil couchant. Un écran extérieur horizontal en cèdre sur deux côtés garantit l'intimité et protège de l'ensoleillement direct, tandis qu'une ouverture permet de libérer la vue. La cabane est surmontée d'un toit végétalisé et garnie d'un mobilier minimaliste en contreplaqué de placage de bouleau. Elle a été préfabriquée à Toronto, puis assemblée sur le site en dix jours. La préfabrication a été utilisée pour réduire le coût de la main d'œuvre et éviter de troubler le milieu naturel.

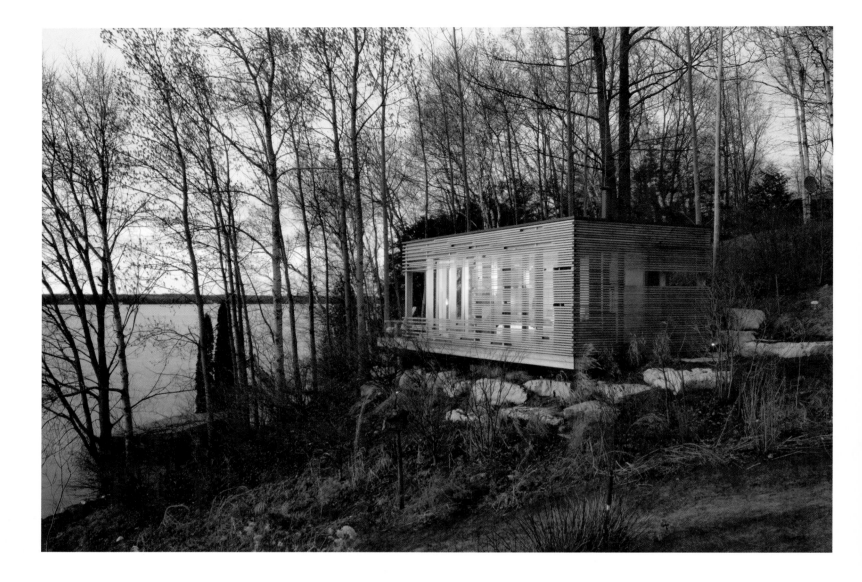

The architect explains that this one-room sleeping cabin is intended to evoke "the original 'Primitive Hut' built of tree trunks and branches and described by Laugier in the 18th century, combined with precise modern detailing that calls to mind Mies van der Rohe."

Den Architekten zufolge bezieht sich diese Ein-Zimmer-Schlafhütte auf die von „Laugier im 18. Jahrhundert beschriebene, aus Baumstämmen und Zweigen errichtete ‚Urhütte', kombiniert mit präzisen modernen Details, die an Mies van der Rohe erinnern".

L'architecte explique que cette cabane à pièce unique évoque « la "hutte primitive" originelle en troncs d'arbres et branchages décrite par Laugier au XVIIIe siècle combinée à des détails modernes rappelant Mies van der Rohe ».

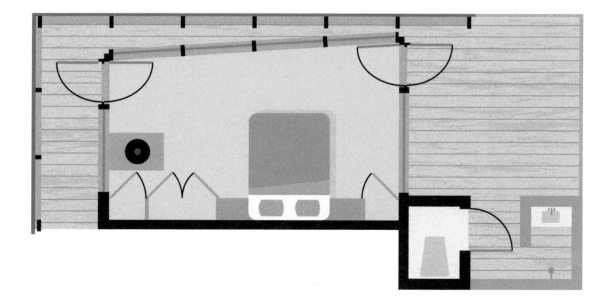

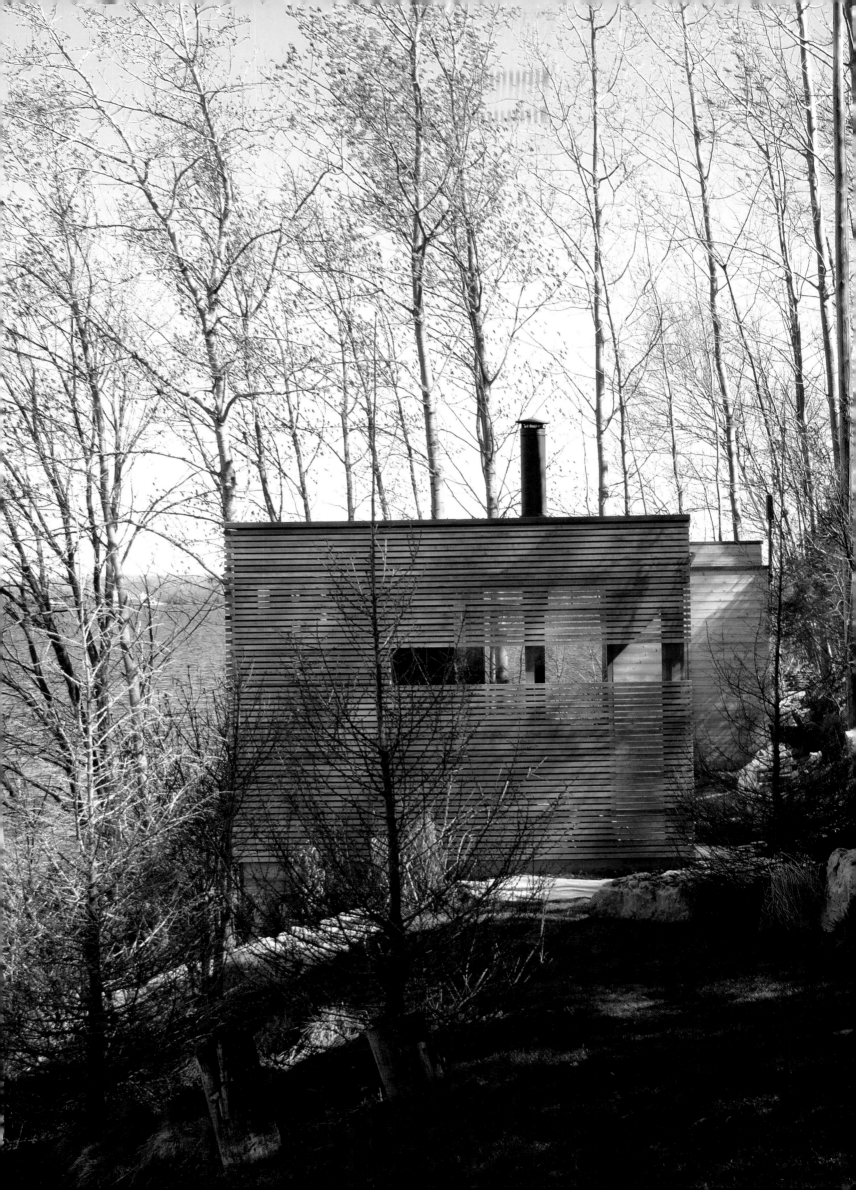

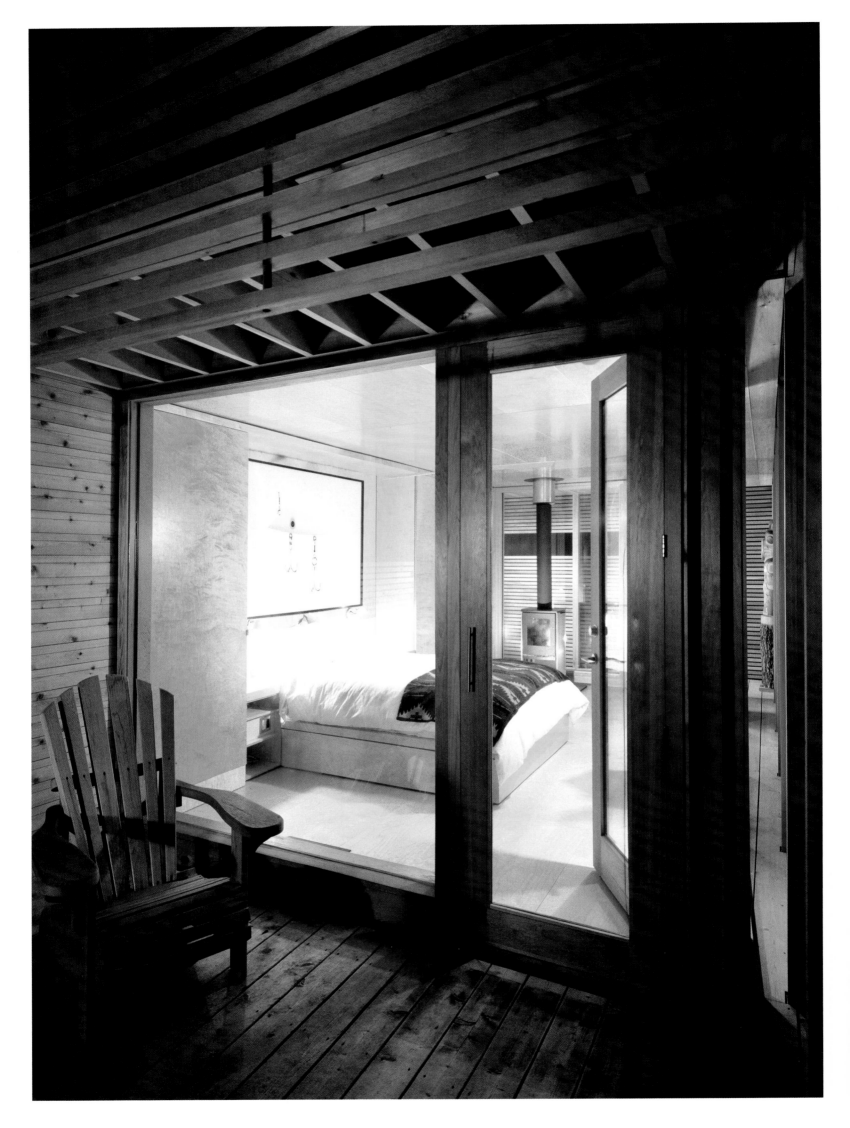

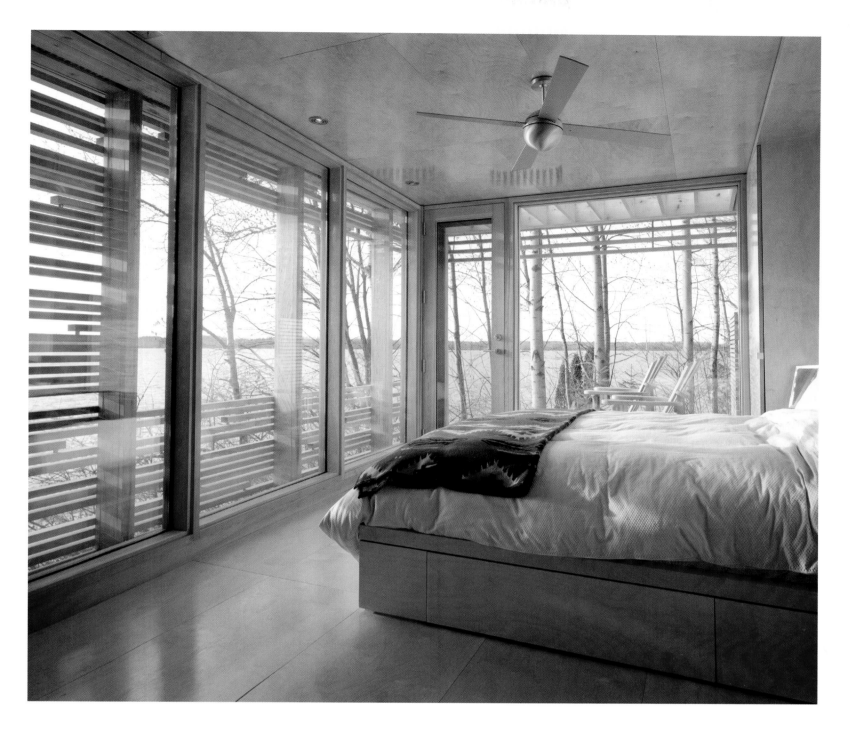

All interior surfaces of the house were made with
birch veneer plywood. Minimal furnishings include a
bed with built-in drawers and a wood-burning stove.

Alle Oberflächen im Inneren der Hütte bestehen aus
Birkensperrholz. Zur reduzierten Einrichtung gehören ein
Schubladenbett und ein Holzofen.

Toutes les surfaces intérieures sont en contreplaqué
de placage de bouleau. Le mobilier minimaliste comporte
un lit à tiroirs encastrés et un poêle à bois.

URS PETER "UPE" FLUECKIGER
Crowell, Texas [USA]
2008–10

# SUSTAINABLE CABIN

Area: 37 m² | Client: Pease River Foundation | Collaboration:
Ben K. Shacklette, Michael Martin, Carol Flueckiger

Motivated by the mere $28.12 ($683.08 being the contemporary equivalent)
that Henry David Thoreau paid for the materials of his house at Walden Pond in
1845, 60 students and their professors from Texas Tech University (Lubbock)
decided to build their own sustainable cabin. Inspired also by Le Corbusier's
"Cabanon" (Roquebrune-Cap-Martin, France, 1949), the project seeks to relate
to its site while studying the minimal spatial requirements for living. They began
their work in the summer of 2008, and employed corrugated, galvanized iron
and cedar. A wood frame is mounted on a steel chassis and recycled cotton was
used for insulation. Inside, yellow pine is used for the walls and ceiling, and
bamboo for the flooring. Using solar energy, the cabin they created will serve
as a "Living Research Laboratory for generations of students to come, testing
the successes and shortcomings of the project and possibly upgrading its com-
ponents as technology continues to develop."

———

Angeregt von den gerade einmal 28,12 Dollar, die Henry David Thoreau 1845
für die Baumaterialien seiner Hütte am Walden Pond ausgab (der aktuelle Ge-
genwert beträgt 683,08 Dollar), entschieden sich 60 Studenten und Professo-
ren der Texas Tech University (Lubbock) für den Bau ihrer eigenen nachhaltigen
Hütte. Das Projekt ist darüber hinaus von Le Corbusiers „Cabanon" inspiriert
(Roquebrune-Cap-Martin, Frankreich, 1949), soll auf seine Umgebung Bezug
nehmen und der Frage nachgehen, wie viel bzw. wie wenig Raum zum Leben
nötig ist. Die Arbeiten begannen im Sommer 2008. Verbaut wurden gewelltes,
galvanisiertes Eisen und Zedernholz. Die Holzrahmenkonstruktion wurde auf
einen Stahlträger montiert. Das Dämmmaterial besteht aus recycelter Baum-
wolle. Für die Wände und die Decke wurde innen Gelbkiefer, für den Boden
Bambus gewählt. Das Projekt nutzt Solarenergie und ist „als Wohnforschungs-
labor für künftige Studentengenerationen gedacht, die prüfen sollen, ob das
Projekt gelungen ist oder nicht, und seine Komponenten mithilfe verbesserter
Technologien gegebenenfalls weiterentwickeln".

———

Basant leur budget sur les 28,12 $ qu'Henry David Thoreau avait déboursés
pour les matériaux de construction de sa cabane au bord de l'étang de Walden
en 1845, 60 étudiants et leurs professeurs de l'université Texas Tech (Lubbock)
ont décidé de construire leur propre cabane durable pour 683,08 $, soit
l'équivalent contemporain de ce que Thoreau avait payé. Également inspiré par
le Cabanon du Corbusier (Roquebrune-Cap-Martin, 1949), le projet cherche à
créer un lien avec le site sur lequel il est construit tout en étudiant les besoins
d'espace minimaux pour vivre. Les étudiants ont commencé à y travailler
pendant l'été 2008 et ont choisi d'utiliser du fer galvanisé ondulé et du cèdre.
Une charpente en bois a été montée sur un cadre en acier et du coton recyclé
a servi d'isolant. À l'intérieur, les murs et les plafonds sont en pin jaune et les
sols en bambou. Ayant recours à l'énergie solaire, ils ont créé une cabane
destinée à servir de «laboratoire de recherches vivant pour les générations
d'étudiants à venir, qui testeront les réussites et les défauts du projet et en
actualiseront éventuellement les composants au fur et à mesure des progrès
technologiques ».

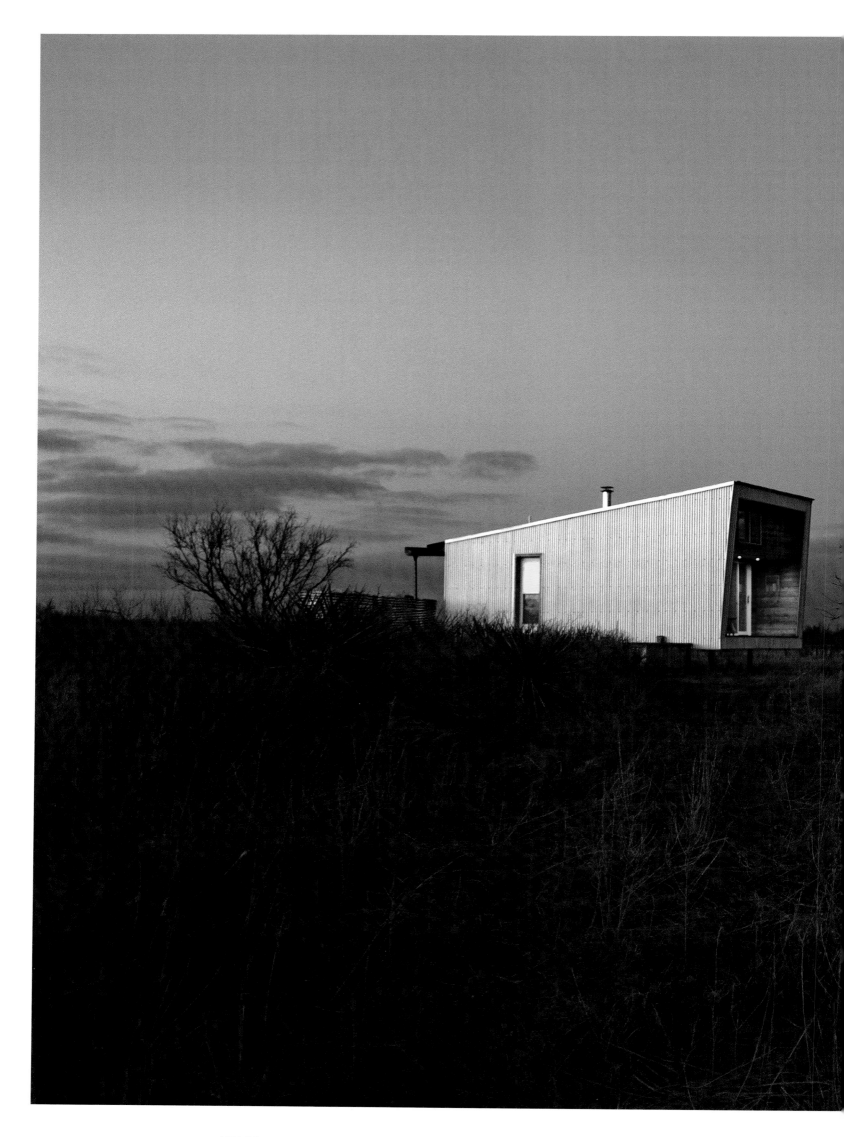

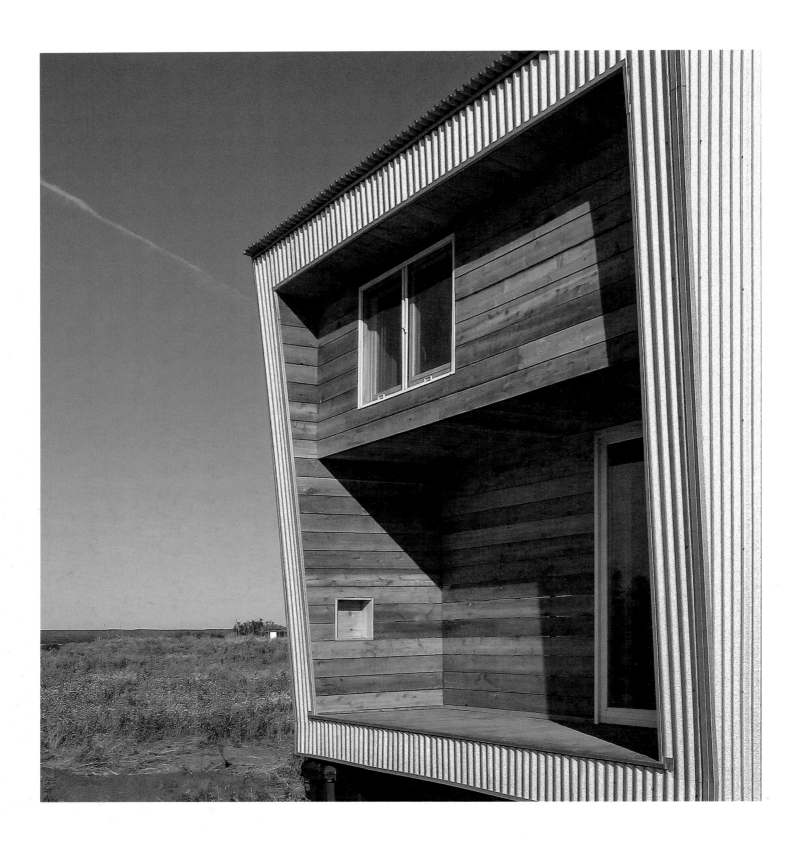

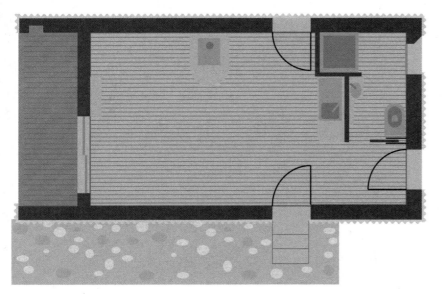

This cabin was designed and built as part of an interdisciplinary product-design elective at the College of Architecture, Texas Tech University, in Lubbock, Texas.

Diese Hütte wurde im Rahmen eines interdisziplinären Wahlpflichtkurses für Produktdesign am College für Architektur der Texas Tech University in Lubbock, Texas, entworfen.

La cabane a été créée et construite dans le cadre d'un projet interdisciplinaire optionnel de design produit au College of Architecture de l'université Texas Tech (Lubbock, Texas).

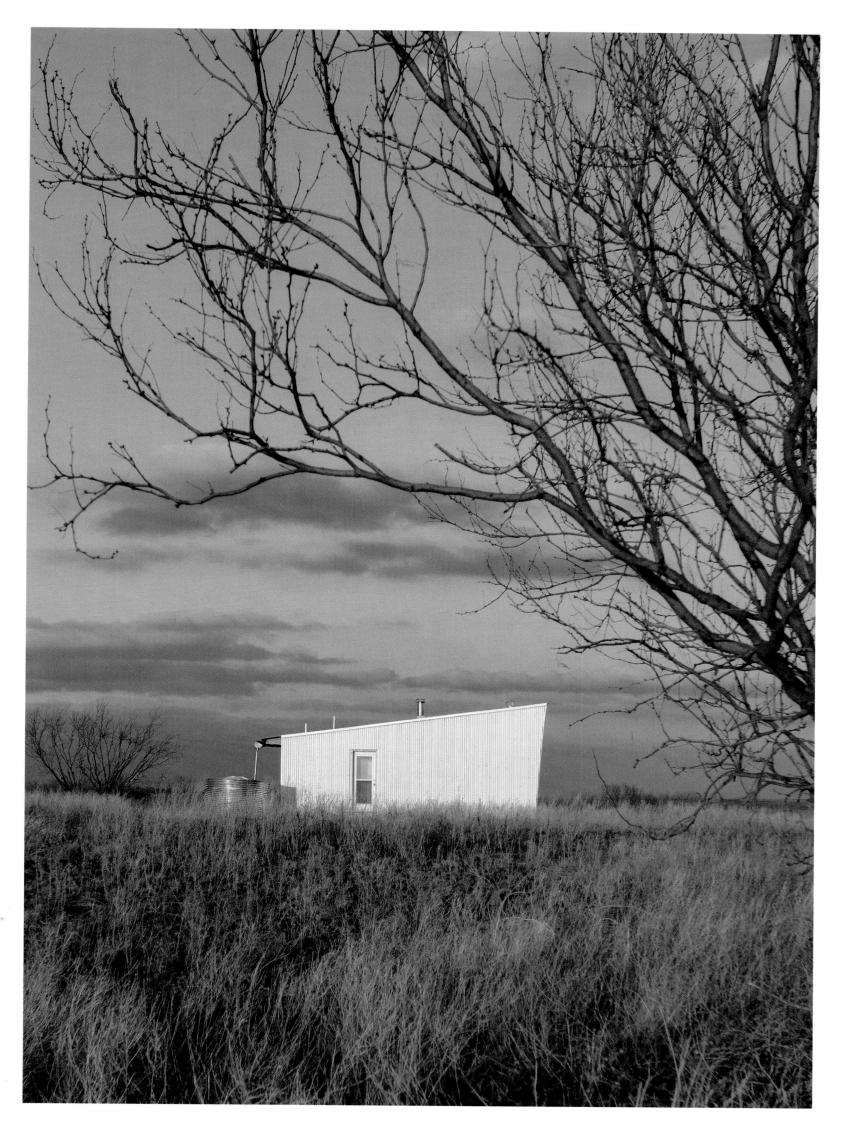

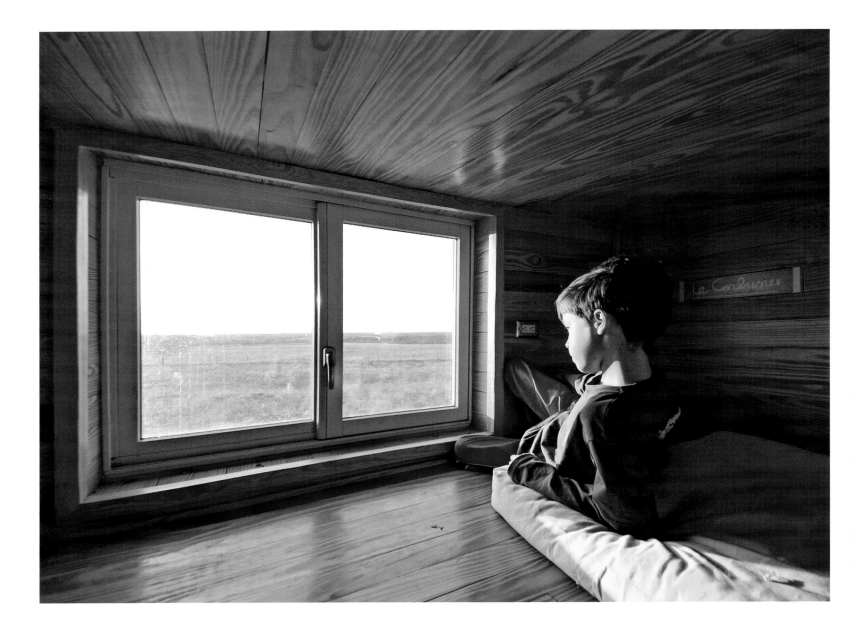

Urs Peter "Upe" Flueckiger writes: "Students at the sustainable lab exchanged the computer and the mouse for the nail and the hammer. They learned about the successes and the shortcomings of affordable/ sustainable design build through experience."

Urs Peter „Upe" Flueckiger: „Die Studenten des Sustainable Lab tauschten Computer und Maus gegen Nagel und Hammer und lernten durch eigene Anschauung etwas über das Gelingen und die Unzulänglichkeiten kostengünstigen/nachhaltigen Entwerfens und Bauens."

Urs Peter « Upe » Flueckiger écrit : « Les étudiants du Sustainable Lab ont échangé leurs ordinateurs et souris contre un marteau et des clous. Ils ont appris par eux-mêmes les réussites et les défauts de la conception et de la construction abordable/durable. »

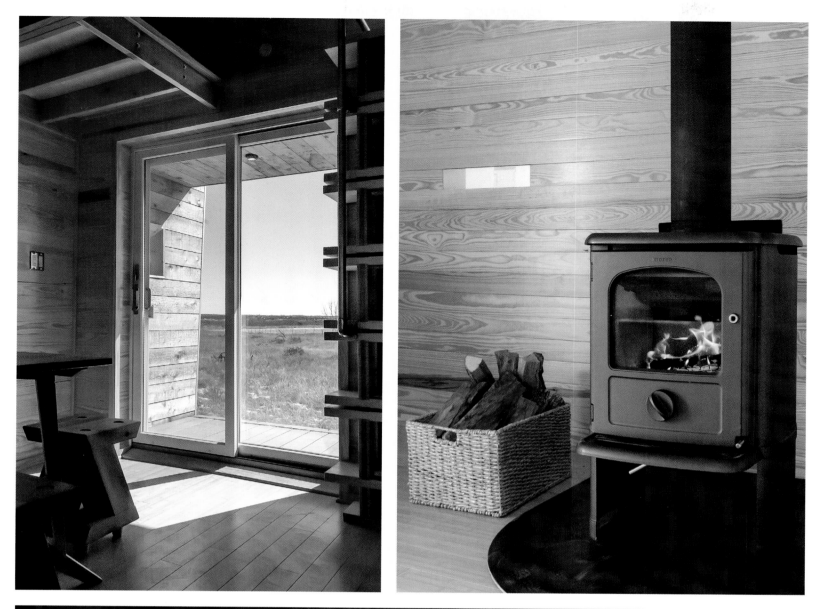

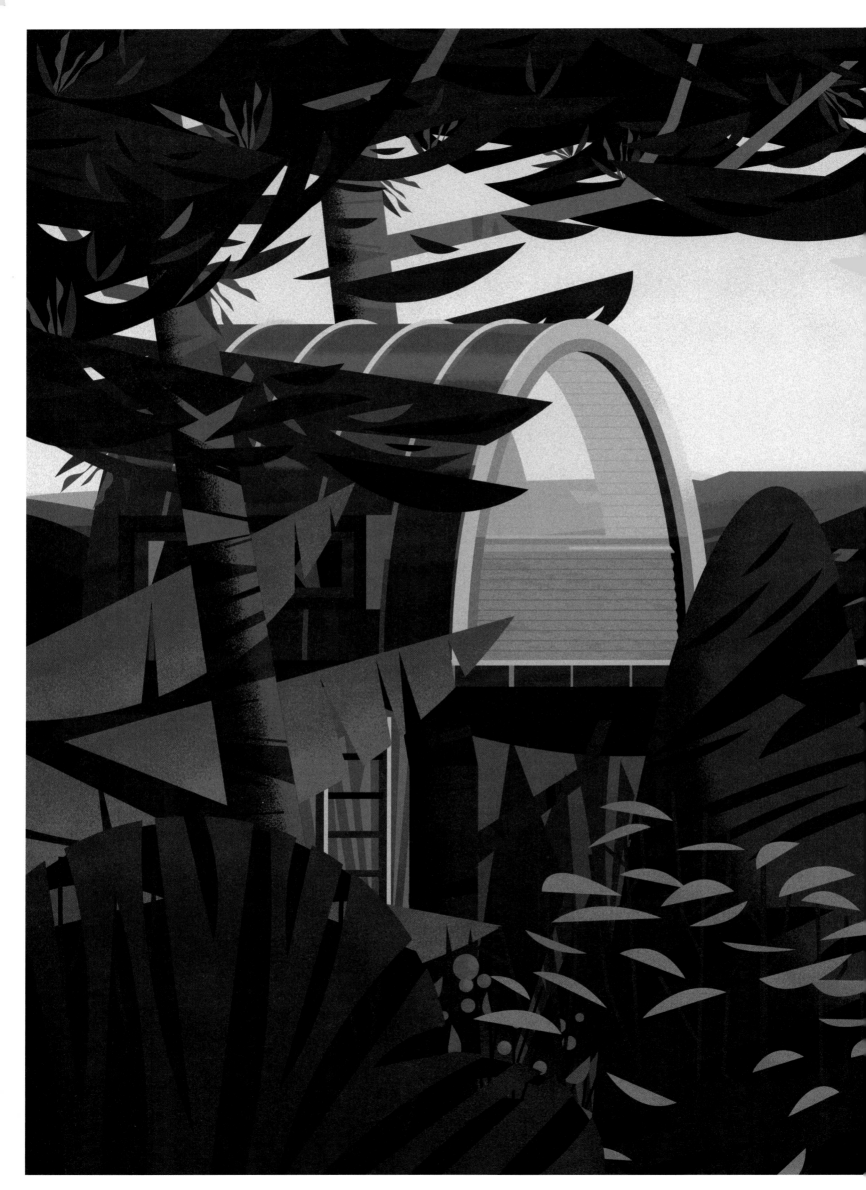

# TAU-NUSS TREE HOUSE

Area: 7.6 m² (interior), 9 m² (terrace)

Located near Frankfurt, Königstein is a residential area in the foothills of the Taunus Mountains. A number of houses in the area have large, mature trees in their yards. The clients of this tree house imagined a small refuge for their entire family, including three children, between pine and chestnut trees in front of their house. Connected to the house by a bridge from one of the children's rooms, the structure can also be reached through the garden via a hatch and a ladder. With the bridge anchored on the main house, the rest of the tree house is suspended from ropes, steel cables, and webbing in the two trees. The rounded form has an ashwood interior, with windows on all sides and a domed skylight. Glazed sheet steel, insulation and spruce boarding with a zinc roof form the basic structure.

———

Königstein ist eine Kleinstadt an den Hängen des Taunus unweit von Frankfurt. In den Gärten vieler Häuser in dieser Gegend befinden sich große ausgewachsene Bäume. Die Auftraggeber dieses Projekts wünschten sich in den Kiefern und Kastanien vor ihrem Haus einen Rückzugsort für die gesamte Familie, zu der auch drei Kinder gehören. Der Bau ist von einem der Kinderzimmer über eine Brücke oder aber vom Garten aus über eine Leiter und eine Luke zugänglich. Außer der Brücke, die am Haupthaus verankert ist, wurde das Projekt mit Seilen, Stahlkabeln und Gurtbändern von zwei Bäumen abgehängt. Die abgerundete Konstruktion ist innen mit Eschenholz verkleidet und hat Fenster auf allen Seiten sowie ein gewölbtes Dachfenster. Der Baukörper besteht aus Stahlblech, einer Fichtenholzverschalung, einem Zinkdach und Dämmung.

———

Königstein, près de Francfort, est une ville résidentielle au pied du Taunus. Beaucoup de maisons y ont de grands arbres anciens dans leur jardin. Les clients de cette maison dans les arbres ont imaginé un petit refuge pour toute la famille de trois enfants entre le pin et les marronniers qui poussent devant chez eux. Reliée à la maison par une passerelle depuis l'une des chambres d'enfants, la cabane est aussi accessible depuis le jardin par une échelle et une trappe. La passerelle est ancrée à la maison principale mais pour le reste, la maison dans les arbres est suspendue à des cordes, câbles d'acier et sangles dans les deux arbres. De forme arrondie, l'intérieur de la structure est en bois de frêne avec des fenêtres de tous les côtés et une lucarne dôme. Des tôles d'acier vernissé, des panneaux isolants en épicéa et un toit en zinc constituent la structure de base.

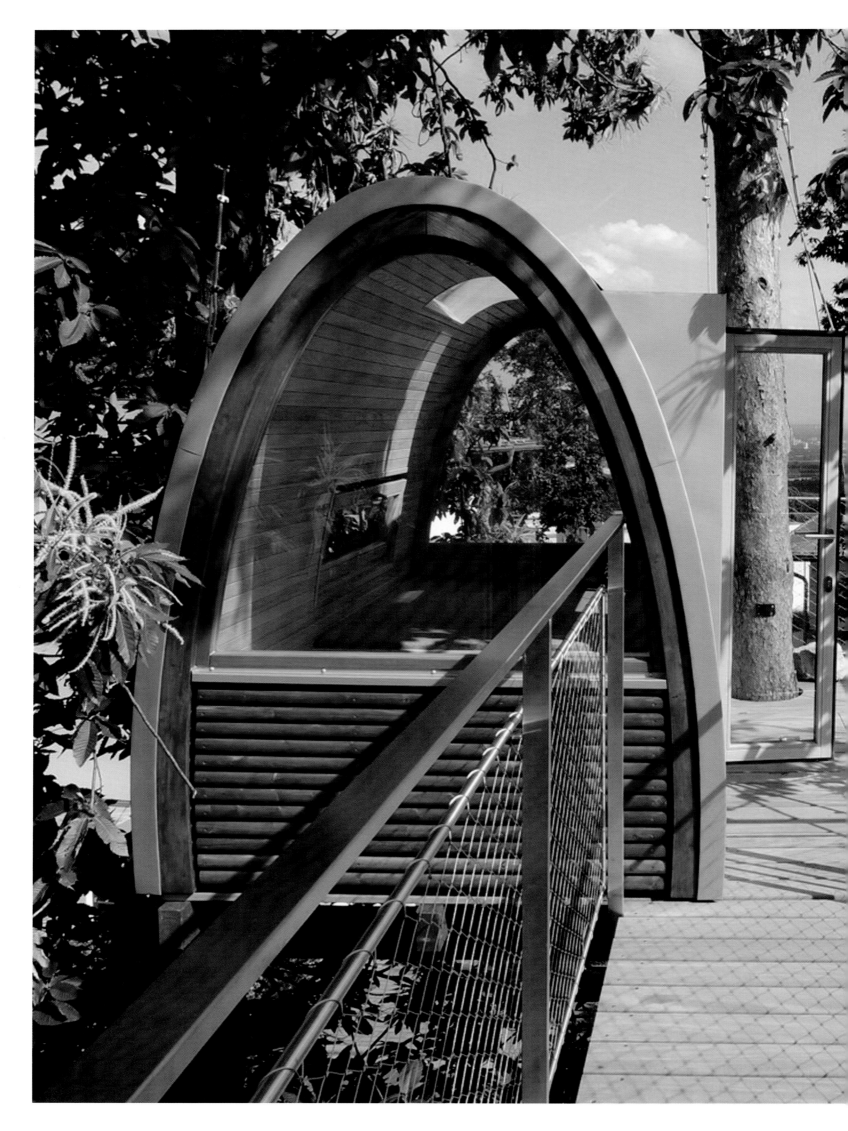

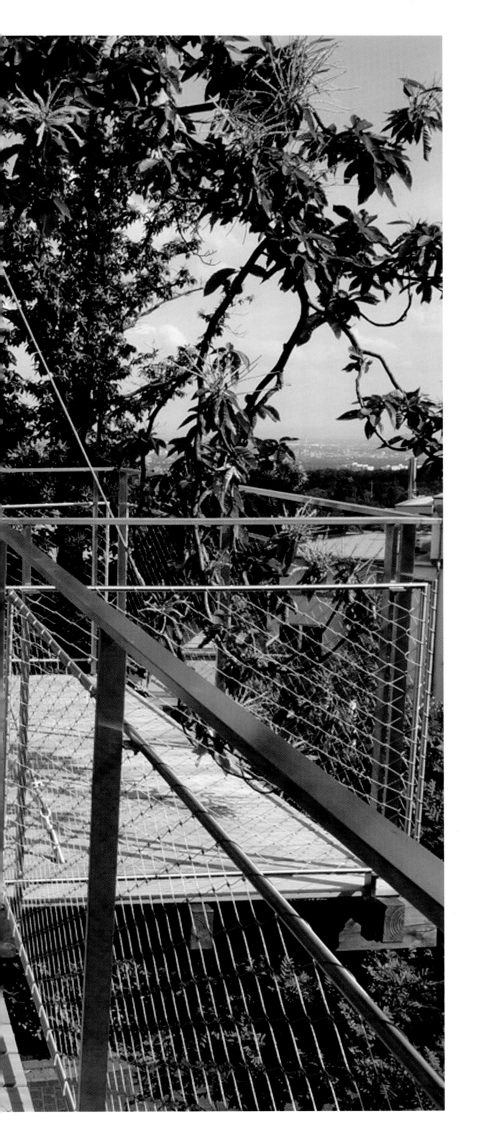

Although it is obviously integrated into its tree setting, the structure stands apart due to its form. It offers a protected view well off the ground while not harming its environment.

Obwohl es offensichtlich in einen Baum integriert ist, sticht das Haus wegen seiner Form hervor. Es bietet in einiger Höhe eine geschützte Aussicht, ohne die Umwelt zu beeinträchtigen.

Bien que naturellement intégrée aux arbres qui l'entourent, la forme de la construction lui confère une place à l'écart. Elle permet l'observation en toute sécurité bien au-dessus du sol sans nuire à son environnement.

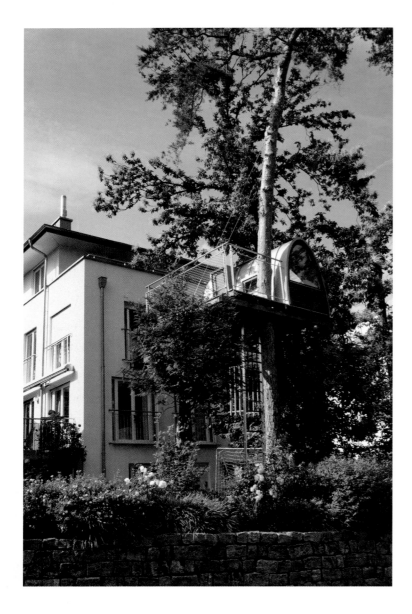

The Tau-Nuss Tree House is located next to a much more traditional residence, as the image to the left shows. To the right, however, the wooden environment with carefully selected openings contrasts completely with more "normal" architecture.

Wie im Bild links zu sehen befindet sich das Tau-Nuss Baumhaus neben einem sehr viel traditionelleren Wohnhaus. Der Holzinnenraum mit den sorgfältig platzierten Fenstern unterscheidet sich vollkommen von „gewöhnlicherer" Architektur.

La maison dans les arbres Tau-Nuss a été placée à côté d'une résidence plus traditionnelle, comme on le voit sur la photo de gauche. À droite cependant, le cadre en bois aux ouvertures disposées avec soin contraste totalement avec l'architecture plus « normale ».

Below, a plan shows the owner's house to the left, the approach bridge in the middle, and the square plan of the actual tree house on the right, with the bed in the upper right corner.

Auf dem Plan unten ist links das Haus des Eigentümers zu sehen, in der Mitte die Zugangsbrücke und rechts der quadratische Grundriss des Baumhauses mit dem Bett in der oberen rechten Ecke.

Ci-dessous, un plan montre la maison du propriétaire à gauche, la passerelle d'accès au milieu et le plan carré de la maison dans les arbres à droite, avec le lit dans le coin en haut à droite.

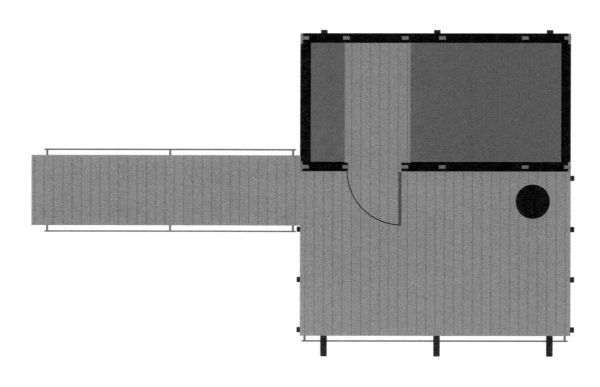

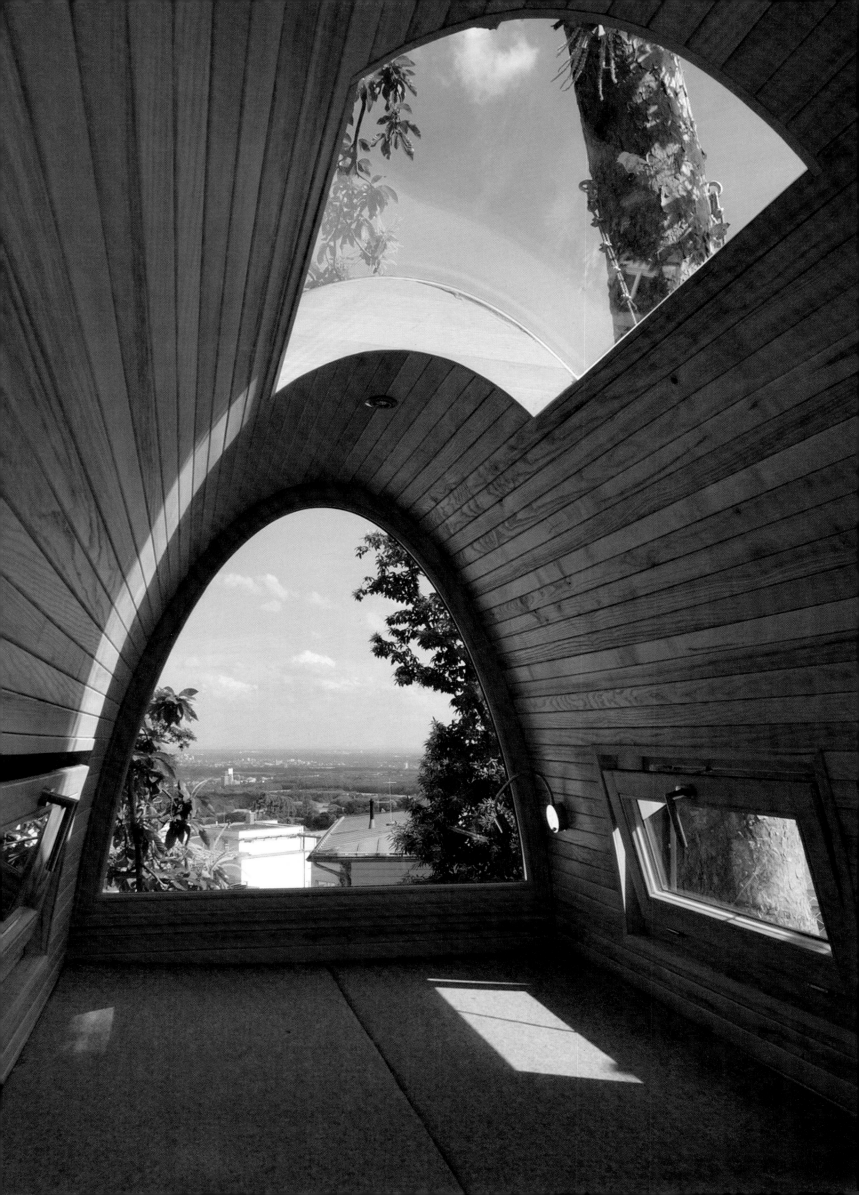

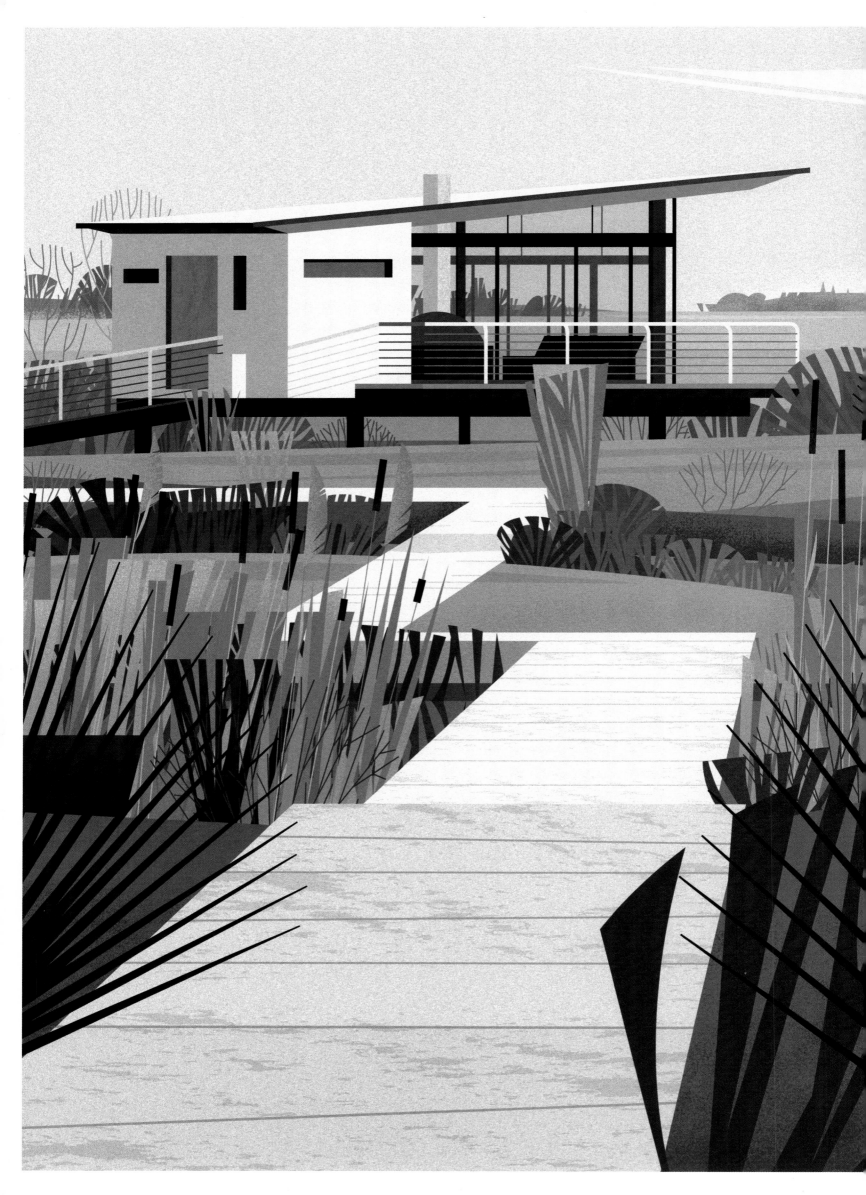

**AR DESIGN STUDIO**
Cotswolds [UK]
2002

# THE BOATHOUSE

Area: 81 m² | Client: Jeremy Paxton | Cost: $240 000

This cabin was conceived as a retreat from the nearby main house, an 18th-century converted barn. The architect explains: "The concept was that it should float over the lake and provide a quiet hideaway with calming views over the still water." The four-legged, steel-frame structure is set on concrete piles that were sunk into the lakebed. Traditional materials, including oak and slate, were used because of the rural setting, but the architect sought to maintain a "highly contemporary" construction and appearance. Sliding glass panels offer uninterrupted views of the natural setting while an overhanging roof was designed to provide ample shade.

———

Dieses Gebäude ist als Rückzugsort konzipiert und gehört zu einem in der Nähe gelegenen Haupthaus, einer umgebauten Scheune aus dem 18. Jahrhundert. Der Architekt erklärt: „Die Idee bestand darin, das Haus über dem See schweben zu lassen als stilles Refugium mit beruhigender Aussicht über das unbewegte Wasser." Die Stahlrahmenkonstruktion ruht auf vier Betonpfeilern, die in den Seegrund getrieben wurden. Aufgrund des ländlichen Standorts kamen traditionelle Materialien zum Einsatz, darunter Eiche und Schiefer. Dem Architekten war dennoch daran gelegen, eine „höchst zeitgemäße" Bauweise und Erscheinung zu bewahren. Glasschiebetüren gewähren einen freien Ausblick auf die Natur, während das überhängende Dach reichlich Schatten spendet.

———

La cabane a été conçue comme une retraite à l'écart de la maison principale à côté, une grange du XVIIIᵉ siècle reconvertie. L'architecte explique son concept : « L'idée était que la maison flotte sur le lac et forme un abri secret avec des vues apaisantes sur l'eau dormante. » La structure à quatre pieds et charpente d'acier est posée sur des piles de béton immergées au fond du lac. Les matériaux utilisés sont traditionnels, avec notamment du chêne et des ardoises, pour correspondre au cadre champêtre, mais l'architecte a malgré tout cherché à conserver une construction et une apparence « hautement contemporaines ». Des panneaux vitrés coulissants offrent des vues parfaitement dégagées sur la nature, tandis qu'un toit en surplomb fournit de l'ombre en abondance.

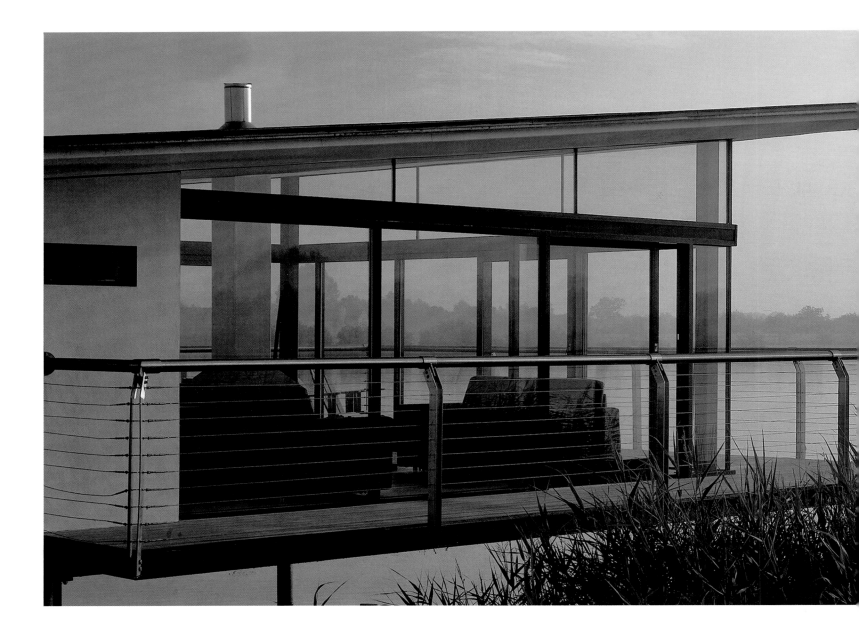

The building consists of a four-legged, steel-frame
structure sitting on concrete piles sunk into the
lakebed. Above, it seems to hover above the water
in the Cotswolds.

Das Gebäude besteht aus einer Stahlrahmenkonstruktion,
die auf vier in den Seegrund versenkten Betonsäulen
ruht. Auf dem Bild oben wirkt es so, als schwebe es über
dem See in den Cotswolds.

La structure à quatre pieds et charpente d'acier est
posée sur des piles de béton immergées. Ci-dessus,
elle semble flotter sur l'eau du lac des Cotswolds.

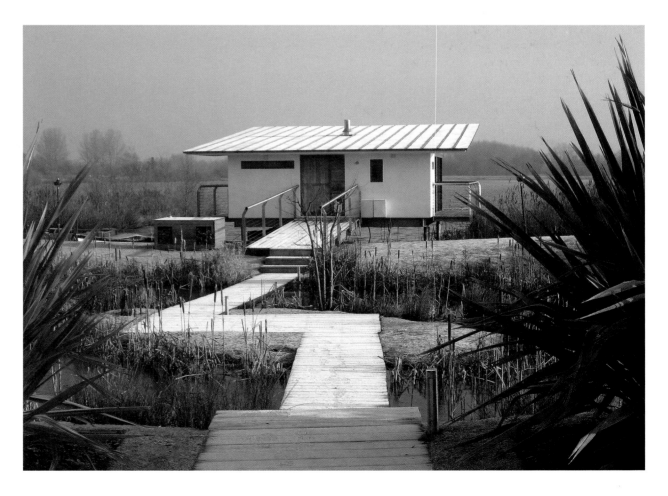

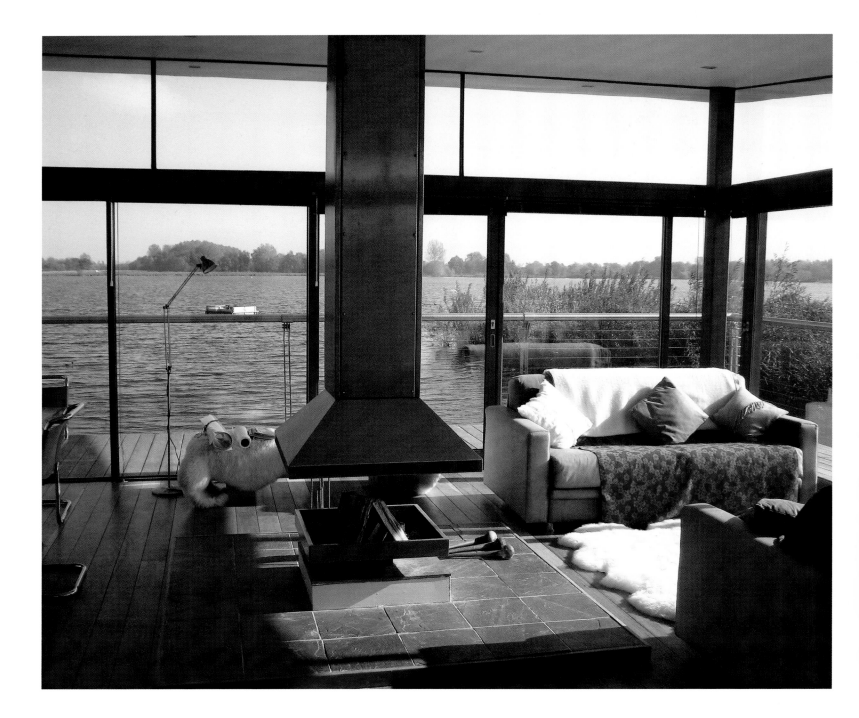

The architect writes: "The construction and appearance is highly contemporary, but the use of traditional materials such as neutral oak and slate acknowledges its rural setting."

Der Architekt: „Konstruktion und Erscheinung sind höchst zeitgemäß, aber die Verwendung traditioneller Materialien wie neutrales Eichenholz und Schiefer verbindet sie mit dem ländlichen Standort."

L'architecte écrit : « La construction et l'apparence sont hautement contemporaines, mais l'utilisation de matériaux traditionnels, avec notamment du chêne et des ardoises, correspond au cadre champêtre de la maison. »

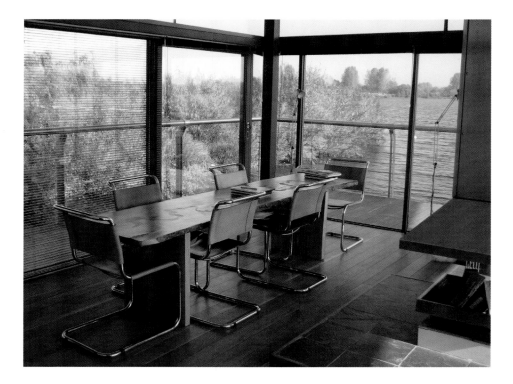

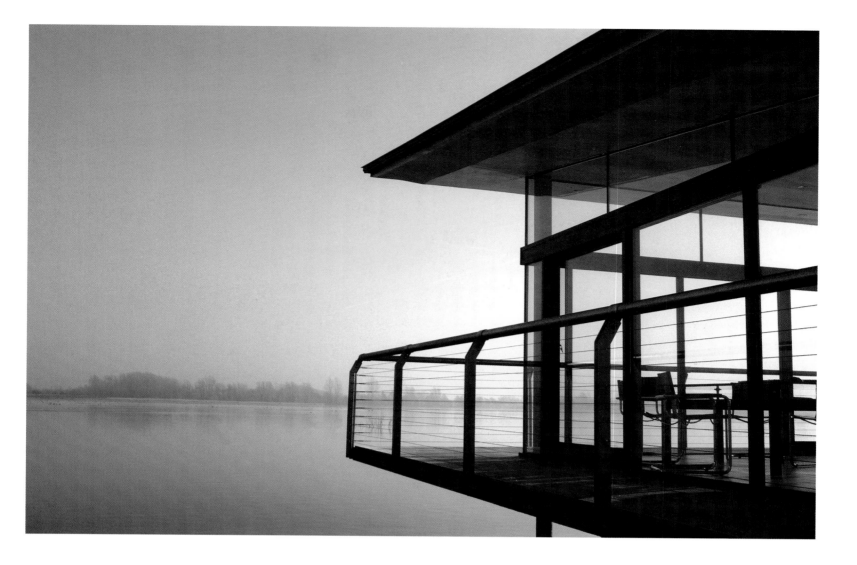

Sliding glass panels offer uninterrupted views of the water and surroundings while the overhang of the roof provides shade. The plan, below, reveals the structure's square form.

Glasschiebetüren gewähren einen freien Blick auf die Umgebung, während das überhängende Dach Schatten spendet. Der Grundriss unten lässt eine quadratische Form erkennen.

Des panneaux vitrés coulissants offrent des vues parfaitement dégagées sur l'eau, tandis qu'un toit en surplomb fournit de l'ombre. Le plan ci-dessous montre la forme carrée de l'ensemble.

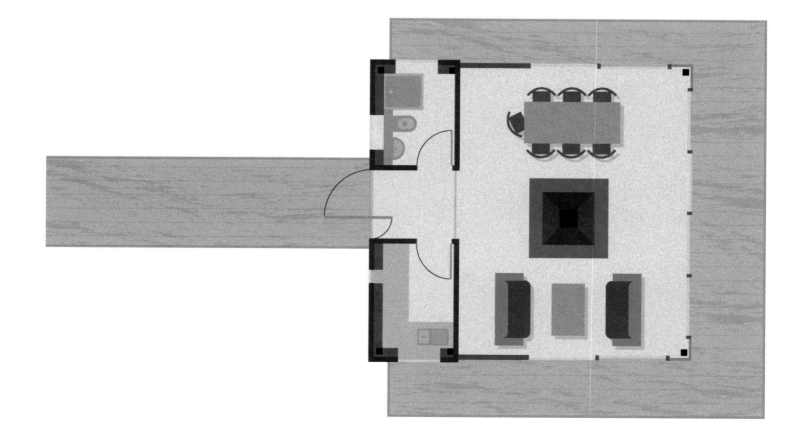

Hood Canal, Washington [USA]
2002–03

# TREE HOUSE ON HOOD CANAL

Area: 74 m² + 37 m² of deck | Clients: Alexandra Loeb and Ethan Meginnes
Collaboration: Ray Freeman III, Scott Lewis

Built as a weekend retreat, this cabin is in a ravine near the Hood Canal. It is set up on four large concrete columns and is accessed via a motorized stairway that can be lifted like a drawbridge when the owners are away. A corner window, nearly five meters high, offers views of the forest and canal. Cedar siding and fiber-cement panels are used for exterior cladding. Birch plywood panels are used inside, where a galvanized-steel stairway wrapped around a large concrete column leads to two sleeping lofts. The small kitchen has a copper counter that can be lowered to "dining height." A two-story bookcase and railings are made of maple wood.

———

Dieses Wochenendhaus liegt in einer Schlucht unweit des Hood Canal. Es wurde auf vier großen Betonsäulen errichtet und wird über eine motorisierte Treppe betreten, die wie eine Zugbrücke eingeklappt werden kann, wenn die Bewohner nicht da sind. Ein nahezu 5 m hohes Eckfenster eröffnet den Blick auf Wald und Kanal. Die Fassade besteht aus Zedernholzbrettern und Faserzementplatten, die Verkleidung im Innenbereich aus Birkensperrholz. Eine Treppe aus galvanisiertem Stahl windet sich um eine große Betonsäule zu den beiden Schlaflofts. Die kupferne Theke in der kleinen Küche kann auf „Esshöhe" herabgelassen werden. Die zweigeschossigen Bücherregale und das Geländer sind aus Ahornholz gefertigt.

———

Prévue comme refuge pour le week-end, cette cabane occupe un ravin à proximité du canal Hood. Perchée sur quatre larges colonnes de béton, on y accède par un escalier à moteur qui peut être relevé comme un pont levant lorsque ses propriétaires sont absents. Une fenêtre d'angle de presque 5 m de haut ouvre des vues sur la forêt et le canal. Le revêtement extérieur est en panneaux de cèdre et de fibrociment. À l'intérieur, les panneaux de bouleau contreplaqué dominent, avec un escalier en acier galvanisé qui entoure une large colonne de béton et mène à deux chambres lofts. Le comptoir de cuivre de la petite cuisine peut être abaissé à « hauteur table ». La bibliothèque haute de deux étages et les balustrades sont en érable.

Seen from below, the house appears to be completely surrounded by its natural setting, and yet it can be approached by car.

Von unten betrachtet scheint das Haus zwar vollständig von der Natur umgeben zu sein, es ist aber mit dem Auto erreichbar.

Vue depuis le bas, la maison semble entièrement entourée par la nature, elle est pourtant accessible en voiture.

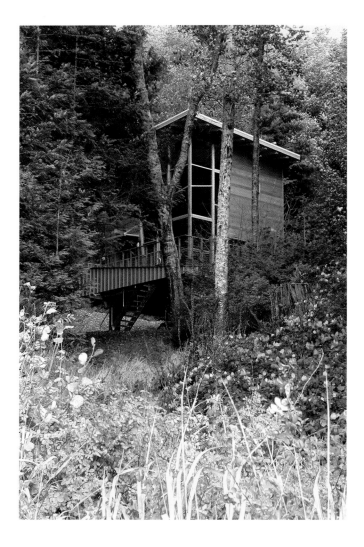

The plans below show the square form of the structure, marked by a retractable stairway and a five-me-ter-high corner window.

Auf den Plänen unten ist die quadratische Form des Baus zu erkennen, der sich durch eine einklappbare Zugbrücke und ein 5 m hohes Eckfenster auszeichnet.

Les plans ci-dessous montrent la forme carrée de la structure, marquée par un escalier rétractable et une fenêtre d'angle de 5 m de haut.

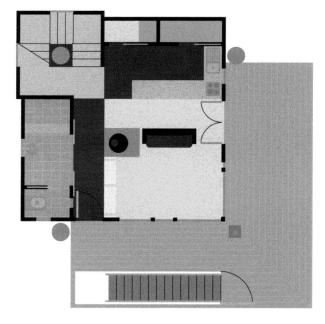

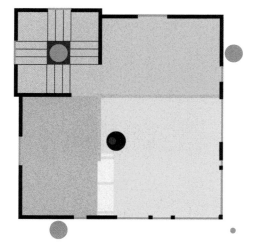

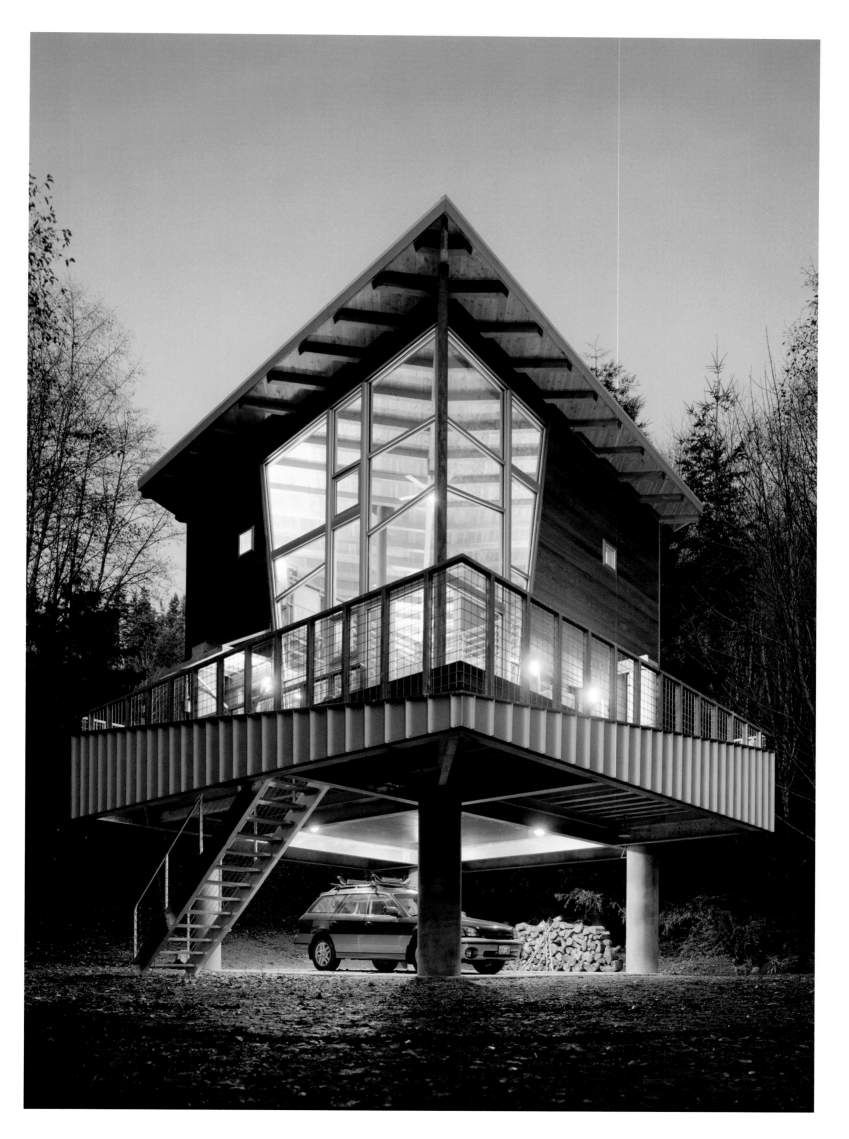

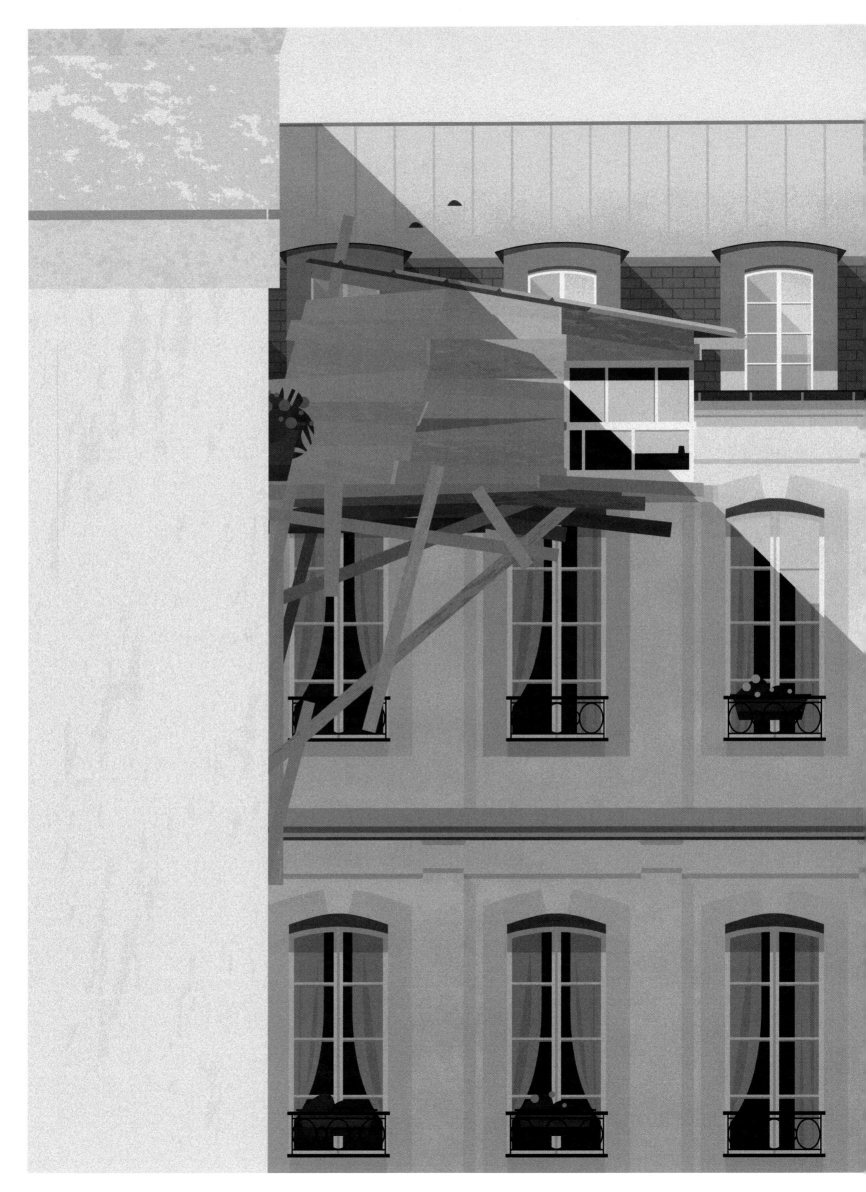

# "TREE HUTS IN PARIS"

Since 2008, Tadashi Kawamata has installed a good number of his temporary "Tree Huts" in locations around Paris, or other cities, such as New York and Miami. In Paris, he did so in the Tuileries Gardens (2008), the Monnaie de Paris (2008), and the Centre Pompidou (2010), before his most recent installation at the Place Vendôme (2013). He compares these works to tribal huts, to the shelters of homeless people, or even to pigeon houses. Like cabins in more "natural" settings, these structures evoke refuge, but do so in a spirit of resolute contradiction with their urban environment. Whether on the Colonne Vendôme itself in the center of a very formal Parisian square, or on façades nearby, Kawamata's "Tree Huts" may also bring to mind bird's nests of a certain kind.

———

Seit 2008 hat Tadashi Kawamata verschiedene temporäre „Baumhütten" in Paris und anderen Städten installiert, darunter New York und Miami. Vor seiner jüngsten Installation am Place Vendôme (2013) waren seine Arbeiten im Jardin des Tuileries (2008), der Monnaie de Paris (2008) und dem Centre Pompidou (2010) zu sehen. Er vergleicht seine Arbeiten mit Stammeshütten, den Verschlägen von Obdachlosen oder gar Taubenhäusern. So wie Hütten in einem „natürlichen" Umfeld lassen auch diese Gebilde an eine Zuflucht denken, wenn auch in entschiedenem Widerspruch zu ihrer urbanen Umgebung. Kawamatas Baumhütten erinnern, egal ob auf der Colonne Vendôme mitten auf einem formal sehr strengen Pariser Platz oder an Fassaden, an Vogelnester.

———

Depuis 2008, Tadashi Kawamata a installé de nombreuses « huttes dans les arbres » temporaires à Paris ou dans d'autres villes comme New York et Miami. Il les a fait fleurir dans le jardin des Tuileries (2008), à la Monnaie de Paris (2008) et au Centre Pompidou (2010), ou encore, plus récemment, place Vendôme (2013). Il compare ses cabanes à des huttes tribales, des refuges pour sans-abris, ou même des pigeonniers. À l'instar des cabanes dans des décors « plus naturels », ces structures évoquent l'idée de refuge, mais dans un esprit de contradiction délibérée avec leur environnement urbain. Sur la colonne Vendôme, au centre d'une place parisienne très classique, ou sur les façades voisines, les « huttes dans les arbres » de Kawamata peuvent aussi faire penser à des nids d'oiseaux.

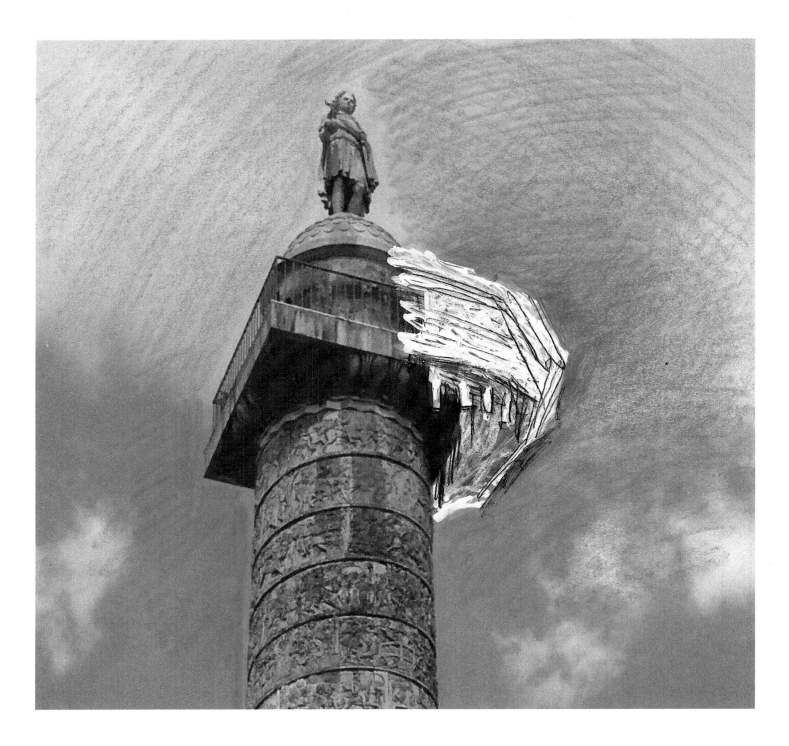

Perched on the column in the Place Vendôme in Paris,
Kawamata's Tree Hut is not meant to be a place to stay,
but rather an incongruous, almost haphazard presence
in the sophisticated heart of Paris.

Kawamatas an der Säule des Place Vendôme hängende
Baumhütte ist kein Wohnort, sondern eine mit dem Ort
unvereinbar, fast zufällig wirkende Erscheinung im
stilvollen Herzen von Paris.

Perchée sur la colonne de la place Vendôme, la hutte de
Kawamata n'est pas conçue pour rester, mais crée plutôt
une présence incongrue, presque là par hasard, au cœur
du raffinement parisien.

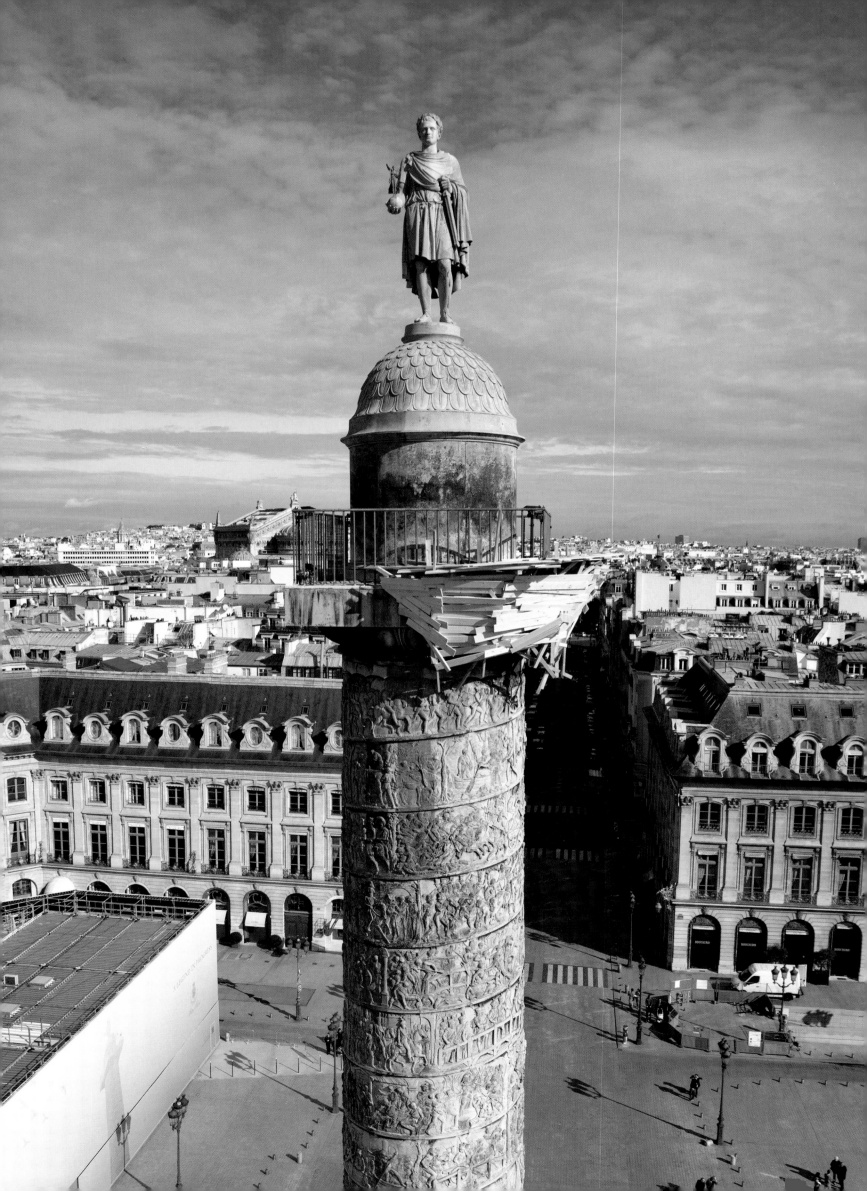

Other Tree Huts were built on the façade of the Centre Pompidou (left page), at the Monnaie de Paris (left), and in a private house in Paris (below).

Weitere Baumhütten entstanden an der Fassade des Centre Pompidou (linke Seite), an der Monnaie de Paris (links) und an einem Pariser Privathaus (unten).

D'autres huttes ont été aménagées sur la façade du Centre Pompidou (page de gauche), à la Monnaie de Paris (à gauche) et dans une maison particulière de Paris (ci-dessous).

Another location chosen by Tadashi Kawamata for his Tree Huts in Paris in 2008 was the centrally located Jardin des Tuileries.

Der zentral gelegene Jardin des Tuileries ist ein weiterer Ort in Paris, den Tadashi Kawamata im Jahr 2008 für eine Baumhütte auswählte.

Parmi les autres emplacements élus par Tadashi Kawamata pour ses huttes dans les arbres à Paris en 2008 figurait le jardin des Tuileries.

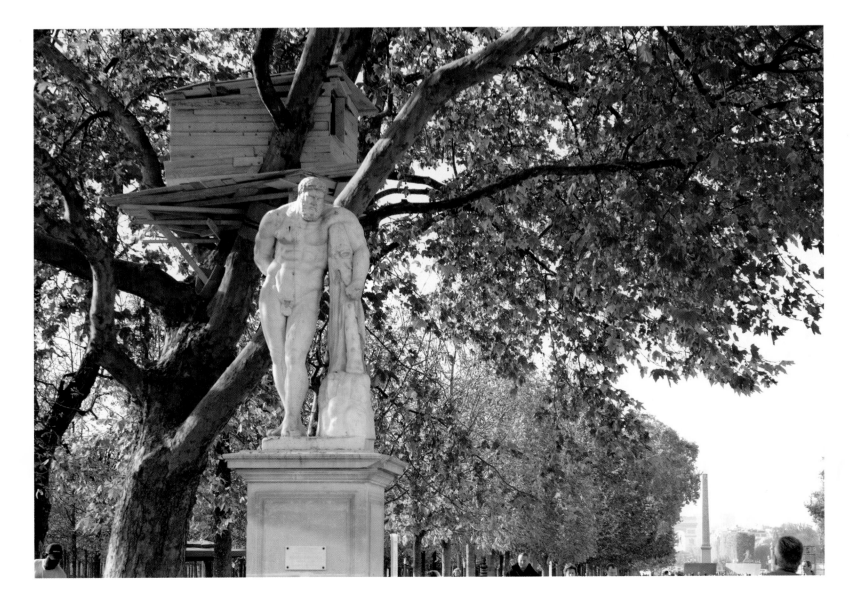

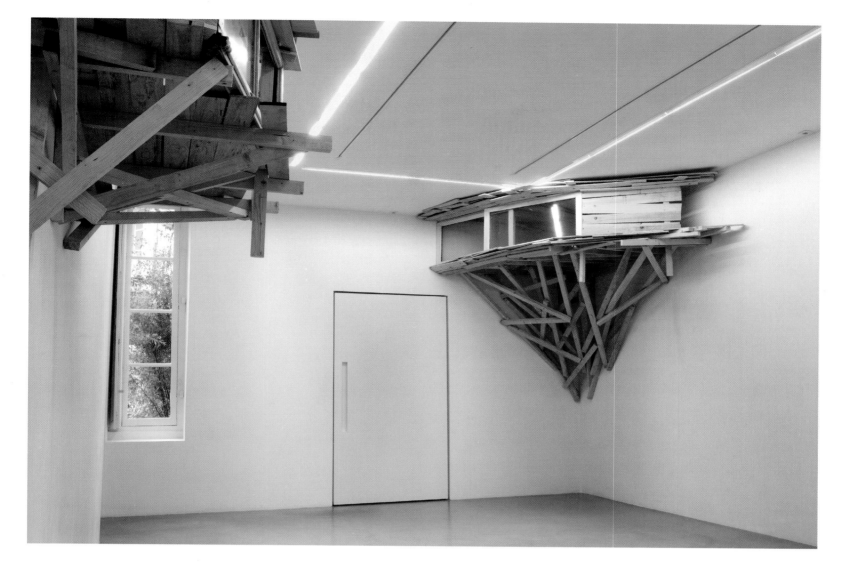

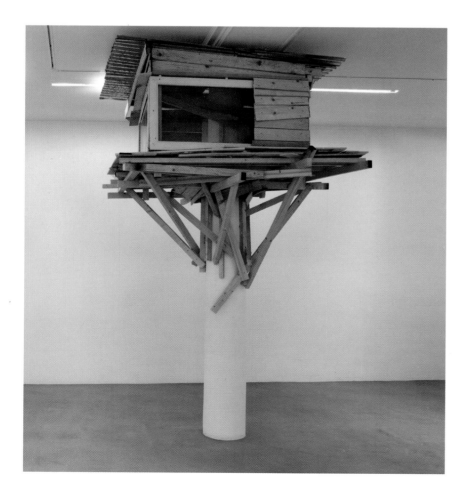

On this page, two images of the 2008 show on the same theme at the Kamel Mennour Gallery in Paris.

Diese Seite zeigt zwei Bilder aus einer Ausstellung 2008 zum diesem Thema in der Galerie Kamel Mennour in Paris.

Sur cette page, deux photos de l'exposition sur le même thème à la galerie parisienne Kamel Mennour.

**RA**
Pedras Salgadas [Portugal]
2013

# TREE SNAKE HOUSES

Area: 27 m² (66 m² with bridge) | Client: Unicer | Cost: €90 000

Developed in collaboration with the Modular System Company, the Tree Snake Houses are part of the Pedras Salgadas Park by the architects Luís Rebelo de Andrade and Tiago Rebelo de Andrade. The architects explain: "The idea was to create an object that would be far away from orthogonality and from preestablished concepts associated with modular construction." They imagined a snake gliding between the trees. Wood and slate were used as the main construction materials. The two Tree Snake Houses were made with careful respect for the environment, using LED lighting systems, water reuse, and solar panels. Each house contains a studio with a bathroom and kitchen. The structures make reference, according to the architects, to "the primitive hut and the wild animal." It is imagined that these modular structures could be built in different locations with different climates.

———

Die Tree Snake Houses wurden von den Architekten Luís Rebelo de Andrade und Tiago Rebelo de Andrade in Zusammenarbeit mit der Modular System Company entwickelt und sind Teil des Pedras Salgadas Parks. Die Architekten erklären: „Die Idee war es, ein Objekt zu schaffen, das so wenig rechtwinklig und so weit von den üblichen Konzepten des modularen Bauens entfernt sein sollte wie möglich." Die Architekten stellten sich eine zwischen den Bäumen hindurchgleitende Schlange vor. Als Baumaterial wurden vor allem Holz und Schiefer verwendet. Beide Tree Snake Houses entstanden mit größter Rücksicht auf die Umwelt, verfügen über LED-Beleuchtung, eine Wasserwiederaufbereitungsanlage und Solarkollektoren. Jedes Haus ist mit einem Studioapartment samt Bad und Küche ausgestattet. Den Architekten zufolge spielen die Häuser auf „primitive Hütten und wilde Tiere" an. Die modularen Bauten sollen an Orten in unterschiedlichen Klimazonen errichtet werden können.

———

Développées en collaboration avec la Modular System Company, les maisons-serpents dans les arbres font partie du parc Pedras Salgadas aménagé par les architectes Luís Rebelo de Andrade et Tiago Rebelo de Andrade. Ils expliquent : « L'idée était de créer un objet qui serait loin de toute orthogonalité et de tout concept préétabli associé à la construction modulaire. » Pour cela, ils ont imaginé un serpent qui glisse entre les arbres. Les principaux matériaux de construction sont le bois et l'ardoise. Les deux maisons ont été réalisées dans le plus grand respect de l'environnement avec des systèmes d'éclairage à LED ou de récupération de l'eau et des panneaux solaires. Elles abritent chacune un studio avec une salle de bains et une cuisine. Leurs structures font référence, selon les architectes, à « la hutte primitive et l'animal sauvage ». Modulaires, elles ont été imaginées pour pouvoir être construites à différents endroits sous différents climats.

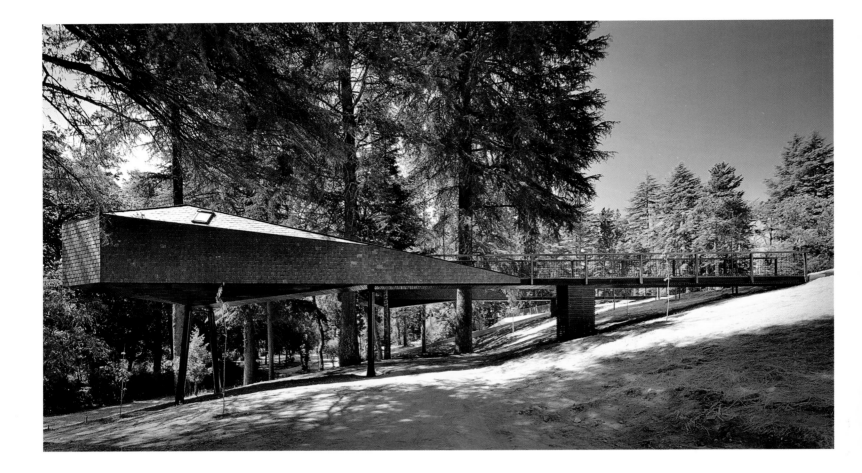

Despite the use of modular systems, the architects sought to create structures as far removed as possible from the preconceived idea of such methods. Though they are called "Tree Snakes," they also resemble boats in the trees.

Trotz modularer Bauweise wollten die Architekten Gebäude entwerfen, die sich möglichst weit von dem entfernen, was man sich gemeinhin unter dieser Methode vorstellt. Zwar heißen sie „Tree Snakes" (Baumschlangen), ähneln aber auch Booten.

Bien qu'ils aient utilisé des systèmes modulaires, les architectes ont cherché à créer des structures le plus éloignées possible de tout concept préétabli associé à la construction modulaire. Leurs maisons portent le nom de « serpents dans les arbres », mais rappellent aussi des bateaux.

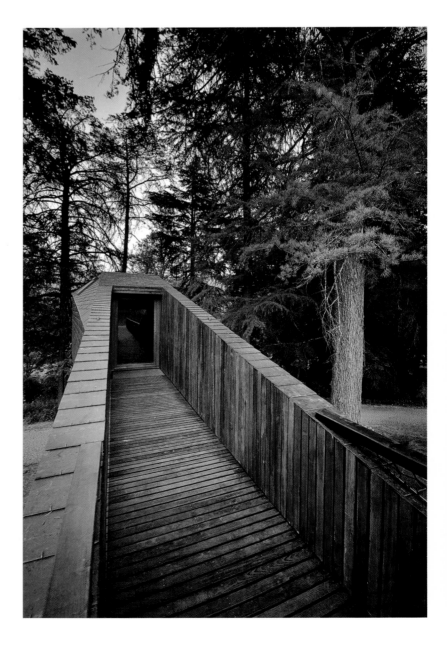

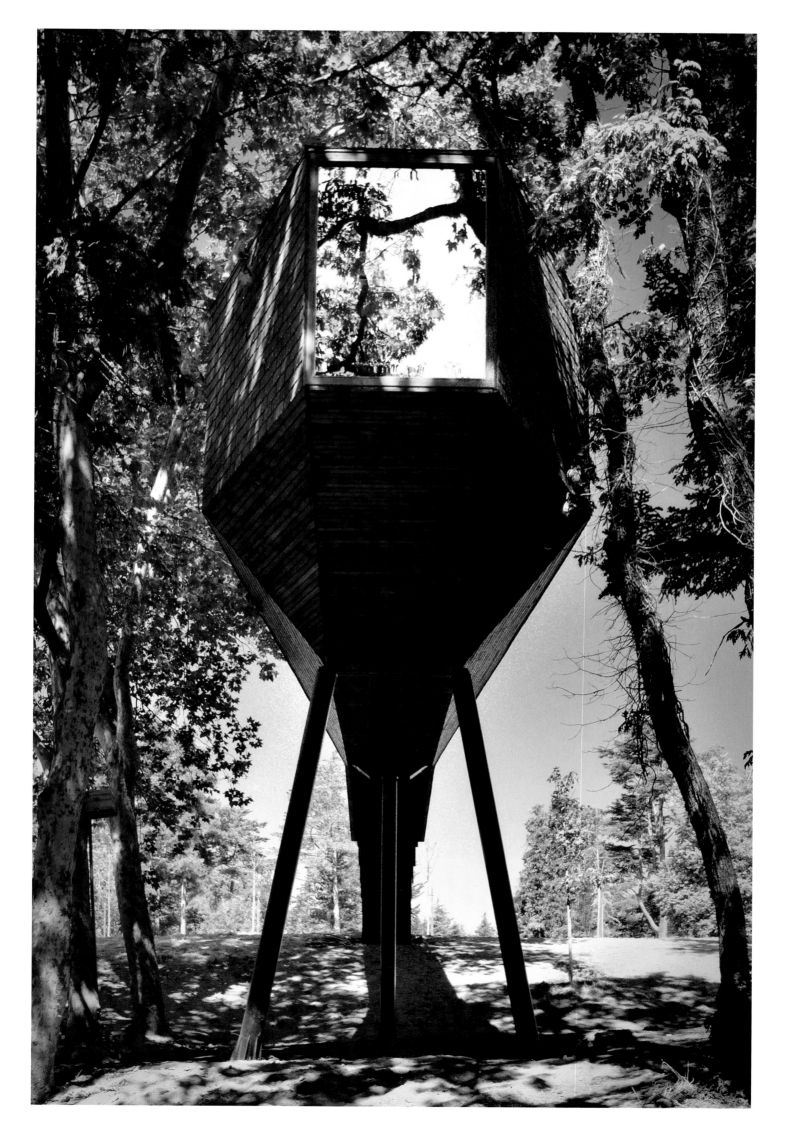

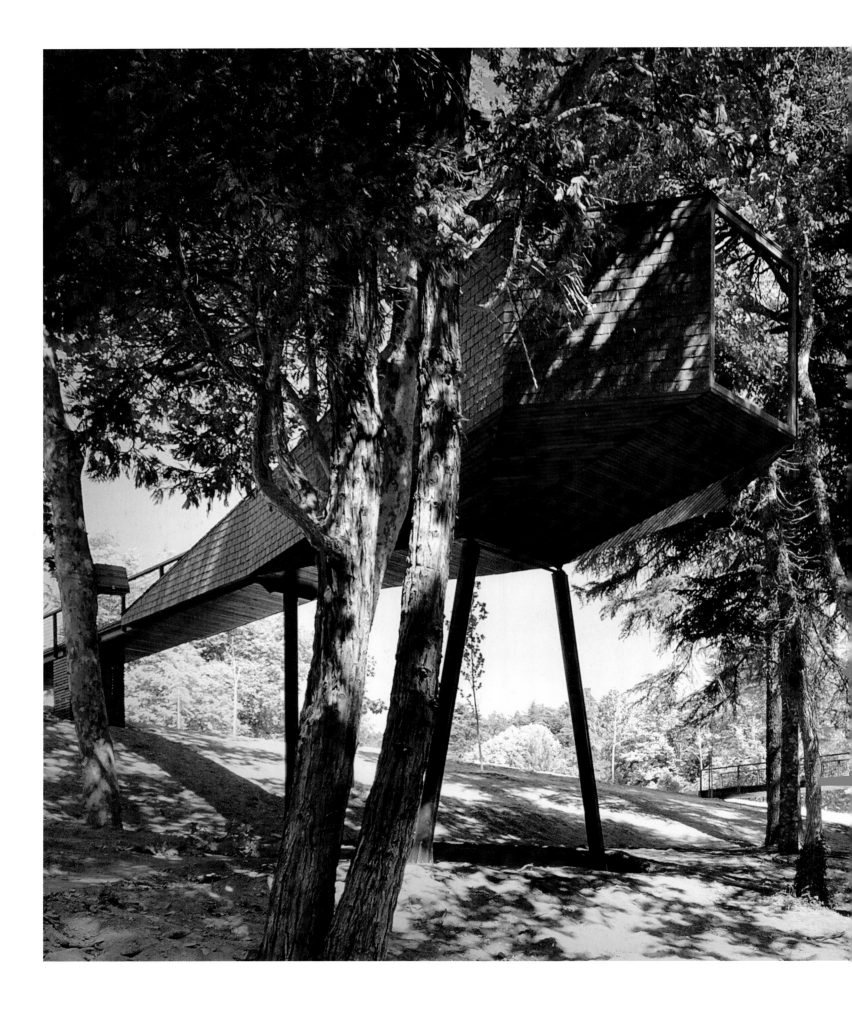

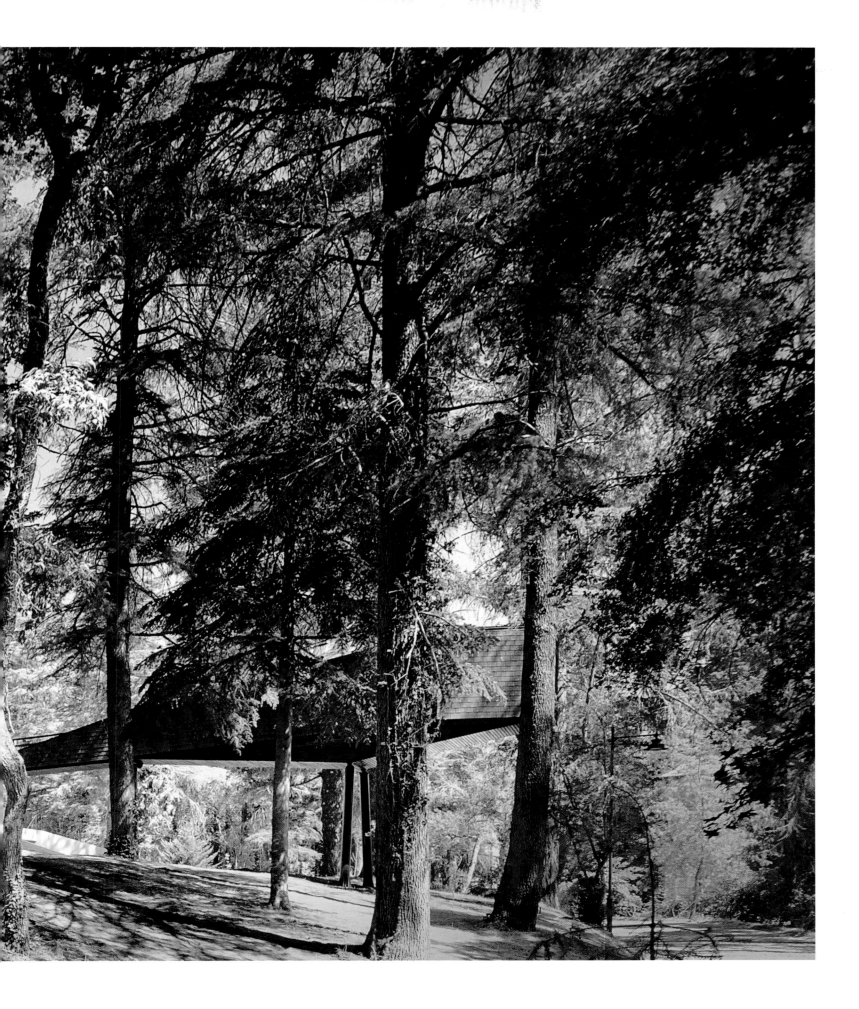

A long approach bridge becomes the "tail" of the "Snakes," whose shingled heads offer an enclosed space.

Der lange Zugangssteg wird zum Schwanz der „Snakes", deren schindelgedeckte Köpfe einen Raum umschließen.

Une longue passerelle d'accès forme la « queue » des « serpents » dont les têtes recouvertes de bardeaux renferment un espace clos.

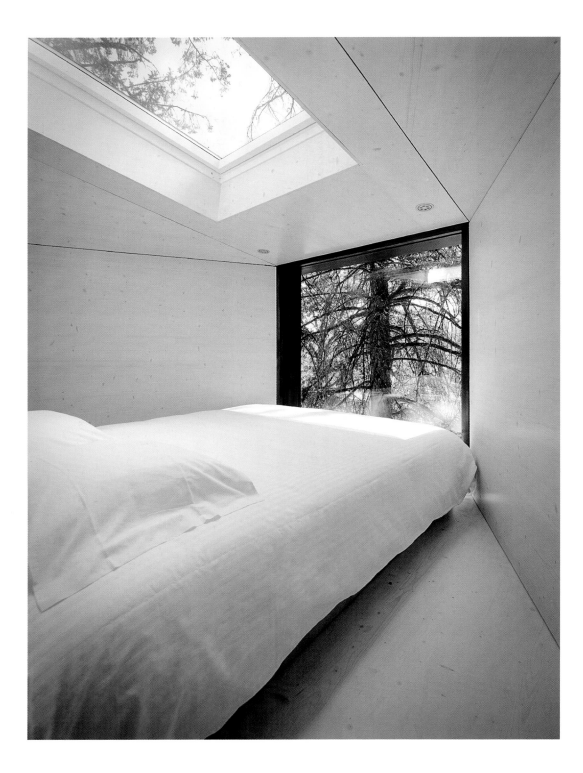

The interiors are narrow, as seen in the drawing to
the right. A bed is placed right next to a large window,
and beneath a skylight.

Der Innenraum ist schmal, wie die Zeichnung
rechts zeigt. Das Bett steht vor einem großen
Fenster und unter einem Oberlicht.

L'intérieur est étroit, comme on le voit sur le schéma
à droite. Un lit dispose d'une vue sur l'extérieur par une
grande fenêtre, mais est aussi placé sous une lucarne.

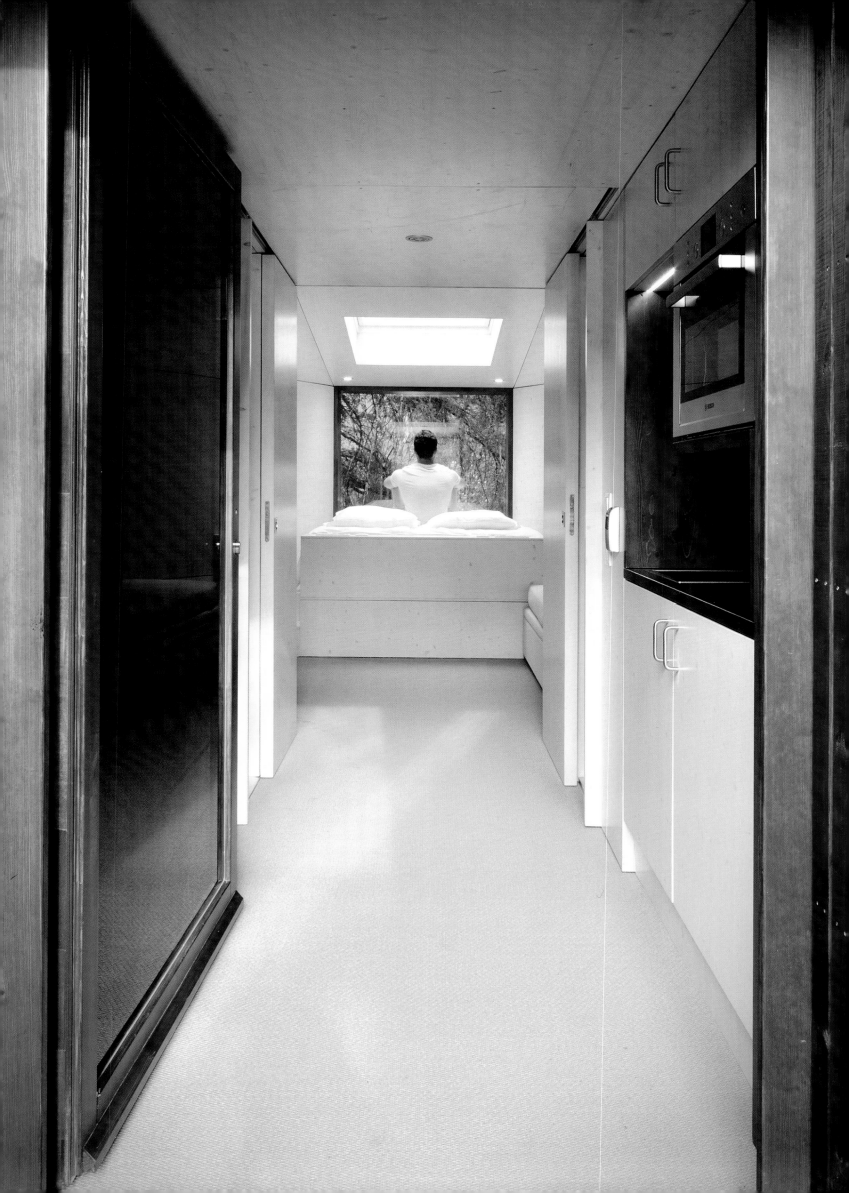

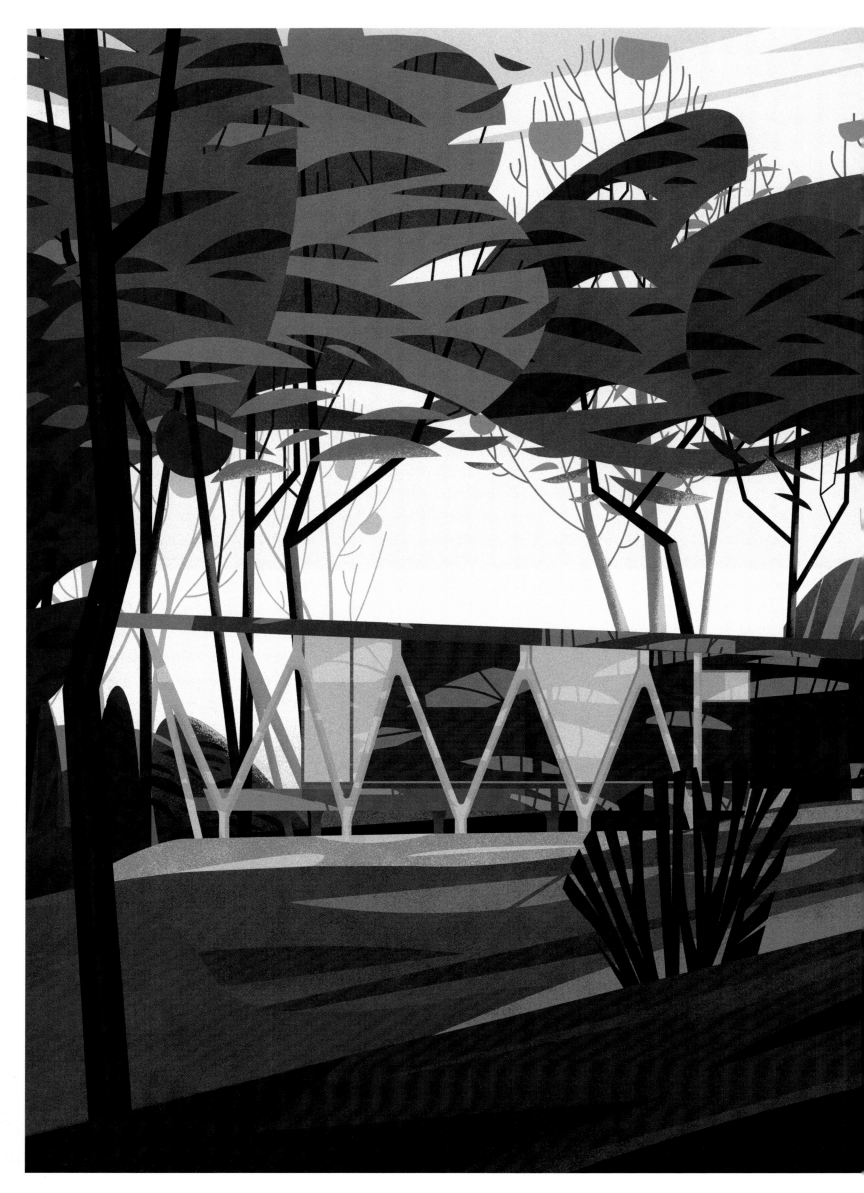

**PAUL MORGAN**
Central Highlands, Victoria [Australia]
2010–11

# TRUNK HOUSE

Area: 63 m² | Collaboration: Karsten Poulsen (Builder),
Mike Conole (Sculptor), SAALA (Landscape Design)

The architect planned this project with a question in mind: "How does one go into a forest and use the forms of the ecology to build a house?" The structure includes a living area, kitchen, bathroom, and two bedrooms. Inspired by the bones of kangaroos and sheep, the architect sought to use "tree forks or bifurcations as the structure for the cabin." These branches were added to straight columns with metal plates. An internal column with radiating beams is also part of the design. Wood used for lining was milled and cured on site. The architect states: "The design sought to achieve an almost transparent relationship with the surrounding forest, achieved through an eco-morphological transformation of remnant timber into structure. It developed the typology of the small Australian house, conflating it with the precedents of the primitive hut and the tradition of Aboriginal structures."

———

Der Architekt plante dieses Projekt vor dem Hintergrund der Frage: „Wie geht man in einen Wald und nutzt Formen des Ökosystems, um ein Haus zu bauen?" Das Projekt verfügt über einen Wohnbereich, eine Küche, ein Bad und zwei Schlafzimmer. Inspiriert von Känguru- und Schafknochen wollte der Architekt „Astgabeln für das Rahmenwerk des Hauses" verwenden. Diese wurden unter Verwendung von Metallplatten mit geraden Pfeilern verbunden. Eine Säule im Inneren, von der strahlenförmig Balken ausgehen, ist auch Teil des Entwurfs. Das für die Wandverschalung verwendete Holz wurde vor Ort gefräst und getrocknet. Der Architekt erläutert: „Der Entwurf sah ein Gebäude vor, das durch die ökomorphologische Verarbeitung von Holzresten ein fast transparentes Verhältnis zwischen Haus und Wald erzielt. Er entwickelt die Typologie kleiner australischer Häuser weiter und verbindet diese mit Vorläufern wie primitiven Hütten und der Bautradition der Aborigines."

———

Pour situer son projet, l'architecte pose une question : « Comment aller en forêt et utiliser les formes de l'écologie pour construire une maison ? » L'ensemble comprend un espace séjour, une cuisine, une salle de bains et deux chambres à coucher. L'architecte s'est inspiré des os de kangourous et de moutons et a cherché à utiliser « les fourches des arbres ou les embranchements en guise de structure ». Les branches en ont été adjointes à des colonnes droites au moyen de plaques de métal. L'ensemble comprend également une colonne centrale à poutres rayonnantes. Le bois qui recouvre les murs a été ouvré et séché sur place. L'architecte déclare : « Le design cherche à créer une relation presque transparente avec la forêt environnante, et ce par la transformation écomorphologique de débris de bois en structure. Il développe la typologie de la petite maison australienne qu'il fusionne avec les antécédents de la hutte primitive et de la tradition aborigène. »

With its wooden interior visible at the approach of nightfall, the house blends into the forest with reflections from its large glazed surfaces, but also because of the natural forked tree trunks that support part of the roof.

Bei Einbruch der Nacht wird das Haus mit seinem sichtbar werdenden Innenraum aus Holz, den großen reflektierenden Glasflächen und den natürlich gegabelten Baumstämmen, die einen Teil des Dachs tragen, eins mit dem Wald.

Avec son intérieur en bois visible à l'approche de la nuit, les reflets de ses grandes surfaces vitrées, de même que les troncs d'arbres en fourches qui portent une partie du toit, la maison se fond avec la forêt.

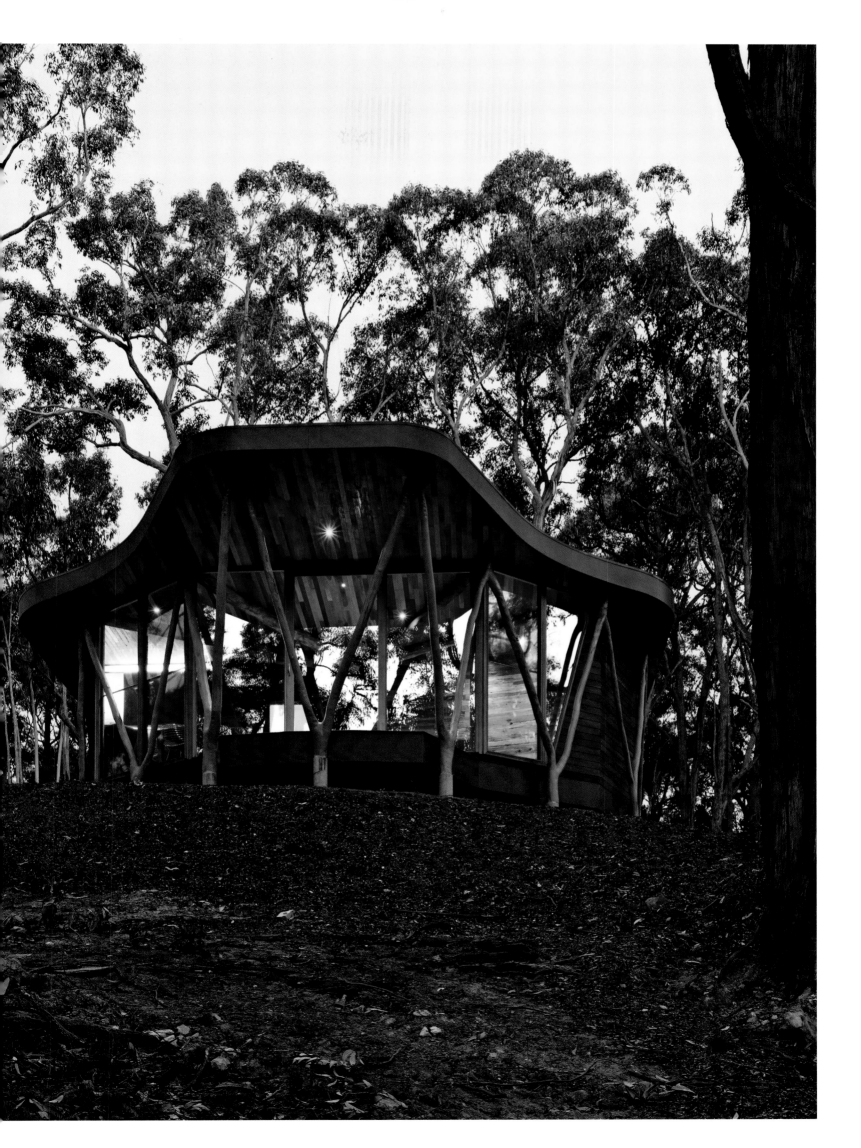

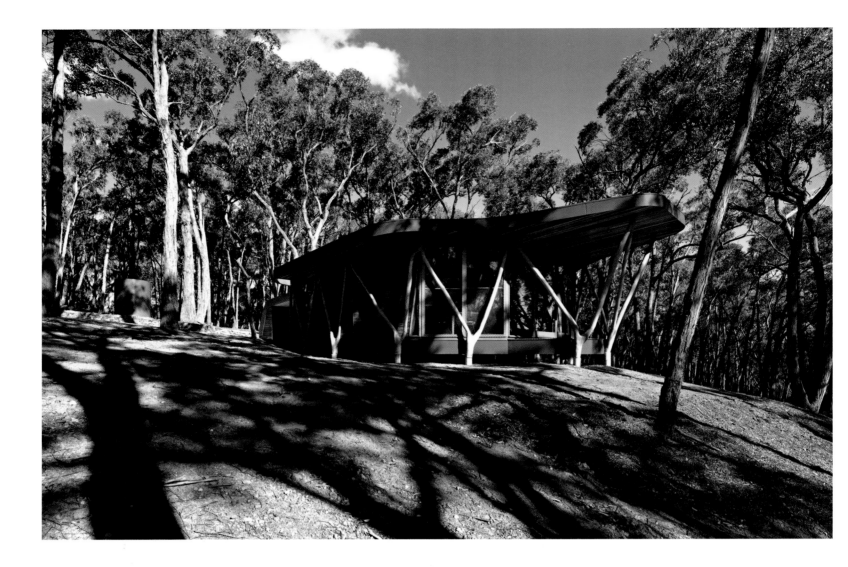

Sitting on its sloped hillside site, the house seems to have little connection with a more civilized or urban environment, but the drawing below shows space for a car.

Das Haus steht in abschüssiger Lage auf einem Hügel, anscheinend fernab von einem zivilisierteren bzw. urbanen Umfeld. Aber die Zeichnung unten zeigt einen Autostellplatz.

Posée à flanc de colline, la maison semble avoir peu à voir avec un environnement plus civilisé ou urbain, même si le schéma montre la place destinée à une voiture.

The house as seen in plan radiates out from a straight façade, forming the curved rear surface visible in most of the images published here.

Das Haus fächert, wie im Grundriss zu sehen, von der geraden Fassade ausgehend zu der hier in fast allen Abbildungen zu sehenden, geschwungenen Rückseite aus.

La maison vue sur le plan rayonne à partir d'une façade droite afin de former la surface arrière arrondie qu'on voit sur la plupart des photos publiées ici.

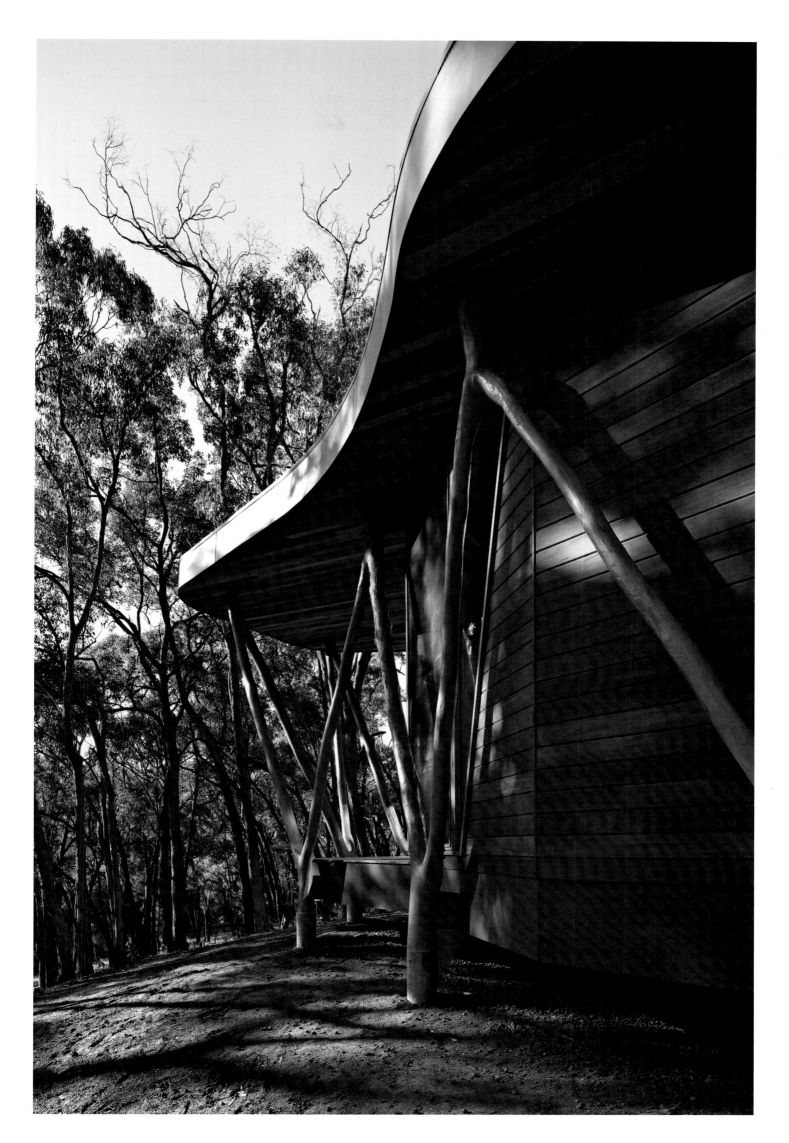

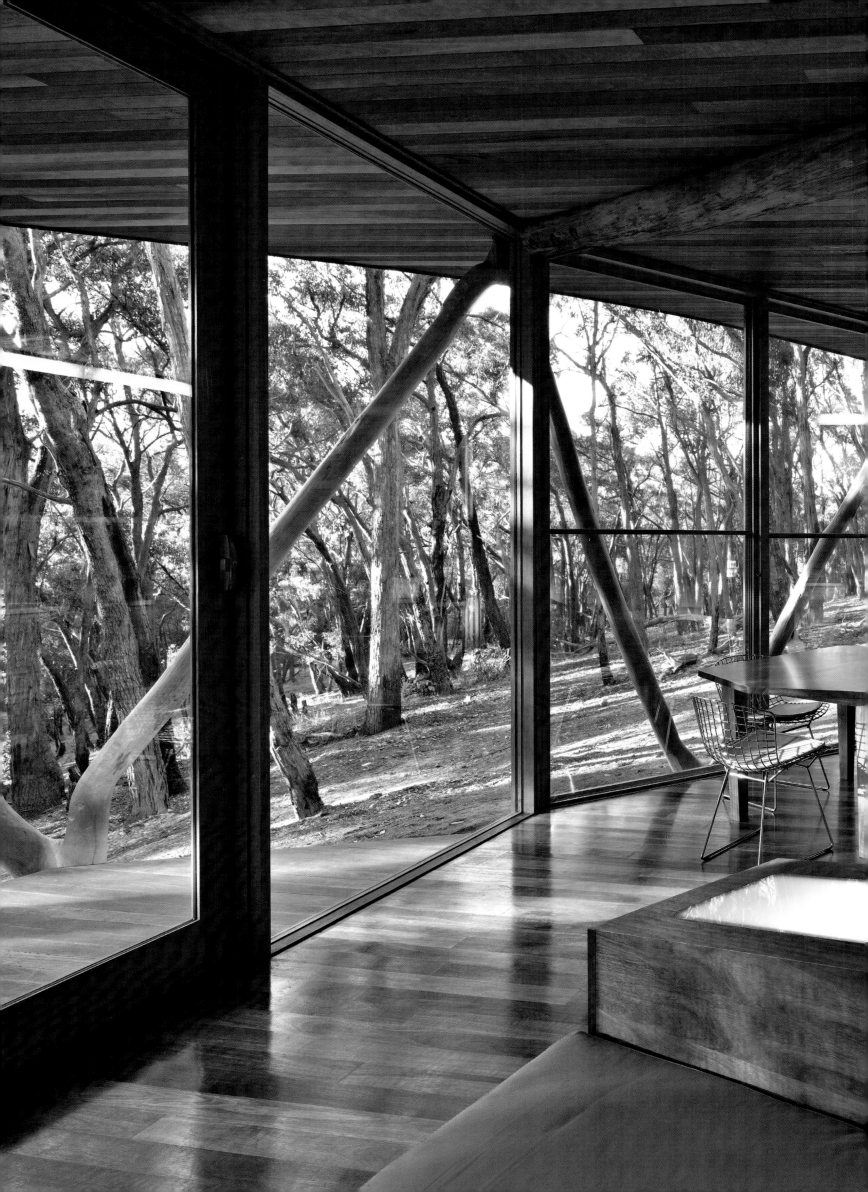

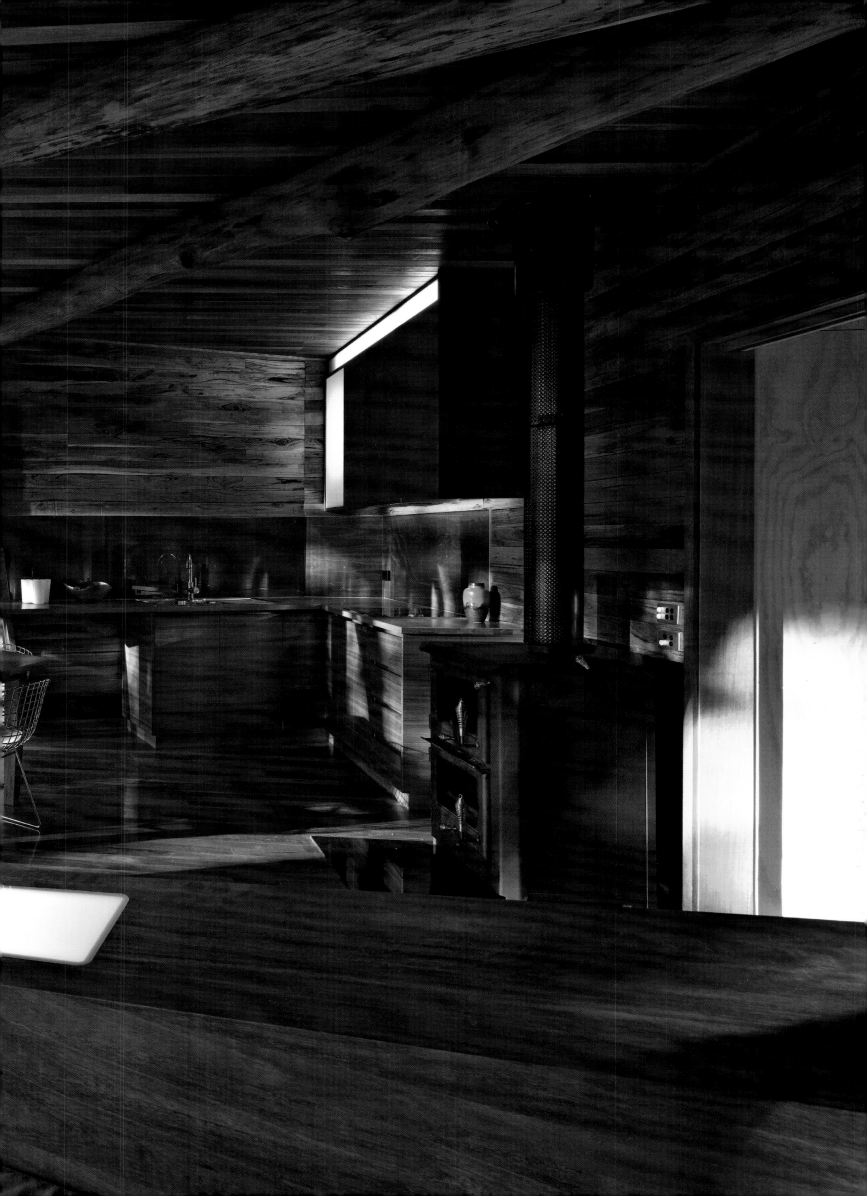

**OLSON KUNDIG**
Skykomish, Washington [USA]
2005

# TYE RIVER CABIN

Area: 116 m² | Collaboration: Kirsten R. Murray, Garin Schenk

Made with wood recovered from an old warehouse that was scheduled for demolition, pour-in-place concrete, and steel, this cabin is set on a 7.6-square-meter concrete base, with concrete patios adding to the small area of the cabin on the exterior. Pivoting glass windows as large as 2.4 x 2.4 meters swing open and an overhanging roof protects the living areas from rain. The cabin includes two small bedrooms and a bathroom. According to the architects: "Interior furnishings, as with the materials for the cabin itself, are warm in tone, yet minimalist. With time, the cabin will become more and more muted, eventually disappearing into the forest."

———

Für den Bau dieses Hauses wurde Holz verwendet, das aus einem zum Abriss vorgesehenen Lagerhaus geborgen wurde. Außerdem kamen Spritzbeton und Stahl zum Einsatz. Das Haus ruht auf einem 7,6 m² großen Betonsockel. Betonterrassen im Außenbereich vergrößern die kleine Grundfläche des Hauses. Die Hütte ist mit Schwingfenstern ausgestattet, die bis zu 2,4 x 2,4 m messen, ein überhängendes Dach schützt den Wohnbereich vor Regen. Im Haus gibt es zwei kleine Schlafzimmer und ein Bad. Die Architekten: „Wie auch das Material für den Hausbau selbst ist die Innenausstattung in warmen Tönen und zugleich minimalistisch gehalten. Nach und nach wird das Haus einen immer gedeckteren Farbton annehmen und schließlich im Wald verschwinden."

———

Construite en bois récupéré sur un vieil entrepôt promis à la démolition, béton coulé en place et acier, cette cabane repose sur une base en béton de 7,6 m², avec des patios en béton qui en agrandissent la surface réduite à l'extérieur. De grandes fenêtres pivotantes de 2,4 m x 2,4 m s'ouvrent et un toit en surplomb protège les espaces à vivre de la pluie. La cabane comporte deux petites chambres et une salle de bains, elle a recours à une pompe à chaleur géothermique pour chauffer l'intérieur. Selon les architectes : « Le mobilier intérieur, comme les matériaux de la cabane elle-même, ont des tons chauds, mais restent minimalistes. Avec le temps, la cabane va prendre une teinte de plus en plus sourde et finira par disparaître dans la forêt. »

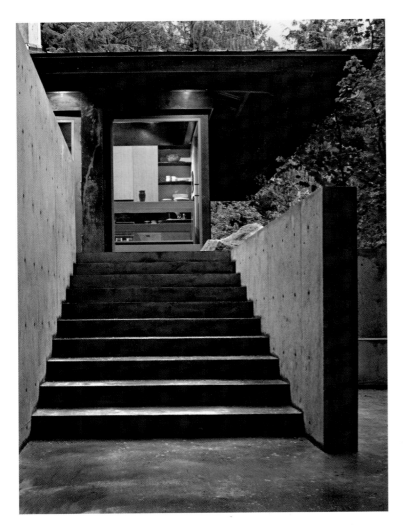

The house was built with salvaged wood, concrete, and steel. The central fireplace (below) "serves as the core and anchor for the cabin."

Das Haus wurde mit recyceltem Holz, Beton und Stahl gebaut. Der zentrale Kamin (unten) „ist Herz und Anker des Hauses".

La maison a été construite en bois récupéré, béton et acier. Le foyer central (en bas) « en est le cœur et l'ancrage ».

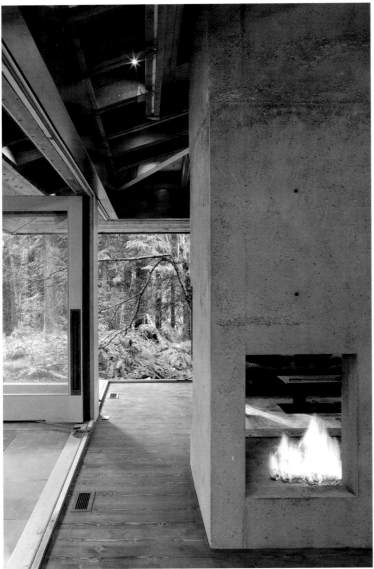

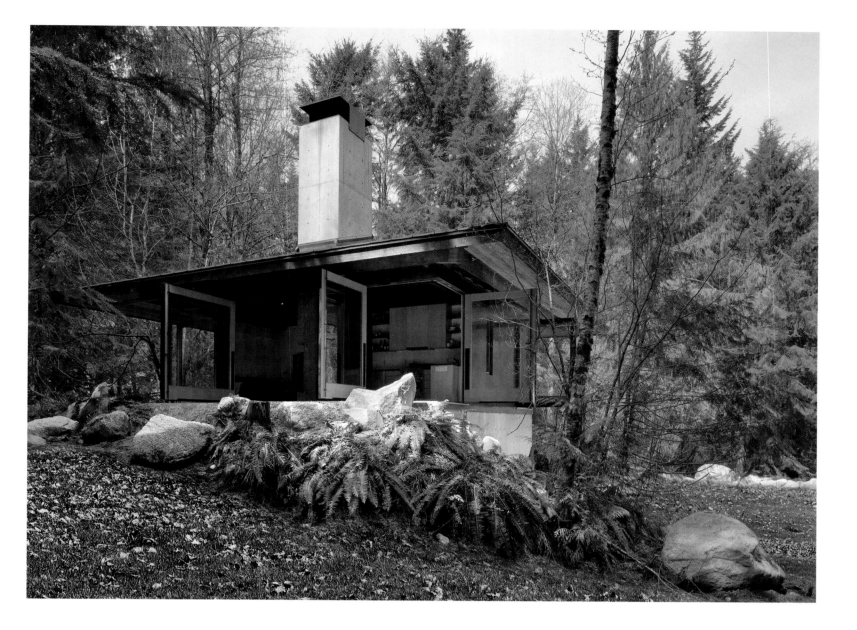

The plan of the house is a 6.4-meter square. Custom-designed, pivoting glass windows are up to 2.4-meters high and were made with salvaged wood.

Ein Quadrat mit 6,4 m Seiten-länge bildet den Grundriss des Hauses. Die Schwingfenster aus Recyclingholz sind Sonderanfer-tigungen und bis zu 2,4 m hoch.

Le plan est un carré de 6,4 m. Des fenêtres pivotantes spécialement conçues dont la hauteur atteint 2,4 m ont été réalisées en bois récupéré.

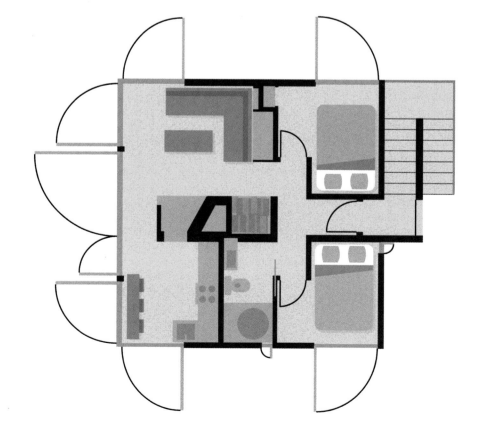

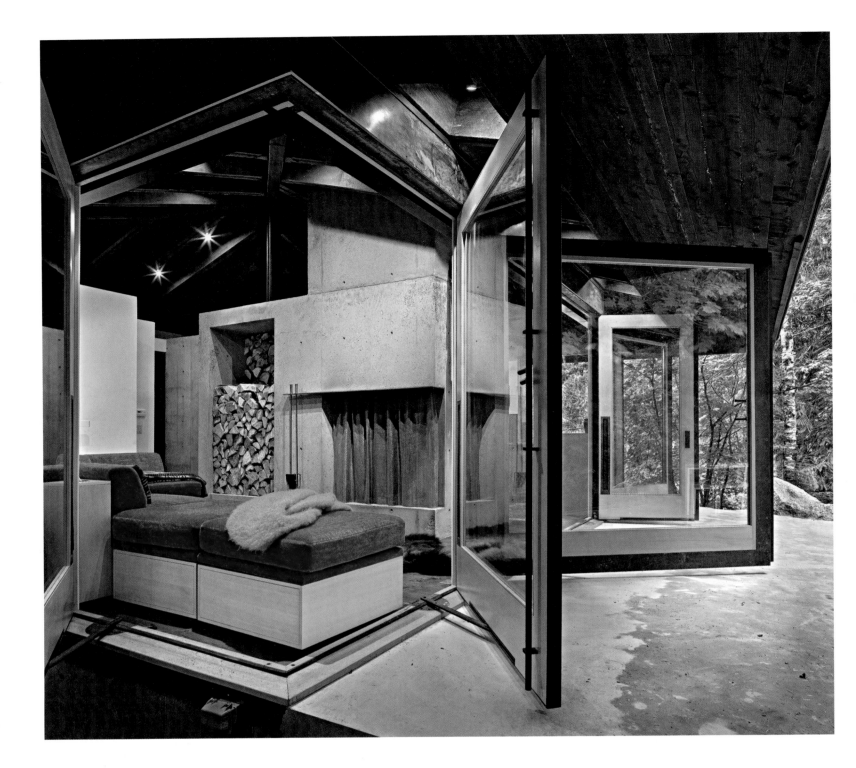

The wood used in the rafters, flooring, window frames, and doors came from an old warehouse destined to be demolished and shows its old, reused character, contrasting with such concrete surfaces as those seen to the right.

Das für Sparren, Boden, Fensterrahmen sowie Türen verwendete Holz stammt aus einem zum Abriss vorgesehenen Lagerhaus. Es lässt sein Alter und die vorherige Nutzung erkennen und hebt sich ab von den Betonoberflächen (rechts).

Le bois des chevrons, du sol, des encadrements de fenêtres et des portes vient d'un vieil entrepôt promis à la démolition, leur aspect ancien et réutilisé contraste avec les surfaces de béton comme celles que l'on voit à droite.

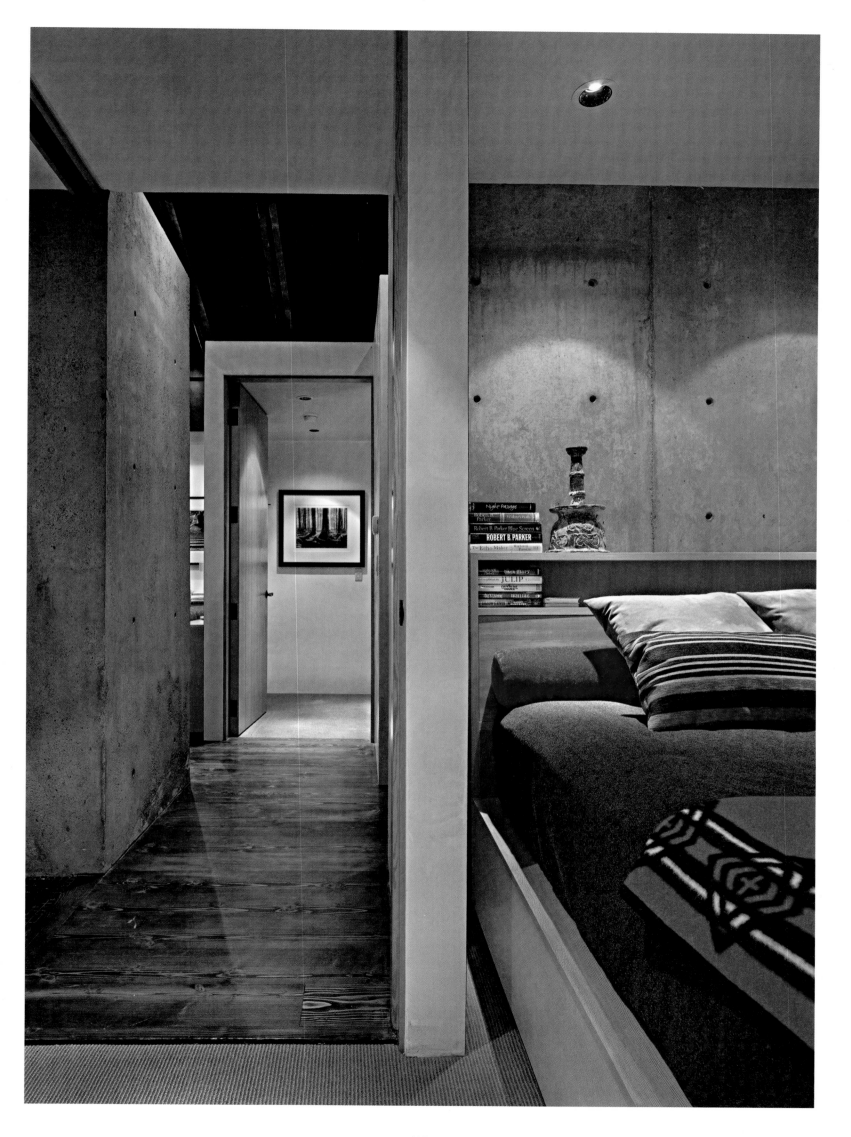

# VARDEHAUGEN CABIN

Area: 77 m² | Client: Matre/Aasarød Family | Cost: €222 000

Håkon Matre Aasarød was the designer of this cabin for his own family. It is located at Vardehaugen, an outcropping near the mouth of the fjord at Grøttingen on the Fosen Peninsula. The structure was built 35 meters above sea level in a small depression at the top of the outcropping, with a panoramic view. The architect explains: "The cabin is shaped in a pose similar to that of a mountain fox curling up to avoid the wind. The body of the building lies snugly by a low mountain ridge and embraces the polished rock furthest out on the property." A small annex defines an atrium and shelters outside spaces from the wind and cold. The black roof is folded in to become the wall of the most exposed surfaces of the cabin. At the entrance and near the living spaces, the rough, dark walls are replaced by horizontal, white cladding.

———

Håkon Matre Aasarød hat dieses Haus für seine Familie entworfen. Es liegt auf der Felszunge Vardehaugen unweit der Mündung des Fjords von Grøttingen auf der Halbinsel Fosen. Der Bau mit Panoramablick wurde 35 m über dem Meeresspiegel auf der Spitze der Felszunge in einer kleinen Mulde errichtet. Der Architekt erklärt: „Die Form des Hauses erinnert an einen Bergfuchs, der sich zum Schutz vor dem Wind zusammenrollt. Der Baukörper schmiegt sich an einen niedrigen Hügelkamm und den glatten Fels am äußersten Rand des Grundstücks." Ein kleiner Anbau dient als Atrium und schirmt die Außenbereiche vor Wind und Kälte ab. Das schwarze Dach wird an den am stärksten exponierten Gebäudeseiten eingeschlagen und so zu einem Teil der Außenwand. Im Eingangsbereich und in der Nähe der Wohnbereiche ist das raue dunkle Holz durch eine horizontale, weiße Verkleidung ersetzt.

———

Håkon Matre Aasarød a conçu cette petite maison pour sa famille. Elle est située à Vardehaugen, un affleurement rocheux près de l'embouchure du fjord Grøttingen, sur la péninsule de Fosen, et a été construite à 35 m au-dessus du niveau de la mer dans une petite dépression au sommet du rocher, afin de disposer d'une vue panoramique. L'architecte explique : « La forme de la cabane est calquée sur la position qu'adoptent les renards des neiges pour se protéger du vent. Le corps de bâtiment est blotti sous une crête basse et embrasse la roche polie jusqu'à l'extrémité du terrain. » Une petite annexe forme un atrium et des espaces extérieurs abrités du vent et du froid. Le toit noir est replié pour devenir le mur des côtés les plus exposés de la maison. À l'entrée et autour des espaces de séjour, les murs noirs bruts sont remplacés par un lambris horizontal blanc.

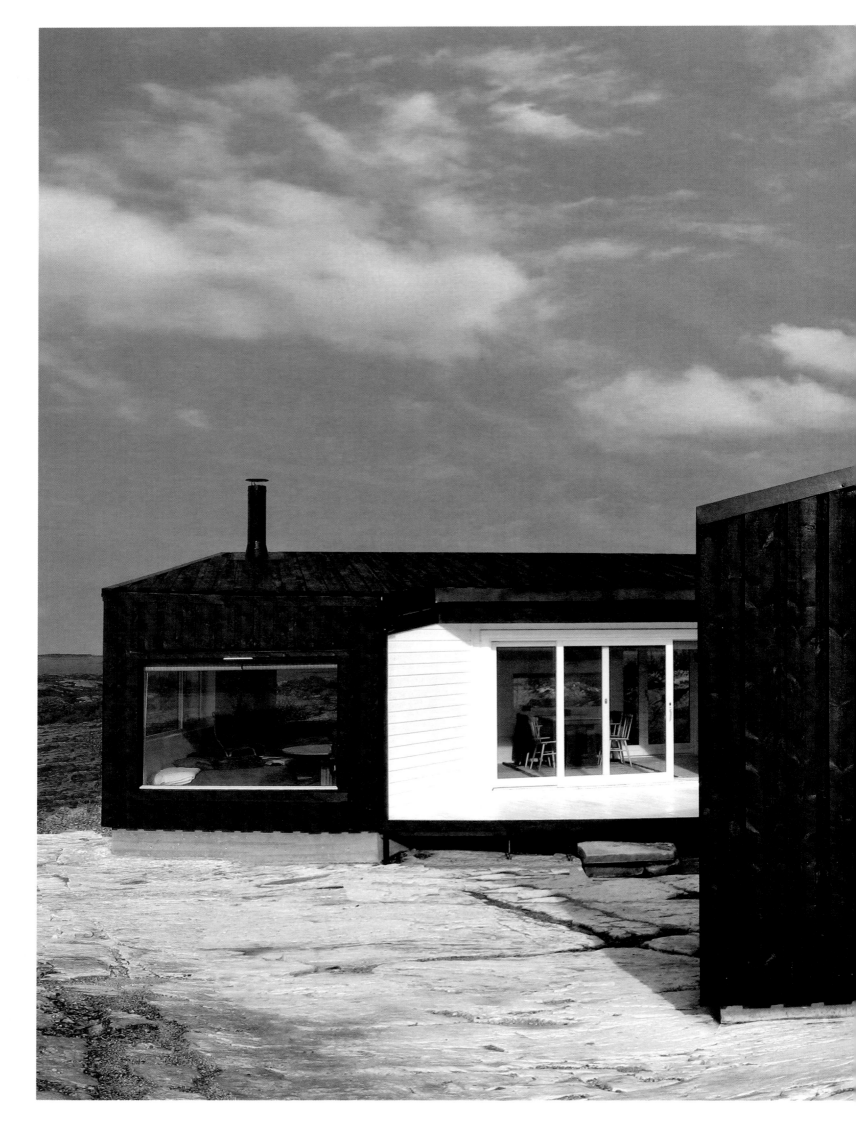

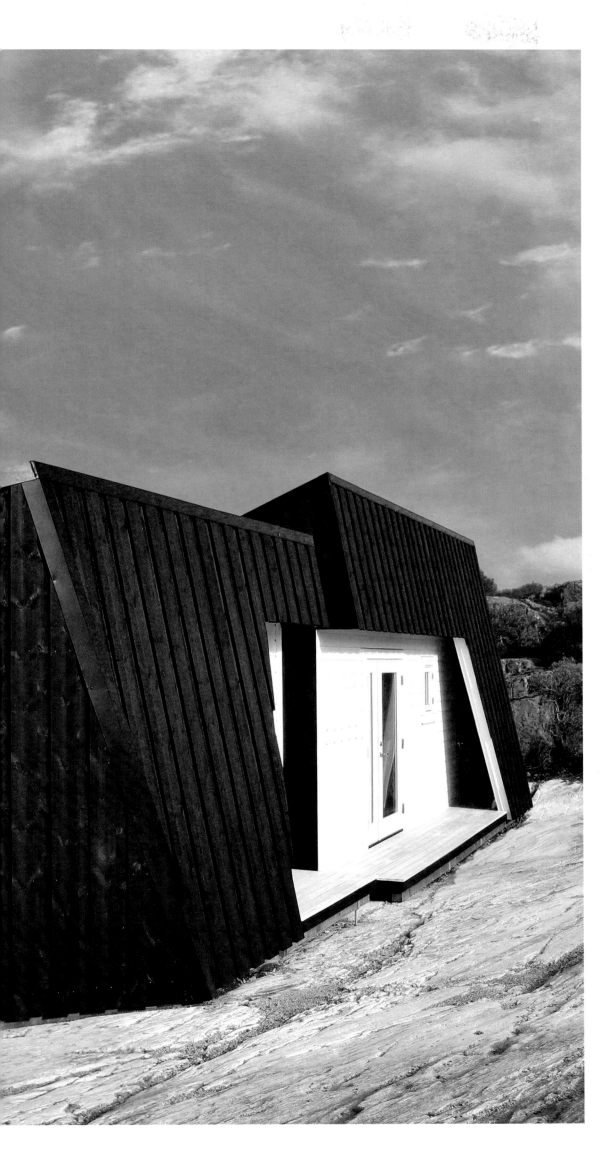

The exterior is clad in vertical black wood panels that also fold up to form the roof. Window and door areas in white contrast with the rest of the house. The structure follows the inclination of the site, as seen in the foreground of this image.

Das Äußere ist mit schwarzen, senkrecht angebrachten Holzbrettern verkleidet, die auch das Dach bilden. Weiße Fenster- und Türbereiche heben sich vom Rest des Hauses ab. Das Haus folgt dem Gefälle, wie im Vordergrund des Bildes auf dieser Seite erkennbar.

L'extérieur est revêtu de panneaux de bois noir verticaux qui se replient pour former le toit. Les entourages des fenêtres et des portes en blanc contrastent avec le reste de la maison. Elle épouse la pente du terrain, comme on le voit au premier plan sur cette photo.

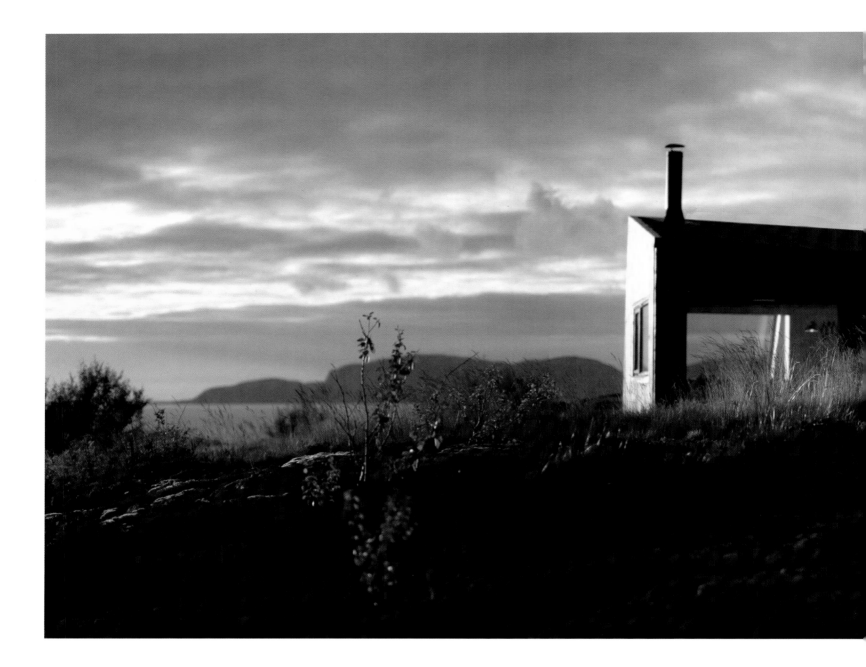

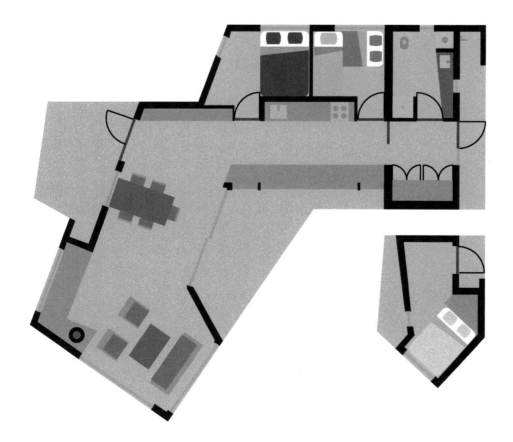

The house is folded into its rocky site, privileging views of the natural setting. Its black roughness blends readily with the environment.

Das Haus mit Blick auf die Umgebung schmiegt sich an seinen felsigen Standort. In seiner schwarzen Sprödigkeit verbindet es sich gut mit der Umgebung.

La maison est serrée sur son rocher et privilégie les vues sur le décor naturel. Sa rudesse noire se fond facilement dans le paysage environnant.

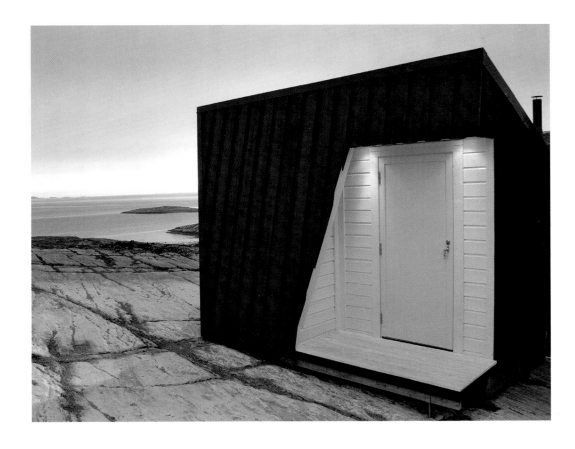

A white door is notched into the black body of the house. Built on a reinforced-concrete base, the framework of the structure is in wood and its surfaces are in impregnated and painted wood.

Die weiße Tür ist in dem schwarzen Baukörper zurückgesetzt. Das Rahmentragwerk ruht auf einem Stahlbetonfundament und besteht aus imprägniertem und lackiertem Holz.

Une porte blanche est percée dans le corps noir de la maison. La maison est construite sur une base de béton armé, sa charpente est en bois et toutes ses surfaces en bois traité et peint.

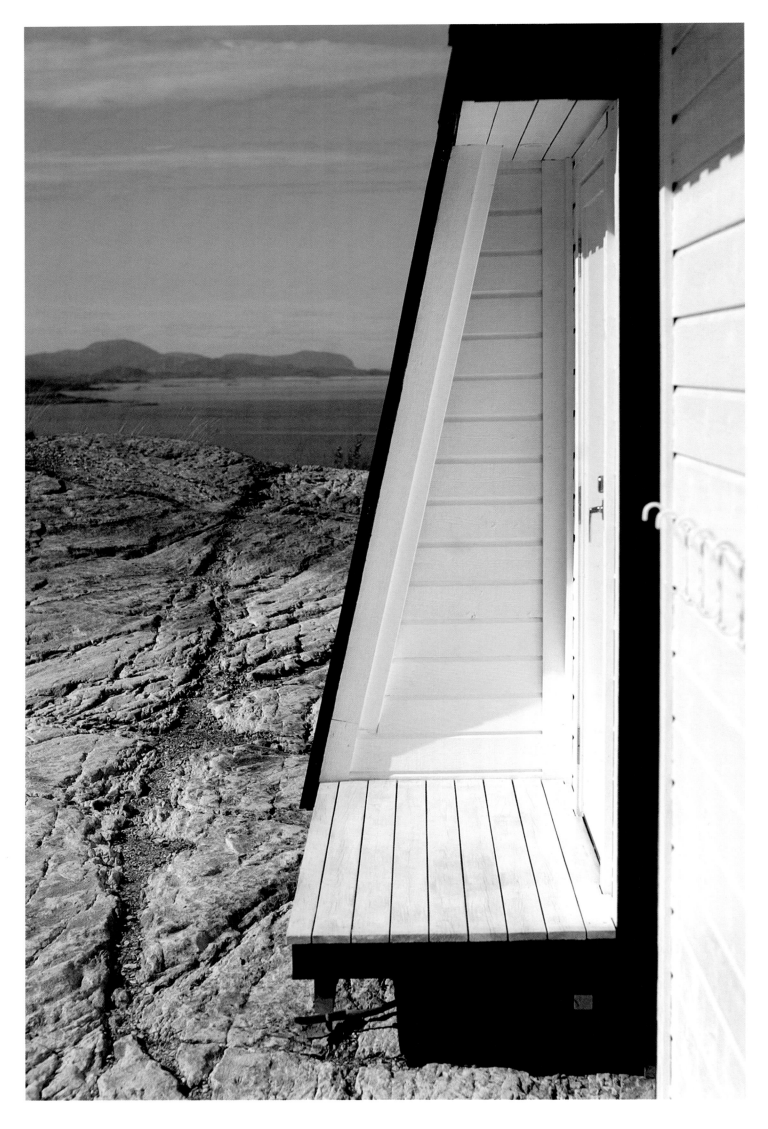

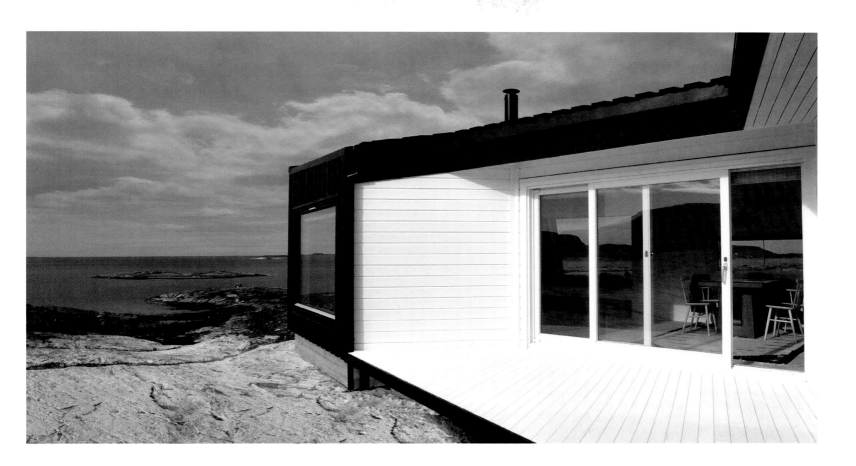

The architect compares the design of the house to a fox "snuggled" into the site. With its folded surfaces, the structure seems well-equipped to brave the inevitable winds and storms. It is also ideally situated to observe and admire nature.

Der Architekt vergleicht die Form des Hauses mit einem Fuchs, der sich „zusammenrollt". Mit seinen abgekanteten Oberflächen ist das Haus für Wind und Sturm gerüstet. Zudem ist es ideal gelegen, um die Natur zu beobachten und zu bestaunen.

L'architecte compare la forme de la maison à un renard « blotti » dans un creux de terrain. Avec ses surfaces repliées, la structure semble prête à résister aux inévitables vents et tempêtes, mais aussi parfaitement située pour observer et admirer la nature.

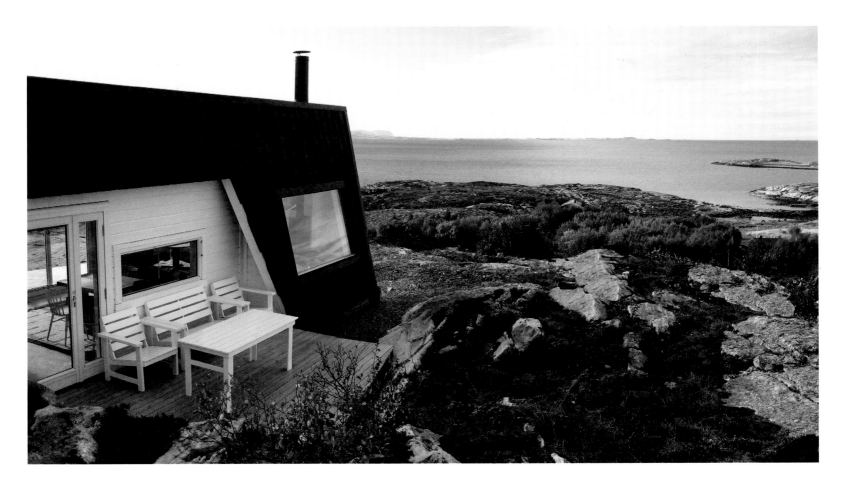

White walls and ceilings are moderated by wooden floors and cabinetry. Large windows and doors allow easy communication between interior and exterior.

Das Weiß der Wände und Decken wird vom Holz der Böden und Schränke gemildert. Große Fenster und Türen ermöglichen die Verbindung von innen und außen.

Les murs et plafonds blancs sont tempérés par les sols et placards en bois. De grandes portes et fenêtres permettent une communication facile entre intérieur et extérieur.

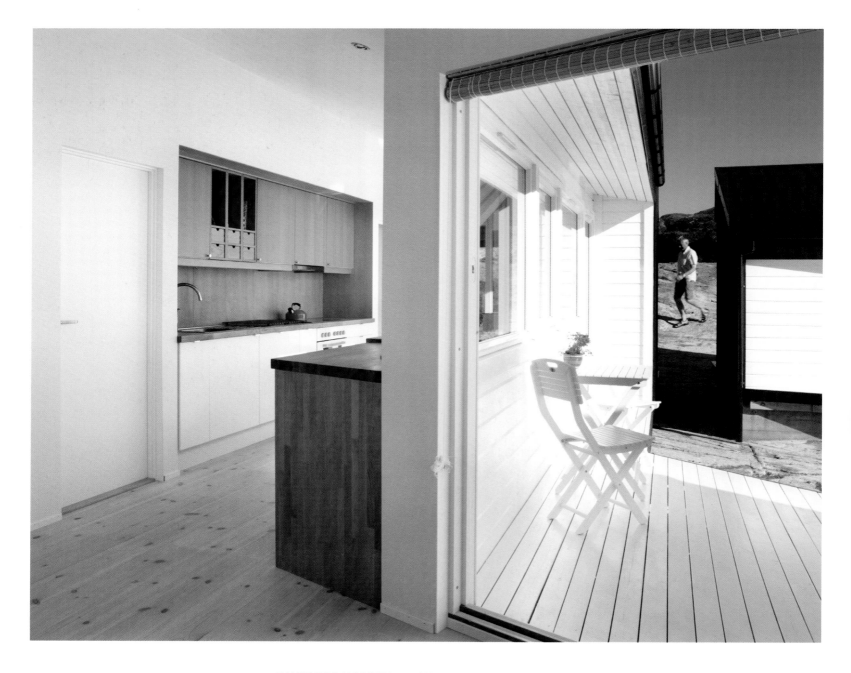

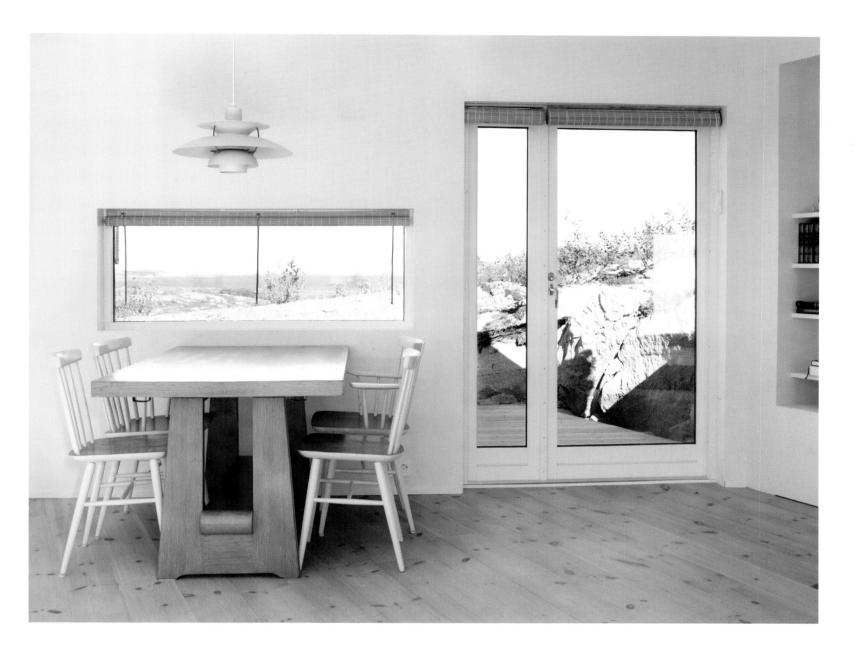

The house is simply furnished, in keeping with the relatively rough finishes of the exterior. White or light-colored surfaces diffuse the strong outside light.

Das Haus ist schlicht möbliert, passend zur relativ rauen Ausführung des Äußeren. Weiße und helle Oberflächen streuen das intensive natürliche Licht.

Le mobilier est sobre, en accord avec les finitions plutôt brutes de l'extérieur. Des surfaces blanches ou légèrement colorées diffusent la forte lumière extérieure.

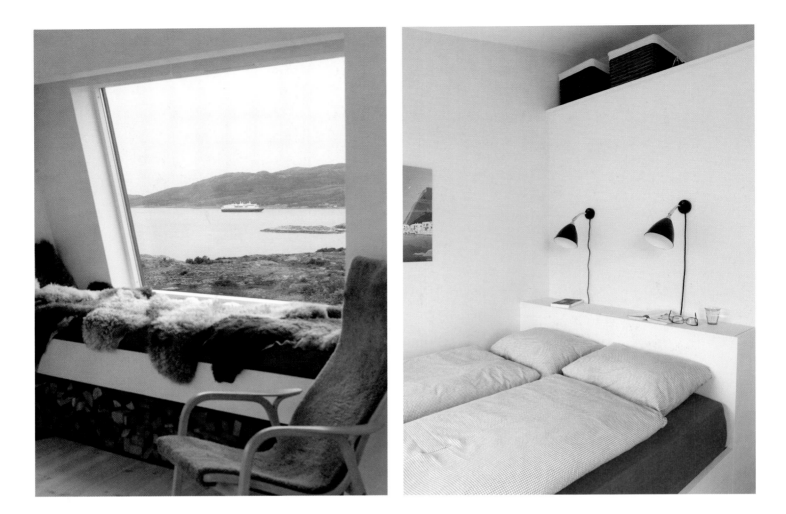

A warm, even cozy, atmosphere contrasts with the largely mineral exterior environment. Broad windows almost make it appear as though the seashore rocks are inside.

Die warme, sogar behagliche Atmosphäre steht im Gegensatz zum hauptsächlich steinigen Umfeld. Die großen Fenster erwecken den Eindruck, die Küstenfelsen befänden sich im Innern.

L'atmosphère chaleureuse, voire douillette, contraste avec le décor extérieur essentiellement minéral. De larges fenêtres donnent presque l'impression que les rochers de la côte sont à l'intérieur de la maison.

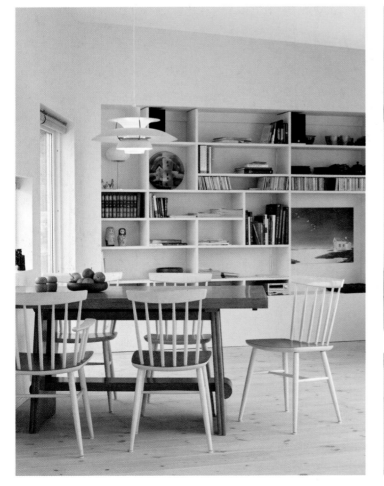

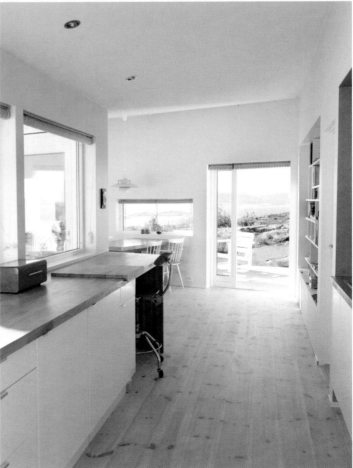

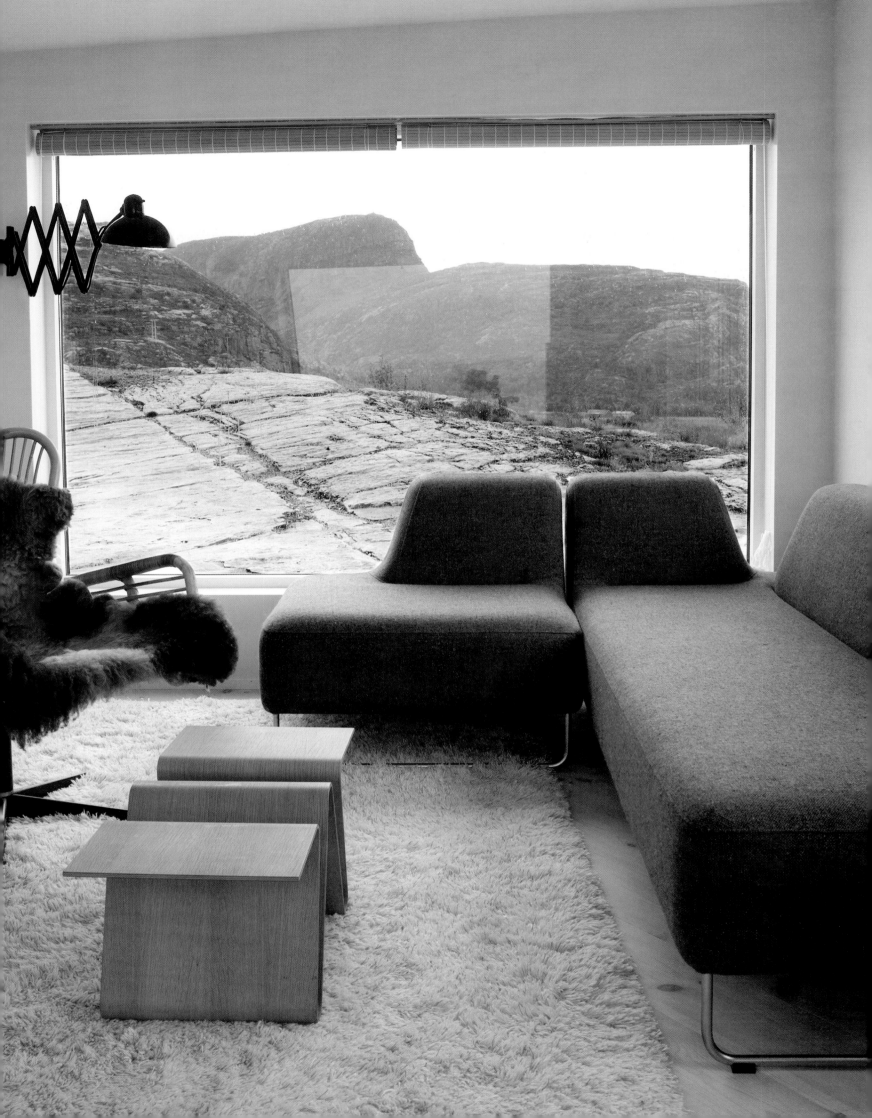

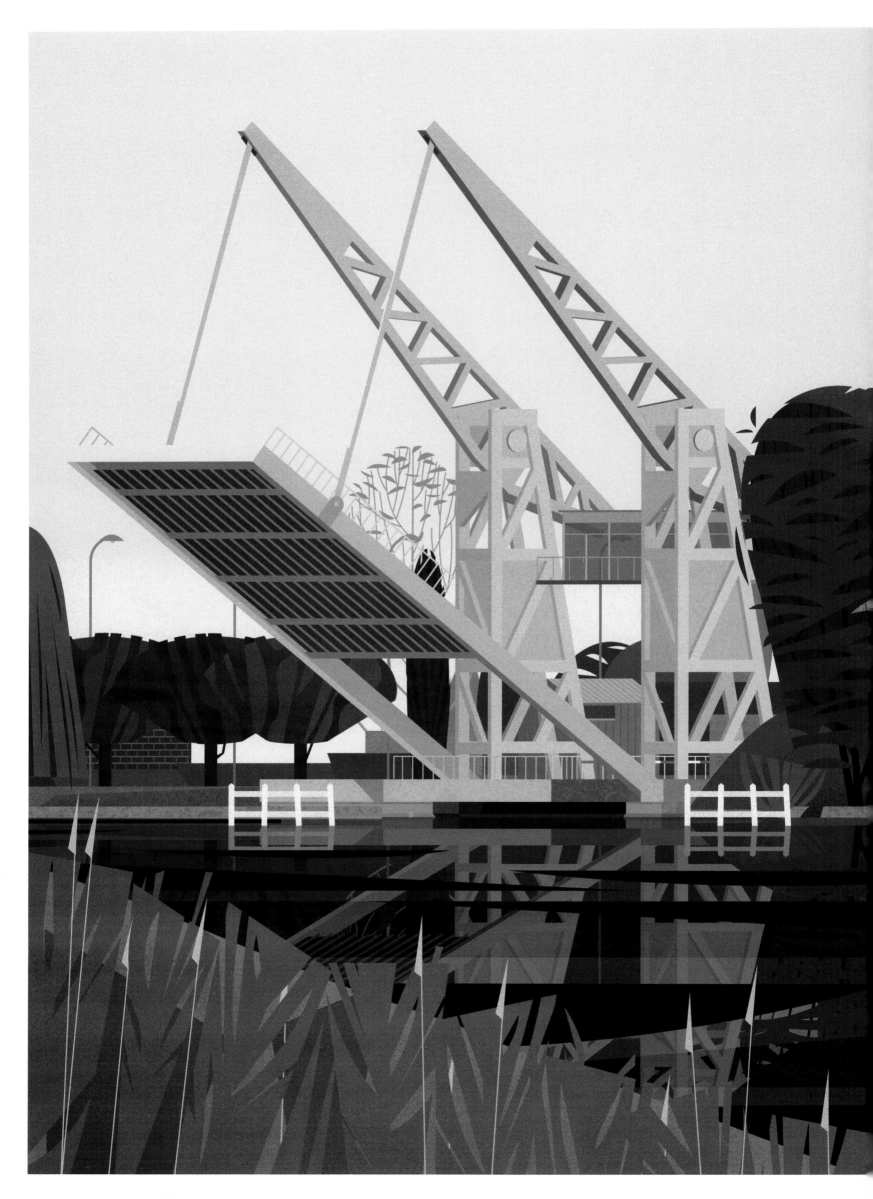

**JOHN KÖRMELING**
Tilburg [The Netherlands]
2011–13

# WELCOME BRIDGE

Area: 112 m² including terrace | Client: City of Tilburg | Cost: €2.5 million (total for bridge)
Collaboration: Rijk Blok, Jan van den Burg, Witteveen+Bos

John Körmeling won the Dutch competition to design a new drawbridge leading to the Pius Harbor in Tilburg in 2009. The completed bridge is 14 meters high, exactly the same width as the road it carries. As it opens, the cabin at its top comes down 6.5-meters and hangs 4.5-meters above the road, allowing a view of boats going by or of waiting vehicular traffic.

————

John Körmeling gewann 2009 in den Niederlanden einen Wettbewerb für den Neuentwurf einer Zugbrücke am Eingang des Tilburger Piushafens. Die fertige Brücke ist mit 14 m so hoch, wie die Straße, die über die Brücke führt, breit ist. In geöffnetem Zustand senkt sich die Kabine um 6,5 m und hängt 4,5 m über der Straße. Von hier blickt man auf den vorbeiziehenden Schiffsverkehr und die wartenden Autos.

————

John Körmeling a remporté le concours néerlandais pour créer un nouveau pont à bascule menant vers le port Pius à Tilburg en 2009. Le pont achevé est haut de 14 m, soit exactement la largeur de la route qu'il porte. Lorsqu'il se lève, la cabine tout en haut descend de 6,5 m et se trouve suspendue à 4,5 m au-dessus de la route, offrant une vue sur les bateaux qui passent ou les voitures qui attendent.

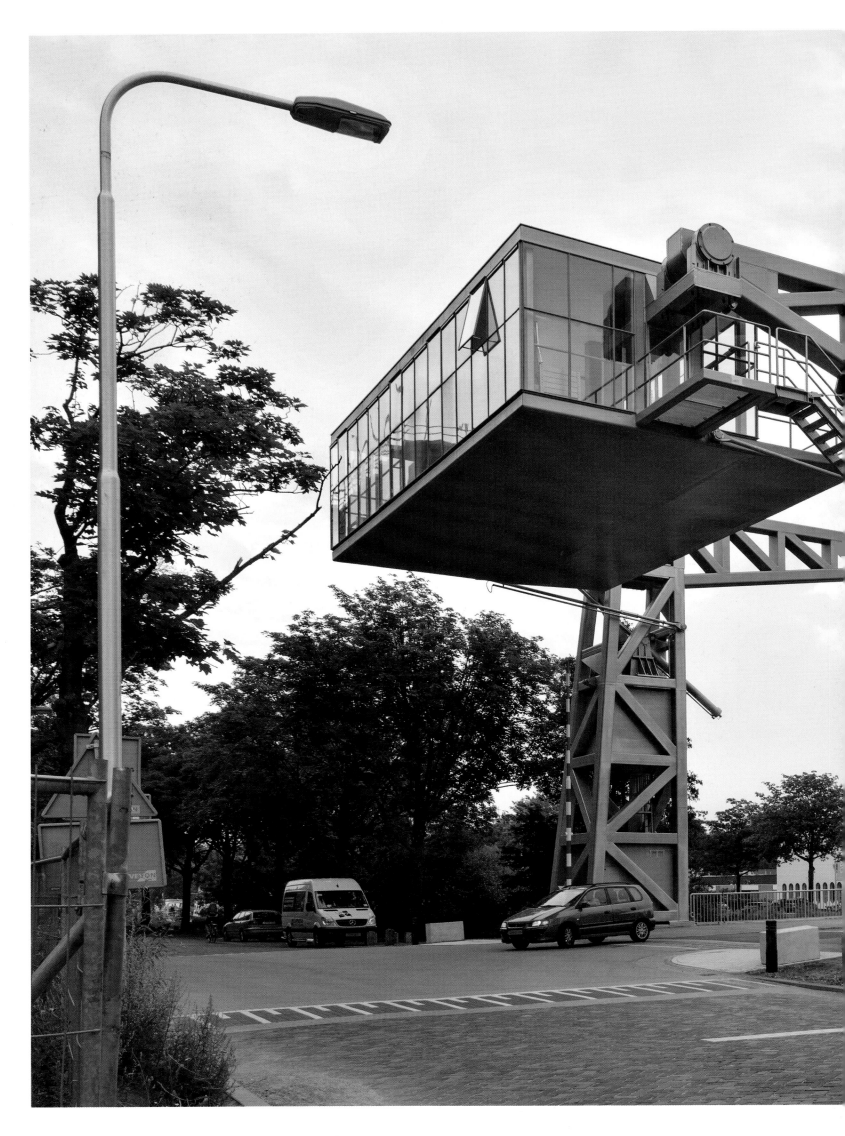

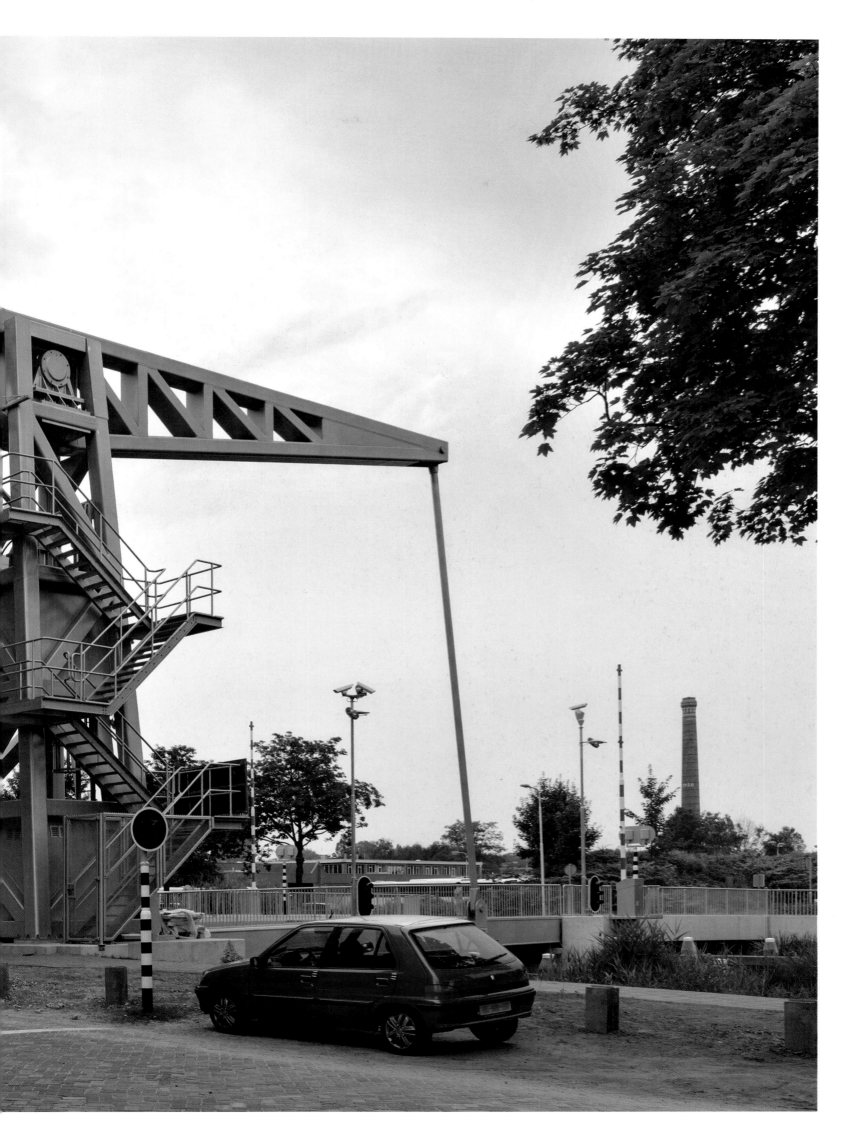

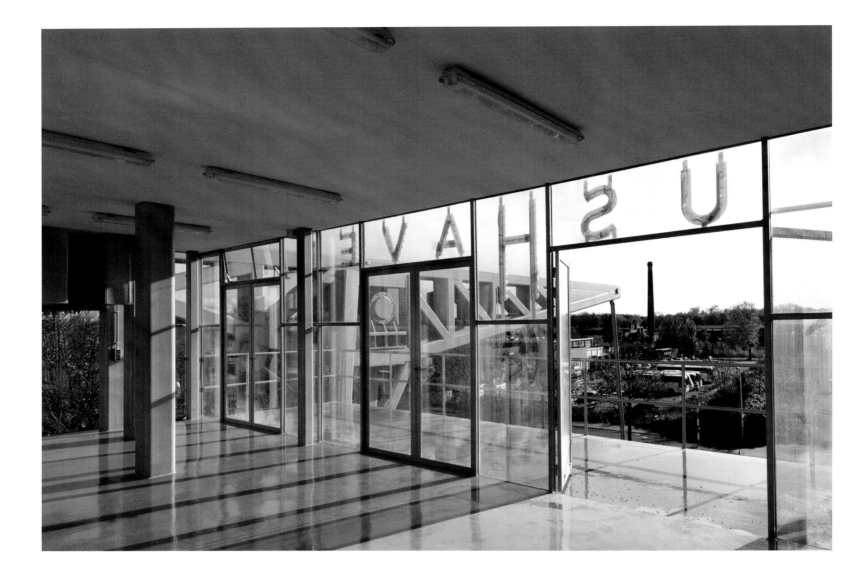

Although the cabin was originally designed to be inhabited by the bridge keeper, local regulations seem thus far to have prohibited that use.

Die Kabine wurde ursprünglich als Wohnung für den Brückenwächter entworfen, doch städtische Vorschriften haben diese Nutzung bisher verhindert.

La cabane a été conçue à l'origine pour être habitée par le pontier, mais les règlements locaux semblent interdire cet usage jusqu'à présent.

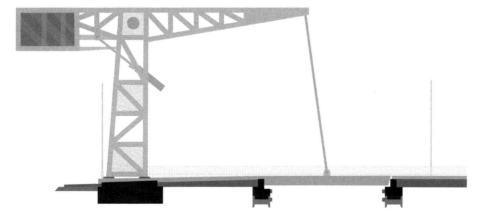
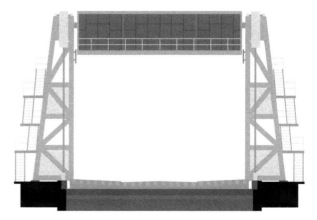

The cabin moves up and down with
the bridge and is suspended high above
the ground when the bridge is closed.

Die Kabine bewegt sich mit der Brücke
auf und ab und hängt bei geschlossener
Brücke hoch über dem Boden.

La cabine monte et descend avec le pont
et se trouve suspendue haut au-dessus
du sol lorsque le pont est descendu.

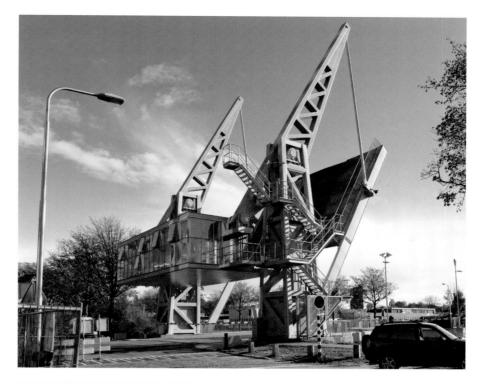

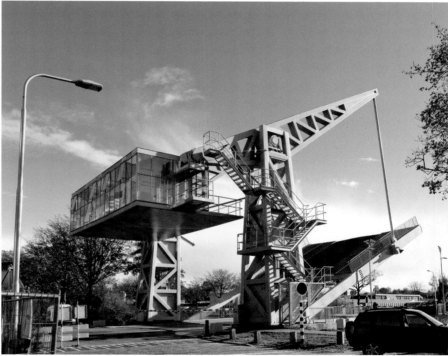

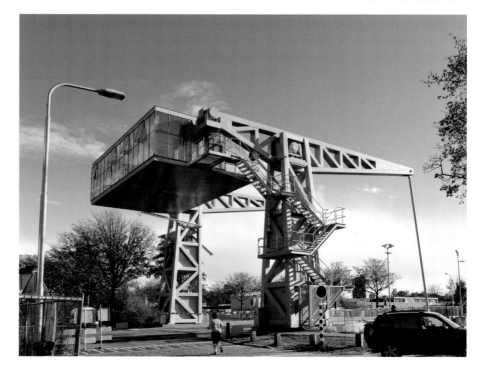

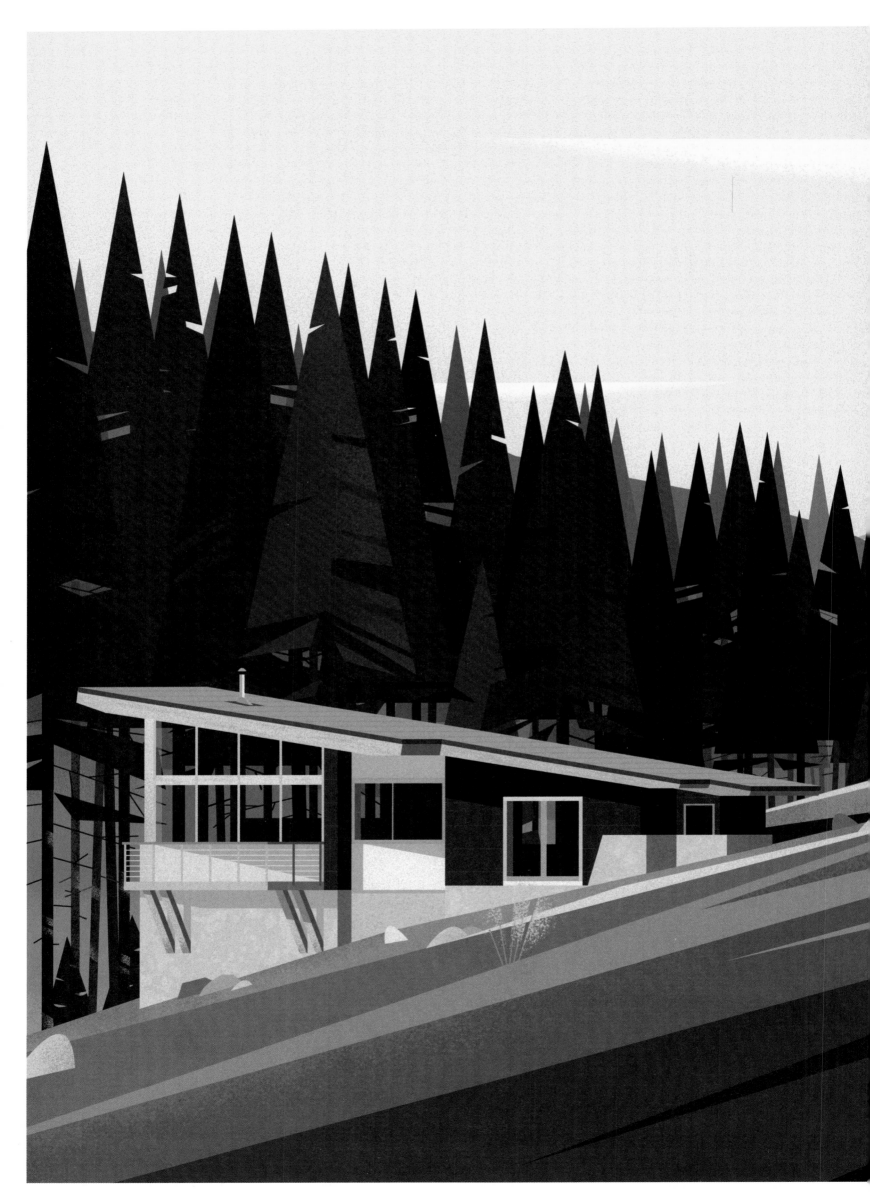

# WINTERGREEN CABIN

Area: 148 m² | Collaboration: Timothy Posey

Set on a steeply sloped, 8100-square-meter site, this cabin overlooks a stream and mountains in the distance. The concrete base of the structure contains a garage and utility spaces. Living spaces are located on the upper level, with a living, dining and kitchen area on the south side, with full-height glazing forming a glass box on three sides. Decks are cantilevered from the concrete base on three sides as well. The private areas, with smaller windows, are recessed into the hillside. A continuous overhanging roof unites the different elements into a coherent whole.

———

Die Wintergreen Cabin liegt auf einem 8100 m² großen Grundstück mit Blick auf einen Bach und Berge in der Ferne. Im Betonsockel des Gebäudes befinden sich eine Garage und weitere Nutzflächen. Die Wohnräume liegen im Obergeschoss, ein großer Wohn-, Ess- und Küchenbereich ist nach Süden orientiert und auf drei Seiten von raumhohen Glaswänden begrenzt. Balkone kragen auf drei Seiten aus dem Betonsockel. Die Privaträume sind mit kleineren Fenstern versehen und gehen auf die Hügelseite hinaus. Ein durchgehendes, überhängendes Dach vereint all diese Elemente zu einem stimmigen Ganzen.

———

Cette cabane placée sur un terrain de 8100 m² en pente raide surplombe un ruisseau et des montagnes au loin. La base en béton contient un garage et des espaces fonctionnels. Les pièces à vivre sont situées au niveau supérieur avec un salon, une salle à manger et une cuisine côté sud, le vitrage sur toute la hauteur formant un cube de verre sur trois côtés. Également sur trois côtés, des balcons s'avancent de la base en béton. Les espaces privés aux fenêtres plus petites sont encastrés à flanc de colline. Un toit en surplomb d'un seul morceau regroupe les différentes parties pour former un tout cohérent.

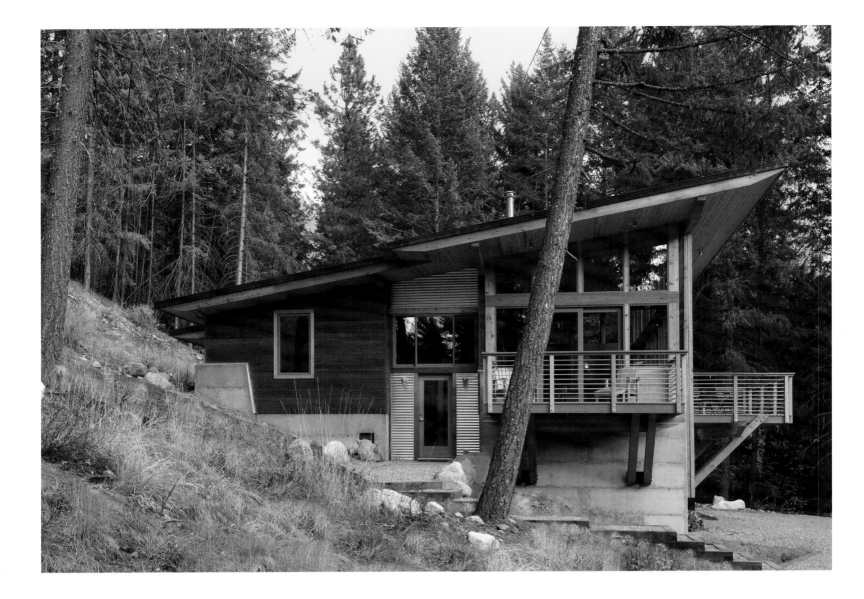

The cabin is anchored in the hill by a concrete base that contains a garage. Living areas are all located on the floor above.

Das Haus ist durch den Betonsockel, in dem sich eine Garage befindet, im Hügel verankert. Alle Wohnräume befinden sich in der Etage darüber.

La cabane est ancrée dans la colline par une base en béton qui contient un garage. Les pièces de séjour sont situées au niveau supérieur.

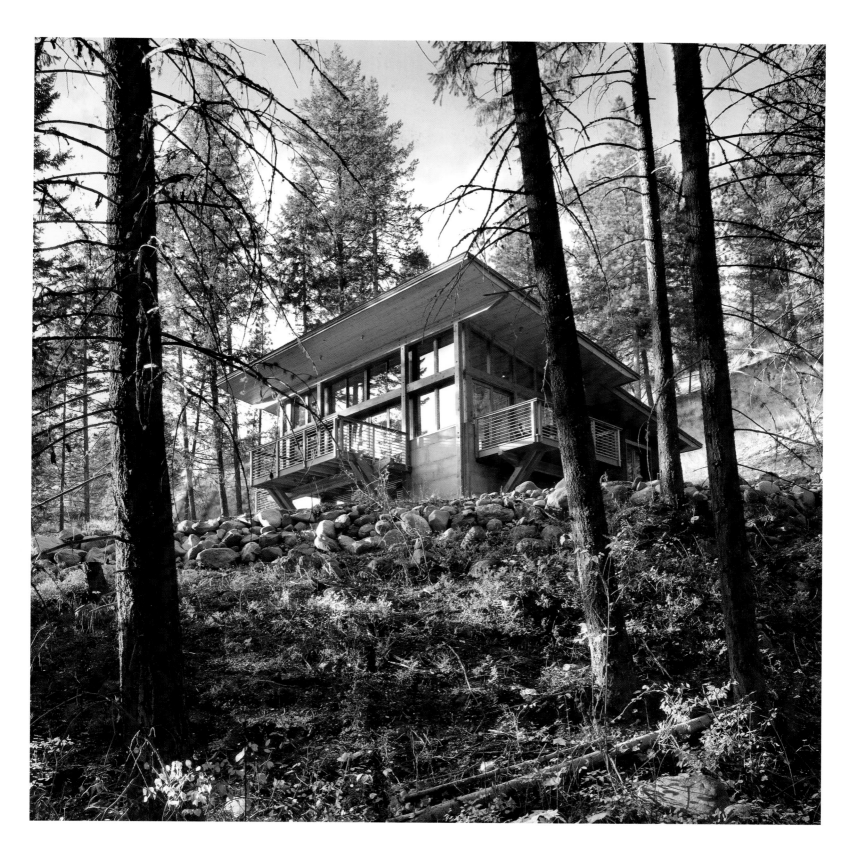

Decks are cantilevered off the concrete base on three sides, allowing views of a stream that runs below the house.

Drei Balkone ragen aus dem Betonsockel hervor, von hier aus blickt man auf einen Bach, der unterhalb des Hauses fließt.

Des balcons s'avancent de la base en béton sur trois côtés et ont vue sur un ruisseau qui passe sous la maison.

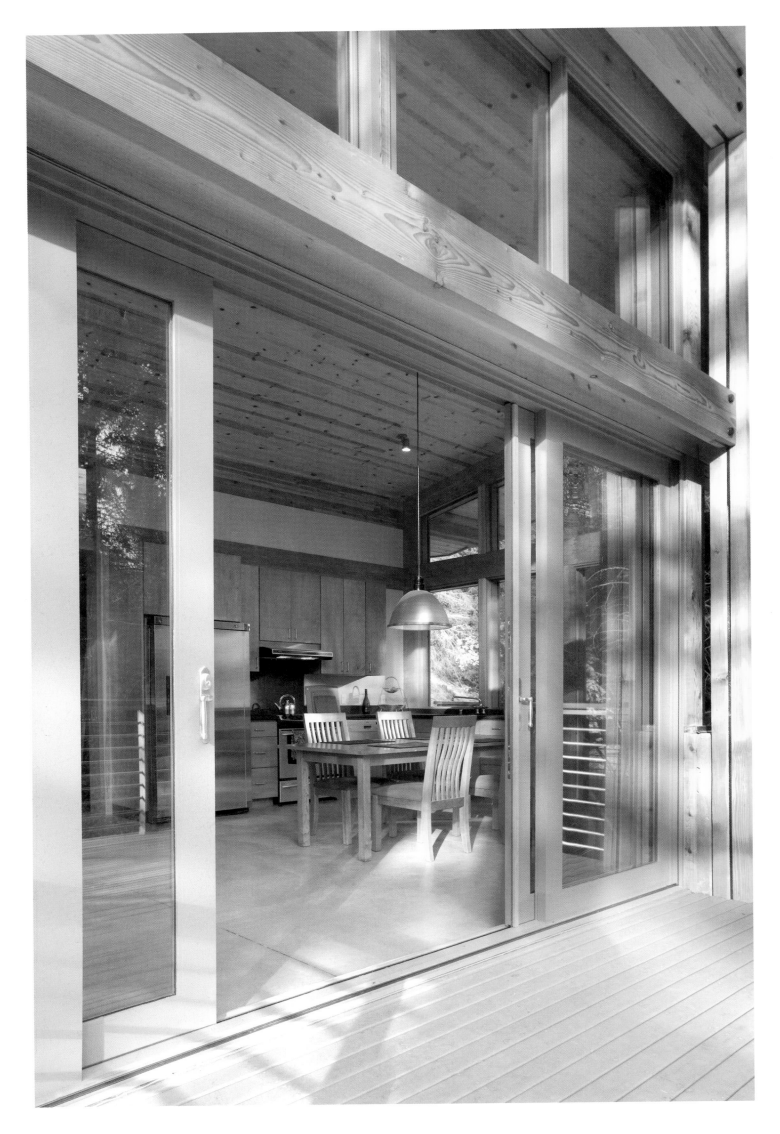

The living/dining/kitchen area is a single space on the south side of the cabin with high "window walls" on three sides.

Der von drei hohen „Fensterwänden" umgebene Wohn-, Ess- und Küchenbereich ist ein einziger Raum auf der Südseite des Hauses.

Le salon/salle à manger/cuisine occupe un seul espace commun côté sud avec de hauts « murs fenêtres » sur trois côtés.

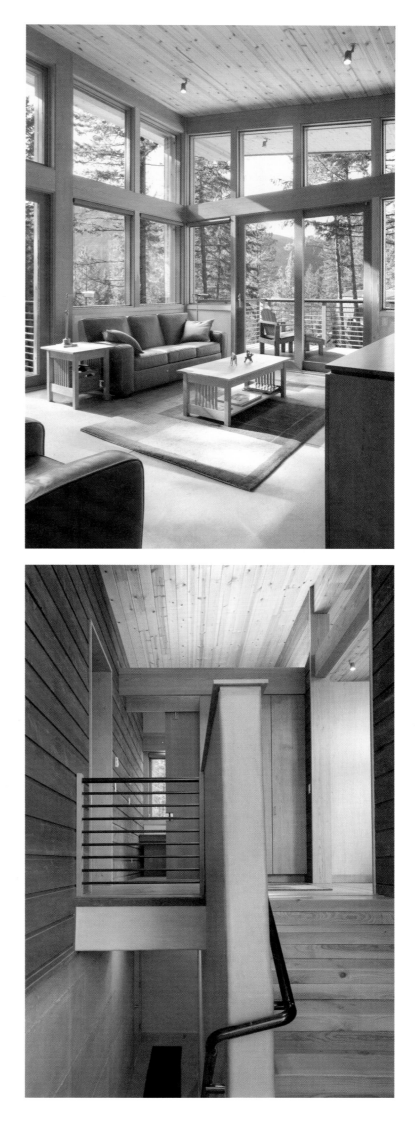

**DREW HEATH**
Wollombi, New South Wales [Australia]
2002

# ZIG ZAG CABIN

Area: 10 m² | Client: Ross Harley | Cost: AUS $40 000

This structure was intended as a study of minimum living requirements and use of space. The client wanted a traditional house, but Drew Heath proposed a small, camp-like dwelling that he described as a "wheel-less caravan" with references to the regional landscape. A 15-square-meter deck is part of the design, which includes two sleeping areas on the interior ground level and a bunk bed located on a suspended mezzanine. The twisted wood frame of the house, which is held together by a plywood beam, allows for window and door openings at each corner. Masonite and cypress pine were used, in keeping with the architect's rejection of "precious materials."

—

Mit diesem Gebäude sollten Mindestanforderungen ans Wohnen und die Raumnutzung untersucht werden. Der Bauherr wünschte sich ein traditionelles Haus, stattdessen schlug Drew Heath eine kleine, campingartige Behausung vor, die er als „radlosen Wohnwagen" mit Bezug zur Landschaft der Umgebung beschreibt. Teil des Entwurfs sind eine 15 m² große Veranda, zwei Schlafbereiche im Erdgeschoss und ein Hochbett auf einem abgehängten Mezzaningeschoss. Der gedrehte Holzrahmen des Hauses, das von einem Sperrholzbalken zusammengehalten wird, ermöglicht Fenster- und Türöffnungen an jeder Ecke. Dem Anspruch des Architekten gemäß, keine „kostbaren Materialien" zu verwenden, fiel die Wahl auf Masonit und das Holz der Schmuckzypresse.

—

Ce projet se voulait une étude des exigences minimales de vie et de l'utilisation de l'espace. Le client souhaitait une maison traditionnelle, mais Drew Heath lui a proposé ce petit logis de type campement qu'il a décrit comme une « caravane sans roues », en référence au paysage régional. Une terrasse de 15 m² est incluse dans l'ensemble qui contient deux espaces de couchage au rez-de-chaussée et une couchette sur une mezzanine suspendue. La charpente torsadée en bois, assemblée et maintenue par une poutre en contreplaqué, permet d'ouvrir la fenêtre et la porte aux angles. Du masonite et du cyprès ont été utilisés, conformément au refus de l'architecte de tout « matériau précieux ».

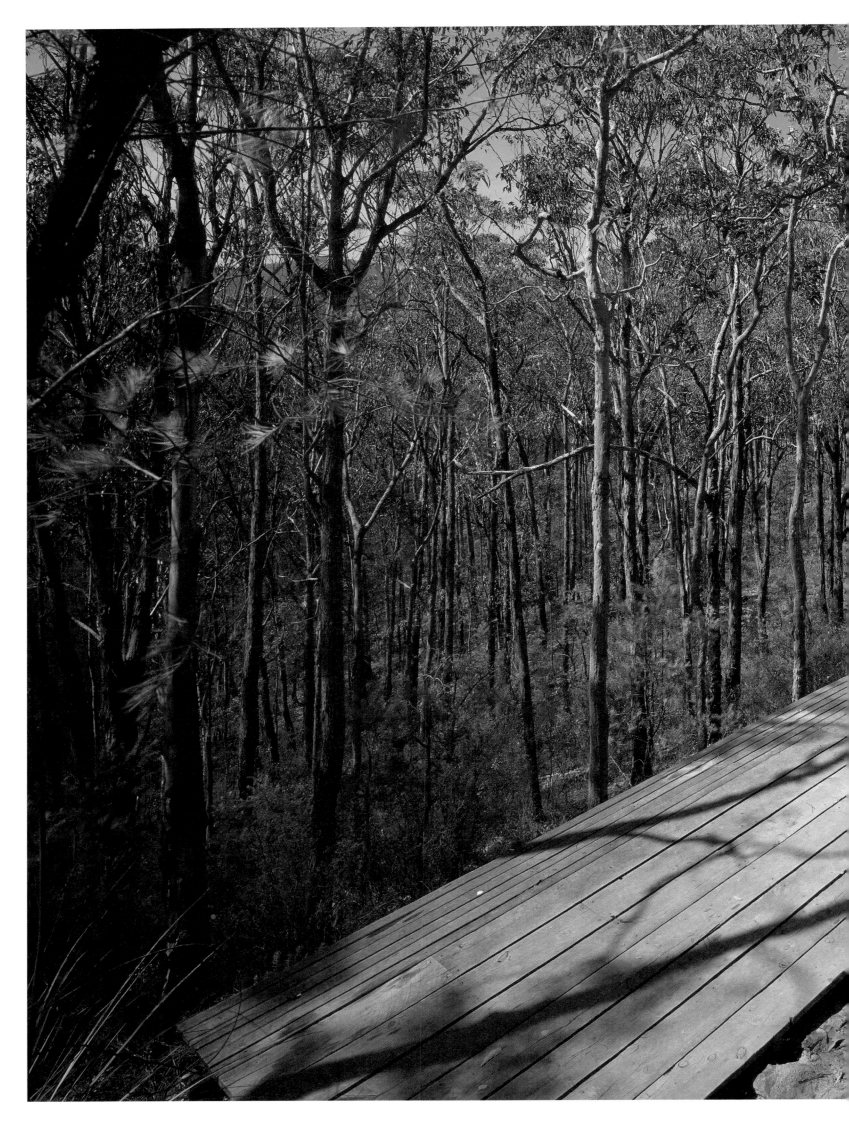

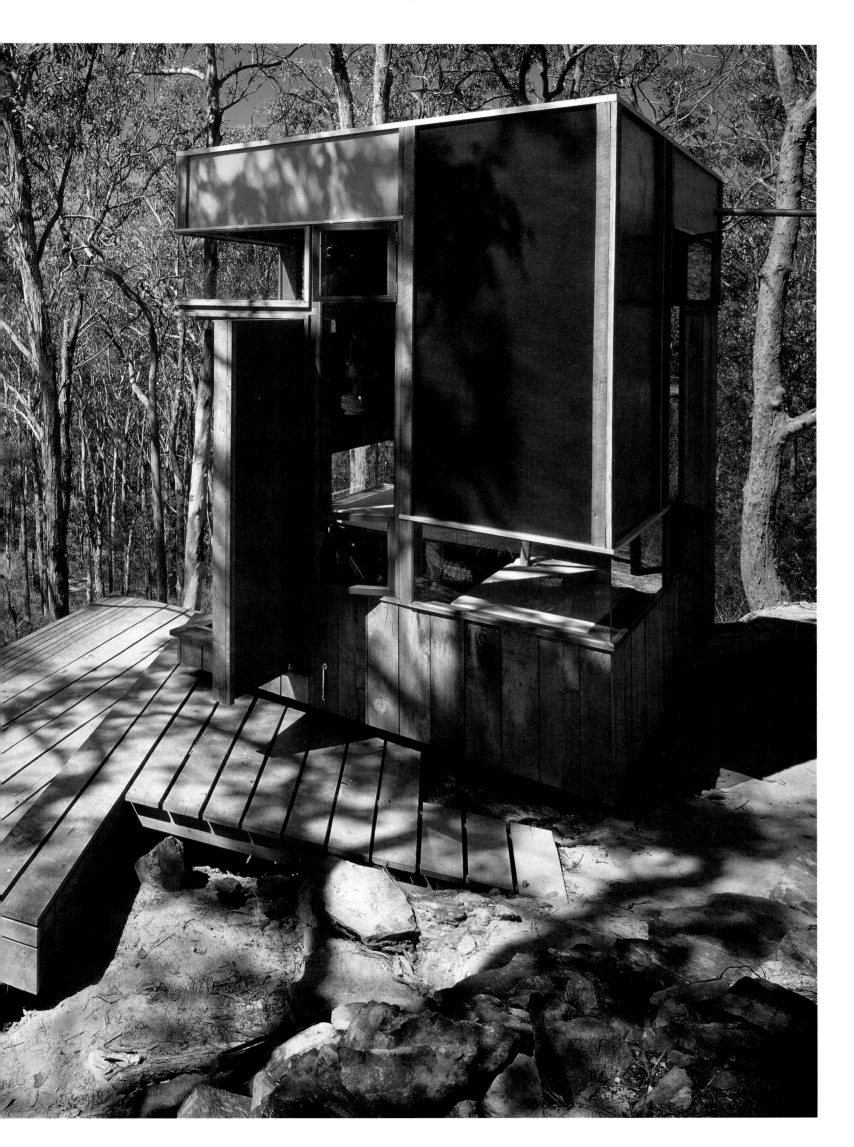

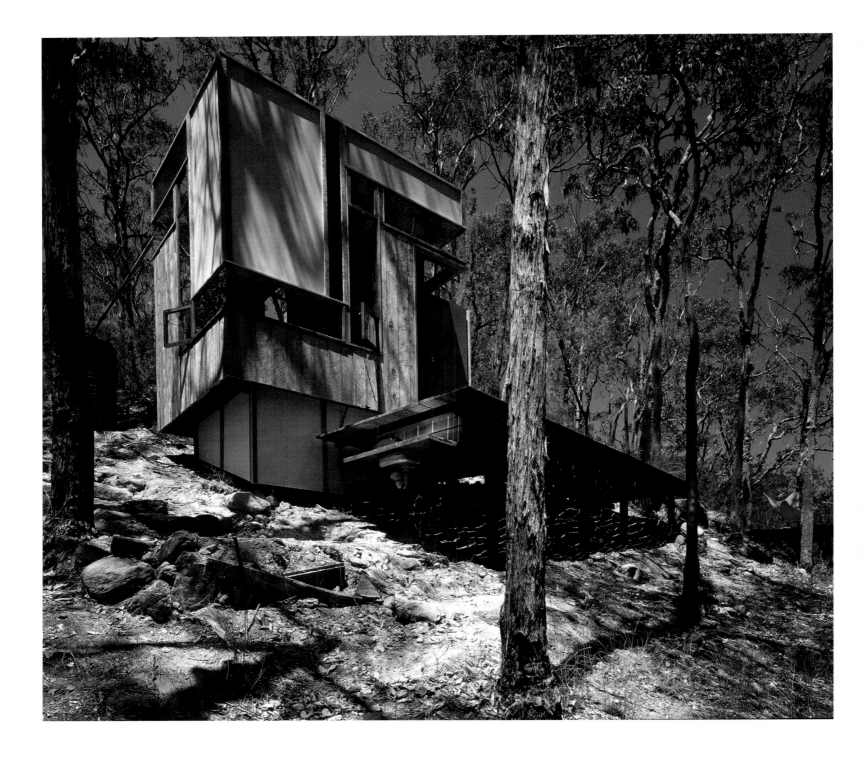

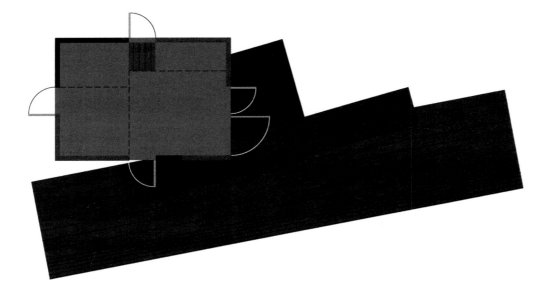

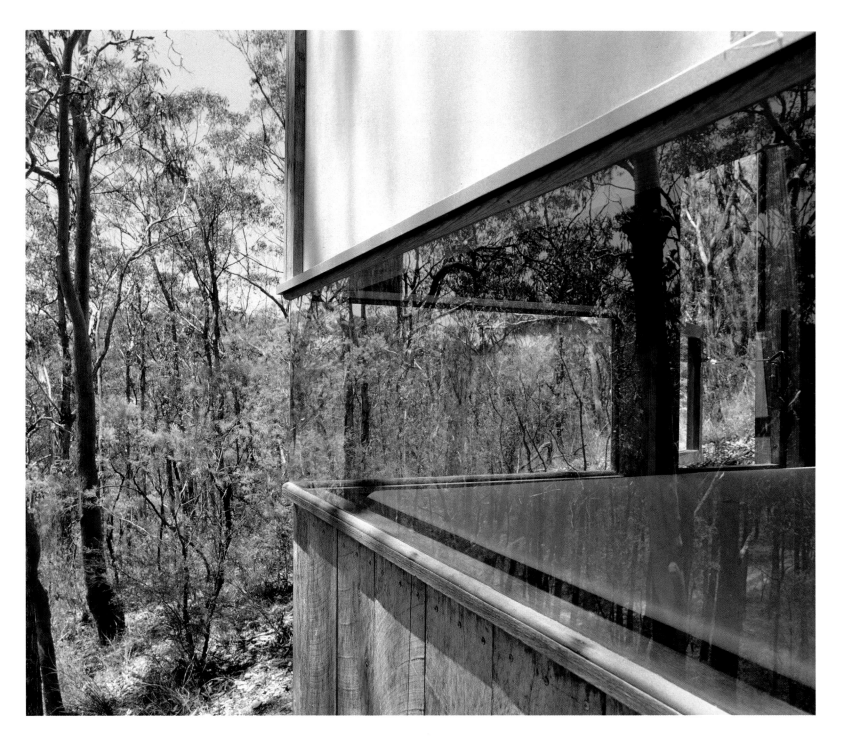

The architect calls this cabin "a box with some nice bits," or a "wheel-less caravan." He convinced the clients from Sydney to scale back the original dimensions of their project, creating a ten-square-meter box with a 15-square-meter terrace.

Der Architekt bezeichnet die Hütte als „Kasten mit ein paar hübschen Extras" und als „radlosen Wohnwagen". Er überzeugte die Bauherren aus Sydney, die Größe ihres Projekts zu reduzieren und eine 10 m² große Box mit einer 15 m² großen Terrasse zu bauen.

L'architecte qualifie sa cabane de « boîte avec quelques jolis morceaux » ou de « caravane sans roues ». Il a convaincu ses clients de Sydney de réduire les dimensions d'origine de leur projet et a créé un cube de 10 m² avec une terrasse de 15 m².

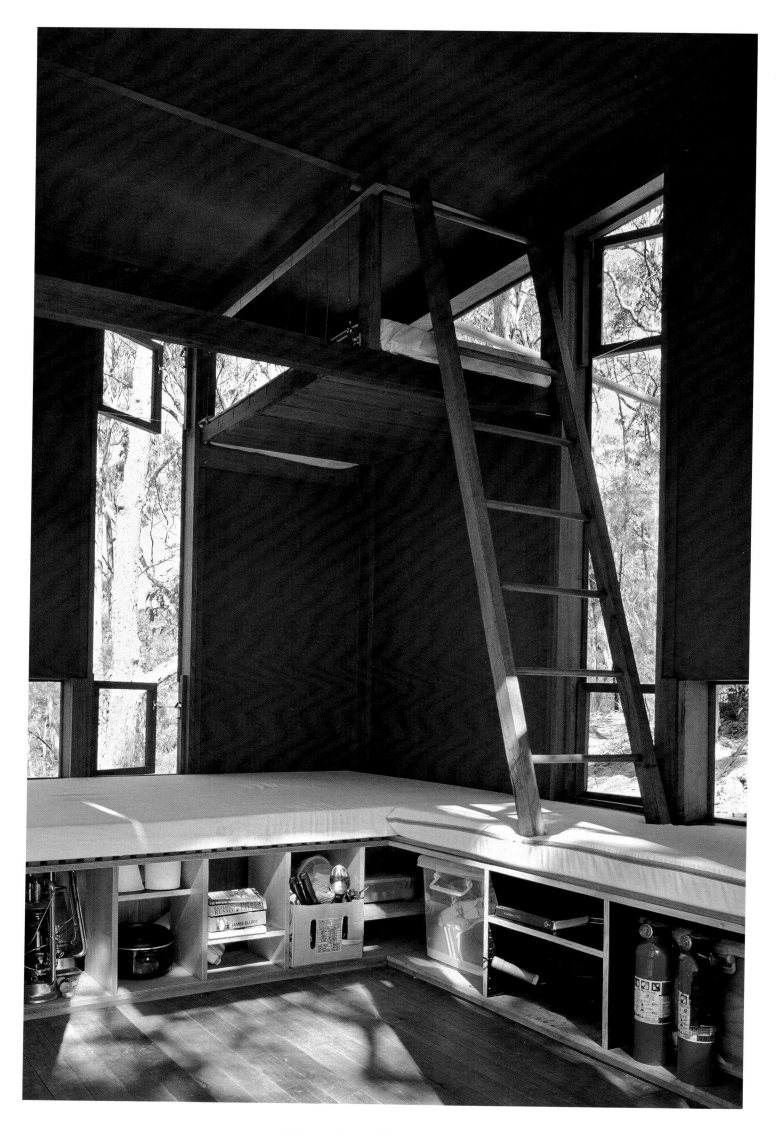

# ARCHITECTS

## 2BY4-ARCHITECTS

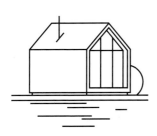

2by4-architects | Westzeedijk 487
3024 EL Rotterdam | The Netherlands

Tel: + 31 10 223 6640 | E-mail: info@2by4.nl
Web: www.2by4.nl

Remko Remijnse was born in 1974 in Epsom, UK. He studied at the School of Architecture of Michigan State University (MSU, 1998–99) and graduated in Architecture from the Technical University (TU) of Delft (1997–2001). After working in the office of Claus & Kaan (Rotterdam, 2001–02), he founded Remijnse Architectuur (Rotterdam, 2002) and was then a cofounder of 2by4-architects (Rotterdam, 2005). Rocco Reukema was born in 1972 in Assen, the Netherlands. He also attended MSU (1999–2000), and graduated in Architecture from the TU of Delft (1998–2002), also cofounding 2by4 in 2005. Their work includes a Spa and Wellness Resort (Dordrecht, 2008–11); the Island House (Breukelen, 2011–12, published here); and a public square in Glashaven (Rotterdam, 2011–13). Current work includes Eltheto Healthcare Housing (Rijssen, 2008–14); and a Water Ski Track and Facilities (Sneek, 2013–14), all in the Netherlands.

## AATA

AATA Arquitectos Asociados
San Pio X 2460 of 604 | Providencia
Santiago 7510041 | Chile

Tel: +56 2 2335 8978 | Web: www.aata.cl

AATA **Arquitectos** was founded in 2005 by Nicole Gardilcic Venandy and Sebastián Cerda Pé. Nicole Gardilcic Venandy was born in 1971 in Santiago. She received a Master of Construction Management degree from the Pontificia Universidad Catolica (PUC)

de Chile, and graduated in architecture from the Universidad Central de Chile. She also has a degree in Real Estate Management from PUC. Sebastián Cerda Pé was born in Santiago in 1974 and graduated as an architect from the PUC. As part of an exchange program, he studied at the Mackintosh School of Architecture in Scotland. After graduating, he cofounded a company dedicated to digital architecture and graphic design called Impulsando. com. Their work includes the Mining Hotel (El Peñon, II Region, 2006); the Guesthouse (Navidad, Licancheu, 2006, published here); Morerava Cottages (Easter Island, 2009–10, also published here); Colorado Rocks (Farellones, 2012); and the El Kaiser Boulangerie (Santiago, 2013), all in Chile.

## ACT_ROMEGIALLI

act_romegialli
Piazza Caduti per la Libertà 12
23017 Morbegno (SO) | Italy

Tel: +39 342 61 40 15
E-mail: actromegialli@gmail.com
Web: www.actromegialli.it

Gianmatteo Romegialli was born in Milan in 1961. He graduated in Architecture from the Politecnico di Milano in 1988. After working in the office of Crotti Invernizzi in Milan (1988–89), he struck out on his own. In 1994, he founded the office act_romegialli with Angela Maria Romegialli. In 2002 he was appointed Professor in the Architectural Design Laboratory I at the Politecnico di Milano, Leonardo First Faculty of Architecture. Their work includes the Moto Guzzi Pavilion (Mandello del Lario, 2010); DMB House (Montagna, 2010); the Green Box (Cerido, 2011, published here); a footbridge (Mandello del Lario, 2010); all in Italy, and the Cinex Showroom (São Paulo, Brazil, 2009).

## AIRES MATEUS

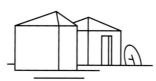

Aires Mateus e Associados
Rua Silva Carvalho 175
1250–250 Lisbon | Portugal

Tel: +351 21 381 56 50
E-mail: m@airesmateus.com
Web: www.airesmateus.com

Manuel Rocha de Aires Mateus was born in Lisbon, Portugal, in 1963. He graduated as an architect from

the Faculty of Architecture at the Technical University of Lisbon (FA-UTL; 1986). He worked with Gonçalo Byrne beginning in 1983 and with his brother Francisco Xavier Rocha de Aires Mateus beginning in 1988. Francisco Xavier de Aires Mateus was born in Lisbon in 1964. He also graduated from the FA-UTL (1987) and began working with Gonçalo Byrne in 1983, before his collaboration with his brother. Their work includes the Sines Cultural Center (Sines, 2000); the Casa No Litoral (Litoral Alentejano, 2000); the Alenquer House (Alenquer, 2002); the Fontana Park Hotel (Lisbon, 2002–07); the Santa Marta Light House Museum (Cascais, 2003–07); a Highway Toll and Control Building (Benavente, 2006–07); a school complex (Vila Nova da Barquinha, 2006–08); 14 private houses, Vila Utopia-Wise (Lisbon, 2005–09); social housing (Madrid, Spain, 2007–09); EDP headquarters, Portuguese Electric Company (Lisbon, 2008–09); Portugal Telecom Call Center (Santo Tirso, 2008–09); Parque de los Cuentos Museum (Málaga, Spain, 2008–09); a House in Leiria (Leiria, 2008–10); a House in Aroeira (Aroeira, 2009–10); and the Cabanas no Rio Huts (Alcácer do Sal, 2013, published here), all in Portugal unless stated otherwise. They participated in the 2010 Venice Architecture Biennale curated by Kazuyo Sejima.

## WERNER AISSLINGER

Studio Aisslinger
Heidestr. 46–52
10557 Berlin
Germany

Tel: +49 30 31 50 54 00
Fax: +49 30 31 50 54 01
E-mail: studio@aisslinger.de
Web: www.aisslinger.de

Werner Aisslinger was born in Nördlingen, Germany, in 1964. He studied design at the University of the Arts (Hochschule der Künste, 1987–91), Berlin. From 1989 to 1992, he freelanced with the offices of Jasper Morrison and Ron Arad in London, and at the Studio de Lucchi in Milan. In 1993, he founded Studio Aisslinger in Berlin, focusing on product design, design concepts, and brand architecture. From 1998 to 2005, he was a Professor of Product Design at the Design College (Hochschule für Gestaltung) in Karlsruhe (Department of Product Design). He has developed furniture with Italian brands such as Cappellini and Zanotta, and office furniture with Vitra in Switzerland. He works on product designs and architectural projects with brands like Interlübke, Mercedes-Benz, Adidas, and Hugo Boss. In 2003, he designed the Loftcube, a temporary residence intended for rooftop installation (Berlin), that is directly related to the Belgian project published here (Hotel Château de la Poste, Maillen, 2011). Recent work includes a number of furniture design projects for Vitra, Interlübke, and Moroso, as well as the 25hours Hotel (Berlin, 2013).

## ANDERSSON-WISE

Andersson-Wise Architects
807 Brazos Street, Suite 800
Austin, TX 78701 | USA

Tel: +1 512 476 5780
E-mail: robin@anderssonwise.com
Web: www.anderssonwise.com

Arthur W. Andersson and F. Christian Wise founded Andersson-Wise Architects in 2001, subsequent to a 15-year collaboration with the late Charles W. Moore. Arthur Andersson was born in Gillette, Wyoming, and received a Bachelor of Environmental Design from the University of Kansas in 1979. He cofounded Moore/Andersson Architects with Charles Moore in 1990. F. Christian Wise was born in Lancaster, Pennsylvania, and received a B.Arch from the University of Texas (Austin, 1987) and a Master in Design Studies / History and Theory from the Harvard GSD (Cambridge, 1995). He worked with Venturi, Rauch, and Scott Brown, before becoming a Senior Associate in Moore/Andersson Architects. Their work includes the Chihuly Bridge of Glass near Arthur Erickson's Tacoma Museum of Glass (Tacoma, Washington, 2000–02); Lake House (Austin, Texas, 2002, published here); the Beach Museum of Art (Manhattan, Kansas, 2006); the Cabin on Flathead Lake (Polson, Montana, 2007, also published here); Topfer Theater at ZACH (Austin, 2012); Dormitory and Faculty Residences, St. Stephen's Episcopal School (Austin, 2012); and the Dining Hall and Student Center, St. Stephen's Episcopal School (Austin, 2013), all in the USA.

## ANM

ANM
22–7 Samcheong-ro 11-gil | Jongno-gu
Seoul 110–230 | South Korea

Tel: +82 2 732 0382
Fax: +82 2 732 0389
E-mail: welcome@studioanm.com
Web: www.studioanm.com

Kim Hee Jun was born in 1968 in Jangheung, South Korea. He graduated from Hanyang University in Architectural Engineering (1996). From 1996 to 1998, he worked with BCHO Architects in Seoul as a designer. From 1998 to 2005, he was an architect with Studio A&M, also in Seoul, and then a Partner of the firm from 2005 to 2009. He founded ANM in 2009. His work includes Manas Gallery (Yangpyeong, 2005); Kim Residence (Yangpyeong, 2006); Second House (Gapyeong, 2009); Monk's Cabin (Pyeongchang, 2009, published here); Mook-ri Residence (Yongin, 2012); Dasarang Church (Yeoju, 2012–); and C Church (with eu.k architects; Paju, 2013–), all in South Korea.

## AR DESIGN STUDIO

AR Design Studio Ltd.
Calpe House
20 Little Minster Street
Winchester
Hampshire SO23 9HB
UK

Tel: +44 19 62 86 45 45
E-mail: info@ardesignstudio.co.uk
Web: ardesignstudio.co.uk

Andy Ramus was born in London in 1971. He was educated at the University of Plymouth, School of Architecture (B.A. and DIP Arch). He completed RIBA Part 3 at the AA in London in 2000. He has been the Director of AR Design Studio since 2000. His work includes the Boathouse (Cotswolds, 2002, published here); Abbots Way (Southampton, 2010); Lighthouse 65 (Hill Head, Fareham, 2011); the Glass House (Winchester, 2012); and the Manor House Stables (Winchester, 2013). Work in progress includes the Folding House (Ringwood), all in the UK.

## AVANTO ARCHITECTS

Avanto Architects, Ltd.
Kalevankatu 31 a 3
Helsinki 00100 | Finland

Tel: +358 50 353 10 95
E-mail: ark@avan.to
Web: www.avan.to

Anu Puustinen was born in Kuusamo, Finland, in 1974. She studied Mathematics at the University of Helsinki (1993–94), before going on to study Architecture at the Technical University of Delft (1999–2000). She obtained her M.Sc in Architecture from the Helsinki University of Technology (HUT, 1994–2004). She worked with SARC Architects in Helsinki from 2000 to 2004. Ville Hara was born in 1974 in Helsinki. He studied at the École d'Architecture Paris-Belleville (1997–98) and obtained his M.Arch from the HUT (1994–2002). He also worked with SARC (1999–2004), before cofounding Avanto Architects with Anu Puustinen in 2004. The Four-Cornered Villa (Virrat, published here) and the Chapel of St. Lawrence (Vantaa) date to 2010, while their recent work, all in 2013, includes Villa Anna (Lappeenranta); invited competitions for a new church with White Arkitekter (Rørvik Kirke, Norway); and competitions for new housing solutions for autistic people (Kotka, Seinäjoki), all in Finland unless stated otherwise.

## BALANCE ASSOCIATES

Balance Associates, Architects
80 Vine Street, Suite 201
Seattle, WA 98121
USA

Tel: +1 206 322 7737
E-mail: balarc@balarc.com
Web: www.balanceassociates.com

Balance Associates began consulting for government agencies and utilities on energy-efficient building designs and programs in 1980. Tom Lenchek is the founder of Balance Associates Architects, an eight-person firm with offices in Seattle and Winthrop, Washington. The firm focuses on residential architecture and planning. Lenchek studied at the University of Wisconsin, Milwaukee, and has co-authored several books on energy-efficient design. The firm's work includes Elbow Coulee (Methow Valley, Washington, 2001); Edelweiss Cabin (Methow Valley, Washington, 2002); the Wintergreen Cabin (Mazama, Washington, 2005, published here); the Foster Loop Cabin (Mazama, Washington, 2007, also published here); the Bottle Bay Residence (Sand Point, Idaho, 2007); Stud Horse Mountain (Methow Valley, Washington, 2007); and Cortes Residence (Cortes Island, British Columbia, Canada, 2010), all in the USA unless stated otherwise.

## BAUMRAUM

baumraum
Andreas Wenning
Borchersweg 14
28203 Bremen
Germany

Tel: +49 421 70 51 22
Fax: +49 421 79 463 51
E-mail: a.wenning@baumraum.de
Web: www.baumraum.de

Andreas Wenning was born in 1965 in Mönchengladbach, Germany. He studied as a cabinetmaker in south Germany (1982–85), and as an Architect at the Technical University of Bremen, where he obtained his degree in 1995. He worked in various offices in Germany and in the office of José Garcia Negette in Sydney, Australia (2000–01), before creating his own office, baumraum, in Bremen in 2003. His completed work includes the Lookout Tree House (Seeboden, Austria, 2005); Casa Girafa (Curitiba, Brazil, 2006); Meditation Tree House (Rome, Italy, 2007); Cliff Tree House (New York State, USA, 2007); Copper Cube Tree House (near Berlin, Germany, 2009); Belvedere Tree House (Basel, Switzerland, 2010); Tree Whisper Tree House Hotel (Bad Zwischenahn, Germany, 2011); House on Stilts (Menoz, Argentina, 2012); the Tree House (Hechtel-Eksel, Belgium, 2012); Tree House Resort (Schrems, Austria, 2013); Tau-Nuss Tree House (Königstein, Germany, 2013, published here); and "Tree House"—an installation in the Schlossgarten (Oldenburg, Germany, 2014). His firm offers to build unique tree houses and other hideaways for clients. In 2009, he published a book on his work entitled *Baumhauser: Neue Architektur in den Bäumen* (Berlin).

## JOSEPH BELLOMO

Bellomo Architects
116 University Avenue, Suite 100
Palo Alto, CA 94301 | USA

Tel / Fax: +1 650 326 0374
E-mail: contact@bellomoarchitects.com
Web: www.bellomoarchitects.com

Without attending architecture school, Joseph Bellomo, born in 1953, began to work on a number of design-build projects during a six-year period after his high-school education. He then studied at the University of California, Berkeley and at Harvard, and is today a licensed architect in California, Arizona, and Hawaii. He is an active proponent of modular and sustainable designs and has served on the Planning and Transportation Commission and Architectural Review Board of the City of Palo Alto, California. His work includes Alester House (Palo Alto, 2010); 102 University Circle (Palo Alto, 2011); House Arc (Kailua-Kona, Big Island, Hawaii, 2011, published here); and 102 Residential Units (Palo Alto, 2011), all in the USA.

## JIM CASTANES

Castanes Architects
1932 First Avenue, Suite 828
Seattle, WA 98101
USA

Tel: +1 206 441 0200
Fax: +1 206 728 2341
E-mail: info@castanes.com
Web: www.castanes.com

Jim Castanes was born in Vallejo, California. He lived in Naples, Italy, for four years while traveling in Europe, before obtaining his B.Arch degree at the University of Arkansas (1970–75). He established his firm in Seattle in 1984, after an apprenticeship in the Chicago firm Schmidt, Garden and Erickson. His work includes the Villa Astra (Lake Washington, Seattle, 1997/2012); Tree House on Hood Canal (Hood Canal, Washington, 2002–03, published here); Beachball House (Westport, Washington, 2010); Lake Washington Residence (Seattle, 2011); and Similk Bay (Anacortes, 2012), all in Washington, USA.

## CCS ARCHITECTURE

CCS Architecture
44 McLea Court
San Francisco, CA 94103
USA

Tel: +1 415 864 2800
Fax: +1 415 864 2850

E-mail: info@ccs-architecture.com
Web: www.ccs-architecture.com

Cass Calder Smith established his architectural firm in 1990. Born in 1961 in New York, he has lived in California since 1972. He received his B.Arch and M.Arch degrees from the University of California, Berkeley. The son of an Academy Award winning filmmaker and a California landscape painter and designer, "his early years were influenced by both Greenwich Village intellectuals and rural California artisans." His work includes the Sandton Sun Resort (Johannesburg, South Africa, 2010); Twenty Five Lusk (San Francisco, 2010); the Mill Valley Residence (Mill Valley, California, 2011); Diane Middlebrook Studios (Woodside, California, 2011, published here); Hyatt Regency Atlanta (Atlanta, Georgia, 2012); Grand Hyatt San Francisco, Union Square (San Francisco, 2012); the Olympic Club (San Francisco, 2013); and, currently under construction, the Stone Casino (Citrus Heights, California, 2014–), all in the USA unless stated otherwise.

## CPLUSC

CplusC Architectural Workshop
62 Ivy Street
Darlington, NSW 2008
Australia

Tel: +61 2 9690 2211
E-mail: info@cplusc.com.au
Web: www.cplusc.com.au

Clinton Cole received his B.Sc degree in Architecture from the University of Sydney in 1994. He also received a B.Arch from the University of Sydney in 1999. He worked with a number of Sydney offices before creating CplusC Architectural Workshop in 2004. He is one of only a few registered architects and licensed builders in Australia. His built work includes St. Albans Residence (St. Albans, NSW, 2002, published here); Bowen Mountain Residence (Bowen Mountain, NSW, 2004, also published here); the Tennyson Point Residence (Tennyson Point, Sydney, 2009); Castlecrag Residence (Castlecrag, Sydney, 2011); Curl Curl Residence (Curl Curl, Sydney, 2011); and the Kensington Residence (Kensington, Sydney, 2012). The Waverley Residence (Waverley, Sydney, 2014) is under construction, and the architect has other projects in the planning stage, such as the North Bondi Residence (Waverley, Sydney, 2015); and the Castlecrag Tree House (Castlecrag, Sydney, 2015), all in Australia.

## DMVA

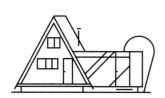

dmvA Architects
Drabstraat 10
2680 Mechelen | Belgium

Tel: +32 15 33 09 86
E-mail: info@dmva-architecten.be
Web: www.dmva-architecten.be

Tom Verschueren was born in Hoogstraten, Belgium, in 1970 and studied architecture at the Henry van de Velde College in Antwerp (1993). He created dmvA with David Driesen in 1997. dmvA is the Dutch abbreviation for "by means of Architecture." David Driesen was born in 1968 in Duffel, Belgium. In 1992, he graduated in Architecture, with Town-Planning as his specialty, from Sint Lucas, Brussels. Their work includes Blob VB3 (various locations, 2008–09); offices for Mahla Solicitors (Mechelen, 2010); sports hall, KA Hiel (Brussels, 2010); Extension vB4 (Brecht, 2010–11, published here); BUSO (Mechelen, 2011); Pool K (Grimbergen, 2011); House Vmvk (Sint-Katelijne-Waver, 2012); and the extension of the Hof Van Busleyden City Museum (in collaboration with Hlc R, Mechelen, 2013). Current work includes School 1 (Brussels, 2013–15) and School 13 (Brussels, 2013–15), all in Belgium.

## EGGLESTON FARKAS

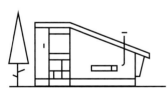

Eggleston Farkas Architects
1821 Tenth Avenue West
Seattle, WA 98119
USA

Tel: +1 206 283 0250
Fax: +1 206 283 0247
E-mail: info@eggfarkarch.com
Web: www.eggfarkarch.com

John Eggleston was born in Buffalo, New York. He received a B.A. in Architecture from the University of Idaho (1984). He was a cofounder of Eggleston Farkas (1999). Allan Farkas was born in Washington, D.C., and studied at the University of Pennsylvania (B.A. in Design of the Environment, 1989) and at the University of Washington (M.Arch, 1993). Their Methow Cabin (Winthrop, Washington, 2000, published here) was the winner of an AIA Northwest and Pacific Region Honor Award (2002) and was Architectural Record's House of the Month (October 2003). Other completed work includes the

Decatur Cabin (Decatur Island, Washington, 2008); Nighthawk Retreat (Eastern Cascades, Washington, 2008); Lopez Cabin (Lopez Island, Washington, 2010); and the Swallow's Nest (Shelton, Washington, 2013–), all in the USA.

## ROBIN FALCK

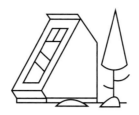

Robin Falck
Katajanokankatu 3 G
00160 Helsinki
Finland

Tel: +358 482 92 99
E-mail: mail@robinfalck.com
Web: www.robinfalck.com

Robin Falck was born in 1990. He received his B.A. degree in Industrial Design from the Aalto University of Art, Design, and Architecture (Helsinki) in 2011. He has been the Creative Director of his own firm, Falck Helsinki, since 2012. Before that, he worked as a photographer. As he is quite young, his project list is not long, but it is clear that Robin Falck has numerous talents, including those required to design Nido (published here), when he was just 19.

## FANTASTIC NORWAY

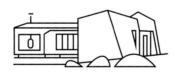

Fantastic Norway
Storgata 37a
0182 Oslo
Norway

Tel: +47 95 18 82 15
E-mail: mail@fantasticnorway.no
Web: www.fantasticnorway.no

Håkon Matre Aasarød was born in 1979 and received his B.Arch from the Bergen School of Architecture (Norway, 2000–03) and his M.Arch from the Oslo School of Architecture and Design (Norway, 2006–07). He is a Founding Partner of Fantastic Norway and chief designer of its cabins. He designed the Vardehaugen Cabin (Fosen, Norway, 2007–08) published here. Cofounder and Partner Erlend Blakstad Haffner was born in 1980. He attended the Bergen School of Architecture (Norway, B.Arch, 2000–03) and London Metropolitan University (M.Arch, 2006–07). The architects were hosts of an architectural program on on NRK television (2010). Their work includes temporary exhibitions, such as

the "Cardboard Cloud" (Oslo, 2009) or "Walking Berlin," in the context of the 2009 International Design Festival in the German capital. Other work includes the Mountain Hill Cabin (Sjoga, 2010); Bogyvær Cabin (Bogøyvær, 2010); and the institutional building House of Families (Nuuk, Greenland, 2011), all in Norway unless indicated otherwise.

## URS PETER "UPE" FLUECKIGER

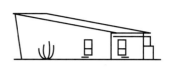

Urs Peter "Upe" Flueckiger
College of Architecture, Texas Tech University
18th Street and Flint, 309 Architecture Building
Lubbock, TX 79410–2091 | USA

Tel: +1 806 742 3136
E-mail: upe.flueckiger@ttu.edu
Web: http://upeflueckiger.com

Urs Peter "Upe" Flueckiger was born in 1964 in Herzogenbuchsee, Switzerland. He is a Full Professor in the College of Architecture at Texas Tech University in Lubbock, Texas, where he also maintains his architectural practice. Prior to 1998, he worked for several architectural firms in Switzerland, including the office of Mario Botta in Lugano, and in New York City in the office of David Rockwell (Rockwellgroup). In 1998, he joined the faculty of the College of Architecture at Texas Tech. He holds an M.Arch degree from Virginia Polytechnic Institute and State University in Blacksburg, Virginia. His work includes the House on 21st Street (Lubbock, 2001–04); Sustainable Cabin, a prefabricated design-build project as part of an elective Product Design course conceived at the College of Architecture, Texas Tech University (Crowell, 2008–10, published here); Four Artists Studio for Charles Adams at LHUCA (Lubbock, 2009–10); Charles Adams Gallery and Residence (Lubbock, 2010–11); and Talkington Studios (Lubbock, 2010–13), all in Texas, USA.

## MALCOLM FRASER

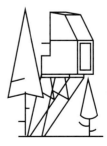

Malcolm Fraser Architects
28 North Bridge
Edinburgh EH1 1QG | UK

Tel: +44 131 225 25 85
Fax: +44 131 226 18 95
E-mail:architecture@malcolmfraser.co.uk
Web: www.malcolmfraser.co.uk

Malcolm Fraser was born in 1959, and raised and educated in Edinburgh, Scotland. Following graduation, he worked as a community architect in Wester Hailes, for Christopher Alexander in California, and for the artist and philosopher Ian Hamilton Finlay, at his garden of Little Sparta, in the Scottish Borders. In 2012, he was named Chair of the Scottish Government's Town Center Review. His firm's projects include the Scottish Ballet Headquarters (Glasgow, 2009); the Outlandia Fieldstation (Glen Nevis, Lochaber, 2008–10, published here); Royal Conservatoire of Scotland, Speirs Locks Studios (Glasgow, 2010–); and the Edinburgh Center for Carbon Innovation (2013). Current work includes the Lews Castle and Museum (Stornoway, Lewis, Western Isles, 2014); the Royal Conservatoire of Scotland, Speirs Locks Studios Phase 2 (Glasgow, 2014); and the Arcadia Nursery, Edinburgh University (2014), all in the UK.

## TERUNOBU FUJIMORI

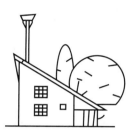

Terunobu Fujimori
Kogakuin University
1-24-2 Nishi-shinjuku
Shinjuku-ku
Tokyo 163-8677 | Japan

Tel/Fax: +81 3 3340 3574
E-mail: dt13300@ns.kogakuin.ac.jp

Born in Chino City, Nagano, Japan, in 1946, Terunobu Fujimori attended Tohoku University (1965–71) in Sendai, before receiving his Ph.D. in Architecture from the University of Tokyo (1971–78). He is a Professor Emeritus at the University of Tokyo's Institute of Industrial Science. Although research on Western-style buildings in Japan from the Meiji period onwards remains his main activity, he is also a practicing architect. "I didn't start designing buildings until my forties, so the condition I set for myself is that I shouldn't just repeat the same things that my colleagues or professors were doing," he has stated. His first built work was the Jinchokan Moriya Historical Museum (Chino City, Nagano, 1990–91), which won mixed praise for the use of local materials over a reinforced-concrete structure. Other completed projects include the Akino Fuku Art Museum (Hamamatsu, Shizuoka, 1995–97); Nira House (Leek House, Machida City, Tokyo, 1995–97); Student Dormitory for Kumamoto Agricultural College (Koshi City, Kumamoto, 1998–2000); Ichiya-tei (One Night Teahouse, Ashigarashimo, Kanagawa, 2003); the Takasugi-an (Too-High Teahouse, Chino City, Nagano, 2004), set six meters above the ground like a tree house; Chashitsu Tetsu (Teahouse Tetsu, Musée Kiyoharu Shirakaba, Nakamaru, Hokuto City, Yamanashi, 2005); and Charred Cedar House (Nagano City, Nagano, 2006–07). He also completed the Roof House (Omihachiman, Shiga, 2008–09) and Copper House (Kokubunji City, Tokyo, 2009). Recent work includes

the "Beetle's House" (Victoria & Albert Museum, London, UK, 2010); the Walking Café (Munich, Germany, 2012); Hamamatsu House (Shizuoka, 2012); and the Storkhouse (Raiding, Austria, 2011–13, published here), all in Japan unless stated otherwise.

## GABRIELA GOMES

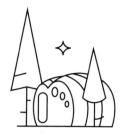

Gabriela Gomes
Rua Barão de S. Cosme 261
Porto 4000-503 | Portugal

Tel: +351 916 30 85 01
E-mail: gg@bygg.com.pt / info@shelterbygg.com
Web: www.shelterbygg.com / www.bygg.com.pt

Gabriela Gomes was born in 1968 in Porto. She graduated in Fine Arts—Sculpture at the School of Fine Arts of Porto in 1992. She also concluded the Graduate Industrial Design program at the School of Art and Design of Matosinhos. She worked on a number of art-related projects in Portugal, France, and Brazil between 1992 and 2006. In 2006, she created bygg, a personal product-design project. In 2010, her work was selected in the framework of "Destination Portugal" for shops at MoMA in New York and Tokyo. In 2012, her Shelter ByGG, a "habitable sculpture" (published here), was presented in the context of Guimarães 2012—European Capital of Culture. She also presented a play under the name "Shelter ByGG" in the Devesa Park of Famalicão in 2013.

## HAWORTH TOMPKINS

Haworth Tompkins
33 Greenwood Place
London NW5 1LB | UK

Tel: +44 20 72 50 32 25
E-mail: info@haworthtompkins.com
Web: www.haworthtompkins.com

Graham Haworth studied Architecture at the Universities of Nottingham and Cambridge. After graduation in 1984, he worked in the US for Skidmore, Owings & Merrill, and Holt Hinshaw Pfau Jones. On returning to the UK, he worked for Bennetts Associates, before forming Haworth Tompkins with Steve

Tompkins in 1991. Steve Tompkins studied architecture at Bath University and traveled in Asia, before joining Arup Associates in London. He was a founding member of Bennetts Associates in 1987 prior to forming Haworth Tompkins with Graham Haworth. Projects by the practice include the Coin Street Housing and Neighborhood Center (South Bank, London, 2001–07); The Young Vic (London, 2006); Aldeburgh Music Creative Campus (Snape Maltings, Aldeburgh, 2009); Dovecote Studio (Snape Maltings, Snape, 2009, published here); the Open Air Theater, Regent's Park (London, 2000–12); and The London Library, St. James's Square (London, 2007–13). Current work includes the Royal College of Art (London, 2009–14); the Chichester Festival Theater (2014); and the National Theater South Bank (London, 2013–15), all in the UK.

## DREW HEATH

Drew Heath Architects
10 Mitchell Street
McMahons Point
Sydney, NSW 2060
Australia

Tel: +61 4 1449 1270
E-mail: drewheath@ozemail.com.au
Web: www.drewheath.com.au

Drew Heath was born in 1968. He graduated from the University of Tasmania in 1993 and worked from 1993 to 1996 with Sam Marshall Architects. In 1996, he founded Drew Heath Architects. His work includes the Zig Zag Cabin (Wollombi, New South Wales, 2002, published here); Mitchell Street (McMahons Point, Sydney, 2011); the Bondi House (Sydney, 2012); and the Marrickville House (Sydney, 2013), all in Australia.

## HERREROS ARQUITECTOS

Herreros Arquitectos
c/Princesa 25
Hexágono, Planta 5ª oficina 7
28008 Madrid | Spain

Tel: +34 91 522 77 69 | Fax: +34 91 559 46 78
E-mail: estudio@herrerosarquitectos.com
Web: www.herrerosarquitectos.com

Juan Herreros Guerra was born in San Lorenzo de el Escorial, Spain, in 1958 and studied in the school there. He was a Founding Partner of Ábalos & Herreros from 1984 to 2006. Their built work included the notable Woermann Tower and Square (Las Palmas de Gran Canaria, 2001–05). He is the Chair Professor and Director of the Thesis Program at the Madrid School of Architecture, as well as Full Professor at Columbia University (New York). The work of Herreros Arquitectos includes the Satellite Control Center and Headquarters of Hispasat (Madrid, Spain, 2010); Garoza House (Ávila, Spain, 2010, published here); an urban folly (Gwangju, South Korea, 2011); and the Bank of Panama Tower (Panama City, Panama, 2012). Work currently in progress includes the Munch Museum (Oslo, Norway, 2009–); Bogotá International Convention Center (Bogotá, Colombia, 2011–); Panama City Waterfront (Panama City, Panama, 2011–); and the Ecocité Marseille Housing Complex (Marseille, France, 2013–).

## PAUL HIRZEL

Paul Hirzel Architect
1575 SW Wadleigh Drive
Pullman, WA 99163 | USA

Tel: +1 509 592 7725
E-mail: paulhirzelarchitect@gmail.com
Web: www.paulhirzel.com

Paul Hirzel received Bachelor's degrees in Humanities from Washington State University; in Art Education and Industrial Education from the University of Washington; and in Architecture from Cornell University. He received his M.Arch with a minor in Landscape Architecture from Cornell University in 1984. His professional experience includes a private practice in Ithaca, New York; Louisville, Kentucky; Bainbridge Island, Seattle; and Pullman, Washington. Work includes the Canyon Houses (Clearwater River Canyon, Idaho, 2004); Mountain House (Moscow Mountain, Idaho, 2010); and River Structures (Potlatch River, near Julietta, Idaho, 2010–12, published here), all in the USA.

## IMANNA

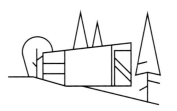

Imanna Arkitekter AB | Jungfrugatan 64
115 31 Stockholm | Sweden

Tel: +46 73 985 05 78
E-mail: info@imanna.se | Web: www.imanna.se

Joakim Leufstadius was born in 1968 in Stockholm, Sweden. He received his architectural education at the Politecnico di Milano, Italy, and the KTH Stockholm. He has founded several firms, called Movado, Joakim Leufstadius Arkitektur, and most recently Imanna together with Anna Ericson. Their work includes Cabin 4:12 (Ingarö, 2000–02, published here); Whyred Stores (various European locations between 2003 and the present); Dos-Distans Pharmacy (Falun, 2006); Villa Listuden (Stockholm, 2007); Flying a Flagship Store (Copenhagen, Denmark, 2011); Centralbadet (Stockholm, 2011); Villa Strand, Garden Shed (Stockholm, 2013); and Villa Cuckoo Nest (Sollentuna, 2013–), all in Sweden unless otherwise indicated.

## IN-TENTA

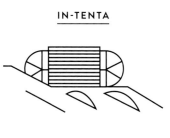

In-Tenta
Aribau 12, 5° 2ª
08011 Barcelona
Spain

Tel: +34 93 317 37 89
E-mail: bcn@in-tenta.com
Web: www.in-tenta.com

Manel Duró was born in 1969 in Jaén, Spain. He is an interior designer and photographer. He did Multimedia Studies at the Universitat Oberta de Catalunya (UOC, 2007). Marta Gordillo was born in 1972 in Barcelona. She studied Architecture at the Barcelona ETSAB (1998) and worked in several architecture offices, before creating estudibasic Design & Image, an interior design studio specialized in graphic communication and CGI (computer-generated images), in 2007 with Manel Duró. Daniela Seminara, born in 1976 in Rho, Italy, received a Ph.D in Design and Communication at the Politecnico di Milano (2009). She set up her own business in 2007, the danielaseminara studio. In January 2012, Manel Duró, Marta Gordillo, and Daniela Seminara cofounded In-Tenta, which is a design studio that has also been involved in "micro architecture." The All-in-Square kiosk with modular urban furniture and external floor covering for the public was completed in Barcelona in 2012. They have also designed street furniture, OLED lighting fixtures, and furniture for children's seating. Their DROP Eco-Hotel (various locations, 2012, published here) is meant to be usable in natural settings.

## JENSEN & SKODVIN ARCHITECTS

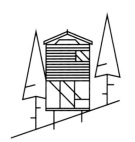

Jensen & Skodvin Arkitektkontor AS
Fredensborgveien 11
0177 Oslo | Norway

Tel: +47 22 99 48 99
Fax: +47 22 99 48 88
E-mail: js@jsa.no
Web: www.jsa.no

Jensen & Skodvin was founded in 1995 by Olav Jensen and Børre Skodvin. Born in 1959, Olav Jensen received his degree from the Oslo School of Architecture in 1985. He has been a Professor at the Oslo School of Design and Architecture since 2004. He was the Kenzo Tange Visiting Critic at Harvard University (1998), and won a 1998 Aga Khan Award for Architecture for the Lepers Hospital, in Chopda Taluka, India. Børre Skodvin was born in 1960 and received his degree from the Oslo School of Architecture in 1988. He has been a teacher at the Oslo School of Design and Architecture since 1998. Their built work includes the Storo Metro Station (Oslo, 2003); Headquarters and Exhibition Space for the Norwegian Design Council (Oslo, 2004); Sinsen Metro Station (Oslo, 2005); a multipurpose city block (Trondheim, 2005; collaboration with Team Tre); the Tautra Maria Convent (Tautra Island, 2004–06); and a thermal bath, therapy center, and hotel (Bad Gleichenberg, Austria, 2005–08). They have worked on the Gudbrandsjuvet Tourist project, viewing platforms, and bridges (Gudbrandsjuvet, 2008); the Juvet Landscape Hotel (Gudbrandsjuvet, 2007–09, Phase 1); and Giørtz Summer House (Valldal, 2012), all in Norway unless stated otherwise. Phase 2 of the Juvet Landscape Hotel (2012–13) is published here. Ongoing work includes a plan for a new town in south Oslo (2005–15).

## GUÐMUNDUR JÓNSSON

Guðmundur Jónsson Arkitektkontor
Aslakveien 16 A
Oslo 0753
Norway

Tel: +47 92 64 92 28
E-mail: gjonsson@online.no
Web: www.gudmundurjonsson.com

Guðmundur Jónsson was born in 1953 in Iceland. He attended the Oslo School of Architecture (AHO, 1975–81) and worked in the offices of Eliassen & Lambertz-Nilssen and Lund & Slaatto in Oslo between 1981 and 1987. He created his own office in 1987 as a result of having won the Scandinavian competition for the Icelandic Concert Hall. His work includes the Norwegian Fjord Center (Geiranger, 2002); the Ibsen Museum (Oslo, 2006); Pavilion for a Viking Ship (Reykjanesbær, Iceland, 2008); and Hardangervidda National Park Center (Hardangervidda, 2012). He designed a number of cabins in Bjergøy, including

Cabin GJ-9 (2010–11, published here), all in Norway unless stated otherwise, and is presently working on several single-family houses in Oslo.

## TADASHI KAWAMATA

kamel mennour
47 Rue Saint-André des Arts /
6 Rue du Pont de Lodi
75006 Paris | France

Tel +33 1 56 24 03 63
Fax: +33 1 40 46 80 20
E-mail: galerie@kamelmennour.fr
Web: www.kamelmennour.fr

Annely Juda Fine Art
23 Dering Street
London W1S 1AW | UK

Web: annelyjudafineart.co.uk

Tadashi Kawamata was born on the Island of Hokkaido, Japan, in 1953. As a young man in Tokyo, Kawamata was struck by the impermanence of the Japanese capital, its construction sites, dumping grounds, and the cardboard shelters of the homeless. He has used wood and improvised passageways as a form of artistic expression since the early 1980s in several different countries. In 1992, he completed the Roosevelt Island Project, a wooden assemblage in and around the abandoned Small Pox Hospital, just across the river from the skyscrapers of midtown Manhattan. His "Passage des Chaises" was a construction made of wooden chairs inside a Paris chapel (Le Passage des Chaises, Saint-Louis de la Salpêtrière Chapel, 1997). Recent work includes his "Tree Huts" in New York (New York, USA, 2008); his "Tree Huts" at the Centre Pompidou (Paris, France, 2010); and the Mukaijima Project (Japan, 2010). Since 2008, he has built "Tree Huts" in various locations in Paris, most recently in the Place Vendôme (October 21—November 11, 2013, published here).

## JOHN KÖRMELING

John Körmeling | Tongelresestraat 64
Eindhoven 5613DM | The Netherlands

Tel: +31 40 245 47 86
E-mail: john@kormeling.nl
Web: www.kormeling.nl

John Körmeling was born in 1951 in Amsterdam, the Netherlands, and lives and works in Eindhoven. He studied Architecture at the Eindhoven University of Technology (1969–81). His work includes Drive-In Wheel (Utrecht, 1998–99); a Teashop (Breda, 1995–2002); the Rotating House (Tilburg, 1999–2008); Hot Spring (Matsunoyama, Japan, 2001–03); Echt iets voor u, the "shortest covered bridge in the world" (Van Abbemuseum, Eindhoven, 2006); Happy Street, Dutch Pavilion, Shanghai World Expo (China, 2006–10); Stage Door (Middelheimmuseum, Antwerp, Belgium, 2004–12); and the Welcome Bridge (Tilburg, 2011–13, published here), all in the Netherlands unless otherwise indicated. Körmeling is described as an "artist and architect," and his work is, indeed, often situated at the juncture between these two disciplines.

## LEAPFACTORY

LEAPfactory
Via Alessandria 51/E
10152 Turin | Italy

Tel: +39 011 230 80 42 | Fax: +39 011 230 80 19
E-mail: info@leapfactory.it
Web: www.leapfactory.it

Stefano Testa was born in Milan, Italy, in 1966 and graduated in Architecture in 1992 from the Politecnico di Milano. He is a Partner in the architecture office Cliostraat in Turin. Luca Gentilcore, born in Sanremo in 1978, studied Architecture at the Politecnico di Torino, from which he graduated in 2004. In 2008, he founded is own office, Gandolfi Gentilcore Architetti, in Turin. The pair created LEAPfactory (which stands for Living Ecological Alpine Pod) in 2010. This Italian firm seeks to design and produce a new generation of shelters and technological structures. The alpine Gervasutti Refuge (Mont Blanc, Courmayeur, Italy, 2011) is only one of the LEAPfactory projects. They are working on a number of other modular products for "living at zero impact" in sensitive environments that need protection, while another current research trend explores the opportunities to apply their experience gained at high altitudes to prefabricated housing systems. The architects have also studied a modular system to dispose of human waste and other refuse in high-altitude structures, such as their Depuration Unit LEAPeco R (G. Bertone Refuge, Courmayeur, Italy, 2013). Published here is LEAPrus 3912 (Mount Elbrus, Caucasus, Russia, 2013).

## MAFCOHOUSE

Mafcohouse
Toronto, Haliburton
Ontario | Canada

Tel: +1 416 985 0597
E-mail: info@mafcohouse.com
Web: www.mafcohouse.com

Dan Molenaar, born in Port Hope, Ontario, in 1959 is the owner of Mafcohouse. He is "a licensed journeyman carpenter and is trained in architectural technology, building design, and construction." He studied Architecture at Ryerson University, Toronto, and apprenticed as a carpenter at the Darlington Nuclear Facility, Ontario Power Generation. He has completed projects for Taillon Silvan (Muskoka, 2012); Colero Thomson (Georgian Bay, 2012); Bradley Lothian (Kinmount, 2013); Perey (Georgian Bay, 2013); Bullock Howell (Prince Edward County, 2013); and Angus Abelsohn (Haliburton, 2013); as well as the Franke-Mirzian Bunkhouse (Haliburton, 2013, published here), all in Ontario, Canada.

## MARTE.MARTE

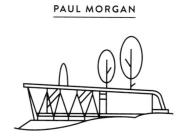

Marte.Marte Architects
Totengasse 18
Weiler, Vorarlberg 6833 | Austria

Tel: +43 552 35 25 87 | Fax: +43 552 352 58 79
E-mail: architekten@marte-marte.com
Web: www.marte-marte.com

Bernhard Marte was born in 1966 in Dornbirn, Vorarlberg, Austria, and his brother, Stefan Marte, was born in the same locality in 1967. They obtained their M.Arch degrees from the Technical University of Innsbruck. Stefan Marte worked in the office of Gohm + Hiessberger in Feldkirch until Marte.Marte was created in Weiler in 1993. Their work includes the Schanerloch Bridge (Dornbirn, 2005–06); State Pathology Hospital (Feldkirch, 2003–08); Alfenz Bridge (Lorüns, 2009–10); Grieskirchen School Center (Grieskirchen, 2003–11); Special Pedagogical Center (Dornbirn, 2008–11); Diocesan Museum (Fresach, 2010–11); Mountain Cabin (Laterns, 2010–11, published here); Maiden Tower (Dafins, 2011–12); and a Tourism School (Villach, 2011–13), all in Austria. They are currently working on the SFVV Museum (Berlin, Germany, 2013–16).

## PAUL MORGAN

Paul Morgan Architects
Level 10, 221 Queen Street
Melbourne, Victoria 3000
Australia

Tel: +61 3 9605 4100 | Fax: +61 3 9602 5673
E-mail: office@paulmorganarchitects.com
Web: www.paulmorganarchitects.com

Paul Morgan was born in 1960. He received his B.Arch (1987) and Master of Design (Urban Design, 1992) degrees from RMIT University. He has been the Director of Paul Morgan Architects since 2003. His work includes the Cape Schanck House (2006); Avenel House (Avenel, Victoria, 2006); Trunk House (Central Highlands, Victoria, 2010–11, published here); Automotive and Logistics Center (Dandenong, Victoria, 2011); Center for Neural Engineering, University of Melbourne (Carlton, Victoria, 2011); Epping Student Center (Epping, Victoria, 2011); and the South Melbourne Market Roof (Port Philip, 2013), all in Australia.

## HIDEMI NISHIDA

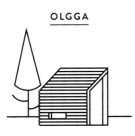

Hidemi Nishida Studio
Fantoft Studentboliger | Postboks 630
5075 Bergen | Norway

Tel: +47 41 07 99 39
E-mail: studio@hdmnsd.com | Web: hdmnsd.com

Hidemi Nishida was born in 1986 in Kanagawa Prefecture, Japan. He describes himself as an "environmental artist." He received a degree in engineering from the Kushiro National College of Technology (Hokkaido, 2002–07), a Bachelor's degree in design from Sapporo City University (2009–11), and is presently attending the Master's program at the Bergen Academy of Art and Design (2012–14). His projects include Fragile Shelter (Sapporo, Japan, 2010–11, published here); "Quiet Dining" (Old Silo, Bergen, Norway, 2013); "NextUtopia Reggio-Emilia" (Bee-Live, Reggio-Emilia, Italy, 2013); and "Garden Sky" (Mt. Rokko, Kobe, Japan, 2013).

## OLGGA

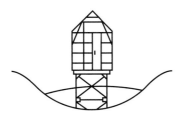

Olgga Architectes
95 Rue Montmartre
75002 Paris | France

Tel: +33 1 42 40 08 25
Fax: +33 1 42 40 08 59
E-mail: contact@olgga.fr
Web: www.olgga.fr

Alice Vaillant was born in 1976 in Saint-Lô, France. She attended the architecture schools at Paris-La Villette (1995) and Paris-Belleville (1997), before receiving her degree in Architecture (Paris-Belleville, 2002). She worked in the office of Suzel Brout (Paris, 2001–03), before the creation of Olgga Architectes in 2006. Guillaume Grenu was born in 1976 in Mont-Saint Aignan, France. He attended the École d'Architecture de Normandie (1995), Paris-La Villette (1999), and received his degree from the École d'Architecture de Normandie (2001). Nicolas Le Meur was born in Rouen, France, in 1978. He attended the École Supérieure d'art et de Design de Reims (1997), the École d'Architecture de Normandie (1998), before obtaining his degree from the École d'Architecture de Normandie (2006). Aside from the Flake House (Frossay, 2008–09, published here), the architects have completed 21 houses in Beuvrages (2011) and the Stadium du Littoral (Grande-Synthe, 2011). They have housing projects underway in Lille (2014 and 2015); Wattrelos (2014); and Colombes (2015), all in France.

## OLSON KUNDIG

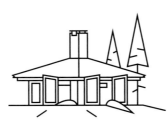

Olson Kundig Architects
159 South Jackson Street, Suite 600
Seattle, WA 98104 | USA

Tel: +1 206 624 5670
E-mail: info@olsonkundig.com
Web: www.olsonkundig.com

Tom Kundig received his B.A. in Environmental Design (1977) and his M.Arch (1981) degrees from the University of Washington. He was a Principal of Jochman/Kundig (1983–84), before becoming a Principal of Olson Kundig Architects (since 1986). Tom Kundig is the recipient of the 2008 National Design Award in Architecture Design, awarded by the Smithsonian's Cooper-Hewitt National Design Museum. As Olson Sundberg Kundig Allen Architects, the firm received the 2009 National AIA Architecture Firm Award. Jim Olson is the Founding Partner and Owner of Olson Kundig. The firm's work includes the Olson Cabin (Longbranch, Washington, 1959/2003); Delta Shelter (Mazama, Washington, 2005); Tye River Cabin (Skykomish, Washington, 2005, published here); the Rolling Huts (Mazama, Washington, 2007); Outpost Residence (Bellevue, Idaho, 2008); Montecito Residence (Montecito, California, 2008); Gulf Islands Cabin (Gulf Islands, British Columbia, Canada, 2008); The Lightcatcher at the Whatcom Museum (Bellingham, Washington, 2009); The Pierre (San Juan Islands, Washington,

2008–10); Art Stable (Seattle, Washington, 2010); Sol Duc Cabin (Olympic Peninsula, Washington, 2010–11); Charles Smith Wines Tasting Room and Headquarters (Walla Walla, Washington, 2011); Studio Sitges (Sitges, Spain, 2010); and the Bill and Melinda Gates Foundation Visitor Center (Seattle, Washington, 2012), all in the USA unless stated otherwise.

## NAREIN PERERA

Archt. Narein Perera
36 Arethusa Lane
Colombo 0600 | Sri Lanka

Tel: +94 7 7736 4638
E-mail: nareinperera@gmail.com
Web: www.mrt.ac.lk/web/staff/archt-n-perera

Narein Perera was born in 1972 in Colombo, Sri Lanka. He received a B.Sc in the Built Environment (1998) and a M.Sc in Architecture (2001) from the Department of Architecture of the University of Moratuwa, Sri Lanka. He created his own practice in 2003. Work includes the Residence at Thalangama Lake (2003); Gymkhana Club Pool Complex (Colombo, 2005); Estate Bungalow (Mathugama, 2007–09, published here); Furniture Factory, Warehouse and Showroom, Raux Brothers (Piliyandala, 2009); and additions and alterations to the Library, University of Moratuwa (ongoing), all in Sri Lanka. He was granted the Sri Lanka Institute of Architects Young Architect of the Year Award in 2010.

## RENZO PIANO

Renzo Piano Building Workshop
Via P. Paolo Rubens 29
19129 Genoa | Italy

Tel: +39 010 617 11
Fax: +39 010 617 13 50
E-mail: italy@rpbw.com
Web: www.rpbw.com

Renzo Piano was born in 1937 in Genoa, Italy. He studied at the University of Florence and at Milan's Polytechnic Institute (1964). He formed his own practice (Studio Piano) in 1965, associated with Richard Rogers (Piano & Rogers, 1971–78)—complet-

ing the Centre Pompidou in Paris in 1977—and then worked with Peter Rice (Piano & Rice Associates, 1977–80), before creating the Renzo Piano Building Workshop in 1981 in Genoa and Paris. Piano received the RIBA Gold Medal in 1989 and the Pritzker Prize in 1998. Recently completed work includes the Broad Contemporary Art Museum (Phase I of the LACMA expansion, Los Angeles, California, USA, 2003–08); the California Academy of Sciences (San Francisco, California, USA, 2008); the Modern Wing of the Art Institute of Chicago (Chicago, Illinois, USA, 2005–09); the Resnick Pavilion (Phase II of the LACMA expansion, Los Angeles, USA, 2006–10); the Ronchamp Gatehouse and Monastery (France, 2006–11); the London Bridge Tower (London, UK, 2009–12); the Tjuvholmen Icon Complex (Oslo, Norway, 2009–12); Kimbell Art Museum expansion (Forthworth, Texas, 2007–13); and Diogene (Weil am Rhein, Germany, 2013, published here). Ongoing work includes the new Whitney Museum at Gansevoort (New York, New York, USA 2007–); the Stavros Niarchos Foundation Cultural Center (Athens, Greece, 2008–); Valletta City Gate (Valletta, Malta, 2008–); and the Botín Art Center (Santander, Spain, 2010–).

## JIM POTEET

**Poteet Architects**
1114 S. St. Mary's Street, Suite 100
San Antonio, TX 78210 | USA

Tel: +1 210 281 9818
Fax: +1 210 281 9789
E-mail: info@poteetarchitects.com
Web: www.poteetarchitects.com

Jim Poteet was born in 1959 in Richmond, Virginia. He received his M.Arch at the University of Texas at Austin (1987). From 1990 to 1992, he worked with Kieran Timberlake & Harris (Philadelphia), before creating his own firm in San Antonio in 1998. Recent work includes Capps Residence (2008); Linda Pace Foundation Offices (2008); the Container Guesthouse (2009–10, published here); Ricos Products Headquarters (2010); Hill Residence (2012); Causeway Advisory Group Offices (2012), Elmendorf Residence (2013) and the Condon Residence (2013), all in San Antonio, Texas.

## RA

**RA**
Av. João Crisóstomo, 18 — 1º Esquerdo
Lisbon 1000–179 | Portugal

Tel: +351 21 356 22 86
E-mail: info@rebelodeandrade.com
Web: www.rebelodeandrade.com

Luís Rebelo de Andrade graduated in 1986 from the Faculdade de Belas Artes de Lisboa in Architecture, while working with Intergaup, a Portuguese architectural practice. He created his own firm in 1988 and began developing a project for the English Embassy in Lisbon, and the Casa do Artista, a public building for retired artists. His Aquapura Douro Hotel and Spa, in the UNESCO World Heritage district of the Douro Valley, was recognized as the best hotel in Portugal in 2008, and one of the 100 best hotels in the world, by several national and international publications. Born in Lisbon in 1982, Tiago Rebelo de Andrade received an M.Arch degree from the Faculty of Architecture of the University of Porto (2010). He completed part of his B.A. degree at Facoltá di Architettura Civile di Milano Bicocca, Politecnico di Milano, Italy, in the Erasmus program. He has also completed the Advanced Management Program at the NOVA School of Business and Economics (Lisbon, 2011). He created the firm Studio Subvert in Lisbon in 2011. He participated in the design of the House of Fragrances (Travessa do Patrocínio, Lisbon, Portugal)—in partnership with Luís Rebelo de Andrade and Manuel Cachão Tojal, Architizer prize-winner project for the Building of the Year 2012 and finalist on the site Archdaily for Building of the Year 2012; and the Tree Snake House (Pedras Salgadas Park, Portugal, 2013, published here), also in partnership with Luís Rebelo de Andrade.

## REVER & DRAGE

**Rever & Drage Architects**
Claus Riis' 6A
Oslo 0457 | Norway

Tel: +47 97 04 44 00
E-mail: post@reverdrage.no
Web: www.reverdrage.no

Tom Auger was born in 1979. He received degrees in Communication Technology at the Norwegian University of Science and Technology (NTNU, 2000–03) and an M.Arch at NTNU/AHO (Oslo School of Architecture, 2008). Amongst other offices, he has worked with Reiulf Ramstad Architects (Oslo, 2007). Eirik Lilledrange was born in 1978 and received his M.Arch degree from the NTNU in 2008 as well, as did Martin Beverfjord, who was born in 1980. Their recent work in the firm Rever & Drage Architects includes the Hustadvika Tools, tool shed and annex (Hustadvika, 2013, published here) and the Feisteinveien House (Stavanger, 2013). They are currently working on the Rådyrvegen House (Molde, 2013–); the Eidsvågveien House (Bergen, 2013–); and the Reksteren Boathouse (Reksteren, currently in development), all in Norway.

## RINTALA EGGERTSSON

**Rintala Eggertsson Architects**
Bentsebrugata 13f
0476 Oslo | Norway

Tel: +47 22 22 03 22 / +47 48 20 72 90
E-mail: post@ri-eg.com | Web: www.ri-eg.com

Rintala Eggertsson Architects was established in 2007 by the Finnish architect Sami Rintala and the Icelandic architect Dagur Eggertsson. Today, the office also includes the architects Vibeke Jenssen, Kaori Watanabe, and Masae Asada. Seeking to "occupy the space between architecture and public art," their work has been seen in the Victoria & Albert Museum in London, the MAXXI Museum in Rome, and in the Venice Biennale. Sami Rintala was born in 1969 in Helsinki, Finland. He obtained his degree in Architecture from the Helsinki University of Technology (1990–99). Dagur Eggertsson was born in 1965 in Reykjavik, Iceland. He obtained his M.Arch degree from the Helsinki University of Technology (1995–97), having previously studied at the Oslo School of Architecture and Design (1986–92). Their work includes the "Ark Booktower" (Victoria & Albert Museum, London, UK, 2010); an Arboretum (Gjövik, Norway, 2011); Seljord Watchtower (Seljord, Telemark, Norway, 2011); Hut to Hut (Kagala, Karnataka, India, 2012); Suldal Bridge (Suldal, Norway, 2013); Dragonfly (Harads Treehotel, Harads, Sweden, 2013, published here); and the Zhoushan Art Gallery (Zhoushan, Zhejiang, China, currently in development).

## HANS-JÖRG RUCH

**Ruch & Partner Architekten**
Via Brattas 2
7500 St. Moritz | Switzerland

Tel: +41 81 837 32 40 | Fax: +41 81 837 32 50
E-mail: info@ruch-arch.ch
Web: www.ruch-arch.ch

Hans-Jörg Ruch was born in 1946 and received his diploma in Architecture from the ETH in Zurich in 1971. He received his Master's from the Rensselaer Polytechnic Institute (Troy, New York, 1973) with a thesis entitled "Towards an Architecture of Tourism." From 1974 to 1977, he worked in the office of Obrist und Partner, St. Moritz, and then created a partner-

ship with Urs Hüsler (Ruch + Hüsler, Architekten, St. Moritz, 1977–88). He created his own firm in 1989. In 2010, he founded Ruch & Partner Architekten with his long-time collaborators Peter Lacher (born in 1956), Stefan Lauener (born in 1962), Heinz Inhelder (born 1970), and Thorsten Arzet (born in 1976). Since working on the Chesa Madalena in Zuoz (2001–02), he has completed numerous projects, including the Palace Gallery opposite Badrutt's Palace Hotel (St. Moritz, 2002); the reconstruction and extension of the Chamanna da Tschierva Hut for the Swiss Alpine Club (St. Moritz, 2002); Hotel Castell (Zuoz, 2004, renovation project, undertaken with UNStudio); Not Vital House (Tschlin, 2004); Chesa Albertini (Zuoz, 2006); and the renovation and extension of the Krone Guesthouse (La Punt, 2008), all in Switzerland. More recently, he completed the renovation of the Clavo Lain (Lain, 2011–12, published here).

## TODD SAUNDERS

Saunders Architecture
Vestre Torggate 22
5015 Bergen | Norway

Tel: +47 55 36 85 06
E-mail: post@saunders.no
Web: www.saunders.no

Todd Saunders was born in 1969 in Gander, Newfoundland (Canada). He obtained his M.Arch from McGill University (Montreal, Canada, 1993–95) and a Bachelor of Environmental Planning from the Nova Scotia College of Art and Design (1988–92). He has worked in Austria, Germany, Russia, and Norway (since 1996). He teaches part-time at the Bergen School of Architecture. His work includes the Aurland Lookout (with Tommie Wilhelmsen, Aurland, 2006); Villa Storingavika (Bergen, 2004–07); Villa G (Hjellestad, Bergen, 2007–09); Sogn og Fjordane summer cabin (Rysjedalsvika, Norway, 2007–10); and Solberg Tower and Parks (Sarpsborg, Østfold, 2010), all in Norway. He is currently realizing the Fogo Island Studios, four of which have been completed out of a program of six (Fogo Island, Newfoundland, Canada, 2010–11) together with the Fogo Island Inn (2010–13) in the same location; and the Salt Spring Island Cabin (Mount Tuam, Salt Spring Island, 2012, published here), also in Canada.

## SCOTT & SCOTT

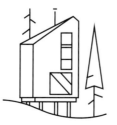

Scott & Scott Architects
299 E 19th Avenue
Vancouver, B.C. V5V 1J3
Canada

Tel: +1 604 737 2541
E-mail: hello@scottandscott.ca
Web: www.scottandscott.ca

Susan Scott received her Bachelor of Environmental Design degree from the Technical University of Nova Scotia (Halifax, 1998). She received her M.Arch at Dalhousie University (Halifax, 2000). She worked at MGB Architecture + Design (Vancouver, 2004–12), before becoming Director of Scott & Scott Architects in 2012 (Vancouver). David Scott also obtained a Bachelor of Environmental Design degree in 1998, and his M.Arch from Dalhousie University in 2000. He worked with Peter Cardew Architects, Associate (Vancouver, 2000–12), before also becoming Director of Scott & Scott in 2012. Their work includes the Alpine Cabin (Vancouver Island, 2008–13, published here); Bestie Restaurant (Vancouver, 2013); the Lac le Jeune Cabin (Lac le Jeune, 2014); and the Pender Island Farm (Pender Island, 2012–), all in British Columbia, Canada.

## STUDIO WG3

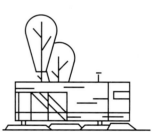

Studio WG3 | Griesgasse18
Graz 8020 | Austria

Tel: +43 664 88 46 96 71
E-mail: studio@wg3.at | Web: www.wg3.at

WG3 describe themselves as "a group of furniture designers and architects." The Partners are Albert Erjavec, Matthias Gumhalter, Christian Reschreiter, and Jan Ries. Albert Erjavec was born in 1982 in Villach. He studied Architecture at the Technical University (TU) of Graz (2000–12), before being involved in the creation of WG3 in 2011. Matthias Gumhalter was born in 1980 in Vienna. He also studied at the TU in Graz. Christian Reschreiter was born in 1982 in Salzburg, also studying at the TU Graz (2003–10). Finally, Jan Ries was born in 1981 in the Czech Republic, with studies at the TU Graz between 2003 and 2009. Their work includes the Hypercubus (Graz, 2010, published here), and the HGO 15 House (Ollersdorf, Burgenland, 2011), both in Austria.

## TAALMAN KOCH

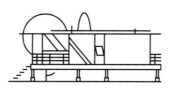

Taalman Koch Architecture
1570 La Baig Ave, Unit A
Los Angeles, CA 90028
USA

Tel: +1 213 380 1060
E-mail: laura@taalmankoch.com
Web: www.taalmankoch.com

Alan Koch was born in 1965 in Los Angeles, California. He received a BFA degree from the Otis Institute of Art, Parsons School of Design (1987–91). He then received his B.Arch degree from Cornell University (1992–95). Linda Taalman was born in 1974 in Norwich, Connecticut. She received her B.Arch degree from the Cooper Union (New York, 1993–97), and attended the Cornell University School of Architecture, Art, and Planning (Ithaca, New York, 1992–93). Taalman and Koch founded Taalman Koch Architecture in 2003. Their work includes the Saratoga IT House (Saratoga, 2008–10); Clearlake IT Cabin (Clearlake, 2010–11, published here); Goddard IT House (Santa Monica, 2010–12); and the IT Studio (Pioneertown, 2013), all in California. Current work includes the Mt. Drive IT House (Santa Barbara, 2014); the Spiess IT House (Rhinebeck, New York, 2015); and McFadden Lakey (Hollywood, California, 2015), all in the USA.

## TAYLOR SMYTH

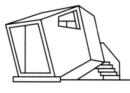

Taylor Smyth Architects
245 Davenport Road, Suite 300
Toronto, Ontario M5R 1K1
Canada

Tel: +1 416 968 6688
Fax: +1 416 968 7728
E-mail: info@taylorsmyth.com
Web: www.taylorsmyth.com

Michael Taylor is a Founding Partner of Taylor Smyth Architects. Born in 1957, he received a B.A. from the University of Chicago (1979) and an M.Arch from Harvard University (1983). From 1983 to 1987, he worked for Barton Myers Associates and then became a Senior Associate at Kuwabara Payne McKenna Blumberg Architects from 1987 to 1994. He founded Taylor Smyth Architects in 2000 with Robert Smyth, and was previously a Founding Partner of Taylor Hariri Pontarini in 1994. His work includes a number of residential projects, such as the House on a Ravine (Toronto, 2001); Sunset Cabin (Lake Simcoe, Ontario, 2004, published here); Bishop Street Residence (Toronto, 2005); Armstrong Avenue Residence (Toronto, 2008); and House on the Bluffs (Scarborough, 2011), all in Canada. He has designed office interiors, including those for Agnico-Eagle Mines Ltd. (2008), Aquilon Capital Corpora-

tion Offices (2008), and HudBay Minerals Offices (2011), all in Toronto. He is currently working on two villas on the island of Anguilla, as well as an addition to the Dr. Eric Jackman Institute of Child Study for the University of Toronto (Canada).

## THAM & VIDEGÅRD

**Tham & Videgård Arkitekter**
**Blekingegatan 46**
**11662 Stockholm**
**Sweden**

Tel: +46 8 702 00 46
E-mail: info@tvark.se
Web: www.tvark.se

Tham & Videgård was created in 1999 in Stockholm. It is still directed by its cofounders and chief architects, Bolle Tham (born in 1970) and Martin Videgård (born in 1968). Their work includes the Kalmar Museum of Art (Kalmar, 2004–08); Summer House (Söderöra Island, Stockholm Archipelago, 2007–08, published here); the new Moderna Museet Malmö, the Swedish Museum of Modern Art (Malmö, 2009); the Tellus Nursery School (Telefonplan, Stockholm, 2009–10); Mirrorcube (Harads Treehotel, Harads, 2009–10); and the New School of Architecture at the Royal Institute of Technology (Valhallavägen, Stockholm, 2007–13), all in Sweden. Tham & Videgård is recognized as one of the significant newer firms on the international architecture scene.

## MATTEO THUN

**Matteo Thun & Partners**
**Via Appiani 9**
**20121 Milan**
**Italy**

Tel: +39 02 655 69 11
Fax: +39 02 657 06 46
E-mail: info@matteothun.com
Web: www.matteothun.com

Matteo Thun was born in 1952 in Bolzano, Italy. He studied at the Salzburg Academy with the painter Oskar Kokoschka and received his doctorate in Architecture in Florence in 1975. He began working with Ettore Sottsass in Milan in 1978 and was a cofounding member of the Memphis group with Sottsass in 1981. He was the Chair for Product Design and Ceramics at the Vienna Academy of Applied Arts (1983–2000), and created his own office in Milan in 1984. He served as Creative Director for Swatch from 1990 to 1993. Matteo Thun & Partners, founded in 2001, comprises a team of 60 professionals, architects, interior and product designers, as well as graphic designers, who work on an interdisciplinary basis. The work of the studio ranges from hotels and restaurant interiors to low-energy prefabrication systems, to watches for Bulgari or Swatch, or lighting systems for Zumtobel. Recent examples of his work are the Vodafone Italia Stores (various Italian cities, 2006–08); the Hugo Boss Special Concept Store (New York, New York, USA, 2008); and the Longen-Schloeder Winery (Longuich, Germany, 2011–12, published here). Current work includes the JW Marriott Resort and Spa (Venice, Italy, 2015); the Waldhotel Healthy Living (Bürgenstock, Switzerland, 2015); and the Fontenay Hotel (Hamburg, Germany, 2016).

## TNA

**Makoto Takei + Chie Nabeshima / TNA**
**9-7-3F Sumiyoshicho**
**Shinjuk-ku**
**Tokyo 162-0065**
**Japan**

Tel: +81 3 3225 1901
Fax: +81 3 3225 1902
E-mail: mail@tna-arch.com
Web: www.tna-arch.com

Makoto Takei was born in Tokyo, Japan, in 1974. He graduated from the Department of Architecture of Tokai University in 1997. Between 1997 and 1999, he was at the Tsukamoto Laboratory, Graduate School of Science and Engineering, Tokyo Institute of Technology, and worked with Atelier Bow-Wow. Between 1999 and 2000, he worked in the office of Tezuka Architects, before establishing TNA (Takei-Nabeshima-Architects) with Chie Nabeshima. Chie Nabeshima was born in Kanagawa, Japan, in 1975 and graduated from the course in Habitation Space Design, Department of Architecture and Architectural Engineering, College of Industrial Technology, Nihon University (1998), before working at Tezuka Architects (1998–2005) and cofounding TNA. Their projects include the Color Concrete House (Yokohama, Kanagawa, 2005); Ring House (Karuizawa, Nagano, 2006); Passage House (Karuizawa, Nagano, 2008, published here); Division House (Nagano Prefecture, 2009–10); Mist House (Tokyo, 2011); and the Kamoi Museum (Kurashiki, Okayama, 2012), all in Japan. Recent work includes the Cube House (Schanf, Switzerland, 2012); and the Joushuutomioka Station (Tomioka, Gunma, Japan, 2014).

## TYIN

**TYIN tegnestue Architects**
**Fosenkaia 4b**
**7010 Trondheim**
**Norway**

Tel: +47 73 60 50 12
E-mail: post@tyinarchitects.com
Web: www.tyinarchitects.com

TYIN tegnestue Architects was established in 2008. The office has completed several projects in poor and underdeveloped areas of Thailand, Burma, Haiti, and Uganda. TYIN is currently run by M. Andreas G. Gjertsen and Yashar Hanstad, and has its headquarters in Trondheim, Norway. Their projects include the Safe Haven Library, Tak Province (Thailand, 2009); Old Market Library (Bangkok, Thailand, 2009); a Boathouse (Aure, Møre og Romsdal, Norway, 2010–11, published here); Klong Toey Community Lantern (Bangkok, Thailand, 2011); and the Cassia Co-Op Training Center (Sumatra, Indonesia, 2011).

## ZEROPLUS

**zeroplus**
**1000 South Weller Street**
**Seattle, WA 98104**
**USA**

Tel: +1 206 323 4009
E-mail: mail@0-plus.com
Web: www.0-plus.com

Joshua William Brevoort was a founding Principal of zeroplus (1999). He graduated from the University of Oregon (B.Arch, 1990), and worked at Olson Kundig Architects (1990–99). Lisa Anne Chun obtained her B.Arch degree from the University of Oregon (1989) and then worked with ARC Architects (1994–99), before cofounding zeroplus in 1999 with Brevoort. Their work includes the Sneeoosh Cabin (La Conner, Washington, 2006–07, published here); BIO[da]TA (2008); GU Living City (2010); Turco Newsstand (Seattle, 2009); Poppy Restaurant (Seattle, 2008); Aragona Restaurant (Seattle, 2013); Grade Sculpture Studio (Seattle, 2013); and the Hermosa Beach Residence (Los Angeles, California, 2014), all in the USA.

----

**Marie-Laure Cruschi** is a French illustrator who founded Cruschi-form in Paris in 2007. She was born in 1983 and currently lives in Montreal. Her work combines art, graphic design, illustration, and typography. Her sensitivity to color and simple modular forms allows her to create playful and poetic illustrations that she continuously renews. Marie-Laure Cruschi has long worked on cultural and fashion magazines and children's books, as well as with music and luxury brands.

----

Illustrations: **Cruschiform, Paris**
Design: **Benjamin Wolbergs, Berlin**
Project management: **Inga Hallsson and Florian Kobler, Berlin**
Collaboration: **Harriet Graham, Turin**
Production: **Ute Wachendorf, Cologne**
German translation: **Gregor Runge, Berlin**
French translation: **Claire Debard, Freiburg**

Printed in China

ISBN 978-3-8365-5026-0